DICTIONARY OF SUBJECTS
AND SYMBOLS IN ART

JAMES HALL

Dictionary of Subjects and Symbols in Art

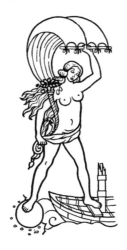

INTRODUCTION BY
KENNETH CLARK

ICON EDITIONS
HARPER & ROW, PUBLISHERS
NEW YORK, EVANSTON, SAN FRANCISCO, LONDON

FIRST U.S. EDITION

ISBN 0-06-433315-9

LIBRARY OF CONGRESS CATALOG CARD NUMBER: 74-6578

Contents

Introduction by Kenneth Clark

Fifty years ago we were told that the subjects of pictures were of no importance; all that mattered was the form (then called 'significant form') and the colour. This was a curious aberration of criticism, because all artists, from the cave painters onwards, had attached great importance to their subject matter; Giotto, Giovanni Bellini, Titian, Michelangelo, Poussin or Rembrandt would have thought it incredible that so absurd a doctrine could have gained currency. In the 1930s, the tide began to turn. In art history the pioneer of this change was a man of original genius named Aby Warburg, and although he himself, for various reasons, left only fragments of his prodigious learning, his influence produced a group of scholars who discovered, in the subjects of mediaeval and renaissance art, layer upon layer of meaning that had been almost completely overlooked by the 'formalist' critics of the preceding generation. One of them, Erwin Panofsky, was unquestionably the greatest art historian of his time.

Meanwhile the average man had become progressively less able to recognize the subjects or understand the meaning of the works of art of the past. Fewer people had read the classics of Greek and Roman literature, and relatively few people read the Bible with the same diligence that their parents had done. It comes as a shock to an elderly man to find how many biblical references have become completely incomprehensible to the present generation. As for the more esoteric sources of pictorial motives, very few people have read the Golden Legend or the Apocryphal Gospels, although without them the full meaning of such supreme works of art as (for example) Giotto's frescoes in the Arena Chapel, cannot be grasped.

Although we are all grateful for the ingenious elucidations of the Warburg Institute or the Department of Fine Arts at the University of Princeton, what the ordinary traveller with an interest in art and a modicum of curiosity requires is a book which will tell him the meaning of subjects which every amateur would have recognized from the middle ages down to the late eighteenth century. The identification of these themes will add greatly to his pleasure in looking at sculpture or painting as 'works of art'. The old painters took their subjects seriously. It is true that they often followed traditional models, but they always wished the spectator to believe that the incidents they depicted had really happened and were still worth remembering. Composition, design, even colour, were used to make these subjects more vivid and comprehensible. If we do not know what a picture

or series of pictures represents, our attention soon wanders, and our so-called 'aesthetic experience' is curtailed.

Mr. Hall's book is intended to help the non-specialist art lover to look at pictures and sculpture with more understanding. It contains much that anyone of average education and over fifty years of age will know already. It also contains a good deal that is new to me, and so, I suppose, will be unfamiliar to some other readers. It is clearly written, well arranged, and can be read for its own sake as a compendium of the image-making faculty of western man. I would recommend it strongly to anyone who wishes to increase his interest and pleasure in visiting a picture gallery or turning over the illustrations of a book on art.

KENNETH CLARK

Preface

This book is about the subject-matter of art, about the stories it tells and the people it portrays. It is concerned not with individual works but with themes, that is to say subjects that recur in the work of artists and craftsmen who lived at different times and in different countries.* Some of these themes have a very long history indeed. For example stories from the Bible, especially ones that could be used to illustrate Christian doctrine, are found in wall painting dating from the 3rd cent. The classical gods and goddesses, after many centuries of comparative obscurity, emerged again at the end of the Middle Ages in scenes of their ancient loves, conflicts and revelry.

The book is devoted mainly, though not exclusively, to Christian and classical themes as they are found in the West, the latter mostly from the Renaissance or later. The repertoire of religious art is derived from numerous sources besides the canonical books of the Bible: there are the legends of the saints, the stories from the Old and New Testament Apocrypha (in the latter we have the life of the Virgin Mary), and the writings of medieval Christian mystics and others. Secular (non-Christian) themes include not only the gods and goddesses of Greek and Roman mythology, but the heroes, legendary or otherwise, of ancient history. The figures of moral allegory, often related in their visual aspect to the pagan gods, are included, as are the characters from romantic epic poetry that established themselves in the art of the 17th cent. and later. The reader will also find here some of the more popular figures in northern European genre painting, the alchemist, the quack doctor and so on.

The field is not quite so large as it might at first appear because religious art, under the guidance of the Church, was restricted to a fairly well-defined range of themes, and the choice of secular subject-matter showed a similar tendency to be channelled by the taste of patrons and the existence of literary sources. Even so, some selection has been unavoidable. On the whole I have concentrated on what might be called the mainstream of the Christian and humanist tradition in art and on subjects of which more than just one example exists. This means for instance that much of the Pre-Raphaelite narrative painting falls outside the scope of the book. As for the Christian saints I have been influenced in favour of those whose

* Individual works of art are mentioned only in the case of comparatively rare or unfamiliar themes or, occasionally, to illustrate a point.

cultus and iconography are general rather than local. Straight historical subjects, battles and the like, that contain no secondary, symbolic, meaning have no place here either.

Entries are arranged in one alphabetical sequence. They are of several kinds: *Descriptions of persons* (and personifications) with their identifying 'attributes' and the themes in which they play the principal part – cross-references lead to the themes in other articles where their role is secondary. For example, under the entry for Venus will be found 'Venus and Adonis' and a cross-reference to 'Judgement of Paris'. *Titles of pictures*, when well-established and familiar, have their own entry: 'Raising of Lazarus', 'Rape of Europa'. *Objects*, especially those traditionally associated with a person as a means of identification (his 'attribute') – each has an article which lists its owners. Under 'Lion' are references to St Jerome and Hercules, under 'Arrow' are Cupid, Diana and St Sebastian.

The elucidation of the 'lost language' of attribute and symbol has been carried far by modern scholarship. It is not only a fascinating subject in itself leading one to a fuller understanding of a work of art, it helps the present-day spectator to see it as the artist's contemporaries saw it. At its simplest level an attribute tells us whom the artist wishes us to recognize in the figure he has depicted. The pig with a bell round its neck standing beside an old cowled monk identifies him as St Antony the Great. (Why a pig with a bell? One explanation is that the pigs bred by the Antonine monks enjoyed special grazing rights and were therefore distinguished in this way.) But an object sometimes does more than just identify, it may stand instead of someone or something. It is then no longer an attribute but has become a kind of visual metaphor, or symbol. Well-known examples are the dove that stands for the Holy Ghost, and the fish for Christ. Renaissance artists, by combining symbols, wove elaborate, complicated allegories into their pictures. Still-life painting, especially in the hands of the Dutch and Flemish masters of the 17th cent., often has symbolic overtones: courtship and love in musical instruments, the vanity of human life in a skull and hour-glass and many other everyday objects, the Christian message in a loaf of bread, a jug and a bunch of grapes. The elements of a picture make not only a unity of design but contain a unity of meaning, sometimes not immediately recognizable. It is one purpose of this book to provide some of the keys.

There are a number of 'signpost' articles to lead the reader to the subject of a picture when he has no external aids to identification and the figures lack any formal attributes. There are personal types such as 'Warrior', 'Hunter', 'Preacher', 'Pilgrim', 'Beggar', 'Artist', 'Writer', 'Infant', 'Blindness' and 'Blindfolding'. Activities or situations are found under 'Lovers', 'Judgement', 'Battle, Scenes of', 'Combatants' (usually

two), 'Death, Scenes of', 'Prayer', 'Repast' and so on. Ones involving what might be termed a disparate relationship are under 'Benediction', 'Supplication', 'Obeisance' or 'Succour'. Numbers may give a clue: 'Three Graces', 'Four Seasons', 'Five Senses'. Remember that among object-articles are parts of the body: 'Head', 'Breast', 'Hand', 'Foot', 'Hair', 'Eye' and others.

In the notes on the following pages are brief explanations of the concept of 'typology' in the Old Testament, the naming of Greek and Roman deities, and the *impresa*.

Acknowledgements

Among the numerous people to whom I have become indebted in the course of writing this book I should like to thank in particular Mr Alistair Smith for his advice and help on countless matters of Renaissance iconography and for putting me on the track of many an object and theme; Mr John Warrington, especially on matters of Church history, hagiology and classical mythology; Miss Carol F. Thompson for her drawings; and my wife Stella not only for her enthusiasm and helpful criticism but for long hours spent at the typewriter. It goes without saying that any errors and omissions are wholly my responsibility.

I am grateful to the following for permission to quote from copyright works:

Oxford and Cambridge University Presses: *The New English Bible*, 2nd ed. © 1970.

Clarendon Press, Oxford: *The Apocryphal New Testament*, translated by M. R. James, 1924.

Mr Robert Graves: Apuleius' *The Golden Ass*, translated by him, 1950.

Penguin Books Ltd: *The Divine Comedy*, translated by Dorothy L. Sayers and Barbara Reynolds, copyright © Anthony Fleming, 1962.

Of the books listed in the bibliography I should mention those that have been my more constant companions: *Iconographie de l'art Chrétien* by Louis Réau; *Barockthemen* by André Pigler; the volumes by Emile Mâle; *Studies in Iconology* and *Early Netherlandish Painting* among the works of Erwin Panofsky; the dictionary of attributes and symbols by Guy de Tervarent; *Iconographie de l'art profane* by Raimond van Marle.

The bibliography as a whole should be regarded as a list of acknowledgements, not merely a guide to further reading.

Notes

THE TYPOLOGY OF THE OLD TESTAMENT

The doctrine that the Scriptures, as divine revelation, form a coherent, integrated whole, their authors guided by the hand of God, was developed by the early Fathers of the Church into a more specific system of correspondences between the two parts. People and events in the Old Testament were seen as having exact counterparts in the New, in other words they were a kind of foreshadowing, or prefiguration, of the future. Abraham's 'sacrifice' of his son Isaac foreshadowed God's sacrifice of Christ; David was seen as a type – in the sense of the original model – of Christ, and his fight with Goliath represented the struggle of Christ with Satan. 'The Old Testament', St Augustine wrote in the *City of God*, 'is nothing but the New covered with a veil, and the New is nothing but the Old unveiled.' Examples of themes that are grouped in such a way as to illustrate their typological relationship may be seen in the medieval *Biblia Pauperum* and in church windows, where a scene from the New Testament is accompanied by one or more relevant episodes from the Old. In time, the themes from the Old Testament that had been given this special relationship acquired an importance in their own right and became established as separate subjects in Christian art. Some of the classical myths too were treated in a similar way by the medieval Church. The story of Danaë, for example, the virgin who was made pregnant by Jupiter in the form of a shower of gold, was regarded as a prefiguration of the Annunciation. This was one of the ways in which the medieval Church came to terms with the pagan world.

THE NAMING OF GODS AND GODDESSES

How has it come about that Roman names are used for the deities in myths of Greek origin? It was Aphrodite who was born of the waves, yet Botticelli depicted the birth of Venus; Dionysus rescued Ariadne from Naxos, yet Titian painted Bacchus coming to her aid. It was not uncommon in antiquity for the gods of one religion to become identified with those of another. The process often occurred between the gods of one nation and another as the result of conquest, or through contacts established by seafaring peoples in the course of trade. The assimilation of Greek gods with Roman probably began before the expansion of Rome, through the influence of Greek colonies in southern Italy and Sicily, and

was well-established by the end of the 3rd cent. B.C. Identification tended to occur between gods having like functions or characteristics, or simply because they were worshipped in the same locality. Thus the Roman god Mars adopted the features and accompanying myths of the Greek god of war Ares. Vulcan, the god of volcanoes, took over the Greek smith-god Hephaestus – who likewise had volcanic connections – acquiring in the process his anvil and other attributes. Venus, on the other hand, originally a comparatively insignificant Roman deity connected with vegetable-growing, was promoted to the front rank by her identification with Aphrodite, without having any obvious similarities. The old Roman divinities, on the whole rather characterless and lacking in colour, were much enriched by their assimilation with the Greek pantheon and its extensive mythology. The Latin language, spread by Roman conquest and kept alive by the early Church, became for many centuries the *lingua franca* of learned intercourse over a large part of Europe, and the classical myths were thus best known in the Latin authors, especially Ovid and Virgil. In England in the 15th and 16th cents. Ovid was the most widely read of the classical poets, and the translation of his *Metamorphoses* by Golding was probably the main source of the mythological imagery in Shakespeare and Milton. In this way the Greek deities have come down to us in their latinized versions. Even those from Homer, when represented in art, are commonly known by their Latin names. The following are frequently met.

Aesculapius, Asclepius	Juno, Hera	Proserpina, Persephone
Aurora, Eos	Jupiter, Zeus	Saturn, Cronus
Bacchus, Dionysus	Latona, Leto	Sol, Helios
Ceres, Demeter	Luna, Selene	Ulysses, Odysseus
Cupid (or Amor), Eros	Mars, Ares	Venus, Aphrodite
Diana, Artemis	Mercury, Hermes	Vesta, Hestia
Hercules, Heracles	Neptune, Poseidon	Vulcan, Hephaestus

THE IMPRESA

The *impresa* was a 'device' consisting of a simple image and an accompanying motto; its use flourished among the educated classes in Renaissance Italy. Unlike armorial bearings which served to identify a family through successive generations the *impresa* was primarily intended to be a personal device adopted by, or sometimes conferred on, an individual perhaps to commemorate some significant event in his life such as a feat of arms or affair of the heart, or to illustrate a trait of character. The word is from the Italian meaning an enterprise or undertaking. Its antecedent was the *impresa amorosa*, the personal emblem worn by the jousting knight, whose meaning was understood only by his chosen lady. It was a requirement also

of the later *impresa* that its sense be veiled and yet remain intelligible to one with a courtier's upbringing. The picture and motto were required to complement each other so that neither should alone convey the full meaning: thus the picture came to be called the *corpo*, or body, and the words, often in the form of a graceful pun, were known as the *anima*, or spirit, without which the body had no life. A good example of such a device was the porcupine of Louis XII of France whose armies invaded Italy in 1499 and from whom the Italian fashion for *imprese* may have originated. The porcupine was represented with its spines shooting off its body in all directions like spears (which according to Pliny was the way in which it defended itself). The accompanying motto *Cominus et eminus* – hand to hand and at a distance – alluded to the king's power to strike his enemies both near and far. The popularity of the *impresa* grew rapidly in the 16th and 17th cents., fostered by a considerable literature. It was adopted not only by the nobility but by judges, lawyers, ecclesiastics, artists and others. Those of the great families, patrons of the arts like the Medici, Gonzaga and Farnese, are to be seen in their palaces, often in the corners of decorated ceilings. They are occasionally incorporated in easel paintings.

Sources

*Only those works to which reference is made in the text
are mentioned below. Books of the Bible are omitted.*

ACTS OF PILATE, see NEW TESTAMENT APOCRYPHA.

AELIAN (Claudius Aelianus) (3rd cent. A.D.). Author of *Variae Historiae*, a series of studies of famous men and women in fourteen books, originally in Greek.

APOLLODORUS (2nd cent. B.C.), native of Athens. The *Bibliothēkē*, a collection of myths formerly attributed to him, probably belongs to the early Christian era.

APOLLONIUS OF RHODES (*c.* 295 – *c.* 215 B.C.). Poet and grammarian, citizen of Alexandria who spent part of his life at Rhodes. Author of the *Argonautica*, the epic account of Jason's quest for the Golden Fleece, the only extended version of the story that survives.

APULEIUS, LUCIUS. Born at Madaura in north Africa early in the 2nd cent. A.D., educated in Athens and Carthage in which latter town he settled. The author of philosophical treatises, but best known for the *Metamorphoses, or The Golden Ass*, a romance in which the narrator is magically turned into an ass. It includes the story of Cupid and Psyche.

ARIOSTO, LUDOVICO (1474–1533). Italian poet and playwright, born at Reggio, the author of *Orlando Furioso*, a romantic epic in verse, first published in 1516, appearing in its final enlarged form in 1532. It deals with the wars between Christians and Saracens at the time of Charlemagne with much interweaving of characters and plot.

ARISTOTLE (384–322 B.C.). Greek philosopher, born at Stageira. His very numerous and varied works include ones on the natural sciences. The *Historia Animalium* assembles and classifies what was then known about animal life. It was an early antecedent of the medieval bestiary.

BOCCACCIO, GIOVANNI (1313–75). Italian poet and prose writer, born in Paris, he lived much of his life in Florence. The *Decameron* (1348–58) is a collection of one hundred mostly amorous tales concerning people from all walks of life in his day. The *De Genealogia Deorum* (1373) is a manual of classical mythology and was an important source-book for Renaissance artists.

BOETHIUS, ANICIUS MANLIUS SEVERINUS (*c.* A.D. 480–*c.* 524). Late Roman statesman and philosopher; the author of *De Consolatione Philosophiae*, written in prison, a dialogue with Philosophy (personified as a woman) on the nature of good and evil. Boethius writes from a non-Christian standpoint.

BOOK OF JAMES, see NEW TESTAMENT APOCRYPHA.

BRANT (BRANDT), SEBASTIAN (1458–1521). German satirical writer and poet, born at Strasburg. His best-known work, the *Ship of Fools* (*Das Narrenschiff*)

(1494) is a topical satire in verse on the follies and vices of his fellow men. It was widely translated, and may have inspired Erasmus' *Praise of Folly*.

CATULLUS, GAIUS VALERIUS (*c.* 84–54 B.C.). Latin poet, born probably at Verona, lived in Rome. His verses, collectively called the *Carmina* ('lyric poems'), are mostly short and highly personal. They often evoke scenes from the classical myths. Those addressed to his mistress Lesbia (Clodia Metelli) are among the best known.

CERVANTES SAAVEDRA, MIGUEL DE (1547–1615). Spanish novelist, playwright and poet, born at Alcala de Henares, near Madrid. *Don Quixote de la Mancha* was published in two parts in 1604 and 1614. Many editions have been illustrated, by French artists in particular.

DANTE ALIGHIERI (1265–1321). Italian poet, born in Florence. The *Vita Nuova* is a series of thirty-one love poems addressed to Beatrice dei Portinari, each with an explanatory narrative and analytical commentary. The *Divine Comedy*, in three parts, *Inferno*, *Purgatorio* and *Paradiso*, was completed in the closing years of his life. It appeared in many illustrated editions including one with drawings by Botticelli. Its influence on Christian iconography was considerable, for example in the treatment of heaven and hell in Italian Renaissance painting.

DARES PHRYGIUS. Trojan priest of Hephaestus (*Iliad* 5:9) to whom was once attributed the authorship of the *Daretis Phrygii de excidio Troiae historia*. The work probably originated with the earliest extant Latin version, about 5th cent. A.D. It was a popular medieval source-book of the story of Troy, though historically worthless.

DICTYS CRETENSIS. Legendary Cretan, said to have been present at the Trojan war. The *Ephemeris Belli Troiani* (4th cent. A.D.) purported to be the translation of an original account in Greek by him. Like the *History* of Dares Phrygius it was much used by medieval writers on Troy.

DIODORUS SICULUS (1st cent. B.C.). Sicilian, author of the *Bibliotheca Historica*, a history of the world in Greek from the early myths of gods and heroes down to the time of Julius Caesar. Fifteen of its forty books have survived.

DIOGENES LAERTIUS (*fl.* first half of 3rd cent. A.D.) probably of Laerte in Cilicia. Author of *Lives of the Philosophers*, a series of anecdotal biographies of the classical Greek philosophers.

EUSEBIUS OF CAESAREA (*c.* A.D. 260–*c.* 340). Born probably at Caesarea in Palestine where he became bishop. His *History of the Church* is a unique account of the development of early Christianity. It appeared about 324. He wrote a life of Constantine the Great.

FÉNELON, FRANÇOIS DE SALIGNAC DE LA MOTHE (1651–1715). Archbishop of Cambrai, born at the château of Fénelon in Périgord. He wrote on religious, educational and other matters. The *Adventures of Telemachus* (1699) amplifies the account in the *Odyssey* of Telemachus' travels in search of his father, combining it with political and moral instruction.

GESTA ROMANORUM. 'The Deeds of the Romans' – a medieval compilation (13th–14th cent.) of stories from classical antiquity and elsewhere, presented for the reader's moral edification.

GOLDEN LEGEND, see VORAGINE, JACOBUS DE.

GOSPEL OF NICODEMUS, see NEW TESTAMENT APOCRYPHA.

GOSPEL OF THOMAS, see NEW TESTAMENT APOCRYPHA.

GUARINI, BATTISTA (1538–1612). Italian pastoral poet, born at Ferrara. The author of *Il Pastor Fido*, 'The Faithful Shepherd' (1589), a play in verse, the source of several themes in baroque painting.

HERODOTUS (*c.* 484–*c.* 424 B.C.). The 'father of history', born at Halicarnassus in Asia Minor. His work is an account of the wars between Greece and Persia. It is interwoven with anecdote and portrayal of character which provided themes for Renaissance and later art.

HESIOD (*c.* 8th cent. B.C.). Early Greek poet and Boeotian farmer, born at Ascra by Mt Helicon. The *Work and Days* deals with the hardships of rural life, the virtue of toil and the need for justice. The *Theogony* is a history of the Greek gods; its authorship is disputed.

HOMER. Greek epic poet of about 9th cent. B.C., reputed author of the *Iliad* and the *Odyssey*. Some authorities have questioned whether he himself wrote either work, or even whether he existed. The *Iliad* describes the individual conflicts between Greek and Trojan heroes during a period of the siege of Troy, with Achilles as the central character; the *Odyssey* describes the adventures of the Greek hero Odysseus on his journey home to Ithaca after the fall of Troy. (See also above, DARES PHRYGIUS; DICTYS CRETENSIS; FÉNELON.)

HOOFT, PIETER CORNELISZOON (1581–1647). Dutch playwright and poet, born in Amsterdam. The pastoral play *Granida* (1605) reflects the influence on him of French and Italian Renaissance culture.

HORACE (Quintus Horatius Flaccus) (65–8 B.C.). Roman poet, born at Venusia. The four books of *Odes*, lyric poems about life, death and the role of the poet, contain his best work.

HYGINUS, GAIUS JULIUS (*fl. c.* 25 B.C.). Roman scholar of Spanish origin, a freed slave, a friend of Ovid. The *Fabulae* (or *Genealogiae*), a compilation of some 300 myths and legends, formerly attributed to him, are now thought to be 2nd cent. A.D.

IMAGINES, unless otherwise attributed, see PHILOSTRATUS.

JUVENAL (Decimus Junius Juvenalis) (*c.* A.D. 60–*c.* 130). Roman satirist. The sixteen *Satires* in five books deal with the corruption and follies of those in public life in his day.

LIVY (Titus Livius) (*c.* 59 B.C.–A.D. 17). Roman historian, born at Padua. His *History of Rome* (*Ab Urbe Condita*) from its legendary foundation was in 142 books of which only part survives. He illustrated all types of moral conduct, good and bad, which provided Renaissance artists with many useful models.

LONGUS (*c.* 3rd or 4th cent. A.D.). Author of one of the earliest pastoral novels, *Daphnis and Chloe*, in Greek. Nothing is known of his life.

LUCIAN (*c.* A.D. 115–after 180). Rhetorician and satirist, born at Samosata in Turkey. His works cover a wide range. *The Dialogues of the Gods* (*Deorum Dialogi*) is a satirical treatment of the Greek myths. The *Imagines* (*Eikones*) consists of sketches purporting to be descriptions of works of art.

METAMORPHOSES, unless otherwise attributed, see OVID.

NEW TESTAMENT APOCRYPHA. The New Testament canon was established not by any decree but by a gradual process of winnowing from a much larger body of early writings. By the end of the 2nd cent. the four gospels, the Acts and the Pauline epistles had been recognized. The criteria applied by the early Fathers were those of apostolic authorship and the extent to which a work had gained general acceptance among the churches. The residue of rejected writings, some of very early date, forms what is called the New Testament Apocrypha. It includes stories of the infancy and child-hood of Christ, the birth and death of the Virgin, the Passion, Acts of apostles, Epistles and Apocalypses, categories in many respects similar to those of the canon. Many of the stories found their way into the *Golden Legend* and so became widely disseminated in the Middle Ages. The follow-ing works are important iconographically:

Book of James (called *Protevangelium* from the 16th cent.) (2nd cent.). Nativity and childhood of the Virgin. Nativity of Christ.

Gospel of Thomas (2nd cent.). Childhood of Christ.

Gospel of Nicodemus, or *Acts of Pilate* (4th and 5th cents.). Passion. Descent into Limbo.

An account of the Death and Assumption of the Virgin attributed to Melito, bishop of Sardis (about 4th cent.).

The Acts of various apostles: *John* (2nd cent.): The Raising of Drusiana, etc. *Paul* (2nd cent.): The story of Thecla. *Peter* (end 2nd cent.): Simon Magus, Domine quo vadis, etc. *Andrew* (3rd cent.): incidents on his missionary journeys and crucifixion. *Thomas* (3rd cent.): King Gundaphorus, etc.

OVID (Publius Ovidius Naso) (43 B.C.–A.D. 17). Latin poet, born at Sulmo east of Rome; exiled to Tomi on the Black Sea at the age of fifty, where he died. The *Metamorphoses* is a retelling of the myths and legends of Greece and Rome, and the east, ingeniously arranged as a continuous narrative in verse. Ovid was widely read in the Middle Ages and the *Metamorphoses* was translated into several languages. A popular version, known as the 'Moralized Ovid', gave Christian interpretations of the myths, making them into prefigurations of biblical events. The *Fasti* (*Festivals*) is a poetic treatment of the Roman calendar and embodies legend, history and descriptions of the seasonal rites and festivals. Only six books, January to June, exist.

PAUSANIAS (2nd cent. A.D.). Greek traveller, probably of Lydia in Asia Minor, the author of an itinerary of Greece (*Hellados Periegesis*) in ten books, describing in detail the Greek cities and religious sites as they then stood.

PETRARCH (Francesco Petrarca) (1304–74). Italian poet and pioneer of the Renaissance movement in Italy. The epic poem *Africa*, in Latin, a history of the second Punic War, extols the Roman general Scipio Africanus Major and contains many descriptions of the classical deities. The *Trionfi* are a set of allegorical poems in which each succeeding figure triumphs over the last (Love, Chastity, Death, etc.).

PHILOSTRATUS. The name of a Greek family from Lemnos three or four of

whom were rhetoricians and writers. The *Imagines* (*Eikones*) is a series of descriptions of pictures, in two books. The first is attributed to Philostratus 'the Elder' (*c.* A.D. 170–*c.* 245), the second to his grandson, known as 'the Younger'. The subjects are mostly from classical mythology, though none has been identified with any known work of art. During the Renaissance they were copied by writers of mythographical manuals and inspired numerous pictures.

PHYSIOLOGUS (The 'naturalist'). Name given to the anonymous Greek author (A.D. 2nd cent. or later) of a natural history of animals. It drew on Aristotle, Pliny and other early sources. It became widely diffused through Europe and the Mediterranean and was the predecessor of the medieval bestiary.

PLATO (*c.* 427–*c.* 347 B.C.). Greek philosopher, born at Athens. His Theory of Ideas, in the *Republic* and *Phaedo*, asserts the existence of pure forms (justice, temperance, fortitude, etc.) underlying and distinct from their individual manifestations. From this concept were ultimately derived some of the personifications in art of the virtues and vices. The *Phaedo* contains the description of the death of Socrates in prison. The *Symposium* (the 'Banquet') is a dialogue on the nature of love.

PLINY THE ELDER (Gaius Plinius Secundus) (A.D. 23–79). Born probably at Como. Of his prolific writings only the *Historia Naturalis*, in thirty-seven books, survives. Books 35 and 36 in particular deal with art and artists.

PLUTARCH (*c.* A.D. 46–after 120). Greek biographer and moralist, born at Chaeronea in Boeotia. His *Lives* of the ancient kings, statesmen and philosophers are mostly arranged in pairs (one Greek, one Roman) followed by a comparison of the two. The emphasis is moral rather than historical. Its influence on later ages was considerable.

PROTEVANGELIUM, see NEW TESTAMENT APOCRYPHA.

PRUDENTIUS, AURELIUS CLEMENS (A.D. 348–after 405). Religious poet, born in Spain; author of the *Psychomachia* (battle for the soul), a long allegorical poem in which the virtues and vices are personified and engage in combat. The subject lent itself to illustration and was widely popular in the Middle Ages.

RIPA, CESARE (*c.* 1560–before 1625). Italian iconographer, born in Perugia; author of the *Iconologia*, descriptions of the allegorical figures of the virtues and vices, the arts, seasons, parts of the world, etc. The first edition, 1593, was unillustrated; the third, 1603, was greatly expanded and illustrated. It rapidly became a standard reference work for artists of western Europe, especially of the Counter-Reformation.

SENECA, LUCIUS ANNAEUS (*c.* 4 B.C.–A.D. 65). Latin Stoic philosopher, born at Corduba (Cordova) in Spain. The *De Beneficiis*, one of a group of Moral Essays, deals with the nature and effects of benefaction, of giving and receiving. The *De Ira* treats of anger and the ways of controlling it. Stoic thought was felt by the Middle Ages and Renaissance to have affinities with Christian morality.

STATIUS, PUBLIUS PAPINIUS (*c.* A.D. 45–96). Latin poet, born at Neapolis (Naples). The *Achilleid*, an epic poem of which only the first part exists, describes the childhood and youth of Achilles.

TACITUS, PUBLIUS CORNELIUS (*c.* A.D. 56–after 117). Roman historian. The *Histories* deals with the period A.D. 68 to 96, from the emperor Galba to Domitian; the *Annals* with the earlier period, A.D. 14 to 68, from the death of Augustus to the death of Nero. Parts of both works are lost.

TASSO, TORQUATO (1544–95). Italian poet, born at Sorrento. The *Gerusalemme Liberata* (*Jerusalem Delivered*) (1575) is a romantic epic poem describing the capture of Jerusalem in the First Crusade by Godfrey of Bouillon. The story contains many amorous adventures between Christian and pagan men and women.

TERENCE (PUBLIUS TERENTIUS AFER) (*c.* 185–159 B.C.). Latin comic poet and playwright, born at Carthage. He came to Rome as a slave and was later freed. The *Eunuch* (162), one of six surviving plays in verse, was adapted from Menander. Terence was performed in Renaissance Italy and influenced later European comic drama.

THEOCRITUS (3rd cent. B.C.). Greek pastoral poet, born probably at Syracuse. His *Idylls* are the earliest bucolic poetry, set in the Sicilian countryside. They were the foundation of the pastoral tradition which flowered in the Renaissance and the 17th cent.

VALERIUS MAXIMUS. Roman historian, living at the time of Tiberius; author of *De Factis Dictisque Memorabilibus Libri IX*, a varied collection of short anecdotes giving examples of good and bad conduct from the lives of the famous, notable events and customs, etc., arranged in nine books. It was popular in the Middle Ages and Renaissance.

VIRGIL (PUBLIUS VERGILIUS MARO) (70–19 B.C.). Latin poet, born at Andes near Mantua. The *Aeneid*, his last work, is the epic story of the journey of the Trojan prince Aeneas and his companions, and their settlement in Latium. For the Romans of Virgil's day it lent substance to an old legend that they were descended from the ancient heroes and hence from the gods. The *Eclogues* (*c.* 37) are pastoral poems in the vein of Theocritus. The *Georgics* (30) describe the ideal life and work of the countryman.

VORAGINE, JACOBUS DE (*c.* 1230–*c.* 1298). Dominican friar who became Archbishop of Genoa. He was the author of the *Golden Legend* (*Legenda Aurea*) (*c.* 1275), a compilation of the lives of the saints, legends of the Virgin and other narratives relating to the Church's feast days. They are arranged in the order of the Church calendar, starting with Advent. Its influence on Christian iconography was very great. It was first translated into English by Caxton in 1483 from a French version.

XENOPHON (*c.* 430–*c.* 355 B.C.). Athenian general and historian, a friend of Socrates. The *Memorabilia* is one of a group of works dealing with aspects of the life and teaching of Socrates.

Bibliography

A selection of iconographical studies and reference books for further reading.

ACKERMAN, PHYLLIS. 'The Lady and the Unicorn,' *Burlington Magazine*, vol. 66, Jan. 1935, p. 35 ff.

AVALON, J. 'Le bain de Bethsabée,' *Aesculape*, vol. 26, 1936, p. 121 ff.

BEHLING, LOTTLISA. *Die Pflanze in der mittelalterlichen Tafelmalerei.* Weimar, 1957.

BERGSTRÖM, INGVAR. 'Disguised Symbolism in "Madonna" pictures and Still Life,' *Burlington Magazine*, vol. 97, Oct. 1955, p. 303 ff; Nov. 1955, p. 342 ff.

BORENIUS, TANCRED. *St Thomas Becket in Art.* London, 1932.

BRECKENRIDGE, JAMES D. '"Et Prima Vidit": The Iconography of the Appearance of Christ to his Mother,' *Art Bulletin*, vol. 39, March 1957, p. 9 ff.

BURCKHARDT, JACOB. *The Civilisation of the Period of the Renaissance in Italy.* (Transl. by S. G. C. Middlemore from the 15th ed.) London, 1929.

CEULENEER, A. DE. 'La charité romaine dans la littérature et l'art,' *Annales de l'Académie Royale d'Archéologie de Belgique,* Anvers, 1920.

CLARK, KENNETH. *The Nude.* London, 1956.

COPE, GILBERT F. *Symbolism in the Bible and the Church.* London, 1959.

DIDRON, A. N. *Christian Iconography* (Transl. by E. J. Millington). London, 1851.

DROULERS, EUGÈNE. *Dictionnaire des attributs, allégories, emblèmes et symboles.* Turnhout, 1949.

FERGUSON, GEORGE. *Signs and Symbols in Christian Art.* New York, 1954.

FREYHAN, R. 'The Evolution of the Caritas figure in the Thirteenth and Fourteenth Centuries,' *Journal of the Warburg and Courtauld Institutes*, vol. 11, 1948, p. 68 ff.

FRIEDMANN, H. *The symbolic Goldfinch.* Washington, 1946.

FRITZ, R. 'Die Darstellungen des Turmbaus zu Babel in der bildenden Kunst,' *Mitteilungen der Deutschen Orientgesellschaft*, no. 71, 1932, p. 15 ff.

GELLI, JACOPO. *Divise, motti e imprese di famiglie e personaggi italiani.* Milan, 1916.

GODFREY, F. M. 'Four Representations of the Prodigal Son,' *Apollo*, vol. 50, July 1949, pp. 3–4.

——'The Baptism of Christ in Flemish painting and Miniature,' *Apollo* vol. 52, Nov. 1950, p. 132 ff.

——'Southern European Representations of the Baptism of Christ,' *Apollo* vol. 53, Apr. 1951, p. 92 ff.

GOLDMAN, HETTY. 'The Origin of the Greek Herm,' *American Journal of Archaeology*, vol. 46, 1942, p. 58 ff.

GOMBRICH, E. H. 'The Subject of Poussin's *Orion*,' *Burlington Magazine*, vol. 84, Feb. 1944, p. 37 ff.

—— *Symbolic Images: Studies in the Art of the Renaissance.* London, 1972.

GUDLAUGSSON, S. J. 'Representations of Granida in Dutch Seventeenth-Century Painting,' *Burlington Magazine*, vol. 90, Aug. 1948, p. 226 ff; Dec. 1948, p. 348 ff; vol. 91, Feb. 1949, p. 39 ff.

HAIG, E. *The floral Symbolism of the Great Masters*, London, 1913.

HARTT, FREDERICK. 'Gonzaga Symbols in the Palazzo del Te,' *Journal of the Warburg and Courtauld Institutes*, vol. 13, 1950, p. 151 ff.

HOHLER, C. 'The Badge of St James,' in *The Scallop: Studies of a shell and its influences on humankind.* London, 1957.

HUGHES, ROBERT. *Heaven and Hell in Western Art.* London, 1968.

HUTCHISON, JANE CAMPBELL. 'The Housebook Master and the Folly of the Wise Man,' *Art Bulletin*, vol. 48, March 1966, p. 73 ff. (Aristotle and Campaspe.)

JAMES, M. R. *The Apocryphal New Testament.* Oxford, 1924.

JAMESON, ANNA B. *Legends of the Madonna.* London, 1852.

—— *Legends of the Monastic Orders.* London, 1850.

—— *Sacred and Legendary Art.* London, 1848.

—— *The History of Our Lord.* (Completed by Lady Eastlake.) London, 1864.

JANSON, H. W. 'A *Memento Mori* among early Italian prints,' *Journal of the Warburg and Courtauld Institutes*, vol. 3, 1939–40, p. 243 ff. (Wild Man.)

—— *Apes and Ape Lore in the Middle Ages and the Renaissance* (Studies of the Warburg Institute, vol. 20) London, 1952.

KAFTAL, GEORGE. *The Saints in Italian Art.* Vol. 1: 'Iconography of the Saints in Tuscan Painting,' Florence, 1952. Vol. 2: 'Iconography of the Saints in central and south Italian schools of painting,' Florence, 1965.

KATZENELLENBOGEN, A. *Allegories of the Virtues and Vices in medieval Art.* (Studies of the Warburg Institute, vol. 10.) London, 1939.

KIBISH, CHRISTINE OZAROWSKA. 'Lucas Cranach's *Christ blessing the Children*: a problem of Lutheran iconography,' *Art Bulletin*, vol. 37, Sept. 1955, p. 196 ff.

KIRSCHBAUM, ENGELBERT (and collaborators). *Lexikon der Christlichen Ikonographie.* Freiburg im Breisgau, 1968–72.

KNIPPING, B. *De Iconografie van de Contra-Reformatie in de Nederlanden.* Hilversum, 1939–40.

KÜNSTLE, KARL. *Ikonographie der christlichen Kunst.* Freiburg, 1926–8.

KUNSTMANN, JOSEF. *The Transformation of Eros.* Edinburgh, 1964. (Putto.).

LADOUÉ, PIERRE. 'La scène de l'Annonciation vue par les peintres,' *Gazette des Beaux-Arts*, s.6, vol. 39, 1952, p. 351 ff.

LARSON, ORVILLE K. 'Ascension Images in Art and Theatre,' *Gazette des Beaux-Arts*, s.6, vol. 54, 1959, p. 161 ff.

LASAREFF, VICTOR. 'Studies in the Iconography of the Virgin,' *Art Bulletin*, vol. 20, 1938, p. 26 ff. (Virgin and Child.)

LAVER, JAMES. 'The Cradle of Venus,' in *The Scallop: Studies of a shell and its influences on humankind.* London, 1957.

LAVIN, IRVING. 'Cephalus and Procris: transformations of an Ovidian myth,' *Journal of the Warburg and Courtauld Institutes*, vol. 17, 1954, p. 260 ff.

LEE, RENSSELAER W. *Ut Pictura Poesis: The Humanistic Theory of Painting.* New York, 1967. (Rinaldo and Armida.)

LUGT, FRITS. 'Man and Angel' (II), *Gazette des Beaux-Arts*, s. 6, vol. 25, 1944, p. 321 ff. (Tobias.)

MÂLE, ÉMILE. 'La Résurrection de Lazare dans l'Art,' *Revue des Arts*, 1951 (I), p. 44 ff.

—— *L'art religieux du XIIe siècle en France.* Paris, 1922.

—— *L'art religieux du XIIIe siècle en France.* Paris, 1910.

—— *L'art religieux de la fin du moyen âge en France.* Paris, 1908.

—— *L'art religieux de la fin du XVIe siècle, du XVIIe siècle et du XVIIIe siècle* (2nd ed.). Paris, 1951.

MARLE, RAIMOND VAN. *Iconographie de l'Art profane au moyen âge et à la Renaissance.* The Hague, 1931.

MARTIN, JOHN RUPERT. *The Farnese Gallery.* Princeton, 1965.

MEIGE, HENRY. 'L'opération des pierres de tête,' *Aesculape*, vol. 22, 1932, p. 50 ff.

MEISS, MILLARD. *Painting in Florence and Siena after the Black Death.* Princeton, 1951. (esp. Catherine of Siena; the Madonna of Humility.)

MORNAND, P. *Iconographie de Don Quichotte.* Paris, 1945.

NORDENFALK, CARL. 'Ein wiedergefundenes Gemälde des van Dyck,' *Jahrbuch der preuszischen Kunstsammlungen*, vol. 59, 1938, p. 36 ff. (Mirtillo, Crowning of.)

PANOFSKY, DORA. 'Narcissus and Echo; Notes on Poussin's *Birth of Bacchus* in the Fogg Museum of Art,' *Art Bulletin*, vol. 31, June 1949, p. 112 ff.

PANOFSKY, DORA AND ERWIN. *Pandora's Box: The changing Aspects of a Mythical Symbol.* New York, 1956.

PANOFSKY, ERWIN. *Early Netherlandish Painting: its origins and character.* (Esp. ch. v, 'Reality and Symbol.') Cambridge (Mass.), 1953.

—— 'Et in Arcadia ego,' from *Philosophy and History, Essays presented to Ernst Cassirer.* Oxford, 1936.

—— *Hercules am Scheidewege und andere antike Bildstoffe in der neueren Kunst.* (Studies of the Warburg Institute, vol. 18.) Leipzig, 1930.

—— *Meaning in the Visual Arts.* New York, 1957.

—— *Renaissance and Renascences in Western Art.* Stockholm, 1960.

—— *Studies in Iconology.* New York, 1939.

PANOFSKY, ERWIN AND SAXL, FRITZ. 'A late-antique religious symbol in works by Holbein and Titian,' *Burlington Magazine*, vol. 49, 1926, p. 177 ff. (Prudence.)

—— *Dürers Melencolia I: eine quellen- und typengeschichtliche Untersuchung.* (Studies of the Warburg Institute, vol. 2) Leipzig, 1923.

PIGLER, A. *Barockthemen.* Budapest, 1956.

—— 'La mouche peinte: un talisman,' *Bulletin du Musée Hongrois des Beaux-Arts*, vol. 24, 1964, p. 47 ff. (Fly.)

RAGGIO, OLGA. 'The Myth of Prometheus: Its survival and metamorphoses up to the eighteenth century,' *Journal of the Warburg and Courtauld Institutes*, vol. 21, 1958, p. 44 ff.

RÉAU, LOUIS. *Iconographie de l'art chrétien*. Paris, 1957.

REINACH, SALOMON. 'Essai sur la mythologie figurée et l'histoire profane dans la peinture italienne de la Renaissance,' *Revue archéologique*, s.5, vol. 1, 1915; also further, WITT, R. C., *ibid.* s. 5, vol. 9, 1919.

RIPA, CESARE. *Iconologia*. Padova. (Facsim. reprint of the 3rd ed., 1603: New York, 1970.)

ROBB, DAVID M. 'The Iconography of the Annunciation in the fourteenth and fifteenth centuries,' *Art Bulletin*, vol. 18, 1936, p. 480 ff.

ROEDER, HELEN. *Saints and their Attributes*. London, 1955.

ROSENAU, HELEN. 'A Study in the Iconography of the Incarnation,' *Burlington Magazine*, vol. 85, July 1944, p. 176 ff.

ROWLAND, BENJAMIN, JR. *The Classical Tradition in Western Art*. Cambridge (Mass.), 1963.

SAXL, FRITZ. *A Heritage of Images* (A selection of lectures). London, 1970.

—— 'Pagan Sacrifice in the Italian Renaissance,' *Journal of the Warburg Institute*, vol. 2, 1938–9, p. 346 ff.

—— 'Veritas Filia Temporis,' from *Philosophy and History, Essays presented to Ernst Cassirer*, Oxford, 1936. (Truth.)

SCHILLER, GERTRUD. *Iconography of Christian Art*. London, 1971–2.

SEZNEC, JEAN. 'Don Quixote and his French illustrators,' *Gazette des Beaux-Arts*, s. 6, vol. 34, 1948, p. 173 ff.

—— *The Survival of the Pagan Gods*. New York, 1953.

SHEPARD, ODELL. *The Lore of the Unicorn*. London, 1930.

SHORR, DOROTHY C. 'The Iconographic Development of the Presentation in the Temple,' *Art Bulletin*, vol. 28, March 1946, p. 17 ff.

SOLTÉSZ, ELIZABETH. *Biblia Pauperum: The Esztergom Blockbook of Forty Leaves*. Budapest, 1967.

STECHOW, WOLFGANG. 'Shooting at Father's Corpse,' *Art Bulletin*, vol. 24, Sept. 1942, p. 213 ff.

—— 'The Myth of Philemon and Baucis in Art,' *Journal of the Warburg and Courtauld Institutes*, vol. 4, 1940–41, p. 103 ff.

TERVARENT, GUY DE. *Attributs et symboles dans l'art profane, 1450–1600*. Geneva, 1958.

THOBY, PAUL. *Le Crucifix des origines au concile de Trente*. Nantes, 1959.

TOLNAY, CHARLES DE. 'L'embarquement pour Cythère de Watteau, au Louvre, *Gazette des Beaux-Arts*, s. 6, vol. 45, 1955, p. 91 ff.

TUVE, ROSEMOND. 'Notes on the Virtues and Vices,' *Journal of the Warburg and Courtauld Institutes*, vol. 26, 1963, p. 264 ff; vol. 27, 1964, p. 42 ff.

VINYCOMB, JOHN. *Fictitious and symbolic Creatures in Art*. London, 1906.

VLOBERG, MAURICE. *L'eucharistie dans l'art*. Grenoble, 1946.

VOLKMANN, LUDWIG. *Iconografia Dantesca. The pictorial representations of Dante's Divine Comedy* (rev. ed.). London, 1899.

WEISBACH, WERNER. 'Der sogenannte Geograph von Velazquez und die

Darstellungen des Demokrit und Heraklit,' *Jahrbuch der preuszischen Kunstsammlungen*, vol. 49, 1928, p. 141 ff.

WHITE, T. H. *The Book of Beasts*. London, 1954.

WHITTICK, ARNOLD. *Symbols, Signs and their Meaning*. London, 1960.

WIEBENSON, DORA. 'Subjects from Homer's *Iliad* in Neoclassical Art,' *Art Bulletin*, vol. 46, March 1964, p. 23 ff.

WIND, EDGAR. *Bellini's Feast of the Gods: a study in Venetian humanism*. Cambridge (Mass.), 1948.

—— *Pagan Mysteries in the Renaissance*. London, 1958.

—— 'Platonic Justice, designed by Raphael,' *Journal of the Warburg Institute*, vol. 1, 1937, pp. 69–70.

WINTERNITZ, E. *Musical Instruments and their Symbolism in Western Art*. London, 1967.

WITTKOWER, RUDOLF. *Architectural Principles in the Age of Humanism*. (Studies of the Warburg Institute, vol. 19.) London, 1949. (Temple.)

A and Ω, or ω. Alpha and omega, the first and last letters of the Greek alphabet. They are the symbol of God as the beginning and the end of all things, and associated in art with the First and Second Persons of the Trinity, from the Book of Revelation (22:13 and elsewhere), 'I am the Alpha and the Omega, the first and the last, the beginning and the end'. The letters are found in conjunction with the CHI-RHO MONOGRAM in early Christian art. In Renaissance painting and later they are generally seen on the pages of an open book held in the hand of GOD THE FATHER. The more usual form of omega is ω, sometimes drawn to resemble the Roman letter W. A hand-sign forming a W stands for omega.

Aaron. Elder brother of Moses whom he accompanies in several scenes (see MOSES, 5, 10, 11, 12). One of the tribe of Levi that had special sacerdotal functions, Aaron was the high priest of the Israelites in the wilderness, and the prototype of the ancient Jewish priesthood which was traditionally descended from his sons. The vestments are described in detail in Exodus (28), though Aaron is by no means always depicted wearing them. They are sometimes characterized by the golden bells that fringe the robe – their sound was supposed to drive off evil spirits – and by the headdress which is either a turban or, as a prefiguration of the Christian priesthood, a papal TIARA. Aaron holds a CENSER and a flowering WAND, or rod.

 1. *The punishment of Korah* (Num. 16:1–35). Probably a conflation of more than one account of revolt against the leadership, which tells how Korah, a Levite, with Dathan and Abiram, contested Aaron's right to the high-priesthood. Challenged by Moses to offer incense to the Lord – a rite reserved to the priest – they and their followers found themselves swallowed up by the earth as soon as they attempted to do so. They are depicted beside an altar, censers flying, as the ground opens beneath their feet. Moses raises his wand; Aaron swings a censer.

 2. *The flowering rod* (Num. 17:1–11). To settle the issue of leadership among the twelve tribes the head of each brought a staff which was laid in the tabernacle. Next day it was found that the staff of Aaron, representing the tribe of Levi, had sprouted, flowered and produced ripe almonds. This example of the unfertilized bearing of fruit, together with the verbal similarity of the Latin *virgo* with *virga*, a rod, led to the adoption in the Middle Ages of the almond as a symbol of the Virgin's purity. (See also MANDORLA.) Jerome's account of the choosing of JOSEPH from among the suitors of the Virgin is an adaptation of the story of Aaron's rod. A flowering staff is hence an attribute of both Aaron and Joseph.

Abacus, attribute of Arithmetic, one of the SEVEN LIBERAL ARTS.

Abduction. Traditionally the fate of helpless maidens, but also sometimes of youths, not always protesting. Maiden: abducted by greybeard, in air, BOREAS; by black-bearded king on chariot (into flaming cavern), RAPE OF PROSERPINE; by white bull into sea, RAPE OF EUROPA; by young man, towards harbour, ships,

HELEN OF TROY. Two maidens: seized by two warriors on horseback, CASTOR AND POLLUX. Youth: borne aloft by eagle, GANYMEDE; borne aloft by bishop, from banquet, NICHOLAS OF MYRA (5). Warrior: sleeping, garlanded, laid in chariot by women, RINALDO AND ARMIDA (2).

Abigail, see DAVID (5).

Abraham. The first of the great Hebrew patriarchs of the Old Testament. Called by God, he left Ur of the Chaldees with his wife Sarah and nephew Lot to go to Canaan. He is white-haired with a flowing beard. His attribute is the knife with which he meant to sacrifice Isaac, his son.

1. *The meeting of Abraham and Melchizedek* (Gen. 14:18–24). After their sojourn in Egypt to escape the famine Abraham and Lot came north again 'rich in cattle'. They separated, Abraham returning to Canaan, Lot settling in Sodom. When raiders attacked the Cities of the Plain, Lot was captured and his possessions seized. The news was brought to Abraham who armed some three hundred men and set off in pursuit. He attacked by night and defeated the foe, releasing Lot and recovering the stolen goods. Abraham returned in triumph. At Salem (Jerusalem) he was received by Melchizedek, the king and high priest, who brought out bread and wine and blessed Abraham. The latter in return paid Melchizedek a tithe (one-tenth) of his spoils of victory. Melchizedek wears priestly robes and a crown or mitre. He carries the eucharistic chalice and bread, since the episode was regarded in the Middle Ages as a prefiguration of the Last Supper.

2. *The three angels* (Gen. 18:1–19). While Abraham 'sat at the tent door in the middle of the day' three men appeared before him. Realizing that they were angels he bowed down before them, fetched water and washed their feet; then with the traditional hospitality of the nomad he brought them food. The angels prophesied that a son would be born to Abraham's wife Sarah. But Sarah laughed at the idea because by now they were both 'old and well stricken in age'. However she afterwards bore Isaac so the prophecy was fulfilled. The three visitors are usually represented as angels, with wings and sometimes with haloes. Abraham kneels before them or washes their feet or fetches food. His dwelling, contrary to the text, is more often a humble building than a tent. The angels were regarded as a symbol of the Trinity and their prophecy was made a prefiguration of the Annunciation.

3. *The banishment of Hagar and Ishmael* (Gen. 21:9–21). Ishmael was Abraham's first son and his mother was Hagar, the Egyptian handmaiden of Sarah. When Isaac, Sarah's son, was born Ishmael mocked his younger brother so that Sarah asked Abraham to banish him, together with his mother. Abraham provided them with bread and a bottle of water and sent them off into the desert of Beersheba. When the water was spent Hagar put Ishmael under a bush to die and then sat some way off, weeping. But an angel appeared, by tradition the archangel Michael, and disclosed a well of water near by, so they were both saved. There are two scenes, the banishment, and the appearance of the angel, both common in 17th cent. Italian and Dutch painting.

4. *The sacrifice of Isaac; the binding of Isaac* (Gen. 22:1–19). To test Abraham's faith, God commanded him to make a burnt offering of his son, Isaac. They went to the place of sacrifice, Abraham on his ass and Isaac carrying the wood for the altar fire. Abraham bound Isaac, laid him on the altar and drew his knife. At that moment an angel appeared and stayed Abraham's hand, saying, 'Now I know that you are a God-fearing man. You have not withheld from me your son'. Abraham raised his eyes and saw a ram caught in a thicket which

he sacrificed instead. This subject occupied a central place in the system of medieval typology – the drawing of parallels between Old and New Testament themes. Abraham's intended sacrifice was seen as a type of the Crucifixion – God's sacrifice of Christ. Isaac carrying the wood prefigured Christ carrying the Cross, the ram became Christ crucified, the thorns in the thicket were the crown of thorns, and so on. Artists commonly portray Abraham with his knife poised; sometimes his other hand covers Isaac's eyes. Isaac kneels or lies, usually naked, on a sort of low altar on which there are faggots of wood. The angel is in the act of staying Abraham's hand and at the same time points towards the ram. According to Moslem tradition Abraham's sacrifice took place on the site of the Mosque of Omar (The 'Dome of the Rock') at Jerusalem.

 Abraham's bosom, heaven: see LAST JUDGEMENT (5); DIVES AND LAZARUS.

Absalom, see DAVID (8).

Abundance. Ample supplies of food, the basis of man's well-being, flowed from peace, justice and good government. Hence the allegorical figure of Abundance is often associated with other such virtues, celebrating the end of a war, sometimes on public buildings, or on a sculptured tomb in allusion to the benefits bestowed by the dead man in his lifetime. The figure of Abundance is found particularly in Italian art. Her principal attribute is the CORNUCOPIA. She may, like CHARITY, be accompanied by several children. She may hold a sheaf of CORN in her hand since her classical prototype was Ceres, the goddess of agriculture. A RUDDER, which came to be associated with the idea of government, dates from ancient Rome and derives from the annual celebration of the grain harvest which mostly came to the city by boat. The rudder, with terrestrial GLOBE and cornucopia together suggest that the world-wide rule of Rome brought about plenty ('Triumph of Caesar', Mantegna, Hampton Court).

Acedia, see SLOTH.

Achelous, see HERCULES (22).

Achilles. Legendary Greek hero, the central character of the *Iliad* which tells of his deeds in the Trojan war. The following are non-Homeric themes concerning his upbringing and death. See TROJAN WAR for the others.

 1. *Thetis dips Achilles in the Styx* (Hyginus 107; Statius, *Achilleid* 1:269). Achilles was the son of Thetis, a sea-nymph. Knowing the destiny in store for her son, she tried to protect him by dipping him at birth in the waters of the river Styx. This made his body invulnerable except for the heel by which she held him. Thetis is shown standing at the water's edge holding the infant upside down by the foot. Its head is submerged. In the background the souls of the dead – wraithlike figures – may be seen thronging the river bank, while Charon ferries a boat-load across the water. Cerberus, the watchdog, lies near by, his three heads showing varying degrees of wakefulness.

 2. *The education of Achilles by Chiron* (*Fasti* 5:385–6; *Achilleid* 2:381–452). In his youth Achilles was handed over to Chiron, a wise and learned CENTAUR who taught him many arts. The Centaur is depicted playing the lyre to his pupil, or they duel, swim side by side, practise gymnastics and so on. The various activities may be combined in one picture. A related theme shows Achilles as an infant being handed over by his mother into the arms of Chiron.

 3. *Achilles and the daughters of Lycomedes* (Hyginus 96; *Met.* 13:162–70; Philostratus the Younger, *Imag.* 1). By far the commonest Achillean theme, yet an unheroic one. Like that of HERCULES (17) and Omphale it concerns a hero dressed in woman's clothes, which perhaps explains its popularity. Knowing her son was destined to die if he went to fight in the Trojan war, his mother

disguised him as a woman and entrusted him to King Lycomedes, in whose palace on the isle of Scyros he lived among the king's daughters. Ulysses and other Greek chieftains were sent to fetch Achilles. They cunningly laid a heap of gifts before the girls – jewellery, clothes and other finery, but among them a sword, spear and shield. When a trumpet was sounded Achilles instinctively snatched up the weapons and thus betrayed his identity. A group of female figures is seen crowding round caskets of gifts. One of them lovingly fingers a sword, or springs up brandishing it to the others' astonishment. Ulysses and other warriors may be present.

 4. *Death of Achilles* (Dares Phrygius, *Excidium Troiae* 34; Dictys Cretensis 4:10–13). Achilles was offered the hand of Polyxena, daughter of Priam, king of Troy, if in return he agreed to raise the siege of the city. But this was a plot to kill him. At Polyxena's request he came to make a sacrifice to Apollo. As he knelt at the altar he was shot by her brother, Paris. The arrow was guided by Apollo to Achilles' one vulnerable spot, his heel. Achilles is seen kneeling before an altar, his foot pierced by an arrow. Or he may be supported in the arms of another of Polyxena's brothers. She stands by with an attendant. Paris is in the doorway, bow in hand, Apollo at his elbow. Homer, whom Ovid follows, tells that Achilles died in battle, but this version is seldom represented.

Acis, see GALATEA.

Actaeon, see DIANA (3).

'Ad Majorem Dei Gloriam', see IGNATIUS OF LOYOLA.

Adam and Eve. God created Adam and Eve together with the plants and animals on the sixth day (Gen. 1:24–31). The theme is often combined with the *Temptation* and the *Expulsion* (2 and 3 below). Before the early Renaissance it was usual to represent God as the Second Person of the Trinity but in later works he conforms to the 'patriarchal' type of God the Father. He breathes life into Adam's nostrils, or reaches out his hand to transmit life by his touch. In the scene of the creation of Eve, Adam lies on the ground, since God caused a deep sleep to fall upon him while removing his rib. Although Genesis states in the second account of the Creation (Gen. 2:21–2) that Eve was fashioned from the rib after God had removed it and closed up Adam's side, there is a widespread convention that depicts her emerging from his body while he sleeps. Another version shows her fully formed, standing before God in a devout attitude. Rarely, artists represent the pair without navels. According to medieval typology Adam prefigured Christ on the grounds that each was the first man of his era, or 'dispensation'. For a similar reason Eve, the first mother, foreshadowed the Virgin, or alternatively the Church itself. (See CRUCIFIXION, Intro., 9 and 10.) The story of the creation of the first man from dust or clay is found in other ancient religions, notably Babylonian. Ovid, retelling a Greek myth, describes how the Titan PROMETHEUS (1) fashioned man from clay.

 1. *Garden of Eden; the naming of the animals* (Gen. 2:8–20). In northern painting the vegetation of paradise is lush, with long vistas and forest glades. Southern artists tend to represent it as an oasis in the desert. It was watered by four rivers (see RIVER), and is often walled. It was inhabited by all kinds of animals. Adam is sometimes depicted naming the animals (Gen. 2:19–21). He may stand above them on an eminence, or they pass before him while he inscribes their names in a book. (See also AGES OF THE WORLD: *The Golden Age*.)

 2. *The Temptation* (Gen. 3:1–7). God warned Adam on pain of death not to eat the fruit of 'the tree of the knowledge of good and evil', and may be so depicted, standing in the Garden. But the serpent, the craftiest of all God's

creatures, persuaded Eve, saying 'your eyes will be opened and you will be like gods knowing both good and evil'. Eve ate the fruit and gave some to Adam who ate it too. 'Then the eyes of both of them were opened, and they discovered that they were naked; so they stitched fig-leaves together and made themselves loincloths.' The tree is usually an apple or a fig. The serpent is twined round its trunk (a type probably derived from the pre-Christian image of the dragon guarding the tree of the Hesperides: see SNAKE) or is standing beside it. It may have a woman's head and sometimes also a torso. If standing, it has four legs and feet like a lizard's. (It was only afterwards that God cursed it: 'On your belly you shall crawl'.) Adam and Eve stand by the tree, Eve holding the fruit or in the act of plucking it, or, having taken a bite, offering it to Adam. Medieval typology saw the Temptation as a foreshadowing of the Annunciation in which the Virgin Mary, as the 'new Eve', redeemed the sin of the old.

3. *The Expulsion* (Gen. 3:8–24). God punished the serpent, decreeing that it should henceforward go on its belly and eat dust. For her disobedience Eve was condemned to painful childbearing and to be ruled over by Adam. His punishment was to toil thereafter in the fields for his daily bread until he died. God clothed them both in skins and expelled them from the garden lest they ate also of the tree of life and thereby gained immortality. To guard the tree, 'to the east of the garden of Eden he stationed the cherubim and a sword whirling and flashing'. Adam and Eve go out naked with their hands covering their pudenda or with a garland of leaves round their loins, their faces expressing utter grief and despair. Also depicted is the angel who drives them away with a sword or whip; God handing them clothing made of animal skins; and the cloaked figure of Death standing by, to signify that they were no longer immortal. In the later scene, at their toil, Adam digs with spade or hoe, ploughs or sows. Eve either helps him or sits holding a distaff while perhaps two young children, Cain and Abel, play around her.

Admetus, see HERCULES (20).

Adonis, Birth of. Adonis was conceived out of the incestuous love of his mother Myrrha for her father Cinyras. Overcome with shame she invoked the gods who changed her into the myrrh-tree. In due time the trunk split open and the infant Adonis was born, to be cared for by Myrrha's nurse Lucina and the nymphs (*Met.* 10:503–14). The theme is found chiefly in 16th and 17th cent. Italian painting and shows Myrrha with upraised arms, half woman, half tree, and the infant delivered into the arms of Lucina or the nymphs. For the death of Adonis, see VENUS (5). See also TREE.

Adoration of the Magi ('Adoration of the Kings') (Matt. 2:1 ff). The magi had come from the east, following a star, to seek the king of the Jews, and were directed by Herod's officials to go to Bethlehem. Herod told them to report back to him, ostensibly that he might then pay homage himself, but really because he feared usurpation. Historically the magi were astrologers of the Persian court, the priests of the cult of Mithras which became widespread in the Roman empire in the early Christian era. In the wall-paintings of the Roman catacombs and in some Byzantine mosaics the magi may wear Mithraic robes and the typical 'Phrygian cap', a kind of pointed hat having the top folded forward (see HAT). The Christian writer Tertullian (*c.* 160–230) was the first to redefine them as kings. Their names may have originated in a 9th cent. pontifical at Ravenna. In earlier Renaissance painting they are dressed in the court fashions of the day. One or other may be drawn in the likeness of the artist's patron, as a mark of his devotion to Christianity. As a prelude to the adoration proper the

magi are occasionally depicted meeting on their journey or travelling together, with their retinues, led by the star. They are represented thus in late medieval frescoes and sculpture, and in illuminated MSS. The adoration itself shows Caspar, or Jasper, the oldest, kneeling before the infant Christ in the Virgin's lap, offering his gift of gold. Behind him stands Balthazar, a Negro, and Melchior, the youngest. Their retinues often show unmistakable signs of their eastern origin: the turban, camels, leopards, or perhaps the star and crescent of the Saracen. Joseph is usually present. In the background may often be seen the annunciation to the shepherds. In some later examples, especially of the 17th cent., the Virgin is represented standing. The receptacles for their gifts, in particular in the 16th cent., are often elaborate examples of goldsmiths' work. Matthew does not mention the number of the magi though three is inferred from the number of their gifts. (In early Christian art there may be two or four or, occasionally, six.) According to Bede (*c.* 673–735) the symbolism of their gifts was: gold, homage to Christ's kingship; frankincense, homage to his divinity; myrrh, used in embalming, a foreshadowing of his death. In the later Middle Ages the magi came to personify the three parts of the known world (Europe, Africa and Asia) paying homage to Christ, hence the traditional portrayal of Balthazar (Africa) as a Negro. But the theme was also used to symbolize the submission of the temporal powers to the authority of the Church, hence its continuing importance in Christian art. The feast of the Epiphany (6 January) celebrates certain manifestations of Christ to mankind, in particular that of the Adoration of the Magi. (See also NATIVITY.)

Adoration of the Name of Jesus. The 'sacred monogram' consisting of the letters IHS was originally an abbreviation of the Greek form of the word Jesus. It was known in the 9th cent. where it appeared on coins of the Byzantine empire. After its adoption by the western Church it sometimes, incorrectly, acquired the meaning 'Iesus Hominum Salvator' – 'Jesus the Saviour of men'. A bar above the H, signifying the elision, is sometimes turned into a cross, perhaps by extending upwards the vertical stroke of the H. It is seen thus in the decoration of religious objects of many kinds. The idea of the monogram as an object of veneration was fostered by BERNARDINO in the 15th cent. In the following century it was adopted as the device of the Society of Jesus for whom its letters also bore the meaning 'Jesum Habemus Socium' – 'We have Jesus for our companion.' The adoration of the name forms the subject of a baroque fresco on the ceiling of the Gesù, the Jesuit church in Rome. The rays emanating from the letters light up the faces of the angels and the blessed thronging round, but at the same time strike down Satan and his attendant vices.

Adoration of the Shepherds (Luke 2:8 ff). The announcement to the shepherds in the fields of the birth of the Messiah by the angel, traditionally Gabriel, is represented in Byzantine art but the scene of the adoration is not found until the end of the 15th cent. The shepherds are grouped round the infant in reverential attitudes. They have doffed their hats and the nearest ones are kneeling. There are usually three of them and their gifts are appropriately rustic. Others stand behind playing pipes. Through a doorway there may be a glimpse of a distant hillside where an angel announces the birth to those watching their flocks. The shepherds' gifts are not mentioned by Luke and were probably invented by analogy with those of the magi. In earlier examples they may consist of a sheep with its feet bound (symbolizing the Christian sacrificial lamb), a shepherd's crook and pipes. The sheep is sometimes borne round the shoulders of a shepherd, after the image of the Good Shepherd (see SHEPHERD). In 17th-cent.

art they bring poultry, a jug of milk, a basket of eggs, etc. The pipes are usually the BAGPIPE and a syrinx (see PIPE). The idea of music on this occasion may derive not only from the pastoral tradition but, more specifically, from a custom in parts of Italy to play the pipes at Christmas before images of the Virgin and Child.

Adoration of the Virgin, see NATIVITY (2).

Adrian and Natalia. Adrian (died c. 304), a Roman officer serving at Nicomedia in Bithynia was, according to legend, converted to Christianity after witnessing the sufferings of persecuted Christians. He was thrown into prison where he was visited by his wife Natalia disguised as a boy. She herself was secretly a Christian. At his execution Adrian had both his hands and his head cut off. Natalia, who was present, took away one of the hands as a memento. The body of Adrian was buried at Argyropolis, near Byzantium, where Natalia passed the rest of her life in mourning. Adrian, the patron saint of soldiers and butchers, protector against the plague, was widely venerated in northern Europe. His attribute is an ANVIL, sometimes with an axe or sword beside it. There may be a LION at his feet, the emblem of his fortitude. He is usually in armour and may be accompanied by Natalia.

Aeëtes, king of Colchis, see JASON.

Aeneas. A Trojan prince who escaped by sea with a band of companions after the sack of Troy by the Greeks. After many adventures they reached Latium in Italy where they settled. They were the legendary ancestors of the Roman people. The story is told in Virgil's epic poem, the *Aeneid*. Throughout, Aeneas was buffeted by fate in the form of deities with conflicting intentions about his future, but ultimately he was always protected by Jupiter, the father of the gods. In this way Virgil demonstrated that the Roman empire was founded on divine authority. Themes from the work have been treated singly and in series (Abbate, cycle, Gall. Estense, Modena). The more important are as follows:

1. *Aeneas rescues his father from burning Troy* (*Aen.* 2:671–729). Aeneas escaped from the city carrying his aged father Anchises on his back, accompanied by his son Ascanius. His wife who set out with him was lost in the darkness. See further, TROJAN WAR (8).

2. *Aeolus releases the winds* (*Aen.* 1:125–143). Aeolus was the god who controlled the winds, which he kept shut up in a cave. The goddess Juno, who took the side of the Greeks and wished to destroy the Trojan fleet, persuaded him to release the winds thereby causing a great storm. Some ships were wrecked but Neptune calmed the waves before too much damage was done. See further AEOLUS; NEPTUNE (2).

3. *Venus appears to Aeneas* (*Aen.* 1:314–371). The goddess Venus, the mother of Aeneas, appeared to him twice, first in the midst of burning Troy to bid him be on his way. Later, when the Trojans were washed ashore near Carthage after the storm at sea, Aeneas and his friend Achates set out to explore. Venus appeared once more, this time with bow and quiver disguised as a huntress, to direct them to Dido's palace.

4. *Dido's banquet* (*Aen.* 1:657–722). To foil any plan Juno might have had to create enmity between Trojans and Carthaginians, Venus caused the Carthaginian queen Dido to fall in love with Aeneas. She sent Cupid, disguised as Aeneas' son, to pay his respects to the queen at a banquet held in honour of the Trojans. As Dido unwittingly embraced the god of love he worked a magic charm on her.

5. *Dido and Aeneas shelter from the storm* (*Aen.* 4:160–172). Caught in a

sudden storm while out hunting Dido and Aeneas became separated from the rest of the party. They sheltered together in a cave, and made love for the first time.

6. *The departure of Aeneas* (*Aen.* 4:362–392). The lovers passed a whole winter in each other's company, until Aeneas was suddenly visited by Mercury, the messenger of the gods, with sharp orders from Jupiter to be on his way. He took his leave amid scenes of passionate pleading, vituperation and tears. When Aeneas had departed Dido built a funeral pyre in the palace and slew herself on it, using her lover's sword. (See further, DIDO.)

7. *The funeral games* (*Aen.* 5). Driven back to Sicily by another storm Aeneas there celebrated the anniversary of the death of his father Anchises with funeral games: a race between the ships, a foot race, boxing, a shooting contest and a mock battle on horseback. The several activities are depicted simultaneously. In the background is the tomb of Anchises. Venus may be seen pleading with Neptune for fair winds for the Trojan's next voyage. By Roman times public games were no longer sporting contests but, rather, ritualistic in character, connected with annual religious festivals.

8. *Aeneas and the Cumaean Sibyl; Aeneas descends into the underworld* (*Aen.* 6). Aeneas and his men sailed in calm seas to the coast of Campania on the Italian mainland, by Cumae. Here he visited the Sibyl, or oracle, in her temple and prayed to be allowed to see his father's face once more. Protected by a branch of mistletoe, an ancient symbol of life, and guided by the Sibyl, Aeneas descended by a pathway to the underworld. Artists have illustrated successive episodes, sometimes combining them in one picture. Aeneas is in armour, generally Greek but sometimes wearing a Phrygian cap (a pointed hat with the top folded forward, see HAT). He may be accompanied by his friend Achates though this is not recorded by Virgil. With the Sibyl, he embarks on Charon's skiff to cross the river Styx, either he or she holding the mistletoe. They alight on the other side at the gates of Hades' kingdom, which are guarded by the many-headed Cerberus. In Tartarus, that part of the underworld reserved for the punishment of the damned, are to be seen: IXION on his wheel; TITYUS, his liver pecked by a vulture; TANTALUS reaching for the fruit. Among the dead Aeneas finds Dido. In the Elysian fields he meets the shade of his father who points out to him the souls of his descendants, those yet unborn, a line of kings, consuls and emperors stretching down to Virgil's own day.

9. *The arrival at Pallanteum* (*Aen.* 8:102–124). Having reached the Tiber the Trojans soon found themselves at war with hostile tribes. Aeneas sailed up river to the city of Pallanteum where he succeeded in making an alliance with its king Evander. He is seen standing in the prow of his boat holding out an olive branch to Pallas, the son of Evander, who stands on the shore with his aides. Behind are the towers and battlements of the city, the site of future Rome.

Aeolus. The winds, which so much influenced the fortunes of early sea-faring man, were controlled by the god Aeolus. ULYSSES on his travels enjoyed his hospitality. To help the Greek hero on his way the god kindly tied up the adverse winds in a leather bag. Ulysses' companions, who were habitually getting into trouble, opened it out of curiosity and caused a tempest. AENEAS and his fellow Trojans came to grief for similar reasons (*Aen.* 1:50–86). The goddess Juno, who took the Greek side in the Trojan war, persuaded Aeolus to unloose the winds when Aeneas and his comrades were on the high seas between Sicily and Carthage. (Juno was the protectress of Carthage and knew what the future held once Aeneas arrived there.) Aeolus, who on this occasion kept the winds imprisoned

in a cave, is seen opening a door in a rock. The winds, in the shape of mischievous putti, are pouring out. Overhead Juno in her chariot drawn by peacocks looks down on the scene, surrounded by nymphs and putti. For the sequel, see NEPTUNE (2).

Aeson, father of JASON.

Africa personified, see FOUR PARTS OF THE WORLD.

Agamemnon, Gk commander, see TROJAN WAR (1, 2); IPHIGENIA; POLYXENA.

Agatha. Christian saint and virgin martyr, believed to have been born in the 3rd cent. at Catania in Sicily, and to have died under the persecutions of the Emperor Decius. According to her legend she rejected the love of the Roman governor and, like Agnes, was thrown into a brothel. She was subjected to violent tortures, including the shearing of her breasts, but was afterwards visited in her cell by the apostle Peter who healed her wounds. Further ordeals led to her death which was accompanied by earthquakes. On the anniversary of her martyrdom Mt Etna erupted, but the citizens of Catania were saved from destruction by her veil which had the miraculous power of deflecting the flow of lava. Agatha is richly dressed, a mark of her reputedly noble birth, and carries the martyr's palm. Her special attribute is a dish holding two breasts. She sometimes has tongs or shears, the instruments of her martyrdom. Her name is invoked against earthquakes and volcanic eruptions and, by extension of the same idea, against fire. She therefore sometimes holds a flaming building. A veil, her supposed relic, in the Duomo at Florence, is popularly believed to extinguish fire. Her other relics elsewhere number at least six breasts. Agatha usually appears as a devotional figure, alone or grouped with other saints; narrative scenes of her mutilation or her healing by Peter are rare.

Ages of Man. The life of a man or woman may be divided into not less than three and not more than twelve ages. Four, five and six are also found; three or seven are the most usual numbers. The theme is not uncommon in Renaissance painting and engravings. Its underlying meaning, like the 'Vanitas' theme (see STILL LIFE), is that earthly things are transient, youth and beauty must pass away, and in the end death comes to us all. Three ages may be represented by children at play, young lovers, and an old man perhaps examining a SKULL, counting his money, or in conversation with another. A fourth, interposed after youth, is the mature man, a warrior in armour or maybe holding COMPASSES to show he is learned in his craft. The span of human life may be linked with the progress of the year, thus four ages with the FOUR SEASONS; twelve – each age lasting six years – with the TWELVE MONTHS. The figure of DEATH surveys the scene or hovers near the old man. In an allegory of PRUDENCE by Titian (Nat. Gall. London), youth, maturity and old age symbolize past, present and future.

Ages of the World. At the beginning of the *Metamorphoses* (1:89–150) Ovid describes how the creation of the world was followed by four ages, Golden, Silver, Bronze and Iron. The first was an earthly paradise, a kind of Garden of Eden or Arcadia, but each succeeding age brought increasing trouble and misery to mankind. Hesiod, the early Greek poet, had written of a fifth, the Heroic age, coming between Bronze and Iron. The theme has been illustrated either singly or as a series, usually confined to three, Golden, Silver and Iron, omitting Bronze.

 1. *The Golden Age.* Man lived in a state of primal innocence, in harmony with his fellow men and with animals. He was without tools or means of cultivation and his simple needs were supplied by nature. He fed on berries, acorns and the honey that dripped from the holm-oak. Saturn, the ancient Roman god

of agriculture, reigned. We see a landscape of trees, rivers and distant mountains. Men and women play together, pluck fruit or recline on the grass, among tame beasts and birds. They eat and drink using shells for cups and platters. Cupid may be seen stealing honey (see CUPID, 3).

2. *The Silver Age.* The eternal springtime was over and man had to build primitive dwellings for protection against the cold, and to learn to plough and sow. He now knew right from wrong. The female figure of JUSTICE with sword and scales is seen floating over a landscape where men are engaged in husbandry.

3. *The Iron Age.* Ovid places the Iron Age before the Flood, but for Hesiod who was a toiling Boeotian farmer it was the 'present day', full of tribulation, not least the greed and malice of his fellows. Herodotus writes of iron having been discovered 'to the hurt of man' (1:68). The scene shows soldiers attacking defenceless women and children, or about to slay a figure crowned with LAUREL (personifying learning and the arts). Another warrior has plundered a temple and makes off with the sacred vessels. In the background a city burns.

The 17th and 18th cents. followed the *Iconologia*, a mythographical dictionary by Cesare Ripa (1593) and represented the Four Ages as female figures with conventional attributes, thus: *Golden*, crowned with flowers, with a beehive and olive branch; *Silver*, ploughshare and sheaf of corn; *Bronze*, brandishing a spear; *Iron*, carrying various weapons and a shield bearing a human-headed serpent (symbol of Deceit).

Aglauros, a jealous woman, see MERCURY (2).

Agnes. Christian saint and virgin martyr, one of the earliest to be venerated by the Church. She lived in Rome at the time of the persecutions under Diocletian. Her invariable attribute is a white LAMB, usually curled up at her feet or held in her hand. It was probably given to her because of the similarity of her name to the Latin *agnus*, a lamb, but this is a false derivation; Agnes comes from the Greek meaning 'chaste'. Her other attributes are the martyr's PALM, sometimes an olive branch or a crown of olives, a SWORD or dagger, her instrument of martyrdom, and a flaming pyre. She is portrayed as a young girl – according to one tradition she died at the age of thirteen – and like Mary Magdalene has long flowing hair. Her story, as told in the *Golden Legend*, resembles that of Lucia. Agnes was ardently courted by the son of the Prefect of Rome but she firmly refused him, declaring that she was already espoused to her heavenly bridegroom. When the young man began to sicken with love the affair came to the ears of his father who summoned Agnes and, on learning that she was a Christian, demanded that she make formal sacrifice to the Roman gods or be thrown into a brothel. She was led naked through the streets of Rome covered only by her hair which had miraculously grown till it reached her feet. In the brothel an angel appeared, surrounding Agnes with a shining light that cloaked her body from the sight of others. Agnes' suitor arrived, determined to ravish her, but in the attempt was struck dead by a demon. Agnes was taken away to be burned as a witch but the flames left her unharmed, burning her executioners instead. She was finally beheaded. The theme of her death is found in baroque painting, especially Spanish and Italian. Agnes kneels on the extinguished faggots while her executioners lie prostrate, except for one who brandishes a sword; overhead, the heavens have opened to reveal Christ and an angel who holds the martyr's palm and a crown. Other virgin martyrs, such as CATHERINE OF ALEXANDRIA and AGATHA, appear with Agnes in devotional pictures, and sometimes Emerantiana, her half-sister, who was stoned to death. The latter can be recognized by the stones in her lap. The recurrent theme of a female martyr thrown into

a brothel seems to have originated in a Roman law which forbade the execution of virgins. They were therefore violated before being put to death.

Agony in the Garden (Matt. 26:36–46; Mark 14:32–42; Luke 22:39–46). After the LAST SUPPER and immediately before his arrest Christ retired to the Mount of Olives to pray. 'Agony' (from the Gk *agōn*, a contest) here signifies the spiritual struggle between the two sides of his nature, the human that feared the imminent suffering and would have avoided it, in conflict with the divine that gave him strength: 'Father, if it be thy will, take this cup away from me. Yet not my will but thine be done.' He had taken with him Peter, James and John, and then withdrawn a little apart from them. According to Luke 'there appeared to him an angel from heaven bringing him strength, and in anguish of spirit he prayed the more urgently'. When he returned to the disciples he found them asleep and rebuked them for their lack of resolve. The theme is seldom found before the 13th cent. In early examples we may see instead of the angel the head of God the Father or his symbol, the right hand pointing out of a cloud. Other early variants may show Christ either kneeling (Luke) or prostrate on his face (Matt., Mark). We may have all eleven disciples sleeping, or alternatively Christ praying alone. By the Renaissance certain features became fairly generally established. Christ kneels on a rocky eminence. Below him are the three disciples: Peter, grey-haired with a curly beard and perhaps a sword (in anticipation of his cutting off the servant's ear: see BETRAYAL); James who has dark hair and a beard; John, the youngest, with long hair sometimes down to his shoulders. In the distance is the city of Jerusalem and a group of approaching figures – the soldiers led by Judas. The nature of Christ's vision came to take two distinct forms. The angel, or angels, may appear before him bearing the instruments of the Passion, or more often the angel brings the chalice and wafer. The convention of representing Christ as if he were about to receive communion, seems to have arisen from the gospels' purely metaphorical reference to a cup, and has of course no textual sanction.

Agostino, see AUGUSTINE.

Agrippina (mother of Nero), see NERO BEFORE THE BODY OF AGRIPPINA.

Agrippina at Brundisium (Brindisi) (Tacitus, *Annals*, 3:1). The sequel to the death of the Roman general Germanicus who died from poisoning in Syria (A.D. 19), (see G., DEATH OF) symbolizes conjugal fidelity. His wife, Agrippina the Elder, brought his ashes back to Rome. She was met by great crowds of mourners on coming ashore with her two children on the Italian mainland at Brindisi. She is seen wearing a widow's veil, standing on the prow of a boat, or stepping ashore. She holds the urn containing her husband's ashes.

Ajax, see FLORA (2).

Alcestis, see HERCULES (20).

Alchemist. The practice of alchemy is of great antiquity. It was carried on throughout the Middle Ages and only finally died, discredited, with the coming of modern chemistry in the 17th cent. The alchemist's objective was to prepare a substance called the philosopher's stone which had the property of transmuting base metals into gold and silver, and also had the power of prolonging a man's life indefinitely. The medieval alchemist was typically a scholar and a philosopher, often a priest, and approached his task in a different spirit from the modern scientist. The course of his experiments included intervals for prayer since success was more likely if he, like the vessels he used, were first purified. Moreover, the furnace, the crucible and the still all had symbolic overtones in Christian theology. Illustrations in alchemical treatises show the secrets of his craft being

handed down to the alchemist from God in heaven. In the 15th and 16th centuries the craft was attracting large numbers of charlatans. By the 17th the alchemist was an object of derision, the aspect of him that is presented in the many Netherlandish paintings of this period. He stands at a furnace, bellows in hand (whence his old nickname, *souffleur*, or puffer), or sits poring over a book. His room is littered with equipment: flasks, crucibles, pestle and mortar, alembic (distilling apparatus), hour-glass, books. A ragged woman with urchins in the background alludes to the neglect and poverty to which he has reduced his family. She may be shaking an empty purse, or a purse lies on the ground, while the alchemist puts their last gold coin in a crucible – because the process of transmutation required a little gold as a 'starter'. The inscription 'Oleum et operam perdis' – 'You waste oil and labour' (Cicero) signifies the vanity of his efforts.

Alcinous, King, see ULYSSES (5).

Alcmena, see HERCULES (14).

Alexander the Great (356–323 B.C.). King of Macedonia, military genius and founder of an empire. He is portrayed in young and vigorous manhood (he died aged 32), and wears armour, if only a helmet. Of his exploits, historical and legendary, the following are most often illustrated.

 1. *The taming of Bucephalus* (Plutarch 33:6). Alexander's horse Bucephalus is depicted in several scenes, generally as a spirited white charger. When first offered for sale it was rejected as untamable by Philip of Macedon, the father of Alexander, until the latter, by coaxing, succeeded in mastering it.

 2. *Timoclea* (Plutarch 33:12). A matron of Thebes, the Greek city sacked by Alexander. She was raped by one of his captains. She avenged herself by telling the officer that her wealth was hidden at the bottom of a well, and then tipped him in as he peered over the edge. She is seen, with her children, brought before Alexander. Recognizing a woman of spirit, he set her free.

 3. *Alexander cuts the Gordian knot* (Plutarch 33:18). During his campaign against Darius, king of Persia, Alexander entered the Phrygian city of Gordium. Here there was a chariot bound with cords that whosoever could untie would, it was said, rule the world. Alexander is depicted in his celebrated act of severing the knots with his sword.

 4. *Alexander and his physician Philip* (Plutarch 33:19; Valerius Maximus 3:8). Alexander fell sick, but his physicians would not venture to treat him for fear of the consequences if they failed – all except his close friend Philip who firmly administered medicine. It happened that Alexander had just received a letter from his general Parmenio warning him that Philip had been bribed by Darius to kill him. As a gesture of trust in his friend, Alexander handed him the letter to read at the very moment that he drank the draught. 'A spectacle well worth being present at', Plutarch remarks. Alexander is seen sitting up in bed holding a cup while Philip stands by reading a letter. Aides are in attendance.

 5. *The battle of Issus*. The plain of Issus in Cilicia was the scene of the battle in which Darius received a crushing defeat at the hands of Alexander in 333. Darius was wounded, according to some by Alexander himself, and fled. Artists depict cavalry and footsoldiers in a typical battle scene. In the centre, Alexander, with drawn sword, spurs his white horse towards Darius whose mount is turning away.

 6. *The family of Darius before Alexander* (Plutarch 33:21; Valerius Maximus 4:7). Though Darius fled, his mother, wife and two daughters were captured by

Alexander who is noted for having treated them honourably and kindly – a similar moral to the Continence of SCIPIO. The scene may be Alexander's tent on the battlefield. The mother, Sisygambis, kneels before the conqueror who may put out a hand to help her rise. Darius' wife, Stateira, and her daughters form the rest of the group. Servants, soldiers and onlookers are present. Diodorus Siculus (17:37) and others tell how Sisygambis first prostrated herself before Alexander's friend Haephestion by mistake and was covered in confusion. Alexander courteously put her at her ease.

7. *Alexander and the body of Darius* (Plutarch 33:43). In 330 Darius, still pursued eastwards by Alexander, was slain by his own men. Alexander found him lying wounded in a chariot at the point of death. He breathed a last message of thanks to the conqueror for caring for his wife and children. Alexander is depicted either, hand to ear, listening to Darius' words or, more usually, throwing his cloak over the corpse.

8. *The wedding of Alexander and Roxana* (Lucian, *Herodotus* 4–6). Alexander married Roxana the daughter of a chieftain of Sogdiana, one of the conquered territories of Asia. 'The only passion', says Plutarch (33:47), 'which he, the most temperate of men, was overcome by.' The theme is found in 17th cent. painting, especially of the Netherlands. Roxana is sitting on a couch while Alexander, in cloak and helmet, places a crown on her head. His companion Haephestion is present, perhaps holding a torch aloft. Amoretti float overhead, and a naked ephebe which is Hymenaeus, the god of marriage, draws the pair together.

See also APELLES PAINTS CAMPASPE; APOTHEOSIS; ARISTOTLE AND CAMPASPE; DIOGENES.

Alexis (5th cent.). The son of a Roman nobleman who was said to have abandoned his bride on their wedding day and passed the rest of his life as a penitent in the city of Edessa in northern Mesopotamia where he ministered to the poor and sick. Another more fanciful legend told how he returned to his father's house and took refuge unrecognized in a hole under the steps before the door. It was not until after Alexis' death that his father discovered whom he had been sheltering. The church of St Alexis in Rome marks the supposed site. He is venerated in hospitals and institutions caring for the poor. He is generally depicted as a ragged beggar with a BOWL and perhaps the martyr's PALM; or as a poor PILGRIM. His death under the stairs is also represented.

All fours. The prophet Daniel foretold that King Nebuchadnezzar would be banished from the society of men, live with the wild beasts and feed on grass like oxen (Dan. 4:32). Blake (Tate Gall. London) represents him thus on all fours. A desert hermit going on all fours is JOHN CHRYSOSTOM or occasionally ONUPHRIUS. An old man on all fours, a young woman riding on his back, ARISTOTLE AND CAMPASPE.

All Saints picture (Ger. 'Allerheiligenbild'). The term 'All Saints' is akin to 'Church triumphant' and refers collectively to all those who, having been victorious for Christianity on earth, have died and entered heaven. Thus an All Saints picture is one of the established ways of representing heaven in art. The Feast of All Saints was inaugurated in 835. Its biblical source is the Book of Revelation (5:11–13 and 7:9–14), which was used for part of the liturgy and, in turn, influenced its iconography. 'Then as I looked I heard the voices of countless angels. These were all round the throne . . . and they cried aloud: Worthy is the Lamb, the Lamb that was slain . . . After this I looked and saw a vast throng, which no one could count, from every nation, of all tribes, peoples,

and languages, standing in front of the throne and before the Lamb . . .' The earliest example, from a 10th cent. sacramentary, the forerunner of the missal, (Univ. Libr., Gottingen), shows the rows of saints and angels turned in adoration to the Lamb in the centre. This was superseded by the 14th cent. by a type in which the Lamb was replaced by the Trinity, or by God in the aspect of the pope (also signifying the Trinity), and in which there now appeared concerts of angels, and also the Virgin who might be enthroned beside the godhead. The textual source for this version is found in the *Golden Legend* (Feast of All Saints). It was first used as an illustration to Augustine's *City of God* and later in devotional books of many kinds. It is seen widely in Renaissance altarpieces.

Almond. Symbol of the Virgin's purity, from Num. 17:1–11, see AARON (2). The almond-shaped aureole surrounding Christ or the Virgin, see MANDORLA.

Almsgiving, see SUCCOUR.

Alpheus and Arethusa (*Met.* 5:572–641). A Greek myth tells how the god of the river Alpheus fell in love with the nymph Arethusa when she was innocently bathing in his waters. She fled, pursued by him over hill and dale. Just as her strength was failing she was rescued by Diana who enveloped her in a cloud and then transformed her into a stream which trickled away underground. Arethusa is shown reaching up to take the hand of Diana who floats on a cloud above, her stags near her. Alpheus, shaggy and bearded, dashes up. An alternative version shows Alpheus, young and handsome, with his arm round Arethusa at the moment of capture. He may have an URN, the attribute of the river god.

Althaea, mother of MELEAGER.

Amazons, Battle of. The Amazons were a legendary race of warrior-women who were skilled with the bow and at horsemanship. They were believed to have established themselves in Asia Minor, after having come from the Caucasus. They invaded Attica and its capital Athens but were repulsed by THESEUS (Plutarch 1:27). The battleground is a mêlée of warriors and horses. The Amazons draw their bows; the Athenian soldiers, led by Theseus, wield swords and axes. In one version they fight on a bridge from which vanquished riders and their horses plunge headlong into the river. See also HERCULES (9).

Ambrose (?340–397). Bishop of Milan, one of the four Latin (western) Fathers of the Church, born at Trèves in Gaul. He was renowned as a theologian and statesman of the Church. In an age of controversy he played a large part in crushing Arianism, a doctrine concerning the relationship of God the Father to Christ, which was regarded as heresy and in direct opposition to orthodox teaching about the Trinity. He sometimes carries a three-knotted scourge (the knots are the symbols of the three persons of the Trinity) in allusion to his castigation of Arius and his followers. He is also shown in the act of laying about them with his whip. His beehive alludes to the swarm of bees which were said to have alighted on his mouth as he lay in the cradle, a story told also of Plato and others who were known for their eloquence. He is dressed in bishop's robes with mitre and crozier. He may hold a pen or a book with the inscription '*In carne vivere preter carnem angelicam et non humanam*' – 'to be nourished by food, but rather the food of angels, not of mortals'. The food of the gods, or angels, was ambrosia, a reference to his name. In devotional art Ambrose often appears with the other three Latin Doctors, Augustine, Gregory and Jerome. He may be shown baptizing Augustine who, as the younger man, was much influenced by his teaching.

The Emperor Theodosius refused admission to the church. For his responsibility

for a massacre at Thessalonica in 390 the emperor was excommunicated by Ambrose until he had done public penance. He is shown on the church steps surrounded by his courtiers. Ambrose, with an admonishing gesture, is in the act of turning him away. The scene symbolizes the authority of the Church over the secular powers.

See also GERVASE AND PROTASE.

America personified, see FOUR PARTS OF THE WORLD.

Amnon, see DAVID (8).

Amor, see CUPID.

Amoretto, a little Cupid, see PUTTO.

Amphitrite, a Nereid, wife of NEPTUNE.

Amphitryon, see HERCULES (14).

Amymone, a Danaid, see NEPTUNE (3).

Ananias, disciple, see PAUL, apostle (2).

Ananias and Sapphira, see PETER, apostle (2).

Anchises, see VENUS (9).

Anchor. Early Christian symbol of hope, found in the art of the catacombs and on gems, from Heb. 6:18–19. Attribute of HOPE personified, also of CLEMENT (pope) and NICHOLAS OF MYRA (bishop). The emblem of an anchor entwined by a dolphin was coupled with the motto 'Festina lente' – 'Make haste slowly', a popular Renaissance maxim, used by, among others, the Venetian printer Aldus Manutius from 1494. The motto was used by the Roman emperor Octavian; the emblem appeared on coins in the reign of Titus.

Andrew. Apostle, brother of PETER, a Galilean fisherman, and the first to follow Christ (John 1:40–41). The gospels contribute little to his iconography; the chief source is the apocryphal book of the 'Acts of Andrew' (3rd cent), retold in the *Golden Legend*. According to this he made missionary journeys to Scythian Russia, Asia Minor and Greece, preaching and performing many acts of healing. At Nicaea he delivered the inhabitants from seven demons who plagued them in the shape of dogs. At Thessalonica the parents of a young man whom he had converted to Christianity set fire to his house, with Andrew and their son in it. When the young man miraculously extinguished the fire by sprinkling a small bottle of water over the flames, his parents, still seeking vengeance, tried to enter the house by climbing ladders, but were immediately struck blind. The *Golden Legend* tells of a bishop dining with the devil, disguised as a courtesan. Just as he was about to yield to Satan, Andrew entered in the garb of a pilgrim, and drove the devil away. Andrew was executed by Egeas, the Roman governor of Patras in the Peloponnese. The governor's wife, Maximilla, being cured of a fatal sickness by the apostle, adopted Christianity and was persuaded by him to deny her husband his marital rights ever again. This, and not his preaching, seems to have been the cause of Andrew's imprisonment and subsequent crucifixion. He is usually portrayed as an old man, white-haired and bearded. His chief attribute is a CROSS in the shape of an X, or saltire, though in earlier Renaissance painting he may have the more familiar Latin cross. He sometimes has a NET containing fish, or a length of ROPE (he was bound, not nailed, to the cross). His inscription from the Apostles' Creed is: 'Et in Jesum Christum, filium ejus unicum Dominum nostrum'. All these episodes from the legends are depicted, also the stages of his martyrdom: scourging; led by soldiers to his execution; being tied to the cross; crucifixion; burial, assisted by Maximilla.

The adoration of the cross. Andrew kneels before the cross, perhaps seeing a vision of the Virgin in heaven. Egeas and his attendants look on. Executioners

prepare the rope, or are in the act of binding him. The subject is found particularly in Counter-Reformation painting.

Andrew is the patron saint of Greece and Scotland. Among differing accounts of his relics, one tells of their being carried to the town of St Andrews in Scotland in the 4th cent.

Andrew Corsini (1301–73). A citizen of Florence who as a youth joined the Carmelite Order. On being informed of his election as bishop of Fiesole in 1349, he fled from his monastery, and had to be persuaded to return for his consecration. According to his biographers the Virgin appeared to him in a vision and urged him to accept the office. It was also related that after his death he appeared in the sky at the battle of Anghiari between the Florentines and Milanese, bringing victory to the forces of his former city. Both scenes are depicted in Renaissance and baroque painting: St Andrew before a vision of the Virgin; and floating, sword in hand, above the battlefield.

Andrians. Inhabitants of the Aegean island of Andros, famous for its wine, and therefore a centre of the worship of BACCHUS (Dionysus) in antiquity. Legend told that the god visited the island annually when a fountain of water turned into wine. Philostratus the Elder (*Imag.* 1:25) describes a river of wine beside which the Andrians drank, danced and sang, garlanded with ivy. Philostratus was known to high-Renaissance Italy and the subject of the Andrians was interpreted afresh. Titian (Prado) depicts a Bacchanalian festival with much drinking, beside a stream of wine. In the distance a river god reclines by the source on a couch of vines. Bacchus' ship is just visible, moored in the background.

Andromache, see TROJAN WAR (3, 4, 6).

Andromeda, maiden chained to rock, see PERSEUS (2, 3).

Anemone. The scarlet anemone grows commonly in the Near East and is associated with death. Anemones sprouted where the blood of Adonis fell on the earth (VENUS, 5; FLORA, 2). Red stands for the blood of Christ and the martyrs in Christian symbolism and the anemone may therefore be found among other flowers in the scene of the Crucifixion.

Angel (Gk. *angelos*, messenger). The messenger of the gods, the agent of divine will and its execution on earth, was found in the ancient religions of the east. In the Graeco-Roman pantheon Mercury was the messenger of Jupiter. Descriptions in prophetic and apocalyptic literature of the appearance of angels were a formative influence in medieval art: 'I saw the Lord seated on a throne . . . About him were attendant seraphim, and each had six wings; one pair covered his face and one pair his feet, and one pair was spread in flight' (Isaiah 6:1–2). (See also EZEKIEL.) Angels were of more than one rank: 'The Lord of Hosts, who is enthroned upon the cherubim' (I Sam. 4:4, and similarly Ps. 80:1); and 'The invisible orders of thrones, sovereignties, authorities and powers' (Col. 1:16). The Old Testament contains many references to beings whose function is to convey God's will to mankind. They act as annunciators (ABRAHAM, 2: *The three angels*), protectors of the righteous (LOT 1: *The destruction of Sodom and Gomorrah*), punishers of wrong-doers (ADAM AND EVE, 3: *The Expulsion*), or may be the mystic personification of God himself (JACOB, 4: *J. wrestling with the angel*). Guardian angels, whose cult was to become popular in the 16th and 17th cents., appear in the Old Testament, among them RAPHAEL (see TOBIAS) and MICHAEL the protector of the Israelites (Dan. 10:13; 11:1). In the New Testament Luke's gospel contains numerous references to angels: the Annunciation to the Virgin by the archangel GABRIEL (who likewise foretold the birth of JOHN THE

BAPTIST to Zacharias, and who also appeared in *Joseph's dream* (see JOSEPH, husband of the Virgin, 2)); the NATIVITY, FLIGHT INTO EGYPT, AGONY IN THE GARDEN, and elsewhere. The primitive Church allowed the existence of angels but with reservations, since they tended to attract worship in their own right. In the 5th cent. their various ranks were codified in a work that the Middle Ages attributed to Dionysius the Areopagite, the convert of St Paul (see PAUL: 8). This work, the *De Hierarchia Celesti*, divided angels into nine categories, or choirs, which were grouped in three hierarchies as follows: 1) Seraphim, Cherubim, Thrones, 2) Dominations, Virtues, Powers, 3) Princedoms, Archangels, Angels. The first hierarchy surrounded God in perpetual adoration, the Thrones sustaining him; the second governed the stars and elements; of the third, the Princedoms protected the kingdoms of the earth, and Archangels and Angels were divine messengers. The nine choirs, since they originated in the east, are commoner in Byzantine art, but they are found also in western art of the Middle Ages and the Renaissance. They provided artists with a convenient framework for the representation of heaven, and are seen in such themes as the ASSUMPTION, CORONATION OF THE VIRGIN and LAST JUDGEMENT. Seraphim and Cherubim are depicted with heads only, and one, two or three pairs of wings. The seraph is traditionally red and may have a candle; the cherub is blue or sometimes golden yellow, perhaps with a book. These two categories are often represented surrounding the image of GOD THE FATHER in heaven. FRANCIS OF ASSISI is depicted receiving the stigmata from the composite figure of a seraph and a man. The next five orders are not consistently distinguished. They usually have human bodies; the Thrones may hold thrones, Dominations may be crowned and hold orbs or sceptres, Virtues have lilies or red roses, the Powers and sometimes the other lower orders may be in armour. Angels appearing in the non-scriptural themes of Christian art – the messengers, the musicians round the Virgin and Child or accompanying CECILIA, the guardian angel presenting a donor in a 'Sacra Conversazione' – may all be regarded as belonging to the ninth category. They are generally, not always, winged (see WINGS); though sexless, they are inclined to be feminine in appearance, and are adolescent or younger, and generally dressed in loose draperies. In Renaissance painting they usually wear haloes. A type found in 14th cent. Italian painting has a second pair of wings in place of the lower trunk and legs. Baroque angels are typically winged infants, indistinguishable from the infant Cupids of secular themes. See also PUTTO.

Other scenes in which an angel plays a significant part are: ABRAHAM: *Sacrifice of Isaac* (staying the patriarch's hand); *Banishment of Hagar and Ishmael* (appearing to them in the wilderness); BALAAM'S ASS (barring his way); GIDEON'S FLEECE (appearing to kneeling warrior); PETER NOLASCO (an aged monk borne by two angels); SAMSON (the annunciation of his birth to his parents); TEMPTATION IN THE WILDERNESS (several, ministering to Christ); APOCALYPSE (8, 10) (agents of the divine will). For the fall of the rebel angels, see SATAN.

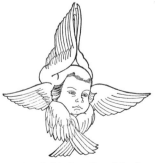

Angelica. The daughter of a king of Cathay in *Orlando Furioso*, by the Italian poet Ariosto (1474–1533), a romantic epic poem about the conflict between Christians and Saracens at the time of Charlemagne. Angelica was loved by

Cherub (blue) or Seraph (red)

several knights, Christian and pagan, among them the Christian hero Orlando (Roland). He was maddened (*furioso*) with grief and jealousy because she became the lover of, and eventually married, the Moor Medoro. (References are to the 1532 edition, translated by Sir John Harington, 1591 (Oxford, 1972).)

1. *Angelica and the hermit* (8:44). A lecherous hermit who longed to ravish Angelica cast a spell over her so that she fell into a deep sleep. But he was unable to achieve his purpose, as the poem explains metaphorically, 'His youthful days were done, he could not dance . . . His weapon lookèd like a broken lance'. He is depicted drawing aside the robe of the sleeping girl (Rubens, Kunsthistorisches, Vienna).

2. *Ruggiero frees Angelica* (10:78–95). A theme very like Perseus and Andromeda. Angelica chained to a rock by the seashore is about to be attacked by a sea-monster, the orc. Ruggiero (Roger), one of the pagan champions, arrives riding on a HIPPOGRIFF. He dazzles the monster with his magic shield, and places a magic ring on Angelica's finger to protect her. He undoes her bonds, she mounts behind him and they ride off together (Ingres, Nat. Gall., London).

3. *Angelica and Medoro.* Medoro, a follower of the Moorish leader Dardinello, is wounded in battle. Angelica discovers him and, having enlisted the help of a shepherd, heals him with the juices of the herb dittany, supposed to have medicinal virtues. She is seen supporting Medoro who has collapsed under a tree. She holds a bunch of herbs. A shepherd with a horse stands behind them (19:19) (Tiepolo, Villa Valmarana, Vicenza). They stayed in the shepherd's hut until Medoro was well again. Here Angelica found herself falling in love with him (19:21). They are depicted taking their leave of the shepherd and his wife (Tiepolo, Vicenza). A popular scene in Italian baroque painting shows Angelica carving her name and her lover's in the bark of a tree (19:28). It was the discovery of these proofs of their love that caused Orlando's jealous rage (23:77–108).

4. *Rodomont and Orlando* (29:41–8). Rodomont, the Saracen king of Algiers, loved the Christian Isabella. Rather than submit to him she tricked him into killing her. He built a great tomb for her that was approached by a narrow bridge over a river, and defended it against all comers. Mad Orlando, naked and unarmed, came and wrestled with Rodomont on the bridge. They both fell in the water, unluckily for Rodomont who was in full armour. They are depicted fighting. In the background is the tomb, hung with the trophies of other knights that Rodomont had beaten (D. and B. Dossi, Wadsworth Atheneum, Hartford, Conn.).

Anianus, see MARK (1).

Animals collectively: God the Father creating the animals, CREATION; Adam naming them, ADAM AND EVE (1); animals boarding the ark, NOAH; the sheep and cattle of JACOB (3) returning to Canaan; animals suspended in a sheet held by angels, PETER, apostle, (9). They surround ORPHEUS playing his lyre; and CIRCE in her palace (chiefly pigs). Animals, especially apes, parodying human activities, see APE. See also individual species.

Anne, mother of the Virgin Mary. For the story of her conceiving, see JOACHIM AND ANNE. For her place in the Holy Family, see VIRGIN MARY (17). She has no distinctive attribute but often wears a green cloak over a red robe. Green, the colour of springtime, symbolizes rebirth, hence immortality; red stands for love. The scene of Anne's death shows the Virgin placing a candle in her hand, while Christ gives her his blessing.

Annunciation (Luke 1:26–38). The announcement by the angel Gabriel to the

Virgin Mary: 'You shall conceive and bear a son, and you shall give him the name Jesus.' The Incarnation of Christ is reckoned to have taken place at this moment. The feast of the Annunciation is celebrated on 25 March, just nine months before the Nativity. It is known in England as Lady Day. The prevalence of the theme in Christian art reflects its doctrinal importance; monastic Orders and lay confraternities placed themselves under its patronage, and the widespread dedication of churches, chapels and altars to the Annunciation led to a diffusion of the subject in places of worship. Its three essential elements are the angel, the Virgin, and the dove of the Holy Spirit descending towards her. In the West it seems to have been represented first in Gothic church art. It is seldom seen without additional symbolic features, some of which are taken from the apocryphal gospels and the *Golden Legend*. St Bernard and others emphasized that the event took place in springtime, hence the motif of a flower in a vase, which later became a LILY, the symbol of the Virgin's purity. A DISTAFF or a basket of wool, seen in some medieval examples, alludes to the legend of the Virgin's upbringing in the Temple at Jerusalem where she would spin and weave the priests' vestments. Her most constant attribute is a book from which, according to St Bernard, she is reading the celebrated prophecy of Isaiah (7:14), 'A young woman is with child (Vulgate: '*Virgo* concipiet'), and she will bear a son . . .' A closed book, held in the hand, was said to allude also to Isaiah (29:11–12), 'All prophetic vision has become for you like a sealed book . . .' Inscriptions, sometimes on a scroll or leaf of parchment, are common, especially in early Netherlandish painting. From the angel issue the words 'Ave Maria', or 'Ave gratia plena Dominus tecum' – 'Greetings most favoured one! The Lord is with you' (Luke 1:28); and from the Virgin, 'Ecce ancilla Domini' – '"Here I am," said Mary; "I am the Lord's servant"' (Luke 1:58). The latter inscription may be upside down so that it can be more easily read by God the Father, depicted above (Jan van Eyck, Nat Gall., Washington). The Virgin either stands, sits, or, more usually, kneels, generally at a *prie-dieu*. If standing she may be turning away from the angel, her hands raised defensively: 'Then the angel said to her, "Do not be afraid, Mary".'

The archangel Gabriel is winged and is traditionally in white. He may be descending towards the Virgin, but usually stands or kneels before her. Italian painting from the first half of the 16th cent. shows the angel on a bed of cloud, suggesting that it comes from heaven. This was seldom omitted in the later painting of the Counter-Reformation. In early examples the angel holds a sceptre tipped with a fleur-de-lys, the attribute of Gabriel, but later it often holds the lily. In Sienese painting it holds an OLIVE branch, an indication of the enmity that existed between Siena and Florence, since the lily was the civic emblem of the latter city. In Counter-Reformation art Gabriel is generally attended by other angels, either fully grown or infant putti. The dove usually descends on a slanting ray of light that touches the Virgin's head or breast. God the Father is sometimes introduced above as the source of the light. The image as a whole is meant to suggest the moment of the Virgin's conception, that is, of Christ's Incarnation through the Holy Spirit which descended from God.

As to the setting, Luke merely mentions that the angel 'went in' to Mary at Nazareth. Italian Renaissance painting however tends to depict an exterior: an open loggia or portico, and only rarely the interior of Mary's chamber. Northern artists of the same period generally introduce ecclesiastical architecture which modern scholarship has shown to contain a symbolic meaning. The Gothic style with tall pointed arches and slender moulded pillars, which to painters of

the early Netherlandish schools was modern, familiar and western, symbolized Christianity and the Church. This is contrasted in the same picture with a kind of Romanesque – rounded arches, plain pillars and domes – meant to correspond to the architectural style of the eastern Mediterranean, and therefore symbolic of Judaism. The Virgin is sometimes depicted within or standing at the door of a Gothic building, while nearby the Romanesque crumbles into ruins. Thus Christ's Incarnation was shown to herald the New Dispensation that replaced the Old. The open area in which the Virgin receives the angel is well lit, illuminated by the light of the Christian faith, in contrast to the small dark windows of the 'eastern' (Romanesque) temple, or synagogue, in the background. Rays of light passing through the glass in a window also signify virginity. In the synagogue may be seen an altar on which rest the tablets of the Old Law. A walled garden, the *hortus conclusus*, and a tower, both symbols of the Virgin's chastity, may be introduced. (See VIRGIN MARY, 4.) With the art of the Counter-Reformation came a complete change of setting. From the late 16th cent. all suggestion of an edifice was usually abandoned. Instead, the background dissolves into clouds and sky, out of which the dove descends in a dazzling light, suggesting to the spectator that heaven is an immediate presence. See also DEATH OF THE VIRGIN (1).

Ansanus (d. 303). Christian saint and martyr, a nobleman of Siena who became a Christian at the age of twelve, and preached the faith as a young man. He was denounced by his father to the emperor Diocletian who, according to legend, had him thrown into boiling oil before he was executed. He died aged 20. Among his attributes are the banner of the Resurrection and a heart inscribed with the letters IHS (qv). He is depicted in the act of baptizing converts, being led to prison, or standing in a vat of oil while a fire is lighted underneath. In devotional images he is sometimes dressed as a warrior, holding the banner and the martyr's palm, perhaps with a bunch of dates hanging from it. He is a patron saint of Siena and appears chiefly in paintings of the Sienese school.

Antaeus, see HERCULES (16).

Antiochus and Stratonica (Plutarch 43:38). Antiochus, the son of Seleucus who founded the dynasty that ruled the Asian provinces after the death of Alexander the Great, was said to have fallen in love with his stepmother Stratonica. Believing his passion to be hopeless he began to starve himself to death. The court physician Erasistratus quickly guessed the nature of his malady, and by sitting in the bedchamber and observing the effect on the patient of female visitors soon discovered who was the cause. He informed Seleucus who, in tears, announced his abdication and handed over not only his kingdom to Antiochus, who would succeed him anyway, but also his wife. The theme, popular with Italian, French and Netherlandish painters of the baroque era, shows a royal bedchamber, with Antiochus in bed, gazing mournfully at a richly attired beauty. Erasistratus sits at the bedside, perhaps taking the patient's pulse. Courtiers are in attendance.

Antiope. In Greek mythology, a nymph or, according to some, the wife of a king of Thebes. She was surprised by JUPITER in the form of a Satyr while she was asleep, and was ravished by him (*Met.* 6:110–111; Hyginus 8). The theme was used at different periods as a medium for the portrayal of the female nude. Antiope reclines asleep in a woodland setting while a Satyr, horned and goat-footed, gently draws aside her robe. CUPID may be present, perhaps also sleeping, his bow and quiver laid aside.

Antlers, see STAG.

Antony of Padua (1195–1231). Christian saint and Doctor of the Church, born in Lisbon. He joined the Franciscan Order and became a friend and disciple of Francis. He was a man of great scriptural learning and preaching ability, and travelled much on behalf of the Order. He is the patron saint of Padua, where he died. His most popular legend concerns the kneeling ass. To convince a Jew of the 'real presence' at the Eucharist, Antony led an ass before the chalice and host, whereupon it knelt down. In Franciscan painting he is usually portrayed as a young man in the brown habit of the Order (see diag. RELIGIOUS DRESS). As a devotional figure he may have an ass kneeling at his side. His other attributes are a FLAME or a flaming heart held in the hand (also an attribute of Augustine, to whose order he once belonged); a book; a flowered CROSS, or CRUCIFIX; a LILY, the symbol of purity. His inscription is 'Homo igit consutu atque nudat queso ubi est' – 'But a man dies, and he disappears; man comes to his end, and where is he?' (Job 14:10). Other scenes from his legends are:

1. *The finding of the miser's heart; 'Ubi est thesaurus tuus, ibi et cor tuum erit'.* Preaching at a miser's funeral he quoted Luke: (12:34): 'Where your wealth is, there will your heart be also'. The scene shows the opening of the miser's treasure-chest in the presence of Antony. It was found to contain his heart.

2. *The healing of the wrathful son.* A young man who had cut off his leg in a fit of remorse after kicking his mother had it miraculously restored by Antony.

3. *Preaching to the fishes.* Finding himself on the seashore and without an audience, Antony turned and preached to the fishes. They press forward to hear him, their heads out of the water. A companion theme to Francis preaching to the birds, by which it was inspired.

4. *The vision of the Virgin with the infant Christ.* A common theme in Counter-Reformation painting, from a vision that came to Antony while in his room. He is sometimes shown holding the infant in his arms, or, as an attribute, it sits or stands on a book held in his hand.

Antony the Great (Antony, Abbot) (A.D. ?251–356). Christian saint and hermit, born in Upper Egypt. On the death of his parents he distributed his property among the poor and retired into the Egyptian desert where he remained in solitude for many years. He is generally regarded as the founder of monasticism. During an epidemic, said to be erysipelas, in Europe in the 11th cent. many cures were claimed in his name and the disease became known as St Antony's fire. He is usually shown as old and bearded, and wears a monk's cloak and cowl as the father of the monastic system. He has a stick with a *tau*-shaped (T) handle like a crutch; the *tau* also appears in blue or white on the shoulder of his cloak. The origin of its application to Antony is uncertain. It is perhaps simply a crutch, the traditional emblem of the medieval monk whose duty was to help the crippled and infirm. Alternatively, the *tau*, also known as the Egyptian cross, was a symbol of immortality in ancient Egypt and was adopted as an emblem by Alexandrian Christians. Antony holds a BELL and is accompanied by a PIG, an animal bred by the Antonine monks in the Middle Ages; its lard was said to have been used as a remedy for St Antony's fire. The bell sometimes hangs round the pig's neck. In the 17th cent. the pigs belonging to the Hospital Brothers of St Antony were allowed special grazing rights and were therefore distinguished in this way. According to some, the bell, which was commonly used to drive off evil spirits, alludes to Antony's temptation.

1. *The Temptation of St Antony.* Antony, like some other hermits, was subject to vivid hallucinations resulting from his ascetic life in the desert. These

'temptations' assume two forms in art, assault by demons, and erotic visions. The demons attack him in his cell or even carry him aloft; they sometimes take the form of wild animals and monsters which tear his flesh. The demons flee when God appears to him in a bright light. As might be expected Antony's temptation by Lust has kindled far more artistic imaginations. In earlier Renaissance painting the women are usually clothed, though they may have horns as a reminder of their satanic origin. From the 16th cent. they are generally nude. Antony wards them off with a crucifix or by prayer.

2. *The visit of St Antony to St Paul the Hermit.* At the age of ninety, according to the *Golden Legend*, Antony set off to find the hermit Paul who was then aged one hundred and thirteen, having spent the greater part of his life in solitude. On the road he met, among other wonders, a Centaur and a Satyr who showed him the way. The two old men embraced and a raven flew down carrying two loaves of bread. Paul told his visitor that the bird had brought him half a loaf every day for forty years. In 13th cent. painting the bird is sometimes represented as a dove, the symbol of the Holy Ghost. Elijah and other desert hermits were also said to have been fed by a raven. When Paul died Antony lacked the strength to dig his grave and the work was carried out by two lions. They may be depicted scratching a hole in the ground with their paws.

Anvil. Attribute of a warrior, who also has an axe or sword, and who stands beside a female saint (see ADRIAN AND NATALIA); also the attribute of ELOI (bishop). A goddess suspended in mid-air, anvils tied to her feet, is JUNO. Thus portrayed she may personify Air, one of the FOUR ELEMENTS. A blacksmith's forge, see VULCAN.

Ape. To Christians in the earlier Middle Ages the ape was a symbol of the devil, by which was meant heresy and paganism rather than man's sinfulness. In the Gothic era an ape with an apple in its mouth came to signify the Fall of Man, and appeared in representations of the Virgin and Child and elsewhere. This image was used in another sense in the Renaissance as an attribute of Taste, one of the FIVE SENSES. Man recognized a distorted, baser image of himself in the ape. It became associated with vice in general, and was used for the personification of LUST (see also WILD MAN). The ape is an attribute of the Sanguine man (see FOUR TEMPERAMENTS).

From the Middle Ages the ape was a symbol of the art of painting and sculpture. The artist's skill was regarded as essentially imitative and became linked with the animal that was known for its imitativeness. The idea was expressed in a popular saying 'Ars simia Naturae' – 'Art is the ape of nature', which was taken up particularly by 17th cent. Flemish painters. They depicted the artist as an ape, in the act of painting a portrait, generally of a female, usually human, or carving a figure in stone. This parody of man was extended to other human activities and apes were represented sitting at the meal-table, playing cards or musical instruments, drinking, dancing, skating and so on. Other creatures, cats and owls in particular, sometimes took the place of apes. The artist was satirizing man's pretentiousness, follies and vanities.

Apelles paints Campaspe. Apelles, the celebrated painter of ancient Greece, was court painter to Alexander the Great. The elder Pliny (*Nat. Hist.* 35:36) tells how Apelles was engaged by the emperor to paint his favourite concubine, the beautiful Campaspe, and how while doing so he fell in love with her. Alexander, as a mark of his appreciation of the painter's work, made him a present of her. The theme is popular in the 16th and 17th cents., especially in the Netherlands and Italy. Apelles stands at an easel painting Campaspe who is generally naked.

Alexander, identifiable by his helmet, is present. Cupid, or amoretti, remind us of Apelles' feelings. See also ZEUXIS PAINTS HELEN.

Aphrodite, see VENUS.

Apocalypse (From Gk, an 'unveiling'). The faith of the early Christians, living under persecution, was sustained by the expectation of Christ's imminent second coming. This found literary expression in the Revelation of John, written at the end of the first cent. A.D., an allegory foretelling the destruction of the wicked, the overthrow of Satan and the establishment of Christ's kingdom on earth, the 'New Jerusalem'. It followed the tradition of Jewish apocalyptic writing going back to Daniel in the 2nd cent. B.C., in which was foreseen the deliverance of Israel from her oppressors by a sudden act of the divine will, and from which the author of the Revelation borrowed much of his imagery. Popular belief, for which there is no historical evidence, identified the writer whose name was John with John the Evangelist, and he is so represented in apocalyptic themes. Though the author is alluding to the contemporary condition of Christians under the Roman empire, succeeding ages placed their own interpretation on the allegory. Thus the figure of the Beast, or Antichrist, which stands for the pagan emperor (either Nero or Domitian both of whom caused the blood of many martyrs to flow), came to symbolize Islam to crusading Christians; to Catholics at the time of the Reformation it stood for Protestant heresy, while Lutherans made it a symbol of the corrupt papacy. The sequence of fantastic images with their often obscure symbolism – the author's 'visions' – forms a loose cycle of themes that are found in religious art from the time of the Carolingian renaissance. They are seen in illuminated MSS, in the sculpture, stained glass and frescoes of churches, and in engravings and tapestries. The famous series of fifteen wood engravings made by Dürer at the end of the 15th cent. influenced the later treatment of the subject in northern Europe, especially France. The following are the more important themes:

1. The 'martyrdom' of JOHN THE EVANGELIST (1) in a vat of boiling oil prefaces the series by Dürer.

2. (Rev. 1:10–16) A voice told John to narrate his vision to seven Christian communities in Asia Minor. He saw seven lamps (sometimes represented as altar candlesticks) in the midst of which was 'one like a son of man', his hair like snow-white wool, his eyes aflame, holding seven stars in his right hand, with a sword coming out of his mouth. (John kneels in prayer before this vision of Christ, who is generally enthroned.)

3. (4:2–8) In another vision John saw Christ enthroned, before him seven burning torches, around him four creatures resembling a lion, ox, man and eagle (the 'apocalyptic beasts', later made into symbols of the FOUR EVANGELISTS); round them were twenty-four elders enthroned, wearing golden crowns, each one with a harp (5:8). Originally probably a choir of angels, but taken to symbolize the twelve prophets, or patriarchs, and twelve apostles, i.e. the Old and New Testaments. John is again kneeling.

4. (5:6–14) A lamb, having seven horns and seven eyes, took from the enthroned one a scroll (containing the secrets of man's destiny) in order to break its seven seals. (The lamb rests its fore-feet on a book lying in the lap of Christ; or it holds the banner of the Resurrection. The elders, with harps and bowls of incense, sing hymns to the sacrificial lamb.)

5. (6:1 8) On the breaking of the first four seals there appeared the 'four horsemen of the apocalypse': 1) The 'conqueror', crowned by an angel, holding a bow, riding a white horse; 2) 'War', with a sword, on a red horse; 3) 'Famine',

with a pair of scales, on a black horse; 4) 'Death', on a 'sickly pale' horse, closely followed by Hades. (The horsemen have been variously interpreted. To the Middle Ages the first stood for Christ and the Church; but more commonly all four are seen as the agents of divine wrath. They trample men under their hooves. Hades, a gaping-jawed Leviathan, swallows a bishop.)

6. (6:9–12) A vision of the martyrs (of Roman persecution) 'underneath the altar' and awaiting their vindication accompanied the breaking of the fifth seal. Each was given a white robe. (The robes, distributed by an angel, are being donned.)

7. (6:12–17) The breaking of the sixth seal brought the day of wrath: the sun turned black, the moon red as blood, the stars fell, mountains and islands moved. (Stars rain from heaven upon pope, emperor and common folk on the earth below.)

8. (7:1–8) Four angels held back the four winds (symbols of the great empires of antiquity) until another angel had placed the protective 'seal of the living God' on the foreheads of the multitudes of Christians.

9. (7:9–17) They stood before the throne of the Lamb, robed in white and holding palms, and gave praise to God. Angels and the apocalyptic beasts stood round the throne. 'The Lamb . . . will guide them to the springs of the water of life.' The latter is represented by a fountain or by four streams (the gospels) flowing from the hill on which the Lamb stands.

10. (8:1–12) When the Lamb broke the seventh seal 'there was silence in heaven for what seemed half an hour'. There then appeared seven angels with trumpets and as each blew further disasters, hail, fire and blood, rained down. A third of the earth and sea were burnt up, a third of the rivers poisoned, a third of the sun, moon and stars went dark. (God in heaven is handing out trumpets to his angels. On earth below cities are on fire, ships sinking.)

11. (8:13) An eagle in mid-heaven cried woe to those on earth when the last trumpets should sound. (The words 'Vae, vae, vae' or 'Ve, ve, ve' issue from its beak.)

12. (9:1–11) The fifth trumpet caused a star to fall into the pit of hell and unloosed a plague of monstrous locusts that tormented those that had not been sealed. (They have human heads and tails terminating in serpents' heads.)

13. (9:13–19) The sixth trumpet released the four angels of death and their cavalry whose horses had lions' heads that breathed fire, and serpent-headed tails. (Watched by God in heaven the angels with drawn swords slay pope, emperor and commoner.)

14. (10:1–11) An angel appeared wrapped in cloud, his face shining like the sun, and with legs like pillars of fire, one planted in the sea, one on land. John was commanded to take the angel's scroll and eat it, thus 'inwardly digesting' the divine message. (John kneels, receiving the book or, as in Dürer, munching one corner. The angel has burning pillars for legs.)

15. (12:1–6) The seventh trumpet brought a vision of God's heavenly temple, followed by earthquake and storm, and the appearance of the famous 'portent': 'a woman robed with the sun, beneath her feet the moon, and on her head a crown of twelve stars'. A dragon with seven heads stood waiting to devour the child she was about to bear, but it was borne by angels safely up to God. (There is doubt about the writer's original meaning for this vision. The woman was probably meant originally to symbolize the Church. Her identification with the Virgin Mary was a medieval interpretation of Bonaventura and others. See VIRGIN MARY, 4.)

16. (12:7–9) War broke out in heaven. MICHAEL and his angels fought and conquered the dragon. (One of the central images of the triumph of Christianity over evil, commonly found as a separate subject apart from the cycle. The dragon's seven heads symbolize the seven Deadly Sins.)

17. (13:1–10) A beast with ten horns and seven heads rose out of the sea and men worshipped it. On each horn was a diadem. One head had a mortal wound that had healed. (The beast stands for Nero, as the well-known riddle of its number, 666, tends to confirm; its seven heads are probably a line of Roman emperors, the horns other rulers. One of its heads may be seen to fall back as if dead. People kneel before it worshipping; those who refuse are executed.)

18. (13:11–20) A second beast with horns like a lamb's, miraculously brought down fire from heaven, and caused men to worship the first beast. (A symbol of paganism, represented as a lion-headed monster with horns and fire descending about it.)

19. (14:14–20) The vision of the harvest of the world, the 'grapes of wrath'. Christ enthroned on a cloud, holding a sickle, sent out his angels with sickles. They gathered the grapes 'and threw them into the great winepress of God's wrath'. (The judgement of the chosen and the damned, the wicked going to their doom.)

20. (17:3–6) The vision of the whore of Babylon was of a woman clothed in purple and scarlet, mounted on a scarlet beast that had seven heads and ten horns. She held a gold cup full of obscenities. An angel foretold her destruction to John. (The whore of Babylon symbolizes Rome to the writer who states that the beast's seven heads represent seven hills. To Protestant reformers she stood for the Rome of the popes.)

21. (18:21–4) 'Then a mighty angel took up a stone like a great millstone and hurled it into the sea and said, "Thus shall Babylon, the great city, be sent hurtling down, never to be seen again"'.

22. (19:11–16) A vision of a rider named Faithful and True, riding a white horse. His eyes flamed like fire, a sword came out of his mouth, he carried a rod of iron, and his garment was drenched in blood. (The symbol of Christ as a warrior, robed in the blood of martyrs, with a sword to conquer and a rod to rule.)

23. (20:1–3) An angel with the key of Hell and a chain seized the dragon, 'that serpent of old', chained him and threw him into a pit for a thousand years.

24. (21: 9–27; 22:1–5) An angel carried John to a mountain-top and showed him the New Jerusalem 'coming down out of heaven'. It was built as a square, with high walls and twelve gates at each of which was an angel. It was made of jewels and gold and the river of the water of life flowed through it. (John stands with the angel gazing at the city. This visual rendering of the expected Second Coming later came to be construed as the building of the Church upon earth.)

Apocalyptic beasts, see FOUR EVANGELISTS.

Apollo. One of the twelve gods of Olympus. He was the embodiment of the classical Greek spirit, standing for the rational and civilized side of man's nature. In this respect he contrasted with Dionysus (Bacchus) who represented man's darker passionate side. In Greek myth he was the son of Zeus (Jupiter) and Leto, and the twin brother of Artemis (Diana); he was born on the island of Delos where Leto had fled to escape the jealousy of Zeus' wife, Hera (Juno). He later became

identified with the sun-god Helios (Sol) who drove his chariot daily across the sky; the cult of the sun-god was widespread under the Roman empire. In classical sculpture Apollo represented the ideal form of male physical beauty, just as Venus represented the female; he is portrayed as a young man, beardless, with delicate, sometimes rather effeminate features. His hair is long, usually held with a fillet, or with a knot behind the neck. He is usually naked, though as a musician he may wear a long tunic. A typical image was the Apollo Belvedere, a Hellenistic statue, discovered in Rome in the 15th cent., showing the god standing with one arm raised as if he had just shot an arrow from his bow (Vatican Mus., Rome). This work influenced generations of later artists. Apollo's many attributes indicate the wide variety of his patronage and functions: the BOW, ARROW and QUIVER, as patron of archery. Ovid (*Met.* 1:438–451) tells how he slew the serpent Python with a thousand arrows; Renaissance mythographers compared the sun-god's arrows to the sun's rays. The LYRE – or other stringed instrument – is his as patron of poetry, music and leader of the Muses (see below 3, 4, 8). A crown of LAUREL leaves, often worn by Apollo, was awarded for achievement in the arts (see also 9). As a sun-god he drives a four-horse CHARIOT and may have a HALO. A SNAKE alludes to his victory over the Python. He may be accompanied by a curious monster with three heads – wolf, lion and dog – having the body of a twined serpent; this originally belonged to the Egyptian sun-god Serapis and was given to Apollo by Renaissance mythographers. (See PRUDENCE.) Other less common attributes are his shepherd's CROOK, as the guardian of flocks; the SWAN, a symbol of beauty; a GLOBE, his universality; a WOLF, one of the forms in which he was originally worshipped.

The Sun-God

To the Greeks the nature and functions of Apollo and Helios were distinct and separate. Apollo's identification with the sun, 'Phoebus (Radiant) Apollo', was, according to some, a later development, and was particularly associated with his cult in Roman times. His golden chariot is a *quadriga*, that is to say, yoked to a team of four horses abreast; they draw it daily across the sky. The god is sometimes seen driving it through a circular golden band, or arch. This represents the zodiacal belt, that region of the heavens, well-known to the ancients, through which the sun was observed to pass annually. Medieval tradition gave the horses different colours, but from the 15th cent. they were usually white, the same as the Roman triumphal *quadrigas*. In baroque art nymphs and amoretti play round the chariot. The sun-god's chariot was lent to PHAETHON with disastrous consequences. As sun-god Apollo was supreme at the court of Versailles where he symbolized the French king, *le roi-soleil*, at the centre of an elaborate allegory of gods and goddesses. The court itself was represented by Parnassus. (See also ELIJAH, 5.)

1. *Apollo and Diana: sun-god and moon-goddess.* Diana came to be identified with LUNA, the moon-goddess (Gk Selene), from whom she acquired the crescent moon over her brow. Selene was the sister of Helios, just as Diana was sister of Apollo. She shared the heavens with him, beginning her journey in the evening just as he finished his. Like him she drove a horse-drawn chariot, though in antiquity she sometimes rode on horseback. In baroque painting Apollo and his prancing horses, surrounded by light, drive Diana and her chariot out of the skies and into darkness, her nymphs fleeing with her. Or he may be seated on a cloud in bright sunlight, holding his lyre, while Diana sits nearby in shadow.

2. *Apollo in Vulcan's forge* (*Met.* 4:171–6). Apollo, the sun who saw and knew everything, witnessed Venus' adulterous love-affair with Mars, and hastened to tell her husband at his forge. Vulcan, the blacksmith of the gods, is shown at his anvil, listening in shocked surprise to the news. Apollo is crowned with the sun-god's halo. (For the sequel, see VENUS, 8.)

The God of Poetry and Music

3. *Apollo and the Muses.* In this role he dwells on Mount PARNASSUS, accompanied by the nine MUSES, the goddesses of poetic inspiration and the creative arts in general, and is named Apollo Musagetes. He is often robed, wears a laurel crown and plucks his lyre or, especially in 15th and 16th cent. painting, plays a *lira da braccio* or other contemporary form of VIOL. A running brook is the Castalian spring which, like another, the Pierian, was a source of inspiration and learning where we are advised to drink deep. Apollo, with Orpheus and Homer, appear together in allegories of poetry and music.

4. *Apollo and Marsyas* (*Met.* 6:382–400; *Fasti* 6:703–8; Philostratus the Younger, *Imag.* 2). Marsyas, a Satyr – one of the followers of Bacchus – was a skilful flute-player. The instrument had been invented by Minerva, but she soon threw it away when the other gods laughed at the sight of her cheeks bulging as she played. But she had laid a curse on it and Marsyas, who found it, was the innocent victim. Marsyas' pride in his skill on the flute angered Apollo who challenged him to a musical contest, the flute versus the lyre, the winner being allowed to impose any penalty he chose on the loser. Since the Muses were the judges, Apollo was, needless to say, declared the victor, and he thereupon inflicted the savage punishment of tying Marsyas to a pine-tree and flaying him alive. According to Ovid the River Marsyas in Phrygia springs from the tears shed by the other Satyrs at his death. The musical contest and the flaying are generally depicted as separate scenes. (a) *The Contest:* Marsyas, usually without the Satyr's normal goat-like features, plays his pipe while Apollo stands regarding him contemptuously. The latter's bow, quiver and lyre lie nearby. Or Marsyas looks on while Apollo plays his stringed instrument. Marsyas' traditional double-flute may become in the 15th and 16th centuries a syrinx, shawm, or more rarely, bagpipes, but always a wind instrument of some kind. Classical antiquity and the Renaissance attached symbolic meanings to the two classes of instrument: the cool sound of strings was felt to have a spiritually uplifting quality, while the coarse note of the reed pipe stirred the passions – the latter was, moreover, an accepted phallic symbol. The theme was thus an allegory in musical terms of the intellect versus the emotions. (b) *The Flaying of Marsyas:* A Hellenistic sculpture from Pergamum (Capitoline Mus., Rome), much copied in the Renaissance, shows Marsyas about to be flayed, and hanging, bound hand and foot to a tree. In Renaissance and later painting an attendant of Apollo applies the knife while another may crown Apollo with the victor's laurels. Baroque artists tended to dwell on the cruelty: Marsyas lies on the ground contorted with pain while Apollo himself performs the act of flaying. The original myth probably echoed an ancient Phrygian fertility rite involving human sacrifice in which the victim was hanged under a sacred pine tree. The 15th cent. Florentine humanists interpreted it allegorically as a kind of spiritual purification, brought about by the shedding of the outer, sensual, Dionysiac, self. Of the Christian saints, BARTHOLOMEW was martyred in this manner.

5. *The Judgement of Midas; Apollo and Pan* (*Met.* 11:146–193). Another musical contest, a theme very similar to, and often confused with Apollo and Marsyas. Pan takes the place of Marsyas, but after his defeat escapes with

nothing worse than ignominy. The contest was judged by the mountain god Tmolus. King Midas, who happened to be present, disagreed with the verdict and was rewarded with ass's ears by Apollo. According to another version the contest was judged by Midas and the Muses. Pan can usually be distinguished from Marsyas by his goat's legs and syrinx. Midas wears a regal cloak and occasionally a crown.

The God of Prophecy

6. *Apollo and Hercules.* In classical Greece Apollo had a special function as a god of divination. At his many shrines the priestess, or SIBYL, the mouthpiece of the god, uttered her prophecies in reply to questioners. She was often consulted on important matters of state. Apollo's most famous sanctuary was at Delphi, the site where, according to myth, he slew the Python. (Hence his title Delphic or Pythian Apollo.) When delivering her oracle the priestess sat on a sacred tripod. Hercules, in a fit of rage, once attempted to steal it (Hyginus 32). He is depicted with club raised, while Apollo tries to wrest the tripod from him. It took one of Jupiter's thunderbolts to part them. They made up their quarrel and the tripod was restored.

7. *Apollo and the Cumaean Sibyl.* Ovid (*Met.* 14:130–153) tells how the Sibyl of Cumae, in southern Italy, was loved by Apollo. He bribed her by offering to prolong her life for as many years as there were grains in a heap of dust, in return for her embraces. She refused him and although he kept his word he denied her perpetual youth, so she was condemned to centuries as a wizened crone. The Sibyl, a young woman, is shown standing before Apollo holding out her cupped hands which contain the heap of dust. He sits on a rock before her, one hand resting on his lyre. A late theme, first seen in the 17th cent.

The Pastoral God

8. *Apollo the Shepherd; Apollo and Mercury.* Apollo was sent by his father Jupiter to serve king Admetus as a shepherd, a punishment for killing the Cyclopes, Jupiter's armourers. This pastoral, or nomadic, Apollo (Apollo Nomius) sits under a tree, perhaps the bay which was sacred to him, and is tuning or playing his lyre while sheep browse in a meadow. He may have a shepherd's crook. In another version (*Met.* 2:678–709) he is a herdsman watching over cattle – somewhat inattentively, since Mercury succeeds in stealing them unobserved. On Jupiter's orders the beasts were returned, and Apollo and Mercury reconciled. Mercury sealed their friendship by the gift of the lyre, which he was said to have invented, and in return received his wand, or CADUCEUS. Mercury is depicted driving away the herd, a stick in one hand, his caduceus in the other, while Apollo sits playing abstractedly. Mercury is also shown, after their reconciliation, handing the lyre to Apollo.

The Loves of Apollo

9. *Apollo and Daphne.* (*Met.* 1:452 ff; Hyginus 203). The nymph Daphne, the daughter of the river god Peneus, was the first and most celebrated of Apollo's loves, and was popular with artists in all ages. According to Ovid, Cupid, in a spiteful mood, was the cause. He struck Apollo with a golden arrow, the sort that kindles love, Daphne with a leaden one that puts love to flight. The god pursued the unwilling girl and, when she had no more strength to flee, she prayed to her father to save her. Whereupon branches sprouted from her arms, roots grew from her feet, and she was changed into a laurel tree. Daphne is usually depicted in flight, her upraised arms already sprouting. Apollo, with bow and quiver and perhaps crowned with laurel leaves, is close behind. Or Daphne may seek refuge beside her father the river god, who reclines on his overturned URN,

perhaps with an OAR beside him. Cupid is often present. The theme symbolizes the victory of Chastity over Love.

10. *Apollo slays Coronis.* (*Met.* 2:602–620). Coronis, a princess, was Apollo's lover and was with child by him, but she left him for another. The news was brought to Apollo by a snow-white crow that he had set to watch over her. In a fit of jealous rage he cursed the crow which turned black, and he then slew Coronis with an arrow. He tore the child from her womb and gave it into the care of the centaur Chiron. It grew up to become the god of medicine, Asclepius. Coronis is shown lying pierced with an arrow while Apollo stands by her, grief-stricken, bow in hand. Chiron holds the infant. The crow may be nearby.

11. *Apollo and Hyacinthus* (*Met.* 10:162–219). Apollo's love for Hyacinthus, a prince of Sparta, is one of the rather infrequent instances of homosexual love in Greek myth – another is Jupiter and GANYMEDE, which is sometimes a companion picture. The relationship was brought to an end by the jealous intervention of Zephyrus, the west wind. Apollo was teaching the youth to throw the discus, when the wind caught it and dashed it against the skull of Hyacinthus, killing him. The hyacinth flower sprang from the earth where his blood fell.

See also ACHILLES (4); LAOCOÖN; NIOBE; PHAETHON.

Apollonia (d.249). Christian saint and virgin martyr of Alexandria. For refusing to sacrifice to the pagan gods it was said that she had her teeth drawn before being burned at the stake. She is depicted as a young woman, in her hand a pair of PINCERS which, unlike those of AGATHA, hold a tooth. The scene of her martyrdom sometimes shows her bound to a plank or pillar. One executioner holds her by the hair while another draws her teeth. She is the patron saint of dentists, and is also invoked by their patients, when in need.

Apotheosis (Gk. 'deification'). The idea of the king as a divine person belongs to man's earliest religious beliefs. He was worshipped as a god not only after death but during his lifetime. This was readily acceptable to the Greeks through the myths of heroes such as HERCULES (26) and other mortals who were received on their death into heaven among the gods. Deification was accorded in his lifetime to Alexander the Great. Among the Romans Julius Caesar was officially recognized after death as a god, establishing a precedent that was followed in the case of later emperors. The ceremony included the release of an eagle which was believed to carry his soul to heaven, rather as GANYMEDE was borne to Olympus by Jupiter's eagle. Apotheosis is represented on Roman tombstones and on coins. It was revived in the 17th cent. in the decoration of the baroque ceiling, at first in Italy and later in northern Europe. The age which extolled the divine right of kings portrayed its own monarchs and other great men being received among the Olympians, led perhaps by Mercury before the throne of Jupiter, and surrounded by allegorical figures that symbolized their earthly virtues. The use of art in this way for the glorification of man was made to serve religious ends in the churches of the Jesuits. Thus in the church of Sant' Ignazio in Rome IGNATIUS OF LOYOLA is depicted being received into heaven in the manner of an apotheosis.

Appearance of Christ to his Mother. The gospels' account of the several appearances of Christ on earth during the forty days between his Resurrection and Ascension corroborate for the Christian the doctrine of the Resurrection, and are for this reason important themes in art. But the gospels are silent concerning any appearance to his mother. The event was nevertheless deemed to have taken place. St Ambrose wrote in the 4th cent. (*Liber de Virginitate*), 'Therefore Mary saw the resurrection of the Lord: she was the first to see him and she believed'.

The Meditations on the Life of Christ by Pseudo-Bonaventura (*c.* 1300), gave a detailed account of the meeting. On the morning of the Resurrection, while the three Maries made their way to the tomb with their precious ointments, the Virgin remained at home and prayed, in tears, that her Son might come and comfort her. Christ appeared clothed in white and she knelt before him. He too knelt; then they both arose, embraced, and exchanged greetings. The scene shows Christ standing before the Virgin dressed in a loose garment, and displaying his wounds as proof that it is he. He may hold the banner of the Resurrection. The Virgin kneels before him, or at a *prie-dieu*, or reaches out to embrace him. An alternative type, based on the presumption that Christ would at that moment have just returned from hell, shows him with a retinue of the redeemed patriarchs and prophets of the Old Testament, led by Adam and Eve. (See DESCENT INTO LIMBO.) The subject occurs first in the earlier 14th cent. Though its devotion was fostered by the Jesuits, it is less often found in Counter-Reformation art.

Apple. By tradition, but not by scriptural authority, the fruit of the Tree of Knowledge (ADAM AND EVE, 2), perhaps a borrowing by early Christian artists from the classical image of the golden apple tree of the Hesperides (HERCULES, 11); hence a symbol of the Fall of Man and, when held by the infant Christ, an allusion to his future mission as Redeemer (VIRGIN AND CHILD, 13; STILL LIFE). An apple in the mouth of an APE has a similar meaning. Golden apples are the attribute of VIGILANCE personified, and of the harpies that accompany AVARICE. They are picked up by a maiden overtaken by a running youth (ATALANTA AND HIPPOMENES). A golden apple was thrown down into the BANQUET OF THE GODS, and was later awarded by Paris to Venus (JUDGEMENT OF PARIS). The apple is an attribute of VENUS (see also PUTTO). Apples are the attribute of the THREE GRACES, the handmaidens of Venus and, with roses in a basket, of DOROTHEA.

Aquarius (Zodiac), see TWELVE MONTHS.

Arachne (*Met.* 6:129–45). A young woman of Lydia who was famed for her skill in weaving. Neighbouring nymphs would come to watch her at work. She rashly challenged to a contest Minerva, the goddess of wisdom, who included among her many functions the patronage of spinners and weavers. Arachne wove a cloth depicting the loves of the gods of Olympus which enraged Minerva so much that she tore it to pieces. Arachne, overcome by Minerva's wrath, hanged herself but was spared from death by the goddess who changed her into a spider dangling on its thread. The scene shows Arachne working at her loom, while the goddess, wearing armour, either sits at one side watching intently or rises and points with outstretched arm at the woven cloth. Another scene shows Arachne at the moment of turning into a spider, her arms entangling themselves in a huge web. In the background the nymphs may be looking on. (The spider's web was believed by the ancients to be woven.)

Arcadia (Arcady). A pastoral paradise ruled by Pan, the god of flocks and herds, and inhabited by shepherds and shepherdesses, and nymphs and Satyrs, who dwell in an atmosphere of romantic love. It is closely linked to the idea of the Golden Age (see AGES OF THE WORLD). It was first given literary expression in the *Idylls* of the Greek poet Theocritus (3rd cent. B.C.) who depicted the attractions of the pastoral life in his native Sicily. Virgil's *Eclogues* did the same for the Italian countryside two centuries later. An early pastoral novel was DAPHNIS AND CHLOE by the Greek Longus. Pastoral poetry and drama flowered in Italy in the 16th cent. Guarini's *Il Pastor Fido*, set in Arcadia, became a source of pictorial themes (CORISCA AND THE SATYR; MIRTILLO, CROWNING OF; SILVIO AND DORINDA). The pastoral spirit is likewise present in parts of *Jerusalem Delivered*

by Tasso, a work of the same period (see ERMINIA AND THE SHEPHERDS and related themes thereunder). In the north Pieter Hooft's *Granida* (1605) was widely represented in Dutch painting (GRANIDA AND DAIFILO). The spirit of classical Arcadia is strongly felt in the work of Poussin (see ET IN ARCADIA EGO). The idealized rural retreat, the place of escape from the reality and complexity of life in town and court, is fundamental to the idea of Arcadia and was expressed in the *fêtes champêtres* of Watteau, Lancret, Fragonard and other French painters in the 18th cent. Historically Arcadia, the central plateau of the Peloponnese, was inhabited by shepherds and hunters who worshipped Pan.

Arcadian stag, see HERCULES (3).

Archimedes (287–212 B.C.). Greek mathematician of Syracuse. Thanks to the military engines he invented, the city held out for two years against the Romans in the second Punic War. He died during its capture. According to Plutarch (16:19), while he was preoccupied with a diagram that he had drawn in the dust on the ground a soldier appeared and demanded his presence before the Roman general Marcellus. Archimedes declined until he had solved his problem, and was immediately killed. The theme occurs chiefly in Italian and German painting of the baroque era, and shows a soldier in Roman armour brandishing a sword before the aged Archimedes, perhaps at the same time grasping his white beard.

Ares, see MARS.

Arethusa, see ALPHEUS AND A.

Argus, the 'all-seeing', a shepherd, see JUNO; MERCURY (1).

Ariadne, see BACCHUS (4, 5); THESEUS.

Aries (zodiac), see TWELVE MONTHS.

Arion (Herod. 1:23–4; *Fasti* 2:79–118; Hyginus 194). A Greek poet of the 7th cent. B.C., famous for his skill on the lyre. He was once threatened with robbery and murder by the crew of a boat in which he was a passenger. He jumped overboard and was carried safely to shore on the back of a dolphin that had been attracted by the sound of his music. He is shown riding on a dolphin holding either a lyre or, in Italian Renaissance pictures, a *lira da braccio*, a bowed instrument of the VIOL type. He may wear a laurel wreath. The boat is in the background.

Aristotle (384–322 B.C.) **and Campaspe** ('Lay of A.'). An allegory of woman's domination over man, popular in the later Middle Ages and Florentine Renaissance, sometimes found in conjunction with other themes expressing the same idea: VIRGIL, LAY OF; SAMSON (4) and Delilah; HERCULES (17) and Omphale. The aged philosopher is seen in a very undignified position, on all fours wearing bit and bridle. The beautiful Campaspe rides on his back holding the reins and brandishing a whip. The connection between them is Alexander the Great whose tutor was Aristotle and whose favourite courtesan was Campaspe. According to a medieval legend Aristotle in an attempt to end the relationship warned Alexander how women had often been the undoing of strong men. To obtain her revenge Campaspe succeeded in rousing the passion of the philosopher and then demanded, as proof of his love, that she be allowed to ride on his back. The incident was witnessed by Alexander who thereby learned to mistrust the wiles of women against whom even old men were manifestly powerless. It is represented in frescoes of Italian Renaissance palaces, on *cassone* panels, tapestries and elsewhere. It is very common in 15th cent. German prints. The figure of Alexander may sometimes be seen looking on from a balcony. The woman may alternatively be called Phyllis.

Aristotle personifies Logic, one of the SEVEN LIBERAL ARTS.

Armour, the dress of the WARRIOR. It lies about the forge of VULCAN; it is strewn over the bed of a woman about to commit suicide, DIDO; it decorates the walls of a study where a gaunt reader sits, DON QUIXOTE. Putti play with the armour of MARS (1). See also WEAPONS.

Arms, a maiden's, upraised and sprouting bushes (laurel), APOLLO (9); CHASTITY. A group of maidens, their upraised arms sprouting twigs and branches (poplars), the Heliads, sisters of PHAETHON. A young woman, her arms and head sprouting (myrrh tree), an infant in the arms of nymphs, ADONIS, BIRTH OF. For the soldier's tools of trade, see WEAPONS.

Arrest of Christ, see BETRAYAL.

Arrow. Not merely a weapon, but traditionally the carrier of disease, especially the plague. In classical themes, the arrow, together with the bow, is the attribute of CUPID, and hence of VENUS and of PUTTI. According to Ovid (*Met.* 1:468 ff) Cupid's arrows were of two kinds, gold that kindled love and lead that drove it away. Bow and arrow are the attribute of APOLLO, and of the huntress DIANA and hence of LUNA with whom Diana became identified. An arrow piercing his heel caused the death of ACHILLES (4). In allegory, DEATH is sometimes represented with an arrow instead of his scythe. An arrow and bow are held by the personification of America, one of the FOUR PARTS OF THE WORLD. A bundle of arrows, like the fasces, is an attribute of CONCORD.

The arrow is the attribute of several saints: arrows piercing the breast, AUGUSTINE; piercing the stag he protects and, perhaps, his hand, GILES; held by a richly attired maiden, URSULA; held by maiden with millstone, CHRISTINA; several piercing his nude body, SEBASTIAN. The Virgin's cloak protects suppliants from Christ's arrows (VIRGIN MARY, 3); she presents DOMINIC, and sometimes FRANCIS, to Christ who brandishes arrows; she herself holds broken arrows in a vision of FRANCES OF ROME.

An arrow embedded in the centre of a shield hanging from the branch of a tree, with the motto 'βάλλ' οὕτως', – 'shoot in this manner' (*Iliad* 8:282), was the *impresa* of Cardinal Alessandro Farnese (1520–1589), patron of the arts (Farnese Gallery, Rome). (The shield must be struck dead-centre otherwise the arrow is deflected.) A bundle of arrows, perhaps held by putti, was one of the *imprese* of the Spanish royal house in the 16th cent.

For scenes of death caused by an arrow, see DEATH.

Ars moriendi. The name, meaning 'the Art of Dying', given to a collection of medieval texts originally meant for the use of the clergy when attending the dying. They were widespread in the 14th and 15th centuries, latterly in the form of illustrated block-books which came to be used by the laity. They depicted in a series of engravings the contest between angels and demons over the fate of a man. In his dying agony as he lies in bed his soul emerges from his mouth to be received by one of a band of angels.

'Ars simia naturae', scc APE.

Artemis, see DIANA.

Artemisia. Wife of Mausolus, the satrap of Caria in Asia Minor. She succeeded her husband on his death in 353 B.C., and erected a great monument to his memory at Halicarnassus – hence 'mausoleum'. It was one of the seven wonders of the ancient world. It was said that she mixed the ashes of Mausolus in liquid which she then drank, thereby, observes Valerius Maximus, making of herself a living, breathing tomb (4:6). Artemisia symbolizes a widow's devotion to her husband's memory. In Renaissance painting she is depicted holding a cup or goblet, or perhaps with an urn inscribed 'Mausolus'.

Artist. A girl drawing the silhouette of a youth on a wall, DISCOVERY OF THE ART OF DRAWING. Artist at easel, sitter a nude girl, others undressing, ZEUXIS PAINTS HELEN; sitter a woman, a soldier present, APELLES PAINTS CAMPASPE; sitter the Virgin and Child, LUKE (2). Sculptor in studio before statue of female nude, PYGMALION. The artist caricatured as a monkey, see APE.

Ascension. The term used for the last 'appearance' of Christ to the apostles after his Resurrection, when he was taken up to heaven in a cloud. But Christ's was not the only ascension to take visible form. The Virgin is shown in art being taken up to heaven (see ASSUMPTION), and likewise prophets and saints (see ELIJAH, 5; MARY MAGDALENE, 5). Nor is the idea confined to Christian belief. Divinity was sometimes conferred on a mortal, such as Alexander the Great and the Roman emperors. They were depicted being received in heaven into the presence of the deity (see APOTHEOSIS). Classical mythology contains several examples of mortals being similarly favoured by the gods (see CUPID, 6; GANYMEDE). Moreover, the cloud that sheltered a god from human sight was a familiar concept to the ancients (see IO; IXION).

The Ascension of Christ occurred (Acts 1:9–12), forty days after his Resurrection, as he was standing with the apostles on the Mount of Olives. 'As they watched, he was lifted up, and a cloud removed him from their sight. As he was going, and as they were gazing intently into the sky, all at once there stood beside them two men in white who said, "Men of Galilee, why stand there looking up into the sky? This Jesus, who has been taken away from you up to heaven, will come in the same way as you have seen him go."' In the Byzantine and western churches in the middle ages the figure of the ascending Christ took different forms. In the hieratic art of the east it was obligatory for him to be portrayed full face; he is usually framed within the almond-shaped MANDORLA which may be borne by angels. The customary place for the image was the ceiling of the central cupola of the church. In Romanesque and Gothic art the figure was often in profile, as if it were climbing to heaven, usually framed in a mandorla, and in this form is often found on the west front of a church, typically on the tympanum of the main portal. A third form shows Christ literally disappearing into the cloud with only the feet visible below. All these versions are found in Renaissance painting. A complete representation of the 'Ascension' is divided into two parts, upper and lower, heaven and earth. In heaven the figure of Christ forms the centre-piece, his feet resting on a cloud, surrounded by cherubim arranged in the shape of a mandorla. He sometimes holds the banner of the Resurrection, and makes the sign of benediction with the right hand. On either side, balancing the composition, may be angels, perhaps playing musical instruments. On earth the apostles stand gazing up in awe at the departing figure, or they kneel in prayer. They should at this time be eleven in number. The Virgin is generally with them, a symbol of the Mother Church which Christ left behind on earth. On either side of her may be seen St Peter, holding the keys, and St Paul, with his sword, symbols respectively of the Jews and the Gentiles to whom the Christian message was brought. The two angels dressed in white who appeared to the apostles may be present. In baroque art the formal composition of the Ascension is lost, the mandorla disappears and the angels tend to assume the character of putti. At this period the subject is used for ceiling decoration for which, like the apotheosis, it is particularly appropriate.

The mandorla motif with its enclosed figure standing on a cloud was in some instances, especially in Italian Renaissance painting, copied from 'stage properties' that were constructed for the religious drama of the time that was

performed as part of the church ceremony. These 'Ascension images' could be raised or lowered with the use of ropes and pulleys, and were sometimes part of an elaborately complicated machine. In time, when these devices were perfected, live actors were used.

Ascent to Calvary, see ROAD TO C.

Asclepius, see APOLLO (10); SNAKE.

Asia personified, see FOUR PARTS OF THE WORLD.

Aspergillum, a brush with a short handle, used by the priest in Catholic churches to sprinkle with holy water those taking part in the ceremony of Asperges. The name derives from 'Asperges me hyssopo . . .' – 'Take hyssop and sprinkle me, that I may be clean'. (Ps. 51:7). The asper- gillum in art is particularly associated with the exorcizing of evil spirits. It is the attribute of BENEDICT, and of MARTHA who has a dragon underfoot. It is held by a bishop super- *Aspergillum* vising a disinterment (STEPHEN, 4).

Ass. Usually represented as a beast of burden. It is the animal of the poor, and therefore is sometimes used to point the contrast with the rich. Its reputation for stupidity probably originated in the folklore of western Europe. The cap of the JESTER has ass's ears. The fat drunkard SILENUS, follower of Bacchus, rides an ass, as does the peasant Sancho Panza, 'squire' of DON QUIXOTE. The ass bears the Virgin and Child, with Joseph walking beside, on the FLIGHT INTO EGYPT; it is ridden by Christ on the ENTRY INTO JERUSALEM; by the Emperor Heraclius, divested of his robes, on entering the same city (TRUE CROSS, HISTORY OF THE); an angel stands in the path of BALAAM'S ASS. An ass kneeling before a chalice is an attribute of ANTONY OF PADUA. In allegory it is the attribute of SLOTH and, with a millstone, of OBEDIENCE. See also OX AND ASS; NATIVITY; PRIAPUS.

Assumption. Term used to denote the taking up to heaven of the soul and body of the Virgin Mary three days after her death. Its derivation (Lat. *adsumere*, to take up) implies that she was borne to heaven – i.e. by angels – unlike Christ who *ascended*, that is, simply went up. For many centuries celebrated as a Church festival, the Assumption was in 1950 declared an article of faith by Pius XII. There is no scriptural foundation for the belief which rests on the apocryphal literature of the 3rd and 4th cents., and the Tradition of the Catholic Church. It forms the continuation of the narrative of the DEATH OF THE VIRGIN. The 13th cent., a period when the cult of the Virgin was ardently fostered, saw the appearance of the *Golden Legend*, a popular source-book for artists, in which the apocryphal story was retold. As the apostles were sitting by the Virgin's tomb on the third day, Christ appeared to them with St Michael who brought with him the Virgin's soul. 'And anon the soul came again to the body of Mary, and issued gloriously out of the tomb, and thus was received in the heavenly chamber, and a great company of angels with her'. The Assumption was first widely represented in 13th cent. Gothic sculpture, especially in the portals of churches dedicated to the Virgin, and was to remain an important devotional theme in religious art. Its typical form in Renaissance and later painting consists of two or sometimes three elements, one above the other. The Virgin in mid-air, standing or enthroned, is being borne aloft by choirs of angels who often play musical instruments. Her hands are joined in prayer or, especially in Counter-Reformation art, her arms are outstretched as she gazes upwards in rapture. She may be framed in a MANDORLA, perhaps composed of angels. Sometimes the archangels Michael and Gabriel accompany her. More rarely Christ and the Virgin

are seen ascending together. On the ground below are the apostles gathered round the empty tomb, either looking up in awe at the Virgin or sometimes weeping. Among the apostles may be doubting Thomas, who is seen receiving the Virgin's girdle. (See THOMAS, apostle, 2.) Attendant saints may be present, as in a 'Sacra Conversazione'. (See VIRGIN MARY, 14.) The tomb itself is sometimes filled with lilies or roses. Rubens, who painted the Assumption many times, introduced two women gathering the roses, a motif that became traditional in 17th cent. painting of the Spanish Netherlands. It has been suggested by one authority that they represent Martha and Mary. Luke's account (10:38-42) of Christ in the house of Martha and Mary (MARY MAGDALENE, 2) is read in churches on the feast of the Assumption. The two women, symbols of the active and contemplative types, were said by a Christian writer of the Counter-Reformation to stand for the body and soul of the Virgin. This is possibly the source of the Rubens motif. The third element, not always present, is the image of God the Father above, waiting to receive the Virgin. He may be surrounded by cherubim and seraphim.

Assumption of the Magdalen, see MARY MAGDALENE (5).

Astyanax, see TROJAN WAR (3, 6).

Atalanta and Hippomenes (*Met.* 10:560-707). In the Boeotian version of the legend, followed by Ovid, Atalanta was an athletic huntress. Her way with her suitors was to challenge them to a race in which the loser was punished with death. She remained unbeaten and a virgin until Hippomenes (elsewhere named Melanion) took her on. As they ran he dropped three golden apples, given to him by Venus, and since Atalanta could not resist stopping to pick them up she lost the race. They later made love in a temple of Cybele, which offended the goddess so much that she turned them both into lions. Atalanta is shown in the act of stooping to pick up an apple as Hippomenes overtakes her. He is occasionally seen receiving the apples from Venus. Atalanta also took part in the Calydonian boar hunt (see MELEAGER).

Athene, see MINERVA.

Atlas. In Greek mythology a Titan, the son of Iapetus, who was condemned to support the heavens on his head and hands, as a punishment for taking part in the revolt of the Titans against Zeus. Perseus, to whom he refused hospitality, changed him by means of Medusa's head into the range of mountains that bears his name. See HERCULES (11).

Atropos, one of the THREE FATES.

Augean stables, see HERCULES (5).

Augustine of Hippo (Ital. Agostino) (354-430). Christian saint and perhaps the Church's most celebrated and influential theologian; Bishop of Hippo in north Africa and one of the four Latin (western) Fathers. He was born at Tagaste in Numidia. His mother Monica who gave him his early religious instruction was also canonized. He is usually dressed as a bishop with mitre and crozier but may wear a monk's habit, sometimes under the cope (see diag. RELIGIOUS DRESS). He is generally middle-aged, either beardless or with a short dark beard. His attribute is a flaming HEART, a symbol of religious fervour. In his *Confessions* he tells how, as a student at Carthage, he was led into dissipation; as a sign of his subsequent remorse he is sometimes portrayed with ARROWS piercing his breast. His other attribute, an infant in a cradle, first appears in the 15th cent. (see below: 5). In devotional painting he often appears with the other Latin Fathers, Ambrose, Gregory and Jerome, and sometimes with his mother Monica. A typical inscription, from his writings, is '*In coelo qualis est Pater talis est Filius;*

in terra qualis est Mater talis est Filius' – 'Such as the Father is in heaven, so is the Son; such as the Mother is on earth, so is the Son'.

1. *St Augustine taken to school by his mother*, shows them arriving, met by the schoolmaster.

2. *St Augustine meditating under a fig tree*. He relates in the *Confessions* how he heard a child's voice saying, '*Tolle, lege*' – 'Take and read'. Opening the Bible at random he read, 'No revelling of drunkenness, no debauchery or vice . . . let Christ Jesus himself be the armour you wear . . .' (Rom. 13:13–14). The incident was a step towards his conversion to Christianity.

3. *The Baptism of St Augustine*. Augustine was strongly influenced by the teaching of Ambrose, Bishop of Milan, and was baptized by him. Monica is usually present.

4. *St Augustine dispensing the Rule of his Order*. He hands the rules to the monks, or is seated at a desk, pen in hand. The Order was in fact established in the 11th cent., its rules being drawn from Augustine's writings.

5. *The vision of St Augustine*. A popular legend, first appearing in 15th cent. art and very common in the 16th and 17th centuries, which tells of Augustine walking by the seashore and meditating on the Trinity. He came upon a child who had made a hole in the sand and, with the aid of a shell, was vainly trying to fill the hole with water. Augustine remarked on the futility of the task and the child replied, 'No more so than for a human intelligence to fathom the mystery you are meditating'. Augustine stands in his episcopal robes or sits on a rock, an open book on his knees. When the subject is treated devotionally the Virgin and angels appear overhead and sometimes Monica kneels in prayer. The child itself, which of course stands for Christ, may be represented as an angel.
See also MARY MAGDALENE OF PAZZI.

Aureole, see HALO.

Aurora (Gk. Eos). In Greek mythology the goddess of the dawn, often called 'rosy-fingered' by Homer. She was the sister of Helios, the sun-god. Every morning she rose from her bed leaving her aged husband Tithonus still sleeping, and led Helios into the heavens. On Greek vases she has wings and drives a four-horse chariot, the quadriga. Or she stands mourning for her son Memnon who was killed by Achilles in the Trojan war; the morning dew was said to be the tears she shed for him. She is a popular figure in 17th cent. baroque ceiling painting, driving a two- or four-horse chariot, or riding the winged horse PEGASUS. She scatters flowers on her way. The bearded Tithonus may watch her go. Sometimes she flies before the chariot of Helios holding a torch. The clouds of night roll away and the horizon lightens. A group of maidens may surround the sun-god's chariot or float in the air before Aurora; they are the HORAE, the goddesses of the Seasons who, according to one tradition, were the daughters of Helios. (See also PHAETHON.)

Aurora and Cephalus; the rape of Cephalus. Aurora was fated to fall in love with a succession of mortal youths. Her passion for Cephalus, all the more ardent because he spurned her, led her to neglect her daily duty of leading Helios through the heavens. This threatened to bring chaos to the universe until Cupid saved the situation by making Cephalus return her love. She then carried him off to heaven in her chariot. A winged Aurora is seen swooping down from the sky upon Cephalus. Her chariot stands waiting in the clouds surrounded by amoretti, symbols of love. Or Cephalus is in the chariot still trying to resist Aurora's embraces, while old Tithonus lies asleep nearby, unaware of what goes on. Cephalus' dog looks up at its master. This is not the Greek myth but a free

adaptation of it by an Italian baroque playwright (*Il rapimento di Cefalo*, by Gabriello Chiabrera, 1552–1637), popular in its day, and widely used by artists. Aurora also features in the story of CEPHALUS AND PROCRIS, another dramatic adaption of the same period. Cephalus' 'rape' signifies his abduction rather than sexual violation, as in the case of Europa and Proserpine.

'Ausculta fili verba magistri . . .,' see BENEDICT.

Author, see WRITER.

Autumn personified, see FOUR SEASONS.

Avarice. One of the seven Deadly Sins. With Lust, it was especially singled out for condemnation by the medieval Church and hence, of the seven, is one of the most commonly depicted. Avarice takes the form of a woman, or occasionally a man, sometimes BLINDFOLD, whose normal attribute is a PURSE, either held in the hand or hanging round her neck. She appears thus in cycles of the virtues and vices in Gothic sculpture, in medieval and Renaissance representations of the LAST JUDGEMENT and in other moral allegories. Another not uncommon attribute is the harpy, a monster with the head and breasts of a woman and the wings and claws of a bird, which was said to torment misers. As a symbol of Avarice, the harpy itself may be blindfold. It may have a number of golden balls or apples, the miser's wealth. See also HELL.

'Ave gratia plena Dominus tecum', see ANNUNCIATION.

'Ave Maria', see ANNUNCIATION.

Averroès, see THOMAS AQUINAS (2).

Axe, with an anvil, the attribute of a warrior who stands beside female saint, ADRIAN AND NATALIA; with carpenter's tools, of JOSEPH, husband of the Virgin; also of MATTHEW. BENEDICT (6) recovered a woodcutter's axe that had fallen in a lake. An axe embedded in the head of a Dominican friar, PETER MARTYR.

Babel, see TOWER OF BABEL.

Babylon, Whore of, see APOCALYPSE (20).

Bacchante, see BACCHUS.

Bacchus (Gk Dionysus), popularly the god of wine, originally a fertility god worshipped in the form of a bull or a goat, whose rites were accompanied by frenzied orgies, when the animal was torn to pieces and its raw flesh consumed, a symbolic eating of the god himself. In Greece the cult seems to have had a particular attraction for women; the Maenad, or Bacchante, Bacchus' female devotee, with her typical swirling drapery, her figure expressing physical abandonment as she beats a tambourine, is first known to us on Greek drinking cups of the 5th cent. B.C. Bacchus himself is usually depicted as a naked youth, wearing a crown of vine leaves and grapes, and holding a THYRSUS, a wand tipped with a pine cone (an ancient fertility symbol) and sometimes twined with IVY (also sacred to Bacchus). He is often drunk. His triumphal car may be drawn by TIGERS, LEOPARDS or GOATS (the first two probably reflecting the spread of his cult in Asia), less often by CENTAURS or HORSES. Bacchus is attended not only by Maenads but by certain minor divinities, associated, like him, with goat-worship, who retain some of the animal's characteristics, such as cloven hoofs and sometimes a goatlike face – the SATYR, SILENUS and, more rarely PAN. They play pipes for the song and dance of the Bacchic ritual. The handling of snakes also formed part of the rites, and Satyrs are often depicted with snakes entwining their bodies. (But see also SATYR in this connection.) To the humanists of the Italian Renaissance the passionate spirit of Bacchus stood in direct contrast to the sober clarity of Reason, personified by APOLLO.

 1. *Birth of Bacchus* (*Met.* 3:310–312). Bacchus was born from the thigh of his

father, Jupiter. He had been sewn into it by Mercury, after his mother, Semele, had been consumed by one of Jupiter's thunderbolts during her pregnancy. Mercury handed the infant over to the nymphs who lived in a grotto on Mount Nysa, to take care of him. Mercury is shown with Bacchus cradled in one arm, his free hand holding his caduceus; or the nymphs have just received the child and gaze on him adoringly. They may recline in a pool in the grotto. Vines grow thickly round the tree-shaded place. Jupiter's eagle flies above, or Jupiter himself may be seen in the sky, lying on his couch.

2. *Education* (or *Nurture*) *of Bacchus* (*Met.* 3:314–15). Among others who helped to bring him up were the Satyrs, the Maenads and Silenus. Bacchus is shown as a fat little boy with curly hair, being given wine from a bowl by a Satyr, or from a cornucopia.

3. *The sailors changed into dolphins* (*Met.* 3:597–691; *Imag.* 1:19). Bacchus, kidnapped by pirates, avenged himself on them by causing ivy to grow over the oars and rigging, and a vine up the mast. Next, phantom shapes of wild beasts appeared on board, whereupon the terrified sailors leaped into the sea and were immediately changed into dolphins.

4. *Bacchus and Ariadne*. It was Ariadne, the daughter of King Minos of Crete, who helped Theseus, whom she loved, to escape from the labyrinth with the aid of a ball of string, but all she had in return was to be abandoned by him on the island of Naxos (THESEUS, 2). Here Bacchus came to her rescue. Classical representations show Ariadne asleep when Bacchus arrives, as described by Philostratus (*Imag.* 1:15). But according to Ovid (*Met.* 8:176–182) she was at that moment lamenting her fate, and Renaissance and later artists generally depict her awake. Bacchus took her jewelled crown and flung it into the heavens where it became a constellation. Ariadne was readily consoled by him and they were married shortly afterwards. Bacchus is seen arriving on his chariot, sometimes with his retinue. He springs to the ground or lifts Ariadne up on to the chariot. He lifts the crown from her head, or it is already in the sky, a shining circle of stars. Bacchus' followers may be celebrating their rites: a Satyr entwines himself with snakes, another brandishes a calf's leg, while an infant Satyr drags the head of a calf after him (cf Catullus, *Carmina*, 64) (Titian, Nat. Gall. London). Ovid (*Fasti* 3:459–516) describes how Bacchus had himself deserted Ariadne to make his journey to the east. Their meeting in this version is therefore a reunion on his return. This would accord with the leopards that often draw his car.

5. *The triumph of Bacchus* (*and Ariadne*). The procession, full of life and movement, is generally led by drunken Silenus, sometimes on his ass and supported on either side by revellers, or on a cart drawn by the ass. Among the throng are Satyrs and Maenads blowing pipes and syrinxes, and clashing cymbals. Putti fly overhead with wine jugs and cups. Bacchus, seated on his car and holding a thyrsus, brings up the rear. Ariadne may accompany him, perhaps on another chariot (see TRIUMPH).

See also ANDRIANS; MIDAS; VENUS (2).

Bagpipe. Wind instrument consisting of a skin bag inflated by air blown through a pipe. The air is emitted through a reed-pipe, or 'chanter', having finger holes. The Middle Ages knew it in this simple form and it is often seen thus in Renaissance and later painting. It can have one or more extra pipes or 'drones', as does the Scottish bagpipe. Suetonius records that Nero played a bagpipe. It was a typical instrument of European folk-culture, and is hence played by shepherds (ADORATION OF THE SHEPHERDS, and in pastoral themes), occasionally by the Satyr Marsyas (APOLLO, 4). It features in concerts of angels. In 17th cent. Dutch

and Flemish peasant scenes it has a deliberately phallic meaning, enhanced by the very shape of the instrument. The *musette*, a similar instrument, operated by small bellows, was popularized by the 17th cent. French court, with its taste for the pastoral, and is represented in *fêtes galantes*. (See diag. MUSICAL INSTRU-MENTS.)

Balaam's ass (Num. 22:1–35). The arrival of the Israelites in the Jordan valley alarmed Balak, king of Moab, who sent for Balaam, a foreigner, to pronounce a curse on them. On his journey an angel, invisible to Balaam, barred the way, causing his ass to turn aside. This led to an altercation between the man and his beast in which the latter, like the animals of fable, acquired the gift of speech. Balaam's eyes were then opened and he saw the angel with a drawn sword. The conversion of Balaam by the vision of the angel was regarded as a prefiguration of the appearance of Christ to the apostle THOMAS, hence the theme's place in religious art. It is found principally in the decoration of Romanesque and Gothic churches but is rare thereafter.

Ball. Three golden balls are the attribute of NICHOLAS OF MYRA, a bishop. Golden balls are also associated with the harpies that accompany AVARICE.

'Βάλλ' οὕτως', see ARROW.

Banner of the Resurrection, see FLAG.

Banquet of Herod, see JOHN THE BAPTIST (7).

Banquet of the gods, also called 'Marriage of Peleus and Thetis'. Peleus, a legendary hero of ancient Greece, and Thetis, a sea-nymph, were the parents of ACHILLES. The gods of Olympus were present at their wedding feast. It was here that an uninvited guest, Eris, the goddess of Strife, threw down a golden apple, setting off a train of events that led to the Trojan war. (See JUDGEMENT OF PARIS.) A table is set out under a canopy or in the shade of trees. Round it are seated the gods and goddesses, with the bride and groom in the foreground. Eris, from the clouds above, throws down the apple that was to be the prize for the fairest goddess. Or Jupiter holds the apple in his hand while JUNO, beside him, reaches out for it, as does MINERVA, dressed in armour. VENUS, with Cupid near her, points to herself. Among the other guests are NEPTUNE with his trident, and MERCURY wearing his winged hat and holding the caduceus. As the gods' messenger it was Mercury's duty afterwards to lead the three goddesses to Paris. GANYMEDE or HEBE bring dishes or drinking vessels. The Muses may provide music. See CUPID (6): *C. and Psyche*, for another wedding banquet of the gods. The theme is sometimes a vehicle for the portraiture of the artist's patron and his court. See also PRIAPUS.

Baptism. The rite of initiation into the Christian Church by immersion or sprinkling with water. It was regarded historically both as an act of purification and also of rebirth in which the font was the symbol of the immaculate womb of the Virgin from which the initiate was born again. Christian art contains many examples of baptism apart from that of Christ: see (2) below. Baptism is the first of the cycle of SEVEN SACRAMENTS.

1. *The baptism of Christ* (Matt. 3:13–17; Mark 1:9–11; Luke 3:21–22; John 1:29–34). Christ was baptized in the river Jordan by John the Baptist 'during a general baptism of the people' so many would be present. 'At the moment when he came up out of the water he saw the heavens open and the Spirit, like a dove descending upon him. And a voice spoke from heaven: "Thou art my Son, my Beloved; on thee my favour rests."' The theme is found in Christian art of all periods from the 3rd cent. paintings in the Roman catacombs onwards. In early representations it was customary to depict the Saviour naked and fully immersed

except for the head and shoulders. The Jordan was portrayed, in the antique manner, as a river god with his URN, perhaps holding Christ's garments. By the time of the Renaissance a formula was well-established in both Italian and northern painting: Christ, wearing a loin-cloth, stands ankle-deep in the river; the Baptist is on the bank in the act of pouring water over his head (baptism by 'affusion'); on the opposite bank, balancing the composition, there are generally two or three angels holding the garments (taking the place of the river god). Above the head of Christ hovers the DOVE of the Holy Spirit, and above that the figure of GOD THE FATHER (head and shoulders, or perhaps only the hands) making the sign of blessing. These features are common to very many representations of the theme until the second half of the 16th cent., though there are considerable variations of detail. The vessel in St John's hand may be a shallow cup or a shell or, more often in northern art, he may use a pitcher or merely the cupped hand. The landscape, especially in Netherlandish painting, sometimes assumes an importance of its own, showing the river winding away into a vista of northern woods and fields. Mark tells how the people 'flocked from the whole Judaean countryside and the city of Jerusalem' to be baptized by John. This may be represented as a few figures undressing in the background or, particularly by baroque painters, as crowded scenes of great movement in which the figure of Christ is only one of many. The attitudes of Christ and the Baptist to each other should be noted. John humbling himself on his knees reflects his words, 'I need rather to be baptized by you'. On the other hand in Counter-Reformation art the kneeling Saviour is more often found. This probably derives from certain Christian mystics of the 16th and 17th cents. who laid emphasis on Christ's humility, exemplified by his acceptance, as one who was sinless, of a purificatory rite. Pictures of the Baptism were commissioned not only for the altarpieces of baptisteries and churches dedicated to St John, but also by donors who shared his Christian name. A kneeling donor is a not uncommon figure in such works.

2. *Other baptisms:* Ambrose baptizing AUGUSTINE; BARTHOLOMEW, his converts; BONIFACE baptizes a heathen, his foot resting on an oak tree; JAMES THE GREATER, the magician Hermogenes; JOHN THE BAPTIST, the people of Judah in the Jordan; JUSTINA, baptized by Prosdocimus, a bishop; LEONARD, by Remigius, a bishop; Anianus, a cobbler of Alexandria, by MARK; Anianus, a disciple of Damascus, by PAUL the apostle (2); Cornelius, a centurion, and his family, by PETER, apostle (10); Processus and Martinian, jailers, by PETER (14); Clovis, in Rheims cathedral, by REMIGIUS; the Emperor Constantine, by SYLVESTER, a pope; Etherius, the betrothed of URSULA, by Pope Ciriacus.

Barabbas, see TRIAL OF CHRIST (4).

Barbara. A former Christian saint and virgin martyr once believed to have lived in Asia Minor in the 3rd cent. Her story, which has no historical basis, dates from about the 7th cent. and is retold in the *Golden Legend.* The father of Barbara, a heathen nobleman named Dioscurus, had a tower built and shut his daughter in it, in order to discourage her suitors. The tower had only two windows, and Barbara persuaded the workmen, in her father's absence, to add a third. She also succeeded in letting in a priest secretly, in the guise of a doctor, who baptized her a Christian. When Dioscurus returned she told him the three windows symbolized the Father, Son and Holy Ghost who lighted her soul. Her father was enraged, and Barbara fled from the tower with him in pursuit, and hid in a cleft in a rock. But a shepherd betrayed her hiding-place and her father dragged her out by the hair and thrashed her. He then handed her over to the Roman

authorities, but she refused to recant and was tortured. Finally, just as she was executed by her father's sword, he was struck dead by lightning and his body consumed by fire. Barbara's special attribute is her tower, usually with three windows. She was invoked against sudden death by storm and lightning and thus sometimes holds a CHALICE and wafer, implying the giving of the last sacrament. In the same connection she may hold the feather of a PEACOCK, a symbol of immortality. Her patronage of armourers and firearms also derived from the idea of sudden death, and her figure once frequently ornamented armour and guns, sometimes in association with the warrior saint, GEORGE. In paintings, she may have a CANNON at her feet. Narrative scenes include the workmen building the third window, supervised by Barbara; her flight from her father; the shepherd betraying her (as punishment his sheep were turned into locusts). But the most common scene is the execution of Barbara by her father. He often wears a TURBAN and brandishes a scimitar, according to the popular type of pagan oriental.

Barnabas, see PAUL, apostle (5, 6).

Barrel, overturned, the abode of DIOGENES.

Bartholomew. The New Testament mentions the apostle by name only, but says nothing of his acts. The *Golden Legend* tells of a missionary journey he made to India, and of his death in Armenia by being flayed alive. He is usually portrayed as dark-haired, bearded and of middle age. His invariable attribute is the knife with which he was flayed. Not uncommonly the flayed skin hangs over his arm, or is held in his hand, as in the Last Judgement in the Sistine Chapel (said to be a self-portrait of Michelangelo). His inscription, from the Apostles' Creed, is 'Credo in Spiritum Sanctum'. Typical narrative themes from Renaissance art show him preaching, exorcizing demons, baptizing, and being hauled before the authorities for refusing to worship idols. The most usual scene is the rather gruesome flaying. Artists sometimes follow the Hellenistic sculpture from Pergamum of the flaying of Marsyas (APOLLO, 4).

Basket, of roses and perhaps apples, attribute of DOROTHEA; of flowers, attribute of HOPE. An infant in a cradle-like basket, MOSES (1); likewise, a snake emerging, ERICHTHONIUS. Baskets of bread, with Christ and disciples, FEEDING OF THE FIVE THOUSAND. The Israelites in the wilderness gather manna in baskets, MOSES (8). Female warrior among basket-makers, ERMINIA AND THE SHEPHERDS; man in basket suspended by rope, PAUL, apostle, (10); also VIRGIL, LAY OF; three maidens, baskets on their heads, MERCURY (2). See also FRUIT.

Bat, the nocturnal animal, an attribute of NIGHT personified.

Bathsheba, see DAVID (7).

Battle, scenes of. Two main contenders on horseback, the rider of the white horse prevailing, ALEXANDER THE GREAT (5) (Issus); warrior women on horseback with bows, against Athenians, AMAZONS, BATTLE OF; a banquet in turmoil, Centaurs and humans (Lapiths), CENTAUR; the same setting, Hercules fighting a Centaur, HERCULES, (19); soldiers separated by women with children, SABINE WOMEN (2), *Reconciliation of Sabines and Romans;* soldiers on bridge, crosses and *chi-rho* monogram on standards and banners, CONSTANTINE (Milvian bridge). Saints in battle: JAMES THE GREATER (2) on white horse vanquishing Saracens (Clavijo); ANDREW CORSINI, bishop with sword, floating in the air above battlefield (Anghiari). A mock battle, other sporting contests nearby, AENEAS (7), *Funeral games.* See also GODS AND GIANTS, BATTLE OF.

Battle for the trousers. An example of the war of the sexes in which the possession of the trousers becomes the emblem of superiority. The saying 'to wear the trousers' exists both in German and English. The theme occurs in northern

painting of the 17th cent. and shows a man struggling with one or several women for a pair of breeches.

Baucis, see PHILEMON AND B.

Bavo (Bavon) (*c.* 589– *c.* 653). A rich landowner of Brabant (now part of Belgium) who, on the death of his wife, turned from a life of dissipation to become a penitent hermit, giving all his possessions to the poor. He was said to have made his home in a hollow tree in a forest near Ghent. He is seen in Flemish painting and engravings at prayer in a tree; alternatively in armour, with a falcon at his wrist, carrying a large stone, the emblem of his former sins. He is the patron saint of falconers.

Bear. According to the bestiaries, bear cubs were born formless and literally 'licked into shape' by the mother, an act that the medieval Church made into a symbol of Christianity converting the heathen. The bear is an attribute of EUPHEMIA and in another sense of GLUTTONY personified. Bears mauled the children who mocked ELISHA. The nymph Callisto was turned into a bear by DIANA (5).

Bearing the body of Christ. The scene that occurs chronologically between the lamentation over the dead body of Christ at the foot of the cross (see PIETÀ) and the ENTOMBMENT is found only in Renaissance painting and then somewhat rarely. It is a subsidiary theme to the 'Entombment' and is indeed sometimes so named. It shows the body of Christ carried usually in a winding-sheet, or on a kind of stretcher, by two or three muscular bearers. In Italian painting the theme is more a vehicle for the artist's anatomical skill than a religious study, and less attention is therefore paid to the bearers' identity. We find the same broad disposition of figures with their identifying features that are seen in the DESCENT FROM THE CROSS and the PIETÀ, that is to say Joseph of Arimathaea at Christ's head, Nicodemus at the feet and St John the apostle standing apart in grief, or perhaps holding one of the Saviour's hands. Behind them is seen another motif from the earlier scenes, the Virgin swooning into the arms of the holy women. According to John (19:41), 'Now at the place where he had been crucified there was a garden, and in the garden a new tomb . . .' This proximity may be indicated by the inclusion in the background of both the hill of Calvary with its three empty crosses and the rock-hewn entrance to the tomb.

Beatitudes, see SERMON ON THE MOUNT.

Beatrice. The woman about whom Dante wrote is generally agreed to have been the daughter of Folco dei Portinari, a distinguished citizen of Florence. They met as children and Dante, according to his own account in the *Vita Nuova*, instantly experienced a consuming love for her which was to last beyond her death. She died in 1290, at the age of only twenty-four. The work is a series of love poems, each with an explanatory narrative and commentary, in which the poet explores his feelings for Beatrice arising from their encounters in daily life, his grief at her death and devotion to her memory. It did not prove an important source of inspiration for art until the 19th cent. when the Pre-Raphaelite poet and painter, Dante Gabriel Rossetti (1828–82), produced a number of drawings and paintings on the theme of Dante and Beatrice, taken from the *Vita Nuova* which he himself had translated. Though he painted Beatrice in the likeness of his wife, Elizabeth Siddal, she was less a woman of flesh and blood than a potent symbol of Rossetti's spiritual conception of ideal love. Among several scenes are those depicting Beatrice's salutation to Dante as they passed in the street (ch. 3); her denial, or withholding, of her salutation at a marriage feast (ch. 14); Dante's dream of the death of Beatrice (ch. 23); Dante drawing an angel on the anni-

versary of her death (ch. 34); 'Beata Beatrix', a vision of the dead Beatrice as a woman wrapt in contemplation of heavenly bliss (ch. 51, 52).

At the end of the second book of the *Divine Comedy* (*Purg.* 30) Dante meets Beatrice again in her after-life and she becomes his guide through the different heavens of paradise. On another, allegorical, level she becomes the vehicle through which Dante perceives the truth of Christian revelation and theology. In the many illustrated editions, both manuscript and printed, and series of drawings which the work has inspired she is represented beside Dante pointing the way or floating upwards to the next higher sphere. In other fields of art the *Paradiso*, by its absence of concrete images compared with the first two books, has contributed little to the iconography of Dante. See also DANTE AND VIRGIL; TRIUMPH.

Bed. Man bearing bedstead or bedding, PARALYTIC, HEALING OF THE. See also BEDCHAMBER; DEATH, scenes of.

Bedchamber. *Childbirth:* midwives bathing infant, NATIVITY OF THE VIRGIN; JOHN THE BAPTIST (2); twins, one perhaps hairy, JACOB. *Sickness:* Christ and disciples, child in bed, RAISING OF JAIRUS' DAUGHTER; Peter and apostles, woman (Dorcas) in bed, PETER, apostle (8); man in bed, physician and woman at bedside, ANTIOCHUS AND STRATONICA; man in bed drinking, another reading letter, ALEXANDER THE GREAT (4). *Sleep:* maiden asleep, angel bearing crown, URSULA; a god observed by maiden with lamp, CUPID (6). *Lovers:* a shepherd (Anchises) and a perhaps bejewelled goddess, VENUS (9). Pan was kicked out of bed by HERCULES (17). A shower of gold descends on nude DANAË. Sometimes the scene of the suicide of DIDO, surrounded by Aeneas' armour. Three girls and their father sit despairing in a bedchamber as NICHOLAS OF MYRA (1) throws them a purse through the window.

Beehive, bee. The beehive is an attribute of BERNARD of Clairvaux (Cistercian monk), AMBROSE (bishop) and JOHN CHRYSOSTOM (Greek bishop), noted for their eloquence, or mellifluous words. In secular allegory it is an attribute of the Golden Age personified (AGES OF THE WORLD). CUPID (3) was stung by a bee.

Beggar. Blind, healed by Christ, BLIND, HEALING OF THE; several blind, following a leader, BLIND LEADING THE BLIND; blind warrior begging, BELISARIUS. A crippled beggar is blessed by PETER, apostle (5). A beggar kneels before a monk, JOHN OF GOD; beside MARTIN of Tours, who is either a soldier on horseback, or a standing bishop. LAURENCE, a deacon, gives alms to a beggar, as does JOHN CHRYSOSTOM. The beggar at the door of a man feasting is Lazarus (DIVES AND LAZARUS). For beggars at a feast, see ROYAL WEDDING. The devotional figure of a saint dressed as a beggar is ALEXIS. A beggarwoman holding a heavy stone personifies POVERTY.

Belisarius (*c.* 505–65). A famous general under the Byzantine emperor Justinian. At the height of his successes he had recovered large areas of Italy from the Goths. His fortunes later went into decline, he was falsely accused of conspiracy against the emperor and imprisoned, deprived of his honours. His innocence was subsequently established. Historians nowadays reject the story that he was reduced, old, blind and unknown, to begging in the streets of Constantinople. He is generally depicted thus, with his begging bowl at the moment of being recognized by a passing soldier. As an example of the transience of fame the theme attracted Italian and northern European artists of the 17th and 18th centuries (J.-L. David, Musée Wicar, Lille).

Bell. Attribute of ANTONY THE GREAT, sometimes attached to crutch or staff; of Music personified, one of the SEVEN LIBERAL ARTS, who strikes a row of bells

with a hammer, as does DAVID in medieval Psalters. Bells fringe the priestly robe of AARON. A bell is tied to a rope by means of which bread is lowered to a hermit (BENEDICT).

Bellerophon (*Iliad* 6:155–203; Hyginus 157). Bellerophon, a Greek hero, residing at the court of Proetus, king of Argus, was loved by the king's wife. When Bellerophon rejected her advances she reacted as other women have done in the same situation (cf JOSEPH, son of Jacob, 2) and falsely denounced him before her husband of trying to violate her. Bellerophon was sent to the king's brother-in-law, Iobates, with a sealed letter containing the request that he be killed. Iobates set him the task of slaying a monster, the Chimaera, thinking that he would be destroyed in the attempt. This creature had a lion's head, goat's body and dragon's tail, and breathed fire. Bellerophon, having first obtained possession of the winged horse PEGASUS, according to some by means of a golden bridle, the gift of Minerva, rode off and slew the Chimaera with his arrows. After other victorious deeds he returned to marry one of Iobates' daughters. Later he suffered the displeasure of the gods and went into a decline. He is depicted in Renaissance art on the back of Pegasus, in the act of killing the monster below him with arrows or a spear. (Rubens, Musée Bonnat, Bayonne.)

Bellows. Demon blowing out candle with bellows, GENEVIÈVE. Old man at furnace, using bellows, ALCHEMIST.

Belshazzar's Feast (Dan. 5). Belshazzar, king of Babylon in the 6th cent. B.C., and son of Nebuchadnezzar, held a great banquet with his courtiers, wives and concubines. They drank to heathen gods, using gold and silver drinking vessels stolen from Solomon's temple at Jerusalem. Suddenly, in their midst, appeared the mysterious fingers of a man's hand which wrote on the palace wall, 'Mene, mene, tekel, upharsin', words which no one could understand. The king was terrified ('his knees smote one against another') and he sent for Daniel who counselled him in such matters. Daniel told him the words portended the fall of the Babylonian kingdom and the death of the king. Belshazzar was slain that night and Darius the Persian took his kingdom. Baroque artists were fond of depicting the barbaric splendour of the setting with the gold and silver vessels and the scared faces of the women. The story, like others from the first part of the Book of Daniel, has no historical basis. This writing dates from the 2nd cent. B.C., and was designed to fortify the Jews, by examples from their past, at a time when they were suffering severe persecution. Belshazzar in Christian art stands for a 'type' of Antichrist, the upholder of paganism.

Benedict (*c.* 480–547). Christian saint, the founder of the oldest western monastic Order, named after him. The known facts of his life are few, but there is a wealth of legend. He was born at Nursia in Umbria and as a young man went to Rome to study. He lived as a hermit for several years near Subiaco. A neighbouring religious community invited him to direct them but they found his code too rigorous and he left them to resume his solitary life. He later founded the famous monastery at Monte Cassino where he promulgated the Rule of his Order, which in time became the basis of western monastic law – requiring poverty, chastity and obedience, and in addition the obligation of manual labour and the irrevocability of monastic vows. Benedict was popularly remembered for his many acts of healing, especially exorcism, the curing of mental illness. In the Middle Ages insanity was believed to be caused by demons taking possession of a man's body, and its cure was to drive them out by prayer. They are generally represented emerging from the mouth. Scenes of Benedict healing the sick are common. He is usually depicted as an old man with a white beard, but may occasionally

be clean-shaven. His dress is not a reliable guide to identity: he wears either the black habit of the original Order of Benedictines, or the white habit of the later reformed institutions (see diag. RELIGIOUS DRESS). His commonest inscription is from the incipit of his Rule: 'Ausculta fili verba magistri . . .' – 'Hear, my son, the words of your master . . .' Several of his attributes are connected with his legends. He has a pastoral staff and a plain mitre, as abbot of Monte Cassino; a rod, or ASPERGILLUM, used to sprinkle holy water, a part of the rite of exorcism; a broken SIEVE, or tray: on his way to Rome his nurse, who was accompanying him, borrowed a sieve which she accidentally broke, and Benedict miraculously mended it. A RAVEN, sometimes with a loaf of bread in its beak, refers to an attempt by an envious priest to poison him. Benedict guessed that the bread was poisoned and ordered a raven to carry it away. The priest was killed when his house collapsed on him. The loaf, as an attribute, may have a snake emerging from it. A broken pitcher, wine-glass or CUP refers to another attempt to poison him. When he blessed the cup it broke, and the poisoned wine was spilled. As an attribute, the cup may stand on a book. A thorn BUSH: the ascetic way of life of the hermit generated sexual feelings which Benedict, like FRANCIS OF ASSISI, overcame by throwing himself into a thorn bush. Benedict may be grouped with his two pupils Maurus (holding a pair of scales or a pilgrim's staff) and Placidus (with the martyr's palm); with his sister SCHOLASTICA, a nun in a black habit; and with Flavia (palm and crown of martyrdom), a young woman, the sister of Placidus. Of the many narrative scenes the following should be mentioned:

1. *Benedict leaving home.* He is depicted at the start of his journey to Rome, mounted on a white horse and followed by his nurse, Cyrilla, on an ass, while his parents stand watching him.

2. *The solitary.* He went into retreat in a rocky desert near what is now Subiaco. The story goes that a neighbouring hermit, Romano, lowered bread into his cave by means of a rope to which a bell was tied.

3. *He receives Maurus and Placidus.* A religious community grew up round Benedict at Subiaco. To him were sent two children, Maurus and Placidus, sons of patrician Roman families, who became closely attached to the saint. They are shown being presented to him by their fathers.

4. *Placidus falls in the lake.* Benedict, learning of the accident in a vision, sent Maurus who saved his friend by walking on the water. He is shown pulling him out by the hair.

5. *The missions of Maurus and Placidus.* Benedict blesses them before they depart on teaching missions, Maurus to France and Placidus to Sicily. The latter, with his sister Flavia, was murdered by Moorish pirates at Messina.

6. *The woodcutter and his axe.* The blade of a woodcutter's axe fell into a lake. Benedict dipped the helve of the axe into the water and the blade was miraculously replaced.

7. *Building the monastery on Monte Cassino.* The place was said to have been the site of a temple of Apollo whose worshippers pulled it to the ground after being converted to Christianity by Benedict. Demons who hindered the work of construction of the monastery are shown being exorcized. A monk, crushed to death by a stone, is restored to life. Monks dig up a bronze idol of Apollo.

8. *Benedict presents the Rule of the new Order.* He hands over the Rule of the Order to the monks of Monte Cassino.

9. *Benedict visits his sister Scholastica.* His sister, a devout woman, and head of a nearby community of nuns, was visited regularly by Benedict. The last time, feeling herself near death, she begged him not to leave her. He was reluctant to

stay so she prayed for a tempest. Her prayer was answered and he was detained with her overnight. She died shortly afterwards. Also depicted is Benedict's vision of Scholastica's soul in the form of a dove rising to heaven. Alternatively he sees her attended by Catherine of Alexandria and Agnes.

10. *The visit of Totila.* Totila, king of the Ostrogoths in Italy, visited Benedict at Monte Cassino to receive his blessing. He made confession, but was then sternly rebuked for his sins by the saint before receiving absolution.

11. *The 'Suore morte'; the dead nuns.* Two nuns, given to gossiping, were reproved by Benedict and threatened with excommunication. After their deaths the spirits of the nuns manifested themselves at certain times in the chapel where they were buried. During Mass, at the Elevation of the Host, as the deacon uttered the words 'Let those who are excommunicated and forbidden to partake, depart', the nuns were seen to rise from their graves and go out. They were pardoned by Benedict and thereafter rested in peace.

12. *The death of Benedict.* He is shown receiving the last sacrament, and also standing, at the point of death, before the open tomb of Scholastica beside whom he was buried. He is supported by monks, or sometimes by two angels.

Benedict of Aniane, see WILLIAM.

Benediction. The patriarch Isaac blesses JACOB (1) who kneels at his bedside. Jacob in old age blesses two children with his hands crossed (JOSEPH, 5). The youths Maurus and Placidus are blessed by BENEDICT (5); the maiden GENEVIÈVE by the bishop Germanus; Francis Xavier by IGNATIUS OF LOYOLA. See further, POPE.

Bernard of Clairvaux (1090–1153). Cistercian monk, and theologian, the son of a noble Burgundian family, an outstanding spiritual leader of his day and influential also in secular affairs. As a young man he founded the monastery at Clairvaux, in France, and was its abbot until he died. Art has emphasized the mystical trait in his character, in particular his devotion to the Virgin, and he is therefore much represented in painting of the Counter-Reformation; he himself forbade sculpture and ornamentation in places of worship, because he thought it out of keeping with the simplicity of the monastic way of life and the vow of poverty. No portrait of him from life exists, though he is usually shown as young and beardless, wearing the white habit of the Cistercian Order and holding a pastoral staff. Among his many attributes are a BEEHIVE, which he shares with Ambrose, in allusion to his eloquence – he was popularly called 'Doctor Mellifluus'; a chained DRAGON, symbolizing his putting down of heresy; three MITRES on the ground, from his thrice refusing an episcopate; a CROSS with the instruments of the Passion, in reference to certain of his writings. Like the early Doctors of the Church, he may carry a pen and a book. His inscription is 'Sustine et abstine', – 'Bear and forbear', a maxim from the Stoic philosopher Epictetus. Two themes predominate in devotional pictures:

1. *St Bernard's vision of Christ.* He kneels in prayer before a crucifix. Christ has detached his arms from it and leans down to embrace Bernard. (FRANCIS OF ASSISI is depicted similarly.)

2. *The miracle of lactation.* Bernard kneels before the Virgin. She is in the act of pressing her breast from which milk spurts, symbolically wetting the lips of the saint. At the same time she is holding the infant Christ in her lap. A scroll reads, 'Monstra te esse matrem' – 'Show thyself to be a mother'. The medieval concept of the Virgin as the mother not only of Christ but of mankind was closely linked with that of her benevolence and mercy, and therefore her role as intercessor before God. (See also BREAST; VIRGIN MARY, 6.)

Bernardino of Siena (1380–1444). Franciscan friar, ascetic and preacher, canonized soon after his death. As a young man he studied law, and during an outbreak of plague in Siena he worked for the relief of the sick. He afterwards joined the Franciscan Order, and in time became renowned throughout the land for his preaching. He is generally portrayed as an old man with emaciated features, dressed in the Franciscan habit (see diagram: RELIGIOUS DRESS). His principal attribute is a tablet or disk inscribed with the letters IHS (qv) in a circle of flames. He may have three MITRES at his feet since he was said, like his near-namesake Bernard of Clairvaux, to have three times refused a bishopric. As patron saint of Siena he holds a model of the city. The DOVE of the Holy Ghost hovers by his ear, implying that his words are divinely inspired. (Gregory the Great has the same attribute.) Bernardino's most frequent inscription, alluding to his preaching, is '(Pater) Manifestavi nomen tuum hominibus' – 'I (Father) have made thy name known to the men (whom thou didst give me out of the world)' (John 17:6).

St Bernardino preaching. In his sermons to the people it was the custom of Bernardino to make use of the written name 'Jesus' as a visible symbol of God. This he displayed to them as the monogram IHS (the abbreviated Greek form of the word) inscribed on a tablet. It was said that he invited his hearers afterwards to kneel before it. The Church regarded his conduct as a kind of heresy, and he was tried at Rome but acquitted. Bernardino is depicted preaching in public places. He holds up the inscribed tablet or disk while the crowd press forward to see. (See also ADORATION OF THE NAME OF JESUS.) In devotional pictures he is sometimes grouped with Francis or with other Franciscans, BONAVENTURA and CLARE.

Bethesda, Pool of, see PARALYTIC, HEALING OF THE; TRUE CROSS, HISTORY OF THE.

Betrayal ('The arrest'; 'The kiss of Judas') (Matt. 26:47–56; Mark 14:43–52; Luke 22:47–53; John 18:1–12). The arrest of Christ in the garden of Gethsemane follows chronologically the AGONY IN THE GARDEN. It is described in all four gospels. The synoptic accounts differ in one respect from John, and this occasionally leads to a certain inconsistency in the subject's portrayal. The first three gospels tell how Judas came up to Christ and kissed him, a sign to the soldiers following that this was the man they were to arrest, and how they then seized him. John makes no mention of the kiss but, on the contrary, describes how Christ identified himself to the soldiers with the words 'I am he', whereupon they 'drew back and fell to the ground'. Early Renaissance artists may depict both the kiss and the fallen soldiers in the same scene. The more usual and consistent formula shows Judas in the act of bestowing the kiss, surrounded by a throng of soldiers and perhaps Jewish elders. The soldiers are armed with spears and halberds and hold aloft torches and lanterns. Their leader is throwing a rope about Christ. Judas may be somewhat shorter in stature than the Saviour, a convention probably deriving from the account given by the 14th cent. mystic, Bridget of Sweden in her *Revelations*. The incident of the cutting off of the servant's ear is rarely omitted. It is mentioned in all four gospels though only John names the participants: 'Thereupon Simon Peter drew the sword he was wearing and struck at the High Priest's servant, cutting off his right ear. (The servant's name was Malchus.)' This spontaneous outburst is variously depicted. In early Renaissance paintings both stand facing each other while Peter severs the ear with an almost formal gesture. In later examples they are depicted realistically struggling together on the ground. The subsequent healing of Malchus'

ear by Christ is also sometimes shown. The ear and knife are represented separately among the INSTRUMENTS OF THE PASSION. The flight of the disciples may be represented in the same scene: 'Then the disciples all deserted him and ran away. Among those following was a young man with nothing on but a linen cloth. They tried to seize him; but he slipped out of the linen cloth and ran away naked.' (Mark 14:51–2). The young man is usually identified with Mark the Evangelist. Artists usually depict him wearing an undergarment.

Betrothal of the Virgin, see MARRIAGE OF THE V.

Biagio, see BLAISE.

Bier. Christ touching a bier, the body restored to life, RAISING OF THE WIDOW'S SON OF NAIN.

Bird. Symbol of the soul in ancient Egypt. It features in this sense in STILL LIFE. It is held in the hand of the infant Christ, or is tied to a string (VIRGIN MARY, 13). Symbol of Air, one of the FOUR ELEMENTS; attribute of JUNO, when personifying Air; attribute of Touch, one of the FIVE SENSES. Birds are caged, snared, tamed on a string, in allegories of Spring, one of the FOUR SEASONS. Birds and fishes were made on the fifth day of CREATION; they nest in a tree at the angel's annunciation to Anne (JOACHIM AND ANNE). FRANCIS OF ASSISI (6) preached to them. HERCULES (6) shot down the monstrous Stymphalian birds. See also individual species.

Bishop. For the vestments of a bishop, see RELIGIOUS DRESS. The following are attributes of bishops. Anvil, hammer, tongs, ELOI. Balls, three golden, or purses, perhaps on book, NICHOLAS OF MYRA. Capstan, ERASMUS. Chalice, broken, DONATUS. Club, or hatter's bow, JAMES THE LESS. Comb, wool-carders', BLAISE. Crown and sceptre at feet, the youthful LOUIS OF TOULOUSE. Fish dangling from crozier, ZENO. Goose, MARTIN of Tours. His own head decapitated, DENIS. Holding model of city: (Modena), mirror, demon at feet, GEMINIANUS; (Florence), fleur-de-lys on halo, book, ZENOBIUS; (Bologna), two towers, one leaning, PETRONIUS. Monastic habit under cope, AUGUSTINE; also BONAVENTURA. Monstrance, or chalice, with spider, NORBERT. Two phials on a book, JANUARIUS. Purse instead of crozier, THOMAS OF VILLANUEVA. Stag, crucifix between antlers, HUBERT. Sword: piercing book, BONIFACE; embedded in skull, THOMAS BECKET. The Virgin robing bishop in a chasuble, ILDEFONSO; appearing to him in a vision ANDREW CORSINI. Whip with three knots, AMBROSE. A bishop struck by a Jew is Rebellion personified (medieval), see OBEDIENCE.

Blacksmith, forging weapons, perhaps a goddess present, VULCAN; shoeing a horse, having first removed the animal's leg, ELOI.

Blaise (Ital. Biagio; Sp. Velasco). Christian saint and martyr believed to have been bishop of Sebaste in Asia Minor, and to have died, perhaps under the persecutions of the emperor Licinius, early in the 4th cent. He is especially remembered for the legends, some of which feature sporadically in early Renaissance painting, concerning his gentle nature which, like FRANCIS OF ASSISI, won him the trust and companionship of wild animals and birds. Before execution he had his flesh torn with iron combs, and he may be seen undergoing the torture tied to a pillar or hanging from a gibbet. As a devotional figure he is portrayed in bishop's robes and a mitre, holding a COMB, usually flat and square with short spikes and a handle, resembling the combs used for carding wool. Blaise became the patron saint of woolcombers. He was also invoked by those with diseases of the throat because he miraculously saved the life of a boy who had half swallowed a fish-bone which could not be extracted. In some districts of France it was the custom to place a pair of crossed candles, previously blessed, at the

throat of sufferers, at the same time calling on St Blaise to cure them. He thus sometimes has crossed CANDLES for an attribute.

Blanket, Sancho Panza tossed in, see DON QUIXOTE (4).

Blind, Healing of the (John 9:1–7). Encountering by the wayside a man who had been blind from birth, Christ restored his sight by means of an 'ointment' made from a mixture of dust and spittle. He sent the man away to wash in the pool of Siloam, and on his return his blindness was cured. Christ is seen anointing the eyes of the blind man, surrounded by the disciples and perhaps a throng of onlookers. The man, in beggar's rags, holds a stick and may be accompanied by a child who guides him. His cure may be represented with his 'double' beside him throwing away the stick. Matthew (20:29–34) describes a similar incident, the curing of two blind men near Jericho. The scene is outside the city walls. Here Christ merely touches the eyes of one of the men; the other kneels awaiting his turn. The theme was seen as a symbol of man's spiritual blindness which Christ came to earth to redeem. The apocryphal story of the curing of blind Tobit (see TOBIAS) was taken as its prefiguration.

Blind leading the blind (Matt. 15:14; Luke 6:39). 'If one blind man guides another they will both fall into the ditch.' In this saying Christ was likening the Pharisees to blind men. Artists depict a country scene with blind beggars. There may be several of them, each holding on to the next for guidance, and having a stick in his other hand. The leader is tumbling into a ditch. The others will clearly soon follow him.

Blindfolding, a symbol of moral or spiritual blindness, hence of the darkness of sin and ignorance. Two Cupids, one of which is blindfold, signify heavenly and earthly, or pure and sensual, love. In the same sense the Synagogue personified is blindfold (CRUCIFIXION, 12); likewise IGNORANCE, and AVARICE and the latter's harpy. A blindfold CUPID in the presence of lovers generally signifies the blindness of love. Also blindfold are FORTUNE and NEMESIS because of their randomness, and JUSTICE for her impartiality. In the MOCKING OF CHRIST the seated Saviour is blindfold; also sometimes the two thieves (CRUCIFIXION, 2). A blindfold saint at his execution, PAUL (13); JOHN THE BAPTIST (8). See also LYNX.

Blindness, cured by Christ, BLIND, HEALING OF THE. A blind soldier begging, BELISARIUS. Several blind beggars, BLIND LEADING THE BLIND. Old blind man, crowned with laurel, perhaps with fiddle, HOMER. Old blind man (Tobit) and wife, within doors, he perhaps anointed by angel, TOBIAS. Blind man grasping pillars, SAMSON. Magician, Elymas, struck blind by Paul, with Barnabas, before Roman governor, PAUL, apostle, (5). Jews beside cortège, blinded by angels, DEATH OF THE VIRGIN. See also BLINDFOLDING.

Blood. Christian symbol of life, and of man's redemption through the shedding of Christ's blood (LONGINUS; CRUCIFIXION, 10), foreshadowed by him at the LAST SUPPER. Red is the symbolic colour of Christian martyrdom. Blood flowing from a shroud pierced by a knife, GREGORY THE GREAT (4). A blood-stained tunic presented to a patriarch, JOSEPH, son of JACOB (1).

Boar. Attribute of LUST personified, it is trodden underfoot by CHASTITY. The Erymanthian boar was captured in a net by HERCULES (4). A boar at bay surrounded by huntsmen, MELEAGER.

Boat, (for the larger vessel and its symbolism, see SHIP). Peter and Andrew in a boat, called by Christ, PETER, apostle (1). Disciples in boat, Christ with them or standing on the shore, MIRACULOUS DRAUGHT OF FISHES; approached by Christ across the water, CHRIST WALKING ON THE WAVES. CHARON plies a boat bearing the souls of the dead or, rarely, the Holy Family. The latter are more usually ferried

by an angel (FLIGHT INTO EGYPT). Another ferryman, JULIAN THE HOSPITATOR, has a boat for attribute. Departing warriors, a woman gesticulating or swooning on the shore, RINALDO AND ARMIDA (5). Three in a boat surrounded by floating 'corpses', DANTE AND VIRGIL.

Bolsena, see MASS; CHRISTINA.

Bonaventura (1221–74). Christian theologian and mystic who belonged to the Franciscan Order, eventually becoming its head, or Minister General. He was later appointed cardinal bishop of Albano. Known as the Seraphic Doctor, his writings included a biography of St Francis. He was a man of intellectual and spiritual humility, as shown by the story, featured in Franciscan painting, that when his cardinal's hat was brought to him he told the papal envoys to hang it on a nearby tree since he was at that moment washing the dishes. He regarded himself as unworthy to receive the Sacrament, and legend tells that it was handed to him by an angel. It is said that St Francis, on seeing him recover from a dangerous illness in infancy, exclaimed 'Oh what good fortune!' ('O buona ventura!') – hence his name. He wears the Franciscan habit, sometimes with a cope over it. As bishop of Albano he wears full episcopal robes (see diag. RELIGIOUS DRESS). A cardinal's hat lies at his feet or hangs from a tree. He may hold a CROSS and CHALICE and, in allusion to his writings, a BOOK. He forms a pendant to FRANCIS OF ASSISI and to CLARE, the founder of the Second (female) Order of Franciscans. See also THOMAS AQUINAS.

Bones. Valley of dry bones, reclothed in flesh, see EZEKIEL. Burning of bones, see JOHN THE BAPTIST (10). Bones are scattered round OEDIPUS AND THE SPHINX. Bones of Sirens' victims, ULYSSES (2). Ass's jawbone, CAIN (2); SAMSON (3).

Boniface (*c.* 675–754/5). English Christian martyr, born at Crediton, and educated at a Benedictine convent. His baptismal name was Winfrid. He was a monastic scholar until his middle years, when he became a missionary and travelled abroad, preaching to unconverted peoples in northern Europe. He founded schools and monasteries, especially in Germany, and became archbishop of Mainz in 744. As archbishop he anointed Pepin 'the Short' as king. He was martyred by the sword in Holland. Boniface is known as the Apostle of Germany. He is represented, chiefly in German art, in bishop's robes and mitre, holding a BOOK pierced by a SWORD. He may be seen baptizing the converted, his foot resting on a fallen oak tree to symbolize the overcoming of druidism.

Book. *Religious art.* Symbol of learning and authorship, too widely used to be by itself a useful aid to identification. It is found in the hands of the prophets, Sibyls, evangelists, PAUL and other apostles, the Fathers of the Church, THOMAS AQUINAS, BERNARD of Clairvaux, DOMINIC and many others known for their writings or learning. It may bear a title or, on its open pages, a quotation. Its owner may hold a pen and perhaps an inkhorn. The Virgin reads a book at the ANNUNCIATION; when with the infant Christ, she or he may hold a book (VIRGIN MARY, 9). The contemplative MARY MAGDALENE reads a book. MARK presents his gospel to the Virgin. God the Father or Christ may hold a book bearing the letters A and Ω (qv). A book pierced by a sword is the attribute of BONIFACE; with a cross lying on it, of FAITH personified; bearing a fleur-de-lys, of ZENOBIUS. Narrative scene depicting the burning of books, DOMINIC and PAUL, apostle (9); a book with seals in the lap of Christ, APOCALYPSE (4); John the Evangelist eating a book, APOCALYPSE (14); The Church Fathers consulting books and debating the Immaculate Conception, VIRGIN MARY (4). For the comparative symbolism of the codex and *rotulus*, see DISPUTE WITH THE DOCTORS.

Secular art. A common attribute of the Virtues personified; the SEVEN LIBERAL

ARTS, especially Rhetoric ('Cicero'), and Grammar whose pupils bend over their books; PHILOSOPHY, with a sceptre in her other hand; HISTORY, who writes in a book; the MUSES, especially Clio (history: 'Herodotus', 'Thucydides') and Calliope (epic poetry: 'Iliad', 'Odyssey', 'Aeneid'). Melancholy, one of the FOUR TEMPERAMENTS may be surrounded by books. Lovers sharing a book are PAOLO AND FRANCESCA. A book and sword offered to a warrior asleep under a tree, see SCIPIO (2). The ALCHEMIST may pore over a book in his workshop.

See also specific books: ARS MORIENDI; BOOK OF HOURS; MISSAL; PSALTER.

Book of Hours. The popular prayer book of the laity in the later Middle Ages. Those commissioned by rich patrons were notable for their sumptuous illumination, especially in the 14th and 15th centuries, for example the Très Riches Heures du Duc de Berry (Musée Condé, Chantilly), illustrated mostly by the brothers de Limbourg. The canonical hours, or Horae, are the separate parts of the day to which are allocated specific devotions, the psalms, prayers, hymns and readings that together constitute Divine Office, the liturgy of the Church. The hours of the Roman Church are eight: Matins, Lauds, Prime, Tierce, Sext, None, Vespers and Compline. The basis of the Book of Hours was the Little Office of the Virgin, special prayers in her honour that had come to be added during the 10th cent. to the normal Divine Office. The make-up of the book varied but might commonly contain also the Hours of the Cross, the Hours of the Holy Ghost, the Hours of the Passion, the seven penitential psalms, the Litany, prayers to the saints, and the Office of the Dead. The book began with a calendar which gave the religious feasts for the year, followed next by extracts from each of the gospels. The calendar might be illustrated with the Labours of the Months and the zodiacal signs appropriate to each (see TWELVE MONTHS), the gospels with pictures of the four evangelists. The Hours of the Virgin were traditionally illustrated as follows: Matins, Annunciation; Lauds, Visitation; Prime, Nativity; Tierce, Annunciation to the Shepherds; Sext, Adoration of the Magi; None, Presentation in the Temple; Vespers, Flight into Egypt; Compline, Coronation of the Virgin. These were interspersed with Old Testament scenes illustrating the psalms. The Hours of the Cross might be accompanied by the scenes of the Discovery of the True Cross; the Hours of the Holy Ghost typically include Pentecost and the apostles setting forth to preach; the Office of the Dead, a funeral service (the *Très Riches Heures* has the death of Raymond Diocrès, see BRUNO, 1), purgatory and hell. The Hours of the Passion have the principal scenes from the Agony in the Garden to the Entombment.

Boreas. In Greek mythology the north wind, and in allegories of the FOUR SEASONS the personification of Winter. He is old and has flowing grey locks and wings. He loved Oreithyia, the daughter of a legendary king of Athens and, against her will, carried her off to be his bride (*Met.* 6:692–722). He is shown flying away with the naked girl clasped firmly in his arms. Amoretti may be present, perhaps playing with snowballs. According to Pausanias (5, 19:1) Boreas has serpent tails instead of feet, and is so represented by Rubens ('Neptune calming the waves', Dresden Gall.).

Bow. The archer's bow has much the same attribution as the arrow, for example APOLLO, CUPID, DIANA and hence LUNA, America personified, one of the FOUR PARTS OF THE WORLD. A bow and quiver is the attribute of the giant ORION; also sometimes of HERCULES. A huntress with bow and quiver, Venus in disguise, appeared to AENEAS (3). A hatter's bow, used in making felt, is an attribute of JAMES THE LESS. Sagittarius, the archer of the zodiac, see TWELVE MONTHS.

Hatter's bow

Bowels. A corpse dangling from a tree, its bowels hanging out, JUDAS ISCARIOT. Martyrdom by disembowelling, the bowels wound on a windlass, ERASMUS. ENVY personified gnaws her own entrails.

Bowl. A bowl is the attribute of the BEGGAR; of ALEXIS, a beggar-like saint; of the Cumaean SIBYL. It is the drinking utensil of DIOGENES which he threw away.

Branch. Attribute of ISAIAH; flowering branch, of Logic, one of the SEVEN LIBERAL ARTS. Females, their arms sprouting branches, see ADONIS, BIRTH OF; APOLLO (9); CHASTITY; PHAETHON. See also OLIVE; PALM.

Brandeum, Miracle of the, see GREGORY THE GREAT (4).

Brazen serpent, see MOSES (12).

Brazier. Soldier, his hand thrust into fire, MUCIUS SCAEVOLA; hence the brazier an attribute of CONSTANCY personified; see also SACRIFICE. Woman snatching coals from brazier, PORCIA. Red-hot iron taken from brazier by woman before king enthroned, JUDGEMENT OF OTTO.

Bread. The Christian symbol of Christ's body and hence of his sacrifice, established at the LAST SUPPER, and having the same meaning in the SUPPER AT EMMAUS. A loaf of bread and wine in STILL LIFE symbolize the eucharistic elements. A loaf is occasionally the attribute of DOMINIC (6); with a snake emerging from it, of BENEDICT; three small loaves, of MARY OF EGYPT. A dog brought bread tò ROCH in the desert. A Capuchin monk receiving a loaf of bread from a child is FELIX of Cantalice. See RAVEN for the several hermit saints to whom the bird brought bread. See also FEEDING OF THE FIVE THOUSAND.

Breast. The goddess of fertility, Diana of Ephesus, was represented in antiquity with, apparently, many breasts. The original image, according to some, was adorned with large dates, symbols of fertility, which later came to be mistaken for multiple breasts. A similar figure in Renaissance painting, especially when surrounded by flowers, vegetables and other evidence of the earth's fruitfulness, stands for Mother Nature (see also ERICHTHONIUS). As a source of life and nourishment the breast came to have several shades of meaning. The milk from Juno's breast ensured immortality for Hercules (ORIGIN OF THE MILKY WAY). A woman pressing milk from her breast personifies Mercy, and the kindred virtue of Benignity who tempers JUSTICE. BERNARD of Clairvaux (2) received the milk of the Virgin Mary in the Miracle of Lactation. Of the images of infants at the breast, that of the infant Christ, the 'Virgo Lactans', goes back to very early Christian art (VIRGIN MARY, 6). The milk of creative inspiration may fall from the breast of a Muse on to the page of a book or a musical instrument (see also INSPIRATION). A woman nursing more than one child may personify Earth, one of the FOUR ELEMENTS, but more often CHARITY. An old man suckled by a young woman in prison represents ROMAN CHARITY. In a double portrait of a man and woman, the man's hand laid in a formal gesture on the woman's breast signifies a betrothal. Two breasts on a dish are the attribute of AGATHA.

Brennus ('*Vae victis!*') (Livy 5:48–9; Plutarch 8:28–9). Leader of the Gauls whose forces attacked Rome in 390 B.C., occupying all but the Capitol to which they laid siege. The Romans agreed to pay a gold ransom to buy off the besiegers, but complained during its weighing that the Gauls were using false weights. Whereupon Brennus threw his sword into the scale pan, making the ransom higher still, and cried, 'Vae victis!' – 'Woe to the defeated!' Roman forces under Camillus arrived and routed the Gauls before the payment was handed over. Romans, he said, were accustomed to deliver their country with iron, not gold. This theme of ancient Roman honour is represented chiefly in Italian baroque painting. Brennus, in the act of throwing his sword into the scales, looks

round angrily as Camillus arrives on horseback, his hand raised in a staying gesture.

Bridge. Battle on a bridge, CONSTANTINE THE GREAT (2). Knight in armour and naked man wrestling on a bridge, ANGELICA (4). A bridge spans the flames of HELL.

Bridget of Sweden (*c.* 1304–1373). A devout noblewoman who in earlier life was attached to the Swedish court. She bore a large family and was widowed in 1344. Thereafter she devoted herself to religion and founded the Order of Bridgettines. She died in Rome. Her religious nature expressed itself in visions which guided her daily life. Her book, the *Revelations*, includes details about the birth and death of Christ that had some influence on Christian iconography (see NATIVITY, 2; BETRAYAL; FLAGELLATION; CROWNING WITH THORNS; RAISING OF THE CROSS). Bridget wears a nun's black habit and a white wimple and veil, sometimes with a red band across the forehead. Her characteristic attribute is a taper or CANDLE, from the story that she would deliberately allow drops of burning wax to fall on her hand in order to simulate Christ's wounds. As head of her religious house she may hold a crozier. A pilgrim's staff with wallet and hat alludes to her travels to Rome and the Holy Land; a book and inkhorn to her writings; a crown at her feet to the giving up of her life at court. She was canonized in 1391 and is represented in art chiefly during the next two centuries. She is seen in Italian painting giving the Rule of her Order to her nuns; at a writing desk receiving the dictation of an angel; and kneeling before a vision of the Virgin and Child.

Bridle, with bit and reins, signifies restraint, hence an attribute of TEMPERANCE; also of NEMESIS, and FORTUNE. Old man on all fours wearing bridle, ridden by woman, ARISTOTLE AND CAMPASPE. A golden bridle was used by BELLEROPHON to capture the winged horse Pegasus.

Bridle

Briseis, see TROJAN WAR (1, 2).

Bruno (*c.* 1033–1101). The founder of the Order of Carthusians, born at Cologne and educated there and at Tours and Rheims. He fled from the latter city after denouncing the archbishop for simony, and then retired with some companions to the Grande Chartreuse, a desolate region in the mountains near Grenoble, where he founded the first Carthusian community. He was summoned to Italy by the pope and, after refusing the archbishopric of Reggio, set about establishing monasteries in Calabria. He was canonized in 1623 and is thereafter represented in art wearing the habit of the Order, distinguished by a white scapular (a long front-and-back apron) tied at the sides. (See diag. RELIGIOUS DRESS.) His hands are generally crossed on his breast and his head bent as a sign of humility. Scenes from the life of St Bruno and other members of the Order are the subject of several extended cycles of paintings. The following occur as separate subjects.

1. *The death of Raymond Diocrès.* Bruno's theological tutor was said, as he lay on his deathbed, to have proclaimed, 'By the justice of God, I am condemned!' – a decisive moment in the life of his young pupil who was present. The scene is a deathbed, with a priest presenting the crucifix, or the funeral service. Two young students, one of whom is Bruno, are standing by.

2. *St Bruno praying in the desert of the Grande Chartreuse.* Among several other scenes of the saint at prayer he is depicted, perhaps with companions, in a barren rocky place among the mountains, the site of the future monastery.

3. *St Bruno refusing the mitre*. He kneels before the pope who is accompanied by cardinals. (His refusal of the see of Reggio.)

4. *Death of St Bruno*. He lies on his deathbed surrounded by monks dressed in the habit of his Order.

Brutus, Lucius Junius (Livy 2:4–5; Plutarch 6:6). Nephew of Tarquin the Proud who led the revolt against his uncle following the RAPE OF LUCRETIA. Brutus was one of the first two Roman consuls, the office instituted after the fall of the Tarquins. His two sons were members of a conspiracy to restore the Tarquin monarchy. It was foiled and they were convicted and sentenced to death by their father. This example of Roman justice at its sternest was commissioned from artists for 17th cent. courts of justice. Brutus stands before the two young men pronouncing his verdict. Onlookers register astonishment. The sons kneel at their father's feet, their hands raised in supplication (Rembrandt, Utrecht Museum). Brutus is also depicted, later, seated in his house while the bodies of his sons are borne in on a bier (J.-L. David, Louvre).

Bubbles. Infants, or putti, blowing soap-bubbles symbolize the brevity of life in 'Vanitas' pictures and allegories of death. An inscription may read 'Homo bulla est' (Varro) – 'Man is a bubble'.

Bucephalus, see ALEXANDER THE GREAT (1).

Bucintoro (Bucentaur), see WEDDING OF THE SEA.

Bucket. Attribute of the warrior saint FLORIAN, who may empty water from it over a burning house.

Building. Construction of: TOWER OF BABEL; Temple at Jerusalem, SOLOMON; monastery of Monte Cassino, BENEDICT (7). A toppling church is supported by DOMINIC (2); and by FRANCIS OF ASSISI (3). A floating palace, with banners, FRANCIS OF ASSISI (1). A house borne in the air by angels, Virgin and Child on roof, VIRGIN MARY (16). For the edifice held in the hand of a saint, see MODEL. See also RUINS.

Bull. An object of worship in primitive religions, for its strength and fertilizing power. A golden bull calf, on altar or pedestal, worshipped by the Israelites, MOSES (11); the same, worshipped by SOLOMON (3). The Cretan bull is captured by HERCULES (10). Achelous, as a bull, wrestles with HERCULES (22). A white bull bearing a maiden into the sea, RAPE OF EUROPA. A female saint tied to a pair of bulls, THECLA. A bull-headed monster, the Minotaur, slain by THESEUS. Two fire-breathing bulls guard the Golden Fleece, JASON. A brazen bull is the attribute of EUSTACE. See also OX; TWELVE MONTHS (Taurus).

Burning Bush, see MOSES (5).

Bush. Burning bush, MOSES (5). BENEDICT and FRANCIS OF ASSISI threw themselves into a thorn bush. Laurel bushes sprouting from a maiden's arms, APOLLO (9).

Butades, a potter, see DISCOVERY OF THE ART OF DRAWING.

Butterfly. In antiquity the image of a butterfly emerging from the chrysalis stood for the soul leaving the body at death. In Christian art the butterfly is a symbol of the resurrected human soul, either in the hand of the infant Christ, or in STILL LIFE. The life-cycle of the caterpillar, chrysalis and butterfly symbolizes life, death and resurrection. In secular painting the HORAE may be represented with butterfly's wings; likewise Zephyr, the spouse of FLORA.

Cadmus. The legendary founder of Thebes, one of the great cities of ancient Greece. On the advice of an oracle he followed a cow which led him to the site. He then sent his companions to a nearby spring to fetch water for a libation but they were all killed by a great snake, or dragon, that guarded the place. After a battle Cadmus slew the dragon. On the instructions of Minerva, his protectress, he

sowed the dragon's teeth and where they fell armed men sprang up. They set about fighting one another until there were left only five who became, with Cadmus, the founders of the city.

1. *Cadmus slays the dragon* (*Met.* 3:28 ff). The scene is a grotto, a shady retreat with a pool, where a man lies dead entwined by a snake. The bodies of other victims lie nearby. One or two attempt to flee. An overturned pitcher or urn reminds us of the reason for their visit. Cadmus stands before the snake brandishing a sword. The monster may take the form of a medieval winged dragon. In some versions Cadmus is absent.

2. *Cadmus sows the dragon's teeth* (*Met.* 3:50–130). He strides along casting the teeth before him. Warriors struggle to their feet out of the earth, attacking one another. Minerva hovers in a cloud overhead.

Caduceus. Originally a magician's wand, later the distinctive emblem of the messenger in ancient Greece, which ensured his unmolested passage. It was already associated with messengers of the gods in near eastern religions before it became the attribute of the classical Hermes (Mercury). Some uncertainty exists as to the origin of its typical features. The caduceus may at first have taken the form of an olive branch or a rod with two or three leaves. Subsequently the rod was tipped with a circle and a crescent, which may in time have assumed the form of entwined snakes. Alternatively it may have been as a symbol of healing that the snake first became part of the caduceus. It usually has a pair of small wings at the tip. Myth tells how Mercury threw his wand at two snakes fighting on the ground and they became fixed to it. Since Mercury was the teacher of Cupid, the caduceus may stand for Eloquence and Reason, the qualities of a teacher. It is also an attribute of PEACE personified.

Caduceus

Caenis, a maiden ravished by NEPTUNE (4).

Caesar, Gaius Julius (102–44 B.C.). Roman military commander and statesman. Not a common figure in art, his portrayal is confined to a few themes, usually found in Italian baroque painting.

1. *The head of Pompey delivered to Caesar*. Caesar's campaign against Pompey began with the crossing of the Rubicon and ended with the latter's flight to Egypt and death by stabbing. According to Plutarch (32:80; 34:48) when Caesar reached Egypt he was presented with Pompey's head by an Egyptian, but turned away in abhorrence. On receiving Pompey's seal he burst into tears. He is depicted, generally in full armour, his face and gesture expressing grief at the sight of the severed head.

2. *The murder of Caesar*. Caesar's death at the hands of the conspirators, led by Brutus and Cassius, occurred on the Ides of March in the senate house at the foot of Pompey's statue. Cimber, on the pretext of presenting a petition, approached and pulled Caesar's robe from his neck, the signal for the attack. Casca struck the first blow, and then the others closed in.

See also APOTHEOSIS; TRIUMPH.

Caiaphas, high priest, see TRIAL OF CHRIST (2).

Caiman. A reptile resembling the crocodile, found in tropical America, an attribute of America personified, one of the FOUR PARTS OF THE WORLD.

Cain and Abel (Gen. 4:1–15). The first children of Adam and Eve. Cain was a settled farmer, Abel a nomadic shepherd.

1. *Their offerings to God*. Cain brought an offering from his harvested crops (represented as a sheaf of corn), and Abel a sacrificial lamb, the best of his flock. God refused Cain's offering but accepted Abel's. 'Cain was very angry,

and his face fell'. God's choice is usually indicated by a pointing hand emerging from the clouds, or by an angel that receives Abel's offering. The theme is found in church art, chiefly of northern Europe, in the 12th and 13th cents.

2. *The killing of Abel.* When they were in the fields Cain attacked Abel and slew him. As punishment God made Cain a fugitive and vagabond and put a mark on him so that he should be recognized. Artists put various weapons into Cain's hand, most often a club or an ass's jawbone. (The latter was used by Samson to slay the Philistines.) This theme is much more widely represented than the first, both as to period and to school. The death of Abel, the shepherd, was regarded as an early 'type' of the death of Christ, with Cain as the person of Judas. Also occasionally depicted is the lamentation of Adam and Eve over the body of Abel; and the death of Cain, slain accidentally by the arrow of the hunter Lamech who mistook him for a wild beast.

Calendar, see BOOK OF HOURS; PSALTER; TWELVE MONTHS.

Calliope, see MUSES.

Callisto, see DIANA (5).

'Calumny' of Apelles. An allegory on the subject of Calumny, by the Greek painter Apelles (4th cent. B.C.), was known to Renaissance scholars through a description in Lucian; the painting itself, like the rest of Apelles' work, being no longer extant. Artists were encouraged, as part of the movement to revive classical antiquity, to attempt the reconstruction of the original picture from Lucian's description. The first and the most famous of these was Botticelli's (Uffizi). According to Lucian, 'on the right sits a man with huge ears, rather like Midas'. He is generally represented as a judge or king with ass's ears, signifying his stupidity. 'Beside him are two women, Ignorance and Suspicion, I suppose'. They whisper evil counsel into the judge's ears. Ignorance, in later examples, is fat, sightless or blindfold, and may wear a crown. 'Calumny approaches. She is portrayed as a beautiful woman, beside herself with passion, as if about to explode with madness and rage. In her left hand she holds a flaming TORCH; with the other she drags along by the hair a young man who raises his arms to heaven, calling on the gods as witnesses'. He personifies Innocence, falsely accused. A figure whom Lucian describes as 'wan and hideous, with piercing gaze, and shrivelled as if by disease' represents Envy, who may guide Calumny, or may stand before the judge in ragged clothes. Two women who accompany Calumny are Guile and Deceit. The latter, who may have a MASK for attribute, is twining flowers into Calumny's hair to make her yet more attractive in the judge's eyes. Next follows 'a woman in deep mourning, her dress black and tattered'. This is Repentance, who turns 'weeping and full of shame' towards the last figure of all, Truth, who stands naked, pointing to heaven. But the last two seem to have arrived too late to save Innocence. Artists took some licence in interpreting the text which was a Latin or Italian translation of Lucian's Greek. (*Peri tou me rhadios pisteuein diabole.*) See further, IGNORANCE; TRUTH.

Calydonian boar hunt, see MELEAGER.

Calypso, nymph, see TELEMACHUS.

Cambyses, see JUDGEMENT OF C.

Camel. The attribute of Asia personified, one of the FOUR PARTS OF THE WORLD; also, in the Middle Ages, of OBEDIENCE. Camels feature especially in Old Testament themes, as in JOSEPH, son of Jacob (1); REBECCA at the well; the exodus from Egypt (MOSES, 6); also in the ADORATION OF THE MAGI.

Campaspe, see APELLES PAINTS C.

Cancer (zodiac), see TWELVE MONTHS.

Candle plays a part in several religious devotions. The Roman Catholic festival of Candlemas – the Purification of the Virgin – has a procession of candles (PRESENTATION IN THE TEMPLE). As a symbol of the light of faith it is an attribute of FAITH personified. The Virgin may hold a lighted candle on her deathbed (DEATH OF THE VIRGIN). The seven lamps standing for the seven churches of Asia Minor are sometimes represented as altar candles (APOCALYPSE, 2). The menorah, the seven-branched candlestick of the Jewish religion (Ex. 37:17–24), identifies the Temple at Jerusalem, and is seen for example in the Presentation. A lighted candle in a 'Vanitas' picture symbolizes the fleetingness of human life (STILL LIFE). A candle is the attribute of BRIDGET of Sweden; of CHARITY personified; and of the Libyan SIBYL; held by a nun, blown out by a demon, of GENEVIÈVE; a pair of crossed candles, of BLAISE; candles set round the rim of a wheel, DONATIAN. A lighted candle with the motto 'Sufficit unum (lumen) in tenebris,' – One light suffices in the dark', was taken as an *impresa* by Isabella d'Este in 1525. It referred to her solitary position at the court of Mantua after her son Federigo had abandoned her for his lover, Isabella Boschetta, accompanied by his courtiers. Her triangular candelabrum resembles that used in the celebration of the Roman Catholic offices of Matins and Lauds in Holy Week (Tenebrae), during which the candles are extinguished one by one, finally leaving alight only that at the top which is extinguished last of all: an allusion to the apostles' desertion of Christ at the crucifixion.

Menorah

Candlemas, see PRESENTATION IN THE TEMPLE.

Cannon, at the feet of a female saint, the attribute of BARBARA, patron saint of gunsmiths and armourers. A scene of cannons firing towards a city is the *impresa* of Duke Alessandro Farnese (1545–1592). The motto 'Invitus invitos', – 'I, the unwilling (conquered) them, unwilling (to be conquered)', alludes to the sacking of Maastricht in 1579 by his troops after he had called in vain for the city to surrender (Farnese Palace, Rome).

Capricorn (zodiac), see GOAT; TWELVE MONTHS.

Capstan, attribute of ERASMUS (bishop).

Cards. Card games, according to the moralist, were the mark of an idle nature, and hence became an attribute of Vice personified, as in the allegory of Hercules at the Crossroads (HERCULES, 21).

Caritas, see CHARITY; motto of FRANCIS OF PAOLA.

Caritas Romana, see ROMAN CHARITY.

Carnation or pink, especially when red, a symbol of betrothal, probably originating in a Flemish wedding custom. In portrait painting, especially of the 15th and 16th cents., when held in the sitter's hand it signifies that the picture commemorates his betrothal. See also FLORA (2).

Carpenter. Visited by angel, JOSEPH, husband of the Virgin (2); at workbench, with Virgin and Child, and sometimes others, VIRGIN MARY (17); carpenters building the ark, NOAH. Daedalus also worked in wood, see PASIPHAË.

Castitas, see CHASTITY.

Castitas, Pulchritudo, Amor, see THREE GRACES.

Castle of Love, see LOVE.

Castor and Pollux (called the Dioscuri, meaning 'sons of Zeus'). Twin brothers, hatched from the eggs laid by LEDA after Jupiter (Zeus) in the shape of a swan

had lain with her. They were renowned as warriors and were inseparable. They took part in the Calydonian boar hunt. (See MELEAGER.) They are the 'heavenly twins', Gemini of the zodiac, and are invoked in the expression 'By Jiminy!' They are also represented as the stars of good omen to ships.

The rape of the daughters of Leucippus (*Fasti* 5:699 ff; Theocritus 20; Hyginus 80). The two daughters of King Leucippus were betrothed to another set of twins, cousins of Castor and Pollux. But the latter pair carried the maidens off and had sons by them. Two armed warriors are seen in the act of seizing the naked maidens and bearing them away on horseback.

Caterpillar, with chrysalis and butterfly, STILL LIFE.

Catherine of Alexandria. Formerly venerated as a Christian saint and virgin martyr, a patron of education and of learning generally, said to have been executed by the Roman emperor Maxentius early in the 4th cent. Because of her very uncertain historicity she was removed from the Catholic Church Calendar in 1969. The earliest surviving account of her life dates from the 9th cent., and is thought to have its roots in the story of Hypatia, a pagan philosopher of Alexandria, renowned for her learning and wisdom, who died in 415, it was said at the hands of a group of fanatical monks. Among female saints Catherine was second only to Mary Magdalene in popularity. The *Golden Legend* tells that she was of royal birth and showed great erudition from an early age. After becoming queen she was converted to Christianity, baptized by a desert hermit, and in a vision underwent a mystic marriage with Christ. The emperor Maxentius, at this time in Alexandria, desired her and tried by argument to undermine her faith; when he failed he sent fifty philosophers to try instead. The luckless men having emerged from the debate firm in the Christian faith were promptly put to the stake, unbaptized, by Maxentius. Catherine comforted them in their last moments. For her the emperor devised an instrument of torture consisting of four wheels studded with iron spikes to which she was bound, but a thunderbolt from heaven destroyed it before it could harm her. Catherine was then beheaded. Her body was carried by angels to a monastery on Mt Sinai which still claims to possess her relics. Her special attribute is the WHEEL, usually but not always with spikes, and either whole or broken. It may be small and held in her hand or, if large, it lies at her feet or she may lean on it. Other attributes are her SWORD of execution, the martyr's palm and the RING of her marriage with Christ. She may tread Maxentius under foot. She sometimes holds a book with the inscription: 'Ego me Christo sponsam tradidi' – 'I have offered myself as a bride to Christ'. She may wear a crown in allusion to her royal birth. As patron of education she is sometimes surrounded by symbols of learning – mathematical instruments, a celestial globe and open books. Her companion is most often BARBARA, sometimes MARY MAGDALENE, CATHERINE OF SIENA or URSULA. Narrative scenes of her martyrdom are comparatively rare: the most frequent subject is the mystic marriage.

The marriage of St Catherine. A version, different from the *Golden Legend*, known in 1337 but probably of earlier origin, tells that Catherine's mentor, the hermit, gave her an image of the Virgin and Child. Catherine's prayers caused the Infant at first to turn its face towards her, and later when her faith had grown to place a ring on her finger. The theme is found in Italian painting from the early 14th cent. and is widely represented thereafter. The Virgin Mary holds the infant Christ in her lap. He leans forward to place a ring on the finger of the saint, who kneels before him. She is richly dressed, especially in Venetian painting of the 16th cent. Anne, the mother of the Virgin, and Joseph are sometimes pres-

ent. The concept of the mystic marriage may be thought of as a rendering in visual terms of the simple metaphor of spiritual betrothal to God. According to some, it had its origin in the Song of Solomon which was interpreted in the Middle Ages as an allegory in which the bride of the poem stood for the Virgin Mary. See also CATHERINE OF SIENA.

Catherine of Siena (*c.* 1347–1380). Catherine Benincasa, a Christian mystic and member of the Dominican Order, born in Siena the youngest child of a large family. According to a contemporary biographer she began to experience visions from the age of seven. She lost brothers and sisters in epidemics of the plague and developed an acute personal awareness of human suffering. In daily life she devoted herself to the care of the sick and needy. She concerned herself with public affairs and was instrumental in bringing about the return of the papacy from Avignon to Rome. As patroness of the city of Siena she features in the painting of that school. She wears the white tunic and veil and the black cloak of the Dominican Tertiary (see diag. RELIGIOUS DRESS). She holds a CROSS with a LILY (for purity) and tramples a demon under her feet. In allusion to her writings she holds a BOOK – she was until late in life illiterate and is therefore sometimes shown dictating to an amanuensis. The ROSARY, which has special associations with St Dominic, is sometimes in her hand. She may show the marks of the STIGMATA. She is sometimes in the company of other Dominicans, PETER MARTYR and DOMINIC himself; with other patrons of Siena, ANSANUS and BERNARDINO; and with her namesake CATHERINE OF ALEXANDRIA, when they personify respectively sanctity and wisdom.

1. *The mystic marriage of St Catherine.* The form taken by Catherine's vision of her marriage to Christ seems to have been influenced by existing paintings, with which she was acquainted, of the mystic marriage of CATHERINE OF ALEXANDRIA. Her biographers' accounts vary, mentioning both the infant and the adult Christ. Both versions are represented in painting from the 14th cent., the former being the earlier. She can be distinguished from her namesake by her habit and veil. She kneels to receive a ring from the infant Christ who is held in the Virgin's lap, or from the adult Christ who usually stands beside his mother. Other saints may be present.

2. *The crown of gold and the crown of thorns.* The Saviour appeared to Catherine in a vision, offering her the choice of two crowns, one of gold and jewels and one of thorns. She is seen kneeling before him, taking the crown of thorns. It is sometimes her attribute in devotional representations.

3. *St Catherine and Pope Gregory XI at Avignon.* During the period of residence of the papacy at Avignon Catherine visited Gregory XI to intercede on behalf of the then excommunicated people of Florence, and to persuade the pope to return to Rome, in both of which aims she succeeded. She is seen before him pleading the Florentine cause; also leading the horse on which he is mounted, surrounded by his court, out of the city.

4. *The pilgrimage to the tomb of Agnes of Montepulciano.* This Dominican nun who died in 1317 was held in special regard by Catherine who made a pilgrimage to her tomb. Legend tells that when Catherine bent to kiss the foot of the nun it raised itself of its own accord to her lips.

5. *The stigmata.* In 1375, while she was at prayer in a chapel in Sta Christina in Pisa, Catherine beheld a vision of rays descending upon her from the wounds in the body of the crucified Christ. The form taken by her vision appears to be another instance of the influence on her of an existing image, in this case of the stigmatization of FRANCIS OF ASSISI. His biographers made no mention of

rays nor, in the earliest accounts, of the crucified Christ. Catherine's description of her vision does however conform to the manner in which the stigmatization of St Francis was represented in painting from the late 13th cent. A controversy arose with the Franciscans in the later 15th cent. who maintained that Catherine should not be portrayed with the stigmata, yet she is in fact very generally depicted thus. She is seen swooning into the arms of two sisters as she receives the marks on her body. (It seems that they were not in fact visibly present on her in life.)

Cato, Death of (Plutarch, 36:70). Cato the younger (95–46 B.C.), a Roman statesman and a man of unbending Stoic principles. He sided with Pompey in the civil war and committed suicide while governor of Utica, near Carthage, on learning that his cause was lost. According to Plutarch he retired to his bedchamber, angrily demanding his sword which had earlier been removed by his son who suspected his intentions. He read Plato's *Phaedo* (on the immortality of the soul and the death of Socrates) until the household was asleep, and then stabbed himself, dying amid a welter of blood. Cato, in 17th cent. painting, is the symbol of the old Roman ideal of honour and integrity that confronts death unflinchingly. He is depicted, usually naked to the waist (but generally fairly bloodless), either on his couch or in a chair. A book and a sword lie nearby. His son and servants enter with horror-stricken faces.

Cattle, see OX.

Cauldron. A number of saints underwent, and survived, immersion in a cauldron of boiling oil: ANSANUS; CECILIA; GEORGE; JOHN THE EVANGELIST (1). A witch brewing a cauldron is MEDEA.

'Causarum cognitio', see PHILOSOPHY.

Cecilia (Cecily). Christian saint and virgin martyr, believed to have lived in the 2nd or 3rd cent. The basilica of S. Caecilia in Trastevere at Rome is known to be of a very early foundation, and contains relics which are thought to be genuine. The record of her life and martyrdom, which cannot be reckoned as history, existed in the 6th cent. Cecilia, brought up as a Christian, took a vow of chastity and, on wedding a Roman nobleman named Valerius, persuaded him to accept sexual abstinence. He agreed on condition that he be allowed to see the angel that he knew watched over his wife. It later descended on them both, placing crowns of roses and lilies upon their heads. (These flowers are sometimes Cecilia's attribute.) Valerius was baptized a Christian and his brother Tiburtius likewise. In due course they were both executed by the Roman governor. Cecilia was condemned to death by suffocation in a steam bath, or alternatively was immersed (like JOHN THE EVANGELIST) in a cauldron of boiling oil, but survived. Three blows from a sword no more than wounded her neck, and she survived another three days, having meanwhile distributed her riches to the poor. Early Renaissance painters drew many themes from this legend. (Cecilia's patronage of music was unknown to them and does not appear in art until the 15th cent.)

The patron saint of music. The origin of Cecilia's patronage of music is to be found in a passage from the account of her life, or 'Passion', which runs, 'While Cecilia was being led into the house of her betrothed on her wedding day to the sound of musical instruments ('cantantibus organis'), she invoked only God in her heart, asking him the favour of keeping her soul and body without stain'. 'Organum' in Latin means any instrument, musical or otherwise, but 16th cent. artists identified it with the contemporary organ, often the portative (or portable) type, and thus it became her attribute. The portative instrument in fact disappeared during the 16th cent., and later she may have a clavichord, harp, lute

or bowed instrument. (See diagrams: MUSICAL INSTRUMENTS.) They may be played by the angels who accompany her. (Note that the pipes of a portative organ descend in length from left to right – bass to treble, like the strings of a piano – but painters freely reverse the direction to suit themselves.) The idea that Cecilia is rejecting earthly instruments for heavenly music underlies some pictures: she holds the organ away from her, upside down, and other instruments, especially those associated with Bacchus – pipes, tambourines and cymbals – lie broken around her, while she listens to angels singing overhead. Musical instruments were widely accepted as erotic symbols, and their association with a virgin bride of Christ would therefore be inappropriate. (cf. APOLLO, 4.)

Cedalion, Vulcan's apprentice, see ORION.

Censer. A receptacle for burning incense, an attribute of the deacons LAURENCE and STEPHEN. Its rising smoke traditionally symbolized prayers ascending to heaven, from Ps. 141:2. Priests with censers, the ground opening under their feet, AARON (1). In secular allegory, the attribute of Asia personified, one of the FOUR PARTS OF THE WORLD.

Censer

Centaur. In Greek mythology, one of a race of creatures, described as 'wild beasts' by Homer, that are represented with the head and torso of a man and the body of a horse. They were the offspring of IXION. Most of them were brutal, drunken and lecherous. They feature in some of the earliest Greek art, and in the sculpture and reliefs of the classical period. Their origin may lie in the primitive and probably barbarous cowmen of the plains of Thessaly who tended their herds on horseback. The district was a centre of horse-breeding in antiquity. To Renaissance humanists they personified man's lower, partly animal, nature and might be contrasted with the higher wisdom symbolized by Minerva. Not all Centaurs were like this: Chiron, the Centaur-teacher of Achilles, was renowned for his wisdom. (See ACHILLES, 2.) Centaurs are sometimes seen in the retinue of BACCHUS.

The battle of Lapiths and Centaurs; Rape of Hippodamia. A bloody affray described by Ovid with a wealth of detail (*Met.* 12:210–535). The Lapiths, a peace-loving people of Thessaly, were celebrating the wedding of their king Pirithous to Hippodamia. The Centaurs were invited but quickly began to misbehave. One of them, Eurytus, full of liquor, tried to carry off the bride and soon a battle raged in which drinking vessels, table legs, antlers, in fact anything to hand, served as weapons. Blood and brains were spattered everywhere. Finally, thanks chiefly to Theseus, the friend of Pirithous, who was among the guests, the Centaurs were driven off. To the ancients and to the Renaissance the theme symbolized the victory of civilization over barbarism. It was used to decorate Greek temples, notably the metopes of the Parthenon (the 'Elgin Marbles'), and was popular with baroque painters. Hippodamia struggles in the clutches of Eurytus, surrounded by the other combatants and a wreckage of banqueting tables. A warrior in armour, brandishing a sword or club, may be Theseus.

See also ANTONY THE GREAT (2); APOLLO (10); HERCULES (19 and 23).

Centurion's servant, Christ heals the (Matt. 8:5–13; Luke 7:1–10). In Capernaum, the town of Galilee that was one of the centres of Christ's teaching, a Roman centurion came to him to beg him to cure his servant-boy who lay at home very sick: 'You need only say the word and the boy will be cured'. It was a measure of the centurion's faith in Christ's powers that he took for granted that the cure

could be effected *in absentia.* And so it came about. The centurion is depicted bending or kneeling before Christ. He has removed his helmet, which is held by a page. He may be attended by Roman soldiers. Some of the disciples are grouped round Christ who is raising his hand in blessing.

Cephalus and Procris. In Greek mythology a young couple, newly married, whose love was destined to end in tragedy. The principal source of Renaissance illustration was a popular play by a 15th cent. Italian writer (*Cefalo*, by Niccolo da Correggio, 1450–1508) who embellished Ovid's version (*Met.* 7:795–866), adding new characters and giving it a happy ending. The play contained a moral for married couples, warning them against mistrust and jealousy of each other, and was performed at wedding celebrations. The story of *Cefalo* tells how Aurora the goddess of dawn fell in love with Cephalus. He rejected her and she retaliated by planting in him seeds of suspicion concerning his wife's faithfulness. To test his wife he disguised himself and tried to seduce her. He nearly succeeded and Procris in her shame fled away and joined the nymphs of Diana, the virgin goddess of hunting. They were eventually reconciled, partly through the mediation of an old shepherd. Procris brought two gifts for her husband that she had received from Diana: a hunting dog and a magic spear that never failed to find its mark. A faun who was in love with Procris mischievously told her that he had overheard Cephalus talking to a secret lover while he was out hunting. To discover the truth Procris followed her husband into the forest and hid in the bushes. Cephalus, hearing a rustling of leaves, threw his spear and killed his wife. Ovid's story ends here; in the play Diana brings Procris back to life. Several episodes have been illustrated, the commonest of which is the death of Procris. She lies under a tree in the forest, a spear piercing her breast. Cephalus has just found her: he raises his hands in horror, or wipes away tears, or sits or kneels beside her, stricken with grief. His dogs are at his heels. Aurora, with Tithonus at her side, may be seen driving her chariot overhead. An unusual treatment by Piero di Cosimo (Nat. Gall., London) shows the faun, which resembles Pan, kneeling sorrowfully beside the body of Procris. Cephalus' dog sits quietly nearby; its master is absent. The not uncommon scene of Aurora abducting Cephalus in her chariot comes from another, different version of the myth: see AURORA.

Cerberus. In Greek mythology a many-headed dog, commonly three, perhaps with a serpent's tail, the guardian of the entrance of Hades in both classical and Christian themes. See HELL; DESCENT INTO LIMBO; ACHILLES (1); HERCULES (12). Cerberus is sometimes the attribute of ORPHEUS.

Ceres (Gk Demeter). In Greek mythology the goddess of agriculture, especially associated with corn; she was sometimes worshipped as the earth-mother, the prime source of fertility. As the personification of the earth's abundance she wears a crown of ears of corn and may have a corn-sheaf, or a CORNUCOPIA flowing with fruit and vegetables, or sometimes a SICKLE. The presence of Bacchus the wine-god complements the idea of plenty. (See also VENUS, 2.) Proserpine (Persephone), the daughter of Ceres, was carried off to the underworld by Pluto. (See RAPE OF PROSERPINE.) Ceres searched everywhere for her and caused the earth to remain barren of crops until her daughter was restored to her (*Met.* 5:438–445; *Fasti* 4:561–562). Proserpine was allowed to return for four months of the year (longer according to some), during which time the earth blossomed again. In the role of mother searching for her daughter Ceres holds aloft a torch, sometimes two, and may ride her chariot drawn by DRAGONS. Originally a dragon was merely a large snake (associated with fertility in primitive religion), and in

classical sculpture Ceres is shown holding a snake in each hand. In the course of her wanderings she rested at a cottage where an old woman gave her a drink. The old woman's son cheekily called the goddess greedy and was immediately turned into a lizard (*Met.* 5:446–461). Ceres is shown sitting at the cottage door holding a pot, while the boy points a teasing finger at her. The old woman stands by. The idea of seasonal death and regeneration expressed in the myth came to be linked with the Easter and Christmas stories and has inspired many works of literature and painting. To the Middle Ages, which discovered a Christian moral in many a classical myth, Ceres stood for the Church, armed with the torches of the Old and New Testaments, seeking those who had strayed from the fold. The boy turned into a lizard stood for the Synagogue.

Chain, see FETTERS.

Chalice. The traditional vessel, usually of gold or silver, holding the consecrated wine at the celebration of the Eucharist. The use of a cup was sanctioned by Christ's words at the LAST SUPPER, 'Then he took a cup, and having offered thanks to God he gave it to them; and they all drank from it' (Mark 14:23). In representations of this theme it generally stands on the table, perhaps in an aureole. The chalice, especially with the Host (the consecrated wafer) is the symbol of the Christian faith, more particularly of the Redemption. In scenes of the CRUCIFIXION one or more angels each hold a chalice into which flows the blood from Christ's wounds (10); or a figure personifying the Church receives the blood in a similar manner (12). A chalice may stand at the foot of the cross (10). The Blood of the Redeemer flows into a chalice in the portrayal of the Mass of St Gregory (GREGORY THE GREAT, 5). The chalice is the attribute of FAITH personified and of several Christian saints: with the wafer, BARBARA; Franciscan with a book, BONAVENTURA; broken chalice, DONATUS; chalice containing a snake, JOHN THE EVANGELIST; containing a spider, NORBERT; an old unkempt hermit, ONUPHRIUS; a Dominican, a star on his breast, THOMAS AQUINAS. In narrative scenes Christ prays before a chalice presented by an angel (AGONY IN THE GARDEN); STEPHEN kneels before St Peter who presents a chalice to him. A chalice stands on the altar before which the kneeling THOMAS BECKET is attacked. The chalice features in a prefigurative sense in the Old Testament scene of ELIJAH receiving food and drink from an angel; likewise when held by the priest Melchizedek (ABRAHAM, 1).

Chameleon. Attribute of Air personified, one of the FOUR ELEMENTS.

Chance personified, see OPPORTUNITY.

Chariot. The triumphal car which, in Renaissance and baroque painting, carries a mythical, allegorical or, more rarely, historical figure, is generally drawn by two or sometimes more creatures of an appropriate kind (see also TRIUMPH).

Angels draw the chariot of Eternity, the last of the six *Triumphs* of Petrarch; an *Ass*, that of SILENUS; *Centaurs*, BACCHUS; *Cocks*, MERCURY; *Dogs*, VULCAN; *Dolphins*, GALATEA; *Doves*, VENUS; *Dragons*, CERES; *Eagles*, JUPITER; *Elephants*, FAME (one of the *Triumphs* of Petrarch); *Goats*, BACCHUS and CUPID; *Horses*, (*a*) four horses, the quadriga of APOLLO (though medieval tradition gave different colours to Apollo's horses, they are usually white in Renaissance and later art). A quadriga likewise draws (*b*) the Sun (see PHAETHON), and (*c*) AURORA. (*d*) Four white horses draw the car of CUPID who personifies Love (the first of Petrarch's *Triumphs*). (*e*) One black and one white horse, DIANA, likewise LUNA with whom she is identified. (*f*) Black horses, usually two, NIGHT. (*g*) Black horses, usually three, draw the chariot of PLUTO; (*h*) horses draw the chariot of Armida (see

RINALDO and A.); *Leopards*, BACCHUS; *Lions*, CYBELE; *Oxen*, usually black, DEATH (one of the *Triumphs* of Petrarch); *Peacocks*, JUNO; *Stags*, DIANA and FATHER TIME (one of the *Triumphs* of Petrarch); *Storks*, MERCURY; *Swans*, VENUS; *Tigers*, BACCHUS; *Unicorns*, CHASTITY (one of the *Triumphs* of Petrarch); *Wolves*, MARS. The chariot of marine deities may be made of a cockle-shell (NEPTUNE; GALATEA), and be drawn by HIPPOCAMPI, or sea-horses.

In narrative scenes ELIJAH (5) ascends to heaven in a fiery chariot; two youths draw the chariot of a priestess (CLEOBIS AND BITO); the chariot of TULLIA drives over a corpse in the roadway; the body of Hector is dragged behind the chariot of Achilles (TROJAN WAR, 4); the cords binding the chariot of Gordium are cut by ALEXANDER THE GREAT (3).

Charity (Lat. *Caritas*). The foremost of the three 'theological virtues' (see VIRTUES AND VICES). 'And now abideth faith, hope, charity, these three: but the greatest of these is charity' (I Cor. 13:13). The N.E.B. uses the word 'love', a closer definition to the modern ear, to which the word 'charity' has undue overtones of almsgiving. The Church indeed taught that charity was both love of God, *amor dei*, and at the same time love of one's neighbour, *amor proximi*, and that the second was of no real worth without the first. Both aspects are reflected in the manner in which it is portrayed. The latter was the easier to interpret visually, and in Gothic art is found the figure of a woman performing the six works of mercy (Matt. 25:35–37) – tending the hungry, the thirsty, the stranger, the naked, the sick and the prisoner. This became abbreviated into the representation of one act only, the naked being clothed: a beggar putting a shirt over his head beside the figure of Charity who perhaps holds a bundle of clothes. In the 13th cent. Bonaventura developed the concept of the love of God into that of light, or burning fire, a metaphor readily rendered in visual terms. Henceforward in Italian art the figure of Charity came to be represented with a FLAME, usually issuing from some form of vase, held in her hand. Or she holds a CANDLE. From the 14th cent. she may hold up a flaming HEART as it were offering it to God. This sometimes came to be combined with attributes suggesting earthly charity, such as a CORNUCOPIA or bowl of FRUIT. The vice opposed to Charity was, in the Middle Ages, Avarice who has money-bags or a purse or fills a coffer. A Renaissance tradition derived from Giotto substituted Envy (*Invidia*) gnawing a heart, and perhaps with a snake. There appeared in Italy in the first half of the 14th cent. a new type of Charity, possibly derived from the old image of the *Virgo Lactans* (VIRGIN MARY, 6), the woman suckling two infants. At first combined with the older motifs of the flaming heart and the candle, it gradually predominated until by the 16th cent. it was the standard type of representation throughout European art. (The opposing vice of this type of Charity, sometimes represented in 14th cent. Italian painting, is Cruelty (*Crudelitas*) who attacks a child.) In later versions there are clustered round the mother figure three or four infants, one of whom is usually at the breast. Though the Counter-Reformation continued to uphold the dual aspect of *amor*, this strictly human image of Charity remained the acceptable form. From the early 16th cent. a motif with a similar meaning, the PELICAN feeding its young with its own blood, became a common attribute of Charity.

Charlemagne (c. 742–814). Son of Pépin 'the Short' and king of the Franks. In a series of wars, undertaken as a Christian crusade, he greatly extended and strengthened the Frankish kingdom. As the founder of the Holy Roman Empire he was crowned in Rome by Pope Leo III on Christmas Day in the year 800. He was a considerable patron of learning and its ancillary arts. But, for all this,

Charlemagne's own place in Christian iconography is small. As a devotional figure he may stand beside CONSTANTINE THE GREAT. He generally wears armour and over it a cloak lined with ermine, sometimes ornamented with the fleurs-de-lys of the French kings; on his head is the imperial crown. He holds the orb and sceptre, or perhaps a book, or a model of a cathedral (Aix-la-Chapelle, where his remains lie).

The Mass of St Giles. Legend tells that an unconfessed sin of Charlemagne (said to have been an incestuous relationship with his sister) was brought to light in the following manner. One day St GILES was celebrating Mass in the presence of the emperor when an angel appeared above the altar bearing a scroll on which the sin was written. Charlemagne then confessed and was given absolution by the saint. (Master of St Giles, Nat. Gall. London.)

Charles Borromeo (1538–84). The son of an aristocratic family of Lombardy who became a cardinal at the age of twenty-two, and later archbishop of Milan. He vigorously applied the reforms called for by the Council of Trent, and in so doing aroused some opposition. An attempt was even made on his life. His way of life was frugal; he distributed his wealth to the poor and cared for the sick, notably during the plague in Milan in 1576. He was canonized in 1610. St Charles is one of the most widely represented figures in Counter-Reformation art, especially in Italy where many churches are dedicated to him. His features are distinctive: an aquiline nose, dark skin and high forehead. He is normally beardless. He may wear the robes of a cardinal or bishop, or simply a cassock and perhaps biretta. His attributes are a CRUCIFIX and SKULL. He sometimes wears the ROPE of the penitent round his neck. He is depicted in the customary scenes of Counter-Reformation art: kneeling at prayer surrounded by angels, or presented to the Saviour by the Virgin Mary. In a Sacra Conversazione he may figure with AMBROSE, one of the patron saints of Milan, his friend PHILIP NERI, or FRANCES OF ROME who in the previous century had worked, like him, among the plague-stricken. The commonest scene shows St Charles in the streets of Milan among the dying and the dead. He may be seen holding in his arms an infant whose father kneels before him and whose mother lies dead; or distributing clothes or administering the sacrament.

Charon. In Greek mythology the boatman who ferried the souls of the dead across the river Styx to Hades. He is old, bearded and filthy, and propels his skiff with a pole. In it are one or more small, sometimes winged, figures. Other souls wait their turn on the bank. MERCURY, who guided the dead to Hades, may stand beside a soul who is about to embark. On the further shore may be seen Centaurs, dragons, harpies (birds with women's faces) and other infernal monsters. See also ACHILLES (1); AENEAS (8); FLIGHT INTO EGYPT (he ferries the Holy Family); HELL; LAST JUDGEMENT.

Chastity (Lat. *Castitas*). A virtue having both religious and secular aspects. In Gothic church sculpture Chastity wears a VEIL, and may hold a PALM as a reminder of the virgin martyrs. Her shield may bear a PHOENIX. She is opposed by LUST, who holds a sceptre and a mirror or is embraced by a man. Or she tramples underfoot a boar or pig, the symbol of Lust. In Renaissance art Chastity may have a pair of turtle DOVES, normally the attribute of Venus, but here an allusion to the belief that, once separated, these birds never took another mate. A SIEVE refers to the legend of the Vestal virgin TUCCIA. The virtues of chastity, POVERTY and OBEDIENCE form the three vows of the monastic Orders and are therefore sometimes represented together, in particular in Franciscan art. A fresco in the lower church at Assisi, once attributed to Giotto, shows Chastity at prayer in a

square TOWER defended by angelic figures representing Purity and Fortitude. The tower as a symbol of chastity occurs also in the legends of BARBARA and DANAË. In secular allegory chastity is represented by the goddess DIANA, the virgin huntress; or by a female figure with upraised arms from which bushes sprout, from the story of the nymph Daphne who escaped amorous pursuit of APOLLO (9) by changing into a laurel bush. Chastity may be depicted binding Love, in the form of Cupid; or in combat with Love. In the latter theme the arrows from Love's bow are deflected and broken by Chastity's shield. See also UNICORN; TRIUMPH; THREE GRACES.

Chasuble. The priest's outer vestment, worn when celebrating Mass. In essence it is a circular cloak with a hole for the head. It may be of various colours, is embroidered, often in gold (orphrey), and usually has a cross on the back. It is worn by IGNATIUS OF LOYOLA over the black Jesuit habit; MARTIN of Tours; PHILIP NERI; THOMAS BECKET and, in general, in representations of the celebration of Mass. The Virgin is depicted robing ILDEFONSO in a chasuble. (See RELIGIOUS DRESS.)

Cherry. The 'Fruit of Paradise', held in the hand of the infant Christ, VIRGIN MARY (13).

Cherub, see ANGEL.

Chest. Treasure-chest opened, containing heart, ANTONY OF PADUA. Woman placing coin in chest in Temple, WIDOW'S MITE.

Chiara, see CLARE.

Child, see INFANT.

Chimaera, see BELLEROPHON.

Chi-rho monogram. The monogram formed by the Greek letters *chi* and *rho* (X and P), the first two letters of the name of Christ, was adopted by early Christians as a symbol of Christianity and was very commonly found in primitive Christian art from the 4th cent. on sarcophagi, eucharistic vessels and lamps. The letters *alpha* and *omega* (see A AND ω) often formed part of the same monogram. By itself it had already long existed as an abbreviation of the Greek word *chrēstos* (auspicious), used as a symbol of good omen, and it was probably in this sense that it was adopted by the Emperor Constantine on the Roman imperial standard, as shown on contemporary coins. The sign that, according to his biographers, appeared in a vision, or dream, to Constantine on the eve of the battle against Maxentius at Saxa Rubra in 312 came to be traditionally regarded as the *chi-rho* monogram (see CONSTANTINE THE GREAT). There is no historical proof that the emperor used it with any specifically Christian intent.

Chi-rho
monogram

Chiron, a Centaur, see ACHILLES (2); APOLLO (10).

Chosroes II, king of Persia, see TRUE CROSS, HISTORY OF THE (5).

Christ at supper with Simon the Pharisee, see MARY MAGDALENE (1).

Christ bearing the Cross, see ROAD TO CALVARY.

Christ blessing little children (Matt. 19:13–15; Mark 10:13–16; Luke 18:15–17). 'Suffer the little children to come unto me, and forbid them not'. The words were provoked by the disciples' attempt to turn away those who brought their children to Christ to be blessed. The Saviour is depicted laying his hand on the head of a small child who may be standing or kneeling beside him. Other children cluster round. Mothers, holding infants in their arms, look on. Fathers too may be present. Two or three of the apostles, usually Peter and perhaps also James and John, watch disapprovingly. The theme is with few exceptions confined to

the art of northern Europe where it was first popularized in the 16th cent. by Lucas Cranach and his studio. It is afterwards often found in the work of painters of the Spanish Netherlands. According to one authority the sudden flowering of the theme arose from the friendship between Cranach and Luther, and reflects the painter's support of the religious reformer in his controversy with the Anabaptists. On the grounds that infants were incapable of faith this sect denied the validity of infant baptism, a doctrine which Luther however strongly upheld, and which the passage from the gospels may also be said to support. The theme is sometimes a vehicle for family portraiture, in contemporary dress, and may then commemorate a baptism or a confirmation.

Christ driving the money-changers from the Temple, see CLEANSING OF THE TEMPLE.

Christ in the house of Martha and Mary, see MARY MAGDALENE (2).

Christ stripped of his garments. One of the final scenes preceding the crucifixion itself. It is not mentioned specifically by the evangelists but is implied by the references to the soldiers casting lots for the Saviour's clothes. He stands before the cross while one or more of his executioners tear off his garments, generally with some violence. The subject was used to decorate the sacristy, or robing-room, of a church. Its sequel, more rarely depicted, shows the Virgin binding a loin-cloth round the Saviour's naked body.

Christ taking leave of his mother. It is related in the *Meditations on the Life of Christ* by Giovanni de Caulibus (Pseudo-Bonaventura), how Christ bade his mother farewell at the village of Bethany before entering Jerusalem for the last time. The theme occurs first at the end of the Middle Ages and features particularly in German painting of the 16th cent. The weeping Virgin kneels before her Son. She is sometimes accompanied by the Holy Women. St Peter may be present. Another version, somewhat rarer and generally of later date, depicts Christ on his knees before his mother.

Christ walking on the waves ('Navicella') (Matt. 14:22–33). The disciples were alone in a boat on the Sea of Galilee, Christ having sent them on ahead while he went up into the hills to pray. A storm arose and in the early hours of the day they saw the figure of the Saviour walking towards them on the water. They were terrified, thinking that he was a ghost. By way of establishing Christ's identity Peter called to him and stepped out of the boat to walk to him. But he soon began to sink. Christ caught hold of him, uttering the words, 'O thou of little faith, wherefore didst thou doubt?' We see Christ standing on the water a little way from the shore, reaching out a hand to Peter who is partly submerged. In the background are the other disciples in a boat. It is not unusual for the sea to be calm, even reflecting in its surface the figures and the boat. The treatment sometimes resembles the MIRACULOUS DRAUGHT OF FISHES, in one version of which Peter is likewise seen having stepped from a boat into the water to approach Christ. In that instance however Christ is standing on the shore, not on the water. The theme of the boat protected by Christ was taken as a symbol of the Church, the means through which man achieved salvation. (See also SHIP.)

Christ washing the disciples' feet, see PETER, apostle (3).

Christina. Early Christian martyr whose record is wholly legendary. The daughter of a Roman nobleman and a convert to Christianity, she took the gold and silver idols belonging to her father, broke them up, and distributed them to the poor. He had her scourged and thrown into prison where angels came to comfort her. She was thrown into Lake Bolsena with a millstone round her neck, but miraculously floated on the surface. After further tortures she was tied to a

pillar and died by the executioners' arrows. Christina features in Renaissance painting of northern Italy, especially Venetian, and at Bolsena where the cathedral is dedicated to her. Her principal attribute is a MILLSTONE. She may, like Ursula, hold an ARROW. Narrative scenes depict her various ordeals and her execution.

'Christofori Sancti . . .', see CHRISTOPHER.

Christopher. Former Christian saint and martyr. He was removed from the Catholic Church Calendar in 1969 because of his doubtful historicity. (In the 16th cent. the Council of Trent had tried unsuccessfully to abolish his cult.) In art he is nearly always represented in the same scene, carrying the infant Christ on his shoulders across a river. The popular version of his story, in the *Golden Legend*, describes him as a Canaanite of huge stature who sought to serve only the most powerful person in the land. His first master, a king, failed him when Christopher discovered that he went in fear of Satan. He accordingly left him to serve the devil whom, in turn, he deserted when he saw him trembling before the cross. Thereafter Christopher served Christ and, guided by a hermit, devoted himself to carrying the poor and weak across a river. One night he carried a small child who grew heavier and heavier with each step he took. The child revealed that he was Christ and told the saint that he had therefore been carrying the weight of the world upon his shoulders. As a sign, he told Christopher to plant his staff (a palm-tree) in the ground, and next day, like Aaron's rod, it blossomed and bore fruit. The legend also tells how Christopher was shut up with two harlots whose task was, by seducing him, to make him renounce his Christian faith. As with the philosophers of CATHERINE OF ALEXANDRIA, the opposite happened and they were themselves converted. At his martyrdom forty archers failed to harm him, their arrows being miraculously deflected, one of them returning to strike his persecutor, the king of Lycia, in the eye. He was finally beheaded. Christopher is usually bearded, has somewhat Petrine features, and his staff is generally a palm-tree, bearing bunches of dates. A curious tradition in the eastern Church depicts him with a dog's head, possibly from a faulty transcription of 'cananeus' (Canaanite) into 'canineus' (canine). As Christopher wades through the water, the hermit is seen standing on the further bank beside a chapel, a lantern in his hand. Christopher's name in Greek means 'Christ-bearer'. His inscription is 'Christofori sancti speciem quicumque tuetur illo namque die nullo langore tenetur' – 'Whoever looks on the figure of St Christopher will assuredly on that day be overcome by no faintness'. Accordingly, in places where his cult existed, his image was made very large, often on the outside walls of buildings, in order to be visible at a distance – hence the origin of his great size. He was for long the patron saint of travellers.

Christ's charge to Peter, see PETER, apostle (2).

Ciborium, see PYX.

Cicero, personification of Rhetoric, one of the SEVEN LIBERAL ARTS.

'Ciceronianus es', see JEROME (2).

Cimon and Iphigenia (Boccaccio, *Decameron*, 5:1). Cimon, the son of a nobleman of Cyprus, a handsome youth though coarse and unlettered, fell in love with the maiden Iphigenia, and after several turns of fortune, married her. The effects of love were wholly beneficial to his nature, changing him into an accomplished and polished gallant. This moral allegory was popular with 17th cent. Netherlandish painters who depict the moment that Cimon first sets eyes on Iphigenia. She lies asleep beside a fountain in a setting of meadow and woodland. He, clad in rough peasant clothes, stands quietly gazing at her. (Rubens, Kunsthistorisches Mus., Vienna.)

Cimon and Pero, see ROMAN CHARITY.

Cincinnatus called from the plough (Livy 3:26). A Roman of the time of the early republic, remembered for having combined public service and valour in arms with an exceptionally modest way of life. After serving as consul he retired to a small farm near the Tiber, but later, at a time of crisis, was recalled to assume temporary dictatorship. He held office for fifteen days and then returned once more to the land. This example of ancient Roman virtue is found in 17th and 18th cent. painting, especially Italian. Cincinnatus, dressed like a peasant, with his plough and team of oxen, watches the approach of a mission from the city. They are Roman soldiers, some on horseback and carrying standards. Their leader offers a sword or baton to Cincinnatus (Tiepolo, Hermitage, Leningrad).

Circe. A sorceress whom ULYSSES encountered on his wanderings. In the *Odyssey* (Bk 10) Homer tells how the Greek hero and his companions came to Circe's island on their journey home after the Trojan war. It was her way with travellers to feast them on viands containing a magic potion which turned them into pigs. This was the fate of some of Ulysses' companions. But he himself, forewarned by Mercury, ate a herbal antidote with the help of which he overcame the sorceress. He then forced her to restore his men to their normal shape. Circe is seen in her palace surrounded by various domestic animals. She is attended by her maidens who may be driving pigs away to the sties. Men, half-transformed, recline on the floor. Ulysses may stand before Circe, with Mercury at his elbow, taking a bowl of soup from her. Or he forces her submission with a drawn sword. Circe usually carries a magician's wand.

Circle, see TEMPLE.

Circumcision of Christ (Luke 2:21). When the infant Christ was a week old 'the time came to circumcise him, and he was given the name of Jesus'. The operation was required by Mosaic law as a token of the Covenant, and might be performed by the parents or by a priest of the Temple specially allocated to the task. Luke does not relate the circumstances but Christian art always sets the scene in the Temple. The infant is usually held in the arms of Mary, while beside her stands the priest, in his hand a knife which he has taken from a tray held by an acolyte. Joseph may be present. To the medieval Church the event was significant as the first occasion on which the Redeemer's blood was shed. The theme occurs in Italian Renaissance painting, and enjoyed a revival in the art of the Counter-Reformation in Jesuit churches. The Society of Jesus, for whom the Saviour's name had a special sanctity, laid emphasis on the Feast of the Circumcision because of the association of the rite with the naming of the Infant.

Clare (Ital. Chiara) (*c.* 1194–1253). Christian saint and founder of the Order of Poor Clares, born in Assisi. Clare came of noble parentage and as a young woman was received into the Franciscan Order, much against the will of her family who wished her to marry. Her austere way of life exemplified the Franciscan ideal of poverty and dependence on alms. She wears the grey habit of her Order with a knotted girdle like the friars, and a white coif usually covered by a black veil (see diag. RELIGIOUS DRESS). She usually holds a MONSTRANCE in allusion to her repulsion of the Saracens (see below). Alternatively she may like other female saints hold a LILY or a CROSS, especially in earlier representations, or, as founder of her Order, a CROZIER. In devotional pictures of the Virgin she may be accompanied by FRANCIS OF ASSISI, or by CATHERINE OF ALEXANDRIA (symbolizing respectively piety and wisdom), or by MARY MAGDALENE (piety and penitence).

1. *St Clare received by St Francis.* On fleeing from her family Clare put herself in the care of St Francis. She is seen making confession at his feet.

2. *St Clare repulsing the Saracens.* The *Golden Legend* tells how Clare succeeded in turning away the Saracens when they attacked Assisi. She rose from her sick bed in the convent of San Damiano, carrying in her hands a pyx, a receptacle for the Host. The sacred contents overcame the invaders and they fled. Instead of a pyx artists generally depict a MONSTRANCE (see diag.). The soldiers tumble off their scaling ladders while Clare stands above with her nuns.

3. *The death of St Clare.* She lies on a bed surrounded by nuns and by various female martyrs. Christ and the Virgin appear as in a vision, or the Virgin may hold her head.

Claudia (*Fasti* 4:291–348). In Roman legend a VESTAL VIRGIN who was accused of unchastity but proved her innocence by performing a miracle. A ship, bearing the sacred stone image of the goddess CYBELE, the 'Great Mother', from Pergamum to Rome, had stuck fast in the mud at the mouth of the Tiber. The Vestal Claudia Quinta, who was rumoured to be an adulteress, having first called on the mother goddess to witness her innocence, tied her girdle to the prow and proceeded to draw the boat up the river. She is seen pulling the boat while elders look on in astonishment. As an allegorical figure Claudia, holding a boat in her hands, stands for Confidence, or Trust. (Montagna, Ashmolean, Oxford.)

Cleansing of the Temple ('Christ driving the money-changers from the Temple') (Matt. 21:12–13; Mark 11:15–18; Luke 19:45–46; John 2:14–17). The sight of the Temple in Jerusalem turned into a market place by money-changers and by traders in cattle, sheep and pigeons provoked the famous outburst, 'Jesus made a whip of cords and drove them out of the Temple.' In the centre stands Christ brandishing a makeshift whip of bunched cords. Those around him are fending off the blows, others make for the doors, driving the animals before them and overturning tables and benches in the general confusion. The money-changers attempt to gather up their money or are clutching their purses. A woman picks up a basket of pigeons. According to Matthew the episode took place in the Temple precincts but it is customary to represent the interior. Only John mentions the whip. The beasts were sold as sacrificial animals, the sheep and oxen for the rich, the pigeons for the poor. (cf PRESENTATION IN THE TEMPLE where Joseph's offering of pigeons is a sign of his poverty; also Lev. 12:8.) Christ's outburst was the kind of dramatic act that invites a symbolic interpretation, the more so since it was untypical of him. The Middle Ages saw it prefigured in the mysterious horseman who had driven HELIODORUS from the same Temple a few centuries earlier. Renaissance humanists found a pagan prefiguration of it in the fifth labour of HERCULES, the cleansing of the Augean stables. To the Reformation the theme symbolized Luther's condemnation of the sale of papal indulgences.

Clement. (*fl.* end 1st cent.) Early pope and the first of the Apostolic Fathers, that is, one believed to have had personal contact with the apostles themselves. Legend tells that, for refusing to renounce his faith, he was banished to work in marble quarries in the Crimea; here he once quenched the thirst of his companions, like Moses, by striking a rock thereby causing water to flow from it, having been led to the spot by a lamb. On another occasion his persecutors tied an anchor to his neck and cast him into the sea. The waters receded to reveal a temple wherein was found Clement's body. The phenomenon of the receding waters was said to recur annually, and the site became a place of pilgrimage. A woman who left her child behind one year returned the next to find it safe

and well, sleeping in the temple. These themes are the subjects of paintings of the early Italian Renaissance. As a devotional figure Clement is dressed in pontifical robes and wears a TIARA. He may be accompanied by a LAMB. His normal attribute is the ANCHOR; he leans on it or it hangs round his neck. The anchor was probably originally associated with Clement simply as the regular Christian symbol of steadfastness and hope, the legend being invented later to explain the association. Many English churches are dedicated to the saint, among them the parish church of St Clement Danes in London whose coat of arms includes an anchor.

Cleobis and Bito (Herodotus 1:31). Cleobis and Bito were brothers, renowned for their strength. One day they yoked themselves to their mother's chariot, when there happened to be no oxen, and pulled her to the temple of Juno at Argos, where she was priestess. It was a great distance and when they arrived they lay down in the temple exhausted. Their mother prayed to the goddess to grant them what was best for mortals and they immediately fell asleep, never to reawaken. Cleobis and Bito are represented in art, especially in 17th cent. France, as an example of filial devotion. They are shown arriving with their mother, watched by an admiring throng, before a temple where the priest and his attendants are making ready a sacrifice (Galerie François Ier, Fontainebleau). Their statues have been unearthed at Delphi.

Cleopatra (68–30 B.C.). Queen of Egypt, one of several of the same name, famous for her beauty, intellect and the extravagance of her hospitality, much of it doubtless romantic legend. As for her liaison with Mark Antony, the Roman statesman and war leader, it is legend rather than historical fact that is commemorated in painting.

1. *Cleopatra's banquet*. The story goes that Antony, invited to a banquet by the queen, expressed surprise at its magnificence. In reply, Cleopatra removed a priceless pearl ear-drop, and dissolved it in her glass of wine which she then drank, showing by this ostentatious gesture her indifference to riches. The scene, as shown for example in Tiepolo's frescoes in the Palazzo Labia, Venice, is Cleopatra's palace. She sits at a table with Antony, and sometimes with his companion Enobarbus, the 'red-bearded.' Between her finger and thumb she holds a pearl, poised over a goblet; or she is about to drink. Servants go to and fro carrying food and drink. Courtiers sit at other tables.

2. *Cleopatra and Octavian*. The defeat of Antony and Cleopatra by the fleet of Octavian (Augustus) at the battle of Actium was followed by the latter's invasion of Egypt. Antony's forces were again beaten and he committed suicide. According to Plutarch (44:83) Octavian visited Cleopatra to comfort her, on which occasion she gave him a list of her treasures. He is depicted, accompanied by his aides, receiving a paper from the hand of Cleopatra.

3. *The death of Cleopatra* (Plutarch 44:86). Cleopatra, rather than accept defeat, took her own life, it is said from the bite of a cobra. This favourite theme, much in evidence in 17th cent. Italian painting, shows her seated, or lying on a couch, holding an asp to her bared breast, her attendants around her. Some artists follow Plutarch: 'They saw her stone dead, lying upon a bed of gold, set out in all her royal ornaments. Iras, one of her women, lay dying at her feet, and Charmion, just ready to fall, scarce able to hold up her head, was adjusting her mistress' diadem.' The basket of figs in which the snake was said to be concealed, may also be seen.

Clio, see MUSES.

Cloak. Warrior, with horse, dividing his cloak with a sword, MARTIN of Tours.

The Virgin's outspread cloak sheltering supplicants, VIRGIN MARY (3). Hat and cloak are the dress of the PILGRIM. Cloak lined with ermine, CHARLEMAGNE, URSULA and others. A fur-lined cloak is, in general, an indication of rank.

Clock. Attribute of TEMPERANCE personified. In portraiture, an allusion to the sitter's temperate nature. In a 'Vanitas' picture, the symbol of the passing of time, see STILL LIFE.

Cloelia (Livy 2:13; Plutarch 6:19). One of ten daughters who, with ten sons, of patrician Roman families, were given as hostages to Lars Porsena, the Etruscan king of Clusium, as a token of good faith following the conclusion of a treaty between Rome and the Etruscans. Cloelia escaped to Rome by re-crossing the Tiber on horseback, persuading her female companions to swim after her. The girls were sent back by the Romans but Porsena, in admiration of Cloelia's courage, presented her with a horse, and restored her freedom together with that of some of her companions. She ranks with the other Roman heroes of the campaign against Porsena, HORATIUS COCLES and MUCIUS SCAEVOLA, whose feats were commemorated by Renaissance and baroque artists. She is depicted making her escape on horseback, perhaps about to enter the water while her companions undress on the river bank. A single female figure seated on a horse that breasts the waves is likely to be Cloelia rather than a marine deity. The theme is common in Italy and northern Europe.

Clorinda, see OLINDO AND SOPHRONIA; TANCRED AND C.

Cloth, bearing an image of Christ's head, VERONICA. Blood-stained cloth (a tunic), presented to patriarch, JOSEPH, son of Jacob (1).

Clotho, one of the THREE FATES.

Clovis, baptism of, see REMIGIUS.

Club. Attribute of HERCULES and hence of FORTITUDE personified. THESEUS, victorious over the Minotaur, holds a club. As an instrument of martyrdom it is the attribute of JUDE and JAMES THE LESS (a fuller's club); as a weapon, of the WILD MAN.

Clymene, mother of PHAETHON.

Clytemnestra, see LEDA.

Clytie, see SUNFLOWER; FLORA (2).

Cock. Attribute of PETER, apostle, an allusion to his denial and repentance; of MERCURY, whose chariot they draw; of LUST personified.

Coffer, see CHEST.

Coffin. Drusiana restored to life, rising up in her coffin, JOHN THE EVANGELIST (3). Lazarus sometimes rises from a coffin (RAISING OF LAZARUS). Three open coffins containing corpses, observed by three princes, DEATH (2).

Coins, on table, tax-gatherer seated, Christ and others standing, MATTHEW: *Calling of M.* Christ with Pharisee holding coin, TRIBUTE MONEY (1). A coin drawn from fish's mouth, TRIBUTE MONEY (2). Coins offered to high priest, or thrown down, JUDAS ISCARIOT (1). Coins on a dish, attribute of LAURENCE; at the feet of old, unkempt hermit, ONUPHRIUS. An old man counting money, AGES OF MAN. Coins, a symbolic element in the 'Vanitas' theme, STILL LIFE; an attribute of VANITY personified. The theme of 'mercenary love', in German painting, shows a young man receiving money, unknown to an old lecher who is occupied with a young woman. The golden rain descending on DANAË may resemble coins.

Columbine, literally 'like a dove'; the flower of the genus Aquilegia, so named because the shape of the flower was thought to resemble doves in flight. Hence it is a symbol of the Holy Ghost. There are generally seven blooms which symbolize

the 'Seven Gifts of the Holy Spirit' (see DOVE). The columbine was not used as a Christian symbol after the 16th cent.

Column, see PILLAR.

Comb, the kind used by wool-carders, attribute of BLAISE (bishop); the same, on the ground, near LAURENCE, at his scourging. See also HONEY-COMB.

Combatants. The muscular hero at grips with a human adversary is most often HERCULES. He fights Geryon, who has three bodies on one pair of legs (10); the fire-breathing giant Cacus (15); Antaeus whom he seizes round the waist (16); the river god Achelous (22); the unfortunate messenger Lichas whom he flings into the sea (24). He also struggles with APOLLO (6) for possession of a tripod.

Comb

'Cominus et eminus,' see PORCUPINE.

Communion. In religious art one of the SEVEN SACRAMENTS, that which commemorates the LAST SUPPER. Among those depicted receiving their last communion are the dying FRANCIS OF ASSISSI, JEROME, MARY MAGDALENE and the Virgin Mary (see DEATH OF THE VIRGIN). The hermit ONUPHRIUS receives communion from an angel; MARY OF EGYPT from the hermit Zosimus in the desert.

Communion of the Apostles, see LAST SUPPER; SEVEN SACRAMENTS.

Compasses, or 'dividers', an instrument for measuring length, the attribute of numerous abstract personifications: Astronomy, one of the SEVEN LIBERAL ARTS, and Urania, the MUSE of astronomy (crowned with stars, holding a globe); Geometry, another of the Liberal Arts, and Euclid, its historical representative; JUSTICE (with scales and sword); Maturity, one of the AGES OF MAN; Melancholy (books, skull, other geometrical instruments), one of the FOUR TEMPERAMENTS; PRUDENCE (snake, mirror). Dividers held by the sitter in a portrait identify him as an architect or navigator. In Renaissance and baroque themes they may denote an artist (from his command of geometry and perspective). See also CREATION.

Concord. One of the minor virtues, represented in Gothic sculpture as a woman with an OLIVE branch on her shield. She is opposed by the vice of Discord, a scene of domestic strife. In later periods Concord appears in works celebrating affairs of state, such as an end of war. She has a CORNUCOPIA (the plenty that peace will bring). Two DOVES facing each other allude to the peaceful intentions of the two sides. A bundle of ARROWS, like the fasces, signifies the strength that comes from unity, or concord. A bound sheaf of CORN has the same meaning.

Confession, one of the SEVEN SACRAMENTS (Penance).

Confirmation, one of the SEVEN SACRAMENTS.

'Consequitur quodcunque petit,' see SPEAR.

Constancy. A minor virtue, found more often on Renaissance medals and on funerary sculpture, represented as a woman in a militant attitude holding a raised SPEAR (occasionally a SWORD), and leaning against a PILLAR (her steadfastness). More rarely she has a brazier, an allusion to the constancy of MUCIUS SCAEVOLA.

Constantine the Great (*c.* 280–337). Roman emperor, the son of HELENA. He came to overall power in 312 after defeating the Emperor Maxentius at the battle of the Milvian bridge on the Tiber, an event traditionally regarded as the turning point in the establishment of Christianity within the empire. According to Eusebius' Life of Constantine (1:27–32), on the eve of the battle Constantine saw in a dream a cross in the sky, and heard a voice saying, 'In hoc signo vinces,' – 'By this sign shalt thou conquer.' Henceforth, it is said, he substituted the emblem

for the Roman eagle on the standard, or labarum, of the legions. On coins of his reign there is represented a CHI-RHO MONOGRAM. (For Constantine's baptism, see SYLVESTER.) Constantine is dressed as a Roman emperor or soldier. He wears a CROWN and holds a SCEPTRE or, more often, the labarum. As a standing figure he may be accompanied by his mother Helena or by CHARLEMAGNE, the first of the Holy Roman Emperors. In Byzantine mosaics he presents a model of the city of Constantinople to Christ.

1. *The dream of Constantine.* He lies asleep in his tent guarded by soldiers. It is the eve of his battle with Maxentius. The angel that foretold his victory descends from above.

2. *The battle of the Milvian bridge*, or *Saxa Rubra* (red rocks). The raised standards of the Roman soldiers carry a cross or the *chi-rho* monogram. Constantine on a white horse confronts Maxentius with upraised spear, among a mêlée of soldiers. Maxentius, also on horseback, may turn as if to flee from the sign of the cross. The dead and dying are trampled under the horses' hooves, or collapse into the river.

3. *The donation of Constantine.* It was claimed that one of Constantine's acts as emperor was to donate to Pope Sylvester and his successors the territory of central Italy and to grant him primacy over all other bishops. The document by which this transfer was effected was proved to be a forgery by Lorenzo Valla, a 15th cent. Italian scholar. Sylvester, enthroned and in pontifical robes, is seen receiving the gift of the Roman lands from the emperor who kneels before him.

Contumacia, Rebellion personified, see OBEDIENCE.

Cope. A cloak; the outer vestment, worn principally, in the Roman Church, by the celebrant at Masses and in processions. In art it is one of the main identifying vestments of the bishop. It is generally richly ornamented. The vertical embroidered bands at the front and round the collar, called the orphrey, from the use of gold thread, may be woven with cycles of scenes from the gospels or lives of the Virgin or saints. A vestigial hood is attached to the collar. The cope is fastened at the front with a heavily jewelled clasp, the morse. (See diag. RELIGIOUS DRESS.)

Coral. According to Ovid (*Met.* 4:740 ff) coral was a kind of petrified seaweed, formed at the instant that Perseus laid down the Gorgon's head, after rescuing Andromeda from the sea-monster. (See PERSEUS, 1, 2.) The Mediterranean red coral, used for ornament, was believed by the Romans and the Middle Ages to have healing properties and the power of averting the attentions of the 'evil eye'. It was often hung round children's necks as a protection. It is seen in this sense, usually as a string of beads, in pictures of the Virgin and Child. A necklace of coral is an attribute of Africa personified, one of the FOUR PARTS OF THE WORLD.

Coriolanus ('Volumnia with her sons before Coriolanus') (Livy 2:40; Plutarch 12: 34–6). A Roman general, banished from Rome in 491 B.C., he joined the Volsci, a neighbouring people against whom he had earlier campaigned. Put in command of their forces, he returned to assault his native city. He was met by his wife with their two small sons and by his mother. They successfully pleaded with him to call off the attack. On his return to the Volsci he was put to death as a traitor. (Note: Coriolanus' wife and mother are named Volumnia and Veturia respectively by Livy; but Vergilia and Volumnia by Plutarch, whom Shakespeare follows in this respect. In the naming of pictures Livy is generally followed.) As a moral example of the strength of family ties the theme was popularized in Italian Renaissance painting where it is found fittingly on the panels of the bride's marriage chest (*cassone*) and elsewhere. It is also common in the baroque art of Italy and northern Europe. Coriolanus, in armour and flanked by aides, stands

before the kneeling figure of his wife Volumnia who is accompanied by their children and perhaps by other women among whom is his mother.

Corisca and the Satyr. An incident in the pastoral play, *Il Pastor Fido* (2:6), 'The Faithful Shepherd' (1589), by the Italian poet Guarini. Corisca, a nymph, is captured by a Satyr who accuses her of unfaithfulness. Though he clutches her firmly by the hair she still succeeds in escaping: 'Thy looks and speeches falsifièd were/But thou must likewise falsify thy hair?' (R. Fanshawe, 1647). The theme is found in Italian baroque painting. The nymph flees, leaving her wig in the Satyr's hands.

Corn. The attribute of CERES, the classical goddess of agriculture. She is crowned with ears of corn and may hold a sheaf. In this and in some other respects she resembles Summer personified, one of the FOUR SEASONS; likewise ABUNDANCE. A sheaf of corn with a ploughshare, is the attribute of the Silver Age personified, one of the AGES OF THE WORLD; a bound sheaf, of CONCORD. In religious art corn and the vine together symbolize the eucharistic elements, as in pictures of the Virgin and Child (VIRGIN MARY, 13). Cain's offering to God was a sheaf of corn (CAIN AND ABEL). Joseph and Pharaoh both dreamed about corn (JOSEPH, son of Jacob, 1 and 3). See also HARVEST.

Cornelia. Daughter of the Roman general Scipio Africanus Major, and wife of Tiberius Sempronius Gracchus. Her two sons, Tiberius and Gaius, known as the Gracchi, also held important public office. It was told of Cornelia (Valerius Maximus 4:4), who was a woman noted for her virtue and abilities, that she was once visited by a Roman matron who ostentatiously showed off her jewellery. When she asked to see Cornelia's, the latter produced her two young sons, saying, 'These are my jewels.' The theme occurs in Italian baroque painting and shows two women, both richly attired. One has jewels on a table beside her, the other has two children to whom she may be pointing.

Cornelius, centurion, baptized by PETER, apostle (10).

Cornucopia, the horn of plenty. A large horn, its mouth overflowing with the earth's fruits, is the attribute of many virtues, beneficent personifications and gods and goddesses. According to Ovid (*Fasti* 5:121–4) the cornucopia had its origin in the horn of the goat Amalthea that suckled the infant JUPITER (1), or alternatively (*Met.* 9:85–92) in that of the river god Achelous, broken off in his fight with HERCULES (22). Its true origin is probably to be found in the ancient belief that power and fertility resided in the goat's or bull's horn. A cornucopia is the attribute of CERES, goddess of agriculture, of ABUNDANCE, and of Earth, one of the FOUR ELEMENTS, whom the goddess sometimes personifies. It is the attribute of Autumn, one of the FOUR SEASONS, who is sometimes personified by BACCHUS, and from antiquity of the PUTTO; also of the allegorical figures of PEACE, CONCORD and FORTUNE. The cornucopia of Fortune features on Renaissance medals to celebrate an occasion of public rejoicing. It is the attribute of HOSPITALITY who holds out her hand to a pilgrim; of Europe, one of the FOUR PARTS OF THE WORLD, also occasionally of Africa; and of the Cimmerian SIBYL. Zephyr, the West Wind, wed to FLORA, scatters flowers from a cornucopia. An old woman and a naked goddess with a cornucopia under a tree are VERTUMNUS AND POMONA.

Coronation of the Virgin. The subject forms either the final and culminating scene in the narrative cycle of the life of the Virgin when it follows the DEATH OF THE VIRGIN and her ASSUMPTION, or, more usually, it portrays her as a devotional, non-narrative figure, the personification of the Church itself. The latter type of Coronation originated in Gothic art of the 13th cent. and is seen particularly

in the sculptured portals of French cathedrals. It occurs later in paintings made for the altars of churches dedicated to the Virgin or belonging to the monastic Orders under her tutelage. Its most usual form shows the Virgin seated beside Christ who is in the act of placing a crown on her head. She may alternatively be kneeling before him. Or she may be crowned by God the Father, a common type in 15th cent. Italian painting, or by the Trinity. In the last instance Christ, God the Father and the dove, the symbol of the Holy Ghost, are all present, the crown usually being placed on her head by Christ. Christ may hold in one hand a book inscribed 'Veni, electa mea, et ponam te in thronum meum,' – 'Come my chosen one, and I will place you upon my throne.' The Virgin is generally richly robed, fitting to her role as 'Regina Coeli,' Queen of Heaven. The central group is often surrounded by choirs of angels, perhaps with musical instruments. There may be many attendant figures: the patriarchs, Fathers of the Church, martyrs and other saints of Christendom. The latter, especially when accompanied by kneeling donors, have the same function as in a 'Sacra Conversazione' with the Virgin and Child. (See VIRGIN MARY, 14; ALL SAINTS PICTURE.) In the art of the Counter-Reformation the theme tended to be replaced by the Immaculate Conception. As a narrative subject it is accompanied by the scene of the apostles below, standing round the Virgin's empty tomb.

Coronis, daughter of Coroneus, see NEPTUNE (5).

Coronis, daughter of Phlegyas, see APOLLO (10).

Cosmas and Damian. Early Christian martyrs about whom little is known except that they met their deaths at Cyrrhus in northern Syria. According to legend they were physicians, twin brothers, who gave their services free to all, and who finally died for their faith during Christian persecution under the Emperor Diocletian. They were the patrons of the Medici family in Renaissance Florence, and thus feature in Florentine painting, especially of the 15th cent. Their principal role was that of protectors against sickness, the plague in particular; they therefore appear most often in votive paintings of thanksgiving, standing before the Virgin. They may be grouped with ROCH and SEBASTIAN who were likewise invoked against disease. They wear the long gown of the Renaissance physician, usually dark red and lined and edged with fur. The round cap is also red. They hold a box of ointment, a LANCET or other surgical instrument, or occasionally a PESTLE AND MORTAR. Narrative scenes are rare. They are seen performing acts of healing and undergoing their martyrdom. They once amputated a leg and grafted on to the stump the leg of a Moor; the patient recovered to find that he had one white leg and one brown (Fra Angelico, Museo di San Marco, Florence). Cosmas and Damian survived being cast into the sea, crucified and stoned. They were thrown into a fire but, like AGNES, were unharmed by the flames. They were finally beheaded.

Cow. A white heifer beside Jupiter (with eagle), Juno arriving on chariot, see IO. The same, browsing, while the cow-herd falls asleep to the sound of Mercury's pipe, MERCURY (1). Hollow wooden cow, fashioned by a carpenter, or woman climbing into, PASIPHAË. A cow led CADMUS to the site where he founded Thebes.

Crab. Cancer, the fourth sign of the zodiac, is associated with June, one of the TWELVE MONTHS. A crab bites the foot of HERCULES (2) as he fights the Lernaean hydra.

Crane, a long-legged wading bird, rather similar to the STORK. It is typically represented with one leg raised, holding a stone in its claw, see further VIGILANCE.

Creation. Of the several stages of the creation of the world the last, the making of man, is the most frequently depicted. (See ADAM AND EVE.) The subject, as a

cycle of scenes, is found in illuminated MSS of the book of Genesis and in monumental art of the 12th cent. It is more widely represented in the sculptured portals and stained-glass windows of Gothic churches. The decoration of a medieval church aimed to give a complete visual statement of the Christian universe – a microcosm of Christianity – in which the stages of the Creation took their proper place. The first two chapters of Genesis contain two accounts, varying somewhat in the order of events. In the first chapter the six days are as follows: 1st: The division of light from darkness. 2nd: The division of the waters above and below the firmament. 3rd: The creation of dry land and vegetation. 4th: The creation of the sun, moon and stars. (God may be seen placing them in the sky, sometimes with the help of angels.) 5th: The creation of birds and fishes. 6th: The creation of the animals (sometimes shown on the 5th day) and of man and woman. Throughout the cycle each act of creation is seen to be carried out by either the First or Second Person of the Trinity. The composition of the cycle may vary. Michelangelo, in the Sistine chapel, modified it and added the Fall of Man and his punishment through the Flood. God is also represented measuring the earth with a pair of compasses.

'Credo in Deum' (written in blood on ground), see PETER MARTYR.
'Credo in Deum Patrem Omnipotentem . . . ,' see PETER, apostle.
'Credo in Spiritum,' see BARTHOLOMEW.
Crescent Moon, see MOON.
Cretan bull, see Hercules (7).
Crocodile. The attribute of the warrior saint, THEODORE. See also CAIMAN.
Crocus, see FLORA (2).
Croesus and Solon (Herodotus, 1:29–33; Plutarch 5:27). Croesus, king of Lydia, whose riches were proverbial, was said to have been visited by Solon the Athenian sage. The words of Solon – that the humble, when blessed with good fortune, were happier than Croesus with all his wealth – earned the king's displeasure. (Solon illustrated his argument with the story of CLEOBIS AND BITO.) Later the Persian king Cyrus conquered Lydia and built a pyre for his vanquished foe. About to be burned alive, Croesus remembered the wisdom of Solon and thrice called out his name, which so roused the curiosity of Cyrus that he spared his victim's life. The scene is a room in Croesus' palace. The king, in royal robes and wearing an oriental turban, points with his sceptre to heaps of golden vessels and other riches. Solon, white-bearded and in contrastingly simple attire, stands beside him. In the background may be seen the sequel with Croesus on the pyre. The theme occurs in baroque painting as an allegory of the vanity of earthly riches. (F. Francken II: Louvre, Kunsthistorisches, Vienna, and elsewhere.)

Cronus, see SATURN; FATHER TIME.

Crook. The shepherd's staff, curved into a hook at one end. It is the attribute of APOLLO (8) as guardian of flocks; of PAN who likewise guarded flocks and herds; of Argus (see MERCURY, 1); of the one-eyed giant Polyphemus (see GALATEA); in religious art, of Christ the shepherd, of the shepherdess GENEVIÈVE. A crook was one of the gifts of the shepherds at Christ's Nativity (see ADORATION OF THE SHEPHERDS). See also CROZIER.

Crook

Cross. The symbol of Christ's sacrifice and, more generally, of the Christian religion. After the recognition of Christianity by Constantine the Great, and more so from the 5th cent., the cross began to be represented on sarcophagi,

lamps, caskets and other objects, taking the place of the CHI-RHO MONOGRAM, hitherto the distinctive emblem of the early Christians. In the Middle Ages its use widened. It became the mark of ecclesiastical authority, and was used by the guilds and orders of chivalry, and was borne on arms and banners. The ground-plan of churches followed its shape. It took several forms: the familiar Latin cross, the type on which, according to Augustine, Christ was crucified; the Greek cross; the St Andrew's cross, or saltire (see ANDREW); the *tau*-cross, shaped like the letter T, known in ancient Egypt, and associated with ANTONY THE GREAT. The cross has many decorative variations of these basic shapes when used for ecclesiastical ornament, often in association with inscriptions and symbolic objects. By tradition the mark made on the door-posts on the eve of the Passover (MOSES, 6) was a *tau*-cross. (See also CRUCIFIXION, 1.) The addition of the *titulus*, or inscription, above the transom of the Latin cross led to the development of the double cross, called the cross of Lorraine. This type was authorized to be borne before patriarchs (bishops of the five principal sees of medieval Christendom). A cross with a triple transom belongs exclusively to the pope. GREGORY THE GREAT and SYLVESTER, though both were popes, generally have the double cross for attribute. The cross, sometimes with a chalice, is the attribute of FAITH personified, when it may lie on a book (the Bible).

(1) *St Andrew's cross;* (2) *Latin cross;* (3) *Tau-cross;* (4) *Cross of Lorraine;* (5) *Greek cross*

The attribute of saints. A flowered cross, ANTONY OF PADUA. With the instruments of the Passion, BERNARD. With a chalice, BONAVENTURA. With a lily, CATHERINE OF SIENA. With a monstrance, CLARE. With a scroll, the prophet JEREMIAH. With the martyr's palm, MARGARET OF ANTIOCH. With a saw, SIMON ZELOTES. A cross surmounting a pomegranate, JOHN OF GOD. A processional cross carried by a deacon identifies LAURENCE; with triple transverses, or the Latin cross upturned, PETER, apostle. A cross staff, perhaps a *tau*, belongs to PHILIP, apostle; made of reeds, to JOHN THE BAPTIST. A cross is sometimes the attribute of the Hellespontic, Phrygian and Cimmerian SIBYLS.

Two burning staves crossed saltire-wise were the *impresa* of Piero de' Medici (1471–1503), with the motto 'In viridi teneras exurit medulas' – 'In youth (love) burns to the marrow.'

Narrative scenes. The cross is borne by Christ on the ROAD TO CALVARY; on the road to Rome, where he met PETER, apostle (15); and in a vision of GREGORY THE GREAT (5). The True Cross is carried by the Emperor Heraclius, riding on an ass or horse into Jerusalem; the True Cross, one of three, restores a corpse to life (TRUE CROSS, HISTORY OF THE). The True Cross, borne by angels, appears in a vision to HELENA. The shape of a cross is formed by two canes or staves held above the seated Christ (CROWNING WITH THORNS); by two sticks held by the widow Zarephath (ELIJAH, 2); by the crossed arms of Jacob blessing his grandchildren (JOSEPH, 5).

The cult of the infant Christ in the Counter-Reformation was expressed in a number of themes showing the Child in relation to the cross, as it were an anticipation of his death. He is depicted in 17th cent. painting in the Virgin's lap reaching out towards a cross borne by angels, or towards that of the infant John the Baptist. A common theme of this period, especially in Italy, shows the Infant lying asleep on a cross.

Crow. The attribute of HOPE personified. Coronis, a maiden changed into a crow, see NEPTUNE. A crow was the messenger of APOLLO (10).

Crown. The emblem of sovereignty, divine and earthly, and of the Christian martyr; the reward for accomplishment in the arts and for victory in love.

Crown, other than on the head. Christ in the act of crowning the Virgin, CORONATION OF THE VIRGIN; woman crowned by soldier, ALEXANDER THE GREAT (8); youth crowned by maiden, or vice versa, pastoral scene, MIRTILLO, CROWNING OF; laurel crown bestowed by goddess, VICTORY. Crown offered by kneeling king to woman, SEMIRAMIS; one of gold and one of thorns offered by Christ to kneeling female saint, CATHERINE OF SIENA; held in the hand of allegorical female, the MUSE Melpomene; the same, a crown of laurel, the MUSE Calliope; crown falling from the head of allegorical blindfold figure, the Synagogue personified, CRUCIFIXION (12); crown, with sceptre, lying at feet of bishop, LOUIS OF TOULOUSE; crown and armour at feet of Benedictine monk, WILLIAM of Aquitaine; crown at feet of unkempt hermit, ONUPHRIUS; at the feet of nun, BRIDGET; trodden underfoot by infant, MOSES (2); by female with lamb, HUMILITY personified. HOPE reaches out to grasp a crown. See also STILL LIFE.

Crowned heads. CHARLEMAGNE; CONSTANTINE THE GREAT; CUNEGUNDA (holding red-hot ploughshare); DAVID; Europe personified, one of the FOUR PARTS OF THE WORLD; HELENA (holding the instruments of the Passion); Henry II (CUNEGUNDA); Herod (JOHN THE BAPTIST, 6, 7, 9); IGNORANCE personified (fat, blindfold female); JUSTINA (sword piercing breast); MIDAS; Otto III (JUDGEMENT OF OTTO); PLUTO; URSULA (with arrow, wearing ermine cloak). A triple crown is the attribute of ELIZABETH OF HUNGARY (Franciscan nun). A crowned allegorical female holding a chalice personifies the Church (CRUCIFIXION, 12). A crown decorated with three heads belongs to PHILOSOPHY (with sceptre and books). Twenty-four crowned elders flank Christ enthroned (APOCALYPSE, 3; LAST JUDGEMENT, 1).

The Crown of Thorns. Worn by Christ: CROWNING WITH THORNS; ECCE HOMO; ROAD TO CALVARY; RAISING OF THE CROSS; CRUCIFIXION (1). Attribute of saints: JOSEPH OF ARIMATHAEA; LOUIS IX; MARY MAGDALENE; and of the Delphic SIBYL.

Laurel crown. The victor's award in the Pythian festival held at Delphi in Apollo's honour; in Rome, worn by the conqueror in the triumphal procession, and by emperors. Hence in art by APOLLO; HOMER (aged, blind, perhaps with violin); DANTE AND VIRGIL; ARION (riding dolphin); the poet personified (HERCULES, 21); the MUSES Calliope (epic poetry) and Clio (history); the personifications of FAME (with trumpet) and TRUTH (naked). Roman emperors and provincial governors may wear a laurel crown (PAUL, apostle, 5; and elsewhere in scenes of JUDGEMENT).

Other crowns. Flowers: FLORA; the MUSE Terpsichore (dancing and song); personifications of Asia, one of the FOUR PARTS OF THE WORLD, and of the Golden Age, one of the AGES OF THE WORLD. *Roses:* DOROTHEA. *Ears of corn:* CERES. *Reeds or rushes:* river gods (see URN). *Olive:* AGNES; PEACE. *Vine:* BACCHUS; GLUTTONY. *Feathers:* America, one of the FOUR PARTS OF THE WORLD. Turretted, mural crown: CYBELE; Earth, one of the FOUR ELEMENTS.

See also TIARA.

Crowning with Thorns (Matt. 27:27–31; Mark 15:16–20; John 19:2–3). One of the last of the series of scenes comprising the TRIAL OF CHRIST, and the prelude to the ECCE HOMO, after which Christ was led away to be crucified. According to Mark 'the soldiers took him inside the courtyard [of Pilate's house] and called together the whole company. They dressed him in purple [according to Matthew

'a scarlet mantle'], and having plaited a crown of thorns, placed it on his head. Then they began to salute him with, "Hail, King of the Jews!" They beat him about the head with a cane and spat upon him, and then knelt and paid mock homage to him.' The theme has similarities with the earlier MOCKING OF CHRIST before Caiaphas and artists sometimes combine elements from both. The earlier scene should depict Christ blindfold with his hands tied, but sometimes it also shows him holding the makeshift 'sceptre' which properly belongs only to the 'Crowning'. Christ is generally enthroned on a dais, the crown of thorns on his head, dressed in a red or purple robe and holding a reed sceptre. Soldiers with clenched fists are about to strike him or are kneeling in mock homage. A convention that prevailed widely in Italian painting of the 15th and 16th cents. shows two soldiers each holding a cane or a staff with which they press down the crown of thorns, the canes symbolically forming the shape of a cross. This common feature probably derived from the manner in which the scene was performed in medieval religious drama. As for the crown itself, southern artists tend, with greater restraint, to depict the smaller-thorned plants, in marked contrast to the huge fantastic spines of the German and Netherlandish painters. The latter may be held in a soldier's mailed gauntlet, about to be placed on the head of Christ, or it pierces his brow from which the blood trickles. An influence here may have been the writings of the 14th cent. Christian mystic St Bridget of Sweden whose *Revelations* describe the sufferings of Christ with much vivid and circumstantial detail. The theme became more widespread in Christian art from the 14th cent. from the cult of the crown of thorns as a holy relic, which dates from about this time (see LOUIS IX).

Crozier. The processional staff terminating in a cross, borne before patriarchs and archbishops, that of the former having two cross-pieces, the latter one. A pope's has three. The triple transverse is an attribute of the apostle PETER. The name is more commonly used for the crook-shaped pastoral staff of a bishop or abbot. This type is an attribute of BENEDICT, BERNARD, MARTIN, CLARE, and occasionally BRIDGET. A fish dangles from the crozier of ZENO.

Crozier Pastoral staff

Crucible, on a fire, holding a number of bars (of gold), the *impresa* of Francesco Gonzaga, the husband of Isabella d'Este. The motto 'Probasti me, Domine, et cognovisti,' – 'Lord, thou hast examined me and knowest me,' (Ps. 139:1) alludes to an accusation, which he successfully refuted, that he had betrayed the Venetian troops whom he led at the battle of the Taro (1495). (Ducal Palace, Mantua.) A crucible, by melting metal, refines it, i.e. is, metaphorically, a test of true worth. Crucibles, flasks and other equipment litter the workshop of the ALCHEMIST.

Crucible

Crucifix. The image of Christ on the cross, usually carved or modelled, and used as an object of public and private devotion. The crucifix, often with a skull, is an attribute of CHARLES BORROMEO; FRANCIS OF ASSISI; MARY MAGDALENE as penitent; PETER MARTYR (with hatchet in his head). It is also the attribute of the Jesuit FRANCIS XAVIER; when entwined with lilies, of NICHOLAS OF TOLENTINO; of SCHOLASTICA (with a dove); with the head of Christ inclined, of JOHN GUALBERTO. A crucifix between a stag's antlers appeared to EUSTACE (a soldier) and HUBERT. A desert hermit praying before a crucifix is usually JEROME. Bonaventura (a

Franciscan) in his cell shows a crucifix to THOMAS AQUINAS (a Dominican). See also STILL LIFE.

Crucifixion (Matt. 27:33–56; Mark 15:22–41; Luke 23:33–49; John 19:17–37). (See ANDREW, COSMAS AND DAMIAN, PETER, apostle (16), and PHILIP, whose crucifixion is likewise represented.) The death of Christ on the cross is the central image in Christian art and the visual focus of Christian contemplation. The character of the image varied from one age to another reflecting the prevailing climate of religious thought and feeling; expressing doctrine by means of symbols and allegory, as in medieval art; or, as in Counter-Reformation painting, serving as a simple aid to devotion by portraying nothing but the solitary figure on the cross; or again, narrating the gospel story in a canvas crowded with people, as in the work of Italian Renaissance artists. The early Church avoided the subject. At the time when Christianity was a proscribed religion under the Romans the crucifixion was represented symbolically by the lamb of Christ juxtaposed with a cross. (See LAMB.) Even after the age of Constantine the Great, when Christians were allowed to practise their religion without interference, the cross itself was still represented without the figure of Christ. The image of the crucifixion as we know it is first found in the 6th cent. but is rare until the Carolingian era when representations multiplied in ivories, metalwork and manuscripts. At this period there are regularly found those other figures from the gospels which were to become a permanent feature of the crucifixion: the Virgin Mary and St John the Evangelist, the centurion and the sponge-bearer, the two thieves, the soldiers casting lots. Also seen from this time on either side of the cross are the symbolic sun and moon and the allegorical figures representing the Church and Synagogue; these latter features were however to die out early in the Renaissance. For many centuries the west, under Byzantine influence, represented Christ himself alive and open-eyed, a triumphant Saviour wearing a royal crown. In the 11th cent. there appeared a new type, the emaciated figure with its head fallen on one shoulder and, later, wearing the crown of thorns. This version prevailed in western art thereafter.

Some features of the crucifixion bear closely on aspects of Christian doctrine. By sacrificing himself on the cross Christ brought about the possibility of man's redemption, that is to say his delivery from the original sin of Adam which all mankind inherited. Medieval writers set out therefore to establish 'historical' links between the Fall and the crucifixion, maintaining for example that the cross was made from the very wood of the Tree of Knowledge in the Garden of Eden (or from one that grew from its seed) (see TRUE CROSS, HISTORY OF), and that Adam's burial place was at the site of the crucifixion. The skull commonly seen at the foot of the cross alludes therefore not merely to Golgotha, 'the place of the skull', but represents Adam's own skull. Furthermore, the blood of Christ, shed on the cross, was early understood to have redemptive powers, a concept embodied in the sacrament of Communion. Hence it became customary to represent the stream of blood that issued from the wound in Christ's side being caught in a chalice, the eucharistic vessel. In these and other ways the image of the crucifixion served as a reminder of Christian teaching. (See also TRINITY.)

The following sections describe the more important figures that are seen beside the cross. The subject as a whole lends itself to symmetrical treatment, and there is a marked tendency towards the use of figures in pairs, one balanced against the other on either side of the cross, for example the Virgin and St John (section 5). Note also the moral distinction between the right and left sides: good on the right of the Saviour, evil on his left, as in the positioning of the

penitent and impenitent thieves (2), or the two women who symbolize Church and Synagogue (12).

1. *The cross and the figure of Christ.* (*a*) *The cross.* In Roman times crucifixion was a widely used form of capital punishment, reserved for baser criminals and slaves. It was probably carried out in a manner rather different from the one to which art has accustomed us. At the site of the execution the upright post (*stipes*) was already set into the ground, a fixture that could be used more than once. The condemned man was led to the place bearing only the horizontal piece (*patibulum*) to which his hands were already tied to prevent resistance. On arrival his hands (or wrists) were nailed to the ends of the cross-bar which was then lifted on to the upright. It either rested across the top, to form a 'T', called the *tau*-cross (from the Greek letter 't') or *crux commissa* (joined); or was set somewhat lower down, forming the familiar *crux immissa* (intersecting). In either case the pieces were secured by some form of mortise and tenon. Finally the feet were nailed to the upright. The foot-rest, or *suppedaneum* was an invention of medieval artists. Though it is customary for the two thieves to be shown tied to the cross, nailing was probably universal. In art up to the 13th cent. the usual number of nails was four (including one for each foot), thereafter with few exceptions it was three, (one foot nailed over the other). The only reference to Christ's nails in the gospels is made by doubting Thomas (John 20:25). Nails as holy relics number well over twenty. In antiquity an inscription (or *titulus*) stating the nature of the condemned man's offence was hung round his neck as he was led to execution, and was afterwards fixed to the head of the cross. John (19:19–20) tells how Pilate 'wrote an inscription to be fastened to the cross; it read, "Jesus of Nazareth King of the Jews" . . . in Hebrew, Latin and Greek.' In Renaissance art it is usually given in Latin only, 'Iesus Nazarenus Rex Iudaeorum', abbreviated to 'INRI'; it may be seen in full, in three languages, in counter-Reformation painting. In the 13th cent. the cross sometimes assumes the shape of a living tree (*lignum vitae*), a form that occasionally recurs in later periods. This was the Tree of Knowledge, brought to life again, according to Bonaventura, from whose writings the motif is derived, by the power of the Redeemer's blood, another manner of expressing the relationship between the Fall and the crucifixion. (*b*) *The figure of Christ.* As we have seen, artists of the Renaissance and later depicted Christ dead upon the cross. His head inclines on his shoulder, generally to the right. (John, 19:30, states that he 'bowed his head' at the moment of death.) The crown of thorns became widely depicted from the mid-13th cent. when Louis IX, king of France, returned from a crusade to the Near East bringing the holy relic with him. Until the Counter-Reformation it is seldom omitted. The medieval Church debated whether Christ would have been naked on the cross, though the condemned in Roman times generally were. In the very earliest examples he wears, in the east, a long sleeveless garment; elsewhere he has a thin band of cloth extending round the waist and under the crotch, the *subligaculum*. Either could be correct historically. There is however no sanction for the familiar loincloth, or *perizonium*, an invention of artists in the early middle ages. See (10) below concerning the wound in Christ's side.

Persons round the Cross

2. *The two thieves.* All four gospels relate that two thieves ('bandits' or 'criminals' in the New English Bible) were crucified with Christ, one on each side. Luke adds that one rebuked the other saying that their punishment was deserved whereas Christ was innocent, and was told by the Saviour, 'Today you shall be with me in Paradise.' (In fulfilment of this promise, he was among those rescued

by Christ on the DESCENT INTO LIMBO.) Art, following Luke, distinguished between the penitent and impenitent thief. The good is on Christ's right (the 'good' side); his expression is composed and peaceful where the other's is anguished. The soul of the good is borne away by angels; that of the bad by demons. The Byzantine painters' guide states, 'the thief to the right, a grey-haired man with round beard; he to the left, young and beardless,' but this is by no means always followed in the west. The early Italian Renaissance tended to follow the Byzantine practice of depicting the thieves, like Christ, nailed to their crosses though, conforming to the medieval custom of relating size to sanctity, they were made smaller than the Saviour. But in order to differentiate clearly between him and them it became general in the west to show the thieves bound, not nailed. Moreover their crosses, unlike Christ's, became the T-shaped *crux commissa*, from the cross-bar of which they hung by the armpits. They are occasionally blindfold. John tells how the soldiers broke the legs of the thieves to hasten their death. They may be seen in the act of so doing; or the thieves are shown bleeding from leg wounds, motifs found principally in 15th cent. German painting. The names by which they are most generally known, Dismas and Gestas (good and bad), are taken from the apocryphal Gospel of Nicodemus.

3. *The lance-bearer and sponge-bearer.* 'When they came to Jesus, they found that he was already dead . . . One of the soldiers stabbed his side with a lance, and at once there was a flow of blood and water.' (John 19:34). Much legend and speculation surrounded the soldier. He was named Longinus (from the Gk word for a lance) and came to be identified with the centurion in the synoptic gospels (not mentioned by John) who exclaimed, 'Truly this man was a son of God.' The *Golden Legend* tells that Longinus was cured of blindness by the blood from the wound and was later baptized and martyred. He was canonized (see also LONGINUS). Artists often keep the identities separate, showing both a soldier piercing the side of Christ, and a centurion in armour, perhaps on horse-back, with an expression of wonder on his face. The lance-bearer's blindness may be indicated by a bystander guiding his hand.

All four gospels mentioned that a sponge soaked in wine and fixed to the end of a cane was offered to Christ just before he died. Legend gave the sponge-bearer the name of Stephaton and medieval art regularly paired him with Longinus. The two, standing symmetrically on either side of the cross and holding up their slender wands, symbolized the Church and the Synagogue, Longinus on the right standing for the Church (see also section 12). The sponge-bearer becomes somewhat rare in Renaissance art but the sponge itself may often be seen upraised among the soldiers' weapons.

4. *The soldiers casting lots.* This theme occurs fairly often in all periods of Christian art. John's account (19:23–24) is the fullest and the one generally followed. Having crucified Christ the soldiers divided his clothes into four parts 'one for each soldier.' Of the seamless tunic, woven in one piece, they said, 'We must not tear this; let us toss for it.' They are seen either at the foot of the cross or in a corner of the picture. One is in the act of throwing dice while the others look on. Alternatively they are quarrelling together, one with a drawn knife with which he is about to cut the garment, while another tries to mediate. The number of soldiers varies and may be only three.

5. *The Virgin and St John standing by the cross.* This very common scene from the crucifixion was originally intended to express in visual terms the passage from John's gospel (19:26–27) in which Christ, while he still lived, entrusted the Virgin to the care of the apostle John: 'Jesus saw his mother, with the disciple

whom he loved standing beside her. He said to her, "Mother, there is your son"; and to the disciple, "There is your mother"; and from that moment the disciple took her into his home.' The pattern became established in the 9th cent. in the art of the Carolingian Renaissance. The Virgin stands on the right of Christ, St John on the left. Their heads are inclined. She may have raised her left hand to her cheek, supporting the elbow with the other hand, a traditional gesture of sorrow that dates back to Hellenistic times. Christ is alive, in conformity with the gospel account and with the prevailing artistic convention. Later, as the living, triumphant figure on the cross gives way to the dead Christ with the wound in his side, so the two figures below manifest grief in a more naturalistic manner, and the strict sense of the gospel is lost. In the 15th cent. the theme tended to be overtaken by that of the Virgin swooning (see next section).

6. *The Virgin swooning; the holy women.* There is no biblical sanction for this incident, beloved by Renaissance artists. It is a creation of later medieval monastic preachers and mystical writers. In dwelling on the sorrows of the Virgin it was natural for them to assume that she was overcome with anguish by the events of the Passion. It was told that she swooned three times: on the Road to Calvary, at the crucifixion and after the descent from the cross. The change from the upright, stoically grieving figure of medieval art came about gradually. In earlier examples she is still on her feet but supported in the arms of the holy women or St John; in the 15th cent. she has collapsed to the ground. The motif was explicitly condemned by the Council of Trent who directed artists to John's words (19:25): 'Near the cross . . . *stood* his mother.' It is consequently rarely seen after the second half of the 16th cent.

The holy women, the companions of the Virgin, are mentioned by all the evangelists but the varying descriptions are difficult to reconcile. Mary whom John calls the wife of Clopas was said to be the same as Mary whom Matthew and Mark call the mother of James and Joseph. Similarly, Salome, mentioned by Mark, was regarded as the same person as the 'mother of Zebedee's children' in Matthew. These two, together with Mary Magdalene, are commonly known as the Three Maries. In art their numbers vary, but they are generally three or four. Their appearance is not clearly differentiated except for Mary Magdalene who, in early Renaissance art, wears red. (But see VIRGIN MARY, 17, *The Holy Family*, for an alternative tradition.)

7. *Mary Magdalene.* It was not until the Renaissance that Mary of Magdala came to be distinguished from the other holy women. As mentioned above, in early works she may sometimes be recognized by her red cloak among those supporting the swooning Virgin, but her typical role throughout Renaissance and Counter-Reformation art shows her as a separate figure, often richly attired and with her usual copious hair, kneeling at the foot of the cross or embracing it in passionate grief. She may kiss the bleeding feet or wipe them with her hair, thus turning the earlier episode in the house of Simon the Pharisee into a prefigurative act (see MARY MAGDALENE, 1). She is even seen catching the drops of blood in her mouth, another reminder of the Eucharist.

8. *Saints and donors.* From about the mid-15th cent. may be found a form of the crucifixion in which saints, regardless of the age in which they lived, are assembled together before the cross, in much the same manner as in the Sacra Conversazione (see VIRGIN MARY, 14) which came into being at about this time. It is a devotional treatment of the subject found principally in Italian art. The saints, who can be recognized by their customary attributes, may be the patrons of the city or church, or founders of the Order, for which the work was com-

missioned; by virtue of this FRANCIS OF ASSISI, DOMINIC, AUGUSTINE (with MONICA) are often to be seen. JEROME and CATHERINE OF ALEXANDRIA, perhaps as patrons of learning, are equally common. SEBASTIAN and ROCH, protectors against the plague, often accompany a kneeling donor, signifying that the work is a votive offering to the church in thanksgiving for the donor's escape from sickness. JOHN THE BAPTIST may be present either as one of the tutelary saints or for his place in the scheme of Christian belief as the prophet of Christ's divinity and the redemptive sacrifice. ('There is the Lamb of God, it is he who takes away the sins of the world.') The Virgin and St John the apostle are nearly always to be seen standing behind.

Symbols and Allegorical Figures

9. *The skull and the serpent.* Adam's relevance to the crucifixion through the doctrine of the Redemption and hence the appearance of his skull at the foot of the cross has been mentioned above. It is first seen in the 9th cent. and recurs thereafter throughout Christian art. The skull is frequently sprinkled with the blood that drips from the Saviour's body. This symbolic washing away of Adam's sin is particularly a feature of the art of the Counter-Reformation. At the same period the skull may be depicted upside down, as it were a chalice, in which the blood is caught. A serpent with an apple in its mouth, near the skull, is a further allusion to the Fall.

10. *The wound and the chalice.* The special significance attaching to the wound in Christ's side and much of the symbolism surrounding it is due first to St Augustine. The 'blood and water' which, according to John, issued from the wound was conceived by him to represent the Eucharist and Baptism. Just as Eve was fashioned from the rib taken from Adam's side, so the two main Christian sacraments flowed from the side of Christ, the 'New Adam'; thus the Church, the 'Bride of the Lord', was born, as it were, from the wound. In the later Middle Ages the figure of Adam, perhaps emerging from the tomb, is seen below the cross, holding a chalice in which he catches the redeeming blood. From the 14th cent. one or more angels, each bearing a chalice, are similarly engaged floating beside the cross, one at each wound. A chalice sometimes stands at the foot of the cross as a reminder of the theme. The wound is generally on the right side of the body, the 'good' side, and, once more according to Augustine, the side of 'eternal life'. By the early 17th cent. this symbolism was forgotten and the wound is found on either side.

11. *Sun and moon.* The sun and moon, one on each side of the cross, are a regular feature of medieval crucifixions. They survived into the early Renaissance but are seldom seen after the 15th cent. Their origin is very ancient. It was the custom to represent the sun and moon in images of the pagan sun gods of Persia and Greece, a practice that was carried over into Roman times on coins depicting the emperors. It seems to have found its way into primitive Christian art through the festival of Christmas which took over an existing pagan feast celebrating the rebirth of the sun. Long before the first representations of the crucifixion the sun and moon appeared in other Christian themes: the Baptism, the Good Shepherd, Christ in Majesty. When art began to depict Christ on the cross their appropriateness to the theme was seen to be already established in the Bible and by theologians. The synoptic gospels relate that from midday a darkness fell over the whole land, which lasted until three in the afternoon. The eclipse might be simply a sign that the heavens went into mourning at the death of the Saviour; but more specifically, according to Augustine, the sun and moon symbolized the prefigurative relationship of the two Testaments: the Old (the

moon) was only to be understood by the light shed upon it by the New (the sun). (See note p. xv): *The typology of the Old Testament*.) In medieval examples the sun and moon may be represented in their classical forms: the sun as a male figure driving a *quadriga*, the moon as a female driving a team of oxen, each within a circular disk. (See also APOLLO: *The Sun god*.) Or the sun is simply a man's bust with a radiant halo, the moon a woman's with the crescent of DIANA. Later they are reduced to two plain disks, the moon having a crescent within the circle, and may be borne by angels. The sun appears on Christ's right, the moon on his left.

12. *Church and Synagogue*. The two allegorical figures seen on either side of the cross and standing for the Church and the Synagogue belong strictly to the Middle Ages and are included here as another example of the 'moral symmetry' of the crucifixion. Matthew (27:51) tells how, at the moment of Christ's death, 'the curtain of the temple was torn in two from top to bottom.' This, in the eyes of Christian commentators, marked the end of the Old Law and the beginning of the reign of the New – the triumph of the Church over the Synagogue. They are portrayed as fully draped female figures. The Church, on the right of the cross, is crowned and holds a chalice in which she catches the Redeemer's blood. The Synagogue, on the left, is blindfold, and her crown falls from her inclined head. The tables of the Law may likewise fall from her hands. The figures first became widespread in the Carolingian Renaissance and are to be found later in the sculpture and stained glass of cathedrals of the 12th and 13th cents.

13. *Pelican*. Legend tells how the pelican feeds its young with blood by piercing its breast with its beak. The earliest bestiary, by the anonymous *Physiologus*, says that the hen smothers her young by her excess of love but the male bird, returning, restores them to life by piercing its side and shedding its blood over them. The image was used as a symbol of Charity in the Renaissance, but just as aptly fitted the concept of the shedding of Christ's blood to redeem mankind. Dante (*Paradiso* 25: 112) refers to the apostle John as 'he who leant upon the breast of Christ our Pelican.' The bird is sometimes to be seen perched, or nesting with its young, on the top of the cross.

Crudelitas. Cruelty, see CHARITY.

Crutch. A sign of great age; or of the crippled, or the emblem of those who care for them. In Christian art it is the attribute of ANTONY THE GREAT (sometimes with a bell hanging from it); JOHN GUALBERTO; ROMUALD. For the healing of a cripple, see PARALYTIC, HEALING OF THE; PAUL, apostle (6); PETER, apostle (5 and 7). A BEGGAR is commonly represented with a crutch. The aged throw away their crutches on entering the Fountain of Youth (see LOVE). A crutch is the attribute of SATURN and of FATHER TIME. VULCAN, the lame blacksmith of the gods, uses a crutch.

Cube. A square block, a symbol of stability on which FAITH personified rests her foot; likewise HISTORY. Its shape contrasts with the unstable globe of FORTUNE. See also OPPORTUNITY.

Cuirass. The breast-plate, see ARMOUR. Mounted on a pole it is the occasional attribute of MINERVA, and hence of WISDOM personified. According to a 16th cent. mythographer the breast was the seat of wisdom.

Cunegunda (d. 1033). Christian saint, the wife of Henry II (also canonized), king of Germany and Holy Roman Emperor. Accused of marital infidelity, it was said she underwent trial by ordeal and walked unharmed over red-hot plough-shares. She was not the only emperor's wife to get herself into this kind of a predicament (cf JUDGEMENT OF OTTO). Cunegunda is dressed in royal robes and

crowned, and walks over ploughshares, or holds one in her hand. Henry II (b. 972) (who in fact succeeded Otto in 1002) was an ecclesiastical reformer and founder of churches, among them Bamberg cathedral where he and Cunegunda are entombed. He is represented in armour, sometimes wearing the imperial crown and holding a model of the cathedral. He may stand beside his wife (who may likewise hold the model of a church). They are represented in German and early Florentine painting.

Cup, or goblet. Generally with a stem and without handles, often ornamental. *Poisoned cups:* a sage in a prison cell, youths lamenting, death of SOCRATES; richly attired matron holding or receiving a cup, SOPHONISBA; similar female with cup from which heart protrudes, GHISMONDA; another, similar, about to drink, ARTEMISIA (not poison but a solution of her husband's ashes). A broken cup, perhaps on a book, the attribute of BENEDICT. A cup discovered in a sack of corn, JOSEPH, son of Jacob (4). An overturned cup in a STILL LIFE picture symbolizes 'Vanitas', emptiness. See also CHALICE.

Cupid (Lat. Amor; Gk Eros). The god of love. Though one of the lesser figures in Greek and Roman mythology he was widely represented in Hellenistic art and in the Renaissance and later. In much art his presence is symbolic: he features in paintings, though he plays no part in the story, simply as a reminder that the theme is about love. Thus in the many examples of maidens seduced by Jupiter he hovers round the lovers; or when Adonis takes leave of Venus, Cupid dozes under a tree indicating that Adonis' thoughts are turned elsewhere. He plays with Mars' weapons or carves a bow from the club of Hercules to symbolize the power of love to disarm the strong. He is often blindfold, not merely because love is blind, but in allusion to the darkness that is associated with sin. He is punished by those who disapprove of his activities, especially Diana and Minerva who stand for chastity. Though to the early Greeks Eros stood for the deepest and strongest forces in man's nature, in later times they reduced his stature in art to the familiar, pretty, winged boy. In the Renaissance he was generally depicted as a winged youth; baroque and rococo painters often turned him into a chubby infant. His usual attributes are the BOW, ARROW and QUIVER. A TORCH, upturned and extinguished, held by a sometimes sleeping Cupid, signifies the passing of earthly pleasures, and may feature much in this sense in Christian funerary sculpture. A terrestrial GLOBE symbolizes love's universality. Cupid's chariot may be drawn by four white horses, after the description in Petrarch's *Triumph of Love* (see TRIUMPH), or by goats, well-known symbols of sexuality.

1. *The education of Cupid.* According to the most popular tradition Cupid was the son of Venus. He is seen poring over a book between his mother and his teacher MERCURY. The education of gods and heroes was a popular theme in the Renaissance, reflecting interest in the revival of classical learning.

2. *The punishment of Cupid.* Cupid was often punished for the mischief that his arrows caused. Venus is shown taking them away from him. Or she may have him across her knee; her raised hand holds a bunch of roses with which to strike him. He was naturally a target for Diana's nymphs, the guardians of chastity. They steal, break or burn his arrows while he is sleeping, or clip his wings. Minerva, another virgin goddess, may be seen striking him; likewise Mars the god of strife, whom however Cupid more often succeeds in conquering.

3. *Cupid stung by a bee* (Theocritus 19). This moral fable tells how the infant Cupid was stung by a bee while in the act of stealing a honeycomb. He ran to his mother who told him sharply that the wounds he inflicted on others were much more painful. He is shown standing tearfully beside Venus, holding a

comb of wild honey. Bees fly round him. The theme may form part of the 'Golden Age'. (See AGES OF THE WORLD.)

4. *Eros and Anteros*. Anteros, the brother of Eros, was known in antiquity. Venus, concerned that her young son seemed to have stopped growing, was told by him that only a brother would cure the trouble. He was therefore given Anteros who symbolized reciprocated love; that is to say, love that grows and is strengthened when it is returned. They are shown together, either fighting, perhaps for the possession of a palm branch, or reconciled and embracing. Their fight was said to signify not discord but the strength of their feeling towards each other. Renaissance humanists distinguished between two kinds of love: sacred, that which is aroused by the contemplation of God, and profane, that is, the common, earthly, or sexual kind. They are usually portrayed as twin Venuses or as twin Cupids. The struggle of Eros and Anteros symbolized this dual aspect of love.

5. *Love the conqueror*. The theme comes from a once-popular quotation from Virgil: 'Omnia vincit Amor' – 'Love conquers all' (*Ecl.* 10:69). It is represented in various ways. (*a*) Cupid has subdued the god Pan by grasping one of his horns. Pan is down on one knee. Since Pan stood for carnal lust, the theme was seen as the combat of divine and earthly love, Cupid in this case having the more virtuous role. But Pan also personified universal nature (Gk *pan* = all), so it equally illustrated the all-embracing power of love. (*b*) Cupid stands triumphant in the midst of various symbolic objects lying around him – books, a laurel wreath or branch (learning and the arts); musical instruments (love); arms and armour (war). (*c*) Cupid stands over a sprawling warrior whom his power has vanquished.

6. *Cupid and Psyche*. Not a myth but a late antique fairy tale, by Lucius Apuleius (2nd cent. A.D.), in the *Metamorphoses*, or *Golden Ass* (Bks. 4–6). Psyche was a maiden so beautiful that she aroused even Venus' envy. Cupid, sent by the goddess to arouse Psyche's love in some worthless being, fell in love with her himself. He had her brought to his palace where he visited her only after dark, forbidding her to set eyes on him. Curious and fearful about her lover's appearance and urged on by her two jealous sisters, Psyche one night took a lamp and gazed on him as he lay asleep. But she carelessly let a drop of hot oil fall on him so that he awakened. He left her angrily, and his palace vanished. Psyche wandered over the earth seeking her lover and performing various apparently impossible tasks, set by Venus, in the hope of thereby winning him back. She succeeded in sorting a heap of grain with the help of friendly ants. She fetched a casket from Proserpine in Hades which she disobediently opened and was overcome by sleep. Ceres and Juno interceded in vain with Venus. Finally Jupiter, moved by Cupid's pleas, took pity on Psyche and she was carried up to heaven by Mercury, reunited with her lover and married at a festive banquet. Renaissance humanists treated the story as a philosophical allegory of the search of the Soul (Psyche) for union with Desire (Eros), the outcome of which is Pleasure (their offspring). The most frequently depicted single episode is that of Psyche in her chamber holding a lamp above the sleeping Cupid, but the story is also represented as a series of scenes, sometimes numerous, in the decoration of Renaissance palaces. (See also SOUL.)

Curius Dentatus (3rd cent. B.C.). The type of virtuous ancient Roman who combined high office – he was three times consul – with a humble way of life. The neighbouring Samnites, with whom Rome had long been sporadically at war, attempted to bribe him with gold. According to Plutarch (18:2) ambassadors

from Samnium came to his little cottage to find him boiling turnips in the chimney corner. He turned them away saying that it was more honourable to conquer those who had gold than to possess it oneself. He later brought about the defeat of the Samnites. He is depicted, especially in Italian baroque painting, preparing turnips for the pot. The ambassadors, dressed as soldiers, are offering him gold and silver ware which he rejects with a gesture. Curius Dentatus can be mistaken for FABRICIUS LUSCINUS, a similar theme of incorruptibility, or for CINCINNATUS.

Cybele. Ancient Phrygian 'earth mother' who ruled over all nature. Her worship was characterized by the frenzy of her devotees and their practice of ritual mutilation. In antiquity Cybele was represented wearing a turreted 'mural' crown, the normal attribute of the Asiatic mother goddess, and riding a chariot drawn by LIONS. She retains these features in the Renaissance with, in addition, a SCEPTRE, or KEY, and sometimes a GLOBE. Her dress is predominantly green and decorated with flowers. As one of the FOUR ELEMENTS she personifies Earth. Cybele was worshipped in Phrygia in the form of a sacred stone which was brought to Rome in 204 B.C., during the second Punic war. For the story of the Vestal virgin who was able to prove her innocence when the vessel carrying the stone was stuck on a sandbank in the Tiber, see CLAUDIA. The stone image of Cybele is depicted being borne by priests into the city in the presence of the Roman general Scipio, while Claudia kneels before it (Mantegna, Nat. Gall. London). See also ATALANTA AND HIPPOMENES.

Cygnus, youth changed into swan, see PHAETHON.

Cyrus the Great (6th cent. B.C.). Founder of the Persian empire. According to Herodotus (1:109–129) Astyages, king of Media and grandfather of Cyrus, ordered that he be slain as an infant because of a prophecy that he would grow up to overthrow him. A kinsman, Harpagus, was entrusted with the deed but secretly handed the child over to a shepherd to be exposed on the mountainside. The shepherd's wife substituted her own still-born child, and brought up Cyrus as her own. As a boy Cyrus was summoned before Astyages on some offence of insulting a nobleman's son, and was recognized by his grandfather who restored him to his parents, at the same time punishing Harpagus. It was put about that Cyrus owed his survival on the mountainside to being suckled by a bitch. Later Harpagus plotted with Cyrus to bring about the downfall of Astyages, at one time conveying a message to him concealed in the body of a hare. Cyrus overthrew his grandfather in the course of his conquests. Scenes from the childhood of Cyrus are sometimes found in works of the 16th and 17th cents. (Brussels tapestries, Gardner Mus., Boston).

Daedalus. A legendary Greek craftsman of marvellous skill. For PASIPHAË, the wife of Minos, king of Crete, he fashioned a wooden cow in which she concealed herself to facilitate her intercourse with a bull. He designed the Labyrinth which housed her monstrous offspring, the Minotaur, half man, half bull. It was slain by Theseus. Imprisoned on the island of Crete by the king, Daedalus made wings so that he and his son Icarus could escape by flying. See further THESEUS; ICARUS.

Dagger. Sometimes substituted for the sword as the instrument of a saint's martyrdom; see also DEATH, SCENES OF. The attribute of THOMAS, apostle; and of LUCIA, piercing her neck; with crown and sceptre, of Melpomene the MUSE of tragedy. WRATH personified attacks her victim with a dagger. Lucretia killed herself with a dagger (RAPE OF L.).

Dalmatic. The characteristic vestment of the deacon, a long-sleeved outer tunic worn over the alb. It is often partly slit at the sides, with embroidered ornament

at the hem, cuffs and neck. It is worn by the deacons LAURENCE; LEONARD (decorated with fleurs-de-lys); STEPHEN; VINCENT OF SARAGOSSA. See diagram, RELIGIOUS DRESS.

Danaë. In Greek mythology, the daughter of Acrisius, king of Argos. It was foretold that the king would be killed by his daughter's son, and he therefore shut Danaë in a bronze tower to keep her suitors away. But Jupiter visited her in the form of a shower of golden rain and lay with her (*Met.* 4:611). Their offspring was Perseus, who eventually killed his grandfather accidentally with a discus. The theme was popular with Renaissance painters as a vehicle for portraying the female nude. Danaë reclines on cushions on a canopied couch, looking upwards expectantly. A golden light or a shower, sometimes in the shape of coins, falls on her from a cloud. An old woman, Danaë's attendant, may hold out her apron to catch the gold. Cupid and amoretti may be present. To the Middle Ages, Danaë was both a symbol of chastity and an example of the conception of a virgin solely through divine intervention. The theme was thus regarded as a prefiguration of the Annunciation. The idea of a mystic impregnation occurs also in the story of GIDEON'S FLEECE which was similarly said to prefigure the Annunciation.

Dandelion. A bitter herb (Exod. 12:8) and a common Christian symbol of grief. It is easily recognizable in paintings of the crucifixion by early Flemish and German artists. It is occasionally found in other subjects related to the Passion, such as 'Noli me tangere', and St Veronica (Master of Flémalle, Städelsches Kunstinstitut, Frankfurt).

Daniel. One of the four 'greater prophets'. (The others are EZEKIEL, ISAIAH and JEREMIAH.) The book of Daniel, partly legendary history and partly apocalyptic prophecy, describes how Daniel rose to a position of influence in the Babylonian court, because, like another Jewish exile, Joseph in Egypt, of his skill in interpreting dreams. He is also a personification of Justice.

1. *The three Hebrews in the fiery furnace.* (Ch. 3) Daniel's companions, Shadrach, Meshach, and Abed-Nego, because they refused to worship Nebuchadnezzar's golden image, were thrown into a furnace. They survived unscathed, demonstrating the power of the God of the Jews to protect his people. The theme is among the earliest in Christian art and is found in the wall-paintings in the Roman catacombs. It virtually disappears by the end of the Middle Ages. Each period interpreted the theme in its own way. Latterly it was made a prefiguration, like the Burning Bush, of Marian virginity. (See MOSES, 5.)

2. *Daniel in the lions' den.* (Dan. Ch. 6, and Apocryphal Additions to Dan. vv. 23–42). The second version, from the apocryphal book, is that usually depicted. Daniel was thrown into the lions' den for disobeying a religious edict of the Persian king Darius, or, according to the more colourful apocryphal account, for causing the death of a sacred dragon, or serpent, by feeding it with cakes made from an indigestible mixture of pitch, fat and hair. The prophet Habakkuk was informed by an angel, traditionally the archangel MICHAEL, of Daniel's plight. The angel directed Habakkuk to take food and then, lifting him by the hair of his head, carried him to the lions' den. Daniel saw this as a sign that God had not forsaken him. After seven days the king returned and, finding Daniel alive and well, was convinced of the power of the Jewish God. The courtiers who had attempted to bring about Daniel's downfall were themselves thrown to the lions and immediately devoured. Like the fiery furnace, the subject is predominantly medieval. It is rare in the Renaissance but recurs in the 17th cent. Daniel, seated or standing in a kind of sunken courtyard or pit, is surrounded by

lions. Habakkuk, carrying food and drink, and usually accompanied by the angel, may be floating overhead.

See also SUSANNA AND THE ELDERS; BELSHAZZAR'S FEAST.

Danse Macabre, see DEATH (1).

Dante and Virgil (1265–1321; 70–19 B.C.). On his journey through hell and purgatory, which comprises the first two parts of the *Divine Comedy*, Dante's companion and guide was the Latin poet Virgil. At the beginning of the poem Dante, lost in the Dark Wood, met Virgil who led him to the entrance of hell. They passed down through its twenty-four circles and then, on the other side of the earth, climbed the terraces and cornices of Mount Purgatory. At the summit, when Dante entered the Earthly Paradise at the start of the third stage of his journey, Virgil left him. He ascended through the different spheres of paradise with BEATRICE for his guide. In addition to the cycles of drawings and many illustrated editions since the poem's appearance during the second decade of the 14th cent., it has inspired a limited number of large-scale works. Virgil wears a LAUREL crown, occasionally Dante as well. Dante as a standing figure may hold a book inscribed with the opening words of the *Divine Comedy*, 'Nel mezzo del chamino di nostra vita . . . ' – 'Midway in our life . . . ' The pair are depicted together at different stages of their journey, generally in the role of bystanders witnessing either the tortures of the damned in hell or the less grievous penalties of those in purgatory. Delacroix (Louvre) depicts them ferried by Phlegyas through the Stygian marsh in which the souls of the Wrathful are rotting (*Inf.* 8:28 ff). In the second circle of hell Dante met Francesca da Rimini who told him the tragic story of her love (see PAOLO AND FRANCESCA). Dante's vision of hell inspired Renaissance artists who selected elements from it to represent aspects of Christian eschatology, or even reproduced the whole programme (see HELL).

Dante and Virgil are grouped with Homer in Raphael's 'Parnassus' (Vatican, Stanza della Segnatura). See also VIRGIL, LAY OF.

Daphne, see APOLLO (9).

Daphnis and Chloe. Diodorus Siculus (4:84) tells of the shepherd Daphnis, the inventor of bucolic poetry, who was the son of Hermes by a Naiad. He was taught to play the pipes by Pan. For betraying the love of a nymph, he was struck blind. The story of another Daphnis, and Chloe, by the late Greek writer Longus (3rd or 4th cent. A.D.), is a pastoral romance about a pair of lovers, their adventures and final happy reunion and marriage. The classical Daphnis is represented beside Pan who is teaching him to play the syrinx. The lovers Daphnis and Chloe are depicted in Italian baroque painting as shepherds, often with a syrinx.

Darius, see ALEXANDER THE GREAT (5, 7).

Date. The fruit of the date palm is picked by Joseph on the rest on the FLIGHT INTO EGYPT. A bunch hanging from a martyr's palm, ANSANUS. See BREAST; PALM.

Daughter of the woman of Canaan, Christ heals the (Matt. 15:21–28; Mark 7:24–30). In the gentile district of Tyre and Sidon Christ was approached by a Canaanite woman who begged him to cure her daughter, 'possessed of an unclean spirit.' The disciples were for turning her away, and at first Christ was of the same mind, saying to her that his mission was to the Jews alone: 'It is not right to take the children's bread and throw it to the dogs.' The woman neatly answered him in the same metaphor: 'Yet the dogs eat the scraps that fall from their masters' table.' When she returned home she found her daughter cured. The woman is depicted kneeling at the feet of Christ, around whom stand some of the disciples,

their expressions registering disapproval. She may be pointing at a dog, an animal only rarely found in Christian art. This motif helps to distinguish the theme from the similar WOMAN WITH AN ISSUE OF BLOOD.

David. The shepherd boy who became king of Israel. Much legend appears to surround the biblical account of this complex and many-sided personality. He was a bandit chief, a warrior and a statesman; he made Israel a united kingdom and captured Jerusalem, making it his capital; he was a musician and was traditionally believed to be the author of the Psalms; as a king he was not above intrigue which brought about the death of his mistress' husband. He is important in Christian art not merely as the 'type' or prefiguration of Christ; according to Matthew he was a direct ancestor. (See also JESSE, TREE OF.) His attributes are a stringed instrument, usually a harp, and a crown. Though medieval books of psalms show David playing a harp or sometimes a psaltery, in Renaissance art, especially in the 16th cent., he very often holds some instrument of the VIOL family. (See diags., MUSICAL INSTRUMENTS.)

1. *David anointed by Samuel* (I Sam. 16:1–13). Samuel, the prophet and spiritual leader of the Israelites, was looking for a man fit to be king in succession to Saul. He went to Bethlehem and sought out the family of Jesse, taking with him a sacrificial heifer. Jesse presented seven of his sons but Samuel rejected them all. Finally he sent for the youngest, David, who was in the fields watching the flocks. Samuel chose him and anointed him with oil from a horn. David is depicted as a young shepherd, perhaps with a staff, kneeling beside an altar before Samuel. The seven brothers stand in the background while Jesse prepares to sacrifice the beast.

2. *David playing the harp.* He is sometimes represented playing the harp in a pastoral setting while keeping his sheep, reminiscent of Orpheus charming the animals with his music. More often he plays before Saul (I Sam. 16:23). The king suffered from spells of melancholia which David succeeded in alleviating with his music.

3. *David slaying the lion and the bear* (I Sam. 17:32–37). In order to persuade Saul that he was worthy to go out and fight Goliath, David recounted how as a shepherd he was accustomed to tackle the wild beasts that threatened his flock. When a lion or a bear made off with a lamb David went after it fearlessly, and if it turned on him he caught it by the throat and killed it. The lion's more usual role as a symbol of courage and strength is here reversed: the theme symbolizes Christ's victory over Satan. It is found particularly in psalters and medieval stone carving.

4. *David and Goliath.* There are two scenes: (*a*) the fight, (*b*) David's triumphant return carrying Goliath's severed head. (*a*) *The fight.* (I Sam. 17:38–51). The armies of the Philistines and Israelites were ranged against each other. Goliath of Gath, the Philistines' champion, was over eight feet tall with a helmet of brass, a coat of mail and greaves of brass on his legs; he had a spear like a weaver's beam. David refused the armour Saul offered him (though he is sometimes wrongly portrayed wearing it) and instead took five stones for his sling, putting them in his scrip, or bag. The affair was soon over. The two combatants approached exchanging taunts. David took a stone from his bag, slung it and struck Goliath on the forehead, felling him. He then quickly took the Philistine's own sword and cut off his head. This was the signal for the Israelites to attack and they routed the enemy. The story was made a prefiguration of Christ's temptation in the desert, by the devil, and was used in a wider context to symbolize the victory of right over wrong. (*b*) *The Triumph of David* (I Sam. 18:6–7).

When David returned from battle the Israelite women came out singing, dancing and playing instruments. They praised him saying, 'Saul hath slain his thousands, and David his ten thousands.' David is depicted carrying Goliath's head in his hand or sometimes aloft on the point of a sword or spear. He may be on foot accompanied by women or on horseback; or he may be standing on a car in a triumphal procession in the Roman style. The episode was seen as a prefiguration of Christ's entry into Jerusalem.

5. *The offering of Abigail* (I Sam. 25). During his exile in the Judean desert David and his band of outlaws kept themselves victualled by 'strong-arm' methods. One rich but churlish farmer refused to supply them and they threatened to punish him. But his wife Abigail, 'a woman of good understanding, and of a beautiful countenance,' went out to meet David with a peace-offering of food and drink. It was graciously received. Abigail's husband learning about it next day, while recovering from a bout of feasting, had a severe stroke and died soon after. Abigail married David. She is usually depicted kneeling before him. Behind her are hand-maidens, laden asses and attendants bearing baskets of loaves.

6. *David dancing before the Ark* (II Sam. 6). The Ark of the Covenant was the chest that held the Jews' sacred relics. Although at one time it was captured by the Philistines it brought them such ill-fortune that they sent it back. David, with a large band of Israelites, bore it into Jerusalem 'with shouting, and with the sound of the trumpet.' David, in a frenzy of joy, leaped and danced naked in front of the Ark. He was seen from a window by his wife Michal, 'who despised him in her heart.' She later reproached him sarcastically for behaving in such a manner before the servants.

7. *David and Bathsheba* (II Sam. 11:2–17). One evening while he walked on the roof of his palace David saw below him a beautiful woman bathing. This was Bathsheba, the wife of Uriah the Hittite who was then away on service in David's army. In an act of seignorial arrogance he had her brought to the palace and made love to her. She became pregnant as a consequence. Later he wrote to Uriah's army commander saying, 'Set ye Uriah in the forefront of the hottest battle . . . that he may be smitten and die.' This indeed came about and David afterwards married Bathsheba. The child survived only a few days. David subsequently did penance. Bathsheba is depicted at her toilet in various states of nudity. Earlier Renaissance artists show her clothed and merely washing her hands or feet, helped by attendants. Sometimes a messenger is shown arriving with a letter, though the Bible does not record this detail. David's morally indefensible conduct did not deter the medieval Church from drawing a typological parallel: he prefigured Christ and Bathsheba the Church.

8. *David and Absalom* (II Sam. chs. 13–19). David's son Absalom had a sister named Tamar. She was raped by her half-brother Amnon, another of David's sons. The king refused to punish his son, and Absalom for two years secretly nursed the determination to avenge his sister. He finally invited Amnon to a sheep-shearing and had him slain as he was feasting in his tent. While David was grieving the death of a son, Absalom took refuge with another tribe. But the king also pined for Absalom whom he loved, and in time they were reconciled. Absalom however was determined to usurp his father and mustered an army among the tribes for a rebellion. He was defeated by the forces of David and met his own death in a dramatic fashion. Riding a mule under an oak tree, his hair caught in the branches. His mount passed on and he was left dangling, an easy prey for David's soldiers. The king grieved long over the death of Absalom.

Death. Medieval man was made aware of the presence of death in his daily life in a way that is unknown in the West today. Some twenty-five million are believed to have died in the plagues that swept Europe in the 14th cent. Death was no respecter of persons: young and old, popes and emperors as well as humble folk, the lover and the soldier, were alike apt to be carried off without warning. This equality before death was reflected in several themes in art. The figure of Death, represented by a skeleton with perhaps a cloak and hood, and holding a SCYTHE and HOUR-GLASS – attributes that he shares with Father Time – is found in illustrations of the *Triumphs* of Petrarch (see TRIUMPH) which began to appear in the first half of the 15th cent. From this time Death is seen in numerous allegories. He surprises a loving couple – the man tries in vain to ward him off with a sword. He is seen, especially in German art, taking a naked woman unawares at her toilet, perhaps trying to ravish her, with implication that beauty is at his mercy. (See also VANITY.) He engages a soldier in combat, or pursues another who flees on horseback. Death himself on horseback victoriously mows down with his scythe people who are caught under his horse's hooves; or he shoots his victims with arrows, probably an allusion to the plague which was traditionally believed to be carried by arrows. Surprisingly, Death is rarely represented on funerary sculpture before the Counter-Reformation. From the second half of the 16th cent., the skull, sometimes winged, is seen on the stone carving of tombs. This motif developed in the next century into the representation of the complete skeleton. (See also SKULL.)

1. *The Danse macabre* illustrates the idea that all are equal before Death. In essence it consists of a row of figures of descending social rank beginning with the pope (wearing a tiara), and the emperor (a crown), cardinals and lesser ecclesiastics, persons of various occupations and ages, and finally the peasant. Between each is a skeleton. The procession is being led to the grave. It was performed as a ritual dance in religious drama and is depicted in frescoes of churches and cemetery buildings of northern Europe, especially in the 15th cent. It is also common in illustrated books of the period. The *danse macabre* is distinct from the 'Dance of Death', a popular medieval belief that the dead rose from their tombs at midnight and performed a dance in the graveyard before setting off to claim fresh victims from among the living. The two themes tended to become merged.

2. *The meeting of the three dead and the three living.* A legend of eastern origin told how three princes returning, carefree, from the chase met on the road three dead who accosted them saying, 'That which you are, we were; that which we are, you will be.' The saying occurs as a Latin epitaph: 'Sum quod eris, quod es olim fui.' Another version told how the three princes, or kings, were shown by a hermit three open coffins, each containing a corpse. The theme is found in either form in late medieval and Renaissance church frescoes in Italy and France. The three living are usually crowned, and may be on horseback. Their faces express terror.

See also AGES OF MAN; ARS MORIENDI; DEATH, SCENES OF.

Death of the Virgin (Dormition). The death of the Virgin Mary forms a cycle of scenes that are widely depicted in Christian art, particularly in churches dedicated to her. The scene of the death itself is sometimes joined to that of the ASSUMPTION. Early apocryphal literature contains several versions of the story, some of them probably dating from the 4th cent. The *Golden Legend*, which appeared in the 13th cent., at a time when popular devotion to the Virgin was intense, gives an extended account based on the apocryphal works. The subject was frequently represented from this period.

1. *The annunciation of the Virgin's death.* In old age the Virgin, who longed to be with her son again, was visited by an angel who foretold her death in three days time. It presented her with a branch of the 'Palm of Paradise' which was to be borne before her bier. She prayed to be allowed to see the apostles and her kin before she died. The scene sometimes resembles the annunciation of Christ's Incarnation except for the palm in the angel's hand, instead of a lily or sceptre. More rarely it holds a taper or candle. It was traditionally identified with the archangel MICHAEL, the harbinger of death, but is not necessarily so portrayed.

2. *The Communion of the Virgin.* The Virgin's last Communion which she is seen receiving from the hands of John the Evangelist or from Christ, was a theme favoured by the Church of the Counter-Reformation in fostering devotion to the SEVEN SACRAMENTS. Parallel themes are the Last Communion of JEROME, FRANCIS OF ASSISI and MARY MAGDALENE.

3. *The death of the Virgin.* The most widely depicted of the series. According to one tradition she was not dead but only sleeping during the three days until her resurrection, hence 'Dormition.' The *Golden Legend* tells how the angel caused the apostles, who were scattered over the world, each to be caught up in a cloud and borne to the Virgin's door. (They are occasionally depicted thus.) 'And about the third hour of the night Jesus Christ came with sweet melody and song, with the orders of angels,' and with the patriarchs, martyrs, confessors and virgins. 'And thus in the morning the soul issued out of the body and fled up in the arms of her son.' The scene shows the Virgin's body on a couch, or bier, or, especially in northern Renaissance art, on a canopied bed in a typical domestic interior. She may be still living and holding a lighted candle, in accordance with an old custom of putting a candle in the hands of a dying person, its light a symbol of the Christian faith. The apostles stand round. St John holds the palm, handed to him by the Virgin, or is perhaps weeping or kneeling by the bed. St Andrew may be swinging a censer. St Peter, sometimes dressed in bishop's robes, holds a book and conducts the service. The figure of Christ, who is seen only in earlier works up to about the 15th cent., stands behind the bed holding in his arms a tiny effigy which is the Virgin's soul; or he appears with angels in an aureole or mandorla above. Two mourning women represent widows, friends of the Virgin, to whom she bequeathed her robes. The Counter-Reformation taught that the Virgin died without pain, death taking her unawares; she is therefore sometimes depicted in 17th cent. art not on a bed but on a chair or throne, her head fallen back, surrounded by the apostles.

4. *The bearing of the Virgin's body to the tomb.* The body was carried by the apostles, St John going before and bearing the Palm of Paradise as a talisman. A high priest of the Jews tried to overturn the bier. 'Then suddenly both his hands waxed dry and cleaved to the bier, so that he hung by the hands on the bier, and was sore tormented and wept and brayed.' Some versions show the angel cutting off the high priest's hands, or a number of Jews being blinded by angels. All are rare outside early Renaissance art.

5. *The entombment.* A somewhat rare subject. The body of the Virgin lies on a sheet or pall which is being lowered by the apostles or by angels into a sarcophagus. Christ may be seen above in a mandorla.

Death, Scenes of. The sufferings of the Christian martyr form a considerable body of themes in religious art. Information about the 'age of martyrs', that is, the early centuries of Christian persecution under the Roman Empire up to the reign of Constantine, and the details of the martyrs' ordeals are known to us

from works such as Eusebius' *History of the Church* which dates from the first quarter of the 4th cent. The cult of martyrs and their relics in the Middle Ages led to the creation of a whole literature, much of it being the deliberate manufacture of imaginary legends which borrowed freely from the early historians. A common feature of these accounts is the martyr's power to survive a series of deadly tortures until he or she is finally dispatched by the sword. Thus scenes of martyrdom in art are often strictly not scenes of death. Sebastian pierced with arrows, John the Evangelist in a vat of oil, and Catherine on her wheel are examples of this kind. The deaths of evangelists and apostles generally do not follow this pattern.

Forms of martyrdom. Beheaded: MATTHEW; JAMES THE GREATER; PAUL, apostle; COSMAS AND DAMIAN (both kneeling together); CHRISTOPHER; CATHERINE OF ALEXANDRIA; BARBARA (executioner in a turban); MARGARET OF ANTIOCH; DOROTHEA (angel hovers with basket of flowers or fruit); APOLLONIA; CECILIA (who survived even the strokes of the sword for three days); AGNES; DONATUS; JANUARIUS; MAURICE (warrior); DENIS. *Pierced by sword, spear or dagger:* THOMAS, apostle; SEBASTIAN; LUCY; JUSTINA; PETER MARTYR; Placidus and Flavia (BENEDICT, 5); URSULA; THOMAS BECKET; CHRISTINA. *Crucified:* The apostles PETER; ANDREW; PHILIP. COSMAS AND DAMIAN. *Beaten with clubs:* JAMES THE LESS; SEBASTIAN. *Stoned:* STEPHEN; PHILIP, apostle. *Flayed:* BARTHOLOMEW. *Dragged through the streets:* MARK. *Tied to wild horses:* HIPPOLYTUS. *Cast into the sea, an anchor round his neck:* CLEMENT. *Immersed in a vat:* JOHN THE EVANGELIST. *Roasted on a gridiron:* LAURENCE. *Flesh torn with iron combs:* BLAISE. *Breasts sheared:* AGATHA. *Disembowelled:* ERASMUS.

The deathbed of a saint, particularly one who was founder of an Order, forms an important part of devotional imagery, often the last of a series depicting incidents from his or her life. The saint commonly lies before an altar surrounded by mourning monks, friars or nuns of his Order, or by priests, or is carried on a bier to his grave attended by mourners. Depicted thus are ANTHONY THE GREAT; JEROME; FRANCIS OF ASSISI; DOMINIC; BENEDICT; BERNARDINO; CLARE; ELIZABETH OF HUNGARY; PHILIP BENIZZI; JOHN GUALBERTO; BRUNO; NORBERT.

There are many other scenes of death in art, especially from the Old Testament, ancient history and mythology. The more important are as follows:

Violent Death

Execution, murder, accident. (a) *Male. By the sword:* sage in loincloth, by Roman soldier, ARCHIMEDES; Egyptian, by MOSES (3); Amnon, feasting in tent, by Absalom's men, DAVID (8). (See further under HEAD: *Severed Head.*) *Arrow:* in the heel, ACHILLES (4); several piercing strung-up body, SHOOTING A DEAD BODY. *Dagger:* CAESAR, Gaius Julius, by the conspirators; old man, Pelias, by his daughters, MEDEA. *Flayed with knife:* Marsyas hanging by wrists from tree, APOLLO (4). *Torn by Maenads:* ORPHEUS (3). *Tent peg:* SISERA, SLAYING OF. *Jawbone:* the Philistines, by SAMSON; Cain's fratricide, CAIN AND ABEL. *Discus:* Hyacinthus, APOLLO (11). Adonis, slain by a boar, was discovered by VENUS (5). Darius, lying wounded in a chariot, was found by ALEXANDER THE GREAT (7).

(b) *Female. By the sword:* kneeling at altar, by Greek soldiers, POLYXENA; snake-haired woman, Medusa, by PERSEUS (1); kneeling maiden, by soldier, JEPHTHAH'S DAUGHTER. *Arrow:* maiden in old man's arms, kneeling youth, SILVIO AND DORINDA; maiden, discovered by youth, or mourned by Faun, CEPHALUS AND PROCRIS; maiden, by god with bow, Centaur holding infant, APOLLO (10). *Snake bite:* snake entwining maiden's foot, ORPHEUS, death of Eurydice. The mortal SEMELE died by Jupiter's lightning.

Suicide. (*a*) *Male.* On a pyre, HERCULES (25); a youth, by the sword, discovered by maiden, PYRAMUS AND THISBE; in bedchamber, by the sword, with book, CATO; old man in bath or feet in basin, soldiers present, SENECA, DEATH OF; suspended from tree, bowels hanging out, JUDAS ISCARIOT.

(*b*) *Female.* On bed, armour lying nearby, by the sword, DIDO (or on a pyre); by sword or dagger, RAPE OF LUCRETIA; by snake bite, CLEOPATRA (3).

Natural Death

Death-bed. (*a*) *Male.* Woman and child mourning, perhaps armour and soldiers, (death of Hector), TROJAN WAR (6); similar, but no child, GERMANICUS, DEATH OF; priest administering Extreme Unction, SEVEN SACRAMENTS; saint reviving dead body on couch, astonished tribesmen, FRANCIS XAVIER.

(*b*) *Female.* The Virgin, surrounded by apostles, sometimes Christ, DEATH OF THE VIRGIN; naked woman observed by Roman emperor, NERO BEFORE THE BODY OF AGRIPPINA; MARY OF EGYPT, discovered in the desert by a priest; SCHOLASTICA, her soul in the form of a dove ascending.

Other natural deaths. MOSES, on a hilltop mourned by his kinsmen (10); OMOBUONO, a rich merchant, in church, supported by angels; FRANCIS XAVIER in a lonely hut, discovered by natives; HUBERT, a bishop in robes, long dead, lifted from the grave; beggar below a doorstep, ALEXIS; pilgrim in a prison cell, discovered by a jailer, ROCH; NARCISSUS, a youth, lies dead beside a pool.

Multiple Death

Humans and animals strewing the ground, MOSES (6), death of the firstborn; infants slain by soldiers, MASSACRE OF THE INNOCENTS; Ananias and Sapphira struck dead, PETER, apostle, (6); man and woman in bed, killed by JULIAN THE HOSPITATOR; massacre of young women by soldiers, a harbour and ships, URSULA; soldiers of the 'Theban legion' crucified, MAURICE; plague victims in the street tended by CHARLES BORROMEO; youths and children killed by arrows of Apollo and Diana, NIOBE; youth and maiden, both fallen on one sword, PYRAMUS AND THISBE; man with four children in a chamber, UGOLINO DELLA GHERARDESCA. See also BATTLE.

Deceit (or Fraud; Lat. *Fraus*). A vice that is personified in one of the earliest examples of Christian allegorical literature, the 4th cent. 'Psychomachia' (see VIRTUES AND VICES). Dante (*Inf.* 17:1–27) described a monster inhabiting the Circle of Fraud, having a human face – that of a just man – but with a reptile's body and a tail with a sting. In profane allegory of the Renaissance Deceit is represented in a rather similar manner. The head is that of a beautiful woman, the scaly body being half concealed by her dress. She has lion's claws for feet, as in Bronzino's allegory of Lust unveiled by Time (Nat. Gall. London). Her attribute is a MASK, as in the CALUMNY OF APELLES. She may alternatively take the form of a crone whose features are concealed behind the mask of a young woman. See also INNOCENCE.

Deianeira, see HERCULES (22, 24).

Demeter, see CERES.

Demetrius. Early Christian martyr of unknown date whom the Church made into a warrior saint. His cult was confined to the east. He became the patron of Salonika. He is represented, chiefly in Byzantine frescoes and mosaics between the 7th and 14th centuries, in armour, with his hand resting on his sword, or holding a shield and lance (Ortolano, Nat. Gall. London).

Democritus and Heraclitus ('The laughing and crying philosophers') (D.: *c.* 460– *c.* 370 B.C.; H.: *c.* 540–*c.* 475 B.C.). Democritus, a Greek philosopher, born at Abdera in Thrace, was known as the laughing philosopher because he found

amusement in the folly of mankind. (The citizens of Abdera were proverbially stupid.) His philosophic system was contrasted with that of the earlier Heraclitus of Ephesus, who was known as the 'Dark' or 'Obscure' and was reputed to be melancholic. They were linked as a contrasting pair by Seneca (*De Ira*, 2, 10:5), by Juvenal (*Satire* 10:28 ff) and others. The 15th cent. Florentine humanists, to whom such classical texts were well-known, used the pair to support the view that a cheerful demeanour was proper to a philosopher. They are widely represented in European painting of the Renaissance and baroque periods, either in one picture or as companion pieces. Democritus has a terrestrial GLOBE for attribute. He may point to it. Heraclitus weeps or at least looks sorrowful, and may fittingly wear a black cloak.

Demons. Evil spirits, the 'fallen angels' who are the servants of SATAN. The gospels maintain that disease and insanity are caused by possession by demons, and hence their exorcism depicts the typical small black figure emerging from the mouth of the afflicted person. They are the messengers of Satan as angels are the messengers of God; thus they are seen bearing the soul of the sinner to hell in the way that angels bear the righteous to heaven. Or they contend with angels for a man's soul (ARS MORIENDI). Satan was commonly identified with heathenism and demons may therefore feature in scenes representing the conversion or vanquishing of the pagan. Demons resemble Satan, with his wings, horns and tail. They are armed with a barbed spear or fork. They are exorcised by BARTHOLOMEW, BENEDICT, ZENO and others, often with the aid of an ASPERGILLUM. A demon lies at the feet of NORBERT (his own conversion), GEMINIANUS (an exorcism), CATHERINE OF SIENA (her temptations subdued). ANTONY THE GREAT was likewise assailed by demons of temptation. At the LAST JUDGEMENT they try to tip the scales of St Michael, and drive the damned into hell (3 and 6); they bear away the soul of the impenitent thief (CRUCIFIXION, 2), and drag the soul of Eurydice to hell (ORPHEUS). A demon whispers in the ear of JUDAS ISCARIOT, and blows out the candle of a nun, GENEVIÈVE. They are the agents of Satan in the destruction of the children of JOB. They support the air-borne Simon Magus (PETER, apostle, 12). Vanquished demons flee before Christ on his DESCENT INTO LIMBO; before the preaching of IGNATIUS OF LOYOLA, chased by angels; and from a ship in a storm, banished by three saints (MARK).

Denial and repentance of St Peter, see PETER, apostle (4).

Denis (Dionysius) of Paris. Bishop and martyr, probably 3rd cent., patron saint of France. His identity is obscured by much legend. He was said, without foundation, to be the same as the 1st cent. Dionysius the Areopagite (Acts 17:34), and as the 5th cent. Pseudo-Dionysius who wrote the *De Hierarchia Celesti* (see ANGELS). He was said to have been executed in Paris, on the orders of the Roman prefect, together with two companions, SS Rusticus and Eleutherius. His body then miraculously rose to its feet carrying its severed head to the place later known as the Mount of Martyrs (Montmartre), where it was buried. The supposed remains were later transferred to the site of the present abbey of Saint-Denis. St Denis is represented in French Gothic sculpture and stained glass wearing bishop's robes and carrying his head in his hand. Scenes from his life in French painting include his conversion by PAUL (8); his receiving the blessing of pope Clement I in Rome on the eve of his missionary journey to Gaul; his preaching, and martyrdom.

Departure. The Saviour, before the entry into Jerusalem, CHRIST TAKING LEAVE OF HIS MOTHER. Depicted taking leave of their parents, JOHN THE BAPTIST (3); BENEDICT (1); the PRODIGAL SON. Women deserted by their lovers, Dido by

AENEAS (6); Ariadne by THESEUS; Armida by Rinaldo (RINALDO AND ARMIDA, 5); VENUS (5) by Adonis. Hagar and Ishmael are banished by ABRAHAM (3). The Israelites load their camels and asses on departing from Egypt (MOSES, 6). The Virgin makes her farewells while Joseph saddles the ass before the FLIGHT INTO EGYPT.

Deposition, see DESCENT FROM THE CROSS.

'Descendit ad inferos'; see THOMAS, apostle.

Descent from the Cross ('Deposition') (Matt. 27:57–58; Mark 15:42–46; Luke 23:50–54; John 19:38–40). The episode that immediately succeeds the crucifixion is mentioned in all the gospels. Joseph of Arimathaea, a rich and respected member of the Sanhedrin – the Jewish legislative council in Jerusalem – and secretly a disciple, obtained permission from Pilate, the Roman governor, to take the body of Christ from the cross. He brought a linen sheet and, together with Nicodemus who brought myrrh and aloes to preserve the body, they took it down and swathed it, with the spices, in strips of the cloth. (According to John this Nicodemus was the man who visited Christ by night – see NICODEMUS, CHRIST INSTRUCTING.) We see the nails being removed from the body, or the moment that it is lowered from the cross. Some authorities make a distinction between this and the deposition proper, that is the act of laying, or depositing, the body on the ground, but it is seldom observed in the naming of pictures. The earliest examples in western art are based on Byzantine originals of the 10th and 11th cents. showing four principal participants: Nicodemus with pincers drawing the nail from the left hand, Joseph taking the weight of the body, the Virgin holding the right hand which is already free, and the apostle John standing sorrowfully a little apart. The last two, who were present at the CRUCIFIXION (5), are also regularly portrayed with Joseph and Nicodemus in the ensuing series of scenes leading to the entombment. (See PIETÀ; BEARING THE BODY OF CHRIST; ENTOMBMENT.) The development of the theme through Renaissance and baroque painting is always in the direction of greater complexity and more numerous figures. In the 14th and 15th cents. one usually sees two ladders, one resting on each end of the cross-bar, and on them two men, Joseph and Nicodemus, supporting the body. Below are the Virgin with her female companions and St John. The skull of Adam may be seen at the foot of the cross. (See CRUCIFIXION, 9.) From the 16th cent. and especially in later painting of the Spanish Netherlands the treatment is freer and fuller. The cross is viewed aslant, there are often four ladders, and two unidentified men lean over the cross-bar helping lower the body to Joseph and Nicodemus. Mary Magdalene kneels, perhaps kissing the feet of Christ. A third woman will be Mary the wife of Clopas whom John mentions being present at the crucifixion. The instruments of the Passion lie on the ground: the crown of thorns, nails, and sometimes the inscription and sponge. Another version shows the body being lowered by sliding it down a long winding-sheet, stretched from top to bottom.

Joseph and Nicodemus can be distinguished by their dress. The former is often richly and elegantly clad, perhaps hatted, in contrast to the latter who is usually of more lowly appearance. In supporting the body Joseph takes the upper part, Nicodemus the lower. In the early Renaissance it is Nicodemus who is seen removing the nails from Christ's feet. St John is, as always, of youthful appearance, often long-haired. He sometimes takes an active part, especially in the later period, helping to receive the body as it is lowered. Prior to the Counter-Reformation the Virgin is sometimes seen swooning into the arms of her companions, but in later works she stands, perhaps clasping her hands in

silent anguish. (See CRUCIFIXION, 6.) The Magdalen, who was specially venerated in the Counter-Reformation as the personification of Christian penitence, is often the central figure in 17th cent. examples of the theme. She is richly robed and with her long hair may wipe the feet of Christ, as at the crucifixion, in allusion to her original penitent gesture in the house of Simon the Pharisee. (See MARY MAGDALENE, 1.)

Descent into Limbo ('The harrowing of hell'). ('Harrow' is used in the old sense of 'ravage' or 'despoil'.) The Christian tenet that after his death Christ descended into hell has no very clear scriptural basis, but the concept appealed strongly to the early Church, and it first became an article of faith in the 4th cent. The god or hero who descends to the lower regions to fetch the dead back to the upper world is well-known in classical mythology (see ORPHEUS, 3; HERCULES, 20), and may have been the seed out of which the Christian idea grew. As early as the 2nd cent. there existed a body of writing containing descriptions of Christ's descent, how he overcame Satan and liberated the souls of the Old Testament saints. It was taught that because they lived and died in an era that was without benefit of the Christian sacraments they were relegated to a lower place until such time as Christ should come to redeem them. The story is first told as a continuous narrative in the apocryphal Gospel of Nicodemus (perhaps 5th cent.) where we read that 'the gates of brass were broken in pieces . . . and all the dead that were bound were loosed from their chains . . . and the King of glory entered in.' After Satan had been bound in irons, 'the Saviour blessed Adam upon his forehead with the sign of the cross, and so did he also unto all the patriarchs and prophets and martyrs and forefathers. And he took them and leaped up out of hell.' The early Fathers of the Church who speculated about the matter concluded that the precise region was not in hell itself but on its border, or Limbo (Lat. *limbus*, a hem). The subject enjoyed great popularity in medieval drama and literature. It is retold in the *Golden Legend*, after the version in the Gospel of Nicodemus; in Dante's *Inferno* (canto 4) Limbo forms the first Circle of Hell and its inhabitants include the virtuous pagans, poets, philosophers and heroes of classical antiquity. In medieval art the subject formed one of the scenes in the cycle of Christ's Passion. It continued to be represented through the Renaissance but is seldom found after the 16th cent. Christ, holding the banner of the Resurrection (a red cross on a white ground, occasionally vice versa), enters through a doorway. The doors, broken from their hinges, have fallen to the ground, crushing Satan underneath. Demons flee into the darkness. A throng of figures approaches from a cavern, the foremost of whom reaches out to take Christ's hand; this is Adam. He is old and grey-bearded. Behind him may be Eve, and Abel with a shepherd's crook and perhaps clothed in pelts. Among the others are Moses with horn-like rays of light; King David wearing a crown; the penitent thief, whom Christ promised should be with him in heaven, holding the cross; John the Baptist, the last of the prophets, holding a cross-staff. Other lesser crowned heads and bearded patriarchs followed behind. In later examples classical elements may appear, with Cerberus, the three-headed dog, guarding the entrance and Pluto and Proserpine enthroned over the scene.

Descent of the Holy Ghost (Pentecost) (Acts 2:1–4). The apostles returned to Jerusalem after witnessing the ASCENSION of Christ. Ten days later, on the day of the Jewish feast of Pentecost, while they were together in a room, 'suddenly there came from the sky a noise like that of a strong driving wind, which filled the whole house where they were sitting. And there appeared to them tongues like flames of fire, dispersed among them and resting on each one. And they

were all filled with the Holy Spirit and began to talk in other tongues, as the spirit gave them power of utterance.' The theme is surprisingly uncommon in Christian art after the Middle Ages, considering that it marks an important point of departure in the Christian story, the birth of the Church itself. The company consists of twelve apostles (the place of Judas had been taken by Matthias after the drawing of lots), the Virgin Mary, and occasionally Mary Magdalene and the other holy women. The Acts make no mention of the presence of the Virgin or other women, though it was usually understood from the earlier reference (1:14) that they and the apostles were 'constantly at prayer together.' But the Virgin's role here is in any case symbolic: she personifies the Church itself, also perhaps the spiritual mother of the apostles. She is generally the centre of the picture, and around her are grouped the apostles, either seated or starting up in fear and wonder. Above them is the dove of the Holy Spirit. Beams of light radiate from it to each apostle on whose brow burns a tongue of flame. A motif found in the early Renaissance and borrowed from Byzantine art shows an old man holding twelve scrolls, or *rotuli:* he is the personification of the World with the gospels in twelve languages. Or he represents the prophet Joel: in a discourse to the orthodox Jews who mistook the apostles' gift of tongues for drunkenness, St Peter quoted Joel (2:28), 'The day shall come when I will pour out my spirit on all mankind.' These words may appear as a Latin inscription, 'Effundam de Spiritu meo super omnem carnem.' Beneath the apostles are sometimes seen twelve figures, variously dressed, representing twelve nations of the world, gazing up in astonishment: 'The crowd gathered, all bewildered because each one heard his own language spoken' (Acts 2:6).

Despair personified, see HOPE.

Deucalion and Pyrrha (*Met.* 1:348–415). The story of a great flood occurs in the mythology of many races. The Greek version tells of Deucalion, son of Prometheus, who, like Noah, escaped the destruction that overtook the rest of mankind by building an ark in which he floated for nine days with his wife Pyrrha. After the waters had subsided they were advised by an oracle to veil their heads and 'throw the bones of your great mother behind you', which they took to mean the rocks of Mother Earth. They did as they were bid, the rocks which Deucalion threw turning into men and Pyrrha's into women. Thus a new human race was created. They are shown with arms upraised and sometimes with faces veiled, in the act of casting the rocks behind them. On the ground rocks change into men and women who scramble to their feet. The temple of the oracle may be in the background. (Rubens (ascribed to), Prado.)

Devil, see SATAN.

Dew. Dew falls on GIDEON'S FLEECE, laid on the ground; he kneels beside it. Beads of dew on flowers and leaves symbolize evanescence in STILL LIFE.

Diana (Gk Artemis). One of the twelve gods and goddesses of Olympus. The familiar virgin huntress of the Greeks, the stern and athletic personification of chastity, is only one aspect of a many-sided deity. In her pre-Greek origins she was an earth goddess, one of whose functions was to watch over, not destroy, wild life. Latterly she became identified with the moon goddess, LUNA (Selene) who was not remarkable for her chastity. The Romans worshipped her as a triple deity, Luna (the sky), Diana (the earth), Hecate (the underworld). According to myth she was the daughter of Jupiter and Latona (Leto), and the twin sister of Apollo. When portrayed as a huntress she is tall and slim, wears a short tunic and has her hair tied back. She carries a BOW and QUIVER, or javelin (SPEAR), and is accompanied by DOGS or a STAG. Her chariot has, since antiquity,

been drawn by stags. Her attribute, as a moon goddess, is the crescent MOON worn over her brow. In this role she rides in a chariot drawn by horses or by nymphs. As the personification of Chastity she may carry a SHIELD to protect her against Love's arrows. Chastity versus Lust, an allegorical contest depicted in Gothic church windows and sometimes in Renaissance painting, is represented by the figures of Diana and Venus. She is seen punishing Cupid. Chastity may be aided by MINERVA, goddess of wisdom. Diane de Poitiers, the mistress of Henry II of France, was sometimes portrayed as the goddess Diana, with her attributes.

1. *Diana the huntress.* A Greek sculpture of the 4th cent. B.C., which inspired Renaissance artists, shows Diana dressed in a knee-length tunic, girdle at the waist, and shod in buskins. One hand grasps a bow; the other is raised in the act of drawing an arrow from the quiver at her shoulder. She is accompanied by deer ('Diana of Versailles', Louvre). The subject has been treated with much variety. She is shown with her hounds, pursuing an animal, usually a stag, in the company of nymphs and sometimes Satyrs, armed with spears. Or they return from the chase carrying their spoils: birds and animals, even an armful of fruit. After hunting, Diana rests; sometimes she sleeps, her nymphs also, her weapons lying about her on the ground together with an abundance of dead game.

2. *Diana bathing.* The naked goddess is seated beside a pool in a shady grotto or woodland glade while attendant nymphs sweep off her robes, remove her sandals or bathe her feet. Their bows and quivers lie discarded around them. Diana wears her crescent moon.

3. *Diana and Actaeon.* Ovid describes at length (*Met.* 3:138–253) how the young prince Actaeon, hunting in the forest, stumbled accidentally upon the grotto where Diana and her companions were bathing. To punish him for his glimpse of divine nudity, the goddess turned him into a stag. He was pursued and torn to pieces by his own hounds. There are two scenes: (1) Actaeon has just discovered Diana; he stands with his dogs at his heels, his hands raised in astonishment. The nymphs retreat in disorder, at the same time trying to protect their mistress from the young man's gaze. (2) Actaeon has now grown a stag's head, or at least has sprouted antlers. He staggers backwards as his own dogs spring at him. Diana may be dressed and armed as a huntress.

4. *Diana and nymphs surprised by Satyrs.* A simple allegory of Chastity overcome by Lust, in which a band of gleeful, lascivious Satyrs, the goat-like followers of Bacchus, indulge in their favourite pastime. They spring out on a party of naked, unsuspecting nymphs, and embrace them and tear off their robes. The terrified maidens struggle to escape, and flee into the woods. Diana raises a spear in self-protection; her dogs snarl at the intruders.

5. *Diana and Callisto; Jupiter and Callisto* (*Met.* 2:442–453; *Fasti* 2:155–192). Diana's nymphs were expected to be as chaste as the goddess herself. One of them, Callisto, was seduced by Jupiter who first disguised himself as Diana in order to gain the nymph's presence. Her pregnancy was eventually noticed by Diana who punished Callisto by changing her into a bear and setting the dogs on to her. But Jupiter snatched her up to heaven just in time. There are two scenes: (1) Jupiter, in the form of Diana, bends over the naked reclining nymph, perhaps fondling her. His expression is earnest, hers faintly suspicious. His eagle perches in the background, perhaps with a thunderbolt in its claws. (2) Diana in her grotto confronts Callisto, pointing accusingly. Callisto, her robes drawn aside by nymphs to reveal an unmistakable pregnancy, cringes in shame. The nymphs

register surprise and disapproval. Or we see Callisto, a moment later, changed into a bear.

6. *Diana and Endymion* (Lucian, *Dialogues of the Gods*). The beautiful youth, Endymion, who fell into an eternal sleep, has captured the imagination of poets and artists as a symbol of the timelessness of beauty that is 'a joy forever.' Here Diana has the unusual role of lover, albeit a chaste one. The story was originally told of the more amorous moon goddess Luna, or Selene, with whom Diana became identified. Endymion, sent to sleep for ever by the command of Jupiter, in return for being granted perpetual youth, was visited nightly by the goddess. She is shown embracing the recumbent figure who lies in a leafy bower, sometimes with animals sleeping beside him. Or her presence is indicated symbolically by the moonlight which bathes him. Cupid or amoretti may be present. Another version shows Endymion awake, kneeling to welcome the arrival of the moon goddess, while her brother the sun god is just beginning his journey across the heavens in his golden chariot. (See APOLLO, 1.)

7. *Diana and Pan*. Virgil in the *Georgics* (3:391–393) tells how Pan won the love of the moon goddess with a gift of snow-white wool. He is depicted handing the bundle of wool to Diana who floats above him. He holds a shepherd's crook; his syrinx hangs on a tree. A goat, the symbol of lust, stands nearby.

8. *Sacrifice to Diana*. In the foreground is an altar on which the sacrificial fire burns. Women bring offerings of animals. Behind stands a temple and in it a statue of the goddess. (See SACRIFICE.)

See also ALPHEUS AND ARETHUSA; APOLLO; LAOCOÖN; LETO; NIOBE; IPHIGENIA.

Dido. Legendary queen and founder of the city of Carthage who, according to Virgil, fell in love with the Trojan hero Aeneas. The *Aeneid* tells how the ship-wrecked band of Trojans were cast up on her shores, and how Venus caused an unquenchable passion for Aeneas to be kindled in Dido's breast. It was bound to end in tragedy because Aeneas' departure was fore-ordained by Jupiter. Dido's death is the most frequently represented scene from her story. (See AENEAS for others.)

Dido on the funeral pyre; the death of Dido (*Aen.* 4:642–705). Having failed to persuade Aeneas to stay, Dido had her sister Anna build a great pyre in the courtyard of the palace in the pretence that she was going to make a ritual burning of Aeneas' belongings, including his arms, which he carelessly seemed to have left behind, and their bridal bed. At the sight of the Trojan ships actually sailing away Dido threw herself on the pyre and ran Aeneas' sword through her body. We see Dido, sword in hand, on the pyre, amid the broken bedstead and bedding. Her servants are lamenting. In the distance Aeneas' ships sail away. The goddess Juno, the protectress of Carthage, sent her messenger Iris to cut a lock of Dido's hair in order to release her soul from its body. Iris descends, perhaps on a rainbow. The idea was common in ancient folklore that a person's soul could exist outside his body provided that it had an object in which to reside. (cf MELEAGER whose soul existed in a log of wood.) The release of the soul from the body by cutting a lock of hair belongs to the same class of belief.

Die, Dice. A symbol of the Passion, from the soldiers who cast lots for Christ's tunic (CRUCIFIXION, 4). The attribute of FORTUNE personified. The attribute of the THREE GRACES, derived from Venus in antiquity: among the 'children' of Venus in her astrological aspect were those who played games of chance.

'Dilatasti cor meum,' see PHILIP NERI.

'Diligite iustitiam . . . ' see NICHOLAS OF MYRA.

Diogenes of Sinope (4th cent. B.C.). Cynic philosopher who lived at Athens and Corinth. Some of the anecdotes recorded about his extremely austere way of life have been depicted. He despised wordly possessions to the extent of making his home in a tub. The Greek biographer Diogenes Laërtius tells (6:37) how he threw away his drinking cup on seeing a child drinking from its cupped hands. The same writer (6:38) describes how Alexander the Great visited the philosopher and invited him to ask any favour he chose. Diogenes simply requested that the emperor stand aside as he was shading him from the sun (also Plutarch 33:14). Alexander is seen, having dismounted from his horse Bucephalus, standing before Diogenes. The latter sits by his tub gesturing to Alexander to step aside. The incident of Diogenes 'looking for an honest man' is widely represented, especially in 17th cent. Netherlandish painting. The scene is usually a market place in broad daylight, crowded with people of all ages and conditions, in the middle of which Diogenes holds up a lighted lantern. Another treatment of the theme shows the single figure of the philosopher holding a lamp, a symbol of the search for truth or virtue.

Dionysius the Areopagite, see DENIS.

Dionysus, see BACCHUS.

Dioscuri, see CASTOR AND POLLUX.

Discovery of the art of drawing ('Invention of the art . . . '). The Greek city-state of Sicyon was famous in antiquity for its painters and sculptors. According to the elder Pliny (*Natural History*, 35:43), the first sculptor was a potter of Sicyon named Butades. His daughter, in love with a young man who was about to depart on a long journey, traced the profile of his face on a wall, from the shadow thrown by a lamp. Butades filled in this outline-drawing with clay, producing the first relief. It was widely believed in antiquity that the art of drawing began by the tracing of outlines in some such fashion (Pliny 35:5). The theme is found in 17th cent. painting, chiefly French. The manner of its representation varies but it generally shows the youth, sandalled and perhaps holding a spear, and his betrothed who draws on the wall behind him. There may be onlookers gazing in wonder. (Poussin, Louvre.)

Discus, the youth Hyacinthus killed by, see APOLLO (11).

Dismas and Gestas, see CRUCIFIXION (2).

Dispute with the Doctors ('Jesus among the Doctors'; 'Dispute in the Temple') (Luke 2:41–51). When he was twelve years old the child Jesus accompanied his parents to Jerusalem for the festival of the Passover. Afterwards, Mary and Joseph set off home again unaware at first that he had remained behind. When they returned to the city to look for him they found him in the Temple engaged in learned conversation with the Jewish scribes – a 'dispute' in the sense of debate, not quarrel. The scene is the interior of Solomon's Temple. The youthful Jesus stands in the centre of a group of grey-bearded elders who listen to him earnestly or wonderingly. He may be counting on his fingers to enumerate his arguments. One of the elders holds a book in the form of a roll (a *rotulus*) in contrast to Christ who holds a codex – a manuscript book in the form we know today, symbolizing respectively the Old Law and the gospels. (The form of the codex originated early in the Christian era.) Mary and Joseph are usually seen entering at one side, or Mary places a hand on Christ's shoulder, about to lead him away – 'Your father and I have been searching for you in great anxiety.' The theme is significant as the first recorded example of Christ's teaching; it occurs also as one of the cycle of the Seven Sorrows of the Virgin. (See VIRGIN MARY, 2.)

Distaff, the stick that holds the bunch of wool or flax from which thread is spun, hence a symbol of the domestic role of woman. Held by Eve (ADAM AND EVE, 3); by a shepherdess, GENEVIÈVE; by the transvestite HERCULES (17); by Clotho, one of the THREE FATES. It was an attribute of the Virgin in medieval representations of the AN-NUNCIATION.

Distaff

Dives and Lazarus (Luke 16:19–31). The parable that teaches that riches on earth have to be paid for in eternity while the poor will enjoy their reward in heaven. There was a rich man (Latin: *dives*) who dressed in fine clothes and feasted every day while a poor man, Lazarus, lay at his gate starving. The dogs would come and lick the sores that covered the poor man's body. In time, both died and the poor man was carried to 'Abraham's bosom' or lap (see LAST JUDGEMENT, 5); the rich man descended to Hades where, in spite of his pleas to Abraham, he was condemned to remain. Lazarus is seen lying at the rich man's door, a begging bowl and a leper's clapper beside him, dogs licking his ulcers. Dives sits within at table with two courtesans, attended by servants and perhaps entertained by musicians. A servant at the door threatens Lazarus with a stick. A woman shaking out a cloth alludes to the 'crumbs from the rich man's table' that the poor man would gladly eat. Another scene shows Dives tormented by demons in hell while, above, Lazarus rests in Abraham's lap. Lazarus became popularly identified with the leper in the Middle Ages and, as though he were an historical figure, was in due course canonized and made the patron saint of lepers and beggars. The dog was regarded as an unclean animal in the ancient east, hence its place in the story.

Dividers, see COMPASSES.

Dog. Regarded in the East as a scavenger and thief and rarely mentioned in the Bible except in an unfavourable light. To the elder Pliny (*Natural History*, 8:40) it was, with the horse, the animal most faithful to man, a virtue which it exemplifies in medieval and later art. It accompanies the HUNTER. It is the attribute of DOMINIC (with a flaming torch in its mouth); MARGARET OF CORTONA (usually a spaniel); ROCH, a pilgrim, to whom it brings bread in the desert. In Dominican painting dogs (*Domini canes*, dogs of the Lord, a pun on the Saint's name) may be seen driving away wolves (heretics) that are attacking sheep (the faithful). At the LAST SUPPER a dog may lie beside Judas. In scriptural scenes it accompanies TOBIAS and the angel; the beggar at the rich man's gate (DIVES AND LAZARUS); the Canaanite woman kneeling before Christ (DAUGHTER OF THE WOMAN OF CANAAN, CHRIST HEALS THE). The apostle ANDREW exorcised seven dogs possessed of demons. In classical themes the dog is the attribute of the huntress DIANA. Actaeon's dogs attack their master (DIANA, 3). They accompany the hunters Adonis (VENUS, 5) and Cephalus (CEPHALUS AND PROCRIS; AURORA). In allegory the dog is the attribute of FIDELITY personified. In portraiture, at the feet of a woman or in her lap, it alludes to her marital fidelity or, if a widow, to her faithfulness to her husband's memory. It has a similar meaning in double portraits of husband and wife. In a contrary sense, the dog is sometimes the attribute of ENVY. It accompanies Melancholy, one of the FOUR TEMPERAMENTS; Smell, one of the FIVE SENSES; and is part of the three-headed monster symbolizing PRUDENCE. A many-headed dog (usually three) is CERBERUS.

Dolphin. The fish that symbolized their faith to the early Christians was often represented as a dolphin, as was the 'great fish' that swallowed JONAH. The latter theme was seen as a prefiguration of Christ's death and resurrection and, probably for this reason, the dolphin came to be its symbol. The dolphin in

classical themes is the attribute of NEPTUNE; of VENUS who was born of the sea; of Water personified, one of the FOUR ELEMENTS. Dolphins draw the chariot of the Nereid GALATEA. FORTUNE personified, resembling the marine Venus, may ride on a dolphin, as does ARION, a youth with a lyre. Sailors leaping overboard change into dolphins (BACCHUS, 3). See also ANCHOR.

'**Domine, quo vadis?', see PETER, apostle (4).**

Dominic (1170–1221). Founder of the Order of Preachers, also called Dominican, or Black, Friars. He was born in Spain of noble parentage. As a young man he became a canon, and found his vocation preaching against heresy. He was active among the Albigensians of southern France where he had accompanied his bishop, endeavouring to convert their heresies by persuasion, side by side with the papal forces under Simon de Montfort which were destroying them. He travelled much, preaching throughout Europe, and died in Bologna. His tomb in that city is decorated with scenes from his life. The Order included numerous artists among its members, notably Fra Angelico and Fra Bartolommeo whose works are among the glories of Dominican churches and convents. Dominic wears the habit of his Order, a white tunic and scapular underneath a long black cloak with a hood. (See diag. RELIGIOUS DRESS.) He holds a LILY (for chastity) and a BOOK (the gospels), and may have a STAR on or above his forehead: according to one contemporary account his brow radiated a kind of supernatural light; another tells that his godmother saw a star descend on his brow at his baptism. A black and white DOG with a flaming torch in its mouth alludes to the story that his mother dreamed she gave birth to such a creature; it is more likely explained as a pun on his name: 'Domini canis'. The ROSARY, the special sequence of prayers to the Virgin Mary, is thought to have been instituted by Dominic; he may therefore hold a rosary, the string of beads used as a mnemonic device when praying. Or he receives the rosary from the Virgin, or from the Infant in the Virgin's lap. (See further VIRGIN MARY, 15). Among his several inscriptions is 'Pater Sancte serva eos quos dedisti mihi in nomine tuo' – 'Holy Father, protect by the power of thy name those whom thou hast given me.' (John 17:11). Dominic may be grouped with the other saints of his Order, especially PETER MARTYR and CATHERINE OF SIENA. The following narrative scenes are, except for the last, found in the *Golden Legend.*

1. *The burning of the heretical books.* During his mission among the Albigensians a bonfire was made of heretical books. The book of Dominic, however, when cast into the flames sprang out again unconsumed.

2. *Dominic holds up the Lateran church.* While Dominic was in Rome obtaining papal sanction for his Order the pope, Innocent III, dreamed that the Lateran church was toppling and that Dominic with his own hands held it up. A similar story was told of FRANCIS OF ASSISI.

3. *Dominic receives the commission to preach from SS Peter and Paul.* As he knelt at prayer there appeared to him in a vision Peter, who handed him a staff, and Paul, a book, i.e. the gospels.

4. *The vision of Christ with three arrows.* In Rome Dominic had a vision of Christ above his head, brandishing three spears, or arrows, which he was about to unloose against the world to destroy the sins of Pride, Avarice and Lust. The Virgin, interceding for mankind, presented to Christ SS Dominic and Francis, his fighters on earth for the corresponding virtues of Obedience, Poverty and Chastity. Francis is sometimes absent.

5. *The resurrection of Napoleon Orsini.* The nephew of Cardinal Stephano di Fossanuova fell from his horse into a ditch and was killed. The body was laid

before an altar. Dominic prayed, and then cried aloud, 'O young Napoleon, in the name of our Lord Jesus Christ I bid you arise!' – and the young man did so, miraculously restored to life.

6. *The supper of St Dominic.* Dominic was about to take a meal with the friars of St Sixtus in Rome when it was found that they lacked bread. Nevertheless he bade them be seated and presently two men, who may be depicted as angels, appeared as if from nowhere laden with bread which they gave to Dominic, and as mysteriously disappeared again. Hence Dominic may have a loaf of bread for attribute.

7. *The Soriano portrait.* It was told that in 1530 a Dominican monk of Soriano in southern Italy dreamed that the Virgin, accompanied by Mary Magdalene and Catherine of Siena, presented him with a portrait of St Dominic. He awoke to find himself possessed of just such a portrait, which was discovered to have miraculous properties. The theme occurs in Dominican church art of the baroque period and shows the monk dressed in the habit of his Order kneeling before the Virgin and two saints, receiving the portrait. It is usually a full-length picture of Dominic and shows him holding a lily and a book.

See also HYACINTH.

'Dominus possedit me . . . ', see VIRGIN MARY (4).

Don Quixote. Cervantes' famous work was first published in 1605 and was widely translated. The adventures of the Knight of the Sad Countenance and of his 'squire' Sancho Panza were a source of inspiration to both painters and book illustrators, especially in France. The image of the pair is well-established. Don Quixote is gaunt and lanky, his horse Rozinante a bag of bones. His expression and posture convey dignified melancholy. Sancho Panza on his ass is in contrast a robust, well-fed peasant. The following incidents are drawn from the very large number that have been illustrated.

1. *Don Quixote in his study.* It was excessive indulgence in the literature of medieval chivalry that turned his head and set him off on his fantastic exploits. He is shown seated among his books, with armour and weapons around him. Members of his household peer anxiously at him round the door. Later, the village priest, helped by the barber and by Don Quixote's housekeeper and niece, made a bonfire of the books.

2. *The innkeeper's daughters.* At an inn that he mistook for a medieval castle the knight sat down to eat, undeterred by the fact that his helmet was stuck fast on his head. Two harlots whom he took to be damsels of the castle endeavoured to feed him. One plied him with wine, using a hollow reed for a funnel.

3. *The windmills.* Don Quixote is depicted attacking the windmills that his imagination saw as giants. He was knocked flying by one of the sails. Sancho, on his ass, gestures in mock despair.

4. *Sancho Panza tossed in a blanket.* For their refusal to pay for a night's lodging at an inn Sancho was tossed in a blanket. His master, on horseback, watches from a safe distance.

5. *The finding of the dead mule.* The pair are depicted on their journey through the mountains coming upon the corpse of a mule. Its owner was a love-lorn nobleman Cardenio who had taken to the mountains, demented with grief.

6. *Dorothea at the pool.* Dorothea, a wronged maiden, hiding her shame in the mountains, was discovered by a party of three: Cardenio, the priest and the barber. Dorothea is depicted at a pool washing her feet. Her long hair, which she had kept up in order to disguise herself as a boy, is falling down. She is being covertly observed by the others.

7. *The wedding of Gamacho and Quiteria*. A wedding arranged by the bride's father against her wishes to a rich farmer is about to be celebrated in the open with feasting and dancing. It is watched by Don Quixote and Sancho. In the end Quiteria's true love, the poor Basilio, by the ruse of pretending to stab himself to death, persuaded the priest to marry her to him instead. Gamacho was eventually pacified.

Donatian (d. 390). Christian saint and martyr, bishop of Rheims and patron saint of Bruges. His legend tells that he was thrown into the River Tiber by his persecutors. In order to locate his body which lay on the river bed, a wheel, into which were stuck five lighted candles, was floated down the stream. It stopped over the spot where the saint lay. The body was recovered and restored to life by prayer. Donatian is represented in early Netherlandish painting wearing bishop's robes. He holds a wheel with candles set round its rim.

Donation of Constantine, see CONSTANTINE THE GREAT (3).

Donatus, grammarian, personification of Grammar, see SEVEN LIBERAL ARTS.

Donatus of Arezzo. A Roman nobleman of the 4th cent., brought up as a Christian with Julian who later became the emperor Julian the Apostate. The emperor's renunciation of his faith led to the oppression of Christians in Rome, and Donatus departed to Arezzo where he eventually became bishop. He was noted for his powers of healing. The legend goes that while he was celebrating Mass heathens interrupted the service, knocking the chalice from his hands. It broke on the floor but thanks to Donatus' prayers was miraculously mended. He is depicted in bishop's robes with a broken CHALICE for attribute. It was also told of him how he proved the innocence of a tax-gatherer, falsely accused of theft: the money had in fact been hidden by the man's wife who had since died. Donatus summoned the corpse of the woman to reveal its whereabouts. Donatus is the patron saint of Arezzo. Scenes from his life and martyrdom are depicted in the Gothic cathedral of the city. He died by the sword in about 361.

Donor. A patron or benefactor, one who commissioned a painting in thanksgiving for favours received – deliverance from the plague, victory in war, release from captivity after military defeat and so on. Such votive pictures are generally of the Virgin and Child with saints and include the donor, portrayed in his own likeness, kneeling before the Virgin's throne, often with his wife and family. He may be of smaller stature than the sacred figures around him. His patron saint may present him to the Virgin. With the growth of secular patronage of art during the Renaissance such paintings became common in many schools. (See further, VIRGIN MARY, 3, 14.)

Dorcas, see PETER, apostle (8).

Dormition, SEE DEATH OF THE VIRGIN.

Dorothea. Christian saint and virgin martyr of Caesarea, a city of Cappadocia in Asia Minor. She was condemned to death by the Roman governor, Fabricius, about the year 303 for refusing to recant her belief. According to the *Golden Legend* she was accosted on the way to her execution by a scribe named Theophilus who mockingly asked her to send him roses and apples from the garden of her heavenly bridegroom. After her death a child appeared to Theophilus and presented him with a basket of roses and apples. Because of this he was converted to Christianity. He was himself later executed. Dorothea's attribute is a basket of ROSES, or roses and APPLES, or she holds the hand of an angelic child who has a basket; or she is crowned with roses, or holds them in her hand. Or she offers the basket to the Virgin or the infant Christ. Her martyrdom shows her kneeling

at the scaffold before her executioner or tied to the stake about to be burned, in the presence of the Roman governor. Angels hover above with garlands of roses. She is depicted more often in northern European painting.

Dorothea at the pool, see DON QUIXOTE (6).

Dove. The Christian symbol of the Holy Ghost, from the words of John the Baptist, 'I saw the spirit coming down from heaven like a dove and resting upon him' (John 1:32). In this sense it appears in representations of the ANNUNCIATION, BAPTISM of Christ and of PAUL, apostle (2), DESCENT OF THE HOLY GHOST and TRINITY; likewise at the ear of a saint noted for his writings, inspiring his words, in particular GREGORY THE GREAT, but also BERNARDINO, JOHN CHRYSOSTOM, TERESA, THOMAS AQUINAS. A dove issuing from a nun's mouth symbolizes her soul rising to heaven, thus SCHOLASTICA, sister of BENEDICT to whom it appeared in a vision; also REPARATA and others. In the former instance the dove may rest on her hand or a book, or hover above her head. A dove with a phial in its beak is the attribute of REMIGIUS; on a flowering wand, of JOSEPH, husband of the Virgin; two on a dish, wings spread, of NICHOLAS OF TOLENTINO; a two-headed dove on his shoulder, of ELISHA. Seven doves arranged about the devotional image of Christ or the Virgin and Child, seen more often in Gothic stained glass, symbolize the seven gifts of the Holy Spirit, from Isaiah (11:1–2); they may be inscribed Sapientia, Intellectus, Consilium, Fortitudo, Scientia, Pietas, Timor. Doves for sacrificing, see CLEANSING OF THE TEMPLE; PRESENTATION IN THE TEMPLE. The dove of the ark (NOAH) became the symbol of good tidings and peace and is hence an attribute of PEACE personified. From antiquity it symbolized love and constancy and thus a dove or pair of doves is one of the chief attributes of VENUS, and by extension of LUST. Billing doves suggest lovers' embraces. A pair, facing each other, belong to CONCORD. The dove is sometimes, surprisingly, an attribute of CHASTITY.

Dragon. In the ancient east a beneficent deity associated with the element water, but in Christian culture a symbol of SATAN. The Latin word *draco* means both dragon and snake, and hence the two are sometimes used interchangeably. A dragon chained or trodden underfoot symbolizes the conquest of evil. It appears thus beneath the feet of the Virgin of the Immaculate Conception (VIRGIN MARY, 4), and as an attribute of BERNARD of Clairvaux; MARTHA; SYLVESTER; and MARGARET OF ANTIOCH who may emerge from its belly or lead it by a cord. The 'serpent of old' is thrown into a pit by an angel, APOCALYPSE (23). A dragon is slain by the warrior MICHAEL (winged angel); by GEORGE; by the Greek hero PERSEUS; by the pagan knight Ruggiero (ANGELICA, 1). In the last three instances the creature is a sea-serpent. A dragon is the attribute of the warrior saint THEODORE. The Lernean hydra slain by HERCULES (2) is sometimes represented as a dragon. A pair of dragons draw the chariot of CERES. It is the attribute of VIGILANCE personified. See also SNAKE.

Drusiana, Raising of, see JOHN THE EVANGELIST (3).

Eagle. Sacred to JUPITER and his attribute, sometimes with a thunderbolt in its claws; GANYMEDE was borne to heaven by Jupiter's eagle. A young goddess with a jug, an eagle beside her, is HEBE. An eagle sent by Jupiter pecks the liver of PROMETHEUS. The eagle was an ancient symbol of power and victory and was represented on the standards of the Roman legions. In the same sense it has since been adopted in the armorial bearings of numerous nations. It was a medieval symbol of Christ's Ascension. It is the attribute of JOHN THE EVANGELIST, perhaps with a pen or inkhorn in its beak, and is one of the four 'apocalyptic beasts' (FOUR EVANGELISTS; APOCALYPSE, 3, 9). An eagle utters cries of woe as

the last trumpet sounds (APOCALYPSE, 11). In allegory the eagle is an attribute of PRIDE (with lion, peacock), and of Sight, one of the FIVE SENSES. It is an *impresa* of the Gonzaga family of Mantua, patrons of the arts in the Renaissance.

Ears. Pointed ears with a goat-like face and legs, the attributes of PAN and the SATYR. Ass's ears growing on a human head, see ASS. Peter the apostle cutting off an ear, see BETRAYAL.

'Ecce Agnus Dei,' see JOHN THE BAPTIST.

'Ecce Ancilla Domini,' see ANNUNCIATION.

Ecce Homo (John 19:4–6) – 'Behold the Man!' – the words of Pontius Pilate, the Roman governor of Judaea, to the Jews gathered outside the judgement hall, after Christ had been scourged and then mocked by the soldiers. (See FLAGELLATION and CROWNING WITH THORNS.) ' "Here he is; I am bringing him out to let you know that I find no case against him"; and Jesus came out, wearing the crown of thorns and the purple cloak. "Behold the Man!" said Pilate. The chief priests and their henchmen saw him and shouted, "Crucify! crucify!" ' The theme is very seldom found in Christian art until the Renaissance when it became widely represented in all schools of European painting. It is treated in two distinct ways, either as a devotional image, showing the crowned head or half-figure of Christ alone; or as a narrative statement that includes the many persons of the drama in the setting of a town square or on the balcony of Pilate's *praetorium* or judgement hall. Christ is invariably represented wearing the emblems of kingship with which the mocking soldiers had earlier invested him: the crown of thorns and a purple or red cloak; he may also hold a reed sceptre. His wrists, often crossed, are usually tied with a cord or chain and he may have a rope knotted round his neck. His body sometimes shows the marks of his scourging. His expression, always a challenge to artists in this context, is generally one of compassion towards the hostility that surrounds him; in earlier Renaissance painting he sometimes weeps. In narrative versions of the theme Christ is attended by two guards. Pilate, standing nearby, gestures towards him, illustrating his words. The crowd of people below the balcony brandish their fists as they call for his crucifixion. In works of northern Europe especially they wear the dress of the burghers and common people of the artist's era.

'Ecce virgo concipiet (et pariet filium),' see ISAIAH.

Echo, see NARCISSUS.

Education of the Virgin. The *Golden Legend*, drawing on the apocryphal gospels, tells how the Virgin Mary was brought up as a child in the Temple at Jerusalem 'with other virgins . . . and was visited daily of angels,' since it had been foretold to her parents, JOACHIM AND ANNE, that their daughter was to be consecrated to the Lord as the 'chosen vessel' of Christ's Incarnation. The theme became popular in the 16th cent. and remained so after the Counter-Reformation in spite of some disapproval by the Church because of its apocryphal character. Mary is seen in earlier examples teaching her young companions, sewing the priests' vestments or being ministered to by angels who bring bread and water. But the favourite theme, especially in Counter-Reformation art, depicts her education in the strict sense, at the knee of her mother Anne, learning to read. Angels may descend above her head bearing a floral crown.

'Effundam de spiritu meo . . . ,' see DESCENT OF THE HOLY GHOST.

Egg. In ancient near eastern religions a symbol of creation which came to be associated with spring festivals of revival and rebirth, and hence later with Easter. It is a Christian symbol of the Resurrection, see STILL LIFE. The ostrich's egg symbolizes virgin birth; according to the bestiaries it digs a hole for the egg,

covers it with sand and leaves it to hatch of its own accord (Piero della Francesca, altarpiece, Brera Gall., Milan).

Two infants hatching from an egg, see LEDA.

'Ego me Christo sponsam tradidi . . . ,' see CATHERINE OF ALEXANDRIA.

'Ego vobis Romae propitius ero,' see IGNATIUS OF LOYOLA.

Elements, personified, see FOUR ELEMENTS.

Elephant. A beast of burden with which the Romans became acquainted during the Punic wars, and therefore associated with military victory. Thus the chariot of FAME is drawn by elephants (see also TRIUMPH). It is the attribute of Africa personified, one of the FOUR PARTS OF THE WORLD. She may wear an elephant's head as a kind of head-dress. An elephant in a tent, disclosed by one soldier to another, FABRICIUS LUSCINUS.

Elevation of the Cross, see RAISING OF THE CROSS.

Eligius, see ELOI.

Elijah (*c.* 9th cent. B.C.). Hebrew prophet, a forceful character who vigorously opposed the cult of Baal among the Israelites. Though his historicity is not in doubt, the events of his life are told in strongly mythical terms intended to emphasize the miraculous power of the god of the Jews. Elijah's usual attributes are the ravens which fed him in the desert and a wheel of the fiery chariot in which he ascended to heaven. He is usually dressed in pelts like John the Baptist, whom he was said to prefigure, or in the Carmelite habit, a white mantle over a dark brown tunic. According to legend he lived as a hermit on Mount Carmel and was traditionally regarded by the early Carmelites as the founder of their Order. Next to the Virgin Mary, the protectress of the Order, Elijah is the most prominent figure in the decoration of Carmelite churches.

1. *Elijah fed by ravens* (I Kings 17:1–6). During a prolonged drought Elijah went to dwell by the brook Cherith which still ran. Ravens brought him bread and meat morning and evening, as they did to PAUL THE HERMIT, ANTHONY THE GREAT and others in the desert. He is depicted at the water's edge. The bird brings food in its beak.

2. *Elijah and the widow of Zarephath* (I Kings 17:8–24). But the brook dried up so Elijah moved on to the city of Zarephath where he met a widow gathering sticks who gave him food and drink. The widow's son was mortally sick so Elijah carried him upstairs where 'he stretched himself upon the child three times' and called upon God. By this means the child was revived. The widow's sticks are depicted in the form of a cross. (cf ELISHA, 1.)

3. *The rival sacrifices of Elijah and the priests of Baal* (I Kings 18:17–40). Jezebel, the wife of Ahab, king of Israel, fostered the worship of Baal. Elijah challenged the priests of Baal to a contest to prove the power of their god. Two sacrificial altars were set up on Mount Carmel, one to Baal and one to the god of the Jews. Each side then called on his own god to ignite their pyre. Baal did not answer, in spite of the frenzied invocations of his priests, but Elijah's god sent fire which burnt up his sacrifice. This was seen as a prefiguration of the pentecostal fire which descended on the apostles.

4. *Elijah visited by an angel* (I Kings 19:4–8). Driven into the desert by Jezebel and about to die, Elijah lay down under a juniper tree. An angel appeared to him bringing food and drink which gave him strength to continue in the desert for forty days. The angel sometimes holds a chalice and bread, to symbolize the Eucharist.

5. *The chariot of fire* (II Kings 2:9–15). As Elijah and his follower Elisha were walking together 'there appeared chariots of fire and horses of fire, which

separated them one from the other, and Elijah was carried up in the whirlwind to heaven.' Elisha took up the mantle which fell from Elijah as he ascended. Commentators point out that Elijah was not expressly carried up in the chariot itself, though he is universally depicted thus. The theme first appears in primitive Christian art. The Resurrection, a new and important concept to early converts, was represented symbolically by the use of themes such as Jonah expelled by the whale and Elijah's ascent. Artists of that era, faced with unfamiliar subjects, drew on existing imagery, much of it pagan. Thus Apollo's quadriga, which appeared on coins of every city that practised the sun-cult, became Elijah's chariot. Although medieval artists reduced it to a crude four-wheeled cart, its classical treatment was restored in the Renaissance. (The ancient Babylonian sun-god, with his fiery chariot and horses, may have been the source from which the biblical writer embellished his account of Elijah.)

Elisha. The disciple of the Hebrew prophet ELIJAH, he was called from the plough to follow his master. Numerous miracles are recorded of him. He is generally dressed in the Carmelite habit, like Elijah, and is often bald. Some small boys who mocked him for his baldness were mauled by bears (II Kings 2:23-4). A two-headed DOVE may rest on his shoulder.

1. *The raising of the Shunammite's son* (II Kings 4:8-37). A remarkable instance from the Bible of resuscitation by the 'kiss of life'. Elisha was sent for by a rich woman of Shunem – who had earlier befriended him – because her son had collapsed in the fields and was seemingly dead. He went to the boy's room and 'lay upon the child, put his mouth to the child's mouth . . . he pressed upon him and breathed into him seven times; and the boy opened his eyes.' The theme features in Christian art as a prefiguration of the RAISING OF LAZARUS.

2. *The cleansing of Naaman* (II Kings 5:1-19). Naaman, the commander of the army of the king of Damascus, was a leper. He was advised to seek out Elisha who bade him wash seven times in the river Jordan in order to be cured. Naaman did so, in spite of misgivings, and 'his flesh was restored as a little child's.' The theme prefigures the BAPTISM of Christ in the Jordan. Naaman may have a halo, a sign that he was free from sin through his baptism.

Elizabeth. The mother of John the Baptist, generally represented as an elderly woman, her head veiled. She has no regular attribute. See VISITATION; JOHN THE BAPTIST (2); MASSACRE OF THE INNOCENTS; VIRGIN MARY (17).

Elizabeth of Hungary (1207-31). A princess of the Arpad dynasty of Hungary. She was married at the age of fourteen to Ludwig, the landgrave of Thuringia, who died only six years later. Elizabeth then entered the Franciscan Order, devoting her few remaining years to the care of the sick and needy in the city of Marburg, where she died. Elizabeth was especially venerated in Germany, and her image is widespread in the art of northern Europe. For the Franciscans she is the symbol of female charity and features in the work of Italian painters of the Order. She is dressed as a Franciscan nun (see diag. RELIGIOUS DRESS), sometimes wearing a CROWN in allusion to her royal birth; she may have a triple crown, perhaps symbolic of her three states of virgin, wife and widow. Alternatively she is richly dressed as a princess in a fur-lined cloak. The model of a church held in her hand refers to the city of Marburg. ROSES are her commonest attribute, usually in her lap. The legend goes that her husband once met her in the street as she was carrying bread in her apron to take to the poor. When he opened the apron to know what it contained, he found it full of roses. Elizabeth is depicted tending the sick, especially those with leprosy and other skin diseases. A legend of her charity, sometimes depicted in German Renaissance art, told

that she put a leper child in her bed. Her husband, returning, angrily pulled off the bedclothes to find instead the form of the infant Christ lying there. In devotional images beggars and cripples surround her, waiting their turn to be healed.

Elmo, see ERASMUS.

Eloi (Eligius) (*c*. 588–660). A craftsman in metal, born near Limoges of humble origin, he rose to become master of the mint under the Frankish king, Clotaire II. He combined piety with industry and undertook missionary work, founding monasteries and hospitals. He was made bishop of Noyon (Oise), *c*. 641. Eligius is the patron saint of gold- and silver-smiths and farriers. He is often represented in pictures of the Bolognese school, as one of the patrons of the city. He is dressed either as a bishop, or as a smith with a leather apron and cap. His attributes are the tools of his trade, a HAMMER and TONGS, or an ANVIL and bellows at his feet. A legend, sometimes depicted, tells how, in order to shoe a kicking horse which was possessed by the devil, he cut off its leg the more easily to handle the job, and afterwards miraculously replaced it. He is seen subduing Satan, holding him by the nose with a pair of tongs. In works commissioned by the guilds of which he was patron, he is depicted chasing a cup or presenting a gold shrine to the king.

Elymas, magician struck blind, see PAUL, apostle (5).

Embarkment for Cythera. The island of Cythera, off the coast of Laconia in southern Greece, is associated with Venus since, according to one version of her myth, she landed there after being born of the sea. In a play, *Les Trois Cousines*, by the French dramatist Dancourt, first performed in 1700, the young men and girls of a village prepare to board a boat that will take them to the temple of Love on the island. They are dressed as pilgrims and are of all classes – courtier, bourgeois and peasant. The subject was made famous by Watteau who painted it more than once (Louvre and elsewhere), but it attracted few other artists. The young lovers are depicted about to embark. Their amorous purpose is suggested by a garlanded herm of Venus, brooding over the scene. In the background is the sea. Cythera can be seen in the distance. The departure from the island is also depicted.

Emmaus, see JOURNEY TO E.; SUPPER AT E.

Endymion, see DIANA (6).

Entombment (Matt. 27:57–61; Mark 15:42–47; Luke 23:50–55; John 19:38–42). This episode from the Passion of Christ is related in all the gospels, coming after that of BEARING THE BODY OF CHRIST, and featuring the same principal figures. According to Matthew, Joseph of Arimathaea 'took the body, wrapped it in a clean linen sheet, and laid it in his own unused tomb, which he had cut out of the rock; he then rolled a large stone against the entrance, and went away. Mary of Magdala was there, and the other Mary, sitting opposite the grave.' John mentions that Joseph was helped by Nicodemus, 'the man who had first visited Jesus by night' (see NICODEMUS, CHRIST INSTRUCTING), who brought myrrh and aloes to preserve the body. He also adds that the tomb was in a garden near the place of crucifixion. The setting of the scene so that it conforms to the gospels' account presents a problem which artists have handled in various ways. The action may take place in front of a hollow rock, perhaps with a neatly rectangular entrance and a flat stone slab for a door; or we are within the sepulchre and have a view through a rough archway of the landscape outside. But Italian Renaissance painting, generally disregarding the written word and basing its composition on antique reliefs, has a simple rectangular sarcophagus in an open setting. The

body of Christ, lying on a winding-sheet, is about to be lowered into it. Joseph of Arimathaea, who traditionally takes precedence over Nicodemus by virtue of rank and age, holds the sheet at the head; his companion, more humble in appearance, takes the feet. (Their places are occasionally reversed.) The Virgin and John the apostle, who were present at the CRUCIFIXION (5, 6) and in the subsequent scenes leading up to the 'Entombment', stand beside the body. She may lean forward to kiss Christ's face, and is sometimes gently supported by John. Mary Magdalene, as in the preceding scenes, may embrace the feet which in Christ's lifetime she anointed as an act of penitence (Luke 7:36–50); or she stands with her arms thrown up in a dramatic gesture of grief. Two or three other holy women may also be present. When the subject is treated devotionally rather than as an illustration of the gospel narrative, angels may take the place of the human figures. This is to be seen particularly in the art of the Counter-Reformation where they are found carrying the body to the sepulchre or lowering it into the tomb. Since the Entombment forms part of the total concept of the Resurrection the two subjects may sometimes be combined. In the lower half of the picture we have the customary group round the tomb while above is the figure of the resurrected Christ, perhaps accompanied by angels holding the instruments of the Passion.

Entry into Jerusalem (Matt. 21:1–11; Mark 11:1–10; Luke 19:29–38; John 12:12–15). Christ's final visit to Jerusalem, his entry into the city riding on an ass and surrounded by a crowd crying Hosanna, is given in all four gospels though with some variation of detail. In art it forms the first scene of the cycle of the Passion, and is also treated as a separate subject. It is found first in Christian art of the 4th cent. on sarcophagi from the Roman catacombs. As part of the Passion cycle it is often to be seen in the stained glass and stone carving of Gothic cathedrals. The subject seems to have fallen out of favour in the later Renaissance. The gospels variously describe the disciples as being sent to fetch an ass and its foal (Matt.), or an unbroken colt (Mark, Luke) (the colt can be the young of an ass as well as a horse). According to John, Christ merely 'found a donkey and mounted it.' Artists show the Saviour seated, generally astride, with the foal often following behind. In the eastern Church he traditionally sits 'side-saddle' – a normal way of riding an ass in the East – and is thus presented full-face, as if enthroned. In the background is a city gate out of which pour a throng of young and old. The foremost lays his cloak on the ground before Christ, while behind follow children holding branches. The canonical gospels make no mention of children but the apocryphal Gospel of Nicodemus relates that 'the children of the Hebrews held branches in their hands.' The branches are usually recognizable as palms, sometimes also olives. According to John the people 'took palm branches and went out to meet him.' It is from this that Palm Sunday takes its name, the festival on the Sunday before Easter commemorating the Entry and which, in the Roman and eastern Churches, includes a procession of palms. The olive branches are explained by the fact that the scene takes place by the Mount of Olives. In the background are two trees, usually olives but sometimes palms, and in each is the figure of a man. One is cutting branches 'to spread in his path' (Matt.). The other is Zacchaeus, a rich tax-gatherer, of whom Luke (19:3–4) says that 'being a little man, he could not see him for the crowd. So he ran on ahead and climbed a sycamore tree in order to see him.' This incident which occurred in Jericho earlier on Christ's journey, is transferred to the scene of the Entry.

Envy (Lat. *Invidia*). One of the seven Deadly Sins (see VIRTUES AND VICES). Envy,

when personified, is generally but not always female. Ovid (*Met.* 2:768 ff) described her feeding on snakes' flesh and having a sickly face, squinting eyes, decayed teeth, a wasted body and a tongue dripping poison. The Renaissance portrayed her gnawing either her heart, which she holds in her hands, or her entrails. Having a poisoned tongue Envy naturally acquired a SNAKE for attribute. It may protrude from her mouth. Or, like MEDUSA, she has snakes for hair. A DOG, large and barking viciously, is occasionally associated with her. (See INNOCENCE.) Envy may form one of a group of personified sins in the allegory depicting a historical figure who turns his back on vice. In the form of a hideous old woman, Envy herself turns away from a pair of lovers. See also CALUMNY OF APELLES.

Eos, see AURORA.

Epimetheus, brother of Prometheus, see PANDORA.

Erasmus (Ital. Elmo; Sp. Ermo). Early Christian martyr, bishop of Formiae in Campania, he died *c.* 303. According to legend his executioners disembowelled him, winding his entrails round a windlass. As patron saint of Mediterranean sailors his attribute was a capstan and this, according to some, was the origin of the story of his martyrdom. He is depicted lying naked on a block while his bowels are wound on to a windlass (Poussin: Vatican Gall.). As a devotional figure he is dressed as a bishop with a CAPSTAN for attribute, or occasionally a sailing ship. Carpenters' nails pushed under his finger-nails allude to further tortures.

Erato, see MUSES.

Erichthonius (*Met.* 2:553–563). The story, part of the legendary history of Athens, has echoes of a primitive fertility rite. It tells how Vulcan, in a clumsy attempt to ravish Minerva, accidentally let his semen spill over the ground, and Mother Earth, thus fertilized, gave birth to Erichthonius. Minerva shut the infant in a chest, or basket, which she entrusted to the three daughters of Cecrops, king of Attica, forbidding them to open it. But one of them, overcome by curiosity, did so and discovered that the child had a serpent's tail for legs (or that a serpent lay beside it). Maddened with terror the three threw themselves from the top of the Acropolis. Erichthonius, brought up by Minerva, became king of Athens. The three sisters are depicted in the act of opening the basket, out of which a snake uncurls itself. The infant lies inside. A crow which, according to Ovid, witnessed the scene, may be perched in a tree. Mother Earth may be represented by a statue of Diana of Ephesus, the many-breasted goddess of fertility. The theme is most often found in 17th cent. Netherlandish painting. (Jordaens, Antwerp Mus.)

Eris, goddess of Strife, threw a golden apple into the BANQUET OF THE GODS; (also JUDGEMENT OF PARIS).

Ermine. The stoat in winter, when it has white fur and a black tip to the tail; a symbol of purity from the legend that it died if its whiteness became soiled. Hence an attribute of Chastity at her TRIUMPH and, when included in female portraiture, an allusion to the sitter's virtue. Virgin saints of rank may wear a cloak lined or trimmed with ermine, in particular URSULA who has an additional claim to it. The Magdalen's cloak is sometimes of ermine. It is the attribute of Touch personified, one of the FIVE SENSES. It is the *impresa* of Anne of Brittany and of her daughter, the wife of Francis I (1494–1547), the latter a patron of the arts; thus seen in royal châteaux of France, e.g. Blois. The arms of the dukes of Brittany were Ermine.

Erminia and the shepherds ('E. and the basket-makers') (Tasso, *Jerusalem Delivered,*

7:6 ff). This episode from the romantic epic poem of the first Crusade by Tasso tells how Erminia, daughter of a Saracen king, loved the Christian knight Tancred and, believing him to be wounded, set off to search for him. She was disguised in armour belonging to the female warrior Clorinda. She came upon an old shepherd sitting outside his hut playing a pipe, while nearby his three sons were weaving baskets. The shepherd extolled to her the joys of his secluded, peaceful existence, in contrast to the war raging not far away, and which Erminia in her armour seemed to typify. As an evocation of the virtues of the pastoral life the theme was popular among baroque painters. The scene is a woodland clearing. Erminia is in armour, perhaps dismounting from a horse. Beside her is a pipe-playing shepherd. She may symbolically be in the act of removing her armour, the shepherd's wife and children helping her. There are baskets and bundles of osiers. Sheep and cattle graze nearby. Further related incidents are TANCRED AND CLORINDA and TANCRED AND ERMINIA.

Ermo, see ERASMUS.

Eros, see CUPID.

Erymanthian boar, see HERCULES (4).

Esau, see JACOB (1, 3).

Esther. The Old Testament book of Esther describes how a young Jewess interceded with a Persian king to prevent the massacre of her people. For this deed she is still commemorated in the Jewish festival of Purim, when the story is read aloud in the synagogue. It tells of King Ahasuerus (Xerxes) of Persia who reigned in the 5th cent. B.C. Having dismissed his queen, Vashti, because she had offended him the king chose Esther to replace her, not knowing that she was Jewish. Esther, an orphan, was 'fair and beautiful' and had been brought up by her cousin, Mordecai. The king's chief minister, Haman, an enemy of the Jews and the personal foe of Morcecai, decreed that all the Jews in the Persian empire should be massacred. Mordecai asked Esther to intercede with the king. To enter the king's presence without being summoned was forbidden on pain of death, even to the queen, but Esther, having dressed in her finest robes, took her courage in both hands and entered the royal chamber. Ahasuerus held out his golden sceptre to signify that he would receive her and Esther swooned with relief. She led up to the matter by first inviting the king to a banquet where, in due course, her intercession on behalf of her people succeeded. Haman was hanged on the gallows he had prepared for Mordecai.

Esther in the act of pleading with the king was regarded by the Church as a prefiguration of the Virgin in her role of intercessor on the Day of Judgement. This became established early on as the central episode of the Esther narrative in Christian art. The more secular theme of the 'Toilet of Esther' gained popularity with artists of the Renaissance and later.

'Et dabo vobis cor novum . . .,' see EZEKIEL.

Et in Arcadia ego. A phrase coined in 17th cent. Italy expressing, in an elliptical way, the humanistic sentiment: 'Even in Arcadia I (i.e. Death) am to be found.' That is to say, even the escapist, pastoral world of Arcady is no refuge from death. The words feature in paintings from that time inscribed on monumental stonework, especially a tomb, which stands in rural surroundings. The earliest representation of the theme (Guercino, Gall. Corsini, Rome) shows two shepherds coming unexpectedly upon a skull – the typical *memento mori* – that lies on a piece of fallen masonry bearing the words 'Et in Arcadia ego.' In the hands of Poussin who made two versions the sense was gradually modified. Shepherds are seen before a tomb deciphering the inscription with an air of melancholy

curiosity. The skull is no longer significant or is omitted. The words now seem to imply an epitaph on the person – perhaps a shepherdess – who lies entombed: 'I too once lived in Arcady', an alteration to the meaning that somewhat stretches the grammar of the original Latin. The 18th cent. tended to follow the same interpretation, so that the theme eventually became simply one of nostalgia for a lost golden age, or for the passing of youthful love.

'Et in Jesum Christum . . . ,' see ANDREW, apostle.

Euclid, personification of Geometry, one of the SEVEN LIBERAL ARTS.

Eumenides, see THREE FATES.

Euphemia (died *c*. 307). Virgin martyr, believed to have died at Chalcedon on the Bosphorus, under the persecution of the Roman emperor Galerius. Legends concerning this saint have little factual basis, and chiefly relate to the manner of her death. She was cast into the flames and thrown to the lions and bears, neither of which harmed her. She finally died by the sword. Many churches of both eastern and western Christendom are dedicated to her. She features in Italian Renaissance painting, her principal attributes being a LION or BEAR and a SWORD, the latter perhaps piercing her breast. She may hold a LILY for chastity, and the martyr's PALM.

Europa, see RAPE OF E.

Europe personified, see FOUR PARTS OF THE WORLD.

Eurydice, see ORPHEUS (2, 3).

Eurytion, Centaur, see HERCULES (19).

Eurytus, see CENTAUR.

Eustace (d. 118). Legendary Christian martyr, an officer in Trajan's army. His conversion to Christianity was said to have come about when he was out hunting one day and was confronted by a white stag which had a radiant crucifix between its antlers. A voice told him that he would be sent many tribulations as a test of his new faith. He was baptized in the name of Eustace, having up to that time been known as Placidus. His legend, which lacks any historical basis, goes on to tell how, on a voyage to Egypt with his family, the captain of the boat seized Eustace's wife by way of payment of his fare since he had no money. Carrying his two sons one at a time across the Nile, he was returning for the second when a lion and a wolf, one on each side of the river, sprang out and seized a child. The family were later all miraculously reunited, but suffered martyrdom by being roasted alive in a hollow, brazen bull. Narrative scenes of the saint's life depict all the above episodes. Most widely represented is Eustace's vision of the crucifix, when he is seen on horseback, usually in a woodland setting, the stag appearing before him. The same legend is told of HUBERT. Eustace however can generally be distinguished by his dress which is the armour of a Roman soldier or medieval knight. As a standing figure his attribute is the STAG's head with a crucifix, which may appear on a banner; or a BULL of brass. He may carry his two sons in his arms, and have his wife with him. He may be accompanied by JOB whose faith, like that of Eustace, was tested by suffering. Scenes from his legend are found especially in French cathedrals of the 13th cent. His image was superseded by that of Hubert during the Renaissance.

Euterpe, see MUSES.

Evangelists, see FOUR EVANGELISTS.

'Ex praeterito – praesens prudenter agit – ni futura actione deturpet,' see PRUDENCE.

Expulsion, see ADAM AND EVE (3).

Expulsion of the money-changers, see CLEANSING OF THE TEMPLE.

Extreme Unction, one of the SEVEN SACRAMENTS.

Eye. Like the hand, an earlier symbol of GOD THE FATHER before he came to be represented in human form. In the Renaissance it may be framed in a triangle to signify the TRINITY. Eyes in a dish, or on a stalk, are the attribute of LUCIA. POLYPHEMUS had one eye; all-seeing Argus, one hundred (see IO; JUNO; MERCURY, 1). A prisoner, his eye about to be put out, before a judge who points to his own eye, JUDGEMENT OF ZALEUCUS. The 'evil eye', see CORAL.

Ezekiel. One of the four 'greater prophets.' (The others are ISAIAH, JEREMIAH and DANIEL.) He was among the Hebrews exiled to Babylon in 579 B.C. where, beside the River Kebar, he experienced visions of an apocalyptic kind. His call to prophesy (ch. 1) came about through a vision of God enthroned among four creatures that had the faces of a man, lion, ox and eagle, each with four wings – the 'apocalyptic beasts' that recur in the book of Revelation and that the medieval Church made into symbols of the FOUR EVANGELISTS. The four creatures each had a wheel beside it that 'sparkled like topaz' and had a rim full of eyes, an image sometimes adopted in the representation of angels in Byzantine and Gothic art. His literary style is thought to have been influenced by the images of the Babylonian myths that surrounded the Jews in captivity. Ezekiel as portrayed by Michelangelo (Sistine chapel) is old with a flowing white beard. He sometimes has for attribute a double wheel symbolizing the Old and New Testaments. His inscriptions are, 'Et dabo vobis cor novum . . . ' – 'I will give you a new heart and put a new spirit within you' (36:26); and 'Porta haec clausa erit; non aperietur,' – 'This gate shall be kept shut; it must not be opened' (44:2). The latter became a well-known metaphor of virginity (see VIRGIN MARY, 4). Ezekiel's poetic allegory of the valley of dry bones that were reclothed in flesh and restored to life (37:1–14) was seen as a prefiguration of the general resurrection of the dead and is hence sometimes found as a motif in the LAST JUDGEMENT.

Fabricius Luscinus. An example of the virtues of abstinence and continence among the ancient Romans, quoted by Valerius Maximus (4:3). Fabricius (3rd cent. B.C.) refused offers from the Samnites of gold, silver and slaves. Plutarch (21:20) relates a similar episode on the occasion of Fabricius' embassy in 280 B.C. to Pyrrhus, king of Epirus. The scene shows Fabricius rejecting precious objects brought to him by soldiers. Pyrrhus may be present, pointing to the proffered gifts. (The theme resembles that of CURIUS DENTATUS.)

Plutarch further describes how Pyrrhus, in an attempt to unnerve Fabricius who had never before seen an elephant, suddenly produced one that he had hidden behind a curtain. Fabricius is seen sternly standing his ground as Pyrrhus draws aside the hangings of a tent to disclose the beast which, says Plutarch, 'raising his trunk over the head of Fabricius, made a horrid and ugly noise.' (Ferdinand Bol, Royal Palace, Amsterdam.)

Faith (Lat. *Fides*). With HOPE and CHARITY, one of the three 'theological virtues' see VIRTUES AND VICES), and like them represented as a woman with identifying attributes. Faith is usually seen as one of the group of three. In Gothic art she occupies the place of honour on the right hand of Christ, and holds a CROSS and perhaps a CHALICE, attributes that she retains later. She may have a FONT, a reminder of the rite of initiation into the Christian faith. She is opposed by the vice of Idolatry, represented as a man worshipping a monkey, a symbol of paganism in the Middle Ages; or, in the early Renaissance, as a man with a cord tied to his neck, the other end of which is attached to an idol. In Counter-Reformation art Faith may carry an open book on which lies a cross – showing that it represents the Scriptures. Her foot rests on a stone block (see CUBE), her

unshakeable foundation. She sometimes holds a CANDLE, the light of faith, an attribute that she shares with Charity. A HELMET protects her against the assault of heretics. Her characteristic gesture is to hold her hand to her breast.

Falcon. Bird of prey, trained for hunting. The attribute of BAVO and JULIAN THE HOSPITATOR. With a diamond RING in its claw, and the motto 'Semper' the *impresa* of Piero de' Medici (1414–1469).

Falerii, Schoolmaster of (Livy 5:27; Plutarch 8:10). During the siege of the Etruscan town of Falerii by the Romans under Camillus in the 4th cent. B.C., a Falerian schoolmaster, taking advantage of a period of military inactivity, was accustomed to exercise his pupils outside the city walls. A traitor at heart, he one day succeeded in leading them into the Roman camp where he offered them as hostages to Camillus. The latter rejected him contemptuously, and had his officers strip the schoolmaster and bind his hands behind his back. The children were then supplied with sticks and bidden to drive their teacher back to their city. The Falerians, overcome by this example of Roman probity, yielded. Camillus is depicted on a seat of judgement, flanked by soldiers carrying Roman standards and FASCES. The naked schoolmaster, hands tied, is about to be set upon by the children (Poussin, Louvre).

Fall of Man, see ADAM AND EVE (2).

Fall of the rebel angels, see SATAN.

Fame. The personification of Fame as a female figure was known in classical antiquity. She is found in the company of the illustrious dead, and occasionally the living, whom she bears away on wings that, according to Horace, never tire (*Odes*, Bk 2, 2:7–8). Her TRUMPET (which she did not possess in antiquity) is an invariable attribute in Renaissance and later art. It is long and straight and may have wings. Sometimes she has two, a long and a short, for good and ill repute. She may hold a PALM branch, the symbol of victory to which she is generally the sequel; she may for the same reason wear a CROWN. She sometimes sits on a GLOBE, a sign of her ubiquity. Fame is naturally found in association with historical figures, and is often seen on funerary sculpture. She may lead the SEVEN LIBERAL ARTS up to Olympus. The TRIUMPH of Fame, in which she overcomes Death, shows her riding on a car drawn by elephants. The winged horse PEGASUS is also a symbol of Fame. MERCURY, or Fame herself, may be mounted on it. See also HERCULES (21).

Farrier, see BLACKSMITH.

Fasces. Bundle of wooden rods enclosing an axe and bound with a red strap, the emblem of higher Roman magistrates, signifying their authority to scourge and to behead, and carried by their attendants the lictors. (Within the city of Rome the fasces had no axe, since there was there a right of appeal against a capital sentence.) Commonly seen in scenes of Roman justice; see JUDGEMENT. An attribute of JUSTICE personified. A symbol of unity, especially conjugal, when it may be held by Cupid.

Fates, see THREE FATES.

Father Time. The familiar figure with SCYTHE and HOUR-GLASS, generally winged and nude except for a loin-cloth. He may have a CRUTCH and sometimes a SNAKE with its tail in its mouth. Father Time's origins are curious. The classical personification of Time had none of the well-known attributes. But it came about that the Greeks confused their word for 'time', *chronos*, with their old god of agriculture Cronus, who had a sickle for attribute, and this in due course became the scythe of Father Time (see SATURN, 1.). The Romans identified Cronus with their Saturn who, as a god of agriculture, also

Fasces

had a sickle. As an aged deity Saturn had a crutch which Father Time likewise acquired. The snake with its tail in its mouth, an ancient Egyptian symbol of eternity, was given to him by mythographers of late antiquity; the wings and hour-glass by early Renaissance illustrators. In Renaissance painting Father Time is depicted in a very literal way performing numerous allegorical actions: he records in his book the deeds of heroes (or the figure of HISTORY records them on a tablet which rests on his shoulders); he unveils TRUTH, and reveals Innocence (conveying the idea that right must in the end prevail); he destroys youth and beauty; he adds to the burden man bears on his back – man, if he is fortunate, may be supported on either side by Innocence (identified by her LAMB) (or perhaps Faith) and by Hope (with her ANCHOR); he eventually takes away life itself, and may therefore be accompanied by the figure of DEATH. (See also PHAETHON; HERCULES, 21.)

Fatness. The figures of GLUTTONY and IGNORANCE are fat. An aged corpulent drunkard, attended by Satyrs, is SILENUS.

Faunus, see PAN.

Feast of the gods, see BANQUET OF THE G.

Feast of Venus, see PUTTO.

Feather. Head-dress of feathers, the attribute of America personified, one of the FOUR PARTS OF THE WORLD; worn by tribesmen of the Indies, see FRANCIS XAVIER. Three feathers, resembling the ostrich's, passing through a ring, sometimes white, green and red, and symbolizing faith, hope and charity, are the *impresa* of Lorenzo de' Medici (1448–92) and the Medici popes Leo X (1513–21) and Clement VII (1523–34).

Feeding of the five thousand ('Multiplication of loaves and fishes'). The miracle is described in all four gospels, but representations of it are more often derived from John's account (6:1–13) which contains elements not found in the other three such as the part played by the apostles Andrew and Philip, and the presence of the young lad who brought the loaves and fishes. Matthew and Mark describe two separate occasions of the feeding of the multitude but artists rarely differentiate between them except sometimes in the number of loaves (the first: five; the second: seven), and the number of basketfuls of uneaten scraps that were collected afterwards (twelve; seven).

It is related how Christ went up a hillside near the shore of the Sea of Galilee with the disciples and sat down and soon a great crowd of people, some five thousand, gathered round him. Philip, asked by Christ how they might be fed, admitted that their available money would not buy enough bread. Andrew said, 'There is a boy here who has five barley loaves and two fishes; but what is that among so many?' Christ took the loaves, blessed them, broke them and gave them to the disciples to distribute. The crowd was all well fed and twelve basketfuls of leftovers were collected. The theme is represented in all periods of Christian art from the 3rd cent. In early examples Christ has a wand like Moses' which was capable of performing miracles, and with it he touches the baskets of bread. Artists of the Renaissance and later depict a landscape crowded with people seated in groups among which the disciples move, distributing food. In the foreground Christ sits or stands blessing the loaves. Andrew or Philip is in the act of handing bread to him or taking it from the basket held by a small boy. Andrew is old with white hair and a beard. Philip is younger with dark hair and is usually also bearded. The boy may hold up the loaves and fishes in a cloth. The subject was used, like the Last Supper, to decorate the refectories of convents, and was broadly intended as a 'type' of the Eucharist. But it also served

as an example of a work of mercy – the feeding of the hungry. (See CHARITY.) An artistic convention that seems to have prevailed only in the later 15th cent., and more especially in the Netherlands, portrays the crowds in aristocratic dress and includes among them likenesses of persons in contemporary society.

Felicity (d. 165). Early Christian martyr about whom little is known. Her traditional legend, apparently derived from the story of the seven Jewish brothers (II Macc. 7), describes her as a rich Roman matron with seven Christian sons. The sons were executed one after another before the eyes of their mother who exhorted them to be steadfast in their faith. She herself was finally beheaded or thrown into boiling oil. Felicity is represented in Italian Renaissance painting holding the martyr's PALM and usually accompanied by her seven sons, who may them-selves hold palms.

Felix of Cantalice (*c.* 1513–87). Born of humble parents, he was a farm-worker until the age of 30 when he joined the Capuchins, a branch of the Franciscan Order, and spent the rest of his life at Rome in their service. He features in paintings of the Spanish school in the 17th cent. He wears the Capuchin habit with its long pointed hood hanging at the back. (The Order derived its name from the *capuchon,* the medieval headgear of this type.) His duty was to beg alms for his convent, and he is therefore depicted with a wallet, that is a bag with a pouch at either end and an opening in the middle, slung from his shoulder. A legend, sometimes represented, tells that he received a loaf from a child shining with a mysterious radiance who blessed him and then vanished.

'Festina lente,' see ANCHOR; TORTOISE.

Fetters. Attribute of LEONARD who may hold broken fetters; *Fetters* of Vice personified (HERCULES, 21). In Renaissance allegory a shackled or otherwise bound figure symbolizes man enslaved by his baser, earthly desires.

Fidelity. When personified she stands for the secular aspect of Faith, or the state of trust existing between master and servant. Thus Fidelity holds a golden SEAL in one hand and a KEY in the other. She may be accompanied by a DOG, from antiquity a symbol of faithfulness.

Fides, see FAITH; MOUNTAIN.

Fig. Sometimes an alternative to the apple for the Tree of Knowledge, though not, as one might expect, particularly preferred by painters of southern Europe. After the Fall, Adam and Eve sewed fig leaves together to make themselves loincloths. (Gen 3:7). See ADAM AND EVE.

Fina (d. 1253). A girl of San Gimignano, a town in Tuscany, who lived in the 13th cent. and died at the age of 15 after several years of illness, during which time she devoted herself to the poor. It was said that as she lay on her bed, which was nothing but a bare board, in a room infested with rats, St Gregory the Great appeared to her and foretold her death. When she died, white scented flowers, violets according to some, sprouted from her bed. Her attribute is a RAT, a model of the town of San Gimignano, and a bunch of flowers in her hand. Italian art of the earlier Renaissance depicts Fina – or Serafina – on her bed, her mother beside her, while others are chasing away the rats. St Gregory is also seen standing beside her.

Fire. A test of faith or innocence: the infant MOSES (2); the three in the fiery furnace, DANIEL; FRANCIS OF ASSISI (5) before the Saracens; CUNEGUNDA; JUDGEMENT OF OTTO. A bonfire of bones, JOHN THE BAPTIST (10); of books, PAUL, apostle (9);

a snake fastened to a man's wrist, shaken into bonfire, PAUL, apostle (11); martyr on gridiron over fire, LAURENCE. A burning bush, MOSES (5); burning log cast into fire, MELEAGER; burning robes worn by HERCULES (24), rarely LAURENCE; figure bound to burning wheel, IXION. Burning city: Jerusalem, JEREMIAH; Troy AENEAS (1), TROJAN WAR (8); Sodom and Gomorrah, LOT. Model of burning building, the attribute of AGATHA. Ball of fire above bishop celebrating Mass, MARTIN of Tours. Angels bearing a soul out of the flames of purgatory, GREGORY THE GREAT (2). Altar fire, tended by women, VESTAL VIRGIN. See also FLAME; FOUR ELEMENTS; HELL; PYRE; SALAMANDER.

Fish. Very early symbol of Christian baptism, used in this sense by Tertullian (*c.* 160–230). Believers were called *pisciculi*, little fishes; the font is *piscina*, literally a fish-pond. It was also observed that the letters of the Greek word for fish (IXθYΣ) formed the initials of the words Jesus/Christ/of God/the Son/ Saviour, in Greek. The symbol of the fish, which came to stand also for Christ himself, is found on seals and lamps, in the Roman catacombs and on sarcophagi. The story of JONAH, symbolizing the Resurrection, occurs in 3rd cent. funerary art. The fish is an attribute of ANTONY OF PADUA who preached to the fishes; of PETER, apostle; of the bishop ZENO, dangling from his crozier. TOBIAS, accompanied by the angel, carries a fish. The disciples in a boat, netting fish, MIRACULOUS DRAUGHT OF FISHES; distributing bread and fishes, FEEDING OF THE FIVE THOUSAND. A coin drawn from a fish's mouth by Peter, TRIBUTE MONEY (2). In secular art marine deities, especially TRITONS and NEREIDS, often have fish tails, sometimes fins. An old fish-like sea-god pursuing a female, GLAUCUS AND SCYLLA. Anglers on a river bank sometimes represent Water in allegories of the FOUR ELEMENTS. Pisces, the fish of the zodiac, see TWELVE MONTHS.

Five Senses. The senses are generally represented as five women each engaged in some typical activity, and with attributes appropriate to the artist's period. Thus *Hearing* is usually associated with music, and has a LUTE or a portative ORGAN in the Renaissance, or a bowed instrument in the 17th cent. *Sight* holds a MIRROR and gazes into it admiringly; more rarely she has a flaming TORCH. *Taste* has a basket of FRUIT, and *Smell*, a bunch of FLOWERS and perhaps a VASE of perfume. In baroque painting both fruit and flowers may be offered by a putto. The manner of depicting *Touch* is less constant. She may have a HEDGEHOG and ERMINE (harsh and soft sensations), especially in 16th cent. engravings; later a BIRD perches on her raised hand. Other animals associated with the senses in the 16th cent. are: EAGLE (Sight), noted for its sharpness of vision; STAG (Hearing), traditionally believed to have acute hearing; APE with fruit in its mouth (Taste); DOG (Smell). A series of 16th cent. French tapestries (Cluny Museum, Paris) depicting a maiden with a UNICORN has been interpreted as an allegory of the senses. She is variously represented holding a mirror, playing an organ, stroking the unicorn, taking a sweetmeat from a dish and receiving a crown of flowers from a servant. A different approach was taken by 17th cent. Flemish painters of *genre* whose tavern scenes included drinkers (Taste), pipe smokers (Smell), and lusty singers with a fiddler (Hearing). Touch was represented by a man with his arm round a woman's waist, or by a surgeon letting blood. The theme of the Five Senses features in Netherlandish art in particular, but is found more often in engravings than in painting. Series of paintings even when still wholly extant are often separated among different galleries.

Flag. A long, flowing white flag bearing a red cross is the Christian symbol of victory over death, the banner of the Resurrection. It derived from the vision of CONSTANTINE THE GREAT and his adoption of a cruciform emblem on the Roman

standards. It is held by Christ, in particular in the scene of the RESURRECTION, and the DESCENT INTO LIMBO. It is the attribute of the warrior saints ANSANUS and GEORGE, and of REPARATA, URSULA and the Phrygian SIBYL. It accompanies the LAMB of God. A banner bearing the Austrian eagle is the attribute of MAURICE.

Flagellation (Matt. 27:26; Mark 15:15; Luke 23:16 and 22; John 19:1). Christ's scourging, ordered by Pontius Pilate the governor of Judaea, just before he was led away to be crucified, is mentioned very briefly by all the evangelists. They say simply that Pilate had Jesus flogged. Nevertheless this bare statement has produced a rich harvest in art, perhaps because of the attention it received from later Christian writers. Among other things they speculated about the number of strokes the Saviour was likely to have received, which ranged from forty, prescribed by Jewish law, to over five thousand according to St Bridget of Sweden. It was customary to depict Christ bound to a column, perhaps in the colonnade that formed part of Pilate's *praetorium*, or judgement hall. During the Middle Ages the house of Pilate was, like the Holy Sepulchre, venerated as one of the sacred places of Jerusalem, though some doubt existed as to its exact location. A style of architecture, believed to be derived from it, featuring a colonnade of thin Corinthian columns, became an established tradition in early Italian Renaissance painting. The figure of Christ, apart from certain medieval examples that show him fully clothed, is usually naked except for a loincloth. Artists were presented with the technical problem of showing him receiving the strokes on his back – the usual place – while at the same time leaving his face visible to the spectator. Early Renaissance painting generally overcame this by having him stand full face, bound by the wrists to a very narrow column so that his figure was hardly obscured. Otherwise he stands in front of the column, his hands bound behind his back, and seems to be receiving the strokes on the front of the body. The soldiers who administer the punishment are usually two or three in number. They use birches or thong whips. One sits nearby tying a fresh bundle. Pilate may be present, enthroned on the seat of judgement and perhaps wearing a laurel crown, the Roman emblem of his authority. More rarely a crowd of soldiers and Jewish elders are looking on.

Christ after the Flagellation. The theme occurs first in Italian painting of the early 16th cent. and seems later to have had particular appeal for artists of 17th cent. Spain. Christ is shown at the moment of being untied from the column, or he is alone, still bound, and lies slumped and exhausted at its foot. Or he drags himself along the ground to gather up his clothes. Others may be present: the Virgin, John the Evangelist or other saints.

The saints ANDREW, apostle, and LAURENCE are depicted being scourged at their martyrdom. JEROME (2) was scourged by angels. AMBROSE scourged the Arians with a three-knotted whip.

Flail. Implement for threshing corn, consisting of a long wooden bar loosely jointed to a handle. It is represented in scenes of harvesting, e.g. August, or sometimes September, in the cycle of the TWELVE MONTHS.

Flame. Symbol of religious ardour, especially a flaming HEART, the attribute of ANTONY OF PADUA; AUGUSTINE; CHARITY personified; in secular art, of VENUS. Flames at feet of a bishop, JANUARIUS. A flame on the brow of the apostles DESCENT OF THE HOLY GHOST. Flames from the head of an allegorical female, Fire, one of the FOUR ELEMENTS. Flames may surround Choler, one of the FOUR TEMPERAMENTS. See also FIRE; TORCH.

Flask, the attribute of OMOBUONO.

Flavia, sister of St Placidus, see BENEDICT (5).

Flaying, the stripping of skin with a knife, as a form of torture, see APOLLO (4); BARTHOLOMEW; JUDGEMENT OF CAMBYSES.

Fleece. Warrior kneeling beside a fleece laid on ground, GIDEON'S FLEECE; fleece hanging from tree guarded by dragon, JASON. The Order of the Golden Fleece, instituted in 1429 by Philip the Good, Duke of Burgundy, was an order of knighthood devoted to the protection of the Church. The emblem depicts a pendant ram's fleece, its head and feet dangling. It is occasionally represented in portraits of dukes of Burgundy and of the Emperor Maximilian. See also FLINT AND STEEL.

Order of the Golden Fleece

Fleur-de-lys. Emblem of the French kings. According to legend Clovis chose it as the emblem of his purification by baptism when he embraced Christianity (the lily symbolizing purity), but it was not officially adopted by the monarchy until the 12th cent. It is the attribute of CHARLEMAGNE (on his ermine cloak); LOUIS IX, (perhaps on his cloak); of LOUIS OF TOULOUSE (on cope); of LEONARD (on dalmatic). The fleur-de-lys is also the emblem of the city of Florence, and is thus the attribute of the bishop ZENOBIUS (in halo, on book or morse). A sceptre tipped with the fleur-de-lys is the attribute of the archangel GABRIEL, especially at the ANNUNCIATION.

Flight into Egypt (Matt. 2:13–15). Warned in a dream that Herod was searching for the infant Jesus to kill him (see MASSACRE OF THE INNOCENTS), Joseph took him and his mother away to safety in Egypt where they remained till Herod's death. The bare statement given by Matthew was greatly amplified in various New Testament apocryphal texts which are the source of the themes found in art. The principal figures are three: the Virgin carrying the infant Christ in her arms and riding an ass, and Joseph leading the beast by the halter. Usually one or more angels are guarding them. Early Renaissance pictures may include the three sons of Joseph and the midwife Salome (see NATIVITY, 3). An ox, with an ass, also refers to the Nativity. In Counter-Reformation painting the ass is more often omitted and the party travel on foot. A cornfield with reapers in the background sometimes features in examples from northern France and the Netherlands of the late Middle Ages and Renaissance. It was told that the Holy Family passed by a husbandman sowing seed. He was instructed by the Virgin to say to inquirers that he had seen them go by at the time of sowing. The corn miraculously grew and ripened overnight. Herod's soldiers arriving next day gave up pursuit on being told quite truthfully that their quarry had gone by at the time of sowing. A version sometimes found in 17th and 18th cent. Italian and French painting shows the family embarking on a boat, about to be ferried by an angel across a river. Poussin, and Boucher after him, represent the ferryman as Charon, who ferried the souls of the dead in classical myth, to signify the foreshadowing of the death of the Saviour. The same idea is sometimes further adumbrated by a vision of angels in the clouds above, bearing the cross. The flight is sometimes represented taking place at night, in accordance with the gospel account. Artists sometimes choose to depict the moment of departure showing the Virgin making her farewells, or waiting under a tree while Joseph saddles the ass. The theme may form part of the cycle of the Seven Sorrows of the Virgin (see VIRGIN MARY, 2).

1. *The rest* (or *repose*) *on the flight.* A popular theme in the art of the Counter-Reformation, more often of a devotional than a narrative character. The Virgin and Child are seated in a landscape, usually under a palm tree. Joseph is beside them, and the ass may be in the background. Their belongings lie on the ground,

tied up in a bundle. Angels hover overhead or bring food on a dish. An old woman is Salome, the midwife. Broken images on the ground allude to a story from the apocryphal gospel of Pseudo-Matthew: when the party reached the town of Sotinen in Egypt the Virgin and infant Jesus entered a temple, whereupon the statues of the pagan gods fell to the ground and were broken. This theme is also represented as a separate subject, especially in French medieval cathedrals. From the same source comes the story of the palm tree under which the family were resting, which bent its branches at the orders of the infant Christ so that they could gather its fruit. The tree, whose frond is the emblem of the Christian martyr, features very commonly in the 'Repose'. Joseph may be plucking dates and handing them to the child; sometimes angels are shown drawing down a branch. Another late theme shows the Virgin washing clothes on a rock by the river's edge in the traditional manner of the countrywoman, while Joseph takes care of the child.

　　2. *Return from Egypt*. A theme similar in treatment to the 'Flight' but distinguished from it by the age of the Child, who is now no longer an infant but a small boy. The legendary meeting of the Holy Family with the young John the Baptist was said to have taken place on the Return. It is occasionally found in Italian Renaissance painting.

Flint and Steel. Once used to strike a spark in order to light tinder. The *impresa* of Philip the Good and of Charles the Bold, dukes of Burgundy, the latter's having also two crossed logs of wood. The motif of flint and steel, with sparks being struck, formed in a repeating pattern the collar of the Order of the Golden Fleece, founded by Philip the Good. (Roger van der Weyden, Antoine, Grand Bâtard de Bourgogne, Brussels Museum.) See FLEECE.

Flint and steel

Flood, see NOAH (2).

Flora. The ancient Italian goddess of flowers. Her festival, the Floralia, was celebrated with much licentiousness. (The Greek goddess of flowers was Chloris who was married to Zephyr, the west wind of springtime, who begets flowers. The Romans called her Flora.) Lucretius (*De Rerum Natura*, 5: 736–9) tells how Flora followed the footsteps of Zephyr in springtime, strewing the way with blossoms. Ovid (*Fasti* 5:193–214), on whom Botticelli drew for one element in the *Primavera* (Spring) (Uffizi, Florence), tells of Chloris fleeing from Zephyr. When he at length embraced her, flowers spilled from her lips and she was transformed into Flora. This is the moment that Botticelli depicts, with the two goddesses side by side. Flora scatters flowers; more blooms trail out of the mouth of Chloris. In allegories of the FOUR SEASONS Spring is personified by a nude maiden, especially VENUS, accompanied by the appropriate zodiacal signs: the Ram, the Bull and the Twins.

　　1. *Zephyr and Flora*. The wedded pair are seen together in a flowery glade, she on a couch, he, a young god with butterfly's wings, scattering flowers from a cornucopia, aided by amoretti.

　　2. *The realm of Flora*. Ovid tells of Flora's garden, a gift to her from Zephyr, which he filled with flowers. Poussin shows her dancing lightly through it, strewing flowers. Around her are those figures from myth who were transformed into flowers at their death: Ajax (who was turned into larkspur – a carnation in Poussin's 'Garden of Flora', Dresden) is seen throwing himself on his sword – he became insane and killed himself after losing his claim to the arms of he dead ACHILLES (*Met.* 13:382–398). NARCISSUS broods over his reflection in an

urn. Clytie (who became a sunflower, i.e. probably the marigold (see SUNFLOWER) which has the same property) gazes up in hopeless love at the sun-god, turning her head to follow his daily journey through the heavens (*Met.* 4:256–270). Hyacinthus puts up his hand to his wounded head (see APOLLO, 11). Adonis (anemone) with his spear and hunting dogs, draws aside his cloak to reveal his wounded thigh (see VENUS, 5). Crocus and Smilax, the beautiful youth and the nymph recline in one corner – for his impatience he was turned into the flower that bears his name, as she was likewise, or into a yew tree.

3. *The triumph of Flora.* A triumphal procession led by Venus in which the above-mentioned figures take part. Flora rides on a chariot drawn by putti.

4. *Portraits of Flora.* The goddess was a popular vehicle for female portraiture. The sitter holds a posy of flowers and her hair is sometimes garlanded. Rembrandt's portraits of his wife Saskia in this role are well known. In Venetian painting the portraits are very often of comely prostitutes.

Florian. A Roman soldier of the town of Ems in what is now Upper Austria who was converted to Christianity and martyred in 304 by being thrown into the river Ems with a millstone tied round his neck. Passers-by recovered his body which was watched over by an eagle until taken away for burial. He was said to have miraculously put out the flames of a burning building, or a whole city, with a single bucket of water. He is thus invoked against fire. He is a popular saint in Austria and Bavaria, but rarely found in Italy. He is represented as a Roman soldier or medieval knight, sometimes carrying a banner with a cross, or a millstone; or he holds a bucket or PITCHER, or throws water over a burning house.

'Flos campi . . . ,' see VIRGIN MARY (4).

Flowers. Flowers in general are the attribute of Spring personified, one of the FOUR SEASONS; of Smell, one of the FIVE SENSES; of the goddesses FLORA and AURORA. They symbolize the evanescence of human life in allegorical STILL LIFE. They are also sometimes the attribute of HOPE; and of Logic, one of the SEVEN LIBERAL ARTS. See also ALMOND; ANEMONE; APOLLO (11) (Hyacinth); CARNATION; COLUMBINE; DANDELION; FLORA (2) (Crocus, Marigold); IRIS; LILY; NARCISSUS; POPPY; ROSE; SUNFLOWER; VIOLET.

Flute, see PIPE.

Fly. The representation of a life-size fly or bluebottle is sometimes found conspicuously placed in paintings by Netherlandish, German and Italian artists, especially during the period mid-15th cent. to the first decades of the 16th cent. It seems to have been without symbolic meaning since the subject matter of paintings on which it appears is widely varied, though usually religious. The painted fly is serving as a protective talisman against the real insects which otherwise might settle and leave their dirt marks on the brushwork of a sacred theme. It was common practice to display images of undesirable insects in buildings in order to keep them away. This belief was in line with the homoeopathic character of much medieval medicine, expressed in the phrase 'Similia similibus curentur' – 'Let like be cured by like.' In some later instances the fly seems to be intended merely as a *trompe-l'oeil.*

'Fons hortorum,' see VIRGIN MARY (4, 5).

Font. The vessel for baptismal water, standing at the west end of the church or in a separate baptistery; it appears in scenes of church baptism, as of Clovis by REMIGIUS. A font is the attribute of FAITH personified. See also BAPTISM (2).

Fool, see JESTER; SHIP OF FOOLS.

Foot. Bare feet mean poverty and humility. Christ and the apostles are generally

so depicted, also often the mendicant Orders, especially Franciscan, and POVERTY personified (Sassetta, *Mystic Marriage of St Francis*, Musée Condé, Chantilly). The Order of reformed Carmelites, founded by Teresa of Avila, and known as 'discalced' or unshod, are not generally represented in this way. The Madonna of Humility (VIRGIN MARY, 11) is sometimes barefoot. Late medieval versions of the ASCENSION depict the feet of Christ below the cloud which removed him from the sight of the apostles (Acts 1:9). MOSES (5) is seen taking off his sandals before the Burning Bush because the voice of God told him, 'the place where you are standing is holy ground.' (Ex. 3:5.) MARY MAGDALENE (1) wipes the feet of Christ with her hair. Christ washes the feet of PETER, the apostle (3). A partly naked old man, his feet in a basin of water, SENECA, DEATH OF.

Thorn in the foot; the 'Spinario'. An antique bronze statue (Pal. dei Conservatori, Rome) represents a naked boy, seated, drawing a thorn from his foot. The leg is raised horizontally, the foot resting on his other knee. The subject was often copied in 15th and 16th cent. Italian sculpture. VENUS (6) who pricked her foot with a rose thorn is depicted in a similar pose.

Forge. Blacksmith at anvil, Apollo or a goddess present, VULCAN. Old man with bellows, ALCHEMIST. See also ELOI.

'Forse che si, forse che no,' see LABYRINTH.

Fortitude. One of the four 'cardinal virtues' (see VIRTUES AND VICES), signifying courage, endurance and also strength. Fortitude is represented as a warrior, wearing a HELMET, sometimes in armour, and holding a SHIELD, SPEAR or SWORD. Generally a female, she therefore tends to resemble MINERVA. In Gothic sculpture her opposing vice is Cowardice (*Ignavia*), a knight who flees in terror from a hare; in the Renaissance she is more often opposed by Inconstancy, who loses her balance on a wheel. Some attributes of Fortitude in the Renaissance and later are derived from the heroes of the Bible and myth. From SAMSON she has a PILLAR, perhaps broken, which in baroque painting may be carried by putti. A CLUB and a lion's skin are taken from HERCULES. The LION, itself a symbol of courage, is a common attribute. Fortitude may fight a lion, forcing its jaws apart, the archetypal image of the god or hero performing a feat of strength and courage.

Fortune has two aspects, (1) the inconstant goddess of antiquity, revived by the Renaissance, who bestows her favours at random, and (2), the medieval Dame Fortune turning her wheel.

1. The goddess is naked and usually winged. To Apuleius she was 'blind and even eyeless, because of the way she rewards the unworthy or the positively wicked' (*Golden Ass*, 7:2). Hence she is sometimes BLINDFOLD. Her commonest attribute, a GLOBE on which she stands or sits, originally indicated instability, but to the Renaissance it was rather the world over which her sway extended. Fickleness suggests vice, hence Fortune on her globe sometimes stands contrasted with the personification of Virtue who rests on a solid block or cube, the symbol of stability. (The globe is also an attribute of OPPORTUNITY, or Chance, which might be defined as the workings of fortune.) To Horace (*Odes* 1:35) Fortune was the mistress of the sea whom those in ships feared. She may therefore have a RUDDER, a billowing SAIL, a reminder of the wind's inconstancy, and ride on a SHELL or a DOLPHIN, or hold a model SHIP. Other less common attributes are a CORNUCOPIA (which she shares with many others), a DIE, and a BRIDLE. (See also NEMESIS whom Fortune resembles.)

2. A WHEEL was associated with Fortune in classical antiquity. Boethius (c. 480 – c. 524) in the *Consolation of Philosophy* described Fortune's wheel as

that which raises the fallen and abases the proud. A hopeful figure is carried up on one side of the wheel, another at the top wears a crown, while on the other side a third in rags tumbles off, and perhaps a fourth lies on the ground. Each may be accompanied by an inscription: 'Regnabo', 'Regno', 'Regnavi' and 'Sum sine regno' – 'I shall reign, I reign, I have reigned, I am without sovereignty.' It may be seen carved in stone round the edge of the rose window in French Romanesque churches; it is found in manuscripts, in Renaissance engravings and tapestries.

Fountain. A source of water hence, symbolically, of spiritual life and salvation; in this sense an attribute of the Virgin of the Immaculate Conception (VIRGIN MARY, 4). It is generally represented as the ornamental kind. The Fountain of Life is the source from which the Rivers of Paradise flow, from Revelation (22:1). The fountain in the Garden of Love is surmounted by the figure of Cupid (see LOVE). The old enter, the young emerge from, the Fountain of Youth (see LOVE). A maiden sleeping beside a fountain, observed by youth, CIMON AND IPHIGENIA. A youth gazing into the basin of a fountain, NARCISSUS. See also WELL.

Four Elements. They may be represented either as the conventional anonymous females distinguished only by their attributes or, especially in the 16th cent., as classical gods and goddesses. They are found in Italian Renaissance frescoes and ceilings and as separate pictures in series of four, though the latter are often broken up among different galleries. Northern European painters of *genre* and *fêtes galantes* of the 17th and 18th cents. gave the names of the four elements to series of pictures showing youths and maidens at some appropriate activity.

Earth, as a woman, has numerous attributes that belong to goddesses of fertility: the CORNUCOPIA and SNAKE of Ceres, the SCORPION of the Roman agricultural goddess Tellus Mater. She may suckle one or two children like Ops, the Roman goddess of the harvest. A turreted, mural crown is taken from CYBELE, the ancient Phrygian earth mother. *Genre* scenes depict the activities of gathering fruit, digging, watering plants and so on.

Air was sacred to Juno in antiquity and may be represented by the goddess with her PEACOCK. Or she is shown suspended in the air, an anvil tied to each foot, Jupiter's punishment of his wife's disobedience (*Iliad*, 15:18–21). BIRDS, symbols of the air, may surround her. A woman holding a CHAMELEON stands for Air since, according to Pliny (*Natural History* 8:33), the creature neither ate nor drank but lived on air. Youths and maidens of the 18th cent. are depicted out of doors at play with toy windmills and blowing bubbles.

Fire takes the form of a woman with her head in flames, holding a THUNDER-BOLT. Or she may have for a head-dress a PHOENIX surrounded by fire, which it symbolizes. VULCAN, the blacksmith of the gods, hammer in hand, likewise personifies fire. He may be depicted at work, forging Aeneas' armour, Venus and Cupid watching him.

Water is personified by a river god with his overturned URN from which water flows, or by NEPTUNE and his numerous followers, TRITON and the NEREIDS, accompanied by DOLPHINS, HIPPOCAMPI and sea-centaurs. They occur with this signification in many pictures with a marine theme. Painters of *genre* show anglers on a river bank or in a boat.

See also FOUR TEMPERAMENTS.

Four Evangelists. When represented collectively the saints Matthew, Mark, Luke and John are especially seen in the decoration of churches. Being four in number they aptly occupy the lunettes or pendentives under the dome. They are often combined with other groups of like number, particularly the four Doctors

of the Church, AMBROSE, JEROME, AUGUSTINE and GREGORY THE GREAT who then stand in relation to them as interpreters of their writings; they are also seen with the four greater prophets ISAIAH, JEREMIAH, EZEKIEL and DANIEL. The early Christian Church, which made much use of symbolic imagery, sometimes represented the evangelists as four winged creatures: Matthew, a man; Mark, a lion; Luke, an ox; John, an eagle. The source of this convention was a passage from Ezekiel (1:5–14) where the prophet tells of a strange vision of the four beasts. The book of Revelation (4:6–8) describes the same creatures surrounding the throne of God (APOCALYPSE, 3). Hence they are commonly known as the 'apocalyptic beasts', and early on came to stand for the four evangelists. Medieval commentators found explanations for this hidden in the gospels themselves: the man represents Matthew because it is his gospel that begins with the tree of the ancestors of Christ; Mark opens with the voice crying in the wilderness, an allusion to the lion; the ox, the sacrificial beast, is Luke whose gospel begins with the account of the sacrifice of the priest Zacharias. The eagle, of all birds the one that flies nearest to heaven, represents John whose vision of God was closest and distinct from the others'. The apocalyptic beasts are found frequently in MSS, in the sculpture of Romanesque churches, and to a lesser extent in Gothic, where they surround the image of God. In this symbolic role they did not survive the coming of the Renaissance. Thereafter they live on merely as attributes that identify the four human figures. Other attributes of the evangelists are a SCROLL or BOOK. They may be seen in the act of writing while the DOVE of the Holy Ghost hovers above, inspiring their words. See further under MATTHEW; MARK; LUKE; JOHN THE EVANGELIST; RESURRECTION.

Four Parts of the World, personified as female figures, are found in the art of the Counter-Reformation and later where their commonest function, especially in Jesuit churches, is to serve as a reminder of the world-wide spread of Catholic Christendom. They are sometimes depicted doing homage to the figure of Faith. They were given definitive form in the *Iconologia* of Cesare Ripa, an illustrated dictionary of abstract concepts that was very widely used by artists from the early 17th cent.

Europe. As queen of the world she wears a CROWN and holds a SCEPTRE. A model of a TEMPLE implies, perhaps inaccurately, that she was the cradle, if not of Christianity, at least of the Church. Weapons and a HORSE allude to her supremacy in war, a CORNUCOPIA and numerous objects symbolizing the arts and sciences signify her leadership in the arts of peace.

Asia is crowned with FLOWERS, her dress adorned with JEWELS. She holds a CENSER, since perfumes came from the east, and also a PALM. Her animal is the CAMEL.

Africa has a black skin and wears a CORAL necklace. She holds a SCORPION, a symbol of Africa in antiquity. A LION and a SNAKE may be nearby. Her head-dress is the head of an ELEPHANT, or the animal may stand beside her.

America, discovered by Columbus in 1492, has the attributes of her aboriginal peoples. She wears a head-dress of FEATHERS, and holds a BOW in one hand and ARROW in the other; at her feet is a severed head pierced by an arrow. Her animal is the CAIMAN, a reptile resembling the crocodile, found in central America.

Four Seasons. The representational types of the seasons maintained a remarkable degree of continuity from late antiquity until the 18th cent. In Pompeian and Roman frescoes and mosaics Spring is a young woman holding FLOWERS; Summer has a SICKLE and ears or sheaf of CORN; Autumn, GRAPES and VINE

leaves; Winter is thickly clad against the cold. They are fairly frequently found in paintings of the 15th to 17th cents. Series of pictures are unfortunately often split up among different galleries. Spring has garlands in her hair, occasionally a SPADE or HOE, and a flower garden in the background. Summer, who may be naked, often has both corn and FRUIT, and behind her reapers may be at work. Autumn is invariably associated in some way with the vine (see also WINE-PRESS, MYSTIC). Winter is often an old man, wrapped in a cloak, perhaps beside a fire. The Renaissance also revived the antique tradition of representing the seasons by pagan divinities: FLORA or VENUS for Spring; CERES for Summer; BACCHUS for Autumn; BOREAS or VULCAN for Winter. The Four Seasons were popular with 18th cent. French painters of *fêtes galantes*, though each, seen by itself, would hardly be thought of as belonging to a series. 'Spring' is a scene of young lovers with flowers strewn in their laps, birds in a cage or on a string, or birds being snared; 'Summer' shows them bathing in a river or watching reapers at work; in 'Autumn' they make a picnic after gathering grapes; in 'Winter' they skate on a frozen river, or sit indoors amusing themselves, perhaps at cards. See also AGES OF MAN.

Four Temperaments. Medieval physiology taught that the body contained four kinds of fluids, or humours, which determined a man's temperament according to their relative preponderance, and moreover that the organs which secreted them were subject to planetary influences. Thus a man's character was 'in his stars.' The humours, their associated temperaments, the animals whose nature they were said to share, and the FOUR ELEMENTS to which they also happened to be linked were as follows:

Phlegm	Phlegmatic	Lamb	Water
Blood	Sanguine	Ape	Air
Bile (or Choler)	Choleric	Lion	Fire
Black bile	Melancholic	Pig	Earth

As a series, they are personified in 15th cent. Books of Hours but are rare in the Renaissance. Choler is occasionally found as a separate figure in engraving, tapestry and sculpture, portrayed either as a woman or a naked warrior, with a LION, unsheathing a SWORD, and perhaps surrounded by flames, attributes which also belong to the figure of Wrath, one of the seven Deadly Sins (see VIRTUES AND VICES). But of the four it is Melancholy that caught the imagination of medieval mythographers, the Renaissance humanist philosophers and hence of artists from the 15th cent. onwards.

Melancholy. The daughter of Saturn, hence her saturnine, or gloomy disposition. To the humanists Melancholy was identified more with the introspective, intellectual qualities that typified their ideal 'contemplative man'. Thus artists, philosophers and theologians were all regarded as coming under the influence of Saturn. The figure of Melancholy may have WINGS, and the animal beside her is generally not a pig but a DOG (which for roundabout reasons came to be associated with Saturn). Her attitude – she sometimes sits at a table with her head in her hands – perhaps reflects her despair of acquiring the ultimate wisdom or knowledge, or her loss of creative inspiration. She is surrounded by books and, in baroque painting, has a SKULL which suggests the vanity of her efforts, and often a PURSE because avarice was associated with the melancholic. She may, as in the engraving by Dürer, be surrounded by certain tools, COMPASSES, SET-SQUARE, RULER and so on. They are the attributes of Geometry, of the SEVEN LIBERAL ARTS the one over which Saturn presided. Since carpenters were also among the 'children' of Saturn, Melancholy may also have a SAW, PLANE

and other such implements. An alternative type represents her like CHARITY, surrounded by children, perhaps a connection with the myth of Saturn devouring his offspring.

Frances of Rome (Francesca Romana) (1384–1440). Roman noblewoman, a wife and mother, who devoted herself to charitable work, especially the relief of suffering during the plague. She established a community of like-minded women who became known as the Oblates of Tor de' Specchi, and who worked in association with the Benedictine monastery on Monte Oliveto. She was canonized in 1608, from which time she is represented in art. She is dressed in the black habit and white hood of the Olivetan Oblate (see diag. RELIGIOUS DRESS). An angel holds an open book before her inscribed, 'Tenuisti manum dexteram meam, et in voluntate tua deduxisti me, et cum gloria suscepisti me,' from the Office of the Virgin, taken from Psalm 73:23–4, 'Thou holdest my right hand; thou dost guide me by thy counsel and afterwards wilt receive me with glory.' Her concern for victims of the plague is commemorated in pictures showing her kneeling in prayer among the dead and dying. A vision of the Virgin may appear above her, holding broken ARROWS, symbolizing the conquest of the disease. She may form a pendant to CHARLES BORROMEO who is remembered for similar works of mercy.

Francesca da Rimini, see PAOLO AND FRANCESCA.

Francesca Romana, see FRANCES OF ROME.

Francis Borgia (1510–1572). Spanish nobleman and statesman, the great-grandson of the Borgia pope, Alexander VI, he abandoned his career on the death of his wife in 1546 and went to Rome to join the Society of Jesus. He preached in Spain and Portugal and later became General of the Order. He is depicted being received by IGNATIUS OF LOYOLA at the door of the Jesuit College in Rome. Or he kneels beside FRANCIS XAVIER who is in the act of baptizing the heathen in the far east.

Francis of Assisi (*c.* 1182–1226). Founder of the Order of Friars Minor, or Franciscans. He wears a brown or grey habit, its girdle distinguished by three knots representing the religious vows of poverty, chastity and obedience (see diag. RELIGIOUS DRESS). No authentic contemporary portrait of Francis exists though his earliest biographer, Thomas of Celano, describes him as of puny physique, with unkempt beard and ailing eyesight. He is easily recognized by the stigmata (the five marks corresponding to Christ's wounds) on his hands, feet and side – the last sometimes showing through an oval slit in the tunic. Other attributes are a CRUCIFIX, a LILY (for chastity) and, especially in Counter-Reformation art, a SKULL (a reminder of man's mortality). During the Renaissance paintings of him were mostly confined to Italy and usually consisted of narrative scenes from his life, real or legendary. In the devotional style of painting following the Counter-Reformation, particularly in Spain, he is more often shown at prayer. By the time of his death he was already widely venerated, and legends, sometimes inspired by biblical incidents, soon multiplied. Like Moses, he drew water from a rock, and like Elijah, appeared in a chariot of fire; he had twelve disciples, one of whom rejected him; a disbeliever was converted by touching the stigma in his side and so on. Scenes from his life have been painted in cycles of which perhaps the best-known is in the Upper Church at Assisi formerly attributed to Giotto. The most frequently depicted episodes are:

1. *The Floating Palace.* Francis was baptized Giovanni, the son of a wool and cloth merchant, but became known as Francesco perhaps because his mother was French or from a youthful enthusiasm for the French troubadour ballads.

As a young man he was, according to a later biographer St Bonaventura, 'reared in vanity' and 'given up to pleasures', yet he was of a meek temperament and gave alms freely. The story goes that he once gave his clothes to a poor soldier whom he met on the road, and that night dreamed of a palace floating in the air, adorned with military banners. At first he took this to be God's command to follow a soldier's career, but a voice told him that his vision signified 'that which shall be spiritually wrought.'

2. *Before the Bishop.* While praying in the dilapidated church of St Damian at Assisi he heard a voice from the crucifix telling him to set about repairing it. With characteristic impulsiveness Francis thereupon sold some of his father's merchandise and joyfully offered the proceeds to the priest. But the latter refused the money, fearing the father's wrath. The incident led to a breach between father and son, and Francis was taken before the bishop. Here he threw off his fine clothes (incidentally revealing a hair shirt – though artists generally show him naked), and the bishop covered him with his cloak – a symbolic rejection by Francis of his earthly heritage.

3. *Francis holds up the Lateran Church.* With his own hands he set about restoring the church of St Damian, and after that the chapel of St Mary of the Angels, called the 'Portiuncula', near Assisi, which later became the mother church of the Order. Francis travelled to Rome to seek papal sanction for the Order, and authority to preach. According to St Bonaventura, this was granted after the pope dreamed of the Lateran church about to topple to the ground, and only being saved by Francis who propped it up. (St John in Lateran is the pope's church in his capacity as Bishop of Rome.)

4. *'Lady Poverty.'* The Order grew rapidly and there were accounts of visions and miracles accompanying his work. He met in a vision three women on the road to Siena, who greeted him with the words 'Welcome, Lady Poverty.' Poverty, as the metaphorical 'bride' of St Francis is sometimes represented in the form of a mystic marriage in which Francis places a ring on the finger of Poverty. Or Christ performs the ceremony. The companions of Poverty are Chastity, dressed in white and sometimes standing inside her fortified tower, and Obedience, bearing a yoke (Lower Church, Assisi). (See further POVERTY.)

5. *The Trial by Fire.* Travelling abroad preaching during the last Crusades, Francis succeeded in gaining the presence of the Sultan of Egypt whom he attempted to convert. As witness to the power of the Christian faith Francis offered to submit to the ordeal of walking through a fire if the Sultan's imams would do likewise. When they refused he challenged the Sultan: 'I will enter the fire alone if you will promise me to embrace the faith of Christ if I come forth unscathed.' This too was declined.

6. *Animals and birds.* Stories of Francis' relationship with birds and beasts are well known. Wild animals were said to become tame in his presence, sometimes even to obey him. In his sermon to the birds, told in the *Little Flowers*, he called on them to praise God for his blessings, whereupon they flew into the air in the formation of a cross. The wolf which terrorized the town of Gubbio and which was tamed by Francis (also in the *Little Flowers*), may be an allegory of a brigand who molested the inhabitants until converted to Christianity by the saint. Sassetta (Nat. Gall. London) shows the wolf about to sign a treaty with the citizens.

7. *The crib.* The traditional Christmas crib originated with St Francis who, with the pope's permission, reconstructed the scene of the Nativity in a grotto at Greccio, which included a live ox and ass.

8. *Chastity*. Like others who practised total sexual abstinence for the sake of their beliefs Francis had to wrestle with physical urges, his 'demons' as he called them. He combated them by rolling in the snow, or by throwing himself in a thorn bush. A legend tells that on the latter occasion roses sprouted where drops of his blood fell to earth, (as did anemones from the blood of Adonis: VENUS, 5).

9. *The Stigmata*. In retreat on Mt Alverna in 1224 Francis beheld while at prayer a vision which, according to Thomas of Celano, was of a man like a seraph with six wings, his arms outstretched and feet together 'in the shape of' a cross. While contemplating it the marks of Christ's wounds appeared on the saint's body, where they remained until his death two years later. Subsequent accounts modified the description of his vision, Bonaventura identifying the figure with the crucified Christ. The earliest 13th cent. representations conform to Thomas of Celano, and omit the cross. By the end of the century the image had changed to Christ on the cross, partly enveloped by wings, with rays passing down to the body of the kneeling saint. This form became traditional. (See further CATHERINE OF SIENA, 5.)

10. *Death*. At his death a nobleman, Jerome, who doubted the authenticity of the stigmata, touched the wound in the side of the saint's body and, like Thomas, was convinced. The funeral procession on its way from the Portiuncula to Assisi, stopped at the convent of St Damian where St CLARE and her sisters embraced the body and bade it farewell.

In devotional themes Francis' most frequent companion is Jerome. In paintings of the Counter-Reformation, particularly in Spain, he is depicted at prayer; solaced by angels with music; embracing the body of Christ which bends towards him, half detached from the cross (cf. BERNARD). El Greco alone made some fifty paintings of him.

Francis of Paola (1416–1507). A young man of devout temperament and upbringing, Francis of Paola (a town of Calabria) became a hermit. In time he gathered round him a community known as the Minims (*minimi*, 'the least' of their brethren) whose Rule was based on the Franciscans. Renowned for his power of healing, Francis was sent by Pope Sixtus IV to the deathbed of king Louis XI of France, but was able to perform only the last office. He remained at the French court, becoming an influential figure. He is represented, most often in Spanish painting, as an old grey-bearded friar, wearing the Franciscan girdle (see diag. RELIGIOUS DRESS). His brown habit has a distinctive short scapular, rounded at the corners. His motto 'Caritas' (Charity) is sometimes seen as an inscription. According to a legend, represented in painting, he calmed a storm in the Straits of Messina by spreading his cloak on the waters, enabling his companions to pass safely across. He was canonized in 1519.

Francis Xavier (1506–52). Jesuit missionary, born in Navarre, one of the original group of followers of IGNATIUS OF LOYOLA, the founder of the Society of Jesus. He pioneered Christian missionary work in the far east and became known as the 'apostle of the Indies.' Basing his activities at Goa, he travelled widely through the East Indies, southern India, Ceylon and Japan. While trying to enter China he was taken ill on an off-shore island near the Canton River, and died there in a primitive hut, alone except for a young Chinese companion. He was canonized in 1622. Next to Ignatius, Francis Xavier is the most widely represented of the Jesuit saints in Counter-Reformation art. Cycles of scenes showing him preaching, baptizing and curing the sick are found in Jesuit churches. Like Ignatius, he is seen performing miracles of healing (of a kind that neither

would have laid claim to in life). He is generally depicted wearing a white surplice over a black habit. He is dark-haired and has a short black beard. He may hold a CRUCIFIX or a LILY. He is seen beside the couch of a dead man whom he has restored to life, surrounded by awed Asian tribesmen, while above his head appears a vision of Christ displaying his wounds, the visible symbols of the Passion (Poussin, Louvre). Here and elsewhere eastern paganism has a distinctly Mediterranean look. The architecture of a heathen temple beside which the saint is preaching resembles that of classical Greece, with a Pan-like bust in a niche. A priest and his acolytes fall back in confusion from a pagan altar as light streams down upon it from a heavenly vision of the Virgin. The death scene of Francis Xavier shows either a solitary figure in a hut, holding a crucifix, or the discovery of the body by natives of the Indies. The latter may be depicted wearing a feathered head-dress, the conventional attribute of the American Indian (see FOUR PARTS OF THE WORLD), whom artists failed to distinguish from the Indian of Asia.

Fraud (Lat. *Fraus*), see DECEIT.

Frog. Peasants gathering osiers, changed into frogs, LETO. See also TOAD.

Fruit. Fruit, sometimes flowing from a cornucopia, is the attribute of CERES, goddess of agriculture; of ABUNDANCE, and of Summer, one of the FOUR SEASONS, both of which Ceres may personify. A basket of fruit is the attribute of the goddess Pomona (VERTUMNUS AND POMONA); of Taste, one of the FIVE SENSES. A bowl of fruit belongs to CHARITY; also to the fat figure of GLUTTONY. Angels bring baskets of fruit to Christ in the wilderness (TEMPTATION IN THE W.). See also APPLE; CHERRY; DATE; FIG; GRAPE; NUT; ORANGE; PEACH; POMEGRANATE; QUINCE.

'Fuit in diebus Herodis,' see LUKE.

Gabriel, archangel, the messenger of God, the herald of birth, venerated not only by Christians but also, since he features in the Old Testament (Dan. 8:16; 9:21) and the Koran, by the ancient Hebrews and by Moslems. Gabriel foretold the birth of JOHN THE BAPTIST (1), and of the Virgin Mary (see JOACHIM AND ANNE). The angel who appeared to the mother of SAMSON to announce his birth is, though unnamed, traditionally identified with Gabriel, as is the angel of the Nativity (see ADORATION OF THE SHEPHERDS) and the angel who announced Christ's Resurrection (see HOLY WOMEN AT THE SEPULCHRE). But Gabriel's predominant role in Christian art is that of the angel of the ANNUNCIATION, in which he appears before the Virgin Mary. His attribute is a LILY held in the hand or, in early Renaissance art, a sceptre tipped with a fleur-de-lys. The sceptre may be entwined with a scroll reading, 'Ave Maria,' or 'Ave gratia plena Dominus tecum' – 'Greetings most favoured one! The Lord is with you.' (Luke 1:28).

Gaea, Mother Earth, see SATURN (1, 2).

Galatea. A Nereid, or sea-nymph, of Sicilian origin. Ovid (*Met.* 13:750–897) tells how she loved a handsome youth Acis and was herself loved by Polyphemus, a monstrous one-eyed giant, one of the race of Cyclopes. The giant sat on a promontory overlooking the sea and played a love song to Galatea on his pipes. Afterwards, wandering disconsolately among the rocks, he discovered her lying in the arms of Acis. The couple fled and Polyphemus in a rage flung a great boulder which killed Acis. There are two scenes: (1) Polyphemus, his shepherd's crook laid aside, plays a syrinx – the pipes of Pan, which like the flute are a symbol of lust. Sheep graze nearby on the hillside. On a rock across the water the lovers dally, Tritons and Nereids playing around them in the

waves. Above the head of Galatea may be an arch of drapery, somewhat like a sail in the wind, the classical attribute of a sea-goddess. Alternatively she rides in her cockle-shell car drawn by dolphins; Acis is then probably absent. The Cyclops has one large eye in the centre of the forehead and vestigial eye-sockets in the place of normal eyes. (2) The lovers flee from Polyphemus who stands poised with a rock in his hands about to hurl it.

The triumph of Galatea. A scene of great life and movement. Galatea stands in her chariot (a cockle-shell, sometimes fitted with paddles) or reclines in the arms of a sea-centaur, surrounded by a throng of sea-creatures: Tritons who blow their conch horns, Nereids and hippocampi. Amoretti fly above her head aiming their arrows at her.

See also PYGMALION.

Gamaliel, Rabbi, see Stephen (4).

Ganymede, a shepherd, the son of Tros, a legendary king of Troy. His outstanding beauty caused Jupiter to fall in love with him. According to Ovid (*Met.* 10: 152–161) the god, having transformed himself into an eagle, carried the youth off to Olympus where he made him his cup-bearer. The myth, which is given in a slightly different version by Homer, found favour in ancient Greece because it appeared to provide religious sanction for homosexual love. Ganymede is often depicted in vase painting and sculpture of later antiquity wearing a cloak, sometimes a Phrygian cap (see HAT), accompanied by the eagle, or by a dog. The normal type in Renaissance and later art shows him caught in the embrace of, or on the back of, the eagle which bears him upwards, its wings either spread in flight or enfolding the youth, its claws holding his limbs. Ganymede may carry a small wine jug in anticipation of his heavenly role. Another version shows his arrival at Olympus where Hebe, the former cup-bearer of the gods, relinquishes her cup to him. A banquet is taking place in the background. The medieval *Moralized Ovid* made Ganymede a prefiguration of JOHN THE EVANGELIST, the eagle representing Christ. Renaissance humanists turned the theme into an allegory of the progress of the human soul towards God.

Garden. The idea of an enclosure, walled or fenced, the *hortus conclusus*, within which is fruitfulness, was used as a symbol of the Immaculate Conception (VIRGIN MARY, 4). A garden refers more generally to Mary's virginity when it is made the setting for the ANNUNCIATION; the Virgin with the unicorn (VIRGIN MARY, 5); or the Virgin and Child, perhaps in a bower of roses (10). For the Garden of Eden, see ADAM AND EVE. In secular art the Garden of LOVE is presided over by Cupid on a fountain. A flower garden may be the setting of Spring personified, one of the FOUR SEASONS. See also FLORA; HERCULES (11).

Garden of Eden, see ADAM AND EVE (1).

Geese of Brother Philip ('. . . of Filippo Balducci') (Boccacio, *Decameron*, 4: proem). Filippo, a Florentine, was widowed and left with the upbringing of an only son whom he shut away in the mountains to shelter him from the evils of the world. Not until he was a young man was he allowed out, when he accompanied his father on a visit to Florence. On the way they passed a company of maidens returning from a wedding. 'What are they?' asked the son. 'Take no notice,' his father replied, 'They are young geese, and only cause trouble.' The young man was reproved for wishing to take one home with him. The theme is found in French rococo painting and depicts the youth questioning his aged parent concerning a nearby group of gossiping girls.

Gemini (zodiac), see TWELVE MONTHS.

Geminianus. Bishop of Modena and friend of St Ambrose, thought to have died

in 348. The facts of his life are not well-authenticated. He is represented in northern Italian art as an elderly bishop holding a crozier and perhaps a model of the city of Modena, of which he is the patron. He may also hold a mirror in which is reflected the image of the Virgin. A DEMON at his feet alludes to the story that he went to Constantinople to exorcize the daughter of the Roman emperor. He was said to have twice saved the city of Modena from destruction, first by his intercession when it was under attack by Attila, and secondly from the danger of floods.

Geneviève (born c. 422). Patron saint of Paris. The record of her life, especially her childhood, is open to question. As a child in Nanterre, where she tended sheep, she was once noticed by Germanus, bishop of Auxerre, who encouraged her in a life of piety and chastity. She went to Paris as a young woman and devoted herself to good works and meditation. She acquired a reputation for prophecy which seems to have generated some malice and partisanship among those around her. She played a part in the defence of Paris against the Huns and Franks. Geneviève is represented either as a shepherdess with a CROOK or DISTAFF, or as a nun holding a lighted CANDLE or taper. A demon blows out the candle, perhaps with bellows, and an angel relights it, an allusion to the conflicting sentiments that she aroused in others. Scenes from her life are found in French art from the later Middle Ages onwards. They show her keeping her sheep, receiving the benediction of Germanus, praying to still a storm, feeding and watching over the population of Paris during the Frankish siege. The Panthéon in Paris was originally intended as a church dedicated to St Geneviève. It stands on the site of a former church dedicated to her and is decorated with scenes from her life by Puvis de Chavannes.

Genre. Scenes of everyday life, especially by Netherlandish and French painters of the 17th and 18th cents., may sometimes contain hidden allegories. See FIVE SENSES; FOUR ELEMENTS.

Gentleness (or 'Mansuetude', from the Latin, meaning 'accustomed to being handled'). A minor virtue in religious allegory, represented as a woman with a LAMB, frequently found in medieval MSS and French Gothic sculpture where she may be opposed by the vice of Malignity, which is seen as a master ill-treating a servant. In Renaissance art she may be seated with a lamb at her lap, her hand perhaps resting on its head.

'Genus unde Latinum,' see VENUS (9).

George. Legendary warrior saint and martyr, said to have been born in Cappadocia in Asia Minor and to have died at Lydda in Palestine about the end of the 3rd cent. From early times he was especially venerated in the Greek church; his popularity in the West dates only from the 13th cent. He is patron saint of several European cities including Venice. He was made patron of England in 1222, and of the Order of the Garter about a century later.

1. *St George and the dragon.* The key to the theme lies in the dragon. To the early Christians a dragon symbolized evil, in particular paganism. The conversion of a heathen country to Christianity by a saint would thus be depicted in symbolic form, as the slaying of a dragon with a spear. St George was shown in this manner to signify the winning of Cappadocia for the faith, the place itself being personified by a maiden (a normal convention, see TOWNS AND CITIES PERSONIFIED). The original meaning having been lost, later ages interpreted the image afresh for themselves in terms of the traditional stories from antiquity that were familiar to them. So St George, like PERSEUS (2) was said to have fought a dragon by the sea-shore, outside the walls of a city, in order to rescue

the king's daughter who was being offered as a sacrifice. In this form the story is first known to us through the *Golden Legend* (13th cent.) which located it at Silene in Libya. Other sources refer to Beirut where, according to a local tradition, Perseus' exploit took place. St George, dressed in armour and mounted on a horse (usually white for purity), brandishes his sword. His lance lies already broken on the ground, one piece maybe piercing the monster's neck. The princess is praying for his victory or fleeing. The remains of previous victims are strewn about. Spectators may be seen watching from the city walls. The dragon is typically winged and scaly, often with a forked tongue and tapering tail. The saint wears the armour of a Roman soldier or, particularly in the art of northern Europe, a medieval knight. A sequel to the story is also sometimes depicted. Having leashed the dragon with the princess' girdle, which magically subdued it, St George led it into the city and there slew it in front of the king, courtiers and terrified citizens. They wear eastern dress with turbans. The saint then baptized the royal family who are seen in church kneeling at the font.

As a devotional image St George tramples the dragon under his foot, an allusion to the victory of the Christian faith. He holds a drawn sword, sometimes a broken lance (which helps to distinguish him from other saints in armour), or a banner with a red cross, or a shield bearing a cross. In votive pictures of the Virgin he is seen with SEBASTIAN, another warrior-martyr, with LONGINUS and, especially in German painting, with FLORIAN.

2. *The martyrdom of St George.* After surviving various trials – drinking a poisoned cup, being stretched on a wheel, put in a boiling cauldron – the saint was beheaded. Scenes of his martyrdom are fairly rare, occurring principally in narrative cycles in churches of which he is patron (Altichiero and Aranzo, Oratorio di S. Giorgio, Padua).

Germanicus, Death of (Tacitus, *Annals*, 2:71–2). A Roman general (15 B.C. – A.D. 19), the son of Nero Claudius Drusus, and nephew of the emperor Tiberius. Germanicus was so named after his campaigns against the Germanic tribes. He died, the victim of intrigue, while on a visit to the eastern provinces, probably poisoned by Piso the governor of Syria. The news of his death provoked scenes of great sorrow and mourning in Rome. (See also AGRIPPINA AT BRUNDISIUM.) He is depicted on his deathbed, his wife Agrippina beside him bowed with grief. His loyal officers stand at the bedside pledging themselves to avenge his death (Poussin, Minneapolis Institute of Arts). This example of comradeship and the meeting of death with quiet dignity typify the stoical virtues that are manifested in several of Poussin's works.

Germanus of Auxerre, see GENEVIÈVE.

Geronimo, see JEROME.

Gervase and Protase. Legendary Christian martyrs. There is no historical evidence for their existence, their cult having apparently sprung from the discovery of some human remains in Milan in 386, whose whereabouts were said to have been revealed to AMBROSE in a vision. For refusing to sacrifice to the Roman gods Gervase was beaten to death with a WHIP loaded with lead; Protase, his twin brother, died by the SWORD. In devotional pictures they stand as a pair, each having for attribute the instrument of his martyrdom. Their relics were taken to Paris in the 6th cent., and they were hence much venerated in France. They feature chiefly in French art, especially of the 17th cent. St Ambrose is depicted at prayer, the two martyrs appearing to him in a vision. Their remains are borne in procession to the church, followed by Ambrose; the sick press

forward to be healed. Also depicted is the saints' refusal to worship before a pagan statue.

Geryon, Oxen of, see HERCULES (10).

Ghismonda (Sigismunda) (Boccacio, *Decameron*, 4:1). Ghismonda, daughter of Tancred, prince of Salerno, was in love with a humble page of her father's court named Guiscardo. When the affair came to her father's ears he had the youth killed and his heart cut out and sent to Ghismonda in a large golden cup. She poured poison into the cup and drank it. Ghismonda, like the other tragic females SOPHONISBA and ARTEMISIA, is portrayed in rich attire holding a goblet or other vessel. A heart may be seen protruding from it (Hogarth, Tate Gall., London).

Giant. Goliath, slain and beheaded by DAVID (4); with a child pickaback, CHRISTOPHER; with a youth pickaback, ORION; one-eyed giant, POLYPHEMUS. HERCULES slew the giants Cacus (15) and Antaeus (16). See also BATTLE OF THE GODS AND GIANTS.

Gideon's Fleece (Judges 6:36–40). Gideon, a judge, one of the early leaders of the Israelites after the conquest of Canaan, demanded tangible proof that God would sustain their cause. He laid out a fleece on the ground at night and asked, as a sign, that the dew should fall only on the fleece, leaving the surrounding earth dry. Miraculously, this happened. Not yet satisfied he asked for a further sign, this time the other way about – dry fleece and damp earth – and was again answered by God. He is depicted, generally in armour, kneeling before the fleece. An angel may be present. In the Middle Ages the dew on the fleece was taken as a prefiguration of the Virgin impregnated by the Holy Ghost, and the theme thus became associated with the Annunciation.

Gifts of the Holy Spirit, see SEVEN GIFTS OF THE H.S.

Giles (8th cent.). A popular saint in the later Middle Ages. Little is known of his origins. He is the patron saint of beggars and cripples and many churches in Britain are dedicated to him. The Benedictine monastery of Saint-Gilles near Arles, of which he was the abbot, became the centre of his cult. Near here was supposed to have occurred the celebrated incident concerning one of the animals that he traditionally befriended. The king out hunting shot an arrow into the undergrowth after a fleeing stag or hind. In a clearing Giles was found protecting the beast in his arms, the arrow piercing his body, the hounds halted by some miraculous power. He is depicted holding a stag, sometimes with the arrow passing through his hand and into the animal's body. As a devotional figure St Giles is found chiefly in French and German art. He is usually white-bearded and wears the white habit of the reformed Benedictines (see diag. RELIGIOUS DRESS). His attributes are a STAG and an ARROW. *The mass of St Giles*, see CHARLEMAGNE.

Girdle. The girdle of the Franciscan monk has three knots symbolizing the vows of poverty, chastity and obedience. It may be worn also by the Virgin of the Immaculate Conception (VIRGIN MARY, 4). It was adopted as an *impresa* by Claude, the wife of Francis I, king of France, sometimes forming the border of an emblem consisting of a swan with an arrow. A girdle is the attribute of THOMAS, apostle, who may receive it, kneeling, from the hands of the Virgin in heaven above. The girdle of Venus had the power of bestowing sexual attraction on its wearer. She lent it to Juno in order that she might charm her husband Jupiter (*Iliad* 14:214 ff). In antiquity a girdle was a symbol of marital fidelity and was given by the man as a token to his wife at their marriage.

Girolamo, see JEROME.

Glaucus and Scylla (*Met.* 13:895–967). In Greek mythology Glaucus was a fisherman who was by chance changed into a merman, or sea-centaur, after chewing some magic blades of grass. He fell in love with the nymph Scylla, but she fled from his advances. Circe, the sorceress, who loved Glaucus, turned Scylla into a monster to stop him pursuing her. Scylla is usually seen in the act of fleeing from Glaucus. She scrambles over a rocky shore. He rises behind her with outstretched arms, a white-bearded sea-god with forelegs like fins and a curling fish's tail (Rosa, Brussels Mus.).

Globe, or orb, held in the hand of a monarch, signified his sovereignty over the world. It was first used thus by the Roman emperors. In the Christian era, surmounted by a cross, it was one of the insignia of the Holy Roman Emperors and of English kings since Edward the Confessor (see GOVERNMENT, GOOD AND BAD). In religious art it may be held by Christ as SALVATOR MUNDI, or by GOD THE FATHER. The latter may rest his feet on a terrestrial globe. The globe is widely distributed among personified virtues, the Liberal Arts and some pagan divinities, signifying their universality. It is an attribute of TRUTH, especially from the 17th cent., of FAME, of ABUNDANCE and, with scales and a sword, of JUSTICE. The feet of PHILOSOPHY may rest on a globe. A globe under the feet of FORTUNE originally indicated her instability in contrast to the firm cube on which FAITH and HISTORY sometimes stand. OPPORTUNITY and NEMESIS, both of whom have associations with Fortune, may be similarly represented. Among the gods a globe is the attribute of APOLLO, occasionally of CUPID, and of the earth goddess CYBELE. A terrestrial globe is the attribute of the laughing philosopher (see DEMOCRITUS AND HERACLITUS), and is an element of allegorical STILL LIFE. A celestial globe is the attribute of Astronomy personified, one of the SEVEN LIBERAL ARTS, and of Urania, the MUSE of astronomy. It should bear stars or the mythological figures of the constellations but is not necessarily so represented. See also SPHERE, ARMILLARY.

Gluttony (Lat. *Gula*, lit. 'throat'; *Ventris Ingluvies*, 'greedy guts'). Classified with Lust as *vitia carnalia*, one of the sins of the flesh, Gluttony is also one of the seven Deadly Sins. It is represented in cycles of the VIRTUES AND VICES in medieval sculpture, and found also in the Renaissance, especially on tapestry, where such a moral example, hanging in domestic interiors, might be seen to good effect. The allegorical figure of Gluttony may be male or female, is fat, and is stuffing itself with food and drink. It sometimes vomits. It may be crowned with VINE leaves in the manner of Bacchus, and may hold a dish of FRUIT. Animals associated with Gluttony are the voracious wolf (see INNOCENCE), the PIG, the BEAR (known from Aristotle to A. A. Milne for its love of honey), and the HEDGEHOG which according to the bestiaries gathered fallen fruit on its spines by rolling on the ground.

Goat. The animal on whose milk JUPITER (1) was reared. But to pagan antiquity the goat generally symbolized lust and to Christians it stood for the damned at the Last Judgement (Matt. 25:32–33). It was associated with the worship of BACCHUS, and in art draws his chariot. The chariot of Love is also drawn by goats (see TRIUMPH). PAN and the SATYR, lustful by nature,

Impresa of Cosimo de' Medici

have goat-like features: horns, hairy legs, hooves. The goat is an attribute of LUST personified. Capricorn, a sign of the zodiac, is a goat with a spiral tail instead of hindquarters. Of the series of TWELVE MONTHS it belongs to December, and

hence occasionally to Winter, one of the FOUR SEASONS. The sign of Capricorn was taken for an *impresa* by Cosimo de' Medici (1519–1574), Grand-Duke of Tuscany, to commemorate a military victory won under its influence. The motto 'Fidem fati virtute sequemur,' – 'I shall pursue with valour the promise of destiny,' alludes to his belief in astrology.

God the Father. The first person of the Trinity. From a historical viewpoint representations of God in themes antecedent to the birth of Christ would properly show God the Father. Yet the Creator and Lawgiver of the Old Testament, the figure that appears to Adam and Eve, to Abraham at the sacrifice of Isaac, to Moses and the prophets, is in medieval art until the 15th cent. generally that of Christ, typically recognizable by the cruciform halo. This accords with John (1:1), that 'when all things began, the Word (the Second Person) already was', and with the doctrine expressed in the Nicene Creed, 'Jesum Christum . . . per quem omnia facta sunt' – 'by whom all things were made.' The Renaissance however, notably in the works of Raphael and Michelangelo, identified Yahveh with God the Father, and depicted the 'Ancient of Days' with his long white hair and flowing beard. The figure of God the Father appears not only in the Old Testament but in the Marian themes of the ANNUNCIATION, the Immaculate Conception (VIRGIN MARY, 4), CORONATION OF THE VIRGIN; and in the BAPTISM of Christ and AGONY IN THE GARDEN. See also TRINITY.

Gods and giants, Battle of the. The Greek myth of the race of earthbound giants who assaulted heaven in order to overthrow JUPITER exists in several versions. According to Ovid (*Met.* 1:152–8; *Fasti* 5:35–44) they piled two mountains together, heaping Pelion upon Ossa, to build a staircase to Olympus. But Jupiter hurled his THUNDERBOLTS upon them, flinging down the mountains and crushing the giants. In the city of Pergamum, the centre of Hellenistic culture in Asia Minor, was erected an altar, which still remains, dedicated to Zeus (Jupiter) and decorated with a sculptured frieze depicting the battle, in which many of the Olympians take part. The theme was popular in the 17th and 18th centuries. The band of giants are depicted gathering huge boulders in their arms or bearing them on their backs, to build up the mountain. On a bank of clouds the assembled Olympians look down, ready to counter-attack, Jupiter with his eagle and JUNO with her peacock in the centre. The downfall of the giants lent itself to the decoration of baroque ceilings. Here, Jupiter, perhaps borne on the back of his eagle, hurls his bolts, and near him HERCULES wields his club. The giants tumble headlong off the edge of the ceiling amid falling rocks, earth and broken tree-stumps. The theme was sometimes taken as a pagan parallel to the fall of the rebel angels. (See SATAN.)

Gold and silver vessels, brought before a Roman general sitting in judgement under a canopy, suppliants kneeling, SCIPIO (1). A king indicating his treasures to a sage, CROESUS AND SOLON. Soldiers offering vessels to a man who declines them, FABRICIUS LUSCINUS; the same, the man at fireside with cooking pot, CURIUS DENTATUS. Eastern banquet, precious vessels, monarch and others, writing on wall, BELSHAZZAR'S FEAST. Vessels brought before pope, a deacon kneels; or the deacon distributes them as alms, LAURENCE. A metal-worker is ELOI, the patron saint of gold- and silver-smiths.

Golden Age, see AGES OF THE WORLD.

Golden calf, see MOSES (11); SOLOMON (3).

Golden fleece, see FLEECE.

Golden Gate, Meeting at the, see JOACHIM AND ANNE.

Goldfinch, held by infant Christ, see VIRGIN MARY (13).

Good Samaritan (Luke 10:30–37). Enjoined to love his neighbour as himself, a lawyer among Christ's hearers asked how one should define such a person, and was answered with the famous parable. A traveller on the road from Jerusalem to Jericho was attacked by robbers and left half dead. A priest and a Levite both passed by with averted eyes, but a Samaritan – the traditional enemy of the Jews – stopped and after bathing and dressing the man's wounds carried him to an inn, leaving money with the innkeeper so that he might be properly cared for. Medieval writers, following Augustine, drew another moral: the traveller personified Man who departed from Paradise (Jerusalem) and was assailed by sin. Judaism (the priest and the Levite) failed to redeem him, but Christ (the Samaritan) brought him salvation through the Church (the inn). In early examples the Samaritan is represented by the figure of Christ. The theme is popular in Christian art of all periods. The traveller lies by the roadside tended by the Samaritan who pours oil on his wounds or bandages them. The priest and the Levite are making off in the distance. Or we may see the arrival at the inn: the traveller is carried in by two helpers while the Samaritan with his purse in his hand approaches the innkeeper who stands in the doorway. A boy holds the Samaritan's horse.

Good Shepherd, see SHEPHERD.

Goose. The attribute of MARTIN of Tours. A goose pursued round the supper table by an old man, PHILEMON AND BAUCIS.

Gordian knot, see ALEXANDER THE GREAT (3).

Gorgons. In Greek mythology three monstrous sisters of hideous aspect, with snakes for hair and glaring eyes, one of whom, MEDUSA, was slain by PERSEUS.

Gourd. The dried, hollow fruit of the bottle-gourd, or calabash, was commonly used by travellers to carry water. Thus it became the attribute of the pilgrim and, hence, of JAMES THE GREATER, Christ on the JOURNEY TO EMMAUS, and sometimes the archangel RAPHAEL. The story of the gourd that God caused to grow and give shade to Jonah (4:6–7) made it a symbol of the Resurrection (see JONAH).

Government, Good and bad. Good Government is personified as a judge, enthroned, perhaps crowned and holding an orb and sceptre, symbols of authority. Behind him may be allegorical scenes of peace. The theme is found in Italian art, especially Sienese, of the late 15th cent., and is an expression of the civic pride of the Italian city states. The contrasting figure of Bad Government is a demon, surrounded by the vices, and in the background scenes of warfare.

Gracchi, see CORNELIA.

Graces, see THREE GRACES.

Granida and Daifilo. Lovers, from the Dutch pastoral play *Granida* (1605) by Pieter Hooft. Granida, the daughter of an eastern king, betrothed to Prince Tisiphernes, lost her way while out hunting. She came upon a shepherd Daifilo and his mistress Dorilea who had just quarrelled. Daifilo fetched water for the princess to drink and fell in love with her. He followed her to court and, after several turns in the story, they fled to the woods together to live a pastoral life. Daifilo was taken prisoner by one of Granida's several suitors. They were finally reunited after the intervention of Tisiphernes who yielded his claim to her. The play set a fashion for the pastoral idyll in Holland and long remained popular. It is commonly represented in 17th cent. Dutch painting. The lovers are depicted in a woodland setting, with the suitor and soldiers approaching to arrest Daifilo. Of several scenes the most frequent shows the lovers' first meeting (Act 1, Sc. 3), with Daifilo kneeling before Granida who is on horseback, or just dismounted. He offers her water in a shell. Dorilea looks on with displeasure.

Grape, in Christian art the symbol of the eucharistic wine and hence of the blood of Christ, especially with ears of corn (see VIRGIN MARY, 13; STILL LIFE). The attribute of VINCENT OF SARAGOSSA. A bunch of grapes suspended from a pole borne horizontally on the shoulders of two men, WINE-PRESS, MYSTIC. In secular art grapes are the attribute of BACCHUS, the god of wine, and of the personification of Autumn, one of the FOUR SEASONS. Scenes of harvesting the grape belong to September, one of the TWELVE MONTHS. See also VINE.

Gregory the Great (?540–604). Christian saint and one of the four Latin (western) Fathers of the Church. As pope he proved to be an outstanding administrator who established the form of the Roman liturgy and its music (Gregorian chant). He instituted the rule of celibacy for the clergy and helped to lay the foundations of Christianity in England by sending a mission led by Augustine (of Canterbury). He is usually tall, beardless and dark-haired and wears papal vestments, with the tiara and pontifical crozier with its three transverses. His principal attribute is a DOVE, the symbol of the Holy Ghost, which perches on his shoulder or hovers above his head or at his ear, suggesting the divine inspiration of his writings. His secretary may be seen peering at it in wonder through a curtain. In devotional painting Gregory often appears with the other three Latin Fathers, Ambrose, Augustine and Jerome. In Counter-Reformation art he is associated with scenes of souls in purgatory.

1. *The supper of St Gregory*. It was Gregory's custom to give supper to twelve paupers, from the number who sat down to the Last Supper. Legend tells that one night a thirteenth guest sat with them, who revealed that he was Christ. He may be depicted as an angel or in the garb of a pilgrim.

2. *St Gregory releases the soul of the Emperor Trajan*. The *Golden Legend* tells a curious story of a widow, in the time of Trajan, who demanded vengeance for the death of her son, murdered by the son of the emperor. Trajan in return gave up his own son to her but was still nevertheless condemned to purgatory. Five hundred years later Gregory, by his prayers, brought about the release of Trajan's soul, which is depicted borne upwards by angels out of the flames (Dante, *Purg.* 10:73–94). As a symbol of Justice, the subject often makes a companion-picture to the Judgement of Solomon and of Daniel. Purgatory, a concept developed by Gregory, was thought of as a region, neither heaven nor hell, where the souls of those who had not fully expiated, or 'purged', their earthly sins were detained. Gregory taught that prayer could be effective in hastening their release. The naked figure of the emperor is occasionally an attribute of the saint.

3. *St Gregory delivers the soul of a monk*. Gregory's *Dialogues* (4:40) tell of a monk from whom the last rites were withheld by his abbot because he was found to have hidden three gold coins in his cell. By his prayers Gregory secured the release of the monk's soul from purgatory. He kneels before an altar, the monk beside him surrounded by the flames of purgatory, while angels carry the monk's soul to heaven.

4. *The miracle of the brandeum*. The Empress Constantia, demanding a holy relic from Gregory, was given the brandeum, or shroud, of John the Evangelist, which she rejected with contempt as not being genuine. When Gregory pierced the cloth with a knife blood flowed from it, proving its authenticity.

5. *The Mass of St Gregory*. A late legend, probably evolved from Gregory as compiler of the liturgy of the Mass, tells how the saint, finding a disbeliever among his congregation, prayed for a sign and was rewarded by the appearance above the altar of the crucified Christ and the instruments of the Passion.

The theme occurs frequently in the era of devotional art that followed the Counter-Reformation. Christ may be portrayed carrying the cross on his shoulder or pressing the wound in his side, from which blood spurts into a chalice. The instruments of the Passion most commonly represented are the nails, crown of thorns, sponge, lance, scourge and pillar (Flagellation); but also sometimes a hammer, the rope, the soldiers' dice, the cock which crowed after Peter's denial, the head of Judas, the hands that struck Christ, Pilate's jug, basin and towel, and St Veronica's veil. Angels are usually present, sometimes swinging censers (see also MAN OF SORROWS).

 See also FINA.

Gridiron. The instrument of martyrdom and hence the attribute of LAURENCE and, more rarely, of VINCENT OF SARAGOSSA.

Griffin. A fabulous monster having the head, wings and claws of an eagle, and the body and hinder parts of a lion. Its origin probably lay in the ancient east where with other imaginary beasts it was said to guard the gold of India. The Greeks believed that griffins guarded the gold mines of the Scythians. It is a common bearing in heraldry where it symbolizes the combined qualities of eagle and lion – watchfulness and courage. As a Christian symbol it signifies the dual nature of Christ, divine (bird) and human

Gridiron

(animal), and is a common motif in Gothic church sculpture. Dante(*Purg.* 29:106ff) describes the triumphal car of the Church drawn by a griffin. See also HIPPOGRIFF.

Guillaume, see WILLIAM.

Gula, see GLUTTONY.

Gulielmus, see WILLIAM.

Gun, see CANNON.

Gundaphorus, King, The palace of, see THOMAS, apostle (3).

Gyges in the bedchamber of King Candaules (Herodotus 1:8–12). Candaules, a king of ancient Lydia, was obsessed with the beauty of his wife's body, and persuaded one of his bodyguard, named Gyges, to judge the matter for himself. One night the king secretly stationed Gyges behind the door of the royal bedchamber where he witnessed the queen undressing for bed. Next day she summoned Gyges, told him she had been aware of his presence and offered him a choice: either of being slain ('Among the Lydians,' says Herodotus, 'it is reckoned a deep disgrace to be seen naked.'); or of slaying the king and wedding her, thereby regularizing his carnal knowledge. Gyges chose the latter course and thus won a kingdom. The theme occurs in baroque painting of the Netherlands and Italy. The queen has just let fall her last garment. Gyges peers astounded through the curtains or round a door. Candaules, wearing a crown, may be leaning over his shoulder. (Jordaens, Nat. Mus., Stockholm.)

Hades, king of the underworld, see PLUTO.

Hagar and Ishmael, see ABRAHAM (3).

Hair. A man cutting the hair of another, sleeping, whose head rests in a woman's lap, SAMSON (4). (Delilah herself sometimes cuts it.) A maiden cutting her own locks with a sword, wounded soldiers nearby, TANCRED AND ERMINIA. A maid attending to her mistress' disordered hair, war preparations in background, SEMIRAMIS (*S. called to arms*). The allegorical figure of OPPORTUNITY has a lock of loose hair falling over the brow. A naked goddess wringing her wet hair, 'Venus Anadyomene,' VENUS (7). Long flowing hair, sometimes entirely covering the body, symbolizes penitence and is the attribute of MARY MAGDALENE; and of MARY OF EGYPT. AGNES, led to her martyrdom, is similarly represented. In the

ancient world it was the custom for an unmarried woman to wear her hair long and unbound. Virgin saints, and brides in Renaissance wedding portraits are sometimes depicted thus. In contrast, the hair of the courtesan or of personifications of profane love is usually braided.

Halberd. Weapon consisting of an axe-blade mounted on a staff. It served also as a spear. It was in common use in the 15th–17th cents. The halberd features anachronistically in scenes of ancient battles. It is the attribute of JUDE and MATTHEW; and of MINERVA (Botticelli, 'Pallas and the Centaur', Uffizi, Florence).

Halo, or nimbus. In religious art a zone of light placed round the head of a divine or sanctified person. The ancient gods of India and China were sometimes so represented. It was the attribute of the sun-gods Mithras, Apollo and Helios, generally in the form of radiating beams of light, and was adopted in images of the Roman emperors who were deified. The halo seems to have appeared in Christian art about the 5th cent. Its use was at first confined to the three persons of the Trinity and the angels, but by degrees was extended to the apostles, saints and others. In the East the halo symbolized power rather than sanctity and it was not unusual for it to be given to Satan in early Byzantine art. The halo takes various forms. The cruciform halo is generally the attribute of Christ, though in some representations of the Trinity it may be worn by all three persons. A triangular halo, symbolizing the Trinity, belongs to God the Father. A square halo is given to contemporary living persons, lay and ecclesiastical, such as pope, emperor and donors. The theological and cardinal virtues and other allegorical figures (see VIRTUES AND VICES) have hexagonal haloes. The familiar circular form belongs particularly to the Virgin Mary, angels and saints. In later medieval painting it was represented as a flat plate of gold and, especially in the 14th cent., had its wearer's name inscribed on it. Early Renaissance artists reduced it to a simple ring which was shown in perspective. But the halo fell out of favour and in post-Renaissance art was only rarely used. The term aureole denotes the radiance that surrounds and appears to emanate from the whole figure, not merely the head. It is specifically an attribute of divinity and is reserved for Christ, especially at the TRANSFIGURATION, and for the Virgin Mary. For the stylized almond-shaped aureole, see MANDORLA.

Hammer and nails are instruments of the Passion and the attribute of HELENA; hammer, tongs and anvil, of ELOI, a bishop. VULCAN, blacksmith of the gods, has a hammer for attribute.

Hand. A hand emerging from a cloud was an early form of representing the First Person of the TRINITY. The hand that struck Christ is one of the instruments of the Passion and is also the attribute of the Tiburtine SIBYL. A hand giving money refers to the payment to Judas. The washing of hands, from Pilate's action after the TRIAL OF CHRIST, became a symbol of innocence. Hence a young woman washing her hands stands for INNOCENCE personified. A woman standing with cupped hands before Apollo is the Cumaean Sibyl (APOLLO, 7). A Roman soldier, his right hand thrust into a brazier, is MUCIUS SCAEVOLA.

Hare, like the rabbit, a symbol of lust and an attribute of LUST personified, because of its well-known fecundity. At the feet of the Virgin a hare or rabbit signifies victory over lust. The medieval image of a knight pursued by a hare symbolizes timidity or cowardice (see FORTITUDE). The discovery of a message concealed in a hare's body, CYRUS THE GREAT.

Harp. Musical instrument known in ancient Egypt and Assyria. Its shape and size varied. The form of the Hebrew harp, played by DAVID, is not known. The European instrument of the later Middle Ages, the model for its representation

in art, was of slender, elegant construction, often small enough to be easily portable. It might be hung by a thong. It was much esteemed in royal and aristocratic circles. It features commonly among the instruments played by concerts of angels. The twenty-four elders of the Revelation each has a harp (APOCALYPSE, 3). It is sometimes the attribute of Terpsichore, the MUSE of dancing and song.

Harpy, see AVARICE; MONSTER.

Harrowing of hell, see DESCENT INTO LIMBO.

Harvest. Scenes of harvesting belong to Summer, one of the FOUR SEASONS; to June, July and August, of the TWELVE MONTHS; and to the Silver Age, of the AGES OF THE WORLD. A woman gleaning in the fields is RUTH, perhaps being addressed by Boaz. Reapers in a cornfield may be seen in the background of the FLIGHT INTO EGYPT.

Hat. The simple head-covering of the peasant and traveller in ancient Greece was the *petasus*. It was round, with a shallow crown and a brim to protect against the sun. With wings, it is typically worn by MERCURY. The medieval pilgrim's hat is basically like the *petasus*, sometimes (particularly northern Europe) turned up at the back and sides, giving the effect of a peak at the front. It may bear a scallop SHELL. When not worn

Mercury's petasus

it is slung behind the shoulders, or from the pilgrim's staff. Thus JAMES THE GREATER, ROCH, and Christ as a pilgrim on the JOURNEY TO EMMAUS and SUPPER AT EMMAUS. (See also PILGRIM.)

The 'Phrygian bonnet' was a short, pointed, conical cap worn originally by Persian soldiers and, with the top typically folded forward, is seen in early images of the Persian god Mithras. It was worn by his priests, the magi. The Mithraic cult was widespread in Asia Minor in antiquity and eventually reached Rome. A similar, exaggerated, style was revived in the late 14th and early 15th cent. fashions of Italy and France. Like the turban, the Phrygian bonnet is sometimes used in art to denote eastern origin. It is especially the attribute of

Phrygian bonnet, or cap

PARIS. (See ADORATION OF THE MAGI; AENEAS, 8; GANYMEDE; LIBERTY.)

A cardinal's red hat is the attribute of JEROME and, more rarely, of BONAVENTURA. The latter's may hang from a tree.

See also CROWN; HELMET; MITRE; TIARA; TURBAN.

Hatchet, embedded in the skull of a Dominican monk, the attribute of PETER MARTYR.

Head. *Severed head:* On a charger, JOHN THE BAPTIST (7, 9). Blindfold, on a charger, PAUL, apostle (13). Held by woman with sword, perhaps about to be put in sack, JUDITH. Large head, held by young warrior, or borne aloft on pole, DAVID (4). Snake-haired head held by Greek warrior, PERSEUS. With decapitated body, scene of judgement, MANLIUS TORQUATUS. A head, perhaps crowned, held over urn, TOMYRIS. Held by woman kneeling before enthroned king, JUDGEMENT OF OTTO. Pierced by arrow, at feet of war-like woman, FOUR PARTS OF THE WORLD: America. Before a Roman military commander, CAESAR, GAIUS JULIUS. At or beneath the feet of winged god, MERCURY (1). A cephalophore, i.e. a saint with his head 'tucked underneath his arm', or otherwise holding it, is DENIS. Christ's head portrayed on a cloth, VERONICA. *Head with two faces:* The god JANUS. *Head with three faces:* PRUDENCE personified, who may sometimes have two. See also MONSTER.

Heart. A symbol of love in both sacred and secular contexts; when in flames signifying extreme ardour. A flaming heart is the attribute of AUGUSTINE and ANTONY OF PADUA, of CHARITY personified and of the Renaissance VENUS. A popular Renaissance emblem depicts a heart pierced by an arrow with the motto 'Amor vincit omnia' – 'Love conquers all.' (CUPID, 5). A heart pierced by three nails and encircled by a crown of thorns is the Christian 'sacred heart', whose veneration became widespread in the 17th cent. A heart crowned with thorns is the emblem of the Jesuits and an attribute of their founder IGNATIUS OF LOYOLA. A hag gnawing a heart is ENVY personified.

Heaven, see ALL SAINTS PICTURE; ANGELS; LAST JUDGEMENT (5).

Hebe. Greek goddess of youth, identified with the Roman goddess Juventas. According to myth she was the daughter of Jupiter and Juno, and was wedded to Hercules after his ascent to Olympus. She was the cup-bearer and general handmaiden of the gods, and is depicted on antique vases winged, and bearing a wine-vessel.

Hebe and the eagle of Jupiter. She stands with a jug in one hand, from which she has just poured nectar into a cup. At her side Jupiter's eagle cranes its neck to drink. The theme occurs in 18th cent. painting as a vehicle for female portraiture, flattering the sitter by implying that she shares Hebe's youth and beauty. See also HERCULES (26).

Hector, see TROJAN WAR (3, 4, 6).

Hedgehog. Attribute of Touch, one of the FIVE SENSES, and of GLUTTONY. Not to be confused with the PORCUPINE.

Helen of Troy. In Greek mythology the daughter of LEDA and Jupiter (Zeus), and the wife of Menelaus, king of Sparta. She was famous for her beauty which Homer likened to that of the immortal goddesses.

The abduction (or rape) of Helen. Helen was loved by the Trojan prince PARIS. While her husband was away he forcibly carried her off by sea to Troy. The Greeks mounted an expedition to recover her and thus began the Trojan war. The scene is a harbour or rocky seashore. Paris holds the protesting Helen in his arms while his companions ward off the Greeks with their swords. The handmaidens of Helen wring their hands or tear their hair in despair. The Trojan boats stand in the background. Related themes, less often depicted, are: Helen presented to Priam, the king of Troy and the father of Paris; the wedding of Helen and Paris; Helen in her chamber wooed by Paris with a lyre. See also ZEUXIS PAINTS HELEN.

Helena (c. 255–330). Christian saint, the mother of Constantine the Great, she devoted the latter part of her life to good works after Christianity became officially tolerated in the Roman empire by the edict of her son. She founded churches in the Holy Land and, according to legend, there discovered the cross on which Christ was crucified (see further, TRUE CROSS, HISTORY OF THE). She is usually portrayed as an elderly matron, regally dressed and wearing a CROWN. She holds a cross and sometimes three NAILS and a HAMMER, or a model of a church (the Holy Sepulchre). The cross, borne by angels, appears to her in a vision. As a devotional figure she may stand beside Constantine.

Heliodorus (II Maccabees 3). In the last centuries before the Christian era the Jews in Palestine were dominated by the Syrian Seleucid kings. Heliodorus, an official of the Seleucid court, was sent to Jerusalem to rifle Solomon's Temple of its wealth. According to the apocryphal account, when Heliodorus and his guard arrived at the temple 'they saw a horse, splendidly caparisoned, with a rider of terrible aspect; it rushed fiercely at Heliodorus and, rearing up, attacked him

with its hooves.' The rider's two young companions, represented as angels, scourged Heliodorus who collapsed, but the priest of the Temple took care of him. The subject was regarded as a prefiguration of Christ driving the money-changers from the Temple. (See CLEANSING OF THE TEMPLE.)

Helios, sun-god, see APOLLO; ICARUS.

Hell. To the medieval Christian hell was Satan's kingdom, the place where the bodies of the damned, after reunion with their souls at the general resurrection, were tortured in everlasting flames. As a place of punishment it corresponded to Tartarus of the ancient Greeks, part of Hades' realm, from which Christian art drew some of its features. From about the 12th cent. the entrance to hell was depicted as the gaping jaws of the monster Leviathan (Job, ch. 41), within which a cauldron sometimes stood. This died out during the Renaissance, replaced by a cavern's mouth like that, near Lake Avernus, through which AENEAS (8), guided by the Cumaean Sibyl, descended to the underworld. Or, more rarely, it came to be represented as the doorway of a building. It may be guarded by the three-headed dog CERBERUS of Greek myth. The approach to heaven is occasionally by way of a bridge over which the good pass easily, while the wicked fall into the flames of hell below. The bridge, in Persian mythology, joined earth and heaven as did Jacob's ladder, and is mentioned in the *Dialogues* of Gregory the Great (El Greco, *Dream of Philip II:* Escorial). In the portrayal of hell itself the influence of Dante's *Inferno* is often noticeable, with its series of circles of punishment (Nardo di Cione: S. M. Novella, Florence); in the image of CHARON in his bark, perhaps beating the more laggard souls with his oar (*Inf.* 3:111); or Minos, the judge of Hades, winding his snake-like tail round his body to denote the appropriate number of the sinner's circle of torment (*Inf.* 5:4–12). (The last two, Michelangelo: Sistine chapel). In the 12th and 13th centuries punishment tends to be confined to those guilty of AVARICE, who clutch at the money-bags dangling from their necks, and LUST, females from whose breasts and pudenda hang toads or serpents. In later art the lustful, tormented by demons, are plunged into sulphurous flames, sodomites turn on a spit, gluttons wallow in filth or are forced by demons to consume inedible food, the envious are half-submerged in a freezing river, and the proud are bent by the rocks which, like SISYPHUS, they bear on their backs. SATAN presides, a sinner dangling from each of his three mouths. The principal place of hell in Christian art is in representations of the LAST JUDGEMENT (6). But see also DANTE AND VIRGIL; DESCENT INTO LIMBO; DIVES AND LAZARUS; ROYAL WEDDING; WISE AND FOOLISH VIRGINS. For the classical kingdom of Hades see HERCULES (20); ORPHEUS; PLUTO; RAPE OF PROSERPINE. Condemned to torture in Tartarus were IXION; SISYPHUS; TANTALUS; TITYUS.

Helmet. Part of the accoutrement of the warrior. It helps to distinguish the soldier in scenes where he would not otherwise be in military dress, in particular ALEXANDER THE GREAT. The helmet is from antiquity the attribute of MINERVA, often surmounted by a panache; also of FAITH and FORTITUDE personified. A winged helmet belongs to PERSEUS; it had the power of making him invisible. A soldier pouring water from a helmet over a dying female in armour, TANCRED AND CLORINDA.

Henry II, Holy Roman Emperor and saint, see CUNEGUNDA.

Hephaestus, see VULCAN.

Hera, see JUNO.

Hercules (Gk Heracles). In Greek mythology, a hero and the personification of physical strength and courage, one of the most popular figures in classical and later art. His twelve labours, in which he triumphs over evil against great odds,

are partly myth, partly heroic saga, reflecting his dual nature as god and hero. There are grounds for believing that his story is based on some historical figure. Even so, many of his deeds bear marked similarities to the myths of other countries of the eastern Mediterranean. The much more ancient Sumerian saga of Gilgamesh tells of the hero slaying a lion as Hercules slew the Nemean lion, an exploit that has its Christian counterpart in the story of SAMSON. The central episode of the Gilgamesh saga concerns the hero's descent to the underworld, as Hercules descended to bring back Alcestis – this too has a Christian parallel in the DESCENT INTO LIMBO. In ancient Greece Hercules was worshipped as the protector of people and the guardian of cities, and his cult was widespread and important among the Romans. According to myth he was the son of a mortal woman, Alcmena, fathered on her by Jupiter during the absence of her husband Amphitryon, an act which aroused the jealousy of Jupiter's wife, Juno. In addition to his twelve labours, Hercules performed many other feats, and at his death was rewarded by Jupiter with deification: he was borne up to Olympus in a chariot by Minerva, the goddess who was his protectress during his life. In art, the labours, as a series, lend themselves to treatment as frescoes, and the figure of Hercules has had a particular appeal for the sculptor; for such reasons he appears less often in gallery painting than his popularity might lead one to expect. A typical image is the Farnese Hercules, an antique sculpture by Glycon (Museo Nazionale Archeologico, Naples), discovered in 1540, and much copied afterwards. He is muscular, massively built, and has short curly hair and a short beard. The body is here emphasized by the device (also used by Michelangelo) of making the head disproportionately small. Occasionally in the earlier labours he is beardless. His two main attributes are the CLUB – which itself is sometimes a symbol of virtue (see 21, *Hercules at the crossroads*), and the lion's SKIN, won in his first labour. In classical art, and sometimes later, he wears the skin like a cloak, the lion's head forming a cowl or helmet. Less common attributes are BOW, ARROW and QUIVER, his alternative weapons; two SNAKES (14, *Infant Hercules*); APPLES, held in the hand (11); a DISTAFF (17, *Hercules and Omphale*). In allegory, Hercules personifies physical strength; he is then usually accompanied by some other figure, such as Minerva, representing the complementary virtue of moral strength, or wisdom.

The Twelve Labours

Hercules' labours (Apollodorus 2.5:1–12; Diodorus Siculus 4; Hyginus 30, and others) were undertaken as a penance for slaying his own children in a fit of madness. He was ordered by the Delphic oracle to serve Eurystheus, king of Tiryns, for twelve years and to undertake any task he might require. Serving a mortal in a menial role was the punishment for a god who offended the Olympians. Originally simple tales of the victory of the strong, they acquired in time a moral symbolism, the triumph of right over wrong. They decorated the frieze of Greek temples, and occur frequently as frescoes, especially Italian, in the 15th and 16th cents. The 'canon' of twelve was fixed probably in the Hellenistic era.

1. *The Nemean lion.* The lion that terrorized the citizens of Nemea was invulnerable to Hercules' weapons, so he strangled it to death. He is shown holding its neck in an arm lock, or, more usually, he stands astride its body, a knee in its back for leverage while, with his hands, he forces its jaws apart. His cloak (he has no pelt yet) flies behind him as if he had sprung on the animal from behind. This type, which is also used for SAMSON, was based on the ancient image of the Persian god Mithras slaying a bull. The worship of Mithras was widespread in the Roman empire.

2. *The Lernaean hydra.* This seven-headed (or nine, the number varies) monster, a water-snake, ravaged the country of Lerna, near Argos. No sooner did Hercules cut off one head, than two more grew in its place. With the help of a companion he overcame it by cauterizing the heads with a burning torch. The last head, which was immortal, he cut off and buried under a rock, and then dipped his arrows in the creature's poisoned gall. He is shown with club raised, laying about the hydra, without effect; it twists before him threateningly, its tail curled round his leg. A CRAB, sent by JUNO, bites his foot. The early Renaissance hydra often resembles the medieval winged dragon (a personification of Satan), with one head, and breathing fire. The baroque imagination inclines to the many-headed monster, maybe with its victims strewn about the swampy ground. Or it may have a Gorgon-like head from which serpents sprout.

3. *The Arcadian stag* (Ceryneian hind). Ordered to capture the beast alive, Hercules pursued it for a year, finally wounding it with an arrow. He stands behind it, grasping its antlers with both hands, a knee in its back – posed as in the first labour. Or he carries it away on his shoulder.

4. *The Erymanthian boar.* This fierce animal, which terrorized the neighbourhood of Mt Erymanthus, also had to be taken alive. Hercules drove it into a snow-drift and then caught it in a net. He carried it back to Eurystheus who was so frightened that he hid in a jar. Hercules is usually shown carrying the boar on his shoulder, but may also be in the act of capturing it, perhaps throwing a noose round its neck. Sometimes, wrongly, he brandishes his club.

5. *The Augean stables.* The stables of Augeas, king of Elis, held three thousand oxen and had not been cleaned out for thirty years. Hercules performed the task in one day by diverting river-waters through them. He stands, hand on club, his labour done, watching the waters flow past him through the stables.

6. *The Stymphalian birds.* These birds, with brazen wings, claws and beaks, and feathers that were poisoned arrows, inhabited Lake Stymphalus in Arcadia. Hercules frightened them into the air with a rattle, and then shot them with his arrows. He is shown standing with drawn bow, aiming at the birds.

7. *The Cretan bull.* Hercules was sent to Crete to capture the mad bull belonging to king Minos. Though it belched flames he succeeded after a great struggle, and took it back to Greece. His club is raised to strike; his other hand may hold a rope tied round the bull's neck. (For another episode with a bull, see 22, *Hercules and Achelous.*)

8. *The mares of Diomedes.* These wild animals lived on human flesh. Hercules, with a band of friends, seized them, and in the ensuing battle with their owner, King Diomedes, and his men, the king was slain. They fed his body to the mares which then became tame. Hercules may be seen grasping the rein of a mare, which surprisingly is bridled; his club is raised in the other hand.

9. *The girdle of Hippolyta.* Eurystheus sent Hercules to obtain for his daughter the girdle of Hippolyta, queen of the Amazons, the race of warrior women. Hercules won the girdle after a fight in which Hippolyta was killed. The Amazons were a popular subject in Hellenistic sculpture. Hercules and Greek soldiers, armed with sword and shield, are seen doing battle with them.

10. *The oxen of Geryon.* Geryon, a human monster with three bodies and one pair of legs, kept a herd of oxen on an island in the west, guarded by a giant and a two-headed dog. Ordered to capture the oxen, Hercules slew the dog, the giant, and lastly Geryon, and drove the herd back to his master. The scene of combat shows Geryon thrice-armed with clubs. Or he lies dead while Hercules leads away an ox by the horn. It was on this expedition, too, that Hercules opened the

channel between Mt Abyla, in the Atlas range, and Mt Calpe, the Rock of Gibraltar, known as the Pillars of Hercules. He may be shown wrenching the mountains apart with iron bars.

11. *The golden apples of the Hesperides.* The apples grew on a tree guarded by the serpent Ladon, in the garden of the Hesperides, who were the 'daughters of evening'. The garden lay in the west on the slopes of Mt Atlas. Hercules reached the garden after many adventures, slew the serpent, took the apples, and delivered them to Eurystheus. In another version he persuaded Atlas to pick the apples, while he himself temporarily took over Atlas' burden of supporting the world. The story divides into three scenes: (1) Hercules bears the globe on his shoulders. On a Greek metope Minerva puts a cushion on his shoulders for comfort. In the 16th cent. the theme was made into an allegory of astronomy; according to ancient mythographers Atlas taught Hercules astronomy, and the latter's bearing of the globe was therefore a symbol of his receiving this weight of learning. With Hercules may be two astronomers, recognizable by their attributes: COMPASSES (dividers) and an armillary SPHERE. Sometimes both Atlas and Hercules support the globe. (2) Hercules sits or stands under the tree round which the snake is twined. The Hesperides are sometimes present. This image, well-known in Roman times, may be the source of the tradition that the tree in the Garden of Eden was an apple. (3) Hercules slays the serpent Ladon. It sometimes takes the form of a dragon which Hercules faces with upraised club.

12. *Cerberus.* Hercules descended into the underworld, with Mercury and Minerva, to bring back Cerberus, the dog that guarded the entrance to Hades. It had several heads (usually shown as three) and the tail of a serpent. Pluto allowed Hercules to take the animal provided he could do so without using weapons. He caught it by the throat until it weakened and yielded. Having delivered it to Eurystheus he then returned it to the shades. Hercules is sometimes, incorrectly, seen with upraised club. Or he has chained the animal round the neck, and drags it out of hell.

13. *Hercules resting from his labours.* The standing figure of the Farnese Hercules (see above) is the prototype of many later examples. He rests on his club, the lion dead at his feet, or with its pelt draped over his club. Or he may hold the torch with which he slew the hydra. A different type shows him reclining on the pelt, his club, bow and quiver abandoned on the ground. He is surrounded by evidence of his other exploits: a boar's head, stag's antlers, and so on.

Other Herculean Themes

14. *The infant Hercules killing snakes* (Theocritus 24). Hercules always lived in the shadow of Juno's hostility, because he was the offspring of one of the many infidelities of her husband Jupiter. While he was still an infant she sent two poisonous snakes into his room at night, but he picked them up, one in each hand, and strangled them effortlessly. He is shown sitting on the ground, or in his cradle, grasping the snakes, while Alcmena and Amphitryon stand by, astonished. Juno may fly overhead in her chariot drawn by peacocks.

15. *Hercules and Cacus.* Part of the legendary history of the founding of Rome, it is related by Livy, by Virgil in the *Aeneid* and in Ovid's *Fasti* (1: 543–578). Hercules, returning home with Geryon's cattle, drove them across the River Tiber one evening and then lay down to sleep. The fire-breathing giant Cacus, a Roman god, the son of Vulcan, who lived in a nearby cave, stole some of the beasts during the night, dragging them backwards into his cave to put Hercules off the trail. But their lowing betrayed their whereabouts. Hercules slew the

giant in a great struggle, and recovered the cattle. The theme has been variously treated. He wields his club at Cacus, who is dragging a bull by the tail; or he wrestles with him. Or Cacus, already felled, raises a hand in self-defence against the final blow. Or Hercules rests on his club, the giant dead at his feet. A companion of Hercules leads a great bull from the cave; other cattle are being driven away in the background. The river-god Tiber reclines on his urn by the water's edge.

16. *Hercules wrestles with Antaeus* (Apollodorus 2.5:11; Diodorus Siculus 4). On his way back from the Hesperides, Hercules engaged in a wrestling match with the giant Antaeus who was invincible so long as some part of him touched the earth, from which he drew his strength. Hercules held him in the air in a vice-like grip, until he weakened and died. Hercules is depicted with his arms locked round the waist of Antaeus, crushing the giant's body to his own. Antaeus, his feet dangling and features twisted in pain, levers himself with an arm against Hercules' head in a vain attempt to free himself. This typical image, well known in the Renaissance, does not appear to derive from any classical model. The theme was rare in antiquity.

17. *Hercules and Omphale.* (Apollodorus 2.6:3) (Sometimes called *Hercules and Iole.*) For murdering his friend Iphitus in a fit of madness Hercules was sold as a slave to Omphale, queen of Lydia, for three years. But she soon alleviated his lot by making him her lover. While in her service he grew effeminate, wearing women's clothes and adornments, and spinning yarn. Ovid (*Fasti* 2:303–358) tells how Pan, who had fallen in love with Omphale, went to her chamber one night and, misled by Hercules' change of dress, climbed into bed with him by mistake. He was quickly kicked out. There are two scenes: (1) Hercules seated beside Omphale who is caressing him. The essential feature is the exchange of attributes. She wears his lion's skin and holds the club; he is draped in colourful robes and holds a DISTAFF or spindle, or sometimes a TAMBOURINE (an instrument associated with vice.) Cupid may be present. The subject is absent from classical Greek art, probably because it shows the hero in an unfavourable light, but it is found in Hellenistic times. In Renaissance and particularly baroque painting it illustrates the idea of woman's domination of man. The story is likely to have originated in primitive fertility rites in which the mother goddess was associated with a subordinate male god. Priests enacting the role of the god wore female garments. (2) The scene in Omphale's bedchamber. Pan lies sprawled on the floor, kicked out of bed by Hercules. Omphale's servants have arrived, holding a torch, and are drawing aside the bed-curtains.

18. *Hercules and Hesione* (Hyginus 89). Hesione, daughter of Laomedon, king of Troy, underwent the same ordeal as Andromeda (see PERSEUS, 2); and was chained to a rock as a sacrifice to a sea-monster. This came about because her father had refused payment to Apollo and Neptune (Poseidon) whom he employed to build the walls of Troy. Poseidon sent a sea-monster to destroy the city. Hesione was saved by Hercules who leaped down the monster's throat. (Michele da Verona, Fitzwilliam, Cambridge, Eng.)

19. *The slaying of the Centaur Eurytion* (Hyginus, 33). Eurytion was to marry a young girl who had been Hercules' lover. On the wedding day Hercules returned, slew the Centaur-bridegroom and his brothers, and carried off the bride (whom some identified with Deianeira: see below). The wedding banquet became a battlefield. Hercules is seen clubbing Eurytion while other figures fight in the background. Deianeira stands watching. Cupid flies over the scene holding a flaming torch.

20. *Hercules leads Alcestis from the underworld.* Euripides in *Alcestis* tells how she, a paragon of conjugal love, consented to take the place of her husband, King Admetus, when he was about to die. She was led down into the underworld by Death, but Hercules went after her, wrestled with Death, and brought her back to earth. Hercules stands outside the entrance to hell, holding the hand of Alcestis who is just emerging. Admetus, who may wear armour and a plumed helmet, lifts a veil, wonderingly, from his wife's face. The veil is sometimes lifted by Hercules.

21. *Hercules at the cross-roads; the choice of Hercules.* An allegory which depicts the hero seated under a tree, choosing between two standing female figures who personify Virtue and Vice, each of whom invites him to follow her. He chose the former. This moral fable was invented by the Greek sophist, Prodicus, a friend of Socrates and Plato, and is related by Xenophon (*Memorabilia* 2.1:22 ff) and others. It was not apparently illustrated in antiquity, but became widely popular in Renaissance and baroque art. Virtue's way is a narrow rocky path leading upwards to a plateau where Pegasus may stand, the winged horse that symbolizes fame. The easy path of Vice leads to sunny pastures where naked figures are seen dallying in a pool. Virtue is usually clothed and Vice naked, or at least has her bosom uncovered, a reversal of the more usual symbolism of NUDITY. The attributes of Vice, or Lust, include: the reed PIPE of the Satyrs; a TAMBOURINE; MASKS (deceit which is often the companion of lust); playing CARDS (idleness in which lust thrives); a rod and FETTERS (a reminder of the consequences of wrong-doing). Virtue's attributes are fewer. By her side may be a man crowned with the LAUREL and holding an open BOOK – the poet who will tell of Hercules' deeds. Virtue may take the form of MINERVA herself, the goddess of wisdom and Hercules' mentor. She wears helmet and armour, her shield lies on the ground, and her OWL may be perched nearby. She points the way sternly. Overhead FAME blows her trumpet, or FATHER TIME looks down, signifying that Hercules will be remembered for eternity. Hercules himself is usually young and beardless. In later baroque painting he may betray a certain wistfulness towards Vice, but normally he seems to understand which way duty lies. For the figure of Hercules is sometimes substituted the portrait of a prince or son of a noble family.

The Death of Hercules

The chain of events leading to Hercules' death and apotheosis is related by Sophocles in *The Women of Trachis* and is retold by Ovid and others: how the unwitting actions of his wife Deianeira, whom he had won after a contest with a rival, led to his suffering and death. Several episodes are illustrated in painting and sculpture.

22. *Hercules wrestling with Achelous.* Deianeira, the daughter of the river-god Oeneus, had two suitors, Hercules and Achelous, another river-god. They fought for her and though Achelous craftily changed shape, now assuming the form of a serpent, now a bull, Hercules overcame him. He snapped off one of the bull's horns in the fight. Some artists depict two human figures wrestling, but more often Hercules fights a bull. He has it down, grasping its horns, his knee in its back. His club and quiver lie to one side. Sometimes a group of nymphs in the background make a CORNUCOPIA from the broken horn. (*Met.* 9:85–92)

23. *The slaying of Nessus* (*Met.* 9:101–133; Philostratus the Younger, *Imag.* 16). On a journey, Hercules and Deianeira came to a river where the Centaur Nessus was the ferryman. While carrying Deianeira across he attempted to ravish her. Hercules, already on the further bank, drew his bow and slew Nessus.

The Centaur, knowing his blood was now poisoned with the hydra's gall from Hercules' arrow, cunningly told Deianeira with his dying words to collect it, as it would one day serve as a love-potion. Nessus is seen about to gallop off with Deianeira on his back. Her robes are streaming in the wind. Hercules, on the river bank, draws his bow. Sometimes Cupid flies near Nessus with a flaming torch. A river-god reclines in one corner.

24. *Hercules hurls Lichas into the sea* (*Met.* 9:212–220). While Hercules was away in distant parts, Deianeira, at home in Trachis, learned that he was courting another woman, Iole. She sent a messenger, Lichas, to him with a gift, a tunic smeared with Nessus' 'love-potion' that, unknown to her, was poisoned. When Hercules put it on the poison began to corrode his flesh. (He is shown tearing at the robe which burns with a mysterious fire.) Suspecting the innocent Lichas of treachery, he flung him into the sea. Hercules is shown, his body half-turned in preparation for a last mighty effort. Lichas hangs upside down, his leg held in Hercules' powerful grip.

25. *Hercules on the funeral pyre* (*Met.* 9:230–9). The dying hero was carried home to Trachis. Deianeira, forewarned, had already killed herself. Hercules ordered his son, Hyllus, to build a pyre on a mountain top and to place him on it; or according to others he built it himself. The pyre was hardly alight when Jupiter sent a thunderbolt which immediately consumed it. Hercules reclines on the pyre of timber, while flames curl round him. Or he lies on the lion's skin with his club for a pillow.

26. *The apotheosis of Hercules* (*Met.* 9:240–273). At his death he was borne aloft in Minerva's chariot, or in Jupiter's, and took his place as one of the twelve gods of Olympus. He married Hebe, goddess of youth and daughter of Jupiter and Juno. The subject of APOTHEOSIS, or deification of a mortal, is a feature of baroque art. This period saw the development of ceiling painting, which particularly lends itself to the portrayal of ascent to heaven. Jupiter is seated with Juno on a canopied throne. Hercules rises towards him on a chariot or stands before him on a cloudbank, club in hand. Hebe is handed forward by Jupiter, or ushered by Cupid, in the presence of Neptune, Apollo, Minerva, Mercury and other Olympians.

See also APOLLO (6); GODS AND GIANTS, BATTLE OF; ORIGIN OF THE MILKY WAY; PROMETHEUS.

Herm. The sculptured image of a god, thought to be originally Hermes, which developed a typical form in classical antiquity. Set on a rectangular pillar, it had a bearded face, armless torso and a phallus. It stood in doorways, gardens or by the wayside, for the protection of orchards and vineyards. There is also evidence from vase painting that such an image was used in the performance of the 'sacred marriage' ritual in the Dionysiac mysteries, which were connected with purification and fertility. In the work of Poussin, Rubens and their followers the statue broods over scenes of Bacchanalian revelry and of the festivals of PAN and PRIAPUS. Though depicted without the male member the figure as a whole may convey to the onlooker the phallic overtones which properly belong to it. A herm of Venus features in the EMBARKMENT for CYTHERA.

Hermaphroditus (*Met.*4:285–388). A Hellenistic myth of oriental origin tells of a being who was half male, half female, the offspring of Hermes and Aphrodite (Mercury and Venus), hence his name. As a young man – he began life as a male – he once bathed in a lake where Salmacis, one of Diana's nymphs, dwelt. She fell in love with him at first sight and clung to him with such passion that their two bodies became united in one. Salmacis is seen beside the pool at the moment

that she discovers the young man. Or they both stand in the water, Hermaphroditus trying to resist her embraces. (F. Albani, Pinac., Turin.)

Hermes, see MERCURY.

Hermogenes, baptism of, see JAMES THE GREATER.

Hero and Leander. According to legend, Leander, a youth of Abydos, a town on the Asian shore of the Hellespont, used to swim across the waters at night to Sestos on the opposite side to meet his lover Hero, a priestess of Aphrodite. She would guide him by holding up a lighted torch. One stormy night Leander was drowned. Hero in despair threw herself into the sea. The story is related in this form by the Greek poet Musaeus (4th–5th cent. A.D.). Ovid (*Heroides*, 18, 19) tells of the lovers, omitting their death. The theme is found in Italian and Netherlandish painting, especially of the 17th cent. which depicts Leander swimming the Hellespont towards a distant tower lighted by Hero; or the drowned Leander is borne away by Nereids as Hero plunges to her death into the sea. Alternatively Leander is seen reaching the shore safely, welcomed by Hero, while her nurse holds the torch aloft.

Herod Antipas, tetrarch of Galilee, see TRIAL OF CHRIST (3).

Herse, a maiden, lover of MERCURY (2).

Hesione, see HERCULES (18).

Hesperides, see HERCULES (11).

Hieronymus, see JEROME.

Hippocampus. A fabulous marine creature having the fore parts of a horse and the hind parts of a fish. Hippocampi draw the chariot of NEPTUNE and of GALATEA. The 'great fish' that swallowed JONAH was represented as a hippocampus in very early Christian art, an example of the adoption of a classical image for Christian use.

Hippodamia, Rape of, see CENTAUR.

Hippogriff. Unknown in antiquity, this monster was a creation of the poets of the late middle ages. A hippogriff was ridden by Ruggiero, the pagan knight in Ariosto's poem *Orlando Furioso* (1516) (see ANGELICA, 2). Ariosto says it was the offspring of a GRIFFIN and a mare, having the wings, head and claws of the former – that is to say, like an eagle – the rest of it being like a horse (*O.F.* 4:13).

Hippolyta, Girdle of, see HERCULES (9).

Hippolytus. Of the various Christian saints of this name the one most often represented in art is not the Roman martyr who wrote the *Philosophoumena*, but the legendary soldier who was converted to Christianity at the sight of LAURENCE's martyrdom, and performed his funeral rites. He refused to recant his new faith and died, torn apart by wild horses. The story probably derived from the myth of Hippolytus, the son of Theseus, who was dragged to his death when the horses drawing his chariot bolted. The saint is depicted wearing armour, perhaps holding a bunch of KEYS, as Laurence's jailer. In the scene of his martyrdom he lies on the ground, each foot bound to the tail of a rearing horse. His supposed remains were translated to the abbey of Saint-Denis in about the 8th cent., and hence he features largely in French art.

Hippomenes, see ATALANTA.

History is usually personified in Renaissance and baroque art as a winged female in a white robe who writes in a BOOK or on a tablet sometimes supported on the back of Father Time. Her foot may rest on a solid cube, the symbol of her sure foundation. Her image was derived from the classical winged VICTORY, who recorded the victor's deeds on a shield: hence the tablet of History may be oval-shaped.

Hoe. Alternative implement to the spade in the hands of Adam (ADAM AND EVE, 3, *Expulsion*); and of Christ 'the Gardener' (MARY MAGDALENE, 3, *'Noli me tangere'*). It is an attribute of Spring, one of the FOUR SEASONS.

Hog, see PIG.

Holofernes, see JUDITH.

Holy Company, see VIRGIN MARY (17, *c*).

Holy Family, see VIRGIN MARY (4).

Holy Ghost, see TRINITY; DOVE.

Holy Kinship, see VIRGIN MARY (17, *c*).

Holy Orders, see SEVEN SACRAMENTS.

Holy Trinity, see TRINITY.

Holy women at the sepulchre ('The Three Maries at the sepulchre'; '. . . at the tomb'). (Matt. 28:1–8; Mark 16:1–8; Luke 24:1–11; John 20:1–9.) All the gospels mention the holy women who were the first to discover the empty tomb after Christ's Resurrection, but there is little agreement as to who they were. Of the companions of the Virgin Mary who were present at the crucifixion and who accompanied the body to the tomb, some five or six are named but in the present theme it is customary to depict three only, known as the Three Maries, or *myrrhophores*, bearers of myrrh. (See further CRUCIFIXION, 6.) It is told that they came to the tomb early in the morning bringing spices and aromatic oils to anoint the body, but discovered that the stone sealing the entrance had been rolled away, and the body gone. An angel (or two, the accounts vary) in dazzling white robes announced to them that Christ had risen and that they were to tell the disciples. The tomb may take the form described in the gospels, a cavity hewn out of the rock, but is more usually a conventional stone sarcophagus from which the lid has been removed. It stands in an open space and in the distance can be seen the city of Jerusalem. The figure sitting on the tomb (there are occasionally two) is dressed in white and may be depicted with wings like an angel (Matt.), or simply as a young man (Mark). A wand or sceptre tipped with a fleur-de-lys identifies the angel as GABRIEL. The women stand in awe before him, one perhaps kneeling. Mary Magdalene can usually be recognized by her long hair and sometimes by her jar of ointment; but more often all three carry jars of myrrh. The soldiers, set to watch by Pilate, are round the tomb usually asleep, or apparently so, for, according to Matthew, at the sight of the angel they 'shook with fear and lay like the dead.' (See also RESURRECTION.) Until the 13th cent. the theme was represented in place of the Resurrection which was rarely depicted before then. Thereafter the angel and the Three Maries are sometimes transferred to pictures of the Resurrection.

Homer. The portrayal of Homer belongs to a period untroubled by doubt concerning his identity. To artists he was the blind Greek poet who wrote the *Iliad* and the *Odyssey*. In antiquity it was believed that his blindness was a punishment for having slandered Helen of Troy. Idealized portaits show him as a white-haired old man of noble features, sightless eyes and wearing a LAUREL crown. Nearby a youth takes down his words on a TABLET with a stylus (attributes of Calliope, the MUSE of epic poetry). He may hold two books, his two works. More often he holds or plays a stringed instrument, generally of the violin family, an allusion to the ancient practice of accompanying the recitation of poetry with music (the lyre in Greece). In Raphael's 'Parnassus' Homer is in the company of Virgil and Dante (Stanza della Segnatura, Vatican). For Homeric themes in art see TROJAN WAR; ULYSSES.

'Homo bulla est', see BUBBLES.

'Homo igit consutu . . .,' see ANTONY OF PADUA.

Homo silvestris, see WILD MAN.

Homobonus, see OMOBUONO.

Honeycomb. Attribute of JOHN THE BAPTIST. Cupid, stung by a bee, holds a honeycomb (CUPID, 3); he may feature thus in the Golden Age (AGES OF THE WORLD).

Hope (Lat. *Spes*). With FAITH and CHARITY, one of the three 'theological virtues' (see VIRTUES AND VICES). Hope is also a frequent figure in secular allegory. In Gothic church sculpture she gazes up to heaven and reaches out for a CROWN, the hope of future glory. Later, the crown may be offered to her by an angel. Raised eyes and hands joined in prayer are common in Renaissance art. An ANCHOR, partly hidden by her robes, derives from St Paul who said of hope (Heb. 6:19), 'It is like an anchor for our lives . . . it enters in through the veil.' A SHIP, which may be worn as headgear, is a reminder that early sea-journeys were undertaken in a spirit of hopefulness. Hope's opposing vice is Despair who is seen in medieval art killing herself with a sword or by hanging. In the Greek myth of PANDORA, only Hope remained after the box had been opened and the evil spirit released. In this theme especially, Hope's attribute may be a CROW, the bird associated with her in the Roman era because it calls 'Cras, cras' (Lat. 'Tomorrow, tomorrow'). In FLOWERS the hope of the fruit to come is implicit, hence (from about the 16th cent.) she may hold a basket of flowers, as in Titian's 'Allegory of the Marquis d'Avalos' (Louvre).

Horae. In Greek and Roman mythology spirits who personified the Seasons. As such they carry flowers and fruit. They gave their name to the Hours, which in a later era they came to represent. They are the female attendants of AURORA, the dawn, and also of LUNA (Selene) whose daughters they were. Their number varies, generally not less than three. They are sometimes depicted with butterfly's wings. See also PHAETHON. (By a quite separate tradition the Seasons are also represented by four deities – Venus, Ceres, Bacchus and Boreas. See FOUR SEASONS.)

Horae (canonical hours), see BOOK OF HOURS.

Horatii, Oath of the (Livy 1:23–4). A quarrel between the peoples of Rome and Alba threatened to lead to war. It was agreed to settle the issue by combat between three representatives from each side, from the Roman family of the Horatii and from the opposing Curiatii. At the end, only one man, Horatius, was left alive and Rome was declared the victor. On discovering afterwards that his sister had been betrothed to one of the Curiatii, he slew her. He was tried, found guilty but reprieved after an appeal by his father. The theme is found in 16th and 17th cent. painting of Italy and northern Europe. The three Horatii, symbols of ancient Roman valour, are depicted before the fight in the act of taking the sacrificial oath in front of their father who holds up their swords. To one side are their sisters in attitudes of resignation, one perhaps thinking of her betrothed (J.-L. David, Louvre). The scene of the combat is also occasionally represented.

Horatius Cocles (Livy 2:10; Plutarch 6:16). Legendary Roman soldier whose heroism saved Rome from capture by the Etruscan forces of Lars Porsena. He took his stand with two companions at the head of a wooden bridge across the Tiber, keeping the Etruscans at bay while the Romans demolished the bridge behind him. Then dismissing his two comrades he continued to fight off the enemy single-handed. At the last moment he plunged into the river and, praying for Father Tiber's blessing, he swam to safety. Horatius is depicted at the

entrance to the bridge, sword in hand, warding off his attackers. Behind him soldiers are tearing apart the timbers. In the background is the city of Rome. A reclining river-god looks on. The figure of VICTORY may float above Horatius, about to crown him with laurels (Le Brun, Dulwich).

Horn. Palaeolithic art represents priests wearing horned, animal-headed masks, probably connected with rites intended to bring about success in hunting for food. The horn was moreover a phallic symbol, believed to promote fertility. The association of horns with pagan religion therefore made them a natural attribute for SATAN. Horns, with other goat-like characteristics, are the attribute of PAN and the SATYR. The horn as a musical instrument is, because of its mournful note, the attribute of Melpomene, MUSE of tragedy. A hunting horn is the attribute of HUBERT. Samuel anoints DAVID (1) with oil from a horn. MOSES is sometimes depicted with horns. Horn of plenty, see CORNUCOPIA. See also UNICORN.

Horse. The mount of warriors, kings, nobles and others, on their travels or in battle. Horses draw the triumphal car of numerous mythological figures, see CHARIOT. The horse is an attribute of Europe personified, one of the FOUR PARTS OF THE WORLD. Bucephalus, the horse of ALEXANDER THE GREAT, is generally depicted as white. A Roman soldier on horseback leaping into a pit is MARCUS CURTIUS. A fallen horseman, perhaps in Roman armour, is PAUL (1); see also PRIDE. A rider on a white horse and two angels drive HELIODORUS from the Temple. A monarch on horseback carrying a cross is Heraclius (TRUE CROSS, HISTORY OF THE, 5). A warrior on horseback slaying a dragon is GEORGE; if on a winged horse, PERSEUS or BELLEROPHON, riding PEGASUS. A 'knight' on an emaciated horse, accompanied by a peasant on an ass, is DON QUIXOTE. A maiden, often nude, riding through water is CLOELIA. Four charging horsemen, variously holding bow and arrow, sword, scales and perhaps a trident, APOCALYPSE (5). A white horse, a sword issuing from its rider's mouth, APOCALYPSE (22). A martyr, his feet bound to rearing horses, is HIPPOLYTUS. A horse attacked by hero with club, HERCULES (8). A horse and an olive tree with Neptune and Minerva, Jupiter and other deities looking down, MINERVA (1). Horses, chariot and rider falling out of the sky, PHAETHON (2). A horse in a smithy, its leg removed for shoeing, ELOI. A wooden horse on wheels or rollers, TROJAN WAR (7). Among saints on horseback are EUSTACE, HUBERT, MARTIN. See also CENTAUR and HIPPOCAMPUS.

The equestrian statue or painting (Ger. Reiterstandbild) as a means of commemorating a great leader had its beginnings in the famous classical monument of the Emperor Marcus Aurelius on horseback in the Campidoglio at Rome. Renaissance soldiers were commemorated in the same manner by Donatello (the mercenary leader Gattamelata, Padua) and later by Verrocchio (Colleoni, Venice). Examples from the 17th cent., in painting, of this tradition which continued almost down to the present day are the equestrian portraits of Philip IV of Spain by Velasquez and Charles I of England by van Dyck. Victorious military leaders were also often depicted on horseback in armour directing a battle.

'Hortus conclusus', see VIRGIN MARY (4).

Hospitality. One of the minor virtues, represented as a woman with a CORNUCOPIA, perhaps offering it to a child, while she welcomes a pilgrim with the other hand. Hospitality is personified by a pilgrim, who is none other than Christ, being welcomed by monks – a subject found in monastic mural painting.

Hour-glass. Attribute of DEATH and of FATHER TIME; also a 'Vanitas' symbol, see

STILL LIFE. A winged hour-glass suggests Time's fleetingness. The workshop of the ALCHEMIST often has an hour-glass.

Hubert (d.727). Bishop of Maastricht, later of Liège. According to a late legend he was as a young man given to worldly pleasures, especially the chase. While hunting on Good Friday he was suddenly confronted by a white stag bearing a crucifix between its antlers. This vision brought about his conversion to Christianity. The same story was told of EUSTACE and the two are therefore sometimes difficult to distinguish. As a devotional figure Hubert is dressed in bishop's robes. His attribute is a stag with a crucifix. It stands beside him or is couched on a book in his hand. As patron saint of hunters he may also hold a hunting horn. The scene of his conversion shows him kneeling in the forest before a stag bearing the crucifix between its horns. Unlike Eustace he features only in the art of northern Europe, and then only from the 16th cent. Eustace, the Roman soldier, wears armour; Hubert is generally dressed as a hunter.

Humility (Lat. *Humilitas*). One of the rarer virtues in religious and secular allegory, represented as a woman with a LAMB, and treading a CROWN under her foot. She may hold a GLOBE, her universality. Her downcast look expresses her modesty. In Gothic sculpture she is opposed by the vice of Pride (Lat. *Superbia*), who is depicted as a rider thrown from his horse. In the 15th cent. Humility sometimes has wings which, together with her bent head, suggest the idea that the humbler one is, the higher the spirit rises. For the Madonna of Humility, see VIRGIN MARY (11).

Hunter, usually with bow and quiver, and often dogs. A hunter confronted by a stag, a crucifix between its antlers, EUSTACE or HUBERT; with a stag at his side, JULIAN THE HOSPITATOR. A hunter impatient to be off, restrained by nude female, is Adonis (VENUS, 5). A hunter observing naked Diana and her nymphs, or turning into a stag, is Actaeon (DIANA, 3). Diana herself is depicted as a huntress. A hunter grieving over a woman pierced by an arrow, see CEPHALUS AND PROCRIS. A hind protected from the huntsmen by a saint, see GILES. The unicorn hunted, see VIRGIN MARY (5). A boar hunt, see MELEAGER.

Hyacinth (1185–1257). A Dominican friar, born in Silesia, who joined the Order in Rome, and became a missionary to Poland and neighbouring lands. He is represented in Dominican art. He kneels before St Dominic to receive the habit of the Order, before his departure for the north. In baroque painting he kneels before a vision of the Virgin who is promising to intercede with Christ on his behalf. Legend credited him with numerous miracles. It was related that during an attack by Tartar hordes he snatched from his church the monstrance and a heavy statue of the Virgin and bore them to safety, walking without harm across the waters of the River Dnieper (or, according to some authorities, the Dniester)· He is seen accompanied by angels who help bear his load. He was canonized in 1594.

Hyacinthus. A young prince of Sparta, loved by Apollo, who died after being struck on the head by a discus. The hyacinth flower sprouted where his blood fell. See APOLLO (11); FLORA (2).

Hylas (Theocritus 13). In Greek mythology a handsome youth, the companion and servant of Hercules during the expedition of the Argonauts. After they made landfall one evening he was sent with a pitcher to find fresh water and came upon a spring where Naiads, the nymphs of fountains and streams, were bathing. Captivated by his beauty the nymphs dragged him down into the water, and that was the last anyone saw of him. The scene is a pool, perhaps in moonlight. Hylas, on the bank or in the water, is trying to resist the embraces of the naked

nymphs who surround him. An overturned pitcher usually lies nearby. (Francesco Furini, Pitti Gall., Florence.)

Hypnos, see SLEEP, KINGDOM OF.

Icarus (*Met.* 8:183–235). The son of the legendary Athenian craftsman DAEDALUS, with whom he was imprisoned on the island of Crete. In order to escape, Daedalus constructed for each of them a pair of wings which were attached to the shoulders with wax. 'Follow me closely,' said Daedalus, 'and fly neither too high nor too low.' But Icarus flew near the sun, the wax melted, the wings dropped off, and he fell into the sea and was drowned. The pair were often represented in antique art, on Greek vases and Pompeian wall painting. A well-known Roman relief shows Daedalus, hammer in hand, making a wing while Icarus holds it steady for him (Villa Albani, Rome). The scene of making or fixing on the wings occurs also in painting of the Renaissance and later. The youth is impatient to be off while the older man binds the wings to his shoulders or perhaps raises a warning finger. The wings are usually attached to the whole length of each arm, but occasionally in baroque painting they appear to grow, like angels' wings, from behind the shoulders.

The fall of Icarus. Icarus tumbles headlong out of the sky, scattering feathers. Daedalus looks up in dismay or flies on unawares. Below is the sea with perhaps a boat and sailors or a distant harbour. Icarus' fall may form the background to a landscape in which country people go about their daily work. Sometimes the sun-god, Helios, drives his chariot overhead. Renaissance moralists used the theme to teach the danger of going to extremes and the virtue of moderation, but to others it symbolized man's questing intellectual spirit.

Ignatius of Loyola (*c.* 1491–1556). Born at Loyola in northern Spain, the son of a nobleman. As a soldier at the siege of Pampeluna he was permanently lamed by a wound in the leg. He devoted his convalescence to reading the lives of Christ and the saints and thereafter turned to the study of religion. His famous and influential work, the *Spiritual Exercises*, was begun at an early stage of his conversion. As a student in Paris he was the leader of a group of young men, among them FRANCIS XAVIER, who formed the nucleus of what was to become the Society of Jesus. This Order, founded by Ignatius, received papal sanction and in time became identified with the Counter-Reformation movement and the restoration of the influence of the Catholic Church. Centred on Rome, its objectives were primarily missionary, to pagan countries overseas, the education of the young and the combating of Protestantism. Ignatius is generally portrayed as a man of middle years, balding, square-browed, and with a short, dark beard. He wears the black habit of the Order or, when before the altar, a chasuble. As a standing figure he may have for attribute a BOOK inscribed, 'Ad majorem Dei gloriam,' – 'To the greater glory of God', the opening words of the Rule; IHS, the monogram of the Order (cf BERNARDINO), perhaps on a tablet held by angels or in a halo; a heart crowned with thorns, the Sacred Heart, the emblem of the Jesuits. The most commonly represented scene from his life, found widely in Jesuit churches, shows him at prayer in a wayside chapel where he had halted on the journey to Rome. Before him appears the figure of Christ bearing the cross, with the words 'Ego vobis Romae propitius ero' – 'I will help you on your way to Rome.' The companions of the saint may be seen waiting outside the chapel. Ignatius relates that this vision inspired him to give the name of Jesus to his society. He is seen wounded at Pampeluna, before him a vision of St Peter; kneeling before Paul III, seeking papal confirmation for his Order; blessing the kneeling Francis Xavier on the eve of the latter's missionary journey

to the east; receiving FRANCIS BORGIA (who likewise kneels), a Spanish grandee who became a Jesuit missionary in the Iberian peninsula. Many miracles of healing were attributed posthumously to Ignatius by his followers. In one such, he is depicted in church standing at the top of the altar steps, his companions beside him. Below are a crowd of the sick and lame, mothers with children, and writhing figures who are possessed by spirits. In mid-air are angels in the act of chasing away demons, the evil spirits that the saint has exorcized (Rubens, Kunsthistorisches Mus., Vienna). See also APOTHEOSIS.

Ignavia, Cowardice personified, see FORTITUDE.

Ignorance. One of the vices in secular allegory of the Renaissance, represented as a female, or occasionally hermaphrodite, very fat, and either BLINDFOLD or with eyes that are obviously sightless. She wears a CROWN. Her obesity and blindness are derived from Plutus, the god of riches, with whom Ignorance had certain affinities; her crown from the king of the underworld, Pluto, who was easily confused with his near-namesake. Ignorance sometimes appears thus standing beside the judge in the CALUMNY OF APELLES, and in other allegories such as Mantegna's 'Expulsion of the Vices from the grove of Virtue' (Louvre).

IHS. The abbreviation of the name Jesus in Greek; more rarely IHC, since the form of the letter S in Greek in this context sometimes resembles a C. See further under ADORATION OF THE NAME OF JESUS. On a tablet or disk, encircled with flames, it is the attribute of BERNARDINO; inscribed on a heart, of ANSANUS. The Society of Jesus, the Jesuits, adopted it as their device, see IGNATIUS OF LOYOLA.

IHS (see BERNARDINO)

Ildefonso (*c.* 606–667). Spanish prelate, born Toledo, abbot of its Benedictine monastery at nearby Agli, appointed archbishop of Toledo, 657. Among his numerous theological writings was a defence of the 'perpetual virginity' of the Virgin Mary. His vision of the Virgin is represented in Spanish painting. It is related that he saw the Virgin with attendant angels seated on his episcopal throne in the cathedral. As he approached she threw over him a chasuble of heavenly origin.

Immaculate Conception, see VIRGIN MARY (4).

'In carne vivere . . .', see AMBROSE.

'In coelo qualis est Pater . . .', see AUGUSTINE.

'In hoc signo vinces', see CONSTANTINE.

'In principio creavit Deus . . .', see JEROME.

'In principio erat Verbum,' see JOHN THE EVANGELIST.

'In viridi teneras exurit medulas', see CROSS.

Infant. The infant Christ, see NATIVITY; ADORATION OF THE SHEPHERDS; ADORATION OF THE MAGI; CIRCUMCISION OF CHRIST; PRESENTATION IN THE TEMPLE; FLIGHT INTO EGYPT; VIRGIN MARY (6–17). The infant Christ is the attribute of ANTONY OF PADUA, in his arms or on a book. An infant in arms is the attribute of the Franciscan VINCENT DE PAUL; in a cradle, of AUGUSTINE. Other infants in a cradle or basket, discovered or attended by women, MOSES (1); JUPITER (1); a snake emerging from the cradle, ERICHTHONIUS. For other nativities, see NATIVITY OF THE VIRGIN; JOHN THE BAPTIST (2). An infant in the arms of Mercury is BACCHUS (1); an infant born from a tree-trunk, ADONIS, BIRTH OF; two sleeping infants in arms, perhaps one white and one black, NIGHT, and SLEEP, KINGDOM OF. An infant at the breast, see VIRGIN MARY (6); with milk spurting, ORIGIN OF THE MILKY WAY; with others clustered round, CHARITY. Melancholy, one of the

FOUR TEMPERAMENTS may be surrounded by small children. An infant suckled by a goat, JUPITER (1); by a wolf, ROMULUS (also sometimes with Remus); fed by a Satyr, BACCHUS (2). An infant lying on the ground, discovered by shepherds, PARIS; lying in the path of a ploughing team, ULYSSES (1). An infant in the desert, in its mother's arms, a saint nearby on all fours, JOHN CHRYSOSTOM. An infant held upside down by ankle over river, ACHILLES (1); held similarly before judge and executioner, SOLOMON (1). Infants snatched from their mothers by soldiers and slain, MASSACRE OF THE INNOCENTS. An infant devoured by old man, SATURN. An infant grasping a snake in each hand HERCULES (14). An infant before a monarch, offered two dishes, MOSES (2). A winged infant, see PUTTO. The human soul is represented as a naked infant, sometimes winged.

'Initium Evangelii Jesu Christi', see MARK.

Inkhorn and pen, see WRITER.

Innocence. One of the minor virtues of religious and secular allegory, represented as a young woman, usually with a LAMB, and sometimes washing her hands, from the Psalm (26:6) 'I wash my hands in innocence.' She may be seen in Renaissance allegories of JUSTICE, or among the personifications of other Christian virtues, especially in the decoration of tombs and medieval shrines of saints. She is seen in the act of being rescued by Justice from the vices that threaten her in the shape of fierce animals: a WOLF (Gluttony), DOG (Envy), LION (Wrath) and SNAKE (Deceit). (Tapestry, after a cartoon by Bronzino, Galleria degli Arazzi, Florence.) See also CALUMNY OF APELLES, where Innocence (a man) is hauled before a corrupt judge.

Inopia, see POVERTY.

INRI, see CRUCIFIXION (1).

Inspiration. Sacred writing is inspired by an angel which hovers near a writer, for example St MARK, or by a DOVE which hovers at his ear: GREGORY THE GREAT and several others. The dove may also inspire a preacher. The MUSES were the source of classical inspiration. It was derived in particular from their milk. Virgil says to Dante of the poets in Limbo (*Purg.* 22:101) 'We are with that Greek (Homer) whom above all the Muses suckled'. The personification of Poetry according to Ripa's *Iconologia* is to be represented with full breasts to show the fruitfulness of the ideas that are waiting to be expressed. An allegory of inspiration, not uncommon in Renaissance and baroque painting, shows a Muse squeezing a stream of milk from her breast on to the pages of a book or on to a musical instrument. The Miracle of Lactation (BERNARD, 2) contains a similar idea.

Instruments of the Passion. The numerous objects occurring in the story of the Passion (crown of thorns, nails, lance and many others) are found in other contexts, for example, borne by angels surrounding the enthroned Christ, as the attributes of saints, and in particular in the Mass of St Gregory. (GREGORY THE GREAT, 5, gives further details.)

Invention of the art of drawing, see DISCOVERY OF THE A. OF D.

Invention of the True Cross, see T.C., HISTORY OF THE.

Invidia, see ENVY.

'Invitus invitos', see CANNON.

Io. In Greek mythology, the daughter of Inachus, first king of Argos. Ovid (*Met.* 1:588–600) tells how she was seduced by Jupiter, who first changed himself into a cloud to conceal his infidelity from his wife, Juno. But she was not deceived so Jupiter then changed Io into a white heifer (*Met.* 1:639–663). Juno cunningly asked for it as a gift, which her husband could not refuse. Juno handed the

heifer over to the hundred-eyed giant Argus to guard. Jupiter thereupon sent his messenger Mercury to recover it. Mercury charmed the watchful Argus to sleep with his lyre, and then cut off his head. Juno took Argus' hundred eyes and, as a memento, set them in the tail of the peacock, where they are seen to this day. She sent a gadfly to torment Io which chased her across the world.

1. *Io embraced by Jupiter.* Her expression is rapturous as she submits to Jupiter who is in the shape of a cloud. In another version Jupiter in human form caresses her while Juno looks down angrily from the skies.

2. *Jupiter and the heifer.* The white heifer browses beside a seated Jupiter. Juno has alighted from her chariot, sometimes to be seen in the background, and stands before him. His eagle may be nearby.

For the subsequent episodes see MERCURY and JUNO.

Iole, see HERCULES (17).

Iphigenia (*Met.* 12:25–28). In Greek mythology the daughter of Agamemnon, king of Mycenae. Her father led the Greek forces against Troy. The expedition was at first prevented from sailing by unfavourable winds, so Agamemnon consulted a seer, Calchas. He was told that, because he had killed a stag sacred to Diana, he must propitiate the goddess by sacrificing his daughter to her. Iphigenia accepted her fate out of patriotic motives. According to some, at the last moment Diana substituted a stag for the human victim and carried Iphigenia away to be her priestess. However that may be, the winds changed and the Greeks were able to sail. The scene is an altar before which Iphigenia swoons, or sits resigned and calm. A grey-bearded priest, robed and cowled, makes ready while an acolyte brings faggots or a vessel. Agamemnon is present in helmet and armour. Diana and the stag hover in a cloud overhead, unseen by the others.

Ira, see WRATH.

Irene. According to legend, a widow of Rome who cared for St SEBASTIAN and nursed him back to health after he had been left for dead, his body full of arrows. She is hence a patron saint of nurses. In the art of the Counter-Reformation – she is seldom seen earlier – Irene is represented in the act of drawing an arrow from Sebastian's body. Her usual attribute is a vase of ointment, similar to the Magdalen's.

Iris. In Greek mythology the goddess who personified the rainbow, on which she descended to earth as messenger of the gods. Juno sent Iris to release the soul of Dido when she died on the pyre. She was sent to rouse the sleeping Morpheus (SLEEP, KINGDOM OF).

Iris. Very often the flower of the Virgin, instead of the lily, in early Netherlandish paintings. Both may sometimes be seen together (Roger van der Weyden, Madonna and saints, Städelsches Kunstinstitut, Frankfurt). The substitution of the iris for the *lilium candidum* may have come about simply through a confusion of nomenclature. The common iris is called 'sword-lily' in German, and *lirio* in Spanish, and was thought by some to be the flower of the French fleur-de-lys. In Spanish painting the iris is particularly associated with the Immaculate Conception. It is rare in German art. Three purple irises were the *impresa* of Cardinal Odoardo Farnese (1573–1626), with the motto 'ΘΕΟΘΕΝ ΑΥΞΑΝΟΜΑΙ' – 'I grow with the help of God'. (Farnese Palace, Rome.)

Iron Age, see AGES OF THE WORLD.

Isaac. The second of the great Hebrew patriarchs. God commanded that as a child he be sacrificed by his father ABRAHAM (4). In old age he was deceived into giving his blessing to his son JACOB (1) instead of to Esau. See also REBECCA.

Isaiah. One of the four 'greater prophets'. (The others are JEREMIAH, EZEKIEL and

DANIEL.) He owes his place in Christian art chiefly to two famous prophecies. 'Ecce virgo concipiet et pariet filium', – 'A young woman is with child and she will bear a son' (7:14), which may appear as his inscription on a scroll, is the source of Isaiah's association in art with the theme of the ANNUNCIATION. 'A shoot shall grow from the stock of Jesse' (11:1) is the origin of the image of the Tree of Jesse, in which he also appears. He may hold the branch of a tree as an attribute (see JESSE, TREE OF). His normal attribute is a BOOK or SCROLL. A SAW, the traditional instrument of his death, is occasionally depicted in later medieval MSS. TONGS, holding an ember, allude to the seraph that touched his lips with a glowing coal (6:6–7). The figure of Isaiah may be seen in Gothic sculpture in the LAST JUDGEMENT and the CORONATION OF THE VIRGIN, and among assembled prophets, as in Michelangelo's ceiling frescoes in the Sistine chapel.

Issus, Battle of, see ALEXANDER THE GREAT (5).

'Ita ut virtus', see LAUREL.

Ivy. Sacred to BACCHUS in antiquity. It may garland his brow or entwine his THYRSUS. It is the attribute of his attendant SATYRS. As an evergreen symbolizing immortality, ivy may crown a skull in STILL LIFE.

Ixion. One of four legendary figures who are customarily linked in Greek mythology and in art (the others are SISYPHUS, TANTALUS and TITYUS), because they all underwent punishment in Hades. Ixion, a king of Thessaly, murdered his father-in-law. He also attempted to seduce the goddess Juno, but her husband Jupiter foiled him by making an image in her likeness from the clouds and the drunk Ixion embraced this instead. His punishment was to be bound to a fiery wheel which turned forever (*Met.* 4:461). He is usually depicted bound to the wheel, but is also seen embracing the false Juno. In the latter theme Jupiter and the real Juno with her peacock are looking on. The descendants of this un-promising union were the Centaurs who may be seen galloping about on earth below. See AENEAS (8).

Jael, see SISERA, SLAYING OF.

Jairus, see RAISING OF JAIRUS' DAUGHTER.

Jacob. The twin brother of Esau and the third of the great Hebrew patriarchs, whom the Church taught was a prefigurative 'type' of Christ. He was born the second, clutching the heel of Esau, a sign that he was to supplant him. Esau was a hunter, a man of the fields, and Jacob led a settled life among the tents. Their rivalry was seen as a symbol of the conflict of Church and Synagogue. Jacob's story is represented in the art of many periods both as separate scenes and in cycles.

1. *The stolen blessing* (Gen. 25:19–34; 27; 28:1–5). Jacob not only obtained Esau's birthright by guile – over the episode of the mess of pottage – he also contrived, at his mother's instigation, to deprive Esau of his father's blessing. When Isaac was old and nearly blind he sent Esau out to catch venison and cook it for him 'that I may give you my blessing before I die'. Rebecca overheard and, while Esau was gone, told Jacob to take his place in order to obtain the blessing. She disguised Jacob by dressing him in Esau's clothes, covering his hands and neck with goatskins, for 'Esau was a hairy man'. She prepared meat and Jacob took it to his father. Isaac must have been far gone in senility to have been taken in by such a simple ruse, for he blessed Jacob in mistake for Esau. The blessing once given, could not be undone and Jacob fled from his brother's wrath, taking refuge with his uncle Laban, Rebecca's brother, at Harran in Mesopotamia. The subject is common in 17th cent. painting. Isaac is sometimes propped up in bed in a westernized domestic setting, while Jacob kneels at the

bedside. The latter's arms are not always covered. Rebecca stands behind Jacob with a hand on his shoulder. In the landscape background Esau is sometimes seen with hunting dogs, or he enters the room with the body of a young deer on his shoulder. The story is likely to have been connected originally with the early tribal custom of ultimogeniture, or inheritance through the youngest son.

2. *Jacob's ladder* (Gen. 28:10–22). Resting for the night on his journey to Harran, Jacob took some stones for a pillow and lay down to sleep. He dreamed of a ladder reaching up to heaven with angels going up and down. From the top God spoke to him, promising the land to Jacob's descendants, the Israelites. When Jacob awoke he built a pillar from the stones and poured a libation of oil on it, calling the place Bethel, 'the house of God'. This subject appears first in primitive Christian art and is widely represented thereafter. In the Middle Ages it was regarded as a 'type' of the Virgin Mary, through whom a union of heaven and earth was accomplished. The top of the ladder usually rests on a bank of clouds from which God looks down. Angels go up and down the rungs. Jacob lies sleeping at the foot, his head on a large rock or stone slab. The site at Bethel is thought to have existed as a place of worship from remote antiquity, long before the Hebrews arrived in Canaan. Early peoples believed that dreams were a direct revelation from their god and it was therefore natural to sleep at such a place in the expectation of learning the divine will. The ladder is reminiscent of the stairway on the Babylonian 'ziggurat' which reached from the ground to the temple at the summit in which the god abode. (See TOWER OF BABEL.)

3. *Leah, Rachel and Laban* (Gen. 29:9–30; 30:28–43; 31:17–55; 33:1–11). Near Harran, Jacob met Rachel coming to water her father's sheep at the well. He moved the stone from the mouth of the well – a moment often depicted – and watered Laban's sheep; then 'he kissed Rachel, and was moved to tears'. Laban had two daughters, Leah and Rachel. Leah, the elder, was rheumy eyed, 'but Rachel was graceful and beautiful'. (Like Martha and Mary, they were seen to personify the active and contemplative types.) Jacob undertook to serve Laban as a herdsman for seven years in return for Rachel whom he wished to marry. At the wedding feast Laban substituted Leah by a trick, and then demanded another seven years' labour from Jacob before he should obtain Rachel. By way of wages, Laban agreed to give Jacob all the speckled and parti-coloured sheep and goats that were born in his flocks. Jacob, with equal cunning, took branches of trees from which he partly stripped the bark, and laid them in the animals' drinking troughs. By a kind of sympathetic magic the beasts conceived and bore young that were striped and speckled. Having thus enriched himself, Jacob set off secretly to return to Canaan with both wives, his children and possessions, including great numbers of sheep and cattle. In parting, Rachel stole her father's teraphim, the small sacred figurines which were his 'household gods'. When he discovered the theft Laban set off in pursuit, overtook the party and searched their tents and belongings. Rachel promptly hid the teraphim in a camel's saddle and sat on it, saying to her father, 'Do not take it amiss, sir, that I cannot rise in your presence: the common lot of women is upon me'. This scene is widely represented. Laban and Jacob had a reconciliation before they parted. At the end of his journey Jacob chose the best of his herds to be sent on ahead as a peace-offering to Esau. He is depicted kneeling before Esau, while behind him follow his family and servants. Behind Esau are his soldiers.

4. *Jacob wrestling with the angel* (Gen. 32:22–32). During the journey Jacob came to a ford across the brook called Jabbok, a tributary of the Jordan. When he had sent his caravan across he was left alone, 'and a man wrestled with him

there till daybreak'. The man, unable to prevail, touched the hollow of Jacob's thigh which thereupon withered. Jacob demanded to be blessed before letting him go, and his adversary did so, saying, 'your name shall no longer be Jacob, but Israel, because you strove with God and with men, and prevailed'. This mysterious dreamlike encounter has been interpreted at many levels in terms of religion and of myth and folklore. In early Christian art Jacob's antagonist was God himself but later came to be portrayed as an angel, their fight symbolizing the Christian's spiritual struggle on earth. In medieval art the opponent was sometimes a demon, turning the theme into an allegorical combat between Virtue and Vice. It was also regarded as another instance of the conflict between Church and Synagogue, the withered thigh symbolizing the Jews who would not recognize Christ's Messiahship. (The idea of a withered limb as a symbol of disbelief occurs also in the account of the two midwives at Christ's NATIVITY, 3.) In folklore there are numerous accounts of a river-god who guards the ford and demands recompense from travellers before allowing them to cross.

See also JOSEPH (1) *Joseph sold into slavery*, and (5) *Jacob blessing Ephraim and Manasseh.*

James the Greater (the Great, the More, the Elder, Major. Lat. Jacobus Major; Ital. Giacomo Maggiore; Fr. Jacques Majeur; Sp. Jago or Santiago). Apostle, son of Zebedee, a fisherman of Galilee, and brother of John the Evangelist. He was among the circle of men closest to Christ, being present with Peter and John at the TRANSFIGURATION, and again at the AGONY IN THE GARDEN, where the same three are seen sleeping while Christ prays. He was tried in Jerusalem in the year 44 by Herod Agrippa and executed. The cycle of scenes of his trial and execution is represented in medieval frescoes and stained glass. The frescoes by Mantegna in the Eremitani chapel, Padua, were destroyed in 1944. A series of legends dating from the Middle Ages tells of his mission to Spain and burial at Compostella, both historically untenable, though the latter became one of the great centres of Christian pilgrimage. It is legend rather than Scripture that has been the chief source of inspiration to artists, especially Spanish. James appears as three distinct types: (1) The Apostle. He is of mature years, thin-bearded, his hair brown or dark, parted and falling on either side in the manner of Christ. He holds the martyr's SWORD. In later devotional art he holds the pilgrim's STAFF which usually distinguishes him when grouped with other saints. (2) The Pilgrim (13th cent. onwards). He wears the pilgrim's broad-brimmed HAT and CLOAK. From his staff or shoulder hangs the WALLET or water-gourd of the pilgrim. His special attribute, the scallop SHELL, appears on his hat or cloak, or on the wallet. (3) The Knight and Patron Saint of Spain. He is mounted on horseback holding a standard, and is dressed as a pilgrim or wears armour. His horse tramples the Saracen under its hooves. James' inscriptions are, from the Apostles' Creed: 'Qui conceptus est de Spiritu Sancto, natus ex Maria Virgine'; from the Epistle of James (1:19) (modified): 'Omnis homo velox est' – 'Let every man be swift (to hear)'.

The many Spanish legends about him, some of which are represented in painting, date from about the 10th cent. and were probably promulgated in order to encourage pilgrimage to Compostella. One tells of his evangelizing mission to Spain after Christ's Ascension. In Saragossa the Virgin appeared to him in a vision, seated on top of a pillar of jasper, and commanded him to build a chapel on the spot, a story that served to explain the foundation of the church of Nuestra Señora del Pilar. On his return to Jerusalem he converted and baptized a magician, Hermogenes, after each had tested his powers on the other,

rather in the manner of the apostle PETER (12) and Simon Magus. After James' execution his disciples took his body back to Spain and, guided by an angel, landed at Padron in Galicia. Near here, in the palace of a pagan woman, Lupa, who was converted to Christianity by several miraculous occurrences, James was buried. His supposed tomb was discovered in about the 9th cent. and the place was called Santiago (St James) de Compostella. It was well-established as a place of pilgrimage by the 11th cent., next in importance to Jerusalem and Rome. The origin of the scallop shell as the badge of the pilgrim to Compostella is open to more than one explanation.

1. *The Miracle of the Fowls.* A story with echoes of Joseph in Egypt. The daughter of a Spanish innkeeper tried unsuccessfully to seduce a young and handsome pilgrim who was travelling to Compostella with his parents. Like Potiphar's wife, she sought revenge and, like Joseph, hid a silver cup in the young man's bag when he departed. She caused the cup to be found and the young man was convicted of theft and hanged on a gibbet. When the parents passed by on their return, lamenting the death of their son, the body, still on the gibbet, spoke up and bade them be of good cheer since St James was at his side sustaining him. The couple ran with the news to the judge who happened to be sitting at table, but he scorned them, saying, 'He is no more alive than these fowls on my dish.' At this, needless to say, the birds sprang up and began to crow, and the young man was restored to his parents.

2. *Santiago; St James at Clavijo.* At the battle of Clavijo, about 930, which was going badly for the Spanish against the Saracens, King Ramirez of Castile was, according to legend, promised victory by James in a dream. Next day the saint appeared on the battlefield on a white horse and led the rout of the enemy by the Spanish troops, whose battle-cry thereafter was 'Santiago!' In this context he is known as the 'Moor-slayer', in Spanish 'Matamoros'.

James the Less. Apostle, generally regarded as the same person as James 'the Lord's brother', mentioned by St Paul (Gal. 1:19), who became the first bishop of Jerusalem. Though 'bróther' could here apply to any male relation, it came to be taken in the strict sense and was the source of the tradition that represents Christ and the saint somewhat alike in appearance. This similarity is helpful in identifying St James in scenes such as the Last Supper. It was sometimes given as the reason for the kiss of Judas, because the soldiers then knew which man to arrest. According to early sources James was martyred by being thrown from the roof of the Temple and then stoned and beaten to death. The *Golden Legend* relates that 'a man in that company took a fuller's staff and smote him on the head, that his brains fell all abroad'. James holds a fuller's staff, which may be short- or long-handled, having a clubbed head; or it is shaped like a flat bat. It was once used by the fuller in the process of finishing cloth, to compact the material by beating it. From the early 14th cent., especially in German art, he may instead hold a hatter's bow, which was used in the manufacture of felt for hats and by wool-workers to clean wool. It may be shown without a bow-string. James was the patron saint of hat-makers, mercers and other similar medieval guilds. (See diag. BOW.) As bishop of Jerusalem he may wear episcopal robes, with mitre and crozier.

Januarius (Ital. Gennaro; Fr. Janvier). Christian martyr about whom little is known. He was bishop of Benevento and was martyred about the year 305. Legend relates that his index finger was accidentally cut off as he was beheaded and that his blood was caught in a sponge and thereafter preserved. A PHIAL purporting to contain the saint's dried blood is preserved in Naples cathedral.

A ceremony is performed in public during which this substance can be observed 'miraculously' to liquefy. As a devotional figure Januarius wears bishop's robes and holds a BOOK on which rest two phials. More rarely there may be FLAMES at his feet, as a reminder that he is to be invoked against eruptions of Vesuvius.

Janus. A Roman god, guardian of the doorways of dwelling-houses and city gateways. Hence he was always represented with two faces, one at the back of his head, so that he looked both ways at once. The head of Janus surmounted the ancient Roman 'term', a pillar marking the boundary of property. He was also the god of 'beginnings', invoked at the start of an enterprise, the beginning of the month or year (hence January), and therefore played a part in the creation of the world. The Renaissance made of his two faces a symbol of the past and future (cf PRUDENCE), in allegories concerning Time; in this sense Poussin represents him as a term. He is seen at the beginning of an extended allegory of human life presenting a handful of wool to the THREE FATES for them to spin (Giordano, Palazzo Medici-Riccardi, Florence). His attribute is a SNAKE in the form of a circle, an ancient symbol of eternity.

Jar. Six large standing jars, often in the shape of the Greek hydria, at a banquet, MARRIAGE AT CANA. See also VASE.

Jason (Apollonius of Rhodes, *Argonautica*; *Met.* 7:1 ff; Philostratus the Younger, *Imag.* 7, 11). Of all the Greek heroes Jason is perhaps the most familiar to English-speaking readers through the pages of Kingsley and Hawthorne, though he is not very widely represented in art. It was he who led the Argonauts on their voyage to capture the Golden Fleece from Aeëtes, king of Colchis on the Black Sea. The king's daughter Medea fell in love with Jason, and by her skill in magic helped him to overcome various mortal dangers and win the Fleece. She fled with Jason from the wrath of her father, returning to Greece with him. The story occurs on Italian Renaissance *cassone* panels but is comparatively rare in later art. (The *cassone* was a bride's marriage chest and was often decorated with stories from classical mythology. Such panels are today often hung as pictures.) The following are depicted: Jason, about to set out from his home town of Iolcus, takes leave of King Pelias, his uncle. The ship *Argo* passes between the clashing rocks. The Argonauts, disembarking at Colchis, are received by King Aeëtes. Jason meets Medea. Jason captures the Golden Fleece, which hangs from the branch of a tree at the foot of which a dragon is coiled. Two fire-breathing bulls paw the ground amid clouds of smoke. Jason, with sword and shield and clad in armour, stands before the tree, his followers close behind.

For the sequel to the story of Jason and Medea, see MEDEA. See also HYLAS, the Argonaut who was waylaid by nymphs.

Javelin, see SPEAR.

Jawbone. An ass's jawbone was the weapon with which SAMSON (3) smote the Philistines, and from which he afterwards drank. The same is sometimes depicted in the hand of Cain, slaying Abel (CAIN AND ABEL).

Jephthah's daughter (Judges 11:30–40). In the era of the judges Jephthah, a great warrior, was called upon to lead the Israelites in their war against the Ammonites. On the eve of battle he made a pact with God that, in return for victory, he would sacrifice 'the first creature that comes out of the door of my house to meet me when I return'. The battle won, 'who should come out to meet him with tambourines and dances but his daughter, and she only a child'. The theme occurs more often in 17th and 18th cent. painting, especially French. It shows either Jephthah's return, a warrior rending his garments as his daughter advances

to greet him; or the daughter kneeling beside an altar as Jephthah with raised sword is about to execute her.

Jeremiah. One of the four 'greater prophets'. (The others are ISAIAH, EZEKIEL and DANIEL.) He taught that the spiritual salvation of the Hebrews would come about only through oppression and suffering, a view that led to his persecution and eventual retirement to Egypt where it is said he died by stoning. A late tradition made him the author of the book of Lamentations, from which come his inscriptions, 'Spiritus oris nostri, Christus Dominus, captus est in peccatis nostris', – 'The Lord's anointed, the breath of life to us, was caught in their machinations' (4:20); and 'O vos omnes qui transitis per viam . . .' – 'Is it of no concern to you who pass by?' (1:12). The work is a lament over the destruction of Jerusalem, which took place in 586 B.C. at the hands of the Chaldeans. Jeremiah is depicted sorrowing while the city burns in the background (Rembrandt, Rijksmuseum, Amsterdam). Among the assembled prophets he is old and bearded, and perhaps deep in thought (Michelangelo, Sistine chapel). His normal attribute is a BOOK or SCROLL. As a prophet of the Passion he holds a cross. In medieval art he may have a manticore, a fabulous creature found in the bestiaries having a lion's body, human head and scorpion's tail. See also JESSE, TREE OF.

Jerome (Lat. Hieronymus; Ital. Geronimo or Girolamo) (342–420). His full name was Eusebius Hieronymus Sophronius. He was born at Stridon, in Dalmatia. He is one of the four Latin (western) Fathers of the Church. He is usually greyhaired and bearded, and is portrayed in three distinct ways. (1) The penitent, dishevelled and partly naked, kneeling before a crucifix in the desert, holding a STONE with which he may beat his breast, and often with a SKULL and HOUR-GLASS nearby. (2) The man of learning, seated at work in his study, with books, pen, inkhorn, etc. (3) The Doctor of the Church, standing, wearing cardinal's robes and holding a model of a church. His commonest attributes, seen in all the above, are the cardinal's HAT and the LION. His inscription, on a book, is 'In principio creavit Deus caelum et terram . . .' (Gen. 1:1), an allusion to his translation of the Bible.

1. *The penitent in the desert.* Jerome was a man of powerful intellect and fiery disposition. He was much travelled and as a young man made a pilgrimage to the Holy Land. Later he retired for four years as a hermit into the Syrian desert where he studied Hebrew and had, in his own words, 'only the scorpions and wild beasts for company'. Like St Francis of Assisi, Antony the Great and others who practised severe asceticism in their daily life, he experienced vivid sexual hallucinations, and describes in one of his letters how he would beat his breast until the fever passed. The stone he holds for this purpose is a later invention by artists.

2. *Flagellation by the angels.* His love of classical literature caused him to dream of being accused by God of preferring Cicero to the Bible, and then being whipped by angels as punishment. The subject is common in French and Spanish painting of the 17th cent. and may include the inscription: 'Ciceronianus es' – 'You are (not a Christian, but) a Ciceronian'.

3. *The vision of St Jerome.* While in the desert he sometimes imagined that he heard trumpets sounding the Last Judgement. He is depicted listening while angels blow their trumpets above his head.

4. *The Cardinal.* Jerome was never made a cardinal – the office did not then exist, but while in Rome he held an appointment under Pope Damasus I. It was probably in recognition of this that he came to be portrayed in cardinal's robes –

hence his almost invariable attribute, the cardinal's hat. He may be seen receiving it from the hands of the Virgin.

5. *Translating the Bible.* In 386 Jerome settled in Bethlehem. He was followed there by a Roman noblewoman Paula, whom he had earlier converted to Christianity. She built convents and a monastery and it was there, over many years, that Jerome translated the Old and New Testaments into Latin. His version, known as the Vulgate, was declared the official Latin text by the Council of Trent eleven centuries later. He is shown at this work in countless paintings.

6. *The Lion.* According to a popular fable Jerome pulled a thorn from the paw of a lion which thereafter became his devoted friend. Its subsequent adventures are told in the *Golden Legend.* This story was related about the Roman slave Androclus in the *Noctes Atticae* of Aulus Gellius (*c.* 150 A.D.) who took it from the *Aegyptiaca* of Apion (1st cent. A.D.).

7. *The Last Sacrament.* Jerome is attended and supported by younger priests, one of whom, holding the cup, is about to administer the sacrament. St Paula is often present and sometimes the lion as well.

Cycles of scenes in Jeronymite churches and monasteries include his baptism by Pope Liberius, his death surrounded by his disciples, and burial.

Jesse, Tree of ('Stem of . . .'). The prophecy of Isaiah (11:1–3) that a Messiah would spring from the family of Jesse, the father of David, was interpreted visually in the Middle Ages as a genealogical tree. The typical 'Jesse window', done in the stained glass of a medieval cathedral, shows at the foot the reclining figure of Jesse. A tree rises from his loins on the branches of which appear the ancestors of Christ. It culminates in the Virgin and the Saviour. (Stained glass windows are normally 'read' from bottom to top.) The prefigurative significance of the passage 'a shoot shall grow from the stock of Jesse' ('Egredietur virga de radice Jesse') was plain to the medieval exegete because of the similarity of *virga*, a shoot, and *virgo*, a virgin (cf AARON, 2). The theme occurs also in Renaissance painting, especially of the early Netherlands. The principal figures are DAVID, usually with a harp, the Virgin and Christ. On either side may be seen, among others, the prophets ISAIAH and JEREMIAH. The latter likewise foretold the coming of a Messiah in somewhat similar terms (23:5). See also VIRGIN MARY (4, 12).

Jester. From ancient times the 'fool' – like the dwarf – was the attendant of kings and noblemen. His traditional dress included a cap with ass's ears and bells, and a sceptre – the bauble or marotte – topped by the carved head of a jester. In the *Psychomachia* (see VIRTUES AND VICES) Jocus (Jest) is the companion of Cupid, and Renaissance allegory likewise linked Love and Folly as the joint concomitants of Youth (Pourbus, Allegorical Love-feast, Wall. Coll., London). A jester, personifying Folly, may be opposed to the virtue of PRUDENCE. See also SHIP OF FOOLS.

Jesus among the doctors, see DISPUTE WITH THE DOCTORS.

Jethro, daughter of, see MOSES (4).

Jewels. Symbols of the transience of earthly possessions, in contrast to the durable, eternal virtues; hence an attribute of the richly attired Profane Love (VENUS, 1), of VANITY personified, and an element in the 'Vanitas' theme (STILL LIFE). A bejewelled woman casting off her finery is MARY MAGDALENE. A Roman matron shows off her jewels to another (CORNELIA) whose two sons are beside her. Women cluster round a chest of jewels; one of them is ACHILLES (3) in disguise, eagerly fingering or brandishing a sword. Eliezer offers gifts of gold and jewels to REBECCA at the well. Sticks and stones are changed into golden rods

and jewels before two young disciples by JOHN THE EVANGELIST (4). Jewels are the attribute of Asia personified, one of the FOUR PARTS OF THE WORLD.

Jezebel (II Kings 9:30–37). The wife of Ahab, king of Israel and worshipper of Baal, a forceful woman who, like Lady Macbeth, schemed murder on her husband's behalf. An uprising of the defenders of Yahveh was led by the warrior Jehu. On his coming to Jezreel, Ahab's capital, Jezebel arrayed herself as a queen, having 'painted her eyes and dressed her hair'. She taunted him from a window. He ordered her to be thrown out and she died in the street, trampled underfoot by his horses, her body eaten by dogs. She is depicted in the clutches of two eunuchs, about to be thrown from the window. See also ELIJAH (3, 4).

Joachim and Anne. The story of the parents of the Virgin Mary is told in the 13th cent. *Golden Legend* which took it from the apocryphal New Testament literature. Joachim, a rich man, and Anne his wife were without child after twenty years of marriage. When Joachim came to the Temple in Jerusalem on a feast day to make offering he was rebuked and turned away by the high priest because he was childless. 'Joachim, all confused for this thing, durst not go home for shame.' Instead he went and stayed with his shepherds in the desert, where an angel appeared to him. The angel foretold that Anne would conceive, and that the child would be the mother of Jesus. As a sign, Joachim was to go to the Golden Gate at Jerusalem where he would meet his wife. The angel then appeared to Anne with a similar message. The apocryphal Protevangelium tells that the angel came while Anne was sitting in her garden under a laurel tree, lamenting her barrenness. Seeing a nest of sparrows in the tree she cried, 'Woe unto me, even the fowls of the heaven are fruitful'. The couple met at the appointed place and embraced joyfully, and from that moment Anne was with child. The story has similarities with the Old Testament accounts of the barrenness of Hannah (i.e. Anne), the mother of Samuel (I Sam. 1), and of Sarah, the mother of Isaac (Gen. 18:1–19), whose birth was foretold by angels. It is fairly common in the art of the 14th–16th cents. The meeting at the Golden Gate is the most popular single episode; or it may form part of the cycle of scenes of the life of the Virgin.

1. *Joachim cast out of the Temple.* Joachim stands at the entrance to the Temple with the lamb he has brought for sacrifice; or he is descending the stairs, turned away by the high priest who makes a gesture of refusal. In a few early examples he may be tumbling down the steps after being forcibly rejected.

2. *The annunciation to Joachim.* He kneels before GABRIEL, the angel of the annunciation, identifiable by his wand tipped with a fleur-de-lys. The setting is a rocky place, perhaps before a shepherd's hut, with sheep and shepherds nearby.

3. *The annunciation to Anne.* The scene somewhat resembles the Annunciation to the Virgin Mary, but is usually set in the garden. Anne sits under the laurel tree in which the sparrows are nesting. She may be speaking to a servant, or she kneels before the angel.

4. *The meeting at the Golden Gate.* That Anne conceived, like the Virgin Mary herself, *sine macula* – that is, 'without concupiscence' – was taught by the Church in the doctrine of the Immaculate Conception. (See VIRGIN MARY, 4.) Before the emergence of that theme in art the embrace of Joachim and Anne was used instead to symbolize her conception. According to the Franciscans it was their kiss that brought about Anne's conception, and this was therefore the first redemptive act of God. The Golden Gate was compared to the 'porta clausa', the closed gate (Ezek. 44:1–2) which was the symbol of Mary's virginity. The pair are depicted standing outside a city gate at the moment of their embrace.

The gate may be ornamented with gold. Anne is usually attended by her women servants, Joachim by shepherds. The angel Gabriel floats overhead; other versions may show the angel leading Joachim towards his wife, or Anne on her knees before him. The theme is occasionally found in Counter-Reformation art though by then it had generally been superseded by the Immaculate Conception.

Job. The upright man of Uz whose steadfast refusal to abandon his God in the face of misfortune epitomizes the problem of human suffering. Job's afflictions were the outcome of an argument between God and Satan whether his faith were strong enough to survive adversity. Satan put him to the test: his livestock was stolen and destroyed and his servants slain; his children died in a hurricane which razed their house; Job himself was covered in boils from head to foot. Medieval versions of the story tell of him scolded by his wife and derided by his friends for refusing to give up his faith. Finally he was restored to health and prosperity. Job's story is represented in cyclical form or as a combination of several episodes in one picture or in the form of separate subjects. He features in all periods of Christian art. The paintings in the Roman catacombs established him as a 'type' of the suffering Christ. He was made patron saint of a church in Venice in the Middle Ages and may therefore wear a halo in some Venetian painting. After the black death in the mid-14th cent. he was widely represented in votive pictures as a protector against the plague, because he himself had survived an apparently similar disease. In narrative pictures he is often portrayed as an old man with a white beard, generally nude except for a loin-cloth. He may sit on a dung-hill, his mocking friends around him. (The dung-hill derives from the Septuagint and the Vulgate; the N.E.B. renders it less picturesquely as 'ashes'.) His wife stands by holding her nose in disgust, or she sometimes empties a bucket of water over him. In some medieval and northern Renaissance examples he is scourged by Satan. His children are depicted fleeing from under the toppling pillars of their house in the storm raised by Satan and his demons. (See also EUSTACE.)

John Chrysostom (*c.* 347–407). Christian saint and Doctor of the Greek Church, born at Antioch. He studied law and was looked after lovingly by a widowed mother, but finally renounced his career to become a desert hermit. He joined the Church and in time became archbishop of Constantinople. He was renowned for his charity and eloquence (his name is from the Greek meaning 'golden mouth'), but the latter, combined with a zeal to reform, caused him to fall foul of others, in particular Euxodia the influential wife of the Roman Emperor Arcadius, and Theophilus, Patriarch of Alexandria. John was twice removed from office and exiled, on the second occasion dying from hardship at the hands of his persecutors. Of the Greek fathers he is the only one widely represented in western art. He may have a beehive for attribute, signifying his eloquence, or a DOVE at his ear to inspire him. Churches are dedicated to him in Venice where he is represented enthroned and surrounded by saints of the western Church. He is depicted giving alms to a beggar, an allusion to his great charity. He is seen on the road to exile, in a state of collapse, escorted by soldiers. A curious late medieval legend, popularized in contemporary ballads, told that while he was a desert hermit he lay with a maiden, making her pregnant, and then killed her and hid the body. For this he did penance, abjuring, among other things, speech and the sight of the face of heaven, until a seven-day-old infant should grant him pardon. Upon these words being uttered by the new-born son of a queen, John confessed his crime, and the woman he had wronged and her child were discovered alive and well. The scene depicts a naked woman in the desert with a

child, perhaps suckling it, while in the background the figure of John goes on all fours, so that he shall not see the face of heaven. (Dürer, engraving.)

John Gualberto (*c.* 985–1073). The son of a Florentine nobleman who entered the Benedictine Order and later founded the monastery of Vallombrosa in Tuscany. He attracted many followers and by the time of his death twelve houses of his Order were in existence. He was said to have spared the life of a man who assassinated his brother, and afterwards at prayer to have observed the head of Christ on the crucifix inclining itself towards him. It was this that moved him to become a monk. His attribute is a CRUCIFIX which may show the head of Christ bent forward. He wears the light grey habit of the Vallombrosans and may also hold a book or a CRUTCH. John accused the archbishop of Florence of simony, an action which prompted a monk of his Order to undergo an ordeal by fire to prove the truth of his assertion. The episode appears in early Florentine painting.

John of God ('Juan de Dios') (1495–1550). Born in Portugal, a man of humble station and unsettled way of life, he underwent religious conversion in middle age. Thereafter with the help of the Church, he kept an open house to shelter the destitute of Granada. The charitable community that grew up round him became established after his death into the Order of Brothers Hospitallers. He was canonized in 1690. John of God is widely represented in art commissioned by charitable institutions, generally wearing a brown habit, with hood and large cape. As a devotional figure he holds a POMEGRANATE surmounted by a cross, perhaps as a symbol of resurrection and immortality. A beggar kneels at his feet. He is depicted in the midst of a storm carrying a dying man into his hospice, helped by an angel.

John of the Cross, see TERESA.

John the Baptist (Ital. Giovanni Battista). The forerunner or 'messenger' of Christ, he forms a link between the Old and New Testaments, being regarded as the last in the line of Old Testament prophets and the first of the saints of the New, in which his story is told. He was the son of Zacharias, a priest of the Temple of Jerusalem, and Elizabeth, a kinswoman of the Virgin. He was a preacher and lived an ascetic life in the desert. He baptized in the Jordan waters all who came to him in a penitent spirit. At the baptism of Christ, the Holy Ghost in the form of a dove was seen to descend from heaven. He was imprisoned by Herod Antipas – the son of Herod the Great – and later executed as a consequence of a rash promise made by the tetrarch to his step-daughter Salome. John is portrayed in two ways: (1) As an infant, with the infant Christ, in scenes of the Holy Family (VIRGIN MARY, 17). This theme – for which there is no biblical basis – first occurs in the art of the Italian Renaissance. John is shown as somewhat the older of the two, and holds his reed CROSS. (2) As an adult he is usually emaciated and unkempt, dressed in a tunic of animals' skins, with a leather girdle. He may hold a HONEYCOMB which, with locusts, was his food in the desert (Mark 1:6). He holds a LAMB which in earlier representations may have a cruciform nimbus. The lamb and the accompanying inscription, 'Ecce Agnus Dei', derive from the fourth gospel (1:36), 'John looked towards [Jesus] and said, "There is the Lamb of God." ' His almost invariable attribute is the reed cross with a long slender stem. Occasionally he holds a baptismal cup. A tradition that is confined to Byzantine art, shows John with angels' wings, since both he and they are messengers. Another, less frequent, idealized type found chiefly in Italian and Spanish painting depicts him as a handsome youth, usually alone in the wilderness. John is the patron of several Italian cities, notably Florence. His devotional image

and narrative cycles of his life are found in the many churches of which he is the titular saint. Baptisteries are naturally dedicated to him. He appears in devotional paintings of the Virgin with his namesake JOHN THE EVANGELIST; with other patron saints of Florence such as ZENOBIUS; with COSMAS AND DAMIAN and JULIAN THE HOSPITATOR, the patrons of the Medici family of Florence; and with SEBASTIAN in votive paintings against the plague. Scenes from his life occur frequently in narrative cycles or as single pictures.

1. *The annunciation to Zacharias* (Luke 1:5–22). The birth of John was foretold to Zacharias by the angel Gabriel who appeared to him in the Temple while he was offering incense. Zacharias stands before an altar holding a censer, the angel facing him. Because he disbelieved the angel (Elizabeth was till that time barren), Zacharias was struck dumb. To signify this he may hold his finger to his mouth.

2. *The birth and naming of St John* (Luke 1:57–64). The scene is a bedchamber. Elizabeth, who may be an old woman, is in bed, midwives are in attendance, and neighbours and relatives are entering. The infant may be in his mother's arms or, after the account in the *Golden Legend*, is sometimes held by the Virgin seated on the floor: 'It is said that she did the office and service to receive St John Baptist when he was born'. It was proposed to call the infant Zacharias after his father but his mother refused, insisting that he be called John. They asked Zacharias who signified his agreement by writing on a tablet 'His name is John', since he was bereft of speech. From that moment his speech was restored. Zacharias may sit beside the bed inscribing the infant's name on a tablet, though the naming in fact took place eight days afterwards.

3. *John the Baptist in the wilderness* (Luke 1:80). He is seen taking leave of his parents, and retiring to the desert guided by an angel. He is frequently depicted alone, in a woodland setting, the lamb at his feet; he meditates or is in prayer. Italian and Spanish artists, especially of the 16th and 17th cents., portray him as a pretty child or handsome youth, sometimes accompanied by the young Christ.

4. *St John preaching to the multitude* (Luke 3:1–17). He stands on a rock or on an improvised pulpit in the middle of a throng of listeners, preaching to them. He may have a scroll with the inscription 'Vox clamantis in deserto' – 'A voice crying aloud in the wilderness'.

5. *St John baptizes the people* (Matt. 3:5–6). The Baptist stands beside the river Jordan, pouring water from a cup on to the head of a kneeling figure. Others are undressing by the bank and entering the river.

6. *St John rebukes Herod* (Mark 6:17–20). John rebuked Herod for having married Herodias, the wife of his brother Philip. The tetrarch and his wife are seen on a throne. Herodias' daughter Salome stands beside her mother. John remonstrates with Herod: 'You have no right to your brother's wife'. As a consequence Herod was persuaded by his wife to imprison John.

7. *The banquet of Herod; the dance of Salome* (Mark 6:21–28). Herod held a banquet at which his step-daughter Salome danced before him. He was so carried away that he rashly swore to grant her whatever she asked. Herodias, to take revenge on the Baptist, told her daughter to ask for his head on a dish. Herod, though much distressed, kept his oath. In medieval art Salome may be seen performing an acrobatic hand-stand. Later artists depict her dancing, usually partly draped though in fact she would have been naked. There are often musicians playing perhaps a pipe and tambourine. Salome is also seen kneeling before Herodias, receiving her fatal instructions; or she dances holding above

her head a dish with the Baptist's head on it. The banqueting scene is sometimes combined with the next, the beheading.

8. *The beheading*, or *decollation*, *of John the Baptist*. In a prison yard John kneels before an executioner with a sword. His hands are tied behind his back, and he may be blindfold. Herod and Herodias may be looking on. Or the executioner presents the dripping head to Salome who holds out a dish.

9. *Salome presents the head of John the Baptist to Herodias*. Salome, once more in the banqueting hall, offers the dish, with averted face, to Herod and Herodias who may cover their eyes in horror. Alternatively Herodias pierces the head or the tongue with a knife or hair-pin. The head by itself on a charger is a frequent subject at all periods from the end of the Middle Ages. The image was venerated as a symbol of the saint, and was believed to have curative powers. The head itself, as a sacred relic, is claimed to be in the possession of more than one church.

10. *The burning of the Baptist's bones*. It was said that the Roman emperor Julian the Apostate in the 4th cent. had St John's supposed remains disinterred and publicly burned, as a move to discourage his cult. The theme occurs in late medieval art of northern Europe.

See also BAPTISM (which with the VISITATION is found in narrative cycles of John the Baptist); CRUCIFIXION; LAST JUDGEMENT (1).

John the Evangelist (Ital. Giovanni; Sp. Juan; Fr. Jean). Apostle. The son of Zebedee, and brother of James and the presumed author of the fourth gospel and, by tradition, of the Apocalypse. He was one of the first to be called to follow Christ. He appears with Peter and James in the scene of the TRANSFIGURATION. At the LAST SUPPER he is shown leaning his head on the breast of Christ, from the tradition that identified him with 'the disciple whom Jesus loved'. The AGONY IN THE GARDEN shows him asleep with Peter and James, while Christ prays. In one version of the CRUCIFIXION (5) John and the Virgin are seen standing alone at the foot of the cross. He is shown among the figures at the DESCENT FROM THE CROSS, the lamentation (PIETÀ) that followed and at the ENTOMBMENT. John appears at the DEATH OF THE VIRGIN and her ASSUMPTION because the apocryphal writings on which the scenes are based were ascribed to him. During the apostolic ministry John often accompanied the apostle PETER (5). He was traditionally identified with John who was exiled to the island of Patmos, where he wrote the book of Revelation (see 2, below). He was believed to have died at Ephesus at a great age. John's attributes are a BOOK or SCROLL, in allusion to his writings, an eagle which may hold a pen or inkhorn in its beak (see further under FOUR EVANGELISTS), a CHALICE from which a snake emerges (see below), a CAULDRON (see 1, below) and a PALM – not the martyr's but one belonging to the Virgin and handed on to John at her death; he holds it only in scenes relating to her. John may be represented in two distinct ways: as the apostle he is young, sometimes rather effeminate and graceful, typically with long, flowing, curly hair, and is beardless; or in complete contrast as the evangelist, he is an aged greybeard. Among his inscriptions the commonest are 'Passus sub Pontio Pilato' – 'He suffered under Pontius Pilate', from the Apostles' Creed; 'In principio erat verbum' – 'In the beginning was the Word' (John 1:1); 'Lignum vitae afferens fructus' – 'The tree of life which yields (twelve crops of) fruit' (Rev. 22:2).

1. *The 'martyrdom' of St John, immersed in a cauldron of boiling oil*. According to the *Golden Legend*, during the persecution of the Christians under the Roman emperor Domitian, John was thrown into a vat of boiling oil. He emerged miraculously unharmed, even rejuvenated. He is seen sitting naked in the pot,

his hands maybe joined in prayer, while his executioners apply bellows to the fire and ladle oil over his head. The emperor and senators are looking on. The chapel of San Giovanni in Olio outside the Latin gate at Rome marks the supposed site. See APOCALYPSE.

2. *St John on the island of Patmos writing the Revelation.* John was exiled by Domitian to Patmos, an Aegean island close to the mainland of Asia Minor. He was believed while there to have written the book of Revelation. He is generally depicted in a rocky desert in the act of writing. The eagle, the symbol of his inspiration, is beside him, perhaps with an inkhorn hanging from its neck. Above is sometimes seen John's vision of the Virgin crowned with stars, holding the infant Christ (Rev. 12:1).

3. *The raising of Drusiana.* After the death of Domitian John went to Ephesus. The *Golden Legend* tells how on the way he met the funeral procession of Drusiana, a woman who in her lifetime had followed John's example, and had longed to set eyes on him again before her death. John bid the procession stop, and said in a loud voice, 'Drusiana arise, and go into thy house, and make ready for me some refection.' Drusiana, miraculously restored to life, is seen sitting up in her coffin or, later, receiving John into her house.

4. *John changes sticks and stones into gold and jewels.* Another legend tells how two young disciples of an ascetic philosopher of Ephesus ground precious stones to powder to show their contempt for earthly belongings. But John reproved them for not selling the stones to provide for the poor. The young men were converted to Christianity when John miraculously turned the powder back into stones. They then gave them away, as he had bidden. Later they regretted their generosity so John took sticks and stones which he turned into gold and jewels for them, warning them that they would no longer be able to enter heaven. The two youths are seen standing before John with their precious stones and rods of gold.

5. *St John drinking from the poisoned chalice.* A legend that is seldom seen in narrative painting but which is important as the source of John's familiar attribute, the chalice with a snake, tells how the priest of the temple of Diana of Ephesus gave John a poisoned cup to drink as a test of the power of his faith. Two condemned men had already drunk of the cup and died; John not only survived unharmed but restored the other two to life. From medieval times the emblem had a symbolic meaning, the chalice standing for the Christian faith, the snake for Satan. In medieval art a dragon may replace the snake.

6. *Death and ascension of St John.* Tradition had it that John dug his own grave in the shape of a cross, and he is even depicted descending into it, watched by his disciples! At his ascension he is met by the figures of Christ and the Virgin, with SS Peter and Paul.

See also LAST JUDGEMENT (1); STEPHEN.

Jonah. The book of Jonah relates that he was sent by God to Nineveh to preach to its heathen citizens. But he defected and took a boat at Joppa intending to flee to Tarshish. To punish him, God unloosed a tempest which threatened to sink the boat. When Jonah confessed to the others on the vessel that he was the cause of the storm, they threw him overboard. He was swallowed by a 'great fish' (not specifically a whale). While in its belly he repented to God and after three days was disgorged, unharmed. The story of Jonah was referred to by Christ (Matt. 12:40) as a prefiguration of his own death and resurrection and thereby secured its place in Christian iconography. It is found particularly in early funerary art, on sarcophagi and in the Roman catacombs, because of this

symbolism. The fish is generally represented as a large sea-monster, occasionally as a dolphin or hippocampus.

Joseph. The elder son of the Hebrew patriarch Jacob and of Rachel. His numerous older brothers were strictly only half-brothers, being the sons of Leah or of handmaidens. The events of his romantic life story have been depicted continuously in Christian art from the 6th cent. onwards, especially in the form of narrative cycles. The medieval Church saw the episodes in his life as a prefiguration of the life of Christ, and it is to this that he owes his important place in Christian art.

1. *Joseph sold into slavery* (Gen. 37). Joseph's brothers hated him because, while they worked in the fields, he stayed at home enjoying the privileges of being his father's favourite son. Joseph was much given to oneiromancy, the art of interpreting dreams. He once dreamed that his brothers' sheaves of corn bowed down to his sheaf, and that the sun, moon and stars made obeisance to him. The apparent explanation of this only added fuel to his brothers' hatred and they determined to do away with him. When Joseph came to them one day in the fields they stripped him of his coat and threw him into a pit. However they drew the line at murder and instead sold him for twenty pieces of silver to passing merchants who took him to Egypt. The brothers smeared Joseph's coat with kid's blood and took it to their father. 'It is my son's robe', Jacob said. 'A wild beast has devoured him; Joseph has been torn to pieces'. And he mourned inconsolably. The pit takes various forms in art: it may be a stone cistern, a well, or simply a rocky cleft in the ground. Joseph is sometimes lowered into it by means of ropes. The camels of the Ishmaelite merchants usually appear in the background. The brothers can be distinguished from the merchants by their shepherd's crooks. The act of casting Joseph into the pit and drawing him out again was seen as a prefiguration of the Entombment and Resurrection of Christ. Primitive pastoral society rewarded the youngest with privileges, since to him fell the task of caring for aged and infirm parents, while the elder sons were away tending the flocks.

2. *Potiphar's wife* (Gen. 39:7–20). Potiphar, captain of Pharaoh's guard, bought Joseph from the Ishmaelites and made him steward of his household. Potiphar's wife 'cast her eyes over him and said, "Come and lie with me." ' He refused her though she continued to press him. One day when they were alone together she clutched his robes, pleading with him to make love to her. At this, Joseph fled so precipitately that he left his cloak in her hands. When Potiphar came home she avenged her humiliation by accusing Joseph of trying to violate her, using the cloak as evidence. Joseph was promptly thrown into prison.

3. *The interpreter of dreams* (Gen. 40; 41:1–45). While in prison Joseph gained a reputation by interpreting the dreams of Pharaoh's butler and baker. Some two years later, when the butler was restored to office (the baker had been hanged) Pharaoh himself was troubled by dreams, and the butler, remembering Joseph who was still in prison, recommended him as an interpreter. Pharaoh's dreams – the seven lean cattle devouring the seven fat ones, and the seven thin ears of corn devouring the seven full ones – foretold, according to Joseph, seven good harvests which would be followed by seven years of famine. Joseph was appointed chief administrator, charged with storing up the harvest in the good years. In recognition of his abilities Pharaoh 'took off his signet-ring, and put it on Joseph's finger, had him dressed in fine linen, and hung a gold chain round his neck. He mounted him in his viceroy's chariot and men cried "make way!" before him'. When the famine came the Egyptians were saved from starvation.

This episode was seen to prefigure Christ's feeding the multitude in the desert with loaves and fishes.

4. *Joseph's family in Egypt* (Gen. 42–47). Jacob sent his sons to Egypt to buy corn, except the youngest Benjamin whom he kept at home. Joseph recognized them but did not disclose his identity. He took one of the brothers hostage, demanding in return that they brought Benjamin to him. They did this, but when they set out on their second journey home, their sacks filled with corn, Joseph had his silver cup put secretly in Benjamin's sack. He then sent his servants in pursuit to search the brothers. The cup was found and they were brought back shamefaced to Joseph. Unable to keep up the pretence any longer, he made himself known to them and, amid tears, forgave them their past misdeed. Later Jacob himself travelled to Egypt and was presented by Joseph to Pharaoh. Divination was regarded in antiquity as a way of determining the will of the gods and took many forms. The seer sometimes gazed into a cup filled with water, as into a crystal; Joseph's silver cup was probably used for this purpose.

5. *Jacob blessing Ephraim and Manasseh, the sons of Joseph* (Gen. 48). Joseph brought his two children, Manasseh, the elder, and Ephraim to the bedside of their grandfather Jacob to be blessed by him because he was near death. Joseph had Manasseh on his left hand and Ephraim on his right so that, as they faced Jacob, he would put out his right hand to bless the elder grandson and his left, the younger. However Jacob crossed his hands over, thus giving the opposite effect to his blessing, and resisted Joseph's attempt to uncross them. Jacob foretold that the younger child would be the greater: 'his descendants shall be a whole nation in themselves'. The Middle Ages saw this as a symbol of the Christian Church superseding Judaism, in which Ephraim represented the Gentiles and Manasseh the Jews. Jacob's crossed arms were a 'type' of the cross of Christ. This symbolism continued into Renaissance art though later Jacob is sometimes portrayed with his arms uncrossed.

Joseph (husband of the Virgin). The carpenter who was the foster-father of Christ features in scenes of the infancy of Christ (see NATIVITY; PRESENTATION IN THE TEMPLE; VIRGIN MARY (17) 'Holy Family'; FLIGHT INTO EGYPT), and in some scenes from the life of the Virgin (see MARRIAGE OF THE VIRGIN; VISITATION). On the authority of certain apocryphal accounts of his life it was for long customary to paint Joseph as a white-bearded old man. This type tended to disappear with the Counter-Reformation when his cult was promoted especially by St Teresa of Avila, and he became widely venerated as a saint in his own right. From that time he is depicted as a much younger, though mature, man, and his devotional figure is commonly seen in the art of Italy and, even more, of Spain. His attributes are a LILY (for chastity); various carpenter's tools, and a flowering rod or WAND (see below). He leads the infant Christ by the hand or holds him in his arms. He may be grouped with the apostle PETER or with his namesake JOSEPH OF ARIMATHAEA.

1. *The flowering of Joseph's rod.* According to St Jerome the suitors of Mary each brought a rod to the high priest of the Temple. Joseph's rod blossomed, a sign from heaven that he was chosen to be her husband. The apocryphal Book of James relates that a DOVE came forth from the rod and settled on Joseph's head. He is usually depicted with a flowering rod, sometimes with a dove on it. The suitors are seen in the temple kneeling before the altar on which the rods are placed; or, later, the unlucky ones squabble or break their rods. The theme was condemned by the Council of Trent in the mid-16th cent. though thereafter Joseph retains the rod as an attribute. It was seen as a symbol of the Virgin's

state because it flowered without being fertilized. The story was a borrowing from the Old Testament account, which it closely resembles, of the flowering of Aaron's rod (see AARON).

2. *Joseph's dream.* (*a*) The Book of James relates how Joseph's suspicions were at first thoroughly aroused by Mary's conception, but were allayed by the archangel Gabriel who appeared to him in a dream and gave him the explanation. Joseph is nodding, perhaps at his carpenter's bench, as the angel appears overhead. (*b*) The angel's warning to Joseph to fly with his family to Egypt to escape Herod (Matt. 2:13) is depicted in a similar manner.

3. *The death of Joseph.* The apocryphal book, the History of Joseph the Carpenter, describes how Joseph died, aged 111, in the presence of Christ and the Virgin, with angels descending from heaven. His death is depicted thus. An angel holds his flowering rod; his carpenter's tools are sometimes also shown.

4. *Coronation of Joseph.* Joseph, holding his rod, kneels before Christ who places a crown on his head. The theme is found in the second half of the 16th cent. in churches of the Jesuits who were influential in spreading the cult of the saint.

Joseph of Arimathaea. The disciple 'who was a man of means', who obtained Pilate's permission after the crucifixion to take the body of Christ which he then laid in his own tomb. (Matt. 27:57–60.) At the DEPOSITION he is shown on the ladder lowering the body of Christ, or he stands on the ground receiving it. In the LAMENTATION and the ENTOMBMENT he and Nicodemus, and sometimes a youthful figure which is John the Evangelist, bear it on a shroud, one at the head and one at the feet. As a devotional figure Joseph's attributes are the SHROUD, CROWN of thorns and NAILS. Legend tells that he caught the blood from Christ's wound in the Holy Grail, the cup of the Last Supper, and that he came to England and founded the first church at Glastonbury.

Joshua. Moses' successor, the war-leader of the Israelites who captured Jericho and subsequently conquered Canaan, the Promised Land. The capture of Jericho is the episode most frequently depicted.

The fall of the walls of Jericho (Josh. 5:13–15; 6:1–27). Having besieged the city Joshua sent seven priests with trumpets of rams' horns to march round the walls seven times, followed by the ark of the covenant. Then at a signal from Joshua the priests made a long blast on their trumpets, the people shouted and the walls of the city crumbled. Jericho was burned and the inhabitants put to the sword.

Joshua, whose name is a variant of Jesus, was regarded as one of the many Old Testament prefigurations of Christ, the fall of Jericho foreshadowing the Last Judgement.

Journey to Emmaus ('Road to E.'; 'Walk to E.') (Mark 16:12; Luke 24:13–27). One of the occasions on which Christ appeared to the disciples after his Resurrection, forming, as it were, a prologue to the much more frequently depicted SUPPER AT EMMAUS. Luke, alone, describes how two disciples, on their way from Jerusalem to the neighbouring village of Emmaus, were met by Christ who walked with them. One was called Cleopas; the other was unnamed but was traditionally said to be the apostle PETER, and is sometimes thus depicted. They told the Saviour, whom they failed to recognize, of the recent death and supposed resurrection of Jesus of Nazareth, and were rebuked by him for their slowness in apprehending the teaching of the prophets in this matter. Christ is dressed as a pilgrim, with a WALLET and staff, a hat hanging on his back, sometimes a water-gourd and wearing a goatskin garment. This guise is explained

by Cleopas' words, 'Art thou only a stranger in Jerusalem?' which in the Vulgate is *'Tu solus peregrinus es . . . ?' Peregrinus* in medieval usage meant not only 'stranger' but 'pilgrim'. The common obligation to provide shelter and lodging for the medieval pilgrim led to the theme being represented in monasteries, where he would receive hospitality. The village of Emmaus is called in Latin *castellum,* a 'castle', and is therefore sometimes depicted as fortified town.

Juan de Dios, see JOHN OF GOD.

Judas Iscariot. One of the twelve apostles, he who betrayed Christ to the Jewish chief priests and elders for thirty pieces of silver. (See AGONY IN THE GARDEN and BETRAYAL.) His action was foretold by Christ at the LAST SUPPER. Later, overcome with remorse and spurned by the priests to whom he tried to return the money, he hanged himself. Judas also features in the scene in which the Magdalen anoints Christ's feet. (See MARY MAGDALENE, 1.) He is generally portrayed as a man of mature years with dark hair and a beard, and is sometimes dark complexioned. Among the Twelve he was the steward and may therefore hold a purse. In medieval and early Renaissance art a demon sits on his shoulder whispering Satan's words in his ear, rather in the way that a dove may often be seen at the ear of a saint, delivering God's message.

1. *The remorse of Judas* (Matt. 27:3–5). When the chief priests refused to take back the thirty pieces of silver Judas threw the money down in the Temple. He is seen standing or kneeling before Caiaphas, the high priest, and other elders. He holds out the money or is in the act of throwing it down. Caiaphas signifies his refusal with a gesture.

2. *The hanging of Judas.* The death of Judas, hanging from a tree, occurs in early Renaissance painting. He may be depicted with his bowels hanging out. This detail, popularized by medieval religious drama, is not in fact mentioned in the gospels, but is adapted from the Acts (1:18–19) where his end is differently described. 'This Judas . . . after buying a plot of land with the price of his villainy, fell forward on the ground, and burst open, so that his entrails poured out.'

Jude (Thaddeus), 'the other Judas, not Iscariot' (John 14:22), apostle and martyr, said to have preached the gospel in the countries neighbouring Palestine with SIMON ZELOTES, after Christ's crucifixion. He was martyred in Persia. Jude's attribute is a CLUB, HALBERD or LANCE, according to various accounts of his death. His inscription in early Italian painting is 'Qui tollis peccata mundi' – 'Thou who takest away the sins of the world', from the Gloria of the Mass. He is the patron saint of lost causes.

Judgement. Scenes of Roman judgement, with a judge enthroned, perhaps wearing armour or a toga, attendants often bearing FASCES: the prisoner naked, chastised by children, FALERII, SCHOOLMASTER OF; prisoner stripped of armour, or beheaded, MANLIUS TORQUATUS; his eye about to be put out, judge pointing to his own eye, JUDGEMENT OF ZALEUCUS; two youths judged, BRUTUS, Lucius Junius; a maiden stabbed by a soldier before a judge, VIRGINIA. A youth enthroned, instructed by judge standing before him, JUDGEMENT OF CAMBYSES. Woman and her children judged by soldier, ALEXANDER THE GREAT (2). Woman holding a red-hot iron and a decapitated head, kneeling before king, JUDGEMENT OF OTTO. Two women with infants, one dead, the other about to be slain by a soldier, before a king, SOLOMON (1). A youth dragged by a woman with torch before a king who may have ass's ears, CALUMNY OF APELLES. For the scenes of Christ brought before Caiaphas and his other judges, see TRIAL OF CHRIST. See also

JAMES THE GREATER (before Herod Agrippa); GOVERNMENT, GOOD AND BAD. (cf also themes of OBEISANCE and SUPPLICATION.)

Judgement of Cambyses (Herodotus, 5:25). Cambyses, king of the Medes and Persians (6th cent. B.C.), punished a corrupt judge with death. The body was then flayed, the skin cut into strips and stretched to form the seat of the throne of judgement. Cambyses then appointed the judge's son to serve in his father's place, and, says Herodotus, 'bade him never forget in what way his seat was cushioned'. This stark theme, which was sometimes represented in courts of justice, shows the denunciation and arrest of the corrupt judge by Cambyses, and occasionally the flaying. In the example by Gerard David (Musée Communal, Bruges) the figure of the judge is a likeness of Peter Lanchals, a conspirator who betrayed the interests of the city of Bruges to Maximilian I of Austria.

Judgement of Otto (or Otho). The wife of the Holy Roman Emperor, Otto III (980–1002), caused the execution of a German count, in revenge for his rejection of her advances, by bringing a false accusation against him to the emperor. The count's widow, in order to prove her husband's innocence, voluntarily underwent ordeal by red-hot iron, a normal medieval practice to establish the truth. The emperor, satisfied by this evidence, atoned for his wrong judgement by sentencing his wife to be burned at the stake. The widow may be seen receiving her husband's head from a soldier, while in the background the empress utters calumnies in the emperor's ear. In the subsequent scene the widow kneels before the enthroned Otto, a red-hot iron bar in one hand, the severed head in the other. Near her is a brazier. In the background the empress dies at the stake. (Dieric Bouts, two panels, Brussels Gallery.)

Judgement of Paris (Hyginus 92; Lucian, *Dialogues of the Gods*, 20). The well-known pastoral beauty contest showing Paris, a shepherd, judging three naked goddesses. The scene gives no indication of the dire consequences that flowed from his verdict. The three contestants are Juno with her peacock, Minerva, with her aegis (a shield bearing the image of a Gorgon's head) and her helmet which usually lies beside her, and Venus accompanied by Cupid. Mercury is generally present.

Paris was the son of Priam, king of Troy. Before his birth his mother dreamed that the child she bore would cause Troy to be razed to the ground by fire and so, on the advice of a seer, Paris was handed over to a shepherd who was instructed that the infant be left exposed to die on Mt Ida. But the child survived and was brought up by the shepherd. Eventually he married Oenone, daughter of the river-god Oeneus (who are both sometimes seen at the water's edge, Oeneus with the overturned urn of the river-god and perhaps wearing a crown of reeds.) In revenge, because she alone of the gods had not been invited to the wedding, Eris, the goddess of Strife, threw down among the guests a golden apple inscribed 'To the fairest'. (The banquet is sometimes shown in the background.) There were three claimants for the apple but Jupiter declined to choose between them and instead ordered his messenger Mercury to take them to Paris who was to make the choice. Much bribery ensued. Juno promised Paris land and riches, and Minerva offered him victory in battle. Venus promised to reward him with the love of any woman he chose and went on to describe Helen, the wife of Menelaus, king of Sparta, in glowing terms. Paris promptly awarded the apple to Venus. He later sailed to Sparta, succeeded in abducting Helen and carried her back to Troy, the act which provoked the Trojan war. After the fall of Troy, Paris, who was wounded, returned to Oenone. Though skilled in medicine she

refused to heal him and he was brought back to Troy to die. Oenone relented, but too late. (See HELEN OF TROY; PARIS; TROJAN WAR.)

Judgement of Zaleucus (Valerius Maximus, 6:5). Zaleucus, the lawgiver of a Greek colony, Locri Epizephyrii, in southern Italy in the 7th cent. B.C., found himself called upon to give judgement on his son, accused of adultery, for which the punishment was blinding in both eyes. The verdict was guilty. The citizens, out of regard for the father, would have revoked the penalty but Zaleucus, determined to satisfy the letter of the law which he himself had promulgated, had one of his son's eyes plucked out and one of his own. As an example of ancient justice the theme occurs in 16th cent. Italian and 17th cent. Netherlandish painting. Zaleucus is depicted on the seat of judgement. Behind him are attendants holding FASCES. Before him is a young man in the grasp of executioners, one of whom is about to put out his eye with a dagger.

Judith (O.T. Apocrypha). Jewish patriotic heroine and a symbol of the Jews' struggle against their ancient oppressors in the near east. She is usually shown holding the head of Holofernes, the Assyrian general, whom she has decapitated with a sword. The Assyrian army had laid siege to the Jewish city of Bethulia. When the inhabitants were on the point of capitulating, Judith, a rich and beautiful widow, devised a scheme to save them. She adorned herself 'so as to catch the eye of any man who might see her' (10:5), and set off with her maid into the Assyrian lines. By the pretence of having deserted her people she gained access to the enemy commander, Holofernes, and proposed to him a fictitious scheme for overcoming the Jews. After she had been several days in the camp Holofernes became enamoured of her and planned a banquet to which she was invited. When it was over and they were alone together he had meant to seduce her, but he was by then overcome with liquor. This was Judith's opportunity. She quickly seized his sword and with two swift blows severed his head. Her maid was ready with a sack into which they put the head. They then made their way through the camp and back to Bethulia before the deed was discovered. The news threw the Assyrians into disarray and they fled, pursued by the Israelites. Several episodes from the story have been illustrated, but the commonest shows Judith with the severed head of Holofernes, usually accompanied by her maid who holds a sack. The image of Judith occurs first in the Middle Ages as an example of virtue overcoming vice and may be associated with the allegorical figure of HUMILITY. She is also widely depicted in the Renaissance when her victory sometimes forms a companion-picture to *Samson and Delilah* (SAMSON, 4) and ARISTOTLE AND CAMPASPE. Such juxtaposing suggests that the theme was then regarded as an allegory of man's misfortunes at the hands of a scheming woman. (See also TOMYRIS.) In Counter-Reformation art the theme surprisingly prefigures the Visitation, as an expression of victory over sin.

Julian the Hospitator (or Hospitaller). In medieval romance Julian was a nobleman, fond of hunting, of whom it was foretold that he would one day accidentally slay his mother and father. In his absence, his wife one night gave her bed to Julian's parents and he, returning later and not recognizing them in the dark, drew the obvious conclusion and killed them. To atone for his crime Julian set up a hospice by a ford where travellers could find refuge. He once ferried across the river a leper, dying of cold, to whom he gave his bed. The next day the leper was transformed into an angel who announced that Julian by his penitence had been forgiven his crime. Narrative cycles are found in French Gothic cathedrals. In early French and Italian Renaissance painting are to be found single scenes of Julian slaying his father and mother, and carrying the

leper – sometimes, like St Christopher, on his shoulders. His attributes are a FALCON, a drawn SWORD, and more rarely an OAR. He may be on horseback or may have a STAG at his side. A river and boat may be seen in the background. Julian is the patron of travellers and innkeepers. Churches, hospitals and inns are named after him.

Juno (Gk Hera). The chief goddess of Olympus, both the sister and wife of Jupiter (Zeus). She was worshipped as the protectress of women, in particular watching over marriage and childbirth. Her role in myth and in art is principally that of the wife of a faithless husband, always plotting revenge on his many lovers. Juno's beauty is rather of the handsome and stately kind. She sometimes wears a crown or diadem. Her usual attribute is the PEACOCK (see below) which was sacred to her in antiquity; a pair of them draw her chariot. In order to charm Jupiter she may wear a magic belt or GIRDLE, borrowed from Venus, which had the effect of making its wearer irresistibly desirable. Two attributes which belong to her in antiquity are the POMEGRANATE, its many seeds signifying fertility, and a SCEPTRE surmounted by a cuckoo, the emblem of the deceived spouse. In allegories of the FOUR ELEMENTS she personifies Air, having once been suspended from the heavens by a golden rope with anvils tied to her feet, Jupiter's punishment for her disobedience (*Iliad* 15:18–21). In portrayals of the Olympians Juno is enthroned beside Jupiter in the centre of the group. In the scenes of his love affairs she often lurks in the background, spying on him from behind a bank of clouds, or she arrives on her chariot to interrupt his amours.

Juno and the peacock. The concluding scene from the story of IO. The giant Argus of the hundred eyes, whom Juno set to watch over Io, was murdered by Mercury. In memory of Argus Juno took his eyes and set them in the tail of her peacock (*Met.* 1:721–4). Baroque artists show Argus lying dead, his shepherd's crook beside him, his eyes scattered around. Amoretti pick up the eyes and hand them to Juno who places them in the tail of a peacock.

See also AEOLUS; GODS AND GIANTS, BATTLE OF; JUPITER; JUDGEMENT OF PARIS; ORIGIN OF THE MILKY WAY; HERCULES (14); IXION; SLEEP, KINGDOM OF.

Jupiter, or Jove (Gk Zeus). The supreme ruler of the gods and mortals, and the chief of the twelve Olympians. All the powers and functions of divinity were embodied in him. He was the god of the sky and the changing weather whose thunderbolts destroyed his enemies. But he was also merciful and protected the weak (see PHILEMON AND BAUCIS). In Greece one of the principal seats of his worship was the temple of Zeus at Olympia, which contained the famous statue by Phidias, wrought in gold and ivory, one of the Seven Wonders of the ancient world. The traditional image of Jupiter, his noble features framed by the ambrosial locks that made Olympus shake when he nodded, may have come down to us from this long lost original. But the common picture that emerges through the work of later artists is a different, less majestic one. This is the god of many loves, who deceives maidens, divine and mortal, by his metamorphoses, while his wife JUNO (Hera) hovers in the background, angry and scheming. His main attributes are few: the EAGLE (which flew towards him as he was about to make war on the Titans – an augury of his subsequent victory). It may be regarded as his messenger, or sometimes as the personification of Jupiter himself. The THUNDERBOLT (a curious object – generally a kind of double-ended, two- or three-pronged and barbed fork or, in baroque painting, a bunch of flames) is the ancient attempt to represent lightning. It is often held in the eagle's claws. The SCEPTRE (symbol of regal authority).

1. *The nurture of Jupiter; the infant Jupiter suckled by Amalthea (Fasti 5:121–4).*

Jupiter was the son of Saturn (Cronus), the god who devoured his children because it was prophesied that one of them would usurp him. Jupiter's mother fled to Crete where she gave birth to him in a cave. She gave Saturn a large stone wrapped in swaddling clothes which he unsuspectingly swallowed instead. Jupiter was brought up on the slopes of Cretan Mt Ida by nymphs who fed him on wild honey and on milk from the goat Amalthea. He is depicted in a pastoral setting, lying in a cradle surrounded by doting nymphs, a theme somewhat resembling the finding of Moses. Or a nymph has him in her arms, holding a jug of milk to his lips, while another gathers honeycombs, and a shepherd milks the goat; or the goat suckles Jupiter.

2. *Jupiter and Juno.* A simple allegory of the power of love. Jupiter, seated on his couch, is on the point of embracing Juno who has just approached him. Both may be partly robed. The eagle stands beside him, a thunderbolt in its claws; Juno's peacock is near her. She wears a belt of coloured material under her breasts, perhaps the magic 'girdle of Venus' which made its wearer infinitely desirable, and which Juno sometimes borrowed.

3. *Sacrifice to Jupiter.* On a pedestal is the statue of seated Jupiter, holding a sceptre, with the eagle nearby. In the foreground is an altar on which the fire burns. Worshippers, perhaps the maidens of Mt Ida, are praying, led by a priest, or bring offerings. (See SACRIFICE.)

Other Jovian themes: GODS AND GIANTS, BATTLE OF THE; SEMELE; ULYSSES (3) (all depicting the god of thunder and lightning); BACCHUS (1), *Birth of B.*; DIANA (5); MINERVA (1), *Contest of M. and Neptune* (showing Jupiter with other Olympians); PANDORA; PHAETHON; THETIS (Jupiter enthroned on Olympus); HEBE; GANYMEDE (in the last two he is transformed into an eagle); PHILEMON AND BAUCIS (the protector of the weak and humble). Themes of his amorous pursuits (and the transformations by means of which he attains his end) are: RAPE OF EUROPA (a bull); LEDA (a swan); DANAË (a shower of gold); ANTIOPE (a Satyr); IO (a cloud).

Justa and Rufina. Legendary Christian martyrs, patron saints of Seville. The daughters of a poor potter of that city, it is related that they quarrelled with those who came to buy his wares for use in the temple of Venus. They destroyed the image of the goddess, were accused by the Roman governor of sacrilege, and put to death. They are represented in works of the school of Seville, especially of the 17th cent., often with a model of the Giralda tower (part of Seville cathedral) of which they are the protectors. They have earthenware pots for attribute and each may hold the martyr's PALM.

Justice. With PRUDENCE, FORTITUDE and TEMPERANCE, one of the four 'cardinal virtues' (see VIRTUES AND VICES). In Plato's ideal city it is justice that regulates the actions of the citizens, both socially and individually, and which underlies the harmonious working of the other three virtues (*Republic*, 4:427 ff). Renaissance humanists therefore made Justice the leader of the four, and she is thus often represented. The figure of Justice is very commonly seen on public buildings wherever the law is administered. The SWORD is the emblem of her power. SCALES, which date from the Roman era, signify her impartiality, as does her blindfolding, which however goes back only to the 16th cent. (Elsewhere in Renaissance allegory blindfolding implies absence of judgement, as in the case of CUPID, FORTUNE, IGNORANCE – indeed in antiquity Justice was known for her clear-sightedness.) When represented among the virtues at the Last Judgement, Justice may have an angel in each scale-pan, one of whom crowns a righteous person while the other beheads a sinner. From the 17th cent. her scales may be

replaced by the FASCES, the Roman symbol of authority. Other less common attributes are a GLOBE (her world-wide dominion), SET-SQUARE, COMPASSES and other measuring instruments, and the LION (according to one tradition Virgo, the zodiacal sign that stands between the Scales and the Lion, personifies Justice). Justice may embrace Peace (with a DOVE), from the Psalm (85:10), 'Justice and peace join hands'. Justice may rescue INNOCENCE who is threatened by wild animals representing the vices. A merchant tilting her scales signifies justice corrupted, a comment on dishonest tradesmen. A female companion, pressing milk from her breasts, is Benignity, whose effect is to temper justice. Justice presides over the *Silver Age* (see AGES OF THE WORLD).

Justina of Antioch. A wholly legendary figure once believed to have lived in the 3rd cent. Cyprian, a magician of Antioch, tried by his powers of sorcery to gain the love of the Christian virgin Justina. He failed and was finally converted to the faith by her example. They were beheaded in Nicomedia. They are sometimes represented together, she with a UNICORN and martyr's PALM, he with palm and sword and perhaps treading his books under his feet.

Justina of Padua. Christian martyr of unknown date, said to have died under the persecutions of the Emperor Maximian, by being pierced through the breast with a sword. A church was dedicated to her in Padua in the 6th cent. Its restoration by the Benedictines in the 16th cent. led to her wide veneration and marked the beginning of her popularity in the art of Padua and Venice. She is portrayed as a princess, regally dressed, with a CROWN, martyr's PALM and a SWORD through her bosom. She may have a UNICORN, symbol of chastity, borrowed from her namesake Justina of Antioch. Any evidence of Venice, such as the setting of the picture or the school of the artist, will distinguish Justina of Padua from the other. As the patron saint of Venice she may accompany MARK in pictures of the Virgin. In the scene of her martyrdom Christ and the Virgin with saints appear to her in a vision. Narrative cycles include her baptism by St Prosdocimus, the first bishop of Padua.

Key. Christ delivered the keys of heaven to the apostle PETER (2). They are his attribute, sometimes one golden and one silver (or iron). A bunch of keys is the attribute of MARTHA, hanging from her girdle; also of the warrior HIPPOLYTUS. An angel holding a key while a dragon descends into a pit, APOCALYPSE (23). In secular art the key is the attribute of the earth goddess CYBELE, and of FIDELITY personified.

Kiss of Judas, see BETRAYAL.

Knife. Attribute of ABRAHAM, for the intended sacrifice of Isaac; and of BARTHOLOMEW who was flayed alive. Also flayed with a knife was the Satyr Marsyas by APOLLO (4), and a corrupt judge of King Cambyses' court (JUDGEMENT OF C.). A knife in the hand of the apostle PETER alludes to his cutting off of Malchus' ear (BETRAYAL). The weapon embedded in the skull of PETER MARTYR is sometimes a knife. The goddess Pomona, protector of gardens and orchards, may have a pruning knife (VERTUMNUS AND POMONA).

Knot. A symbol of union. The tying of a knot by Cupid in a scene of Venus and Mars symbolizes the ties of love. When interlaced with initials a knot commemorates a marriage. In such instances a trefoil shape is common. A knot was the *impresa* of Francis I (1494–1547), king of France. The Gordian knot was cut with a sword by ALEXANDER THE GREAT (3). Three knots in the girdle of a friar's habit signify a member of the Franciscan Order. Three knots in a whip, see AMBROSE.

Impresa of Francis I

Korah, Punishment of, see AARON (1).

Labarum, the imperial standard of Constantine, see CHI-RHO MONOGRAM.

Labourers in the vineyard (Matt. 20:1–16). The parable that tells of the landowner who hired labourers for his vineyard at an agreed daily wage. Some he engaged early in the day, some later and some barely an hour before sunset. But he gave them all the same wage regardless of the hours that they had worked, paying off first those whom he hired last. The ones who had worked all day protested, though in vain. 'Thus will the last be first, and the first last' in the kingdom of heaven. The directions in the Byzantine painters' guide provide their own interpretation of the parable: the first hired were to be represented as Old Testament patriarchs, the next as prophets and the last as the apostles. Western art, from the Renaissance, treated the theme literally: the landowner in fine robes is shown seated at a table, his clerk beside him recording payments in a book, while labourers come complaining to him. (A similar subject to the UNMERCIFUL SERVANT.) Others may stand in a group arguing. Sometimes the landowner is seen hiring his men.

Labours of the Months, see TWELVE MONTHS.

Labyrinth. The maze at Knossos in which the Minotaur, the monster slain by THESEUS, was confined. Its pattern varies. A simple maze forms an *impresa* of the princely house of Gonzaga at Mantua, sometimes with a MOUNTAIN in the middle, and sometimes surrounded by water. (The Palazzo Te of the Gonzagas was built on an island in what was then marshland by Mantua.) It is found in the decoration of Gonzaga palaces, perhaps with the motto 'Forse che si, forse che no', – 'Maybe yes, maybe no'.

Labyrinth

Lachesis, one of the THREE FATES.

Ladder, angels ascending and descending, JACOB (2); monks clad in white ascending, ROMUALD. The ladder is one of the instruments of the Passion and features in the RAISING OF THE CROSS and the DESCENT FROM THE CROSS. Soldiers on ladders, scaling city walls, nuns looking down, CLARE. Ladders against the walls of a house, figures climbing, ANDREW, apostle.

Ladle, the attribute of MARTHA.

Lamb (sheep or ram). The sacrificial animal in ancient near eastern religious rites, including the Hebrews', and adopted by the early Christians as the symbol of Christ in his sacrificial role. The substitution of a ram at the sacrifice of Isaac by ABRAHAM (4) – an echo of the historical change from human to animal sacrifice in primitive society – was seen as a foreshadowing of the death of Christ, himself a sacrificial substitute for mankind. Hence the various emblems of which the lamb forms the principal element: with a cross, with a cruciform halo, with blood issuing into a CHALICE; with the banner of the Resurrection. Pictures of the Adoration of the Lamb are derived from Rev. 7:9–17 (APOCALYPSE, 9), and 14:1. A related theme is the ALL SAINTS PICTURE. The Lamb with its fore feet on a book in Christ's lap is from Rev. 5:6–14 (APOCALYPSE, 4). Narrative scenes showing the lamb as a sacrificial beast: CAIN AND ABEL; JOACHIM AND ANNE (1); CLEANSING OF THE TEMPLE. In this sense it is the attribute of JOHN THE BAPTIST, often with a cruciform halo. A lamb, usually with its feet tied, is commonly one of the gifts of the shepherds at Christ's nativity and symbolizes his future sacrifice (ADORATION OF THE SHEPHERDS). Primitive Christian art represented the apostles as twelve sheep, often with the Lamb of God in the middle. From its other qualities, real or imaginary, the lamb became the attribute of the personifications

of INNOCENCE, GENTLENESS, PATIENCE and HUMILITY; also of AGNES and, among the FOUR TEMPERAMENTS, of the Phlegmatic man. It is occasionally the attribute of CLEMENT.

Lamentation, see PIETÀ.

Lamp or lantern. The attribute of LUCIA, of the Persian SIBYL, and of VIGILANCE and NIGHT personified. Ten maidens with lamps, the WISE AND FOOLISH VIRGINS. A naked maiden, Psyche, holding a lamp over a sleeping god, CUPID (6). Unkempt sage holding up a lantern in market-place in daylight, DIOGENES. An abbot anointing the lips of a boy with oil from a lamp, NILUS.

Lance. Unlike the SPEAR, the lance is properly a cavalry weapon, often having a small pennon, hence the attribute of LONGINUS who is commonly on horseback; see also CRUCIFIXION (3). A lance is the attribute of JUDE; a broken lance, of GEORGE.

Lancet. Small, two-edged surgical knife, the attribute of COSMAS AND DAMIAN. It is used by the high priest in the Temple for the CIRCUMCISION OF CHRIST. A quack doctor incising patient's forehead, OPERATION FOR STONES IN THE HEAD.

Landscape. Italian Renaissance painting sometimes uses the landscape background to reinforce a moral allegory. This 'moralized' scenery, or *paysage moralisé*, may depict in one half of the picture a clear sky contrasted with, in the other, dark cloud before which good and evil – virtues and vices personified – are respectively portrayed. The path of virtue on one side is steep and rocky while on the other that of vice runs through pleasant, well-watered meadows; see HERCULES (21). Similarly, a church and a castle may be used to differentiate between sacred and secular figures in the foreground.

Lantern, see LAMP.

Laocoön (*Aen*. Bk 2). A Trojan priest who warned the citizens of Troy not to bring the wooden horse of the Greeks into the city. (The Greeks had caused the story to be put about that the horse was an offering to the goddess Minerva, whose temple was within the walls of Troy.) While he was officiating at the altar of Neptune two huge snakes swam ashore and twined themselves about Laocoön and his two sons, killing all three. The Trojans, appalled by this apparent sign of Minerva's displeasure, dragged the horse into the city (see TROJAN WAR). One of the major discoveries of Renaissance Italy was the famous late-Hellenistic sculpture of Laocoön and his sons wrestling with the snakes (Vatican Mus., Rome). It became a source of inspiration to painters and sculptors. El Greco, who made several versions of the subject, includes the horse and, in the background, city walls (in fact Toledo, the city of his adoption). He depicts also the figures of APOLLO and DIANA who caused Laocoön's downfall (Nat. Gall., Washington).

Laomedon, see HERCULES (18).

Lapiths and Centaurs, Battle of, see CENTAUR.

Last Judgement. The Second Coming of Christ, when, according to Christian doctrine, there will be a general resurrection of the dead who, with the living, will be finally judged and consigned to heaven or hell. Scriptural references are numerous but the principal authority is Christ's discourse to the disciples, related by Matthew (25:31–46). 'When the Son of Man comes in his glory and all the angels with him, he will sit in state on his throne, with all the nations gathered before him. He will separate men into two groups, as a shepherd separates the sheep from the goats, and he will place the sheep on his right hand and the goats on his left'. They would be judged according to the works of charity they had

performed in their lifetime. The unrighteous would 'go away to eternal punishment, but the righteous will enter eternal life'. The millennium, or reign of Christ upon earth, was confidently expected to begin in the year 1000, and when it failed to materialize the Church's teaching came to lay increasing stress on the doctrine of the 'Four Last Things', death, judgement, heaven and hell. From this time representations of the Last Judgement began to appear, notably, in the 12th and 13th cents., on the sculptured west fronts of French cathedrals. It is a large subject composed of several parts. The central figure is Christ, the judge. On either side of him are the apostles to whom he said at the Last Supper, 'You shall . . . sit on thrones as judges of the twelve tribes of Israel' (Luke 22:30). Below, the dead are emerging from their tombs or from the earth or the sea: 'Many of those who sleep in the dust of the earth will wake, some to everlasting life and some to the reproach of eternal abhorrence' (Dan. 12:2). 'The sea gave up its dead, and Death and Hades gave up the dead in their keeping; they were judged, each man on the record of his deeds' (Rev. 20:13). The archangel MICHAEL holds the scales in which he is weighing the souls. The righteous, on the right hand of Christ, are conducted towards paradise by angels, while on his lower left the sinners are driven into hell where they are seen suffering dreadful tortures.

1. *Christ the judge, and the tribunal of apostles and saints.* In Romanesque and Gothic art Christ is seated on a throne or on an arc (a rainbow), his hands raised, palms outwards, displaying his wounds. (In order to be saved it no longer sufficed to have performed the works of charity in one's lifetime, one must accept the Christain faith here manifested in the visible symbols of the Passion.) This type persisted, with variations, into the Renaissance. On the right and left of the face of Christ may be a LILY and a SWORD, symbolizing respectively the innocent and guilty. In some 15th cent. Italian works Christ hurls arrows at the damned. The famous standing Christ in Michelangelo's Last Judgement (Vatican, Sistine chapel, painted 1534–41), whose right arm is raised high in a threatening gesture, like Jupiter about to cast a thunderbolt, bears a marked resemblance to a similar figure painted about two centuries earlier in the Camposanto at Pisa by Francesco Traini, with which Michelangelo would have been familiar. The latter however depicts in reality the same traditional displaying of wounds, though in an unfamiliar posture, the left arm passing across the body to uncover the wound in the right side. Some think that Michelangelo may have misunderstood the earlier image, even though God as 'almighty Jupiter' was a concept not unfamiliar to his age (Dante, *Purg.* 6:118). In early Renaissance painting the apostles and saints are ranged in formal rows on either side of Christ, as in medieval sculpture, but later they are freely grouped round him. They may include the Old Testament patriarchs and prophets, (the twenty-four elders of the APOCALYPSE, 3), and medieval saints such as Francis and Dominic. Among the apostles Peter is usually nearest to Christ, on his right. The Virgin generally kneels on the right of Christ, interceding for those about to be judged. (In a few 14th cent. examples she appears in the role of judge herself, sitting with equal status beside Christ.) Kneeling opposite her is John the Baptist. He is occasionally replaced by the apostle John in French Gothic sculpture. The Virgin may, rarely, stand with her cloak spread out, protecting the figures beneath. (See VIRGIN MARY, 3.)

2. *The resurrection of the dead.* The dead emerge from their tombs or out of cracks and fissures in the earth; also occasionally from the sea. They are sometimes seen to be undergoing a change, having the form of skeletons at the point

at which they emerge, and by degrees, as they leave the ground, being reclothed in flesh. (See EZEKIEL.) St Augustine expressed the opinion that at the general resurrection all would prove to be the same age as Christ at his resurrection – then taken to be 30 years – regardless of their age when they died. They are usually portrayed accordingly.

3. *St Michael and the weighing of souls.* St Michael, the archangel, winged and clad in armour, holds a balance. In each scale-pan is a small naked figure, a human soul. The righteous soul is generally the heavier one, and may be kneeling in prayer. A demon may be trying to tip the scales, a popular motif in Netherlandish painting. The weighing of souls, or psychostasis, was in classical mythology one of the functions of Mercury who in this and some other respects was the pagan prototype of St Michael. Alternatively, the archangel may be depicted with drawn sword barring the way of the damned who are trying to flee from punishment.

4. *The role of angels in the Last Judgement.* Speaking to the disciples about the Son of Man's Second Coming, Christ said, 'With a trumpet blast he will send out his angels, and they will gather his chosen from the four winds' (Matt. 24:31). Angels blowing on trumpets to raise the dead are therefore rarely absent from the Last Judgement. They are also seen conducting the righteous to paradise, and perhaps crowning and robing them; or with drawn swords they drive the damned towards hell. They sometimes hold the instruments of the Passion.

5. *Heaven.* Gothic sculpture used a convenient shorthand to represent heaven: the seated figure of Abraham holding the souls of the righteous in a napkin looped between his hands. The image is derived from the parable of DIVES AND LAZARUS (Luke 16:23) in which the rich man in hell looks up and sees afar off Abraham and the poor man 'in sinu ejus'. *Sinus,* a curve, was also the hanging fold at the neck of a toga, which was used as a pocket. The word also meant a lap. (The King James' Bible, by using here the word 'bosom' – now obsolete in this sense – gave rise to the expression 'in Abraham's bosom', meaning 'in heaven'.) Early Renaissance painting represents heaven by a Gothic church or an archway, perhaps with Peter at the gate welcoming newcomers. A common version, favoured particularly by painters of northern Europe, depicts a garden. Or the righteous may be seen wandering among banks of clouds in the company of angels, or greeting one another.

6. *Hell.* The medieval image of the gaping jaws of hell, found also in some Renaissance painting, is derived from the sea-monster ('Leviathan' in the A.V.) in the book of Job (chap. 41) whose 'breath sets burning coals ablaze, and flames flash from his mouth'. Or the place is a more generalized cavern, normally found in the lower right of the picture (on the left of Christ), into which the damned are dragged by the hair, or driven by demons with forks. Or they are carried down on the backs of winged demons. Michelangelo introduced a motif from the *Inferno* (3:82 ff), which recurs frequently in later periods – that of CHARON in his boat ferrying the dead into hell. The tortures of the damned are appropriate to the nature of their sin; thus it is the gluttonous who wallow in a mire, and the lecherous who burn eternally in a sulphurous pit. Satan, with three faces, has a half-swallowed sinner dangling from each jaw; the one in the centre represents Judas. (See also HELL.)

Last Supper (Matt. 26:17–29; Mark 14:12–25; Luke 22:7–23; John 13:21–30). The last meal which Christ took with the disciples in Jerusalem before his arrest, and at which he announced to the Twelve that one of them would betray him, has been widely represented in Christian art from early times. The meal was a

celebration of the Jewish feast of the Passover – the 'festival of freedom' – commemorating the exodus of the Israelites from Egypt. To Christians the words of Christ as he consecrated the bread and wine mark the inauguration of the central rite of the Church. The two aspects of the theme – the announcement of the betrayal, and the first Communion of the apostles – in turn predominate at different periods of art. The early Church depicted the sacrament, first seen in a fully developed form in Byzantine mosaics of the 6th cent. The disciples are arranged round the curved side of a D-shaped table, Christ at one end. They neither sit nor stand but recline, propped on the left elbow, leaving the right arm free, as was the later Jewish custom in observing the Passover ritual. (Originally the Passover meal was taken standing, just as the Israelites stood to eat in haste on the eve of the exodus. In Roman times a recumbent posture at meals was the mark of the free man and was therefore regarded as more appropriate to the Jewish festival of freedom.) This feature recurs in the 17th cent. in the work of Poussin. In Renaissance painting the disciples are seated, usually at a rectangular table, and Christ, in their midst, is performing the actions of the priest. A CHALICE, the eucharistic vessel, stands on the table before him. He is in the act of consecrating a loaf or handing a communion wafer to one of the Twelve. It is not necessarily represented as unleavened bread, as is required in the Jewish rite. Certain Old Testament themes that were traditionally regarded as prefiguring the Last Supper may be found in association with it, namely *The meeting of Abraham and Melchizedek* (see ABRAHAM, 1), *The Passover* (see MOSES, 6), *The gathering of manna* (see MOSES, 8), *Elijah visited by an angel* (see ELIJAH, 4). This sacramental interpretation of the Last Supper was eclipsed at the end of the 15th cent. by Leonardo who turned away from doctrine to depict the human drama that sprang from Christ's announcement that he would be betrayed by one of those present. Leonardo's work, though the most famous, was not the first to adopt the alternative treatment of the theme. It was already to be seen in the decoration of 14th and 15th cent. refectories and churches. It prevailed until the Counter-Reformation when the Church's emphasis on the SEVEN SACRAMENTS, the Eucharist in particular, restored the former version to favour. There was now greater freedom of treatment with additional figures – servants going to and fro bearing dishes and angels hovering overhead. The disciples, especially among northern painters, are characterizations of the humble folk of the time. A basin and towel discarded on the floor are a reminder of the earlier episode of *Washing the disciples' feet*. (See PETER, apostle, 3.) A dog may sit at the feet of Judas, a convention difficult to account for since the animal normally symbolizes fidelity.

In representations of the announcement of the betrayal, or the 'historical' Last Supper, the main elements are the reaction of the disciples to Christ's words, and the part played by Judas. '"In truth, in very truth I tell you, one of you is going to betray me". The disciples looked at one another in bewilderment: whom could he be speaking of?' There is no chalice. Christ sits at the centre of a long table, his hands outspread in a way that seems to imply resignation. The disciples on either side of him turn to one another with mystification, amazement or denial on their faces and in their gestures. Judas is distinguished in several ways. In early Renaissance examples he sits on the opposite side of the table from the rest and may be in the act of taking the sop of bread from Christ. ('"Lord who is it?" Jesus replied, "It is the man to whom I give this piece of bread when I have dipped it in the dish."' (John 13:26.)) Or Judas dips his own hand. ('It is one of the Twelve who is dipping into the same bowl with me'.

(Mark 14:20.)) Judas is generally dark-haired and bearded, his expression sly. When the disciples are depicted with haloes that of Judas may be black, or he may be without one. He often holds a purse, perhaps in allusion to the thirty pieces of silver, the price of the betrayal, or more simply because according to John 'Judas was in charge of the common purse'.

In the 12th and 13th centuries artists made little attempt to differentiate between the disciples, with the exception of Judas. In works of later periods it is possible to identify at least the chief disciples, occasionally all, with a fair degree of certainty. Though the Twelve are shown without their personal attributes artists have tended to adhere to certain conventions as to their physical appearance and grouping. JOHN, 'the disciple whom Jesus loved', is usually next to Christ and may sit with his head resting on the Saviour's breast. ('He reclined, leaned back close to Jesus and asked, "Lord, who is it?"' (John 13:25.)) He is depicted as young, clean-shaven, with long hair and sometimes rather effeminate features. PETER's characteristics are well-known: hair grey, generally short and curly and a short usually curly beard; his complexion is rubicund as befits a fisherman. He generally wears a blue cloak over a gold robe. He may hold a knife, perhaps in anticipation of the incident of the cutting off of the servant's ear in the scene of the betrayal. He sits near or next to Christ, a sign of his seniority among the disciples. ANDREW is an aged man with flowing grey hair and a long grey, sometimes forked, beard. JAMES THE LESS resembles Christ as to his features and the style of his hair and beard since he was traditionally identified with the apostle whom St Paul called 'James the Lord's brother' (Gal. 1:19). For the remainder identification is less straightforward. JAMES THE GREATER, somewhat older than his namesake, was, like him, related to Christ and is therefore sometimes also made to resemble him physically. As one of the three closest to the Saviour during his lifetime he generally sits near him at table. PHILIP and THOMAS are, like John, among the youngest and are usually clean-shaven. They are sometimes placed on opposite sides of the picture at either end of the table. SIMON and JUDE according to the more popular tradition were brothers and were among the shepherds to whom the angel announced the Nativity. They are therefore customarily depicted as old men, and sit side by side. BARTHOLOMEW has very dark, perhaps black hair and usually a beard, in which respect he may resemble MATTHEW. The accepted identity of the Twelve in the Last Supper of Leonardo is as follows, reading from left to right: Bartholomew, James the Less, Andrew, Judas, Peter (behind), John, (Christ), Thomas (behind), James the Greater, Philip, Matthew, Jude, Simon.

Latona, see LETO.

Laughing and crying philosophers, see DEMOCRITUS AND HERACLITUS.

Laurel. Of the varieties of laurel the small-leaved *Laurus nobilis*, the bay, was that from which the victor's CROWN was made. It is the attribute of APOLLO. A maiden, laurel bushes sprouting from her arms, is Daphne (APOLLO, 9). A grove of laurels grows on the top of PARNASSUS, the home of the Muses. In portraiture a laurel bush or branch implies that the sitter is a literary or artistic figure. The laurel bush was an *impresa* of Lorenzo de' Medici (1448–1492), with the motto 'Ita ut virtus', – 'Thus is virtue', i.e. evergreen.

Laurence (Ital. Lorenzo). Christian martyr of Spanish birth who died in Rome in 258, one of the most venerated saints of Christendom since the 4th cent. He was ordained deacon by Pope Sixtus II and met his death shortly after the pope's own martyrdom. Tradition has it that the pope, when arrested, instructed Laurence to give away to the poor the church's treasures, consisting of precious

vessels and money, for which, as deacon, he was responsible. No sooner had he done so than Laurence was ordered by the Roman prefect to surrender them to him, whereupon Laurence, indicating the poor and sick around him, said, 'Here are the treasures of the Church'. For this he was condemned to be roasted on a gridiron, a torture he underwent with equanimity, merely observing, 'See, I am done enough on one side, now turn me over and cook the other'. Laurence is portrayed as a young man wearing the deacon's dalmatic, which he shares with STEPHEN and VINCENT OF SARAGOSSA (see diag. RELIGIOUS DRESS). He holds or stands on the GRIDIRON, usually a rectangular metal lattice with four or more short legs. He may have a dish of coins or a PURSE, a CENSER, the martyr's PALM or the processional CROSS, which it was the deacon's duty to carry. As a patron saint of Florence he may be accompanied by JOHN THE BAPTIST and COSMAS AND DAMIAN in devotional pictures.

1. *St Laurence ordained deacon by Sixtus II*. He kneels before the pope who hands him the eucharistic chalice.

2. *Sixtus confides to St Laurence the treasures of the church*. Within the church attendants are bringing gold and silver dishes and cups to the pope. Laurence kneels before him. Roman soldiers are beating on the church door.

3. *The charity of St Laurence*. He distributes alms to the poor in the form of the church's vessels. He holds a bag of money. He is surrounded by beggars, cripples, women and small children.

4. *The scourging of St Laurence*. He stands before the prefect guarded by soldiers. Whips and iron combs lie on the ground.

5. *The martyrdom of St Laurence*. The commonest scene. He lies on his gridiron under which a fire burns, and may be in the act of turning on his other side. His executioners bring fuel, stoke the fire and work bellows. The prefect looks on, with other spectators, sometimes from a balcony.

Lazarus, brother of Martha and Mary, see RAISING OF L.; another Lazarus, the leper, see DIVES AND L.

Leda and the swan. A Greek myth tells how Leda, the wife of Tyndareus, king of Sparta, was loved by Jupiter. He came to her by the river in the form of a swan and lay with her. As a result of their union she laid one or perhaps two eggs – accounts vary – from which were hatched the heavenly twins Castor and Pollux, Helen of Troy and Clytemnestra. The standing Leda, after Leonardo, twines her arms around the swan's neck, but at the same time chastely half turns her head away. The bird enfolds her body with one wing, and cranes its neck towards her face. On the ground the infants have just hatched from the eggs. Or Leda reclines, on her back, her body covered by the swan which is in the act of embracing her.

Leg. Pilgrim lifting his tunic to show spot on thigh, ROCH. Youth's severed leg restored by Franciscan, ANTONY OF PADUA. A patient with one white and one black leg, COSMAS AND DAMIAN. Horse's leg removed by blacksmith, ELOI.

Leo (zodiac), see TWELVE MONTHS.

Leonard. Christian saint about whom few facts are known; he is said to have belonged to the court of Clovis in the 6th cent. and would intercede with the Frankish king on behalf of prisoners. As the patron saint of prisoners he was venerated throughout western Christendom. Leonard was thought to be a Benedictine monk who founded a monastery at Noblac near Limoges. He wears the black or the white habit of the Order, or the deacon's dalmatic (see diag. RELIGIOUS DRESS). The dalmatic may be decorated with fleurs-de-lys, the emblem at a later date of the French kings. He holds broken FETTERS. Votaries kneeling

at his feet are freed captives who were perhaps once prisoners of war. Leonard is sometimes in the company of the other deacons LAURENCE and STEPHEN. Narrative cycles of his life include the scene of his baptism by REMIGIUS, the freeing of captives, the founding of the monastery and the episode of Queen Clothilda in childbirth: the queen, the wife of Clovis, was suddenly taken with labour pains while out hunting, and was in danger of dying until Leonard came to her aid with prayer.

Leopard. Sacred to Bacchus (*Imag.* 1:19). Two leopards sometimes draw his chariot (see TRIUMPH).

Lepanto, Battle of, see VIRGIN MARY (6).

Leper, Healing of the (Matt. 8:1–4; Mark 1:40–45; Luke 5:12–14). A leper came to Christ and kneeling before him said, 'If only you will, you can cleanse me'. Seeing his faith, Christ cured him, instructing the man in return to make an offering to the priest, as laid down by Mosaic law (Lev. 14). We see the man, covered with sores, kneeling before Christ who is surrounded by the disciples and other onlookers. The rite of the thank-offering is depicted by Botticelli in a fresco in the Sistine chapel.

Lernaean hydra, see HERCULES (2).

Lesbia, see SPARROW.

Leto (Lat. Latona) (*Met.* 6:317–381). In Greek mythology the mother of Apollo and Diana (Gk Artemis). Once, parched with thirst from much travelling, she stopped to drink at a lake in the land of Lycia but was prevented from doing so by some peasants who were working the osier beds. She promptly punished them by turning them into frogs. She is shown beside the lake, usually with her two infant children. Peasants and large frogs intermingle in the marshy ground. The theme occurs not only in painting but in ornamental garden sculpture, especially in 17th cent. France.

Leviathan, see APOCALYPSE (5); HELL; LAST JUDGEMENT (6).

'Liber generationis Jesu Christi', see MATTHEW.

Liberal Arts, see SEVEN LIBERAL ARTS.

Liberty. The figure of Liberty holds a sceptre and wears a 'Phrygian cap' (see HAT). The freeing of a slave in Roman times was accompanied by a rite in the temple of the goddess Feronia, in which he was ceremonially capped. Liberty came to be so represented in French art from the time of the Revolution (Delacroix, 'Liberty leading the people', Louvre).

Libido, see LUST.

Libra (zodiac), see TWELVE MONTHS.

Lichas, see HERCULES (24).

Lightning, regarded as an act of God in classical and Christian times, especially directed against the sceptic. Lightning striking a tree, dead and fleeing figures, a black-habited monk, PHILIP BENIZZI. Jupiter's attribute, the THUNDERBOLT, is an attempt to represent lightning in visual terms.

'Lignum vitae afferens fructus', see JOHN THE EVANGELIST.

'Lilium inter spinas', see VIRGIN MARY (4).

Lily. Symbol of purity, associated particularly with the VIRGIN MARY (12) and the virgin saints. It features in the ANNUNCIATION in a vase or in the hand of the archangel GABRIEL, and hence became his attribute. Among female saints the lily belongs especially to CATHERINE OF SIENA, CLARE, EUPHEMIA, and SCHOLASTICA. It is also the attribute of ANTONY OF PADUA, DOMINIC, FRANCIS OF ASSISI, FRANCIS XAVIER, JOSEPH, husband of the Virgin, PHILIP NERI who prays before a vision of the Virgin, THOMAS AQUINAS and of the Erythraean SIBYL. Christ sitting in

judgement may have a lily and a sword on either side of his face, LAST JUDGEMENT (1). See FLEUR-DE-LYS. See also IRIS which is sometimes mistakenly called a lily.

Limbo, see DESCENT INTO L.

Lion. Common symbolic beast in religious and secular art, with many attributions. In the Middle Ages it was a symbol of the Resurrection because, according to the bestiaries, the cubs when born lay dead for three days until their father brought them to life by breathing in their faces. The winged lion, an apocalyptic beast (see FOUR EVANGELISTS), stands for MARK and is his attribute, hence the lions that belong to Venice (see TOWNS AND CITIES PERSONIFIED). It is the attribute of saints JEROME, ADRIAN, EUPHEMIA and THECLA. Lions scratching with their paws help to dig the graves of the desert hermits: ANTONY THE GREAT, PAUL THE HERMIT, ONUPHRIUS, MARY OF EGYPT. The strong hero wrestling with a lion may be SAMSON (2), DAVID (3), HERCULES (1), or the personification of FORTITUDE. The lion's skin is the attribute of Hercules and hence sometimes of Fortitude. A defenceless man, his hands trapped in a tree-trunk, attacked by a lion is MILO OF CROTON. DANIEL sits unharmed in the lions' den. A lion is the attribute of CYBELE, of the personification of Africa, one of the FOUR PARTS OF THE WORLD, and of PRIDE, WRATH and Choler, one of the FOUR TEMPERAMENTS. The zodiacal sign of Leo is associated with July in the cycle of the TWELVE MONTHS.

Lizard. The attribute of Logic personified, one of the SEVEN LIBERAL ARTS. An *impresa* of Frederick II of Gonzaga (1500–1540), first Duke of Mantua, and patron of the arts. The accompanying motto, 'Quod huic deest me torquet', – 'That in which she is wanting torments me', alludes to the unresponsiveness of a woman who was the object of his unfulfilled passion (Ducal Palace, Mantua). See also SALAMANDER.

Loincloth, or *perizonium,* worn by the crucified Christ, CRUCIFIXION (1). A loincloth of leaves: ONUPHRIUS; PAUL THE HERMIT and other anchorites.

Longinus. The Roman soldier, unnamed in the gospels, who was present at the CRUCIFIXION (3). John (19:34) relates that he stabbed Christ's side with a lance, hence his name, found in later legend, which is derived from the Greek word for a lance. He is generally identified with the centurion mentioned in the other three gospels who exclaimed, 'Truly this man was a son of God', which may form an inscription on a scroll in Latin: 'Vere filius Dei erat iste'. Longinus is seldom depicted except in the scene of the crucifixion. He is dressed as a Roman soldier or as a medieval knight, and is either on foot or on horseback. He holds a LANCE or, more rarely, a PYX in which he was said to have preserved the drops of Christ's blood. These he took to Mantua, the city of which he is the patron saint. Of the figures standing round the cross Longinus symbolizes the converted Gentile. His statue by Bernini stands beneath the dome of St Peter's.

Loom. A woman weaving, in the presence of young men, PENELOPE; or watched by the goddess Minerva, ARACHNE.

Loretto, Our Lady of, see VIRGIN MARY (16).

Lot, the nephew of Abraham.

 1. *The destruction of Sodom and Gomorrah.* (Gen. 19:1–28). Two angels, arriving at the gates of Sodom, were welcomed by Lot and given hospitality for the night. A lawless band of Sodomites surrounded his house, demanding that he hand over his visitors whom they intended to violate. Lot tried to pacify them, even offering them his daughters instead. But God intervened and struck the Sodomites blind so they blundered away frustrated. The angels warned Lot that God was about to destroy the Cities of the Plain for their iniquities and that he must flee with his wife and daughters: 'Escape for thy life; look not behind

thee . . . lest thou be consumed'. But Lot's wife looked back and she became a pillar of salt. 'And, lo, the smoke of the country went up as the smoke of a furnace'. Lot and his family are depicted in flight, carrying their belongings and sometimes led by the two angels. His wife is glancing backwards or is already partly transformed into a pillar with a human head and shoulders. In the background the cities are in flames and fire rains from heaven. The destruction of cities by the gods to punish the inhabitants for their inhospitality is a recurrent theme in myth. (See PHILEMON AND BAUCIS.) It features in Christian art as an Old Testament 'type' of the damnation of the wicked at the Last Judgement.

2. *Lot made drunk by his two daughters.* (Gen. 19:30–38). Lot took refuge in a cave with his two daughters. Believing that no one but they remained alive on earth to perpetuate the human race, Lot's daughters first made their father drunk and then lay with him in turn. Each bore him a son, Moab and Ammon. This is a not uncommon subject, especially in post-Renaissance painting. One daughter is generally seated on her aged father's lap while the other pours wine.

Louis of Toulouse (1274–97). Second son of Charles II, king of Naples, and great-nephew of LOUIS IX of France who renounced the throne of Naples in favour of his brother Robert and entered the Franciscan Order. He was consecrated bishop of Toulouse at an early age, died when only 23 and was canonized in the same year. He is represented as a strikingly young bishop, principally in Italian painting up to the beginning of the 16th cent. His cope is embroidered with golden fleurs-de-lys, signifying his kinship with the French throne; a CROWN and SCEPTRE at his feet refer to the throne he renounced. A figure kneeling before him is his brother Robert. He is seen in the company of FRANCIS OF ASSISI, BONAVENTURA, ELIZABETH OF HUNGARY and other Franciscans in devotional themes of the Virgin painted for the Order.

Louis IX, king of France (1214–70), canonized 1297. A wise and devout ruler, popularly remembered for his crusade to Egypt and Palestine. He brought back certain supposed relics of the crucifixion, namely the crown of thorns, and part of the True Cross, which the church of Sainte-Chapelle in Paris was built to enshrine. He died of the plague in Tunis during his second crusade. In art his cloak is ornamented with fleurs-de-lys, the emblem of the French kings. His attributes are a CROWN of thorns and the three NAILS of the cross. He wears a royal crown and holds a sword. Louis is the patron saint of Paris and of his birthplace, Poissy (Seine-et-Oise).

Love has several aspects in art. In secular works of the Renaissance CUPID and VENUS are personifications of Love. In religious art the Christian ideal of love is seen in the figure of CHARITY, while the sensual passions are personified by LUST. The literature of chivalry gave rise to themes of courtly love which are found in the art of the later Middle Ages and early Renaissance:

1. *The Garden of Love.* An aspect of ARCADIA, rather than a garden as such, in which couples stroll or sit dallying. The figure of Cupid surmounts an ornamental fountain. Certain motifs such as a woman reading, a small child, and the fountain itself suggest a possible religious origin of the theme, perhaps the *Hortus conclusus.* (See VIRGIN MARY, 10). This theme, like the next two, is found on tapestries and *cassone* panels especially.

2. *The fountain of youth.* According to a Roman myth that recurs in medieval French literature, the nymph Juventas was changed by Jupiter into a fountain that had the property of rejuvenating all who bathed in it. The setting is similar to the last. The aged of both sexes are seen arriving, perhaps throwing away

crutches, and entering the fountain. They emerge as youths and maidens, and embrace or dance under the eye of Cupid.

3. *The castle of Love.* The castle, like the TOWER, symbolizes Chastity. It is defended by maidens against the assault of youths armed with flowers and fruit.

Lovers. A pair of lovers, she carves his name on a tree, ANGELICA (3) (and Medoro); he carves hers, PARIS (and Oenone); he asleep, watched by, or embraced by her, DIANA (6) (and Endymion); the same, but she holds lamp above him, CUPID (6) (and Psyche); they read, sharing a book, or embrace, the book fallen, PAOLO AND FRANCESCA; he reclines, she supports him holding a bunch of herbs, AN-GELICA (3); in a rural setting, soldiers approach, GRANIDA AND DAIFILO; in a flowery glade, he scatters blossoms from a cornucopia, FLORA (1) (and Zephyr); in a garden, he holds a mirror, RINALDO AND ARMIDA (4); she holding Pan-pipes, DAPHNIS AND CHLOE; in a marine setting, with Tritons, Nereids and a one-eyed giant, GALATEA (and Acis); in a bedchamber, he a shepherd, she sometimes robed and jewelled, VENUS (9) (and Anchises); same setting, he perhaps with a lyre, HELEN OF TROY (and Paris); same setting, they are observed by jealous female, whom his wand turns to stone, MERCURY (2) (and Herse); under a net, weapons nearby, observed by the gods, VENUS (8) (and Mars); or Venus and Mars recline, he perhaps asleep, amoretti playing with his armour and weapons; an embrace observed by a goddess, a peacock nearby, IXION (and 'Juno'); in a pool, he resists her embrace, HERMAPHRODITUS; he, a hunter, resists her, VENUS (5) (and Adonis); in a bedchamber, she drags off his tunic or cloak as he flees, JOSEPH (2) (and Potiphar's wife). Lovers together symbolize one of the AGES OF MAN, and personify Spring, one of the FOUR SEASONS.

Lucia (Lucy). Virgin martyr of Syracuse in Italy who died about 304 during the Emperor Diocletian's persecution of Christians. Though she is an historical figure, it is legend that forms the basis of her image in art. The miraculous healing of her mother at the shrine of St Agatha – seen in early Renaissance painting – moved Lucia to distribute her riches to the poor in gratitude. This act so upset her betrothed that he denounced her to the magistrate Paschasius as a Christian. Refusing to recant, Lucia was tied to a team of oxen to be dragged to a brothel, but she stood fast and could not be moved. She survived other tortures – the common lot of the early martyrs in legend – burning, molten lead in her ears, teeth drawn, breasts sheared, boiling oil and pitch, even boiling urine. She was finally killed by a dagger through her throat. Lucia holds the martyr's PALM. Her neck may be pierced by a DAGGER, or the wound alone is depicted. An OX under her feet refers to her martyrdom. Her special attributes are a burning oil LAMP, and EYES. The latter are generally two in number, some-times more. They lie on a dish or sprout like flowers from a stalk in her hand. Originally the eyes and the lamp were given to her simply in allusion to her name which signifies 'light'. The legend that purported to explain their origin came later: it was said that she impatiently plucked out her eyes and sent them to her lover because he would not cease from praising their beauty. Lucia is invoked for diseases of the eye. In the Middle Ages her cult widened beyond Sicily and spread throughout Italy. She is found in Italian and Spanish art of the Renais-sance and later. Narrative cycles include scenes of her praying before Agatha's tomb; distributing her riches to the poor; her betrothed denouncing her before Paschasius; the ordeal of the oxen; her execution.

Lucifer, see SATAN.

Lucretia, see RAPE OF L.

Luke. One of the four evangelists. He accompanied St Paul on his missions to

Greece and Rome and was said to have preached in Egypt and Greece after the death of Paul. He was described by Paul as the 'beloved physician' (Col. 4:14) though he does not feature in art in this role. He was popularly supposed to have been a painter and numerous portraits of the Virgin were once ascribed to him, without foundation. He thus became the patron saint of painters. He was believed either to have died a natural death or to have been crucified with St Andrew. Luke's attributes are a winged OX, one of the apocalyptic beasts (see FOUR EVANGELISTS), and, especially in Counter-Reformation art, a portrait of the Virgin. His commonest inscription, on a book or scroll, is 'Fuit in diebus Herodis regis Iudeae sacerdos' – 'In the days of Herod king of Judaea there was a priest (named Zacharias)' (Luke 1:5.)

1. *St Luke writing his gospel.* Luke, like the other evangelists, is often represented in the act of writing his gospel. The winged ox is usually to be seen. Lucas van Leyden shows him seated on the back of the ox, using its horns to make a desk.

2. *St Luke painting the Virgin.* A popular theme, especially with Netherlandish painters of the 15th and 16th cents., often done for the painters' Guild of St Luke. Its treatment is varied. The Virgin may be alone but usually holds the infant Christ. She sits in the painter's studio or appears to him in a vision, wrapped in clouds. He draws with a pencil, or paints with a brush and palette. Sometimes he is represented in a rather inconvenient posture, kneeling at his easel as he works.

Luna (Gk Selene). The goddess of the moon, whom the Romans identified with DIANA. In art she generally has Diana's attributes, especially the crescent moon on her brow. In Renaissance art her chariot is drawn by two maidens, or by two horses, one black and one white, signifying night and day.

Lust (or 'Luxury'; Lat. *Luxuria, Libido*). To the medieval Church, supreme among the Deadly Sins were Avarice and Lust, the former pertaining particularly to man, the latter to woman. The established type in Romanesque and Gothic sculpture, also seen later especially in the LAST JUDGEMENT, was the rather repellent image of a naked woman whose breasts and genitalia were eaten by toads and serpents. The Church's explanation was that sinners in hell were punished through the bodily organs by which they had offended. Artists were in fact here adapting a long extant image, known in antiquity, of the earth mother, Tellus Mater, who was represented suckling snakes, ancient symbols of the earth. (See also HELL.)

With the Renaissance, attitudes changed. The Florentine humanists were able to regard Voluptas, that is, sensual gratification and an aspect of Luxury, as a virtuous pursuit. From this time Lust tends to shade off into Love in the person of VENUS, several of whose attributes she now shares. She is accompanied by, or sometimes rides, a he-GOAT, an antique symbol of sexuality. Other male animals, less common but with a similar meaning are the BOAR, COCK and PIG. The HARE and, even more, the RABBIT, from their fecundity, have the same significance. Her DOVE is taken from Venus. Luxury often holds a MIRROR, symbolizing woman's vanity and hence her power to seduce. Or the mirror is held by an APE, a common symbol of Lust or Vanity. It is looking at its own reflection.

Lute. A stringed instrument with a bulging pear-shaped body, plucked with the fingers or a plectrum. Its name comes from the Arabic. It was introduced into the west during the Crusades. It enjoyed wide popularity during the 16th cent. In Renaissance painting it is an attribute of Music personified, one of the SEVEN

LIBERAL ARTS, of Hearing, one of the FIVE SENSES, of Polyhymnia, one of the MUSES, and is a common instrument in concerts of angels. It is a familiar attribute of the Lover. In STILL LIFE, with a broken string, it signifies Discord. The lute is sometimes the alternative instrument of ORPHEUS and APOLLO. See diagram, MUSICAL INSTRUMENTS.

Luxuria, see LUST.

Lynx. Wild animal of the cat family, with tufted ears and a short tail, noted for its sharp eyes. A blindfold lynx was an *impresa* of the house of Este at Ferrara, patrons of art and letters in Renaissance Italy.

Lyre. Stringed instrument of ancient Greece. The body, or sound box, was often made of a tortoise's shell. From it projected two arms, the ends of which supported a cross-bar to which the strings were fixed. A larger type, the cithara, had a solid wooden body and heavier arms. According to myth, its inventor Mercury gave it to APOLLO (8) whose attribute it is. Hence it is the attribute of Poetry personified and of Erato, the MUSE of lyric poetry; also sometimes of the Muse Terpsichore (dancing and song); likewise of ORPHEUS, and of ARION on a dolphin. Renaissance art frequently depicted the ancient instruments, copied from sarcophagi, but equally would substitute contemporary alternatives: the lira da braccio or other viol for the lyre and, especially in the 16th cent., the cittern (an instrument somewhat resembling the lute) for the cithara. (See diag. MUSICAL INSTRUMENTS.)

Madonna, see VIRGIN MARY.

Madre Pia, see VIRGIN MARY (8).

Maenad, or Bacchante. A wild woman, the votary of BACCHUS, who took part in his orgiastic rites, the Bacchanalia.

Magi, see ADORATION OF THE M.

Malignity personified, see GENTLENESS.

Man of Sorrows. The name for the devotional, non-narrative, image of Christ displaying the five wounds and holding, or otherwise accompanied by, the instruments of the Passion. He may stand in an open sepulchre, or sit on the edge. He appears thus in the later medieval art of Germany and, less frequently, of Renaissance Italy, in particular in the Mass of GREGORY THE GREAT (5). The image was popularized by the widespread cults devoted to the wounds and blood of Christ. He is represented wearing the crown of thorns, either with arms crossed on the breast – a type first seen in 13th cent. Italian painting – or with arms extended displaying the wounds in his hands, or he is pointing to the wound in his side. Blood may spurt from the wound, to be caught in a chalice. An alternative type shows Christ half-length, displaying three wounds; it may form one panel of a diptych, the other showing the weeping Virgin, making a variation on the theme of the PIETÀ.

Manacles, see FETTERS.

Mandorla (Ital. 'almond'), or 'vesica piscis'. The almond-shaped frame enclosing the figure of Christ at the ASCENSION. The shape has no intrinsic significance, and was varied in early Christian art. Originally the mandorla represented the cloud in which Christ ascended, but in time came to be used as a kind of 'glory' or aureole, the light that emanates from a divine being. Hence it may surround him at the TRANSFIGURATION. Its use was extended to the Virgin at her ASSUMPTION and in other contexts (see VIRGIN MARY, 15; VISITATION); and to MARY MAGDALENE (5) who was likewise borne to heaven.

'Manifestavi nomen tuum hominibus', see BERNARDINO.

Manlius Torquatus (Livy 8:7). A Roman consul at the time of the war with the

Latin League (340–338 B.C.). His son, an impulsive and hot-headed soldier, engaged one of the Latins in single combat, a mode of warfare forbidden by Torquatus. He killed his opponent and laid the spoils at his father's feet, pleading the excuse that he had been challenged. But Torquatus ordered his son to be executed for military disobedience. This example of Roman justice at its sternest is found in 17th cent. painting, especially of northern Europe. It depicts Torquatus enthroned on a seat of judgement. His son, stripped of his armour, is before him in the hands of executioners. Or an executioner stands beside a decapitated body holding up a severed head (Ferdinand Bol, Rijksmuseum, Amsterdam: loan).

Manoah, see SAMSON (1).

Mansuetude, see GENTLENESS.

Manticore, a fabulous monster, see JEREMIAH.

Marcus and **Marcellinus,** Roman soldiers, see SEBASTIAN.

Marcus Curtius (Livy 7:6). The sacrificial death of the Roman soldier Marcus Curtius was one of several legends purporting to explain the Lacus Curtius, a pond in the Forum at Rome. A chasm had suddenly appeared which, according to the soothsayers, could only be filled by throwing into it 'Rome's greatest treasure'. Marcus Curtius interpreted this to mean the city's valorous youth, and therefore sacrificed himself by leaping fully armed, on horseback, into the chasm which closed over his head. The theme occurs in Italian Renaissance and baroque art, and shows a soldier on horseback leaping over the edge of a pit, perhaps watched by comrades and elders. (Antonio Zucchi, Fitzwilliam, Cambridge.)

Mares of Diomedes, see HERCULES (8).

Margaret of Antioch. Legendary virgin martyr, formerly one of the most popular Christian saints. But there is no evidence that her story is anything but a romance, and she was removed from the Church Calendar in 1969. Her legend tells how the prefect of Antioch wished to marry her but she refused him, declaring that she was a Christian virgin. She was cruelly tortured and thrown into a dungeon. Here Satan appeared to her in the form of a dragon and devoured her. But the cross in her hand caused the monster to burst open and Margaret emerged unharmed. She was finally beheaded after praying that women in labour, by invoking her, might be safely delivered of their child, as she was from the dragon's belly. Margaret's great popularity derived from her patronage of those in childbirth. Her attribute is a DRAGON. She tramples it under her feet; or she leads it by a cord or girdle; or she may even rise out of its belly. She holds the martyr's PALM and a cross. A chaplet of pearls alludes to her name which is derived from the Greek word for a pearl. In pictures of the Virgin she is often the companion of CATHERINE OF ALEXANDRIA. Narrative scenes and cycles are not common, but as a devotional figure she is widely represented in the painting of northern and southern Europe, until her popularity declined during the 17th cent. MARTHA also has a dragon under her feet, but can usually be distinguished from Margaret by her ASPERGILLUM.

Margaret of Cortona (1247–1297). The daughter of an Italian peasant and for several years the mistress of a nobleman. On her lover's death she repented her former way of life and sought admission to the Franciscan Order. After some hesitation she was admitted to the Order of Franciscan Tertiaries. It was recorded, among other supernatural incidents in her life, that as she prayed before a crucifix the head of Christ bent forward to signify his forgiveness. She features in Italian baroque painting as a young and beautiful woman, perhaps with a veil, wearing the knotted girdle of the Franciscans (see diag. RELIGIOUS DRESS). The

'Ecstasy of St Margaret' shows her kneeling, perhaps supported by angels, before a vision of Christ who is displaying his wounds to her. Her attribute is a DOG, generally a little spaniel. The legend goes that it belonged to her lover, who was murdered after visiting her. The dog returned to Margaret and succeeded in leading her to its master's body, the incident that brought about her conversion.

'Maria Mater Dei', see VIRGIN MARY (intro.).

Marigold, see FLORA (2).

Mark. One of the four evangelists, he was the companion of Paul and Barnabas on their early missions and was later in Rome with Paul. His attribute is a winged LION. (See further under FOUR EVANGELISTS.) He has several inscriptions of which the most frequent is 'Initium evangelii Jesu Christi filii dei' – 'Here begins the gospel of Jesus Christ the Son of God' (Mark 1:1.) According to Papias, an early Father of the Church, quoted by Eusebius (*Hist. Ecc.* 3. 39:15) he was the 'interpreter of St Peter', whence arose the popular tradition that he wrote down the words of his gospel from Peter's dictation. They are often depicted together, Peter holding a book, Mark with pen and inkhorn; or Peter preaches from a pulpit while Mark is seated, writing. Mark was believed to have visited Alexandria to preach the gospel and to have become the first bishop of that city; hence he sometimes wears bishop's vestments. He was said to have been martyred there. (See 4, below.) His supposed remains were removed from Alexandria and brought to Venice in the 9th cent. the story of which is told in a series of mosaics in the church of San Marco. As the patron saint of Venice he features much in paintings of the Venetian school. In devotional subjects he holds a book, the gospel, in one hand while the doge or some other dignitary of Venice kneels before him; or he is seen presenting them to the Virgin.

1. *The cure of St Anianus.* While in Alexandria, Mark miraculously healed a cobbler named Anianus who had injured his hand with an awl. The cobbler was converted to Christianity and was said to have become bishop of Alexandria after Mark. He is seen curing and also baptizing Anianus.

2. *The miracle of the fisherman.* A 14th cent. legend tells how a Venetian fisherman at the height of a storm was bidden by three strangers to row them out to the open sea. There they met a boat full of demons heading for the city to destroy it. The three strangers, who proved to be the saints Mark, George and Nicholas, exorcized the demons and saved Venice. The storm thereupon abated. Mark handed his ring to the fisherman and bade him take it to the doge as proof of the miraculous event. We see the fisherman's boat in the midst of the storm, with Mark in it making the sign of the cross. George in armour and Nicholas in bishop's robes. The demons leap overboard from their craft; others climb the rigging. Artists have also depicted the scene of the fisherman presenting Mark's ring to the doge.

3. *St Mark rescuing a slave.* Another legend tells of a Christian slave punished by his master by being dragged through the streets of Venice to his execution in the public square. St Mark miraculously swept down from heaven and released the slave from his bonds. His executioners and the onlookers draw back in astonishment as the saint's radiant figure descends over the slave's naked, supine body. (Tintoretto, Accademia, Venice).

4. *The martyrdom of St Mark.* Mark was arrested in Alexandria on Easter day while celebrating Mass. In prison Christ appeared to him. He died after being dragged through the streets with a rope tied round his neck. A hailstorm broke out causing his assailants to flee and his fellow Christians were thus able

to remove his body for burial. Mark's vision of Christ in the prison cell, and his death in the streets are both represented in art.

Marriage at Cana. (John 1:1–12). Christ's first public miracle, performed at a wedding feast at the village of Cana in Galilee. It is related only by John. Among the guests were Jesus, his mother Mary and some of the disciples. When the wine was exhausted Jesus, at his mother's request, ordered six stone jars to be filled with water. The master of ceremonies tasted the contents and was astonished to find that it had turned into wine of the best quality. The guests are usually seated round a table with Christ in the centre. Or Christ appears twice – at the centre and at the side blessing the jars. But the action usually centres on the master of ceremonies tasting the wine. The bride and groom may wear crowns according to the wedding rites of the Greek Church. In later medieval art the groom occasionally wears a halo, from the tradition which goes back to Bede (*c.* 673–735) that he was John the Evangelist. According to later popular belief the bride was Mary Magdalene. The subject was rare in early monastic painting, perhaps reflecting the celibate's attitude to marriage, but from the 15th cent. it became, like the Last Supper, a subject for refectories. Primarily, it has its place in Christian art as one of the three festivals of Epiphany, celebrated by the medieval Church as God's first manifestation to man of Christ's miraculous powers. The other two, the Adoration of the Magi and the Baptism, were in their own ways also first manifestations.

Marriage of Peleus and Thetis, see BANQUET OF THE GODS.

Marriage (Wedding, Betrothal) **of the Virgin;** (the 'Sposalizio'). The marriage of Mary, the mother of Christ, to Joseph, though not mentioned in the gospels is a familiar theme in Christian art, sometimes forming part of the cycle of scenes of the life of the Virgin. The story is found in the Protevangelium (New Testament apocrypha) and thence in the 13th cent. *Golden Legend*, which was an important source-book for artists. It tells how Joseph was chosen from among a number of suitors by a sign, the miraculous flowering of his rod. (See JOSEPH, husband of the Virgin.) The miracle was witnessed by the seven virgins who were Mary's companions during her upbringing in the Temple. The scene of the marriage shows the high priest standing with Mary and Joseph on either side of him. Joseph is generally a man of mature years, not the usual grey-beard of Renaissance Nativities. In one hand he holds his wand surmounted by a dove, and with the other places a ring on Mary's finger. The cathedral of Perugia, the city that was the centre of Umbrian art in the Renaissance, possessed a holy relic, the supposed ring, and the theme therefore features in the work of that school. Other versions show the pair giving their hands to each other – a French marriage custom, and therefore seen commonly in French painting; or they kneel before the high priest. Behind Mary are her virgin companions; behind Joseph the glum, unsuccessful suitors still holding their rods. One of them in a fit of rage breaks his rod across his knee. Another may be seen trying to strike the bridegroom. The scene is usually set before the Temple in which Mary was brought up, rarely inside it. In Counter-Reformation art from about the end of the 16th cent. the number of spectators is reduced, or they may be omitted altogether, and Joseph is depicted without his rod.

Mars (Gk Ares). The god of war, one of the twelve Olympians. His brutal and aggressive nature made him hated by nearly everyone, including his parents, Jupiter and Juno. The exception was VENUS who fell hopelessly in love with him. He is not a popular figure in art, except as the warlike spirit who is tamed by love. There is no fixed type for Mars though he is usually shown in young and

vigorous manhood. His armour consists of HELMET and SHIELD, sometimes also a breastplate, but he is seldom in full panoply. He has a SPEAR, SWORD, and occasionally a HALBERD, a weapon of the 15th to 17th cents. But they are all laid aside when he is conquered by love. In early Renaissance painting he may be accompanied by a WOLF, the animal sacred to him in Roman times and having, like him, an aggressive nature. It is also a reminder that Mars was the father of ROMULUS and Remus who were reared by a she-wolf. He is sometimes shown with his sister Bellona, the Roman goddess of war, a matron in armour.

1. *Mars, Venus and Cupid.* The story of the love of Mars and Venus and how they were discovered making love under Vulcan's net is told in the *Odyssey.* (See VENUS, 8.) The Renaissance made their relationship into an allegory of Strife overcome by Love, reflecting the code of chivalry of the typical courtier of the time who combined the qualities of warrior and lover. Cupid, or amoretti, are seen in the act of disarming Mars who kneels before Venus. Or the couple recline together in the open while the amoretti make playthings of Mars' weapons. One of them may join the pair with a lover's knot. (See also PARNASSUS.) There is a converse theme showing Mars, unconquered, chastising Cupid. One hand is raised to strike Cupid who lies on the ground blindfold, his bow and arrows strewn about, while Venus tries to intercede for him. Her doves, symbols of love, fly away. (See also CUPID, 5.)

2. *Mars and Minerva* (*Iliad* 5:825ff). In the Trojan war Mars took the side of the Trojans, Minerva that of the Greeks. The two met on the plain of Ilium and fought. Mars was soon felled by a well-aimed boulder. He is shown lying defeated on the battlefield, Minerva standing over him victorious (J.-L. David, Louvre). As an allegorical pair Minerva stands for Wisdom, whose arms are used in the defence of the virtues and the arts of peace, and who defeats the destructive forces of war, symbolized by Mars.

Marsyas, see APOLLO (4).

Martha. The personification of the busy housekeeper, the active type, in contrast to her contemplative sister, Mary of Bethany. (See MARY MAGDALENE, 2.) She took the initiative in fetching Christ to their house when their brother Lazarus died. (See RAISING OF LAZARUS.) According to the *Golden Legend* she accompanied Mary and Lazarus on an evangelizing mission to France symbolically overcoming a dragon that terrorized the citizens of Tarascon in Provence by sprinkling it with holy water. As the patroness of housewives Martha is simply dressed and holds a LADLE, or skimmer, or a bunch of KEYS. As the conqueror of the dragon, or Satan, she tramples it under her feet while holding an ASPERGILLUM. In devotional pictures of the Virgin she forms a pendant to Mary Magdalene.

Martin of Tours (*c.* 315–397). Christian saint, born in Pannonia (now Hungary); he became bishop of Tours about 370. He was a preacher, the founder of the first monasteries in France, and a destroyer of pagan shrines. His influence was felt throughout western Europe and many churches are dedicated to him in France and England. Martin is dressed either as a bishop, or as a Roman soldier wearing a cloak which he is about to cut with his sword. In either case he may have a lame beggar near him (see 2, below). A GOOSE at his feet may allude indirectly to the season of his feast-day (Nov. 11) which is said to coincide with the migration of geese (or the season of their killing and eating). Narrative cycles are found especially in French cathedrals of the 13th and 14th cents. Individual scenes occur widely in northern European Renaissance art.

1. *The knighting of St Martin.* He receives his sword from the emperor Constantius II, the son of Constantine the Great, and his shield from an aide. Another is fitting his spurs.

2. *The charity of St Martin; Martin divides his cloak.* After enrolling in the Roman army Martin served in Gaul. Once he found a beggar shivering in the winter cold, and cut in half his *paludamentum*, or military cloak, and shared it with the poor man. That night he dreamed that Christ came to him wearing the piece he had given away. The saint is usually on horseback in the act of cutting his cloak with his sword or putting part of it round the shoulders of a beggar who kneels beside him. His dream of Christ is also depicted.

3. *St Martin renounces his arms.* Martin requested his discharge from the army and, as is generally the lot of Christian pacifists, was accused of cowardice, because a battle was imminent. But he stood bravely in the front line carrying only a cross, and the enemy thereupon sued for peace. He is seen standing before the enemy soldiers, cross in hand, while his commander looks on.

4. *The Mass of St Martin.* Martin once celebrated Mass in an ill-fitting smock, having given his chasuble to a needy beggar whom he met on the way to church. At the altar a ball of fire, the symbol of his burning charity, descended on his head, and angels covered his arms with 'sleeves of gold and full of precious stones'.

Martyr, see DEATH, SCENES OF.

Mary, mother of Christ, see VIRGIN MARY.

Mary Magdalene. The image of the penitent in Christian art from the Middle Ages onwards, but especially from the Counter-Reformation as a result of the Church's move to foster devotion to the sacraments, particularly that of penance. (See SEVEN SACRAMENTS.) Yet the woman who anointed Christ's feet (Luke 7:36 ff), from whom the image of the repentant sinner is derived, was unnamed. John (11:2) identifies her with Mary the sister of Martha and Lazarus of Bethany, but it is only tradition that identifies her with the person named Mary Magdalene from whom Christ exorcized seven devils (Luke 8:2) and who was present at the crucifixion. The eastern Church regarded them as three separate persons, as does most modern opinion, but the western Church, and accordingly western art, treated them as one. The Magdalen's invariable attribute is her jar, or VASE of ointment, held in her hand or standing near her feet, with which she anointed Christ's feet. Her HAIR is untied, long and flowing, sometimes covering her whole body. In this she resembles MARY OF EGYPT, another type of repentant and reformed courtesan. Her inscriptions include 'Ne desperetis vos qui peccare soletis, exemploque meo vos reparate Deo,' – 'Do not despair, you who have fallen into the way of sin; restore yourselves through my example and through God,' and 'Optimam partem elegit' – 'The part that [Mary] has chosen is best' (Luke 10:42). She is portrayed in two distinct ways: (*a*) Before her conversion she is richly attired, jewelled and gloved, the type of Profane Love (see VENUS, 1), and appears thus in two non-scriptural themes: Martha rebuking her for her vanity, and the more popular one of her renunciation of the vanities of the world. In the second she is in the act of casting off her cloak and jewels in the presence of Martha and sometimes Christ. An overturned casket of jewellery lies at her feet. (*b*) As a penitent, she wears a simple cloak or is often naked, covered only by her long hair. She usually has a CRUCIFIX and a SKULL, also sometimes a WHIP and a CROWN of thorns. She reads or meditates or, in baroque painting, raises her tear-filled eyes towards a vision of angels in heaven. The setting may be the entrance to a cave, from the legend that later in life she lived in retreat in a grotto at Sainte-Baume in France. Narrative scenes come from the gospels and the medieval French legend.

The Magdalen in the Gospels

1. *Christ at supper with Simon the Pharisee* (Luke 7:36–50). While Christ was

at table there entered a penitent harlot, whom we identify with Mary Magdalene, who brought oil of myrrh in a flask. As she wept her tears wetted his feet which she wiped with her hair, and then kissed and anointed. Christ told the company that the woman's action proved her love, which made her worthy to be forgiven her sins. The Magdalen kneels at Christ's feet, in the act of wiping or anointing them. Judas Iscariot, the disciple who protested at the waste of the precious ointment (John 12:4–6) may be looking on with an expression of anger or scorn.

2. *Christ in the house of Martha and Mary* (Luke 10:38–42). Martha, the busy housewife and the active type, chided her contemplative sister for sitting, apparently idly, at Christ's feet, listening to his words. But he told her that Mary was playing a necessary, indeed the better, part – hence Mary's inscription, 'Optimam partem elegit'. Martha is shown preparing food, surrounded by her domestic accoutrements, while Mary listens attentively to Christ. Their brother Lazarus, or some disciples, may be present. (See also ASSUMPTION.)

3. *'Noli me tangere'* (touch me not) (John 20:14–18). After the Resurrection Christ appeared to Mary Magdalene as she stood by the empty tomb, weeping. When she recognized him he bade her not to touch him but to go to the disciples with the message that he was now risen. The scene necessarily contains only two figures, the Magdalen usually kneeling or bending forward towards Christ who gently draws back from her outstretched arms. The hoe or spade that is sometimes held in the hand of the Saviour refers to John's remark that the Magdalen at first mistook him for a gardener. The Christian doctrine of the Resurrection is based on such appearances of Christ to his followers after his death.

See also RAISING OF LAZARUS; CRUCIFIXION; DESCENT FROM THE CROSS; HOLY WOMEN AT THE SEPULCHRE.

The Magdalen in Provençal Legend

The story of her pilgrimage to Provence, where she was said to have lived for many years as a hermit, originated in France in the 11th cent. and is told in the *Golden Legend*. It was based on legends about another female penitent, MARY OF EGYPT, which had been current in France from a much earlier date. The discovery of the Magdalen's supposed relics in the 13th cent. led to the rapid growth of her cult. Perhaps her most curious monument is the church of La Madeleine in Paris, a pseudo-classical temple originally intended for the glorification of Napoleon.

4. *The voyage to Marseilles.* Mary, Martha and Lazarus, with other companions set off in a boat without sails, oars or rudder, and, guided by an angel, eventually landed safely at Marseilles. Here Mary preached to the pagan inhabitants and baptized many. The subject occurs principally in churches dedicated to the Magdalen.

5. *The assumption of the Magdalen.* In a solitary mountain retreat near Sainte-Baume, which is a place of pilgrimage today, she passed thirty years in fasting and penance. Seven times a day angels came down and lifted her up to heaven where she was vouchsafed a glimpse of the bliss to come. One day a hermit chanced to witness her elevation and returned to Marseilles with the news of it. The subject occurs in Renaissance art but is commonest from the later 16th cent., in the Counter-Reformation. Earlier versions show her partly draped, floating up in a devotional posture. In baroque art she is naked, or covered by long hair and may recline amid banks of clouds like Venus. She is borne by numerous angels, one of which carries her jar of ointment. The hermit sometimes looks up at her from below. The scene resembles MARY OF EGYPT borne by angels across the Jordan.

6. *The last Communion of the Magdalen.* It is administered either by angels in her cave in the mountains, or, according to a different legend, by St Maximin, one of her companions on the voyage, after she had been carried by her angels to his chapel in Aix. She kneels before him, supported by angels, while he gives her the Host.

See also DOMINIC (7).

Mary-Magdalene of Pazzi (1566–1607). A Carmelite nun of Florence. She was a woman of passionate temperament which found expression in religious mysticism. This manifested itself as a vision of the Virgin who presented her with a white veil, a symbol of purity. She is depicted kneeling before the Virgin who takes the veil from a dish held by an angel and places it on the saint's head. Another of her reported visions, also represented in art, shows her kneeling before St AUGUSTINE, who is dressed in episcopal robes, and is in the act of writing on her breast the words 'Verbum caro factum est' – 'So the Word became flesh' (John 1:14). She is seen before the Virgin taking the infant Christ into her arms; receiving the instruments of the Passion from the Saviour, and performing a mystic marriage with him. The scenes are found principally in works of the 17th cent. in Carmelite churches, especially in Italy. She was canonized in 1669.

Mary of Egypt. A penitent harlot who lived in Alexandria, perhaps in the 5th cent. She went to Jerusalem where, as she was about to enter the church of the Holy Sepulchre, she underwent a sudden conversion. She retired to the desert beyond the Jordan and spent the rest of her life in extreme asceticism. Her legend tells that a hermit named Zosimus discovered her and gave her communion. When he came that way again a year later she miraculously crossed over the Jordan to receive it from him. She is depicted borne across the river by angels. On his third visit Zosimus found her dead body. A lion helped the priest to dig her grave by scratching with its paws, a legend told of other desert hermits. Mary is usually old and haggard, and is either dressed in rags or is naked, covered only by her long hair. MARY MAGDALENE, as a penitent, is often represented naked in the same manner. When they are together Mary of Egypt may be distinguished by three small loaves which were her food in the desert. Zosimus is old and bearded and wears a monk's habit.

Mask. A disguise, therefore a symbol of deceit and an attribute of the personification of DECEIT, of Vice (HERCULES, 21), and of NIGHT who provides a cover for vice. Melpomene, the MUSE of tragedy, has a mask for attribute.

Mass. The celebration of the Eucharist in the Roman Catholic Church, performed by a bishop or priest. In art he is often represented being attended by a deacon only, though in the case of an officiating bishop the presence of a subdeacon and assistant priest is required. The Mass of St GREGORY THE GREAT (5) is accompanied by his vision of the crucified Christ; that of PHILIP NERI by a vision of the Virgin. At the Mass of MARTIN of Tours (4) a ball of fire descends upon his head; at that of BENEDICT (11) two nuns rise from the grave. The Mass of St Giles depicts CHARLEMAGNE kneeling beside the altar, an angel floating above it. The Mass of Bolsena concerns a young priest of Bolsena in central Italy in the 13th cent., who doubted the doctrine of transubstantiation. It was told of him that while he was celebrating Mass, at the elevation of the Host the wafer miraculously emitted blood in five places, as it were from the five wounds of Christ. (Raphael, Vatican, Stanza d'Eliodoro.)

Massacre of the Innocents (Matt. 2:16). At the time of Christ's nativity Herod the Great, learning of the birth of the child who was destined to become 'king of the Jews' and fearing that his own power would thereby be usurped, ordered the

wholesale slaughter of infants in Bethlehem and the surrounding district. But the Holy Family, forewarned by an angel (see JOSEPH, husband of the Virgin, 2), had already fled to safety (FLIGHT INTO EGYPT). The scene is usually the courtyard of Herod's palace. Soldiers with drawn swords are snatching infants from the arms of their protesting, grief-stricken mothers. The ground is littered with dead bodies. Herod watches either from a balcony or from a throne. A fleeing mother, her child hidden in the folds of her cloak, represents Elizabeth, the mother of John the Baptist; her escape into the hills with the infant Baptist is told in the apocryphal Book of James. A seated woman lamenting over her child's body, alludes to a passage from the book of Jeremiah (31:15), 'Rachel weeping for her children refused to be comforted . . . because they were not'. The medieval Church regarded this as a prefiguration of Herod's massacre. The cult of the Holy Innocents, the veneration of the children as the first martyrs, existed from very early in the Christian era. In the Middle Ages and later they might be represented as a devotional group, holding martyrs' palms, and are sometimes included in Italian Renaissance paintings of the Virgin and Child with saints.

Mater Amabilis, see VIRGIN MARY (11).

Mater Dolorosa, see VIRGIN MARY (2).

Mater Sapientiae, see VIRGIN MARY (9).

Matrimony, one of the SEVEN SACRAMENTS.

Matthew. Apostle and traditionally the author of the first gospel. He was a tax-gatherer of Capernaum who, as he sat at the custom-house, was called by Christ to follow him. As one of the evangelists his attribute is a winged person resembling an angel, one of the 'apocalyptic beasts'. (See FOUR EVANGELISTS.) It may be seen dictating as Matthew writes. He has book, pen and inkhorn, the attributes of the WRITER. As an apostle he holds a PURSE, a reminder of his previous occupation. According to legend he was martyred by beheading and may therefore have an AXE or HALBERD. Among Matthew's several inscriptions are 'Sanctam ecclesiam catholicam; sanctorum communionem' – 'The Holy Catholic Church; the communion of saints', from the Apostles' Creed; 'Primum querite regnum dei' – 'Set your mind on God's kingdom before everything else' (Matt. 6:33); 'Liber generationis Jesu Christi' – 'A table of the descent of Jesus Christ' (Matt. 1:1).

The calling of Matthew (Matt. 9:9). 'Jesus saw a man named Matthew at his seat in the custom-house; and he said to him, "Follow me". And Matthew rose and followed him'. Matthew is seen sitting at his desk. Money lies on it. Taxpayers come to him. Christ is present with perhaps Peter and Andrew. Matthew looks up at him or may be in the act of rising from his seat.

Maurice. Legendary warrior saint, the commander of the 'Theban Legion', Roman troops from Thebes in Egypt, who served at Agaunum in Gaul (St-Maurice en Valais) in the 3rd cent. The story, whose authenticity is debated, relates that the soldiers, at the instigation of Maurice, refused to participate in certain pagan rites. They were punished by the Emperor Maximian Herculeus first by decimation and finally by the wholesale massacre of the legion. Maurice and his fellow officers were executed in A.D. 287. St Maurice is represented chiefly in works of the German and Italian Renaissance. He is often dark-skinned (Maurice, from Moorish), and is dressed either as a Roman soldier or in medieval armour, bearing on the breastplate a red cross, the emblem of the Sardinian Order of St Maurice. He holds the martyr's PALM and a banner which may carry the eagle of Austria, of which country he is a patron saint. He is also the patron of Mantua.

The massacre of the legion is occasionally represented (Pontormo, Pitti Gallery, Florence).

Maurus and Placidus, see BENEDICT (5).

'Mausolus' inscribed on an urn, see ARTEMISIA.

Maximilla, wife of Egeas, governor of Patras, see ANDREW, apostle.

Meal, see REPAST.

Medea. In Greek legend the wife of Jason, a passionate and jealous woman. She fled with him from her homeland Colchis, when he returned to Greece after capturing the Golden Fleece. Later he deserted her to marry a Greek woman. Medea stopped at nothing to obtain revenge, even going to the lengths of murdering her own two children, not to mention Jason's new wife and his father-in-law. But except in antiquity artists have been less interested in this aspect of her story than in the fact that she was a witch. The avenging wife is derived from Euripides' play *Medea*, but artists went to Ovid for their themes. In the *Metamorphoses* he dwells on Medea's powers of sorcery, her magic potions, and so on, and hurries over the details of the tragedy. Thus (7:164–294) Medea is depicted rejuvenating Jason's aged father Aeson, which she did by draining off his old blood and replacing it with a special herbal brew of her own. She stands by a steaming cauldron and throws in a handful of ingredients while Aeson lies naked nearby. By means of a trick Medea disposed of Jason's uncle Pelias, who had usurped Aeson's throne (7:298–350). She promised Pelias' daughters that she would perform the same operation on their father, and persuaded them to take knives and draw off his blood. When they had done so Medea made off and left them with the corpse. The women are usually shown in the act of knifing the old man. A sheep or lamb, with Medea standing beside it, alludes to her earlier magical rejuvenation of a ram in order to convince the daughters of her powers. Medea is occasionally seen on her chariot; it is drawn by DRAGONS (7:350, 398). See also JASON.

Medoro, a Moor, see ANGELICA.

Medusa (*Met.* 4:769–803). In Greek mythology one of three terrible sisters, the Gorgons, whose appearance was so hideous that whoever beheld them was turned to stone. They had staring eyes, fangs for teeth, their tongues hung out, and they had snakes for hair. Medusa herself was beheaded by Perseus but even after death her head retained its petrifying power. This led to its use on warriors' shields and elsewhere as a protective talisman. The myth also tells how Minerva, who was Perseus' protectress, placed the Gorgon's head on her aegis, which was a kind of goatskin tunic fringed with serpents. It is commonly seen on Greek vase painting. In later art the head becomes a regular feature of Minerva's shield. It occurs occasionally as a 'portrait study' in baroque painting, also in marble and bronze. See PERSEUS; CORAL.

Meeting. The reunion of two people who sometimes embrace. Old man and woman outside city gate, JOACHIM AND ANNA. Two women, the Virgin Mary and Elizabeth, VISITATION; or JUSTICE and Peace (with a dove); or, if one is nude, TRUTH and Mercy. A father embracing son: DAVID (8) and Absalom, or the PRODIGAL SON (3) (who is in rags). (Compare also OBEISANCE; SUPPLICATION.)

Melancholy personified, see FOUR TEMPERAMENTS.

Melchizedek, see ABRAHAM (1).

Meleager (*Iliad* 9:430–605; *Met.* 8:260–546). In Greek mythology the son of a king of Calydon, a city of Aetolia. His father had offended the goddess DIANA who sent a wild boar to ravage the countryside, and Meleager with a band of companions set out to hunt it. First to wound it was ATALANTA the virgin huntress

whom Meleager loved. When the beast was finally killed Meleager presented her with the head and pelt. This led to a quarrel with the others in which Meleager slew his two uncles. At Meleager's birth the FATES had decreed he should not die until a log of wood burning in the hearth was consumed. His mother had snatched it out of the flames and preserved it, but now, on learning of her brothers' deaths, she threw it back again. Meleager wasted away and died.

The Calydonian boar hunt (Philostratus the Younger, *Imag.* 15). The boar stands under a tree keeping a ring of huntsmen and their hounds at bay. Atalanta has just shot an arrow; Meleager's spear is poised. A man lies dead beside the boar. A later scene shows Meleager presenting the head and pelt to Atalanta who may be sitting under a tree. Cupid is present. Occasionally depicted is Meleager drawing his sword before his uncle; and his mother, Althaea, casting a log into the fire. The theme is sometimes used for paintings that are primarily woodland landscapes.

Melpomene, see MUSES.

Menorah, see CANDLE.

Mentor, a guardian, see TELEMACHUS.

Mercury (Gk Hermes). One of the twelve gods of Olympus and perhaps the most easily recognized. He appears frequently in mythological themes, but often only in a secondary role, as a messenger of the gods or as a guide. In appearance Mercury is the typical Greek youth, graceful and athletic. His regular attributes are the winged SANDALS, for swift travel; winged HAT, a *petasus*, round and low crowned and sometimes pointed at the front; CADUCEUS, or magic wand, with two snakes entwining it, also usually winged. It had the power to induce sleep. He was the son and the messenger of Jupiter, and was charged with leading the three goddesses, Juno, Venus and Minerva to the shepherd Paris to be judged. (See JUDGEMENT OF PARIS.) He is also seen handing Paris the apple of Discord. As a guide he escorted Psyche to heaven for her marriage with CUPID (6) – he may carry her in his arms, and may have a herald's trumpet instead of a caduceus. He bore PANDORA to earth, a theme similar in appearance. He guided the souls of the dead down to CHARON the ferryman, and led Proserpine back from the underworld (see RAPE OF P.). As the patron of travellers his image, the HERM, was erected by the roadside to mark distances or boundaries. It was often no more than a post or stone cairn. It is represented in painting as a pillar surmounted by the head and torso of the god. Mercury was also the god of commerce, especially in his Roman identity, and so may have a PURSE. He was a trickster and a cattle-thief (see APOLLO, 8) – yet was the protector of shepherds and flocks, when his attribute is the RAM. He invented the lyre. (See APOLLO, 8.) In allegory Mercury personifies Eloquence and Reason, the qualities of a teacher. He is shown teaching Cupid to read, perhaps in the presence of VENUS, Cupid's mother, a theme that echoes the ideals of learning in the Renaissance. This aspect of his nature puts him on the side of Apollo, and he may therefore be seen on PARNASSUS.

1. *Mercury and Argus* (*Met.* 1:668–721). One of Jupiter's many loves was Io, a princess of Argos. But the affair was frustrated by his wife Juno, who turned Io into a white heifer and handed the animal over to the hundred-eyed giant Argus, to guard. Mercury was sent by Jupiter to kill the giant, which he did after first lulling him to sleep with music. Argus, usually depicted as a brawny shepherd, with the usual number of eyes, nods off to sleep seated against a rock or under a tree. Mercury plays a pipe, or approaches stealthily with a raised

sword. Io browses quietly nearby. Mercury as a standing figure may have his foot on a severed head, in allusion to Argus. (See also IO and JUNO.)

2. *Mercury and Herse.* Ovid (*Met.* 2:708–832) tells how three sisters, returning from the festival of Minerva and carrying her sacred baskets on their heads, were espied by Mercury who immediately fell in love with the most beautiful of them, Herse. Another of the sisters, Aglauros, was consumed with envy, and tried to prevent Mercury entering Herse's chamber when he came to her one night. He touched Aglauros with his wand and she was turned to black stone, the colour of her thoughts. There are two scenes. The maidens are walking outdoors, baskets on their heads. Mercury flies above them. In the background is Minerva's temple. Cupid may be present. Or Mercury is seen entering Herse's chamber. At the touch of his wand Aglauros falls to the ground at his feet. Herse starts back in surprise. Alternatively, Aglauros, jealousy written all over her face, peers round a curtain at the couch where the lovers are already dallying.

See also: BACCHUS (1); CIRCE; PHILEMON AND BAUCIS; PROMETHEUS.

Mercy, see TRUTH; VIRGIN MARY (3).

Merman, see TRITON.

Michael, archangel. The guardian angel of the Hebrew nation (Dan. 10:13, 21) whom Christianity adopted as a saint – in the broad sense – of the Church militant. His origins probably lie in the religion of ancient Persia whose pantheon was divided into two, light and dark, or good and evil. The gods of light, with whom Michael was associated, were in perpetual conflict with the gods of darkness. The same idea is expressed in the book of Revelation (12:7–9): 'Then war broke out in heaven. Michael and his angels waged war upon the dragon . . . So the great dragon was thrown down, that serpent of old . . .' The source of the passage is probably pre-Christian though the Church explained it in terms of the Christian conflict – Christ versus the Antichrist, represented as St Michael vanquishing the devil. The image occurs widely in religious art, particularly in churches dedicated to St Michael. He wears a coat of mail and is armed with a SHIELD, and SWORD or SPEAR, or both. Like nearly all angels he has wings, (which prevents any confusion with the other dragon-slayer, St George). Satan, either in his semi-human form, or as a dragon, is prostrate under the feet of the saint who is about to slay him. (See also APOCALYPSE, 16).

St Michael is also represented weighing the souls of the dead (psychostasis) to measure their just deserts. This had a counterpart in Greek and ancient Egyptian religion. It was one of the tasks of Hermes (MERCURY), who guided the souls of the dead to the underworld, to weigh in a balance those of the ancient heroes. An engraved gem, dating from the early years of Christianity, depicts St Michael with caduceus and winged hat, the classical attributes of Mercury. Another connection between the two is to be found in the sites dedicated to St Michael, frequently on mounds and hill-tops, where formerly a temple of Mercury is known to have stood. Christian art commonly portrays St Michael holding a balance with a human soul – a diminutive naked human figure – in each pan. One is heavier than the other though artists differ as to which is the righteous and which the sinner. A popular motif shows a demon surreptitiously tilting one of the scale pans. St Michael as weigher of souls often forms a central feature in the LAST JUDGEMENT.

See also ABRAHAM (3); DANIEL (2); DEATH OF THE VIRGIN; MOSES (10).

Midas. In Greek legend a king of Phrygia who was granted a wish by Bacchus in return for a good deed he had done to Silenus, a follower of the god (*Met.* 11:100–145). Midas wished that everything he touched be turned to gold, but

soon realized his mistake when all food became inedible. Bacchus ordered him to wash in the River Pactolus in Lydia. Hence the popular aetiology of the gold-bearing properties of the river, thought to have been the source of the wealth of the kings of Lydia, of whom Croesus was the last. Midas is depicted kneeling penitently before Bacchus, a drunken Silenus sleeping nearby; or washing in the river, watched by the youthful god, while the river god reclines on his urn (Poussin: Met. Mus., New York). On another occasion the unfortunate Midas was awarded ass's ears for offending a god (see APOLLO, 5: *The Judgement of Midas*).

Milky Way, see ORIGIN OF THE M. W.

Millstone, usually with a rope threaded through it. The attribute of the deacon, VINCENT OF SARAGOSSA, the warrior FLORIAN, and CHRISTINA (holding an arrow). In Gothic art an ass with a millstone is OBEDIENCE personified.

Millstone

Milo of Croton. A legendary athlete, renowned for his strength, who lived at Croton, a Greek settlement in southern Italy, in the 6th cent. B.C. According to Valerius Maximus (9:12), on seeing an oak tree partly split open with a wedge he tried to wrench it apart, but only suc-ceeded in causing the wedge to fall out, thereby trapping his hands. He was left a helpless prey to the wild beasts who soon finished him off. He is depicted in Italian baroque painting as a partly naked, muscular figure, his hands imprisoned by a tree trunk. He is either alone or about to be attacked by a lion. (Alessandro Vittoria, bronze, Cà d'Oro, Venice.)

Milvian Bridge, Battle of, see CONSTANTINE (2).

Minerva (Gk Pallas Athena, or Athene). One of the major deities of ancient Greece and Rome, and, like Apollo, a benevolent and civilizing influence. In Greek mythology she was the daughter of JUPITER (Zeus), and sprang fully armed from his head. The familiar figure in armour with spear, shield and helmet, the patroness of institutions of learning and the arts, seen in civic heraldry, sculpture and painting, is only one of her many aspects. In an early form she was a war goddess, hence her weapons. The serpent-haired head of Medusa was given to her by PERSEUS after she had helped him to slay this monster. In antique art the head appears on her 'aegis', or goatskin cloak, which is also fringed with serpents. Later, it decorates her shield. As a war goddess Minerva fights for the defence of just causes, not, like Mars, for the sake of destruction. She is even to be seen holding a copy of Caesar's *War Commentaries*, to signify her wisdom in military matters. Minerva was the guardian of other heroes besides Perseus. (See HERCULES, 21; JASON; TELEMACHUS; PROMETHEUS.) She was the patroness of Athens, and the Parthenon was her temple. (See 1, below.) Like Diana she was a virgin goddess, though she was not without suitors, among them the smith-god Vulcan (Hephaestus) (See ERICHTHONIUS). She was the patroness of many household crafts, especially spinning and weaving (see ARACHNE), and invented the flute. (See APOLLO, 4.) But above all, to the Greeks and Romans, the Renaissance and later, she was the goddess of wisdom. In this role, her OWL, sacred to her in antiquity, is perched near her, often on a pile of BOOKS, symbols of learning. The SNAKE was associated with the Greek Athena at the beginning of her cult. Its association with wisdom, or prudence, comes from Matt. 10:16, 'Be ye therefore wise as serpents' (N.E.B.: 'wary'). Its first use in connection with Minerva, in this specific sense, seems to be in

Renaissance allegory, where the goddess personifies wisdom. She may have an OLIVE branch, also sometimes a symbol of wisdom.

1. *The contest of Minerva and Neptune* (*Met.* 6:70–82). Minerva and Neptune (Poseidon) disputed the ownership of Attica, the region of which Athens was the capital. A tribunal of the gods promised to award the land to whichever of the contestants produced the more useful gift for the inhabitants. Standing on the Acropolis Neptune struck the ground with his trident whereupon a horse sprang up. Minerva caused an olive tree to sprout, the symbol of peace and plenty, and was judged the victor. Jupiter and Juno are depicted enthroned in the heavens among the other gods, looking down on the contest. Neptune, brandishing his trident, has just caused a horse to rise from the ground. Minerva stands by an olive tree. The city of Athens may be seen in the background. The myth served to explain the origin of Athena's patronage of the city, and probably reflected some prehistoric change of rule.

2. *Minerva and the Muses.* Ovid describes (*Met.* 5:250–268) how Minerva visited the Muses on Mt Helicon, their home, to listen to their song and story and to see the sacred spring, the Hippocrene, which flowed from a rock after it had been struck by the hoof of the winged horse, Pegasus. (Hippocrene – from two Greek words meaning 'horse' and 'fountain'.) The scene is usually a wooded mountain-side where the company of Muses are playing their instruments or perusing books. Minerva is just arriving or is sitting at ease among them. Pegasus is nearly always to be seen in the background leaping from a high rock from which water gushes. The association of Minerva and the Muses was in line with the tradition that made her patroness of the arts.

3. *Portraits of women as Minerva.* It was customary to portray men and women in the guise of gods and goddesses (see VENUS, 8; HEBE; DIANA). Women in public life, especially if they patronized the arts, were often portrayed with the attributes of Minerva, usually the owl perched on a pile of books, sometimes even wearing armour. Occasionally the sitter is herself holding a portrait, usually of a relative, perhaps deceased – a token of regard for the person depicted in the inner painting.

See also CADMUS; CUPID (2); JUDGEMENT OF PARIS; MARS; SEVEN LIBERAL ARTS; TROJAN WAR (1).

Minos, judge of the dead, see HELL.

Minotaur, see THESEUS (2).

Miraculous draught of fishes (Luke 5:1–11). Christ had gone aboard the fishing boat of Peter to preach to the people from offshore, and afterwards he told Peter and his companions to lower their nets. Peter doubted that they would make a catch but the nets came up so full of fish that James and John who were in another boat nearby had to help bring them in. They were all astonished. 'Do not be afraid', Christ said, 'from now on you will be catching men.' The scene is the Sea of Galilee (or Lake of Gennesaret). The cartoon by Raphael (V. & A. Mus. London) shows Christ in the boat. Peter kneels before him; behind Peter is Andrew, his hands outspread in amazement. James and John haul in the nets. In John's gospel (21:1–8) the episode is placed after the crucifixion and treated as one of the 'appearances' of Christ. In that version, which is somewhat rare in art, the Saviour stands on the shore, not in the boat, and Peter impetuously plunges into the sea in his haste to approach him. The scene somewhat resembles CHRIST WALKING UPON THE WAVES, in which Peter likewise steps into the water from a boat. In the latter Christ is standing on the water, not on the shore.

Mirror. The attribute of PRUDENCE (with a snake) (her self-knowledge); naked

TRUTH (a mirror does not lie); Sight, one of the FIVE SENSES; of the Vices, PRIDE (the mirror reflecting Satan's image), VANITY and LUST. The latter is sometimes identified in Renaissance allegory with the figure of VENUS whose attribute in classical times was a mirror. The Toilet of Venus (4) depicts Cupid holding a mirror to her. A sage, with a child looking at its reflection, is SOCRATES. Two lovers, he holding a mirror, are RINALDO AND ARMIDA. In religious art a mirror, the 'speculum sine macula', belongs to the VIRGIN MARY (4, 5); when reflecting the Virgin's image it is the attribute of GEMINIANUS, a bishop.

Mirtillo, Crowning of. A scene from the pastoral play *Il Pastor Fido*, the Faithful Shepherd, by the Italian poet Guarini (1538–1612). The shepherd Mirtillo loved the nymph Amarillis. In order to gain her presence he disguised himself as a woman. He joined in a kissing game between Amarillis and her maidens and, being judged the winner, was awarded the crown by Amarillis. Mirtillo however took the crown from his own head and placed it on hers, to show that she was equally deserving. Baroque painters depict a pastoral woodland scene of nymphs embracing. Mirtillo, perhaps dressed as a shepherdess but recognizably male, receives the crown, or returns it to Amarillis.

Misericordia, see VIRGIN MARY (3).

Missal. The book used for the celebration of the mass, containing the Canon of the Mass and the prayers of the masses for the main Church festivals throughout the year. Illuminated missals traditionally included at least a miniature of the crucifixion and of Christ in Majesty.

Mistletoe. An evergreen, parasitic on trees, believed by primitive man to embody a living spirit, and hence the object of certain pagan rites. It was a symbol of life and a protective talisman: AENEAS (8) plucked the 'golden bough' before descending to the underworld with the Cumaean Sibyl.

Mitre. The distinctive head-dress of the BISHOP, also once worn by cardinals and some abbots. It is pointed and has a cleft in the crown. It is often richly ornamented with embroidery and jewels. A plain white mitre may be worn by an abbot, thus sometimes BENEDICT. Three mitres on the ground are the attribute of BERNARDINO and BERNARD, both of whom it was said thrice refused the offer of bishoprics. See diagram RELIGIOUS DRESS.

Mocking of Christ ('Christ derided') (Matt. 26:67; Mark 14:65; Luke 22:63). After his arrest in Jerusalem and either just before or after his appearance before Caiaphas the high priest (the accounts vary) Christ was set upon by the Jews and subjected to various indignities. The scene should not be confused with the CROWNING WITH THORNS, a later and in some respects similar incident. 'Some began to spit on him, blindfolded him, and struck him with their fists.' 'Others said, as they struck him, "Now, Messiah, if you are a prophet, tell us who hit you."' The scene may be depicted taking place before Caiaphas who sits on his seat of judgement; or Christ is himself seated, surrounded by his mockers. He is generally blindfold and his hands tied with cords. He is sometimes wrongly portrayed holding a makeshift sceptre and perhaps orb – these belong strictly to the 'Crowning'. One of the Jews is about to strike him with upraised fist, others with sticks. One tugs his hair, another spits on him. Sometimes musicians with cymbals, drum and pipes try to deafen him with their din. The scene may include Peter's 'Denial' which took place at about the same time. (See PETER, apostle, 4.) The 'Mocking' can be distinguished from the 'Crowning' by the absence of the crown and by the identity of the mockers who are Jews, not Roman soldiers. The theme is less common than the 'Crowning', and belongs chiefly to the art of Renaissance Italy and Germany.

Model, of a building in the hand of a saint, generally alludes to his patronage of, or other special association with a church or city; thus the Franciscan BERNARDINO (Siena); bishop, GEMINIANUS (Modena); bishop, PETRONIUS (Bologna, with two towers, one leaning); bishop, with fleurs-de-lys, ZENOBIUS (Florence); emperor, Henry II, and sometimes his wife CUNEGUNDA (Bamberg); emperor, CHARLEMAGNE (Aix-la-Chapelle); two female saints, JUSTA AND RUFINA (Seville, with a rectangular tower); girl with a rat, FINA (San Gimignano). HELENA holds the church of the Holy Sepulchre (Jerusalem); ELIZABETH OF HUNGARY, in the habit of a Franciscan nun or in princess's robes, the church of Marburg. CONSTANTINE THE GREAT holds the city of Constantinople. A church with rays of light issuing from it is the attribute of JEROME. BARBARA has a model of a tower, sometimes with three windows.

Moirae, see THREE FATES.

Monica (*c.* 330–87). The mother of Saint Augustine whose influence played a large part in his conversion to Christianity, as he relates in his *Confessions.* The growth of her cult dates from the translation of her supposed remains from Ostia, where she died, to Rome in 1430. Monica is dressed in black, with perhaps a white veil or wimple, and holds a BOOK. She stands beside Augustine, sometimes together with NICHOLAS OF TOLENTINO, a saint of the same Order. She appears in narrative scenes from her son's life. (See AUGUSTINE 1, 3.)

Monk. The members of the various religious communities and, in the case of the mendicant Orders, the friars, are typically represented receiving the Rule of the Order from their founder, for example AUGUSTINE and BENEDICT, or surrounding the bier at his death. An old monk, a cloven hoof emerging from under his habit, see TEMPTATION IN THE WILDERNESS. See RELIGIOUS DRESS for the distinctive habits of the Orders.

Monkey, see APE.

Monster. Creatures that combine more than one shape, often human and animal together, are a feature of the Greek myths and of Jewish apocalyptic literature, many of them derived from oriental sources. (Metamorphoses, such as those of Actaeon and Cygnus, are disregarded.) *Monsters with a human head:* human torso, body and legs of horse, CENTAUR; legs of goat, PAN, SATYR; fish's tail, TRITON; lion's body, scorpion's tail, the manticore, (JEREMIAH); serpent's tail, the 'locusts' of the Revelation (APOCALYPSE, 12); three bodies joined to one pair of legs, Geryon, (HERCULES, 10). *Female head:* body of bird, Siren (ULYSSES, 2), and Harpy (AVARICE); breasts, wings, lion's body, serpent's tail, Sphinx (OEDIPUS AND THE S.); scaly body, lion's claws, DECEIT; snakes for hair, Medusa (PERSEUS).

Three-headed dog, Cerberus (HERCULES, 12; ORPHEUS; PLUTO). Three-headed wolf-lion-dog, PRUDENCE. Bull's head, human body, the Minotaur (THESEUS). Horse's head, fish's tail, HIPPOCAMPUS. Lion's head, goat's body, dragon's tail, the Chimaera (BELLEROPHON); eagle's head and wings, lion's body, GRIFFIN; eagle's head and wings, horse's body, HIPPOGRIFF. Lion's head, sheep's horns, (APOCALYPSE, 18); lion-headed 'cavalry', (APOCALYPSE, 13). Goat's head and body, fish's tail, Capricorn, GOAT. The seven-headed Beast of the APOCALYPSE (17) was 'like a leopard, but its feet were like a bear's and its mouth like a lion's mouth', a description treated with much licence in art. See also DRAGON; SATAN.

'Monstra te esse matrem', see BERNARD (2).

Monstrance. Sacred vessel in which the consecrated wafer is displayed in the Roman Catholic Church. It is represented in the scene of the procession of Corpus Christi, out of which the need for some special receptacle for the Host originally arose. The monstrance developed in the 14th cent. from the older

PYX and reliquary. In its simplest form it was shaped like a box with
a circular window, and generally stood on a pedestal. In the 16th
cent. it acquired sumptuous ornamentation. It is the special attribute
of CLARE (c. 1194–1253), an appropriate substitution by artists of
the pyx that is mentioned in her legend. It is also the attribute of
NORBERT. It is carried, with a statue of the Virgin, by the Dominican
HYACINTH. It is borne in triumph on a chariot (see SEVEN SACRAMENTS).

Monstrance

Months, see TWELVE MONTHS.

Moon. A crescent moon was the ancient attribute of the virgin DIANA
and of the moon goddess LUNA who were worshipped as one and the
same in the Roman era. It remains their most constant attribute. The crescent
likewise symbolizes chastity under the feet of the VIRGIN MARY (1, 4). See also
SUN; CRUCIFIXION (11).

'Moralis' and 'Naturalis', entitling two books, the attributes of PHILOSOPHY.

Mordecai, see ESTHER.

Morpheus, god of dreams, see NIGHT; SLEEP, KINGDOM OF.

Moses. The great leader of the Jewish people, the lawgiver and founder of their
institutional religion, and brother of AARON. Exodus tells how Moses led the
Jews out of Egyptian captivity and how he received the Ten Commandments
from God. Among the Old Testament figures whom the Church saw as fore-
shadowing Christ, Moses, even more than David, was pre-eminent, and many
parallels were drawn between the events in their lives. The frescoes in the Sistine
chapel depicting on opposite walls the life-cycles of Moses and Christ were
meant to be interpreted in this sense. In other contexts he is seen as a prefiguration
of St Peter. Moses is usually portrayed with a white beard and flowing hair in
the patriarchal style though sometimes, as a younger man, he is beardless. Rays
of light sprout like horns from each side of his head, indeed medieval and early
Renaissance artists gave him true horns. This tradition derived from the use of
the word *cornutam* ('horned') in the Vulgate, to describe Moses' face when he
descended from Mount Sinai with the tablets of the Law: 'the skin of his face
shone'. In the Latin of this period the word also meant 'flashing with rays of
light' or 'haloed'. Other attributes are his rod, or WAND, and the TABLETS, some-
times inscribed with the numbers 1-10 or with extracts from the Commandments.

1. *The finding of Moses* (Ex. 2:1–10). Fearful of the Israelites' growing num-
bers in Egypt, Pharaoh ordered all their male infants to be put to death. Moses'
mother made an ark of bulrushes, laid him in it and put it in the flags by the
river's brink. Pharaoh's daughter and her handmaidens, coming to the river to
wash, found Moses and recognized him as a Hebrew child. Moses' sister who
had been keeping watch at a distance then came forward and offered to find a
Hebrew woman for a nurse. Pharaoh's daughter agreed and by this ruse Moses
was restored to his mother. Moses may be seen still afloat in his ark, which is
represented by northern artists as a flattish osier basket, or, after his rescue,
surrounded by a group of doting women. Renaissance artists, especially Venetian,
depict contemporary courtiers and pages in attendance, with their dogs. The
Nile is sometimes personified in the classical manner as a river-god with an
overturned urn. The episode was seen as a prefiguration of the 'Flight into
Egypt', the Holy Family's escape from Herod's massacre of the innocents.
Stories of heroes who are exposed in infancy and rescued by the hand of fate
occur elsewhere in near-eastern and Greek myth. The authors of Exodus would
have known of the earlier and similar account of the birth of the Babylonian
king, Sargon I, telling how his mother put him in the river in an ark of bulrushes

daubed with pitch. Paintings of the infant Jupiter guarded by Corybantes some-times resemble the Finding of Moses.

2. *The infant Moses: Pharaoh's crown, and the burning coals.* Moses was adopted by Pharaoh's daughter. One day at court Pharaoh jokingly placed his crown on the head of Moses who immediately threw it to the ground and trampled on it. (Josephus, *Jewish Antiquities* 2. 9:7). This was taken as an omen by the courtiers that Moses would overthrow Pharaoh. To test him, two dishes were brought, one containing live coals and the other, cherries, or, according to another version, a ring set with rubies. Moses, guided by an angel, chose the coals and put them in his mouth which was burned. He was thereby proved in-nocent of any treasonable intent. This is later Hebrew legend, probably intended to furnish the aetiology of Moses' apparent speech impediment: 'I am slow of speech, and of a slow tongue.'

3. *Moses slaying the Egyptian* (Ex. 2:11–15). The Israelites were an oppressed race in Egypt. Moses once saw an Egyptian attacking a Jew and sprang into the fray, killing the Egyptian. He buried the body in the sand but the story got abroad and Pharaoh threatened Moses with death. He fled to the land of Midian.

4. *The daughters of Jethro* (Ex. 2:16–22). He came upon the seven daughters of Jethro, the priest of Midian, at a well. They were prevented from watering their father's flock by some shepherds who tried to drive them off. Moses took their side and watered the sheep himself. Having made their acquaintance he was received into their father's house. He married one of the daughters, Zipporah.

5. *The burning bush* (Ex. 3:1–10). While Moses was tending the flock of his father-in-law he came to Mount Horeb where he had a vision of a bush that burned but was not consumed. God spoke to him from the bush telling him that he was destined to deliver the Israelites out of the hands of their oppressors, the Egyptians, and to lead them into Canaan, 'a land flowing with milk and honey.' Moses is depicted kneeling before the bush, or removing his shoes as Moslems do on holy ground. Sometimes his shepherd's crook has turned into a serpent, a miraculous sign of God's presence. (The same miracle was repeated later by Aaron in front of Pharaoh and his magicians.) To the medieval Church the bush, burning but unconsumed, symbolized the Virgin Mary who bore Christ yet kept her virginity intact. There is a type, of Byzantine origin, that shows her enthroned in its flames.

6. *The Passover and the death of the firstborn* (Ex. 12; 13). Moses, as God's instrument, unloosed a series of plagues on Egypt with the intention of forcing Pharaoh to release the Jews from slavery. But each time Pharaoh only became more obstinate. Finally he was threatened with the death of the firstborn sons of all the Egyptians, his own included. At the same time the Jews were told to make specific preparations for their departure: they were to kill a lamb and with its blood make a mark, by tradition a *tau*-cross (T), on the doorposts of their houses; they were to roast and eat the lamb 'with your loins girded, your shoes on your feet, and your staff in your hand, and ye shall eat it in haste: it is the Lord's passover'. That night the destroying angel came, but passed over the Jews whose houses were protected by the identifying mark on the doorpost, and slew only the Egyptian firstborn. This disaster overcame Pharaoh's obstinacy and he at last sent the Jews away. The Passover, though it remains one of the chief religious festivals of Judaism, owes its place in art to the Christian view of it as a foreshadowing of the Last Supper. The participants are shown standing round a table on which lies the lamb, in a state of readiness for their journey, or loading camels and asses in preparation for their departure. Scenes of the death

of the firstborn include in the background dying cattle which were likewise struck down.

7. *The crossing of the Red Sea* (Ex. 14:19–31). To guide the Israelites out of Egypt on the start of their journey to the Promised Land, God showed them the way in the shape of a pillar of cloud by day and a pillar of fire by night. When he learned of their departure Pharaoh set off in pursuit with an army of horsemen and chariots. On reaching the Red Sea Moses stretched out his hand causing a wind to blow so that the water was divided, leaving a dry passage through which the Israelites marched. When the Egyptians followed, Moses caused the water to return, engulfing Pharaoh's army. The Israelites, safe on the farther shore, made a song of thanksgiving and Miriam, Moses' sister, and other women danced for joy, banging tambourines. Pharaoh and his army are shown drowning in confusion while horses and riders struggle in the water. Chariot wheels float everywhere because God, to add to the Egyptians' predicament, had previously removed them. The pillar may take the form of a classical column and may be accompanied by an angel. The Israelites, after the crossing, still carry their belongings in bundles on their heads as peasants do; or they embrace one another or kneel in thanksgiving. The early Church interpreted the episode as a symbol of Christian baptism.

8. *The gathering of manna* (Ex. 16:11–36; Num. 11: 7–9). In the desert there were murmurings against Moses and Aaron when the Israelites began to fear starvation. But God promised to provide for them 'and in the morning . . . when the dew that lay was gone up, behold, upon the face of the wilderness there lay a small round thing, as small as the hoar frost on the ground.' It had a delicious taste 'like wafers made with honey,' and the Israelites gathered it up in large quantities. The stuff was unknown to them so they called it manna, perhaps from the Hebrew meaning 'What is it?' Since the manna was said to have fallen to the earth like dew, the Israelites are sometimes shown holding up baskets as if catching it from the air. Otherwise they gather it from the ground in various receptacles. The subject was seen as a prefiguration of Christ feeding the multitude, or of the Eucharist. Josephus thought that manna was a kind of edible lichen, or honeydew, but it is now identified as the sweet secretion of certain insects.

9. *Moses drawing water from the rock* (Ex. 17:1–7; Num. 20:1–13). The Israelites complained of thirst in the desert so Moses called on God for help. He was told to take his rod and strike a certain rock, when water would issue from it. Moses did so and the people and their flocks were watered. The elders accompanying Moses to the rock are sometimes shown throwing up their hands in thanksgiving while the people drink or fill their pots. A frequent subject in art throughout the Christian era, it was seen as a symbol of the spiritual refreshment drawn by man from the Church.

10. *Moses' arms held up by Aaron and Hur* (Ex. 17:8–13). While they were in the desert the Israelites fought the tribe of the Amalekites. Moses went to the top of a hill overlooking the battle, with Aaron, his brother, and Hur, his brother-in-law. So long as Moses kept his arms raised the Israelites miraculously prevailed but when he let them fall they were driven back. When Moses tired, Aaron and Hur sat him on a rock and each supported an arm until the end of the day, by which time the Amalekites were defeated. His raised arms became a 'type' of the cross of Christ.

11. *Moses receives the tables of the Law; the Israelites worship a golden calf* (Ex. 19; 20; 32:1–24; 37). Moses ascended Mount Sinai and received from God

two tablets of stone on which the Commandments were written. While he was absent the Israelites asked Aaron to give them idols to worship, so Aaron took their gold ornaments and fashioned out of them a golden calf which he placed on an altar. On his return Moses, enraged at their idolatry, threw down and broke the tablets, and destroyed the golden calf. He later returned to Sinai and received new tablets from God. Recognizing the Israelites' need of a material object to worship, he had built a gilded chest, the Ark of the Covenant, guarded by two 'cherubim' of gold, in which the tablets were deposited. Though, according to Exodus, only the voice of God was heard on Sinai, through smoke and fire, his figure is frequently depicted. Moses kneels to receive the tablets. Below him the statue of the golden calf stands on a pedestal or altar, sometimes garlanded, while the Israelites kneel in front of it or dance, beckoned on by Aaron. The several episodes may be incorporated on one picture, or as a cycle, or as separate subjects.

12. *The brazen serpent* (Num. 21:4–9). The Israelites, discontented with life in the desert, spoke out against God and Moses. They were punished with a plague of poisonous snakes which only increased their hardships. Many died of snakebite. When the people repented, Moses sought God's advice how they should be rid of the snakes. He was told to make an image of one and set it on a pole. Whoever was bitten would be cured when he looked upon the image. Moses accordingly made a serpent of brass on a *tau*-shaped (T) pole, which proved to have a miraculous curative effect. The Israelites are depicted writhing on the ground, their limbs entwined by snakes. Moses, sometimes with Aaron, stands beside the brazen serpent. John's gospel furnishes the typological parallel: 'This Son of Man must be lifted up as the serpent was lifted up by Moses in the wilderness.' Medieval art juxtaposed the subject with the serpent in the Garden of Eden entwining the Tree of Knowledge. Both probably derive from an ancient and widespread fertility image, the 'asherah', associated with the worship of Astarte, which consisted of a snake and a tree representing respectively the male and female elements. King Hezekiah destroyed the asherah, by inference the one made by Moses, at a time when the Israelites were relapsing into idolatry (II Kings 18:4). (See also TRUE CROSS, HISTORY OF THE.)

13. *Death of Moses* (Deut. ch. 34). Moses died in Moab within sight of the Promised Land, but never entered it himself. His body is depicted lying on a hilltop, mourners standing round. (Signorelli, Sistine chapel wall fresco). A medieval legend, occasionally depicted, tells that Satan attempted to make off with the body of Moses but was repulsed by St Michael.

Mountain. The *impresa* of some members of the house of Gonzaga, bestowed by Charles V on Federigo (1500–1540), the son of Gianfrancesco II and Isabella d'Este, for his defence of Pavia in 1522 against the French. It may be surmounted by an altar or a tomb and bear the motto 'ΟΛΥΜΠΟΣ' (Olympus) or 'Fides.' It is sometimes surrounded by the Gonzaga LABYRINTH. It is found frequently in the decoration of Gonzaga buildings, for example the Palazzo Te, Mantua.

Impresa of the House of Gonzaga

Mucius Scaevola (Livy 2:12–13). A hero of Roman legend. When the Etruscan forces, led by Lars Porsena, king of Clusium, were besieging Rome, a young Roman nobleman, Caius Mucius, succeeded in penetrating the enemy lines in disguise, meaning to kill Porsena. By mistake he

killed the king's secretary who was sitting beside him. Mucius was seized but, to show how cheaply he held his life, thrust his right hand into the flames of an altar fire and let it burn. Porsena, amazed at his endurance, set him free. He was thereafter called Scaevola, meaning 'left-handed'. Porsena, on a dais, rises to his feet. The body of the secretary slumps beside him, or is being carried off. Mucius stands with his hand in the flames of a brazier which burns on a tripod. His sword lies beside him on the ground. Forgetful artists may show Mucius wearing a Roman helmet, and even depict a standard bearing the motto 'S.P.Q.R.' (*Senatus populusque Romanus.*) In painting, of the Renaissance and later, Mucius stands for the virtues of patience and constancy. Thus the figure of CONSTANCY personified may have a brazier for attribute. His sacrifice was also held to be a prefiguration of Christ's sacrifice.

Multiplication of loaves and fishes, see FEEDING OF THE FIVE THOUSAND.

Muses. The goddesses of creative inspiration in poetry, song and other arts; the companions of Apollo. They were the daughters of Jupiter and the Titaness Mnemosyne (Memory) who had lain together for nine consecutive nights. The Muses were originally nymphs who presided over springs that had the power to give inspiration, especially Aganippe and Hippocrene on Mount Helicon (see MINERVA, 2) and the Castalian spring on Mount PARNASSUS. The latter eventually became their accepted abode. Thus fountains and streams often feature in pictures of the Muses. In time their number was established as nine and each acquired her sphere of influence over learning and the arts. Their attributes, particularly their musical instruments, are liable to change at different periods, making identification difficult; in the 17th and 18th cents. some may be without attributes. The most constant are the globe and compasses of Urania and Euterpe's flute. From the 17th cent. the attributes given in Ripa's *Iconologia* were generally followed.

Clio (Muse of history), BOOK, SCROLL or TABLET and stylus; occasionally a SWAN; from 17th cent., the book may be 'Herodotus' or 'Thucydides'; laurel CROWN; TRUMPET.

Euterpe (music, lyric poetry), flute, often double (see PIPE), or occasionally TRUMPET or other instrument; from 17th cent. her hair garlanded with flowers.

Thalia (comedy, pastoral poetry), SCROLL; small VIOL, more rarely other instruments; from 17th cent., MASKS.

Melpomene (tragedy), HORN; tragic MASKS; from 17th cent., SWORD or DAGGER; CROWN held in hand; SCEPTRES lying at feet. (Stage properties.)

Terpsichore (dancing and song), VIOL, LYRE, or other stringed instrument; from 17th cent., often a HARP; crowned with flowers.

Erato (lyric and love poetry), TAMBOURINE, LYRE, more rarely a TRIANGLE or VIOL; occasionally a SWAN; from 17th cent., a PUTTO at her feet.

Urania (astronomy), GLOBE and COMPASSES; from 17th cent., crowned with a circle of stars.

Calliope (epic poetry), TRUMPET; TABLET and stylus; from 17th cent., BOOKS (*Iliad, Odyssey, Aeneid*); holds laurel CROWN.

Polyhymnia (or Polymnia) (heroic hymns), portative ORGAN, more rarely a LUTE or other instrument.

Musical instruments. Apart from their place in narrative themes and as attributes, musical instruments have an equally precise meaning as symbols of love. The phallic significance of the various pipe instruments had been widely recognized since antiquity, and medieval astrology taught that musicians of all kinds were among the 'children' of Venus. In many scenes of lovers together the man plays

Pipe instruments: left to right, *Bagpipe, Cromorne, Double flute, Shawm, Syrinx* (see PIPE)

Stringed instruments: left to right, *Lira da braccio* (see VIOL), *Two versions of the lyre, Lute, Psaltery*

Portative organ (see ORGAN)

an instrument. They are contrasted with weapons of war in the scene of Venus and Mars (VENUS, 8), 'Love the Conqueror' (CUPID, 5), and in the popular allegory of the young man who puts down his sword in exchange for a musical instrument. In allegories of virtue and vice they are found on the side of the latter. See also individual instruments: BAGPIPE; HARP; LUTE; LYRE; ORGAN; PIPE; PSALTERY; TAMBOURINE; TRUMPET; VIOL.

Myrtle. Evergreen shrub, sacred to VENUS in antiquity, her attribute and that of her handmaidens the THREE GRACES. To the Renaissance, since it was forever green, it symbolized everlasting love, in particular conjugal fidelity. A sprig of myrtle offered to a sleeping warrior, SCIPIO (2).

Nailing to the Cross, see RAISING OF THE C.

Nails. Symbols of Christ's Passion, usually three in number. According to a medieval legend they were discovered, with the cross, by HELENA, whose attribute they are. (See TRUE CROSS, HISTORY OF THE.) They are the attribute of the Hellespontic SIBYL and, with other instruments of the Passion, of JOSEPH OF ARIMATHAEA, BERNARD of Clairvaux and LOUIS IX. They protrude from the fingers of a bishop, ERASMUS.

Napoleon Orsini, Resurrection of, see DOMINIC (5).

Narcissus and Echo. The story of a handsome youth and the nymph who loved him but whose love was not returned. In Ovid's sad rendering of the myth (*Met.* 3:339–510) Echo was condemned by the goddess Juno to repeat only the last words that were spoken to her; Narcissus, as a punishment for spurning Echo, was made to fall in love with his own reflection, and pined away gazing at himself in a pool. At his death he was changed into the flower that bears his name, and Echo in sorrow wasted away until nothing but her voice remained. Narcissus is often depicted alone, leaning over the edge of a pool or fountain. At his feet narcissi bloom. Or he lies dead beside the water while Echo, pale and ghostlike in the background, grieves over him. The subject occurs not only in painting and sculpture but also in the style of tapestry known as 'millefleurs', to which flower themes are appropriate. The ancient world believed that a man's soul was contained in his reflection and that to dream of it was an omen of death. To the Greeks therefore the fate of Narcissus was readily understandable. The narcissus flower itself became a symbol of youthful death. See also FLORA, (2).

Natalia, see ADRIAN.

Nativity. Only Matthew and Luke describe Christ's nativity. It was perhaps their brevity and absence of detail that led the Middle Ages to devote so much industry to amplifying it. Matthew (2:1–12) tells of the wise men and their gifts, Luke (2:1–20) of the infant laid in the manger and of the shepherds, led by an angel, who came to worship. By the end of the Middle Ages legend had transformed the wise men from priests into kings accompanied by their retinues, the OX AND ASS had appeared in the stable, the shepherds were bearing their own humble gifts and the Virgin herself knelt in adoration.

1. *Setting.* Matthew tells of the wise men following the star and simply 'entering the house'. Luke says that Mary laid the infant 'in a manger because there was no room for them to lodge in the house'. Mention of the cave is made first in the early apocryphal Book of James. 'And he found a cave there and brought her into it ... And behold a bright cloud overshadowing the cave ... The cloud withdrew itself out of the cave and a great light appeared in the cave so that our eyes could not endure it. And by little and little that light withdrew itself until the young child appeared: and it went and took the breast of its mother Mary.' The apocryphal Gospel of Pseudo-Matthew (?8th cent.) is the first

to mention the ox and ass. 'An angel made her dismount and enter a dark cave which began to shine . . . On the third day Mary left the cave and went to a stable and put the child in the manger, and the ox and the ass adored him.' It is often a night scene, as it should be. The building is usually dilapidated, a symbol of the Old Dispensation which had been superseded by the birth of the Redeemer (see RUINS).

2. *Adoration of the Virgin.* The image of the Virgin kneeling in adoration follows the account by St Bridget of Sweden who visited Bethlehem in 1370 and wrote in her *Revelations* of her vision of the Virgin. 'When her time came she took off her shoes and her white cloak and undid her veil, letting her golden hair fall on her shoulders. Then she made ready the swaddling clothes which she put down beside her. When all was ready she bent her knees and began to pray. While she was thus praying with hands raised the child was suddenly born, surrounded by a light so bright that it completely eclipsed Joseph's feeble candle.' This devotional treatment sometimes forms the basis of a Sacra Conversazione with attendant saints and perhaps donors.

3. *The two midwives.* The eastern Church had a different tradition of the Nativity. Byzantine artists showed an actual confinement with the Virgin reclining on a bed and two midwives in attendance, one of them washing the infant. The apocryphal Book of James relates that one of the midwives, Mary Salome, denied that Mary could have given birth and still remain a virgin intact, and examined her for proof. Her arm shrivelled on touching Mary, but was made whole again when she picked up the child. This theme, which is also found in western art, disappeared altogether after its condemnation by the Council of Trent in the mid-16th cent.

4. *The Virgin standing.* Another account was given in the 14th cent. by Pseudo-Bonaventura (Giovanni de Caulibus) in his *Meditations.* 'The Virgin arose in the night and leaned against a pillar. Joseph brought into the stable a bundle of hay which he threw down and the Son of God, issuing from his mother's belly without causing her pain, was projected instantly on to the hay at the Virgin's feet.' The pillar sometimes features in the structure of the stable, and a sheaf of hay or straw lies on the ground. See further JOSEPH, husband of the Virgin; ADORATION OF THE MAGI; ADORATION OF THE SHEPHERDS.

Nativity of the Virgin. The scene following the meeting of JOACHIM AND ANNE at the Golden Gate and preceding the PRESENTATION OF THE VIRGIN, in the cycle of the life of the Virgin Mary. The gospels make no reference to Mary before the ANNUNCIATION, and scenes of her birth and childhood were drawn from the *Golden Legend.* That work drew on the very early apocryphal New Testament literature, in particular the Protevangelium or Book of James, which says of Anne's confinement, 'And her months were fulfilled, and in the ninth month Anne brought forth. And she said unto the midwife, "What have I brought forth?" And she said, "A female." And Anne said, "My soul is magnified this day," and she laid herself down.' The scene, which is seldom represented before the 14th cent. shows a chamber with Anne in the background lying on her bed, perhaps attended by midwives, while to the fore the infant Mary is being bathed by other women. Neighbours arrive bringing gifts, as at the birth of JOHN THE BAPTIST. Since Joachim was a wealthy man the room may be richly appointed. In the 16th cent. the scene is sometimes set in the nave of a church, perhaps an allusion to the child Mary being 'consecrated to the Lord,' and brought up in the Temple. Though the Council of Trent aimed to purge apocryphal elements from the Christian story, the nativity of the Virgin continued to be represented

in the 17th cent. The celebration of the event as a Church festival led to some elaboration in its portrayal, for example by introducing attendant angels who sometimes descend on clouds from heaven. An aged Joachim, the husband of Anne, may be seen gazing (rather like Joseph in the HOLY FAMILY or in Christ's NATIVITY) at the infant who lies in the lap of a midwife.

Nausicaa, see ULYSSES (5).

Navicella, see CHRIST WALKING ON THE WAVES.

'Ne desperetis vos . . .,' see MARY MAGDALENE.

'Nel mezzo del' chamino di nostra vita . . .,' see DANTE AND VIRGIL.

Nemean lion, see HERCULES (1).

Nemesis. In Greek mythology one of the daughters of Night who brought retribution upon those whose natures were hardened by pride, or *hubris*. The figure of Nemesis resembles that of the goddess FORTUNE with whom she has some affinities, since both can bring about man's undoing. Both are represented as naked women, winged, BLINDFOLD, with a terrestrial GLOBE for a footstool. In one hand Nemesis holds a BRIDLE or a ROPE with which she binds man's pride, in the other a VASE containing riches and honour to reward the just. Her victims may crouch at her feet.

Neoptolemus, see POLYXENA.

Neptune (Gk Poseidon). In classical mythology the god who ruled the sea and its inhabitants. Sailors invoked him to ensure a safe voyage, though when roused to anger he would cause storms and shipwrecks. He is portrayed as an old man with copious locks and beard. In antique art he is serene and majestic like Jupiter; in Renaissance and baroque painting he is often haggard, his hair streaming in the wind. He can easily be recognized by his TRIDENT, the three-pronged, sometimes barbed, fork. He may be astride a DOLPHIN, sacred to him in antiquity. His chariot is drawn by HIPPOCAMPI, or sea-horses, which have the fore parts of a horse and the hind parts of a fish. He is sometimes accompanied by his wife, the Nereid, or sea-nymph, Amphitrite, and their son TRITON, a merman, who blows a conch horn. Other Tritons – the name for mermen in general – and Nereids play round them. (They may have normal human legs instead of fish-tails.) Neptune appears among the other gods in the BATTLE OF GODS AND GIANTS, and is present at the wedding of Thetis and Peleus. (See BANQUET OF THE GODS.) As a marine deity he is portrayed beside Mars as c : of the protectors of Venice. In allegories of the FOUR ELEMENTS he personifies Water. To the Greeks Poseidon was also the god of horses. He created the first horse (See MINERVA, 1) and was father of the winged horse PEGASUS.

1. *The triumph of Neptune.* Amphitrite fled from Neptune's wooing, but he sent dolphins after which succeeded in persuading her to return to become his bride. She rides beside his chariot on a dolphin's back or in a cockle-shell car drawn by dolphins. An arch of drapery billows over her head, a common feature of sea-goddesses from antiquity. They are surrounded by a retinue of Tritons and Nereids.

2. *Neptune calms the waves; the wrath of Neptune; 'Quos ego'.* At the beginning of the *Aeneid* (1:125–143) Virgil tells how, after the sack of Troy, the defeated remnant of the Trojans, led by Aeneas, made off by sea. The goddess Juno who had taken the side of the Greeks throughout the war, still pursued the Trojans with her vengeance. She causes the god of the winds to unloose a great storm. This intrusion into his domain angered Neptune and he calmed the waves, but not before several Trojan ships had been sunk. Neptune stands in the midst of the waves on his chariot which is drawn by prancing sea-horses. He brandishes

his trident at the winds who are seen as faces emerging from the clouds, their cheeks puffed out. In the background are the Trojan ships, perhaps sinking with men and cargo bobbing in the waves. 'Quos ego' is Neptune's unfinished threat to punish the winds: 'Audacious winds! *Whom I . . .*' ('. . . shall deal with,' implied).

3. *Neptune rescues Amymone.* Amymone, a Danaid (one of the fifty daughters of King Danaus of Argos) was loved by Neptune who once rescued her from the unwelcome embraces of a Satyr. He is depicted riding away on a dolphin holding Amymone by the waist. In the distance a Satyr gives up the chase.

4. *Neptune surprises Caenis* (*Met.* 12:189–207). Caenis, a maiden famed for her beauty, was once ravished by Neptune when he discovered her wandering by the sea-shore. She found the experience so disagreeable that she prayed to be turned into a man, and this was granted. Neptune stands on the shore embracing Caenis, while her attendants in a nearby bower make gestures of despair. His chariot, harnessed to sea-horses, stands waiting in the waves. The theme somewhat resembles that of Amymone above.

5. *Neptune, Minerva and Coronis* (*Met.* 2:569–594). Coronis, the daughter of Coroneus, king of Phocis, was loved by Neptune. She called on the gods to help her escape his embraces. Her plea was heard by Minerva who turned her into a crow and carried her up to heaven. The subject occurs in baroque painting and shows Minerva looking down from the clouds at the maiden who is sprouting wings. Neptune, below, reaches out in vain towards her.

Nereids. Sea-nymphs, the daughters of Nereus, the 'old man of the sea' in Greek mythology. They are sometimes depicted reclining on the backs of hippocampi, or sea-horses. With the TRITONS they are the attendants of NEPTUNE and his wife Amphitrite (herself a Nereid), and play round them in the waves. Other Nereids were GALATEA, whom they also escort, and Thetis, the mother of ACHILLES.

Nero before the body of Agrippina (Tacitus, *Annals*, 14). Agrippina, an overbearing woman, the mother of the Roman emperor Nero, stood in the way of his wishes concerning divorce and remarriage, so he had her murdered (59 A.D.). He first tried unsuccessfully to have her drowned. She finally met her end when an ex-slave, Anicetus, led a group of armed men to her bedchamber, and she died by the sword. Nero was said to have arrived later and inspected the corpse, praising her appearance. (She was about 44 years old.) He is shown standing over a female body that lies on a couch, naked to the waist. It has jewels in the hair, indicating Agrippina's former rank. A figure in the background may be Anicetus. (Pittoni, Dresden Gall.)

Nero before the body of Seneca, see SENECA. See also PETER, apostle (12).

Nessus, a centaur, see HERCULES (23).

Net. The attribute of the apostle ANDREW. Lovers under a net are Venus and Mars (VENUS, 8).

Nicholas of Myra, or **Bari.** One of the most popular Christian saints, the patron of children, sailors and travellers, the guardian of nubile maidens, and the prototype of Father Christmas. In spite of all this and much more besides, the Catholic Church, recognizing his uncertain origins, officially removed him from the Calendar in 1969, though still permitting him to be venerated locally. All that is known for certain is that Nicholas was bishop of Myra in Asia Minor in the 4th cent. His remains were said to have been taken to Bari in Italy in the 11th cent. Legend records that he was of such precocious piety that on the day of his birth he stood up in his bath with his hands joined in thanksgiving, and while still at his mother's breast abstained from feeding on fast days. As a

devotional figure he is portrayed in bishop's vestments, holding the crozier, and is generally of middle age. His attributes are three golden BALLS or PURSES, lying at his feet or placed on a book (see 1, below), three children in a tub (see 2, below), an ANCHOR as the patron of sailors (which he shares with CLEMENT, who however wears a papal tiara). Among his inscriptions are 'Salve regina mundi,' – 'Hail, Queen of the World' – from the Breviary, and 'Diligite iustitiam qui iudicatis terram' – 'Love righteousness, ye that be judges of the earth' (Wisdom 1:1). Narrative themes from the life of Nicholas are very numerous, mostly telling of his powers as a worker of miracles. They are to be seen widely in the windows of Gothic cathedrals and in Italian Renaissance frescoes. The best-known are as follows:

1. *The charity of St Nicholas.* The *Golden Legend* tells how Nicholas came to the help of a nobleman who was so poor that he was obliged to give over his three daughters to a life of prostitution. On three successive nights the saint threw a bag of gold through the nobleman's window to provide a dowry for each daughter. He was discovered on the third night but persuaded the father to tell no one. Nicholas, dressed as a citizen, is seen throwing a purse, or a golden ball, through the window, while inside the nobleman sits with head in hands. The daughters are asleep in bed or sit weeping.

2. *The three school-children.* During a famine Nicholas lodged with an inn-keeper who had murdered three children and salted down their dismembered bodies to feed his guests. Nicholas miraculously restored them to life. The children are seen standing naked in a pickling tub while the saint, in bishop's robes, makes the sign of the cross over them. The host kneels, begging forgiveness, or flees through the door. The story is thought to have arisen out of another concerning three soldiers who were saved by Nicholas from being unjustly executed. In medieval stained glass the soldiers stand in a tower representing their prison. As was the custom, the saint's stature was greatly enlarged in relation to the other figures, which therefore were the size of children, beside him. In due course, when the original legend was forgotten, the story of the school-children was invented to explain the discrepancy in size.

3. *The famine at Myra.* At a time of famine when sacks of corn were being unloaded from vessels in the harbour at Myra, the saint miraculously multiplied their number. He stands watching men bear away the grain while angels replenish the boats. The theme has echoes of the feeding of the five thousand.

4. *St Nicholas calms the storm.* A 'posthumous' miracle. Nicholas, invoked by sailors whose vessel is sinking, appears overhead and calms the waves.

5. *The nobleman's son taken captive.* A youth, taken captive by a cruel heathen king and made to serve as his cupbearer, spoke of St Nicholas before his master, provoking him to blaspheme in the saint's name. Nicholas appeared overhead in a cloud of glory and bore the lad away, back to his family. The scene is a banquet where confusion reigns. The king and his courtiers, in oriental dress, look up in astonishment at Nicholas, wearing bishop's robes, who holds the youth in his arms.

See also MARK, 2.

Nicholas of Tolentino (*c.* 1246–1305). An Augustine hermit who devoted his life to preaching and good works. Numerous miracles were attributed to him, some apparently derived from his namesake Nicholas of Myra. Like SEBASTIAN and ROCH he was invoked against the plague. He wears the black habit of the Augustine Order. A STAR on his breast alludes to the star or comet that was said to have been seen at his birth. Two pigeons lying on a dish, or flying away, refer to

the story that he restored to life a dish of roast birds that were brought to him while he lay sick. His commonest attribute is a CRUCIFIX entwined with lilies and held in his hand. His effigy is found in Italian and Spanish painting of the 15th to 17th cents, especially in churches of the Augustinian Order. He often stands beside AUGUSTINE and MONICA. He was canonized in 1446.

Nicodemus, Christ instructing. Nicodemus was a Pharisee and a member of the Sanhedrin, the council of Jews in Jerusalem. He came to Christ by night to receive teaching from him (John 3:1–21). In memorable words Christ discoursed among other things upon the need for spiritual rebirth through baptism, likening the spirit of God to the wind that 'bloweth where it listeth, and thou hearest the sound thereof, but canst not tell whence it cometh, and whither it goeth.' The two are seated at a table in candlelight, or Nicodemus stands respectfully before Christ. Nicodemus also took part at the burial of Christ; see DESCENT FROM THE CROSS; PIETÀ; ENTOMBMENT.

Night. To Renaissance humanists Night and Day were destructive powers since they ceaselessly marked the passage of time that led inexorably to decay and death. Hence they were sometimes represented as a pair of rodents, generally RATS, one black and one white. The figure of Night personified floats in the sky, sometimes under a blue canopy studded with stars. She may hold a child in each arm, a white one who is Sleep, a black one, Death. Her usual attributes are an OWL, MASKS (which may be worn by putti) and POPPIES, sometimes worn as a crown. She may be accompanied by the sleeping Morpheus, the god of dreams, who may likewise be crowned with poppies (Giordano, Palazzo Riccardi, Florence). Or she sits in the lamplight with folded wings, her head in her hands, the two children asleep nearby. (See also SLEEP, KINGDOM OF.)

Nilus (910–1004). A Greek from Calabria in southern Italy who entered the monastic life in his middle years after the death of his wife and child. He became abbot at San Demetrio Corone. During Saracen attacks in the south he and his followers took refuge with the Benedictines at Monte Cassino, and later at Rome. He opposed the Holy Roman Emperor Otto III over a matter concerning the papal succession. The Greek monastery of St Basil which stands at Grottaferrata near Frascati, not far from Rome, takes St Nilus for its founder because he was said to have retired there with his monks shortly before his death. Among the frescoes at Grottaferrata, by Domenichino, are representations of the visit of a repentant Otto III to seek absolution from the saint, and the episode of the healing of an epileptic boy which Nilus brought about by anointing the boy's lips with oil from an altar lamp.

Nimbus, see HALO.

Niobe. An example from Greek mythology of pride humbled. Niobe was the daughter of Tantalus and wife of Amphion, king of Thebes. She once tried to dissuade the Theban women from worshipping Leto, the mother of APOLLO and DIANA (Artemis), boasting of her own superiority both in the matter of her family connections (she was the granddaughter and the daughter-in-law of Jupiter), and in the number of her offspring (seven sons and seven daughters) (*Met.* 6:146–203). Apollo and Diana with their customary ruthlessness punished her arrogance by killing all her children. Niobe in her grief was turned to stone, which however continued to shed tears. She is occasionally depicted trying to turn the Theban women away from the temple but the more usual theme is the massacre of her children.

The death of Niobe's children (*Met.* 6:204–312). The scene is a woodland clearing where maidens and youths, the latter sometimes on horseback, are

fleeing from the arrows that rain upon them from heaven. Many have already found their mark and the ground is littered with dead and dying. Niobe throws up her arms imploringly or sits with a dead child in her lap. Apollo and Diana lean over a cloud-bank with bows drawn.

Noah. Descended from Adam and Eve through their son Seth. Noah's sons were Shem, Ham and Japheth. Noah is one of the principal patriarchal 'types' of Christ. He is usually portrayed as an aged white-bearded man. The flood was likened to Christian baptism by the early Fathers and apologists. The ark was a frequent subject in Christian art from its beginnings. In the Roman catacombs it stood for the new Christian concept of the Resurrection, perhaps because the convert would already be acquainted, through Greek and Egyptian myth, with the idea that the dead took a journey by boat to the next world. A SHIP soon became the established symbol for the Church itself. Accounts of a great flood occur in the folk-history of peoples throughout the world. The Greek myth of DEUCALION AND PYRRHA has features similar to the Genesis story.

1. *Building the ark* (Gen. 6:14–22). At the sight of man's wickedness God determined to destroy the human race together with the birds and beasts. He excepted Noah who was a just man, and commanded him to build an ark and take on board two of every kind of living thing. Artists tended to ignore the structural details given in Genesis. In earliest Christian painting in the Roman catacombs the ark is a simple coffin-shaped box; in medieval art, a kind of floating house; in the Renaissance it becomes a true boat and Noah's sons are seen at work sawing the timbers, under his supervision. When the ark is finished Noah shepherds the animals on board.

2. *The Flood* (Gen. 7, 8:1–19). It rained for forty days and nights until even the mountains were covered, and the flood lasted for one hundred and fifty days. When the water began to subside the ark came to rest on Mount Ararat. To discover whether the earth was habitable Noah sent off a raven which did not return. He then twice sent a dove which returned the second time with an olive leaf in its beak. The third time it did not return. Noah led out his family and the animals so that they might be 'fruitful and multiply upon the earth.' The wicked are depicted fleeing from the rising waters. The ark floats amid the pouring rain. Animals stand on deck or sometimes peer through portholes.

3. *The sacrifice of Noah* (Gen. 8:20–22, 9:1–17). As a thanksgiving Noah built an altar and made sacrifice. And God said 'My bow [rainbow] I set in the cloud, [as a] sign of the covenant between myself and earth.' Noah and his family are before the altar, perhaps gazing up to heaven in wonder.

4. *The drunkenness of Noah* (Gen. 9:20–27). Noah tilled the ground and planted a vineyard. Having imbibed too much wine he lay in his tent, naked and stupefied with liquor, and was observed by Ham who told his two brothers. Shem and Japheth came with a cloak. They approached Noah, walking backwards so that they would not see him naked, and laid the cloak over him. 'When Noah woke from his drunken sleep, he learned what his youngest son had done to him.' He laid a curse on Ham's son Canaan. Occasionally Noah is portrayed planting and harvesting his vines, but the usual versions show him in his tent or under an arbour hung with vines. He is slumped in a seat or on the ground, a wine cup beside him, while Ham stands nearby deriding him. The other sons may also be present, covering him with a cloak. The mocking of Noah was seen as a prefiguration of the mocking of Christ on the cross. Rabbinic commentary stated that Ham not merely saw his father's nakedness but that he castrated him, an element that was perhaps deliberately omitted from Genesis. This form of the

story suggests a connection with the myth of Uranus and Cronus. (See SATURN, 1).

'Noli me tangere,' see MARY MAGDALENE (3).

'Nostra Domina de Humilitate,' see VIRGIN MARY (11).

Norbert (*c*. 1080–1134). German nobleman of the court who underwent sudden conversion and became an itinerant preacher. He established a monastic community based on the Augustinian rule at Prémontré, near Laon, which later became known as the Premonstratensians. The name was said to be derived from Norbert's vision of the Virgin who showed him a field (*pré montré*), the place where he should settle. He was made archbishop of Magdeburg in 1126 where he died. A reformer and a vigorous personality, he aroused opposition within the Church. Norbert is represented in German art wearing bishop's robes, with mitre and crozier. He may hold a MONSTRANCE, in allusion to the name of his Order. Or he holds a CHALICE with a spider in it, from the legend that he found a poisonous spider in the cup as he was about to receive the sacrament. He drank, rather than spill the sacred wine, and was unharmed. A demon bound at his feet alludes to his own conversion. He is depicted preaching at Antwerp before Tankelin, a dissenter against Christian sacraments and official priesthood, who held, among other things, that wives as well as goods should be held in common. 'A sort of atheist and socialist of those days,' Anna Jameson remarks tartly.

Nudity. The response of moralists to the portrayal of nudity has in all ages lacked unanimity. Pliny (*Nat. Hist.* 36:20–22) relates that a nude Venus by Praxiteles was rejected by the islanders of Cos, but eagerly purchased by those of Cnidos. In the Old Testament the eulogy of the female body in the 'Song of Songs' is contrary to the generally prevailing sentiment of the ancient Hebrews, such as is expressed by Jeremiah (13:26), 'So I myself have stripped off your skirts and laid bare your shame.' To the Romans nakedness signified not only shame but poverty. The Church in the Middle Ages saw four different aspects of nudity: *Nuditas naturalis* was exemplified by ADAM AND EVE before the Fall, or the nakedness of martyrs such as SEBASTIAN or the resurrected at the LAST JUDGEMENT. *Nuditas temporalis* was nakedness in the figurative sense of absence of worldly possessions, either as a result of poverty, like JOB'S, or from a deliberate act like that of FRANCIS OF ASSISI (2) or the penitent MARY MAGDALENE. *Nuditas virtualis* was a quality of sinlessness maintained in daily life, akin to the nakedness of TRUTH. *Nuditas criminalis*, the ancient sin condemned by the prophets, was embodied in representations of the pagan gods and goddesses, the vices and Satan. In the 14th cent. nude figures of the virtues began to be represented in ecclesiastical art, in addition to the scriptural themes to which nudity properly belonged. Thus in the illustrations of Psalm 85:10 naked Truth was seen beside robed Mercy. The nude human figure was an essential element in the rebirth of classical antiquity in art. The growth of the new, lay, artistic patronage helped to remove it from the censure of the Church. The Florentine humanists went further and taught that, of the two aspects of love, divine and earthly, the former, the superior, was to be personified as a naked woman to signify contempt for the things of the world. The latter was richly attired and adorned with jewels, the symbols of earthly transience. (See VENUS, 1, *Sacred and profane love*.) The Church's attitude from this time was ambivalent. The portrayal of nudity which had become acceptable in religious art during the Renaissance was officially condemned by the Council of Trent except for subjects that specifically demanded it. Individual ecclesiastics, however, who were patrons of art, had freely commissioned subjects from pagan mythology, albeit clothed in moral allegory, and

continued to do so. One may cite Correggio's frescoes in the Camera di San Paolo at Parma (1518), which were once the apartments of the abbess of a convent; and the decoration of the Farnese Palace in Rome by two of the Carracci brothers for Cardinal Odoardo Farnese at the turn of the 16th-17th cents. Nudity is rare in Spanish painting.

'Nunc dimittis, Domine,' see PRESENTATION IN THE TEMPLE.

Nut. A split walnut, a Christian symbol, VIRGIN MARY (13); STILL LIFE.

'Nutrisco et extingo,' see SALAMANDER.

Nymphs. In ancient Greece young and beautiful female spirits who were believed to inhabit certain classes of natural objects. For instance the NEREIDS, daughters of Nereus, the old man of the sea, were the nymphs of the Aegean; among them were GALATEA and THETIS. Naiads were the nymphs of fresh water: see ALPHEUS AND ARETHUSA, and HYLAS. Both JUPITER (1) and BACCHUS (1) were nurtured in their infancy by the nymphs of mountains and grottoes (Oreads). The chaste companions of DIANA are loosely called nymphs. Armed with bows, arrows and quivers they go hunting with their mistress, or bathe with her in secluded woodland pools. They are frequently harassed by the lecherous SATYRS. As guardians of chastity the nymphs punished CUPID by breaking his weapons. The goddess Calypso was attended by nymphs (see TELEMACHUS).

'O vos omnes qui transitis . . .,' see JEREMIAH.

Oak. The tree sacred to Jupiter and to the ancient Druids; hence a bishop in the act of baptizing while his foot rests on a fallen oak, symbolizes the conversion of the pagan (BONIFACE). An oak, or often an acorn, is the *impresa* of popes Sixtus IV and Julius II of the della Rovere family. The latter was the patron of Raphael who executed for him the paintings in the Vatican *stanze*, where the *impresa* may be found.

Oar. A secondary attribute of the river-god, see URN; sometimes of JULIAN THE HOSPITATOR.

Obedience. In Gothic art the figure of Obedience is accompanied by an ASS with a millstone. On her shield is a kneeling CAMEL. She is opposed by Rebellion (Lat. *Contumacia*) who wears a Jewish conical cap and strikes a bishop. The ass survived into the Renaissance but was then replaced by the YOKE of the Christian faith, from Matthew (11:29–30), 'My yoke is good to bear.' Obedience, POVERTY and CHASTITY are the three virtues to which monastic life is dedicated and they appear together in the art of the Franciscan Order. A fresco in the lower church at Assisi, formerly attributed to Giotto, representing Obedience, depicts an abbot placing a yoke on the shoulders of a kneeling monk.

Obeisance. An act of reverence or respect by one person, generally kneeling, towards another. But see also SUPPLICATION, similar in appearance. Before the infant Christ, ADORATION OF THE MAGI, and ADORATION OF THE SHEPHERDS; the child Mary before the high priest, PRESENTATION OF THE VIRGIN; Elizabeth, mother of John the Baptist, before the Virgin, VISITATION; emperor before a pope, the Donation of Constantine, CONSTANTINE THE GREAT (3); a nun before Francis of Assisi, CLARE (1); FRANCIS BORGIA before Ignatius of Loyola; a ragged youth before his father, PRODIGAL SON (3); a monk receiving the habit from Dominic, HYACINTH; a monk receiving a scapular from the Virgin, SIMON STOCK; a warrior receiving the habit from Benedict, WILLIAM of Aquitaine; and in general, authors presenting their books to patrons. An emperor advancing humbly towards an abbot, NILUS; ambassadors before a king, URSULA. See also DONOR.

Occasio, see OPPORTUNITY.

Octavian, Roman emperor, see CLEOPATRA (2); SIBYL.

Odysseus, see ULYSSES.

Oedipus and the Sphinx. In Greek mythology Oedipus was king of Thebes. The tragic story of his quest for truth began with his confrontation with the Sphinx. This monster had a woman's head and breasts, the body of a lion, a serpent's tail and eagle's wings. It accosted Theban wayfarers with the riddle: 'What goes on four feet, on two feet and three, but the more feet it goes on the weaker it be?' Those who failed to answer were throttled. Oedipus destroyed the Sphinx by giving the correct reply: Man – who goes on all fours as an infant and uses a stick in old age. We see Oedipus pondering before the Sphinx. The bones of the monster's victims are scattered on the ground.

Oenone, a Naiad, see PARIS; JUDGEMENT OF PARIS.

'Oleum et operam perdis', see ALCHEMIST.

Olindo and Sophronia. Young lovers whose story is told in *Jerusalem Delivered,* the romantic epic of the first Crusade, by the Italian poet Tasso (1544–95). As a Christian Sophronia was condemned to death at the stake by the Saracen king for supposed complicity in a plot concerning a holy image. Olindo chose to die with her. At the last moment Clorinda, a female mercenary from the east, a kind of pagan Joan of Arc, took pity on the lovers, and offered her services to the king in the coming struggle with the crusaders, in return for their release. They are depicted tied to a stake. Executioners bring faggots. Clorinda, on horseback and in full armour, is appealing for clemency to the Saracen king who watches the proceedings. (Giordano, Palazzo Reale, Genoa). See TANCRED AND CLORINDA for the latter's death.

Olive. The olive branch was an ancient symbol of peace (see AENEAS, 9); it is hence the attribute of PEACE personified, also of the Golden Age (one of the AGES OF THE WORLD) and, in medieval art, of CONCORD. It was sacred to MINERVA (1) who caused an olive tree to sprout during her contest with Neptune. It is her attribute and that of WISDOM whom Minerva personifies. The sprig of olive brought back to the ark by the dove (NOAH, 2) symbolized to Christians the making of God's peace with man. An olive branch is the attribute of the archangel Gabriel in some representations of the ANNUNCIATION; of the VIRGIN MARY (4, 12); and of AGNES. Those who come to meet Christ on his ENTRY INTO JERUSALEM are sometimes depicted carrying olive branches.

Olivetans, see FRANCES OF ROME.

ΟΛΥΜΠΟΣ, see MOUNTAIN.

'Omnia Vanitas,' see VANITY.

'Omnia vincit Amor,' see CUPID (5).

'Omnis homo velox est,' see JAMES THE GREATER.

Omobuono ('Homobonus'), the 'good man' (d. 1197). A merchant of Cremona, married and prosperous, who used his wealth for the relief of poverty in the city, though not with the whole-hearted approval of his wife. Legend relates that while on a journey he gave all his food and drink to a beggar and, on refilling his flask at a wayside stream, found the water miraculously changed to wine. He died suddenly while in church. Though he had not taken Holy Orders he was canonized two years later in response to popular demand by his fellow-citizens. Omobuono features in the work of artists of Cremona and Venice. He is generally dressed in a fur-trimmed cap and habit and may have a flask of wine for attribute, and a beggar kneeling at his feet. He is depicted distributing alms to the poor. Counter-Reformation art shows him at the moment of death, before a crucifix, borne up by angels.

Omphale, see HERCULES (17).

Onuphrius. Legendary Christian hermit of the 4th cent. who passed sixty years in solitude in the Egyptian desert until discovered by Paphnutius, bishop of Thebes. Like PAUL THE HERMIT and other desert anchorites, Onuphrius was fed by a raven that brought a loaf of bread every day in its beak; likewise at his death lions helped to dig the grave with their paws. Onuphrius is old, emaciated and unkempt, with a long grey beard, his body covered with shaggy hair, somewhat like the WILD MAN. He generally wears a tunic or loincloth of leaves. Rarely, he goes on all fours. His attribute is a CHALICE and Host, sometimes a RAVEN or two LIONS. A CROWN or COINS at his feet refer to his rejection of earthly honours (he was traditionally said to have been a prince.) In early Renaissance painting he is seen receiving the communion wafer from an angel; or sitting with Paphnutius who listens to his life story. The two lions assist Paphnutius at his burial.

Operation for stones in the head. The quack doctor was a popular object of satire in 17th cent. Dutch and Flemish painting. A typical theme was the bogus operation for the removal of stones in the head. There was an old Dutch saying for a person whose behaviour was odd and eccentric that he had 'a stone in the head', as one might say in English 'a bee in the bonnet'. Itinerant charlatans, trading on the credulity of simple country people, would offer to perform the operation in return for a fee of poultry or eggs, and found willing patients among those with headaches and other nervous disorders, real or imaginary. The 'surgeon' made an incision in the flesh, generally on the brow, which bled freely, and then with appropriate sleight-of-hand produced one or more pebbles covered with blood. The patient is depicted in a chair, securely bound to it, and sometimes crying out in alarm. The quack has a scalpel or a pair of forceps with a stone in it which he has apparently just drawn out of the wound. He may be holding it up to show the astonished onlookers. His assistants may be bandaging the forehead of another patient. The scene is a village green, or an interior, sometimes with a table on which lies an assortment of instruments.

Opportunity ('Chance'; Lat. *Occasio*). In classical antiquity, time had two aspects, the eternal, and the fleeting moment. The latter was represented by the figure of Opportunity, a youth with a lock of HAIR falling over his brow (the forelock by which time may be seized), holding a razor on which a pair of scales is balanced (the crucial moment, the turning point when affairs hang in the balance). He has winged-heels and his feet rest on a GLOBE. A statue of such a figure by the Greek sculptor Lysippus, the contemporary of Alexander the Great, is known to us from a description. This personification survived until the early Renaissance when it was superseded by the female figure of Fortune, with which Opportunity has affinities. Opportunity on his unsteady globe was contrasted with a figure, perhaps Wisdom, standing on a stable cube. (Mantegna, Ducal Palace, Mantua – here Opportunity has forelock but no scales.)

Ops, see FOUR ELEMENTS: Earth.

'Optimam partem elegit,' see MARY MAGDALENE.

Orange. Sometimes a substitute for the apple in the hand of the infant Christ (VIRGIN MARY, 13), and in representations of the Tree of Knowledge (ADAM AND EVE, 3).

Orb, see GLOBE.

Oreithyia, see BOREAS.

Organ. The portative organ was an instrument of the Middle Ages and Renaissance, small enough to be carried. The player's right hand used the keyboard while his left worked the bellows at the back. See further under CECILIA whose special attribute is an organ. The portative is an attribute of Music personified,

one of the SEVEN LIBERAL ARTS, of Hearing, one of the FIVE SENSES and of Poly.
hymnia, one of the MUSES. It is a common instrument in concerts of angels-
(See diag. MUSICAL INSTRUMENTS.)

Origin of the Milky Way (The nurture of Hercules) (Diodorus Siculus 4:9).
Hercules was the son of a mortal woman, Alcmena, of Thebes, who had lain
with Jupiter. When he was born she took him outside the city and left him to
die because she feared the jealousy of Jupiter's wife, Juno. But Minerva, the
goddess of wisdom and Hercules' protectress, devised a scheme which not only
saved his life but ensured his immortality. She guided Juno, as if by chance, to
where the child lay, and persuaded her out of pity to put it to her breast. Hercules
sucked so violently that Juno's immortal milk spurted across the heavens, where
it became the Milky Way. In the places where some drops fell to earth, lilies
sprouted. Juno is depicted reclining in the sky while a stream of glittering milk
shoots across the heavens. Jupiter's eagle, with a THUNDERBOLT in its claws, may
be present, or Jupiter himself may be dimly seen in the background, looking on.
Juno's chariot, harnessed to PEACOCKS, may be shown (Tintoretto, Nat. Gall.
London).

Orion (Apollodorus 1, 4:3–4). In Greek mythology a hunter of gigantic stature.
Drunk with wine he once tried to rape a princess of Chios, but her father pun-
ished Orion by blinding him. An oracle told him to travel east to the furthest
edge of the world where the rays of the rising sun would heal his sight. On his
journey he passed the forge of Vulcan whence he carried off an apprentice
named Cedalion to guide him on his way. In due course Orion's sight was
restored. Poussin (Metropolitan Mus. of Art, N.Y.) shows the giant, bow in
hand, striding through a wooded countryside towards a distant sea. Cedalion
perches on his shoulders. Vulcan stands at the roadside pointing out the way.
A cloud, wafting round Orion's face, suggests that his sight is veiled. Another
myth tells how Orion eventually died at the hand of Diana who set his image
among the stars. She is seen floating above him.

Orlando (Ariosto, *Orlando Furioso*), see ANGELICA.

Orpheus. Legendary Thracian poet, famous for his skill with the lyre. He married
Eurydice, a wood nymph, and at her death descended into the underworld in
an unsuccessful attempt to bring her back to earth.

1. *Orpheus charms the animals with his music* (*Met.* 10:86–105). Such was his
musical skill that Orpheus charmed not only the wild beasts but also the trees
and rocks which would come after him at the sound of his lyre. He sits under a
tree plucking the lyre or, especially in Italian Renaissance painting, he plays a
lira da braccio, an instrument of the VIOL family (see MUSICAL INSTRUMENTS).
He is young and usually wears a laurel crown, the award for victory in ancient
Greek contests of poetry and song. Animals of many kinds, wild and domestic,
are gathered peacefully round him. Birds perch in the trees. The subject was
popular in Roman times, and early Christian artists used it to represent the
Messiah at whose coming 'the wolf shall dwell with the lamb and the leopard
shall lie down with the kid.' Early representations of Christ as a shepherd,
youthful and beardless, seated among his flock and holding a lyre, were derived
from the Orpheus image. (See also SEVEN LIBERAL ARTS.)

2. *Eurydice killed by a snake* (*Met.* 10:1–10). Eurydice, the wife of Orpheus,
while fleeing from an unwelcome suitor, trod on a snake and died from its bite.
She is depicted lying dead on the ground while Orpheus weeps over her; in the
background demons drag her soul into the entrance of Hades. Or she flees from
the suitor Aristaeus. Or, in a 17th cent. classical landscape, Orpheus plays his

lyre to a group of reclining listeners, unaware that Eurydice nearby is starting to her feet in a fright. The snake entwines her ankle or, occasionally, an arm.

3. *Orpheus in the underworld* (*Met.* 10:11–63). Orpheus descended into Hades and by the power of his music succeeded in persuading Pluto to allow Eurydice to follow him back to earth, on the condition that he did not look back at her until they reached the upper world. But at the last moment he did so and Eurydice vanished for ever into the shades. Losing Eurydice made Orpheus despise women. Because of this he was attacked by frenzied Maenads of Ciconia in Thrace, and torn to pieces (*Met.* 11:1–43). Pluto is depicted seated on his throne, his wife Proserpine beside him. Orpheus stands before them playing, or wringing his hands pleadingly. Or he leads Eurydice away, his arm round her shoulder, his head turned to look back at her. Cerberus, the three-headed dog, sits beside the throne snarling. In the background may be seen a fire-breathing dragon, or perhaps IXION, SISYPHUS, TANTALUS or TITYUS, their torments stayed for the moment by Orpheus' song. The couple are also shown emerging from the mouth of Hades, Orpheus leading the way and looking back. The death of Orpheus at the hands of the Ciconian women is also depicted. The story of a descent into the lower regions to fetch back the dead occurs elsewhere in myth and folklore, and forms a part of Christian belief. See also HERCULES (20); DESCENT INTO LIMBO.

Orsola, see URSULA.

Otto III (or Otho), Holy Roman Emperor, see JUDGEMENT OF O.; NILUS.

Owl. Associated with Athene (MINERVA) in ancient Greece where it is found on the reverse of coins bearing her image. From this it became a symbol of wisdom which Minerva personifies. It is a common attribute of the goddess, perhaps perched on a pile of books. As a nocturnal bird it is also the attribute of NIGHT personified, and of Sleep (see SLEEP, KINGDOM OF).

Ox. The principal draught animal in primitive society. Oxen draw the plough of Cincinnatus (C. CALLED FROM THE PLOUGH), black oxen the chariot of Death (TRIUMPH), an ox and an ass the plough of ULYSSES (1). It is a symbol of strength and an attribute of PATIENCE personified. But also of SLOTH. The ox was a sacrificial animal (see SACRIFICE) and in early patristic writing was designated as the symbol of Christ's sacrifice, an alternative to the lamb. It appears as a sacrificial animal in the CLEANSING OF THE TEMPLE. It is an attribute of THOMAS AQUINAS, LUCIA (who was tied to a team of oxen), SYLVESTER and LUKE (a winged ox). The ox, lion, eagle and angel, the 'apocalyptic beasts' together symbolize the FOUR EVANGELISTS. Oxen driven by soldiers are the cattle of Helios (ULYSSES, 3); led away by HERCULES (10, 15), are those of the Geryon, who may lie dead nearby. See also OX AND ASS; BULL; COW.

Ox and ass are rarely absent from representations of the NATIVITY. They may occasionally kneel before the Child. The earliest reference to an ox and ass at the Nativity is in the Gospel of Pseudo-Matthew (?8th cent.). Isaiah (1:3), 'The ox knows its owner and the ass its master's stall; but Israel, my own people, has no knowledge, no discernment', was seen as a prophecy of the Jews' refusal to recognize Christ as the Messiah. An ox may accompany the ass ridden by the Virgin Mary on the FLIGHT INTO EGYPT, in allusion to the Nativity.

Pallas Athena, see MINERVA.

Palm. Originally a symbol of military victory, carried in triumphal processions, it was adopted by the early Church as the symbol of the Christian's victory over death. In secular themes the goddess VICTORY is depicted bestowing a branch, or frond, of palm; it is hence an attribute of FAME, the sequel to victory;

also of the medieval CHASTITY; and of Asia personified, one of the FOUR PARTS OF THE WORLD. It occurs too frequently in art as the attribute of the Christian martyr to serve by itself as an identification. A group of children holding palms are the Holy Innocents (see MASSACRE OF THE INNOCENTS). FELICITY and her seven sons likewise hold them. A palm tree is used as a staff by CHRISTOPHER. A loincloth of palm leaves is worn typically by the desert hermit, in particular PAUL THE HERMIT, and sometimes ONUPHRIUS. An angel presents a palm frond to the Virgin at the annunciation of her death (DEATH OF THE VIRGIN, 1). It is the attribute of JOHN THE EVANGELIST, handed to him by the Virgin on her death-bed (DEATH OF THE VIRGIN, 3). A palm tree is one of the attributes of the Virgin of the Immaculate Conception (VIRGIN MARY, 4). On the FLIGHT INTO EGYPT Joseph picks dates from a palm tree under which the Holy Family rests. Palms are borne by those meeting Christ at the ENTRY INTO JERUSALEM. A palm tree, sometimes with a unicorn, was an *impresa* of the house of Este, patrons of the arts in the Renaissance.

Palm

Palsy, Man sick of the, see PARALYTIC, HEALING OF THE.

Pan (Lat. Faunus). Greek god of woods and fields, flocks and herds. 'Universal Pan' – the Greek word *pan* means 'all' – pervaded all things. In Renaissance allegory he personifies Lust; he charmed the nymphs with the music of his pipes, and was said to have lain with all the Maenads. His home was ARCADIA, which stood not merely for the region of the Peloponnese where he was originally worshipped, but also for the romantic paradise of the pastoral poets and of artists like Poussin. This realm is inhabited by nymphs and shepherds, by SATYRS, MAENADS, SILENUS, PRIAPUS and the CENTAURS who, with Pan, formed the retinue of BACCHUS. It was from the latter that Pan acquired his goat's legs. Pan has a goat-like face with pointed ears and horns and, especially in baroque painting, coarse rustic features, though in antiquity he was often young and handsome. He invented the syrinx, the reed pipes arranged in a row of ascending length; he is sometimes seen teaching the blind shepherd Daphnis to play it. As the protector of flocks he may have a shepherd's crook.

1. *Pan and Syrinx* (*Met.* 1:689–713). Pan was pursuing a nymph of Arcadia named Syrinx when they reached the River Ladon which blocked her escape. To avoid the god's clutches she prayed to be transformed, and Pan unexpectedly found himself holding an armful of tall reeds. The sound of the wind blowing through them so pleased him that he cut some and made a set of pipes which are named after the nymph. She is seen standing among reeds as Pan approaches. A stream runs at her feet. The old river-god Ladon may be reclining on his urn, or Syrinx may flee into his arms for protection. Amoretti fly overhead perhaps bearing a flaming torch.

2. *Triumph of Pan.* Satyrs with pipes and Maenads with tambourines are dancing in a woodland glade before an image of Pan, which takes the form of a pillar surmounted by a bust of the god (see HERM). A Maenad rides on the back of a goat, the animal that accompanies the followers of Bacchus, to whom it was sacred.

3. *Sacrifice to Pan.* Maenads and Satyrs bring sacrificial offerings to a robed priest. A fire burns in readiness on an altar. A statue or herm of Pan stands nearby. (See SACRIFICE).

See also APOLLO, (5); CUPID, (5); DAPHNIS AND CHLOE; DIANA, (7); HERCULES,

(17). The Faun, which the Romans identified with Pan, is found in the story of CEPHALUS AND PROCRIS.

Pandora (Hesiod, *Works and Days*, 57–101). In Greek mythology Pandora, the 'all-gifted' or 'all-giver', was fashioned from clay by Vulcan. She was endowed with various gifts by the gods, sent to earth by Jupiter, and became the wife of Epimetheus. When she opened her box, originally a *pithos* (a large URN), all the evils which have since beset mankind flew out, and the Golden Age came to an end. Hope alone remained inside. This was Jupiter's punishment to the human race for the theft of fire by PROMETHEUS, the brother of Epimetheus. Representations of Pandora borne to earth by Mercury resemble the apotheosis of Psyche (see CUPID, 6) who was conveyed to heaven by the same god. The early Church drew the parallel between Pandora's story and the Fall of Man, hence she became the pagan counterpart of Eve, and was so depicted by Cousin (Louvre). Cycles of themes are found from the later 18th cent., especially in the English Neo-classical school, showing the creation of Pandora on Olympus, her coming to earth in the arms of Mercury, and the opening of her vase or box, perhaps by Epimetheus. The latter theme is virtually unknown in Renaissance and baroque art.

Paolo and Francesca (Dante, *Inf.* 5). Francesca da Rimini (d. about 1288), was betrothed to the deformed Giancotto Malatesta of Rimini. She fell in love with Giancotto's younger brother Paolo while, it was said, she and Paolo sat reading together. They became lovers. Giancotto one day surprised them together and stabbed them both to death. Dante, who knew both Paolo and the brother of Francesca, introduces the lovers into the *Divine Comedy* where, with other tragic lovers of history, they are condemned to be for ever swept along on the wind in the second circle of hell. The theme was popular with romantic painters of the 19th cent. The lovers sit reading; or they embrace, the book cast away. Or they are depicted in hell, observed by DANTE AND VIRGIL.

Paper. A sheet of paper, handed by a woman to a Roman general accompanied by his officers, CLEOPATRA (2). See also SCROLL; WRITER.

Paphnutius, bishop of Thebes, see ONUPHRIUS.

Paradise, see AGES OF THE WORLD (Golden Age); ADAM AND EVE (1).

Paralytic, (... man sick of the palsy), **The healing of the** (Matt. 9:1–8; Mark 2:3–12; Luke 5:18–26). When Christ was preaching in a house at Capernaum a paralysed man, brought to him to be cured, was let down through a hole in the roof, bed and all, into his presence because the throng prevented any other means of approach. Christ told the man, 'Stand up, take up your bed, and go home,' and he did so. There are two scenes: the paralytic being lowered through the roof, and the cured man carrying away his bed. In some early examples he is shown bearing away an actual bedstead on his back, but more commonly he has a bundle of bedding or a mattress. Christ may be accompanied by two or three of the disciples.

The pool of Bethesda (John 5:1–15). John's version of the miracle lays the scene in Jerusalem at the pool of Bethesda. The place was a resort of the sick since the waters were believed to have miraculous curative powers. It was said that from time to time an angel, traditionally the archangel Raphael, came and disturbed the water and that the first person to enter it afterwards was healed. But the paralytic had never succeeded in being first. Christ came there and found him. He was ordered to take up his bed and walk and immediately found himself cured. John describes it as 'a place with five colonnades', and it is therefore usually represented with some such architectural feature. An angel hovers

overhead or is in the act of stirring the water. Christ is addressing the paralytic who lies at the edge of the pool. Others, sick and infirm, crowd the scene. See also TRUE CROSS, HISTORY OF THE.

Parcae, see THREE FATES.

Paris. A Trojan prince who was also a shepherd. He was the son of Priam, king of Troy. At his birth it was prophesied that he would bring ruin upon Troy. He was therefore left exposed to die on the slopes of Mt Ida, but was rescued and brought up by shepherds. The scene of his discovery by shepherds has occasionally been depicted. He was loved by Oenone, a Naiad, or nymph of fountains and streams, and is sometimes seen dallying with her in the shade of a tree or perhaps carving her name in the bark. But he deserted her for HELEN, the Spartan queen, whom he forcibly carried off to Troy, thus bringing about the Trojan war and fulfilling the prophecy made at his birth. The JUDGEMENT OF PARIS, the story of his award of the golden apple to Venus in a contest of beauty between her, Juno and Minerva, is the most popular of all mythological themes in art. In Neoclassical art he wears a Phrygian bonnet (see HAT). See also ACHILLES (4).

Parnassus. A mountain range in Greece. On its slopes was the temple of Delphi and nearby the stream of Castalia. In antiquity Parnassus was sacred to APOLLO and the MUSES and was hence the traditional abode of poetry and music. It is depicted as a hilltop rather than a mountain, with a grove, perhaps of LAURELS, beneath which sits Apollo playing a lyre or other instrument and surrounded by the Muses. The stream runs at their feet. The winged horse PEGASUS, symbol of Fame, especially of poetic genius, may be present though in that role he strictly belongs on Mount Helicon (see MINERVA, 2). Raphael (Stanza della Segnatura, Vatican) includes the figures of the poets of antiquity, such as HOMER, DANTE AND VIRGIL, and some of his contemporaries. Mantegna (Louvre) crowns the scene with the figures of Mars and Venus who symbolize Strife conquered by Love. The birth of their offspring, Harmony, is being celebrated by Apollo and the Muses with song and dance.

Parts of the World, see FOUR PARTS OF THE WORLD.

Pasiphaë (*Imag.* 1 : 16). In Greek mythology the wife of Minos, king of Crete, who conceived a violent and unnatural passion for a bull. To enable her to consummate her desire Daedalus, the famous craftsman, constructed a life-like hollow wooden cow inside which Pasiphaë positioned herself. The outcome of the union was the fearful monster, the Minotaur, half bull, half man, which Theseus slew. Pasiphaë is depicted watching Daedalus who is putting the finishing touches to his model, or she is in the act of climbing into the cow through an opening in its flank, assisted by Daedalus. In the background the bull looks on eagerly. To humanist philosophers of the Renaissance Pasiphaë stood for the deliberate flouting of natural and divine law, and the overthrow of reason for the sake of animal passion.

Passion. The suffering and death of Christ on the cross. In art the term includes the events leading up to, and following the crucifixion. They are depicted not only as single subjects but as cycles of consecutive scenes. The portrayal of the Passion cycle was furthered in the 13th cent. by the two great teaching Orders, Franciscan and Dominican, who commissioned artists to decorate their churches and monasteries. The story formed one of the main subjects of medieval religious drama. The full series of scenes is reckoned to begin with the 'Entry into Jerusalem' and to end with the 'Descent of the Holy Ghost' at Pentecost, but the number of episodes may vary considerably (often no doubt determined by considerations of space), and may conclude earlier, with the Entombment or

Ascension. The subjects are found under the following headings: ENTRY INTO JERUSALEM; LAST SUPPER; PETER, apostle (3), *Washing the disciples' feet;* AGONY IN THE GARDEN; BETRAYAL; PETER, apostle (4), *Denial and repentance of P.;* TRIAL OF CHRIST; MOCKING OF CHRIST; FLAGELLATION; CROWNING WITH THORNS; ECCE HOMO; ROAD TO CALVARY; STATIONS OF THE CROSS; CHRIST STRIPPED OF HIS GARMENTS; RAISING OF THE CROSS; CRUCIFIXION; DESCENT FROM THE CROSS; PIETÀ; BEARING THE BODY OF CHRIST; ENTOMBMENT; DESCENT INTO LIMBO; RESURRECTION; HOLY WOMEN AT THE SEPULCHRE; APPEARANCE OF CHRIST TO HIS MOTHER; MARY MAGDALENE (3), *'Noli me tangere';* JOURNEY TO EMMAUS; SUPPER AT EMMAUS; THOMAS, apostle (1), *The incredulity of T.;* MIRACULOUS DRAUGHT OF FISHES; ASCENSION; DESCENT OF THE HOLY GHOST.

Passover, see MOSES (6).

'Passus sub Pontio Pilato,' see JOHN THE EVANGELIST.

Pastoral, see ARCADIA.

'Pater manifestavi nomen tuum hominibus,' see BERNARDINO.

'Pater Sancte serva eos,' see DOMINIC.

Patience. One of the minor virtues in Christian allegory, widely represented in cycles of the virtues and vices in medieval art, but somewhat rare later. Patience is represented as a woman with a LAMB for attribute, perhaps on her shield, and is often accompanied by Job, recognizable by his boils. Her opposing vice is WRATH (Ira) who may be slaying himself (or herself) with a sword. In the 13th cent. her attribute is an OX (Paris: Notre Dame cycle). In Renaissance art she retains her lamb. She is also to be seen, together with HOPE, supporting a man weighed down by the burden of Time (A. Janssens, Musée des Beaux-Arts, Brussels).

Patroclus, Greek hero, see TROJAN WAR (2, 4).

Paul. Apostle, though not one of the original twelve. His special mission was to the gentile world. He was born in Tarsus in Asia Minor in about A.D. 10 He was Jewish by race but inherited Roman citizenship from his father, a fact relevant to some of his themes in art. (See *Conversion* and *Martyrdom* below.) He is first mentioned in the New Testament as being present at the stoning of STEPHEN. Early documents describe Paul as of short stature, bald and ungainly. The Renaissance, following medieval artists, generally gave him some of these characteristics, usually including a dark beard. In the art of the 17th cent. and later he is sometimes tall and white-bearded with flowing hair, the type of the patriarch. Aspects of St Paul's teaching were taken up by the Lutherans, causing him to fall out of favour with the countries of the Counter-Reformation, and he is therefore more seldom represented in their art. His normal attributes are the SWORD with which he was executed and, as the author of the Epistles, a BOOK or SCROLL. Paul as a devotional figure is very often paired with the apostle PETER, either alone or one on each side of Christ or the Virgin enthroned. Here they stand for the joint founders of the Christian Church, Peter symbolizing the original Jewish element, Paul the gentile.

1. *The conversion of St Paul.* (Acts 9:1–9). The best-known and most widely represented of the Pauline themes. On the road to Damascus, where he was going to obtain authorization from the synagogue to arrest Christians, Paul was struck to the ground, blinded by a sudden light from heaven. The voice of God, heard also by Paul's attendants, as artists make clear, said, 'Saul, Saul, why do you persecute me?' They led him to the city where, the voice had said, he would be told what he had to do. According to a tradition, connected with the medieval custom of representing PRIDE as a falling horseman, Paul made the journey on

horseback. He lies on the ground as if just thrown from his horse, prostrate with awe, or unconscious. He may be wearing Roman armour. Christ appears in the heavens, perhaps with three angels. Paul's attendants run to help him or try to control the rearing horses.

2. *St Paul's sight restored by Ananias* (Acts 9:10–19). Ananias, a disciple living in Damascus, learned through a vision that he was to go to Paul and restore his sight by laying on hands. Paul is seen kneeling before Ananias. His armour lies beside him. The DOVE of the Holy Ghost hovers overhead. Afterwards Ananias baptized Paul. He reads the words of the Baptism to Paul who stands in a font. An acolyte holds a candle.

3. *St Paul escapes from Damascus* (Acts 9:23–25). Paul's life was threatened by the Jews so he escaped from the city at night, being let down from the wall in a basket. This well-known though rather undignified episode is to be seen in Gothic cathedral art but seldom later.

4. *The dispute at Antioch* (Gal. 2:11–14). An early example of doctrinal controversy. At the outset of his missionary journeys Paul, meeting Peter at Antioch, accused him of compromising his principles as a Jewish Christian by the inconsistent manner in which he associated with gentile converts. The two apostles are seen in earnest discussion, Paul seeming to admonish Peter by his gesture and expression.

5. *Elymas struck blind* (Acts 13:6–12). When preaching at Paphos in Cyprus Paul and Barnabas were sent for by the Roman governor Sergius Paulus who wished to hear them. Elymas, a sorceror of the governor's court, tried to prevent them speaking and was struck blind by Paul. Sergius is seated on a throne; he wears a toga and a LAUREL crown. His officers hold the FASCES, the Roman emblem of authority. In the foreground Elymas gropes blindly forward. Barnabas, like Paul, may be distinguished by a halo. The popular theme of a Christian saint demonstrating the power of his faith before a heathen ruler is seen also in PETER, apostle (12), and FRANCIS OF ASSISI (5).

6. *SS Paul and Barnabas at Lystra; the sacrifice at Lystra* (Acts 14:8–18). The pagan inhabitants of Lystra in Asia Minor, witnessing the miraculous cure of a cripple by Paul and Barnabas, believed that they were Mercury and Jupiter come to earth in human form. When the priest of the temple of Jupiter brought oxen and garlands to make a sacrifice the apostles rent their clothes in dismay. By their exhortations they prevented the sacrifice taking place. The scene is before the temple where the priest, axe in hand, is about to stun the ox. Paul, beside the altar, tears at his cloak, while the crowd press forward. The lame man's crutches lie on the ground.

7. *St Paul imprisoned at Philippi* (Acts 16:16–26). While preaching at Philippi, the ancient city of Macedonia, Paul and his companion Silas were scourged and thrown into prison. An earthquake caused the prison doors to burst open and the prisoners' fetters to break. Paul and Silas, making no attempt to flee, baptized the terrified gaoler and, later, his family. The earthquake may be represented as a Titan thrusting up from under the ground. The subject sometimes forms a companion picture to PETER, apostle (11), released from prison.

8. *St Paul preaching at Athens* (Acts 17:16–34). Paul is seen preaching before the assembled Areopagus, the judicial council of Athens (one of whose functions was to hear religious cases). It was significant as the occasion when Dionysius, otherwise Denis, the Areopagite (seen in the foreground) was converted to Christianity (see also DENIS). According to some early sources he became the first bishop of Athens. The Areopagus (Gk: Mars' hill) was the name of the hill

on which the temple of Mars was situated and from which the court took its name. A statue of Mars (Ares) may be seen before the temple.

9. *St Paul preaching at Ephesus* (Acts 19:19–20). At Ephesus, the great trading city of Asia Minor and a centre of pagan fertility worship, Paul converted some pagan priests who then voluntarily brought their books and burned them publicly. They are seen making a bonfire of books at the feet of Paul who is preaching in the city square.

10. *The ecstatic vision of St Paul.* A theme that appealed to the Counter-Reformation, taken from II Cor. 12:1–3. 'I shall go on to tell of visions and revelations granted by the Lord. I know a Christian man who . . . was caught up as far as the third heaven . . . and heard words so secret that human lips may not repeat them.' Baroque painting depicts Paul borne aloft by angels, usually three in number to symbolize the third heaven.

11. *St Paul shipwrecked on the island of Melita,* or *Malta* (Acts 28:1–6). On a voyage to Rome where he was to stand trial Paul, with other prisoners, was shipwrecked on Malta. The islanders made them welcome and lit a bonfire against the rain and cold. While gathering sticks Paul was bitten by a snake which fastened itself to his hand. He shook it off into the fire, and was unharmed. The credulous islanders took it as a sign that he was a god. The snake as a Christian symbol of Satan lends additional meaning to the theme.

12. *Raising the king's son at Antioch.* The *Golden Legend* tells how Peter and Paul restored to life the son of Theophilus, a king of Syria, at Antioch. The youth kneels before them, about to rise. Skulls and bones lie nearby signifying his return from death. Peter holds out his right hand in blessing. Paul kneels in prayer.

13. *The martyrdom,* or *beheading, of St Paul.* Tradition records that Paul and Peter were martyred in Rome on the same day. They are seen outside the gates of the city being led away to prison. Later, at the moment of their death Peter kneels in prayer by his cross; Paul, who as a Roman citizen was entitled to the more honourable and swifter execution by the sword, kneels at the block. Paul is often depicted alone. He is naked to the waist, his Roman armour lying beside him; the executioner wields a sword; an angel descends carrying the martyr's PALM and a LAUREL crown. Another legend tells that on the way to his execution Paul met a Christian woman named Plautilla who lent him her veil to blindfold his eyes, and he is sometimes shown thus. After his death he appeared to her in a vision and returned the veil stained with blood. Paul's head is sometimes depicted on a platter like John the Baptist's, except that its eyes are blindfold. It may also spurt three jets of blood – perhaps symbols of Faith, Hope and Charity: the traditional place of his execution is known as the 'Tre Fontane', the three fountains.

See also SYLVESTER.

Paul the hermit. Christian saint, traditionally the first of the desert hermits of Egypt, men who chose a life of solitude for the sake of contemplation, asceticism and to escape the persecutions of the Roman emperor Decius in the 3rd cent. Their stories have features in common. Paul, like other hermits, was fed by a raven that brought him bread every day, a fable that probably derived from the ravens that fed Elijah in the wilderness. (I Kings 17:4–6.) When he was ninety years old Paul was visited by Antony the Great who remained with him until his death. The story that two lions helped to dig Paul's grave is told also of Onuphrius and Mary of Egypt. Paul has white hair and a long beard and wears a loincloth of woven palm-leaves. His attributes are a RAVEN and two LIONS. He

is a somewhat rare figure in art except for the scenes of St Antony's visit and his burial. (See further ANTONY THE GREAT.)

Peace. In secular allegory the figure of Peace celebrates the end of a war, the outcome of good government or the pacific qualities of a statesman. She is usually winged, holds an OLIVE branch (and may wear an olive crown) and has a DOVE, attributes deriving from Genesis (8:10–11): the dove returned to the ark 'towards evening with a newly plucked olive leaf in her beak.' A CORNUCOPIA refers to the plenty that peace brings. A CADUCEUS (rather rare) was the insignia of the messenger in antiquity who was always granted peaceful passage. Peace, with a dove, may be seen embracing JUSTICE who holds a sword. In Renaissance and baroque art Peace is seen with a flaming TORCH setting fire to a pile of weapons.

Peach. A peach with one leaf attached to it symbolized in antiquity the heart and tongue and was adopted by the Renaissance with the same meaning as an attribute of TRUTH (which springs from the unison of heart and tongue).

Peacock. From the ancient belief that its flesh never decayed the peacock became a Christian symbol of immortality and of Christ's Resurrection. It is with this meaning that it features in scenes of the NATIVITY. It is the attribute of JUNO, for whom amoretti may be seen gathering up the 'eyes' from its tail; also of PRIDE personified, and of BARBARA.

Pearl. The attribute of MARGARET OF ANTIOCH. CLEOPATRA (1), at her banquet, dropped a large pearl into her wine-glass. Fillet and necklace of pearls are typical adornments of the richly attired earthly Venus, or Profane Love (VENUS, 1).

Pegasus. In Greek mythology the winged horse that sprang from the blood of Medusa when PERSEUS beheaded her. Pegasus was the mount of Perseus when he rescued Andromeda, and of BELLEROPHON when he slew the Chimaera. He is also depicted ridden by AURORA. With a blow of his hoof on a rock he caused the Hippocrene to gush forth (see MINERVA, 2). The 6th cent. mythographer Fulgentius made Pegasus a symbol of Fame since both are winged, and hence he is seen among the Muses, sometimes on Mount PARNASSUS. See also HERCULES (21).

Pelias, king of Iolcus, see JASON; MEDEA.

Pelican. The motif of the pelican piercing its breast to feed its young with its blood became the symbol of the sacrifice of Christ on the cross (see further, CRUCIFIXION, 13). With the same meaning the motif may decorate a vessel in allegorical STILL LIFE. It is an attribute of CHARITY personified. The pelican was then said to be 'in her piety'. To the Romans *pietas* signified devotion to one's parents.

Pelican

'Pellit et attrahit,' see WINDS.

Pelt, see SKIN.

Pen and inkhorn, see WRITER.

Penelope. The wife of the Greek hero Odysseus whom the Romans called ULYSSES. At the beginning of the *Odyssey* Homer tells how Ulysses, because of his continued absence long after the end of the Trojan expedition, was presumed to be dead, and Penelope was surrounded by suitors for her hand. She repeatedly put them off by saying she had first to finish weaving a winding sheet for her father-in-law, but at night she would always secretly undo her day's work, thus postponing the issue. She is seen seated at her loom surrounded by the suitors who may gesture impatiently. Her maids spin, sew and wind bobbins. (Pinturicchio, Nat. Gall. London.)

Pentecost, see DESCENT OF THE HOLY GHOST.

Persephone, see RAPE OF PROSERPINE.

Perseus. In Greek mythology the son of DANAË whom Jupiter caused to conceive after turning himself into a shower of golden rain. His heroic deeds included beheading Medusa, one of the snake-haired Gorgons, and rescuing the beautiful Andromeda from a sea-monster. The latter theme is a common folk-tale. (See also HERCULES (18) and Hesione; and GEORGE and the dragon.) Perseus is depicted either as the typical hero of classical antiquity, young, beardless and naked except for a chlamys, a short cloak, or he is dressed as a warrior in armour. He holds a curved SWORD, somewhat like a sickle, a gift from Mercury, and a polished SHIELD given him by Minerva, his protectress. The two deities are shown in the act of arming him, and sometimes accompany him in other scenes. Like Mercury he wears winged sandals and his helmet, like Mercury's hat, may have wings.

1. *Perseus and Medusa* (*Met.* 4:765–786). The Gorgons' appearance was so terrible that whoever looked at them was turned to stone. When slaying Medusa, Perseus therefore looked instead at her reflection in his polished shield. At her death PEGASUS the winged horse sprang from her dead body. Perseus is shown grasping her snake-hair, about to behead her with his sword. His head is turned towards Minerva who holds the shield. Medusa's sisters sleep in the background. As a sculptured figure Perseus stands, sword in hand, holding the decapitated head.

2. *Perseus and Andromeda* (*Met.* 4:665–739). Ovid tells how Andromeda, daughter of an Ethiopian king, was chained to a rock by the sea-shore as a sacrifice to a sea-monster. Perseus, flying overhead, fell in love at first sight. He swooped down just in time, slew the monster and released Andromeda. He is shown, sword and shield in hand, hovering in the air near the girl. The monster approaches through the waves. The anguished parents and other onlookers stand on the shore. An alternative version which departs from Ovid, shows Perseus riding Pegasus and dangling the Gorgon's head over the monster. A similar theme is the rescue of Angelica by Ruggiero, see ANGELICA (2). See also CORAL.

3. *The freeing of Andromeda.* Perseus stands before her and, sometimes with the help of amoretti, symbols of his love, undoes her bonds. Pegasus is nearby.

4. *Phineus and his followers turned to stone* (*Met.* 5:1–235). The wedding feast of Perseus and Andromeda was interrupted by a mob led by Phineus, the king's brother, a disappointed suitor. After a great battle Perseus finally settled matters by waving the Gorgon's head in their faces and turning about two hundred of them to stone. The scene is a banqueting hall in the king's palace. Tables are overturned and the ground is strewn with bodies. Perseus is in the centre holding the head. His attackers stand with spears for ever poised, their bodies grey and petrified. Minerva may be flying overhead.

Pestle and mortar. An attribute of COSMAS AND DAMIAN. Often among the objects littering the workshop of the ALCHEMIST.

Peter, 'the Prince of the Apostles', brother of Andrew and a fisherman of Galilee. He and his brother were called to be 'fishers of men'. Peter was leader of the Twelve and one of the closest to Christ. His life divides into three parts: he accompanied Christ during his ministry; after the crucifixion he led the apostles in their teaching of the gospel (the Acts); according to several early accounts, he went to Rome where he established the first Christian community and was crucified by Nero in A.D. 64. His appearance has remained remarkably constant in art and he is the most immediately recognizable of the apostles. He is an old but vigorous man, with short grey curly hair, balding or tonsured, and a short,

usually curly beard, and with broad, rustic features. He commonly wears a yellow (gold) cloak over a blue, or sometimes green, tunic. His special attribute is a KEY, or keys: 'I will give you the keys of the kingdom of Heaven'. (Matt. 16:19). A gold and a silver (or iron) key symbolize respectively the gates of heaven and hell, or the power to give absolution and to excommunicate. Other attributes are an upturned CROSS (his form of martyrdom), a CROZIER with triple transverses (papal), a BOOK (the gospel), a COCK (his denial) and more rarely a SHIP or a FISH, symbols of the Church and of Christianity respectively, also of Peter's occupation. His inscription, from the Apostles' Creed, is 'Credo in Deum Patrem omnipotentem, creatorem coeli et terrae.' Devotional images are of three kinds: (1) Grouped with other apostles, he stands in first place, next to Christ. (2) With Paul, the pair represent the Jewish and gentile elements of the Church. (3) He wears papal vestments and tiara, as first bishop of Rome, or as a symbol of the papacy in Counter-Reformation art. Narrative scenes may be divided into three periods: (a) His participation in Christ's ministry. (b) The apostolic ministry, as told in the Acts. (c) The Roman legends.

Christ's Ministry

1. *The calling of Peter and Andrew.* (Mark 1:16–18). 'Jesus was walking by the shore of the Sea of Galilee when he saw Simon [Peter] and his brother Andrew on the lake at work with a casting-net; for they were fishermen. Jesus said to them, "Come with me, and I will make you fishers of men."' The brothers are in their boat, drawing in a net, or one or both of them kneel on the shore at the feet of Christ. Sometimes a crowd of onlookers are present, recalling the time when Christ preached to the multitude at the lakeside.

2. *The delivery of the keys to Peter; Christ's charge to Peter* (Matt. 16:18–19). 'You are Peter, the Rock; and on this rock I will build my church . . . I will give you the keys of the kingdom of Heaven.' This metaphorical saying of Christ's was rendered many times by Renaissance artists. It was regarded as the prototype of the sacrament of Holy Orders. (See SEVEN SACRAMENTS.) Peter kneels before Christ, receiving the keys from him, while other disciples stand about. Occasionally he receives them from the infant Christ in the lap of the Virgin. When sheep are present they allude to the theme, sometimes combined with the delivery of the keys, of Christ's appearance to the disciples after his death when he charged Peter: 'Feed my sheep.' (John 21:15–17). As a symbol of the Church's authority crossed keys often occur in ecclesiastical heraldry. They are a charge in the papal arms and in the arms of several English dioceses.

3. *Washing the disciples' feet* (John 13:4–17). At the Last Supper, Christ 'rose from table, laid aside his garments, and taking a towel, tied it round him. Then he poured water into a basin, and began to wash his disciples' feet and to wipe them with a towel.' When Peter's turn came he protested at Christ humbling himself in this way. It is this scene that is always depicted. Christ stands or kneels in the act of washing or wiping the feet of Peter who is seated on a chair or stool. Peter raises a hand in a deprecatory gesture. A disciple re-tying a sandal is traditionally identified with Judas. On Maundy Thursday the pope annually washes the feet of twelve poor men, a ritual also performed in some Eastern Orthodox Churches, and in the English Church until 1750.

4. *The denial and repentance of Peter* (Mark 14:66–72). After his arrest Christ was questioned by Caiaphas, the high priest, in his house. Peter meanwhile was standing in the courtyard when a serving-maid of Caiaphas recognized him and said, 'You were there too, with this man from Nazareth, this Jesus.' But Peter denied knowing him, whereupon a cock crew. He made three such denials and

each time it crew. When he realized that Christ's earlier prophecy about him had been fulfilled Peter burst into tears. The scene of the denial itself, with the serving-maid and cock, is comparatively rare, sometimes forming a subsidiary element in the scene of Christ before Caiaphas. Peter's repentant weeping occurs frequently in the Counter-Reformation art of Spain and Italy as a devotional image. It was favoured by the Church of the Counter-Reformation in propagating devotion to the SEVEN SACRAMENTS, of which Penance is one.

See also MIRACULOUS DRAUGHT OF FISHES; CHRIST WALKING UPON THE WATER; TRANSFIGURATION; TRIBUTE MONEY (2); ENTRY INTO JERUSALEM; LAST SUPPER; AGONY IN THE GARDEN; BETRAYAL; ASCENSION.

Peter's Ministry (The Acts)

He is depicted in Jerusalem preaching and performing acts of healing often accompanied by other apostles, especially John. When Peter preaches, Mark is sometimes shown taking down his words – according to a popular tradition, the origin of Mark's gospel. The most frequent scenes are:

5. *Peter and John heal a cripple at the gate of the Temple* (Acts 3:1–8). The cripple, usually a ragged beggar, sits on the ground holding out his hand for alms. Peter raises his hands in blessing while John stands by and onlookers crowd round. This early instance of Peter's healing, by the Beautiful Gate, led to the first clash between the apostles and the Jewish priesthood.

6. *The death of Ananias; the death of Sapphira* (Acts 5:1–12). The apostles, by their example and eloquence, persuaded men of property to sell their goods. The money was then distributed among the poor. One such man, Ananias, privately kept back half the proceeds for himself, with the knowledge of his wife. Lashed by Peter's tongue for his deceitfulness, he dropped dead on the spot. His wife, Sapphira, similarly castigated by Peter, suffered the same fate. The scene shows the husband or wife in the throes of death before Peter who stands with an admonishing hand raised, while onlookers gasp with horror. Other apostles are usually present.

7. *Peter healing the sick with his shadow* (Acts 5:14–16). As word spread of the apostles' power of healing, the sick were carried out into the streets of Jerusalem merely in the hope that Peter's shadow might fall on them when he passed by. They are shown lying on beds and pallets or propped against walls of buildings. Peter, sometimes with John, stops to speak to them. In antiquity and in some primitive societies today the belief exists that a man's shadow is an integral part of his being and has the power to influence for good or evil the person on whom it falls.

8. *The raising of Dorcas, or Tabitha* (Acts 9:36–42). Dorcas, a woman of Joppa, who performed many works of charity, making clothes for poor widows, fell sick and died. Peter prayed alone in her room and restored her to life. He sent for the widows and Dorcas' other former companions, who came and marvelled. Peter, sometimes with other apostles, stands at the foot of a bed where Dorcas lies, while her eyes open in wonder. The widows show Peter the garments Dorcas had made for them.

9. *The Vision of Unclean Beasts* (Acts 10:9–16). Peter, praying at midday on a rooftop, beheld a mysterious vision. From the sky descended a great sheet in which were all kinds of creatures, 'whatever walks or crawls or flies.' Commanded by a voice from heaven to kill and eat, Peter refused saying he had never eaten anything profane or unclean. The voice reminded him that whatever came from God could not be unclean. This happened three times, when the sheet rose again into the sky. Peter interpreted his vision as a sign that God

meant Gentiles as well as Jews to be received as Christians. Angels hold the sheet which contains animals such as the pig, the rabbit and certain fowls, forbidden as food to the Jews.

10. *Peter baptizes the centurion Cornelius* (Acts 10, 11). Cornelius, a Roman centurion and a devout man, was told by an angel to send for Peter. He came, enlightened by his vision of the unclean beasts, and baptized Cornelius and his family. Sometimes the whole family kneels before Peter while the dove of the Holy Ghost hovers above. The episode was significant as the first recorded example of the baptism of a Gentile.

11. *Peter released from prison* (Acts 12:1–11). During the persecution of the apostles by Herod, at the time when James the Greater was executed, Peter was thrown into prison. As he slept, guarded by two soldiers, an angel appeared in his cell, telling him to arise. He was led past the guards, out of the prison and through the city gates, unobserved. The scene usually shows Peter, in fetters, awakened by the touch of the angel which appears in a shining light, while soldiers in armour sleep soundly in the cell. Sometimes Peter converses through the barred cell window with Paul who stands outside. The episode was regarded as symbolic of the coming deliverance of the Church from persecution.

See also PENTECOST; STEPHEN (1).

The Roman Legends

12. *Simon Magus.* A magician, first heard of in Jerusalem, where he had a large following, who offered Peter money to buy the secrets of his power – hence 'simony'. The *Golden Legend*, drawing on the early, apocryphal Acts of Peter, relates how he went to Rome and there won favour with Nero through his magic arts. He challenged Peter and Paul to various trials of skill. But in restoring the dead to life Simon failed, where the apostles succeeded. Simon retorted by taking off from the top of a tower in the presence of the emperor, and flying in the air supported by demons. But Peter went down on his knees and prayed that the demons release their hold. whereupon Simon crashed to his death. The story was popular in the Middle Ages and in Renaissance Italy. and even survived in the art of the Counter-Reformation. Peter is depicted refusing Simon's offer of money, restoring a young man to life and, with Paul, disputing before Nero. But the most popular scene shows Simon falling from the sky. In the foreground Peter and Paul pray to heaven, while Nero and his courtiers look on. The demons flee away.

13. *The raising of Petronilla.* Petronilla, a legendary martyr of the 1st cent. was made out to be the daughter of Peter by early Christian writers who, by a false etymology, derived her name from his. According to the *Golden Legend* Peter, fearing for her virtue because of her beauty, caused her to be continually laid low with a fever. When he was visited by the other apostles and questioned by them about her, Peter ordered her to rise and serve them, whereupon she was temporarily restored to health. A Roman nobleman, Flaccus, wished to wed her but she gave herself up to prayer and fasting and shortly afterwards died. In another version Flaccus threatened her with death if she refused him, a choice with which virgin martyrs were often confronted. She is usually shown being raised to her feet by Peter in the presence of other apostles. Petronilla was invoked to cure fevers.

14. *The baptism of SS Processus and Martinian.* Peter and Paul were thrown into the Mamertine prison where they converted many to the Christian faith, including their gaolers, the soldiers Processus and Martinian who subsequently helped them to escape. They were later martyred and canonized. They are generally shown being baptized by Peter in the prison cell.

15. *'Domine, quo vadis?'* The earliest version of the story is found in the early Acts of Peter, the New Testament apocryphal work, and is retold in the *Golden Legend*. At the prompting of his fellow Christians, Peter departed from Rome at the height of the persecutions by Nero. On the Appian Way he met Christ in a vision. Peter exclaimed, 'Lord, where goest thou?', and received the reply, 'I go to Rome to be crucified again.' Peter interpreted this to mean that he was to return to Rome to prepare for his own martyrdom. Christ is shown carrying the cross, and addressing Peter.

16. *The crucifixion of Peter.* According to tradition, Peter was at his own wish crucified upside down, either on the Janiculum hill or in a circus arena between two *metae*, the pair of turning-posts or conical columns set in the ground at each end of the course. Artists have used both settings, depicting Peter on the cross at the moment of being lifted by soldiers, often surrounded by onlookers, or already raised in position, with a small group of women standing by in allusion to the similar group at Christ's crucifixion. A vision of the apostle's crucifixion appeared to PETER NOLASCO.

See also PAUL; SYLVESTER.

Peter Martyr (*c.* 1205–52). A Dominican friar, born at Verona, who is remembered chiefly for his relentless pursuit of heretics. The early martyrs died as witnesses to their faith, but Peter fell at the hands of assassins, hired by two Venetian noblemen, Catharists whose property he had confiscated. He was canonized in the following year. His effigy is common in art of the Dominican Order. He wears the habit of the Order (see diag. RELIGIOUS DRESS) and, like THOMAS BECKET, has a SWORD, HATCHET or KNIFE embedded in his skull. Occasionally a sword pierces his breast. He may hold the martyr's PALM and a CRUCIFIX. The scene of his martyrdom is a forest. Peter lies on the ground, a hand raised in self-defence. An assassin is about to strike him with a sword. The saint's companion is likewise being attacked, or flees on horseback. There may be angels above holding the martyr's palm in readiness. Peter was said to have died reciting the Apostle's Creed, or writing it on the ground with his blood. The first words are occasionally thus depicted, 'Credo . . .' or 'Credo in Deum . . .'

Peter Nolasco (d. 1256). Christian saint, the son of a nobleman of Languedoc, traditionally regarded as the founder of the Mercedarians, an Order, based on Barcelona, devoted to the rescue and relief of Christians who had been captives of the Moors. He is seen, especially in Spanish painting, an old bearded man wearing a white habit bearing the badge of the Order (the arms of King James of Aragon). A legend often depicted tells that when he was very old and infirm he was borne from his cell to the altar by two angels. Also represented is his vision of his patron and namesake, the apostle, who appeared to him crucified, head-downwards.

Petronilla, The raising of, see PETER, apostle (13).

Petronius. Bishop of Bologna who died about 450. He wears episcopal robes and has a mitre and crozier. As patron saint of the city he holds a model of it, recognizable by its two characteristic towers, the tall 'Asinelli' and the smaller leaning tower, the 'Garisenda'. The figure of Petronius is common in the work of Bolognese painters. In devotional pictures of the Virgin he may be grouped with other patron saints of Bologna, DOMINIC and FRANCIS OF ASSISI.

Phaethon. In Greek mythology the son of Helios, the sun-god. His reckless attempt to drive his father's chariot made him the symbol of all who aspire to that which lies beyond their capabilities. Ovid tells of the palace of Helios and his retinue – Day, Month, Year, the Four Seasons and so on. Here Phaethon presented

himself and persuaded an unwilling father to allow him for one day to drive his chariot across the skies. The Hours (HORAE) yoked the team of four horses to the golden car, Dawn (AURORA) threw open her doors, and Phaethon was off. Because he had no skill he was soon in trouble, and the climax came when he met the fearful Scorpion of the zodiac. He dropped the reins, the horses bolted and caused the earth itself to catch fire. In the nick of time Jupiter, father of the gods, put a stop to his escapade with a thunderbolt which wrecked the chariot and sent Phaethon hurtling down in flames into the River Eridanus (according to some, the Po). He was buried by nymphs. His mother Clymene came to lament over his grave, as did his sisters the Heliads who, as they wept, were changed into poplar trees, their tears turning into beads of amber. Cygnus, a friend of Phaethon, turned into a swan as he mourned.

1. *Phaethon asks to drive the chariot of Apollo; Phaethon and Apollo* (*Met.* 2:19–102). Apollo, the Greek god of light, came to be identified with Helios in antiquity, and artists, ignoring genealogy, give to the father of Phaethon Apollo's appearance and attributes. The sun-god sits on a cloudy throne framed in the zodiacal belt, a lyre beside him; Phaethon kneels in front of him. Or the pair stand watching while the team and chariot are made ready. FATHER TIME, winged and bearded, who epitomizes the retinue described by Ovid, is present. Aurora looks down on them as the dawn breaks behind her.

2. *The fall of Phaethon* (*Met.* 2:150–327; *Imag.* 1:11). The popular theme, common in Renaissance and Baroque painting, especially on ceilings of the later period. Phaethon, the chariot, and four horses, reins flying, all tumble headlong out of the sky. Jupiter in one corner throws a thunderbolt. A scorpion is sometimes seen. The horses may all be white, after the Roman triumphal quadriga, or three light and one dark, the traditional colours of the sun-god's team. This theme is sometimes combined with the next.

3. *Phaethon's sisters changed into poplars; the Heliads* (*Met.* 2:329–380). Beside a river Clymene stands or kneels lamenting. Phaethon's sisters cover their faces in grief, or are beginning to sprout twigs and leaves from their upraised arms. Cygnus, part man, part swan, stands in the water. A river-god reclines on his overturned urn. The nymphs who buried Phaethon are sometimes present, perhaps stooping to pick up the amber tears.

Medieval 'moralizers' of Ovid, who provided Christian interpretations for his stories, took Isaiah (14:12) as their text for Phaethon: 'How art thou fallen from heaven, O Lucifer, son of the morning.'

Phial, a small glass flask. Two on a book, the attribute of a bishop, JANUARIUS.

Philemon and Baucis, an old couple who, according to Ovid (*Met.* 8:621–96), once gave hospitality in their humble cottage to two travellers who had been turned away from other, richer houses. During supper, to the hosts' astonishment, the wine bowl miraculously replenished itself; their only goose, which they would have killed for the occasion, flew to the visitors for refuge. Jupiter and Mercury, for it was they, then revealed themselves to Philemon and Baucis, and took them up the mountainside where they observed that the whole country was covered with flood waters, except for the cottage which had been changed into a temple. Granted a wish by Jupiter, the old man and woman chose to be priests of the temple. At their death they were changed into an oak and a lime tree. The gods are usually depicted seated at table, which is spread with food and a bowl or jug of wine. The incident of the goose chase is almost always included; Jupiter stays the hand of Philemon who tries to catch it. Both gods are generally dressed as travellers. Jupiter is bearded and majestic; his eagle may

be present. Mercury is the younger and is beardless, and occasionally has his staff twined with serpents and wears a winged hat. But attributes are usually absent since the gods are in disguise. The story of the god-fearing couple saved from destruction by divine intervention occurs widely, from the folk-tales of Europe to the story of LOT, and readily lends itself to interpretation in Christian terms, Jupiter and his son Mercury standing for God the Father and Christ. In 17th cent. Netherlandish painting the theme acquires certain affinities with the SUPPER AT EMMAUS.

Philip, apostle. He was from Bethsaida and was one of the first to be called to follow Christ. His place in art is not prominent and devotional figures and scenes from his life are fairly rare. He is represented as a man in middle years, usually with a short beard. His attribute is the CROSS. He was said to have journeyed to Scythia preaching the gospel. In the city of Hierapolis he succeeded, with the aid of the cross, in banishing a serpent or dragon which was the object of worship in the temple of Mars. As the monster emerged it gave off such a stink that many people died. The enraged priests of the temple captured Philip and crucified him. According to a tradition in the eastern Church Philip was crucified upside down like Peter.

Philip Benizzi (or Benozzi) (1233–1285). A member, and later the head, of the Servi, or Servites, the servants of Mary, a religious Order founded by seven Florentines, known as the Seven Holy Founders, in 1233, devoted to the contemplation of the Virgin, especially her sorrows. He was instrumental in obtaining papal confirmation for the Rule of the Order. Legends concerning his miracles of healing flourished, perhaps because he had practised as a physician before joining the Order. He wears the black habit of the Servites and is depicted curing a woman possessed, and giving his shirt to a leper. He is seen walking with his companions on a hillside near Florence while lightning strikes a nearby tree, killing some gamblers who were mocking him. The death of the saint shows him lying on a simple couch surrounded by Servite friars and others while in the foreground a dead child is miraculously restored to life. He is rarely represented outside Florence. He was canonized in 1671, but was depicted before then, e.g. Andrea del Sarto, frescoes in the church of SS Annunziata, Florence (c. 1510).

Philip Neri (1515–95). Son of a Florentine lawyer. As a young man he settled in Rome where he studied theology, was ordained, and founded a lay brotherhood devoted to charitable work, the Oratorians. The name was derived from the oratory where they met. His attachment to the cult of the Virgin, together with his reputation for having experienced the state of ecstasy, influenced the manner in which he is generally represented. He kneels at prayer before a vision of the Virgin and Child with angels, a theme true to the spirit of the Counter-Reformation. He wears a chasuble, and on the ground before him there often lies a LILY. He may also be represented experiencing the vision while celebrating Mass, or swooning into the arms of angels. A heart condition, said to have been brought about by his spiritual transport, was the source of his inscription: 'Dilatasti cor meum,' – 'When thou didst enlarge my heart' (Ps. 118:32). He may be depicted with CHARLES BORROMEO, whose friend and adviser he was.

Philosophy. The late Roman philosopher Boethius in *The Consolation of Philosophy* describes how there appeared to him in prison (where he wrote the work) a majestic woman of ripe years, whose stature changed so that she was now of normal height, now so tall that she reached the heavens. Her clothes were dull with long neglect. Among her attributes was a SCEPTRE which she brandished in

her left hand; in her right she held BOOKS. She wore a CROWN. Boethius' description of the allegorical figure of Philosophy was familiar to the Middle Ages and was represented thus in art at that time and later. She may be surrounded by numerous books, or have two only entitled 'Moralis' and 'Naturalis'. The inscription 'Causarum cognitio' on a scroll is the definition of philosophy as 'the knowledge of things through their highest causes.' Philosophy's robe may be decorated with flowers at the bottom, fish in the middle and stars at the top, an allusion to the three branches of philosophy, moral, natural and contemplative, which the Middle Ages identified with the elements earth, water and air (Raphael: Stanza della Segnatura, Vatican). Her crown may likewise be decorated with three heads. As the 'mother' of the SEVEN LIBERAL ARTS Philosophy is often seen in association with them. Her feet may rest on a GLOBE to signify her dominion over them.

Phineus, see PERSEUS (4).

Phoenix. Fabulous bird of which the classical authors, Herodotus, Ovid, the elder Pliny and others, gave varying accounts. It lived to a great age, some said five hundred years, and finally burnt itself to ashes on an altar fire, from which a new, young phoenix arose. The early Christians adopted it as a symbol of Christ's Resurrection and represented it in funerary sculpture. In the Middle Ages it was commonly associated with the crucifixion, and was an attribute of CHASTITY personified. It is rare in later religious art but may be seen decorating a vessel in allegorical STILL LIFE.

Phylactery, see SCROLL.

Phyllis, see ARISTOTLE AND CAMPASPE.

Pickaback. A child borne on the shoulders of a giant fording a river, CHRISTOPHER; a grown person carried through a river, JULIAN THE HOSPITATOR. A giant with a youth on his shoulders, striding through a landscape, ORION. An old man borne from burning city, Aeneas with his father, TROJAN WAR (8).

Picture. A monk receiving a picture of St Dominic from the hands of the Virgin, the 'Soriano portrait', DOMINIC (7). A picture of SS Peter and Paul is the attribute of a pope, SYLVESTER. The portrait of Christ on a cloth, is the attribute of VERONICA, who is also seen on the ROAD TO CALVARY. Painters at work, see ARTIST.

Pietà ('Lamentation'). The term 'Lamentation' is used to describe the scene immediately following the DESCENT FROM THE CROSS in which the body of Christ, stretched out on the ground or on an altar-like block of stone, is surrounded by mourners. It is generally narrative in character in contrast to the 'Pietà' (Ital. 'Pity') which defines a more devotional aspect of the theme, usually of the sorrowing Virgin alone with the body. On this the gospels are silent, but the subject is found in the Byzantine painters' guide and in the mystical literature of the 13th and 14th cents., the *Meditations* of Giovanni de Caulibus and *Revelations* of St Bridget of Sweden. It occurs first in Byzantine art of the 12th cent. and thence passes into the west in the 13th cent. The persons present in narrative versions of the theme are much the same as in the 'Descent', principally the Virgin Mary, St John the Evangelist and Mary Magdalene. The last usually embraces the Saviour's feet, with which she was particularly associated in the theme of her penitence. (See MARY MAGDALENE, 1). The Virgin, or more seldom St John, embraces or supports the head. There may also be present Joseph of Arimathaea, perhaps holding the linen cloth, Nicodemus with a jar of spices (see John 19:38–41), and the holy women. In the background may be seen the base of the cross with perhaps the skull of Adam lying beside it.

The earlier Renaissance, following medieval practice, portrayed the body of Christ lying across the knees of the seated Virgin, but later it is seen lying on the ground on the outspread winding-sheet, with the head raised and resting in her lap. The latter became the established type in the Counter-Reformation. The Virgin is sometimes seen swooning into the arms of St John, or the holy women, or angels, but this feature virtually disappears in the mid-16th cent. having been censured by the Council of Trent. In Counter-Reformation art she may also be seen closing the eyes of Christ, or removing the crown of thorns. Angels may be present when the theme is treated devotionally, perhaps contemplating the body, or supporting it by the arms, or with their hands raised in an attitude of prayer.

Pig (see also BOAR). In Mosaic law an unclean animal; in the Middle Ages a symbol of greed and lust. It is an attribute of LUST personified and is trodden, vanquished, under the feet of CHASTITY; also an attribute of GLUTTONY and SLOTH; with a different meaning, of ANTONY THE GREAT. A youth tending swine or praying among them, is the PRODIGAL SON (2). Pigs roam the palace of CIRCE, perhaps driven off by her maidens.

Pigeon, see DOVE.

Pigritia, see SLOTH.

Pilgrim. The principal places of medieval pilgrimage were the Holy Land, Compostella and Rome. The pilgrim in art generally wears a broad-brimmed HAT, sometimes turned up at the back and pointed at the front. He carries a STAFF. His wallet, or scrip, hangs from it or from his shoulder. The scallop SHELL, seen on the hat, wallet or elsewhere, is his special attribute. Dressed as pilgrims are JAMES THE GREATER; ROCH; Christ on the JOURNEY TO EMMAUS, at the SUPPER AT EMMAUS, and at the supper of GREGORY THE GREAT (1); the archangel RAPHAEL, distinguished by wings. A ragged pilgrim may be ALEXIS. The allegorical figure of HOSPITALITY welcomes a pilgrim. BRIDGET of Sweden may have a pilgrim's staff and wallet.

Pillar. Among the Greeks and Romans the statue of a god, especially Jupiter, surmounted a tall pillar to indicate that he dwelt in the sky. A spiral path might lead up it to heaven. The honour was later extended to the Roman emperors, the spiral often being decorated with their military exploits. A vision of the Virgin Mary on a pillar appeared to JAMES THE GREATER. Busts of the god JANUS and of PRIAPUS generally stand on a pillar (see also HERM). The pillar was also a religious symbol of spiritual strength and steadfast-

Impresa of Charles V

ness (Rev. 3:12) and thence became an attribute of the allegorical figures of FORTITUDE and CONSTANCY. Fortitude's pillar may be broken in allusion to SAMSON. Bound to a pillar were Christ at the FLAGELLATION – perhaps one of a colonnade – SEBASTIAN and APOLLONIA. The Israelites' pillar of cloud, or fire, is sometimes represented as a classical column (MOSES, 7). The Virgin may lean against a pillar in the scene of NATIVITY (4). An angel with legs made of flaming pillars delivers a book to John the Evangelist (APOCALYPSE, 14). A flaming pillar is the attribute of THECLA. A warrior sleeping beside a pillar by a river, a woman kneeling by him are RINALDO AND ARMIDA (1). Twin pillars were the *impresa* of Charles V, king of Spain. They stood for the 'Pillars of Hercules',

the rocks at the western end of the Mediterranean that marked the limit of the known world in antiquity (see HERCULES, 10). The accompanying motto, 'Plus ultra', signified the extension of his dominion beyond to the Americas.

Pincers. The attribute of AGATHA (the alternative to shears); when holding a tooth, of APOLLONIA. A quack doctor holding a stone in pincers, see OPERATION FOR STONES IN THE HEAD. See also TONGS.

Pine cone, wand tipped with, see THYRSUS.

Pipe. The instrument depicted in classical Greek and Roman art was strictly not a flute but a reed pipe, a kind of oboe, in Latin *tibia*. They were often played as a pair by one performer, a practice also adopted in the Middle Ages. It was the instrument of the SATYR, including Marsyas (APOLLO, 4) and of Euterpe, one of the MUSES (Horace, *Odes* I, 1:32–3). A pipe was played by MERCURY, lulling the shepherd Argus to sleep. Renaissance painting depicts a variety of contemporary pipe instruments, the flute (generally vertical), the recorder (a kind of flute), oboe, shawm (with a bell-end), and cromorne (U-shaped at the end). The pipe was a widely accepted phallic symbol in primitive society, and has this meaning when played by the man in pictures of a pair of lovers. It is the attribute of Vice personified (HERCULES, 21). Pan-pipes, also called a syrinx, a row of graduated tubes bound together, were the instrument of the shepherd in ancient Greece. They are played by PAN, who also taught Daphnis to play them. Also by DAPHNIS AND CHLOE; by the shepherd Polyphemus (see GALATEA); and by the shepherds at Christ's Nativity (see ADORATION OF THE SHEPHERDS). See also BAGPIPE. (See diags. MUSICAL INSTRUMENTS.)

Pirithous, see CENTAUR.

Pisces (zodiac), see TWELVE MONTHS.

Pitcher, or jug, a vessel for storing or pouring liquids, with one or two handles, originally of earthenware; to be distinguished from the handleless VASE and the larger URN (see also JAR; POT). The wine-vessel of the SATYR is often an ordinary pitcher, but may also be a classical *amphora* with its tapered base, or the wide-mouthed *krater*. A pitcher is the attribute of HEBE, handmaiden of the gods; of the personification of TEMPERANCE, who pours water from it into another vessel; of the warrior saint FLORIAN; overturned it is one of the elements in allegorical STILL LIFE. A woman watering plants from a pitcher is Grammar, one of the SEVEN LIBERAL ARTS. It is one of the symbolic objects associated with the Virgin and Child (VIRGIN MARY, 13). An overturned pitcher beside a pool, with Naiads embracing a youth, HYLAS; the same, but with a corpse entwined by a serpent, CADMUS (1). Two young women, one pouring wine, the other sitting in an old man's lap, LOT (2). Scenes beside a WELL generally include large pitchers and other vessels. Aquarius, the water-carrier of the zodiac, see TWELVE MONTHS.

Placidus and Flavia, martyrdom of, see BENEDICT (5).

Plane, among other carpenter's tools, the attribute of JOSEPH, the husband of Mary; and of Melancholy, one of the FOUR TEMPERAMENTS.

Plough. Drawn by an ox and an ass, ULYSSES (1). Ploughing is one of man's activities in the Silver Age. The figure personifying this age has a plough for attribute (AGES OF THE WORLD). Ploughing is one of the Labours of the Months (TWELVE MONTHS). A ploughman approached by Roman soldiers is CINCINNATUS. A redhot ploughshare is the attribute of CUNEGUNDA.

Ploughshare

Pluto. The Greek god who ruled the underworld. He is properly named Hades. 'Pluto' from the Greek word meaning 'giver of riches' was used of him euphem-

istically. Hence his near-namesake Plutus, the god of riches, was also sometimes represented with a crown (see IGNORANCE). The wife of Pluto was Proserpine (Persephone), daughter of the corn-goddess Ceres (Demeter). He carried her off by force to his lower kingdom (see RAPE OF PROSERPINE). ORPHEUS (3) pleaded with him to allow Eurydice to return to earth. The name Hades is also given to his kingdom. Its entrance is guarded by the three-headed watchdog Cerberus. It lies on the further shore of the River Styx, or the Acheron, across which the souls of the dead are ferried by Charon in his bark. Mercury in the role of psychopomp, the conductor of souls, leads the spirits of the dead down to Pluto from earth above. To the Greeks Hades was a grey region inhabited by ghosts. In later myth Elysium, the pleasant land reserved for heroes and other righteous, formed part of Hades, as did Tartarus where the wicked were tormented (see AENEAS, 8). See also HERCULES (20).

Polyhymnia, see MUSES.

Polyphemus. A giant, one of the race of one-eyed Cyclopes. He lived in a cave where he imprisoned ULYSSES (Odysseus) and twelve of his companions. Ulysses succeeded in escaping but not before two others had been eaten by Polyphemus. Ulysses first made the giant drunk with wine and then blinded him by driving a stake into his one eye. The giant is shown spread-eagled on his back in a drunken stupor while diminutive warriors in armour approach carrying a stake. Human remains litter the floor of the cave. (Tibaldi, fresco, Bologna Univ.) See also GALATEA.

Polyxena. Polyxena was a daughter of Priam, king of Troy. The Greek hero Achilles, though on the opposing side in the Trojan war, fell in love with her at first sight. According to one tradition, favoured by medieval romances, Polyxena brought about his death by a plot. (See ACHILLES, 4.) After the sack of Troy by the Greeks the ghost of Achilles appeared to the other Greek chieftains and demanded that Polyxena be sacrificed on his tomb. This was carried out. She is seen kneeling beside the tomb. The executioner was Neoptolemus the son of Achilles who stands behind Polyxena with raised sword. On the tomb may be an equestrian statue of Achilles. His ghost floats in the air above. Agamemnon, the Greek leader who dissented from the sacrifice, is seen pleading in vain.

Pomegranate. Christian symbol of the Resurrection after its classical association with Proserpine who returned every spring to regenerate the earth. The many seeds contained in its tough case made it also a symbol of the unity of the many under one authority (either the Church or a secular monarch), and of chastity. As a Resurrection symbol it is held by the infant Christ (VIRGIN MARY, 13) and features in allegorical STILL LIFE. The Virgin's chastity is expressed in the pomegranate tree under which she sits with a unicorn (VIRGIN MARY, 5). A pomegranate was the *impresa* of the Holy Roman Emperor Maximilian I (1459–1519) and of Isabella of Portugal, the wife of his grandson, Charles V of Spain. Surmounted by a cross it is the attribute of JOHN OF GOD.

Pompey, see CAESAR, GAIUS JULIUS.

Pontius Pilate, Christ brought before, hand-washing, see TRIAL OF CHRIST (3, 4, 5).

Pool. Christ healing the sick at the pool of Bethesda, PARALYTIC, HEALING OF THE. A youth gazing into a pool, NARCISSUS. A figure in a pool reaching up for a branch of dangling fruit, TANTALUS. Lovers standing in a pool, he resisting her embraces, HERMAPHRODITUS. Nymphs bathing in a pool, observed by warriors, RINALDO AND ARMIDA (3). A watery grotto is a common setting for scenes of DIANA (2) and her nymphs.

Pope. For the distinguishing pontifical vestments, see RELIGIOUS DRESS. They are worn by CLEMENT, SYLVESTER, GREGORY THE GREAT, sometimes by PETER, apostle, first bishop of Rome. Kneeling before a pope, interceding or otherwise seeking favour, or receiving benediction, are BRUNO (Urban II); CATHERINE OF SIENA (Gregory XI) who also leads him on horseback, the Emperor CONSTANTINE (Sylvester I), DENIS (Clement I), IGNATIUS OF LOYOLA (Paul III), LAURENCE (Sixtus II) perhaps receiving gold and silverware from him, URSULA (Ciriacus) with her betrothed. The founder of a monastic Order may be depicted before a pope, seeking sanction for his Rule. A pope leads the *Danse macabre* (see DEATH). A pope, with a monarch and common folk, is overwhelmed on the day of wrath (APOCALYPSE, 7, 13).

Poppy. Its sleep-inducing properties were well known to the ancients. Poppies are the attribute of Hypnos, the Greek god of sleep (see SLEEP, KINGDOM OF), of Morpheus, the god of dreams who may be crowned with a garland, and of NIGHT personified.

Porcia (Portia). In Roman history the daughter of CATO and wife of Marcus Brutus, one of the conspirators who murdered Julius Caesar. According to Plutarch (46:53), after her husband committed suicide Porcia took her own life by stuffing her mouth with burning coals. She is depicted snatching the coals from a brazier, an action somewhat resembling that of MUCIUS SCAEVOLA. This stern example of conjugal loyalty is found in Italian painting from the 15th cent. onwards. (Mosca, relief, Mus. Archeol., Venice.)

Porcupine. The *impresa* of Louis XII (1462–1515), sometimes crowned, with its spines perhaps separated from its body, from the belief that it could shoot them at its enemies. The accompanying motto 'Cominus et eminus' – 'Hand to hand and out of hand's reach' – allude to the alternative ways of fighting.

Porsena, Lars, see MUCIUS SCAEVOLA; CLOELIA.

'Porta clausa,' see VIRGIN MARY (4, 5).

'Porta haec clausa erit . . .,' see EZEKIEL.

Portia, see PORCIA.

Poseidon, see NEPTUNE.

Pot. Assorted earthenware pots are the attribute of the martyrs JUSTA AND RUFINA.

Poverty (Lat. *Inopia*). The Middle Ages classed Poverty among the vices. She is a somewhat infrequent figure in allegory, generally represented as an old woman with emaciated features, bare feet and dressed in rags. One hand is winged and reaches up; the other is dragged down by a heavy stone, to denote the effect of poverty on man's spirit that would aspire to heaven. Poverty, with CHASTITY and OBEDIENCE make up the three vows of the religious Orders. She may then be represented as a young woman, her robe in tatters and patches, barefooted. FRANCIS OF ASSISI declared himself wedded to poverty and is hence depicted placing a ring on her finger (Church of S. Francesco, Assisi).

Prayer. A saint at prayer, usually before a vision of the crucified Christ or the Virgin and Child, is a frequent theme, especially in the art of the Counter-Reformation. The following may be more readily distinguished. *Prayer before the crucified Christ:* Christ reaching down to embrace the kneeling saint, BERNARD of Clairvaux, FRANCIS OF ASSISI; Christ inclining his head, MARGARET OF CORTONA, JOHN GUALBERTO; Christ presenting the instruments of the Passion, MARY MAGDALENE OF PAZZI; Christ presenting the nails or showing his wounds, TERESA; Christ bearing the cross, GREGORY THE GREAT (5), IGNATIUS OF LOYOLA. *Prayer before the Virgin:* aged saint, saltire cross, ANDREW, apostle; a lily lying nearby, PHILIP NERI; the Virgin presenting a scapular, SIMON STOCK; the Virgin

placing a veil on saint's head, MARY MAGDALENE OF PAZZI; the Virgin handing the infant Christ to the saint, MARY MAGDALENE OF PAZZI, FRANCIS OF ASSISI and others; Virgin and Joseph bestowing cloak and necklet, TERESA. A DONOR and his family kneel before the Virgin and Child with saints. A saint kneeling before Peter and Paul, receiving staff and book, DOMINIC; before an angel, eating proffered book or scroll, John the Evangelist (APOCALYPSE 14). He also kneels before other apocalyptic visions. A saint kneeling, surrounded by angels, CHARLES BORROMEO. Christ kneeling before an angel who holds chalice, three sleeping disciples nearby, AGONY IN THE GARDEN. Ambrose at prayer before two martyrs, GERVASE AND PROTASE. An erotic or monstrous vision, a desert hermit at prayer, ANTONY THE GREAT. Prayer in the desert or in a rocky wilderness: JEROME or BRUNO; in a hollow tree, BAVO. A kneeling figure in monastic habit with a skull, FRANCIS OF ASSISI and others; among plague victims, FRANCES OF ROME. A youth praying among pigs or other farmyard animals, PRODIGAL SON (2). Animals suspended in a sheet held by angels above a kneeling saint, PETER, apostle (9). A magician falling from the sky, emperor and court watching while a saint prays, PETER, apostle (12). Prayer before an altar, with special features: a bishop attacked by soldiers, THOMAS BECKET; a youth restored to life by saint's prayers, DOMINIC (5); a pope, beside him a monk surrounded by flames, angels bearing away a soul, GREGORY THE GREAT (3); several at prayer before an altar on which wands are piled, JOSEPH, husband of the Virgin (1).

Preacher, before an assembly of listeners. Christ, to the multitude, SERMON ON THE MOUNT; JOHN THE BAPTIST likewise, in the wilderness. STEPHEN (2) before the Sanhedrin. The apostle Peter, his words taken down by MARK. The apostle PAUL (8) before the Areopagus at Athens. BERNARDINO, holding the emblem 'IHS'. A bishop in church, a scornful burgher among the congregation, NORBERT. Jesuit preachers are IGNATIUS OF LOYOLA and FRANCIS XAVIER. FRANCIS OF ASSISI (6) preached to the birds, and ANTONY OF PADUA to the fishes.

Pregnancy. The pregnant condition of the Virgin Mary and Elizabeth is frequently indicated in the scene of the VISITATION, often, in Byzantine and western medieval examples, by a tiny effigy of the infant in a mandorla resting against the belly of the mother. The nymph Callisto, manifestly pregnant, is accused by the goddess DIANA (5).

Presentation in the Temple (Luke 2:22–39). The bringing of the infant Jesus by Mary and Joseph to the Temple in Jerusalem to be 'consecrated to the Lord.' (Not to be confused with the CIRCUMCISION.) Mosaic law required that the firstborn of all living things be sacrificed to the Lord, children being redeemed by the payment of 5 shekels (Num. 18:15–17). The rite commemorated the slaying of the firstborn in Egypt when the Jews were spared (Ex. 13:11–15). (See MOSES, 6.) It was adopted as a Christian feast by the early Church. According to Luke the Jewish rite of the 'purification' of the mother – requiring the sacrifice of 'a pair of turtle doves or two young pigeons' (Lev. 12) – was celebrated simultaneously, and this also later became a Christian festival (in the Anglican prayer book it is called the Churching of Women). From early times the feast of the Purification incorporated a procession of candles, hence its name Candlemas.

To the Temple came Simeon, a devout man to whom it had been disclosed that he would not die until he had seen the Messiah. He took the infant Christ into his arms saying 'Lord, now lettest thou thy servant depart in peace . . .' (*Nunc dimittis, Domine*). At the same time he prophesied that through her child Mary would be pierced to the heart. In art of the 14th cent. onwards St Simeon is usually identified with the high priest of the Temple, and wears priest's

vestments, sometimes with the saint's halo. (According to the apocryphal Book of James, or Protevangelium, Simeon had succeeded to the office on the death of Zacharias the former high priest, the father of John the Baptist.) The central figures are Mary and the high priest. She holds out the infant to him, or he is in the act of handing it back to her. A pair of doves, in allusion to the theme of the Purification, are carried by Joseph or by a female attendant or, in early Renaissance pictures, by Mary herself. Joseph may be seen reaching for his purse or counting out the 5 shekels. Also present, according to Luke, was Anna an aged prophetess who may be seen, more often in Italian than in northern painting, with her right hand raised and finger pointing, the gesture of prophecy. Candles are usually carried by the principal figures, or by acolytes, in reference to Candlemas. The theme may form one of the series of the Seven Sorrows of the Virgin (VIRGIN MARY, 2) because of Simeon's prophecy.

Presentation of the Virgin. The 13th cent. *Golden Legend* which relates the childhood of the Virgin Mary after the accounts in the early New Testament apocryphal literature, tells how 'when she had accomplished the time of three years, and had left sucking, they brought her to the Temple with offerings. And there was about the Temple, after the fifteen psalms of degrees, fifteen steps or grees to ascend up to the Temple, because the Temple was high set . . . And then Our Lady was set on the lowest step, and mounted up without any help as she had been of perfect age, and when they had performed their offering, they left their daughter in the Temple with the other virgins . . . And the Virgin Mary profited every day in all holiness, and was visited daily of angels . . .' The theme is found in western Christian art from the 14th cent. – rarely before – either as a separate scene or as part of the cycle of the life of the Virgin. The child is seen climbing the steps of the Temple, not always fifteen in number, towards the high priest Zacharias, who awaits her at the top. She is generally represented as of rather more than three years of age. The aged Joachim, her father, and her mother Anne stand at the foot of the steps, with onlookers, or follow behind her; or, contrary to the text, help her to mount. Counter-Reformation painting adds a devotional aura to an otherwise narrative subject by depicting the child kneeling before the high priest, with angels overhead, perhaps swinging censers. The theme illustrates not merely the carrying out of the requirements of Jewish law concerning the firstborn (see PRESENTATION IN THE TEMPLE), which in any case took place in early infancy, but was meant as a visible symbol of the Virgin's consecration as the 'chosen vessel' of Christ's Incarnation. The fifteen 'psalms of degrees' are numbers 120–134, known as the Psalms of Ascents, or 'Little Psalter of the Pilgrims,' and may once have constituted a separate group. They were sung by Jewish pilgrims as they made their way up to Jerusalem for the three annual pilgrim festivals, or were chanted on the fifteen steps that, according to Josephus, separated the women's court from the men's at the Temple.

Priam, see TROJAN WAR (5).

Priapus. An ancient fertility god, the protector of gardens, vines, bees and flocks, who was worshipped in Greece and Italy. His most notable feature was his enormous genitals. According to one account he was the offspring of Venus and Bacchus; Juno, to mark her disapproval of his mother's promiscuity, gave him his grotesque deformity. In antiquity his image often took the form of a HERM, that is, the head and torso of the god, with a phallus, set on the top of a rectangular pillar. He is represented in this way, but usually without the sexual member, in post-Renaissance painting. The herm, garlanded with flowers, is seen presiding over the revelries of Satyrs and Maenads, the followers of Bacchus.

In the *Fasti* Ovid tells how Priapus, hoping to ravish the nymph Lotis (1:415–440), or alternatively the goddess Vesta (6:319–348), crept up to her as she lay resting on the grass during a banquet of the gods. He was foiled when the ass of Silenus suddenly began to bray and the goddess started up. In Renaissance painting Priapus, in human form, is either naked or clothed, more usually the latter. The folds of his garment fall in such a way as to suggest an erect sexual organ underneath (G. Bellini, 'Feast of the Gods', Nat. Gall., Washington). A braying ass is nearby.

Pride (Lat. *Superbia*). One of the seven Deadly Sins, the root of evil, regularly represented in medieval cycles of the VIRTUES AND VICES as a rider falling from his horse. This was the origin of the non-scriptural convention that depicts St Paul falling from a horse on the road to Damascus (see PAUL, 1). In the combat of virtues and vices Pride is vanquished by HUMILITY. In the Renaissance the female figure of Pride has a LION and EAGLE (the rulers respectively of earth and air in the animal kingdom), a PEACOCK, the proudest of birds, and a MIRROR in which the image of Satan may be seen. In the Renaissance the latter type tends to merge with that of VANITY.

Primavera, see FLORA.

'Primum querite regnum Dei,' see MATTHEW.

Priscian, grammarian, personification of Grammar, one of the SEVEN LIBERAL ARTS.

Prison. In a prison cell the apostle PETER is roused by an angel (11); he baptizes two gaolers (14). An earthquake bursts open the prison of the apostle PAUL (7). A prisoner with a dog, watched by an angel, is ROCH. A young woman suckling an old man in a cell represents ROMAN CHARITY. SOCRATES (2) in prison drinks poison in the presence of anguished youths. A dying man with his dead children in a cell is UGOLINO DELLA GHERARDESCA.

'Probasti me, Domine, et cognovisti,' see CRUCIBLE.

Procession to Calvary, see ROAD TO C.

Processus and Martinian, SS, Baptism of, see PETER, apostle (14).

Procris, see CEPHALUS AND P.

Prodigal Son (Luke 15:11–32). Of all the parables this one is most often represented in art, teaching the virtues of repentance and forgiveness. A man divided his estate between his two sons. The younger went off, squandered his portion in riotous living and was finally, in poverty, reduced to tending a farmer's pigs. He returned home penitently and was joyfully received by his father who dressed him in fine clothes and killed a fatted calf to make a feast. The father mollified the angry elder son, saying, 'Your brother here was dead and has come back to life, was lost and is found.' The theme, continuously popular in the form of narrative cycles and single subjects, is found first in the stained glass of the 13th cent. cathedrals of France. Cycles include the following scenes: the prodigal son receives his inheritance; he departs; he feasts at an inn with harlots; they chase him away when his money is gone; he tends the pigs; he returns home. As the personification of the repentant sinner he may be seen beside MARY MAGDALENE, DAVID and the apostle PETER.

1. *The prodigal son feasting with harlots*. He is seated at table at an inn with two women; servants and musicians are in attendance. In the background there may be scenes depicting his future downfall among the pigs and his return home. The theme is common in Netherlandish painting of the 16th and 17th cents.

2. *The penitence of the prodigal; feeding the swine*. He kneels in prayer in a farmyard or stable. Pigs are feeding in a nearby trough. Farmhands with sheep, goats, cows and horses, may be about. Angels descend from heaven.

3. *The return of the prodigal.* Dressed in rags he kneels before his father who is embracing him or is making a gesture of pardon or blessing. One or more servants bring new clothes. The elder brother receives him with restraint. In the background a calf is being slaughtered, as it were a sacrifice made in atonement for sin.

Prometheus. In Greek mythology the son of Iapetus, a Titan. He created the first man from clay, stole fire from the gods to give to mankind, and was punished by Jupiter, the father of the gods, by being chained to a rock where an eagle came every day to feed on his liver. He was released by Hercules. Each age has attached its own symbolic meaning to the figure of Prometheus, modifying the telling of the myth for its own purpose. From the time of Aeschylus the fire was seen not merely as the natural element but as the spark of divine wisdom that distinguished man from lesser creatures, the source of his knowledge of the arts and sciences; hence Prometheus' role was to rescue man from his original ignorance. Christian writers saw this pagan creator and his act of mediation as a prefiguration of the Christian story; his punishment, chained to the rock, foreshadowing the crucifixion. The nineteenth century Romantic movement made Prometheus a symbol of freedom, a champion of mankind against tyranny; and to many, in different ages, he stood for the artist who receives from heaven the fire of creative inspiration.

1. *Prometheus fashions man from clay* (*Met.* 1:76–88). According to Ovid Prometheus made the figure of a man from clay in the image of the gods. He is shown before a life-size statue which perhaps stands on a pedestal. Minerva, with whose help he stole the fire from the sun's chariot, may stand beside him pointing upwards. Or, having carried out the theft, he is depicted applying a burning torch to the statue to bring it to life. This fusion of two unconnected myths, the creation of man and the theft of fire, lent itself to interpretation as a Christian allegory of man instilled with spiritual grace.

2. *Prometheus bound; the torture of Prometheus.* As a punishment for his rebellious behaviour Jupiter had Prometheus chained to a rock in the Caucasus by Vulcan the smith-god or, according to some, by Mercury. Here for many ages he endured the torture of a daily visit from an eagle that fed on his liver. In this horrific scene, popular with artists since antiquity, Prometheus is outstretched naked on a rock, chained by the wrists and ankles, and writhing in pain as a great eagle pecks at his liver. A torch, a reminder of the reason for his punishment, lies on the ground. Vulcan or Mercury may be present fastening the chains. The theme resembles the punishment of TITYUS, who suffered a similar fate, his liver pecked by a vulture instead of an eagle. Prometheus was finally released by Hercules who is shown loosing his chains. He holds a bow in one hand while the eagle lies dead on the ground, pierced by an arrow.

Prosdocimus, bishop of Padua, see JUSTINA.

Proserpine, SEE RAPE OF P.

Protase, SEE GERVASE AND P.

Prudence. With JUSTICE, FORTITUDE and TEMPERANCE, one of the four Cardinal Virtues (see VIRTUES AND VICES), signifying not caution but simply wise conduct. Prudence is personified as a woman with a SNAKE and a MIRROR. The snake is derived from Matthew (10:16), 'Be ye wise (*prudentes*) as serpents.' She acquired the mirror in the late Middle Ages; it signifies that the wise man has the ability to see himself as he really is. The mirror is seen particularly in Italian Renaissance art, but examples of both attributes are found in painting and sculpture of other periods, notably on tombs where the virtues have a special place. Prudence may,

less often, have COMPASSES (her measured judgement), a BOOK (the Scriptures) or a STAG (prudent in eluding its pursuers). The snake sometimes takes the form of a dragon. Prudence may, like JANUS, have two faces and look in both directions simultaneously, signifying her circumspection. The vice opposed to Prudence is Folly (*Stultitia*) perhaps portrayed as a jester with a bauble or, probably a corruption of the same image, a man crowned with feathers and holding a cudgel.

The allegory of Prudence with three faces. To the moralist a prudent act was neither unpremeditated nor transient in its effect; it combined memory, intelligence and foresight. This threefold nature had a parallel in the three aspects of time: past, present and future, and like two-faced Janus, acquired a typical visual interpretation. This other Prudence is represented as a composite image made up of three male human heads, young, mature and old, facing different ways. It is found in the later Middle Ages and Renaissance and is sometimes accompanied by a snake. The image underwent a striking development in the Renaissance. The works of the late Roman philosopher and mythographer Macrobius (fl. A.D. 400), well known to the Renaissance humanists, contain a description of a statue of the Egyptian sun-god Serapis leading a monster that has the heads of a wolf, a lion and a dog – perhaps originally a kind of Cerberus. Macrobius interpreted the image as three aspects of time (wolf: devours the past; lion: courage that the present calls forth; the fawning dog lulls man's thoughts about the future). In the Renaissance it coalesced with the triple human-headed image of Prudence, forming a single entity. It might be either disembodied, or with a snake entwining its body, just as a snake sometimes entwined the body of the god Serapis. Titian (Nat. Gall., London) depicts the three male human heads surmounting the three animal heads, with the inscription 'Ex praeterito – praesens prudenter agit – ni futura actione deturpet' – 'From past experience the present acts prudently lest future action be vitiated.'

Psalter. The book of Psalms was for many centuries the main collection of sacred writings used both for the liturgy and for private prayer. In its more expanded form in the high and late Middle Ages the Psalter contained in addition a calendar which preceded the psalms, and numerous other prayers. Illumination, often lavish, was a feature of both Byzantine and western Psalters. The calendar was often illustrated with the traditional scenes of the Labours of the Months (see TWELVE MONTHS), and the main body of the book with miniatures of David and episodes from the Old and New Testaments which provided a figurative interpretation of the text. The Psalter as the principal prayer book of the laity was gradually replaced towards the end of the Middle Ages by the BOOK OF HOURS which was based upon it.

Psaltery. A stringed instrument consisting of a shallow box, roughly the shape of a symmetrical trapezium, across which the strings were stretched. It was plucked with the fingers, unlike the similar dulcimer that was struck with a hammer held in each hand. Instruments of this type were known in the ancient near east and Egypt. The psaltery was widely popular in Europe in the 14th and 15th cents. and is commonly depicted in concerts of angels. Next to the harp, it is the usual instrument of DAVID in representations within its period. It is occasionally among the instruments played by the MUSES. See diag. MUSICAL INSTRUMENTS.

Psyche, see CUPID (6).

Ptolemy, astronomer, personification of Astronomy, one of the SEVEN LIBERAL ARTS.

'Pulchra ut luna . . .,' see VIRGIN MARY (4).

Purgatory, see GREGORY THE GREAT; TERESA; DANTE AND VIRGIL.

Purification of the Virgin, see PRESENTATION IN THE TEMPLE.

'Puteus aquarum viventium,' see VIRGIN MARY (4).

Purse. An attribute of MERCURY, as god of commerce; of JUDAS ISCARIOT and of AVARICE and Melancholy personified. (See FOUR TEMPERAMENTS.) It symbolizes the transience of earthly riches in STILL LIFE, and is an attribute of VANITY personified. MATTHEW, the tax-collector, and LAURENCE, the deacon, have a purse. It is the attribute of the bishop, THOMAS OF VILLANUEVA; three purses, of the bishop, NICHOLAS OF MYRA. See also WALLET.

Putto (Lat. *putus*, a little man), or 'Amoretto' (Lat. diminutive of *Amor*, love or Cupid). The winged infant commonly found in Renaissance and baroque art, and having the role either of angelic spirit or the harbinger of profane love, had its origin in Greek and Roman antiquity. The Greek *erotes*, winged spirits, the messengers of the gods, that accompanied a man through his life, were derived from Eros, the god of love (see CUPID). In his earlier manifestation Eros was a youth, or *ephebe*, but by Hellenistic times had grown younger and more child-like in appearance. This form eventually merged with the *genii* of Roman religion, similar guardian spirits that protected a man's soul during his life, and finally conducted it to heaven. Early Christians adopted this pagan image for the representation of angels in catacomb painting and on sarcophagi. The Middle Ages however based its image of the angel on the full-grown Roman goddess, the winged VICTORY, and the infants of antiquity disappeared until the Renaissance. Henceforward putti feature both as angels in religious painting – a role that reached its zenith in the art of the Counter-Reformation – and as the attendants of Cupid, the ubiquitous messengers of profane love in secular themes. They constantly accompany VENUS, and occasionally attend the VIRTUES AND VICES. They are an attribute of Erato, the MUSE of lyric and love poetry. (See also ANGELS.)

 Feast of Venus. The scene of many putti playing before a statue of Venus has elements from Philostratus the Elder and Ovid. The former (*Imag.* 1:6) describes an orchard in which there is a shrine of Venus, where putti fly among the branches picking apples, sacred to the goddess, and gather them in baskets. Others on the ground playfully shoot their arrows, play ball with the fruit, and dance and wrestle together. All are in various childish ways celebrating the rites of love. Ovid (*Fasti* 4:133–164) mentions the rituals performed at the feast of Venus Verticordia (Changer of the Heart) on the first day of April, the month sacred to her. Married women and brides wash the marble statue and garland it with flowers. Another offers incense on a brazier (Rubens, Kunsthistorisches Mus. Vienna).

Pygmalion. A legendary king of Cyprus who fell in love with a statue of Venus – according to Ovid Pygmalion himself carved the statue from ivory, with wonderful artistry (*Met.* 10:243–297). He prayed to Venus that he might have a wife as beautiful as the image he had created, whereupon the goddess caused the statue to come to life. Latterly she came to be called Galatea, but there is no connection with the Nereid of that name. Artists like to portray the very moment of the statue's transformation and often succeed in suggesting both the inanimate quality of the material and, at the same time, by subtleness of pose, that the figure is alive. As a reminder of whom the statue represents, the pose may be that of the classical *Venus pudica*. (See VENUS.) Pygmalion views his handiwork with astonishment and delight. The setting may suggest the interior of a palace; or an atelier, with marble blocks, busts and sculptors' tools lying about the floor.

The goddess Venus may float overhead with her attendant amoretti and perhaps Cupid, who is about to loose an arrow.

Pyramus and Thisbe (*Met.* 4:55–166). A Babylonian couple whose story has something in common with Shakespeare's star-crossed lovers. Ovid tells how, forbidden by their parents to marry, they planned to meet in secret one night outside the city walls. The trysting place was by a mulberry tree beside a spring. Thisbe arrived first but as she waited a lioness, fresh from a kill, came to quench its thirst, its jaws dripping blood. Thisbe fled, in her haste dropping her cloak which the beast proceeded to tear to shreds. When Pyramus arrived and discovered the bloody garment he believed the worst. Blaming himself for his lover's supposed death he plunged his sword into his side. His spurting blood coloured the mulberries red for all time. Thisbe returned to find her lover dying and so, taking his sword, threw herself upon it. The story is not represented in antiquity but the death scene became widely popular in post-Renaissance painting. The scene usually chosen is the moment of Thisbe's discovery of Pyramus' body. He lies outstretched, the sword in his side. Thisbe stands over him, her arms raised in dismay. Or she is in the act of throwing herself on his sword. The lion is sometimes seen in the distance, perhaps attacking cattle while herdsmen try to beat it off. (Tintoretto, Gall. Estense, Modena.)

Pyre. Death on a funeral pyre, DIDO; HERCULES (25); Patroclus (TROJAN WAR, 4).

Pythagoras, personification of Arithmetic and of Music, two of the SEVEN LIBERAL ARTS.

Pyx. Originally a circular box with a hinged, sometimes conical lid and bearing a cross, in which the consecrated wafer was reserved. From it was developed another vessel with a similar function, the more elaborate ciborium which was roughly hemispherical, with a close-fitting lid of the same shape and standing on a pedestal. The term pyx subsequently denoted the flat round box in which the priest takes communion to the sick, the type generally represented. It is the attribute of LONGINUS, and of the archangel RAPHAEL when accompanying TOBIAS.

Ciborium *Pyx*
not to scale

Quack doctor, see OPERATION FOR STONES IN THE HEAD.

Quadrant, see SEXTANT.

'Qui conceptus est de Spiritu Sancto . . .,' see JAMES THE GREATER.

'Qui tollis peccata mundi,' see JUDE.

Quince. A yellow lemon- or pear-shaped fruit, sacred to Venus, and a symbol of fertility and marriage. In portraits commemorating a wedding the woman may hold a quince. When held by the infant Christ it has the same meaning as the apple.

Quiver. Carried by those whose attribute is the BOW, and in general by the HUNTER.

'Quod huic deest me torquet,' see LIZARD.

'Quos ego,' see NEPTUNE (2).

Rabbit. A byword for fecundity in all ages and hence a symbol of LUST and an attribute of VENUS. It is not uncommon in scenes of loving couples. At the Virgin's feet it symbolizes the victory of chastity. The rabbit and HARE are freely interchangeable.

Rainbow. After the flood God set a rainbow in the cloud as a token of his covenant with man (NOAH, 3). A rainbow forms the throne of Christ the Judge, and occasionally of the Virgin, in representations of the LAST JUDGEMENT (1). It can be,

when tri-coloured, associated with the TRINITY. In Greek mythology the rainbow is personified by the goddess IRIS.

Raising of Dorcas, see PETER, apostle (8).

Raising of Jairus' daughter (Matt. 9:18–19 and 23–26; Mark 5:21–24 and 35–43; Luke 8:40–42 and 49–56). Christ went to the house of Jairus, the president of a synagogue, and restored to life his daughter who was believed to be dead. The subject somewhat resembles the raising of Tabitha (see PETER, apostle, 8) but can be distinguished by the presence of Christ. There were five others with him: 'He allowed no one to go in with him except Peter, John, and James, and the child's father and mother.' Jairus is richly dressed, perhaps wearing a turban. Peter, James and John are typically represented as follows: Peter, grey-bearded; James, dark hair and beard; John noticeably the youngest, clean-shaven and usually long-haired. The child lies on a canopied bed. See also WOMAN WITH AN ISSUE OF BLOOD.

Raising of Lazarus (John 11:1–44). Lazarus, the brother of Martha and Mary Magdalene, lay dying at Bethany. Word was sent to Jesus but by the time he came Lazarus had been dead for four days. Jesus was met on the road first by Martha, then by Mary who prostrated herself at his feet. They went to the grave, a cave with its mouth closed by a stone, and Jesus ordered the stone to be removed. Martha feared that by now the corpse would stink but was told that if she had faith she would see a miracle. Jesus 'raised his voice in a great cry: "Lazarus, come forth." The dead man came out, his hands and feet swathed in linen bands, his face wrapped in a cloth. Jesus said, "Loose him; let him go."' Martha and Mary are sometimes both shown kneeling at Christ's feet, at the grave, as Lazarus emerges, thus telescoping two separate moments in the story. In ancient Jewish funeral rites bodies were entombed upright, as John's text confirms. Byzantine art shows Lazarus in this position and examples of it recur until the Renaissance. In later painting he rises from a coffin. Martha and the others are sometimes portrayed holding their noses against the smell of a decomposing body, thus adding force to the presentation of the miracle. The subject features in religious art from earliest times as a 'type' of the Resurrection.

Raising of Petronilla, see PETER, apostle (13).

Raising of the Cross ('Elevation of the Cross'). The gospels say little of the act of crucifying but mystical literature of the 13th and 14th cents., especially the *Meditations on the Life of Christ* by Giovanni de Caulibus and the *Revelations* of St Bridget of Sweden, describe the preliminaries in detail though not always consistently. The nailing of Christ to the cross forms a separate incident and may be represented in either of two ways. Christ was either nailed to the cross as it lay on the ground, or he ascended when it was already *in situ* and was then nailed. The former is the more usual type and was adopted in the West from Byzantine models. The Byzantine painters' guide states, 'A crowd of Jews and soldiers seen upon a mountain. A cross laid upon the ground in their midst. The body of Christ upon it. Three soldiers hold it by ropes at the arms and foot. Other soldiers bring nails and drive them with a hammer through his feet and hands.' The alternative type which is occasionally found in the early Italian Renaissance shows the Saviour either mounting a ladder, or standing in position while executioners, who have climbed ladders placed at either end of the cross-bar, are nailing his outstretched hands to it. The elevation itself – the raising of the cross with the body of Christ attached to it – belongs chiefly to the 16th–18th cents., more particularly to northern European painting. Men with straining muscles are thrusting one end upwards while others heave on ropes. There may

be numerous spectators, among them the holy women. The Old Testament theme of the *Brazen Serpent* (see MOSES, 12) was taken as the prefiguration of the 'Elevation,' after John (3:14) where Christ, speaking to Nicodemus, says, 'This Son of Man must be lifted up as the serpent was lifted up by Moses in the wilderness.' Crucifixion as practised by the Romans was different in some fundamental respects from either form in which it is depicted. (See CRUCIFIXION, 1).

Raising of the widow's son of Nain (Luke 7:11–17). As they were approaching the town of Nain in Galilee Christ and the disciples met a funeral procession. The mother of the dead man was a widow. Moved to pity Christ restored her son to life. Christ is depicted with one hand on the bier, on which the body of the man is raising itself as it comes to life. The mother kneels before Christ. In the background may be seen the gate of the town.

Ram. A sign of the zodiac (Aries) associated with March, one of the TWELVE MONTHS, and an attribute of MARS in his planetary role. A ram is an attribute of MERCURY, the protector of flocks. See also LAMB.

Rape of Europa, (*Met.* 2:836–875). In Greek mythology Europa was the daughter of Agenor, king of Tyre. Jupiter fell in love with her and, disguising himself as a white bull, came to where she played by the seashore with her attendants. Beguiled by the bull's good nature, she garlanded its horns with flowers and climbed upon its back. Jupiter straight away bore her out to sea and off to Crete where, resuming his normal shape, he ravished her. Europa may be shown climbing on to the bull, helped by her attendants, or the animal is seen making its way towards the water with the girl on its back. But the most usual scene shows it plunging through the waves, a frightened Europa clutching a horn, while her maidens stand forlornly on the distant shore. Amoretti fly about her; one may ride on a dolphin, the attribute of Venus. The medieval *Moralized Ovid*, which interpreted the classical myths in terms of Christian allegory, saw Jupiter as Christ, incarnate in the bull, carrying off a human soul to heaven.

Rape of Helen, see HELEN OF TROY.

Rape of Hippodamia, see CENTAUR.

Rape of Lucretia (*Fasti* 2:725–852; Livy 1:57–9). In the legendary history of early Rome Lucretia, a virtuous woman, the wife of a nobleman, was raped by Sextus, the son of the tyrant, Tarquin the Proud. He came to her when she was alone in her chamber and threatened that unless she gave herself to him he would kill her and then cut the throat of a slave and lay his body beside hers, thus making it appear that she had been caught in adultery with a servant. In the face of this Lucretia yielded and afterwards, having informed her father and husband by letter, took her own life. The episode gave rise to a rebellion led by BRUTUS, the nephew of Tarquin, in which the latter together with his family were forced into exile. The scene is Lucretia's chamber, perhaps in a state of confusion as if after a struggle. She lies naked on her couch trying to ward off Sextus who threatens her with a sword or dagger. A servant may be present holding a light.

The death of Lucretia. A rarer subject, showing her falling on a sword, or, dagger in hand, about to stab herself. She indicates her shame by drawing a veil over her face. Brutus, perhaps with his companion-in-arms Collatinus, may be depicted beside the dying Lucretia, swearing revenge.

Rape of Proserpine (Lat. Proserpina; Gk Persephone) (*Met.* 5:385–424; *Fasti* 4:417–450). Proserpine, the daughter of the corn-goddess Ceres, was picking flowers in a meadow with her companions when she was observed by Pluto, the king of the underworld. Suddenly inflamed with love – according to Ovid he

had just been struck by one of Cupid's arrows – Pluto swept her away on his chariot. He caused a great chasm to open before them in the earth and Proserpine was carried down to his kingdom below. Pluto stands on his chariot, one arm grasping Proserpine by the waist, his other hand holding the horses' reins. He is black-haired and bearded and may wear a crown. She flings up her arms in despair, revealing a bare breast above her disordered dress. Amoretti, symbols of love, fly overhead leading the way. Proserpine's companions flee in alarm or stand in the distance watching her go. The flames of hell are reflected on the walls of the cavern into which the chariot plunges (though Hades had no fires for the Greeks). Minerva, with Aphrodite and Diana close behind her, puts a restraining hand on Pluto's shoulder as he is about to set off. (This last feature is not mentioned by Ovid but is derived from antique funerary art.) The horses were traditionally black but are not always depicted thus.

The myth also tells of Ceres' subsequent wanderings in search of her daughter (see CERES), a flaming torch in her hand, and of Proserpine's return to earth each spring for one third of the year. (She is conducted by MERCURY.) At Eleusis, the most famous Greek religious sanctuary, the myth was performed as part of the rites originally intended to promote fertility of the crops. (See also DESCENT INTO LIMBO.)

Rape of the daughters of Leucippus, see CASTOR AND POLLUX.

Raphael, archangel, the ideal of the angel as guardian spirit, especially the protector of the young, and of pilgrims and other travellers. In art he is represented above all as the travelling companion of the young TOBIAS. It was not uncommon in Renaissance Italy for the departure of the son of a family to a distant city or land to be commemorated by a picture of Tobias and the angel in which Tobias was portrayed in the likeness of the son. Raphael, the painter, depicted his guardian namesake presenting Tobias, who holds a fish, to the Virgin and Child enthroned, the 'Madonna del Pesce,' – 'The Madonna of the fish' (Prado). Like nearly all angels Raphael has wings and is dressed as a traveller, wearing sandals and holding the pilgrim's STAFF, sometimes with a wallet or water-gourd. He may hold a small casket or PYX (see TOBIAS). Because his name means 'God heals', Raphael was by tradition identified with the angel who stirred the waters of the Pool of Bethesda (see PARALYTIC, HEALING OF THE).

Rat. Its destructiveness made it, like the mouse, a symbol of decay, hence of the passing of time. Two rats, one black and one white, are the attribute of NIGHT. A rat is the attribute of FINA, whose room was infested with them.

Raven. The story of the raven that brings food, generally a loaf of bread, to a holy man in the desert is widely told: see ANTONY THE GREAT (2); BENEDICT; ELIJAH (1); ONUPHRIUS; PAUL THE HERMIT. A raven was sent from the ark by NOAH to look for land. It is the attribute of the deacon, VINCENT OF SARAGOSSA. See also CROW.

Raymond Diocres, Death of, see BRUNO (1).

Rebecca at the well (Gen. 24). The patriarch Abraham, wishing to find a wife for his son Isaac, sent his servant, Eliezer, to look for a suitable bride among his own kindred in Mesopotamia, rather than among the people of Canaan where he dwelt. When the servant reached the city of Nahor in Chaldea he prayed for guidance, asking that whoever gave him and his camels water at the well would be an eligible woman. This proved to be Rebecca, a virgin, one of the family of Abraham through his brother Nahor. She invited Eliezer to drink from her jar, and drew water for his camels. Eliezer gave her presents of gold and received hospitality at her parents' house. He then took her back to Canaan. Isaac,

meditating in the fields in the evening, saw the camels approaching. When Rebecca learned who he was, she alighted and covered her face with a veil. Isaac took her into his mother Sarah's tent and 'she became his wife, and he loved her.' Several episodes from the story have been depicted but the meeting at the well is the most popular. It shows Rebecca, accompanied by young women with pitchers, giving Eliezer water, or being addressed, or receiving gifts from him. It was regarded as a prefiguration of the Annunciation. See also JACOB (1).

Red Sea, Crossing of the, see MOSES (7).

Reeds. A nymph hiding among reeds, pursued by PAN, is Syrinx, the name also for the pipes of Pan, made from reeds. The cross of JOHN THE BAPTIST is represented as a reed cane. The sponge soaked in wine, offered to Christ on the cross (CRUCIFIXION, 3) was on the end of a cane, which thus became one of the traditional instruments of the Passion.

Regina Coeli, see VIRGIN MARY (1, 7).

'Regno, regnavi, sum sine regno,' see FORTUNE.

Religious dress. See next page.

Remigius (Fr. Rémi) (*c.* 438–*c.* 533). Bishop of Rheims, chiefly remembered for having brought about the conversion to Christianity of Clovis I, king of the Franks. He is depicted in the cathedral of Rheims in the act of baptizing the king. (The architecture is generally appropriate to the building that stands today, begun in 1211.) Clovis may stand naked in the font, perhaps wearing a crown. Remigius in episcopal robes pours the holy water over the king's head. Remigius' attributes are a DOVE, and a phial of oil – the chrism used in administering confirmation which customarily followed the baptism of adults. Occasionally the dove carries the phial in its beak. Effigies of Remigius are found widely in French cathedrals of the 13th and 14th cents., and especially at Rheims. See also LEONARD.

Reparata. Virgin martyr of Caesarea, said to have died under the persecutions of the Roman emperor Decius in the 3rd cent. Until 1298 she was the titular saint of the Duomo at Florence. She features in early Florentine pictures of the Virgin and saints, holding the martyr's PALM and a BOOK. She may hold the banner of the Resurrection. Her attribute is a DOVE, flying out of her mouth or just above her head, from the legend that at her death her spirit in the form of a dove was seen to fly away. The same legend is told of SCHOLASTICA who also has a dove.

Repast. *Christ present:* LAST SUPPER; MARRIAGE AT CANA, with wine jars; SUPPER AT EMMAUS; supper with Simon the Pharisee, MARY MAGDALENE (1). *Royal or otherwise sumptuous feast:* maiden dances or kneels before king, banquet of Herod, JOHN THE BAPTIST (7, 9); soldier guests at Dido's banquet, AENEAS (4); soldiers also at banquet of CLEOPATRA (1) who drops a pearl into a wine glass; BANQUET OF THE GODS, sometimes forming the background to the JUDGEMENT OF PARIS; bishop bearing youth away from eastern banquet, NICHOLAS OF MYRA (5); a banquet of common folk, some infirm, ROYAL WEDDING; rich man feasting, beggar at door, DIVES AND LAZARUS. *Banquet overthrown:* Battle of Lapiths and Centaurs (CENTAUR); a similar scene with Centaurs, HERCULES (19); warrior present holding Gorgon's head, PERSEUS (4). *Humble meal:* old man serving three guests who may have wings, ABRAHAM (2); in a peasant's cottage, two guests served by aged couple, he perhaps chasing goose, PHILEMON AND BAUCIS; a Satyr at table with peasants, SATYR (3); outside an inn, knight in armour, young women, DON QUIXOTE (2); at an inn, youth entertaining women, PRODIGAL SON (1). The Israelites eat the Passover standing about a table, dressed for travel, MOSES (6). Two men or angels bring bread to seated friars, DOMINIC (6). A pope dines with

Religious dress.

Bishop's mitre

Papal tiara

Cope

Chasuble

Dalmatic

In the diagrams below, heavy shading is used to indicate black, light shading grey or brown, and unshaded white.

Reformed Benedictine

Carthusian

Franciscan

Dominican

Augustinian

Benedictine nun

Dominican nun

Poor Clare (Franciscan)

Olivetan Oblate

twelve paupers and a pilgrim or angel, GREGORY THE GREAT (1). A bishop dines with a harlot, a pilgrim entering, ANDREW, apostle. Poultry on a dish, restored to life, JAMES THE GREATER.

Rest (or Repose) on the flight, see FLIGHT INTO EGYPT.

Resurrection. That Christ rose again on the third day after his death is one of the fundamental tenets of the Christian faith. The Resurrection was a return *to earth* where he remained for forty days until the Ascension. Since there were no witnesses at the moment of his return it is in his subsequent appearances to the disciples that the Christian finds confirmation that the event occurred, and it is for this reason that they are important themes in religious art. (See APPEARANCE OF CHRIST TO HIS MOTHER; MARY MAGDALENE, 3: *Noli me tangere;* THOMAS, apostle, 1: *The incredulity of T.;* JOURNEY TO EMMAUS; SUPPER AT EMMAUS.) For centuries the Church avoided the portrayal of a subject for which there was no scriptural guidance and, with few exceptions, it is unknown until Giotto. In cycles of the Passion it was the HOLY WOMEN AT THE SEPULCHRE, or the 'Noli me tangere', perhaps together with other appearances, that served as a substitute. It needs to be emphasized that the Resurrection was a coming back to earth since there is one treatment of the theme, devotional rather than narrative in character, found in Italy in the 14th and 15th cents. and, more rarely, in northern Europe later, showing the figure of Christ floating in the air, perhaps framed in a MANDORLA, which gives it more the appearance of an Ascension. The scene sometimes includes not only the usual figures of the soldiers guarding the tomb but the subsequent arrival of the holy women, and the angel seated on the tomb who addressed them. But the predominant type, originating in the later Middle Ages and followed by the Renaissance, shows the Saviour firmly on the ground, holding the banner of the Resurrection with its red cross, either standing upright in the open sarcophagus or in the act of stepping out of it. The Council of Trent, which demanded a return to scriptural accuracy, disapproved both of the open tomb and of the floating figure; from the second half of the 16th cent. therefore it is more usual to see Christ standing before a closed tomb.

Matthew, alone among the gospels, mentions the guard of soldiers that Pilate had put on the tomb. The passage seems to have been introduced by the evangelist to refute the charge made by Jews in his day that the disciples secretly removed the body. The soldiers are generally recumbent around the tomb, either in attitudes of sleep, or awake and shading their eyes from the dazzling aura that surrounds the figure of Christ. In Italian painting, when the subject is treated devotionally, the soldiers may occasionally be replaced by saints or the four evangelists.

Rinaldo and Armida. A pair of lovers, from the Italian epic poem *Gerusalemme Liberata* (Jerusalem Delivered) by Tasso (1544–95). It is an idealized account of the first Crusade which ended with the capture of Jerusalem in 1099 and the establishment of a Christian kingdom. Armida, a beautiful virgin witch, had been sent by Satan (whose aid the Saracens had enlisted) to bring about the Crusaders' undoing by sorcery. She sought revenge on the Christian prince Rinaldo after he had rescued his companions whom she, like CIRCE, had changed into monsters. The pastoral story of hate turned to love, of the lovers' dalliance in Armida's magic kingdom, and Rinaldo's final desertion of her, forms a sequence of themes that were widely popular with Italian and French artists in the 17th and 18th cents.

1. *Armida and the sleeping Rinaldo.* Beside the River Orontes in Syria Rinaldo found a marble pillar with a legend inviting the passer-by to discover the wonders

of a little island that lay in mid-stream (14:57–8). Here he fell into a bewitched slumber. Armida emerged swearing revenge, but at the sight of the handsome youth, fell in love (14:66). Rinaldo is depicted lying by the river bank, wearing a breastplate, his helmet and weapons laid aside. Armida kneels, gazing into his face. Her chariot stands in the background; near it is the pillar. The god of the River Orontes reclines beside his overturned URN.

2. *Abduction of Rinaldo.* The sorceress bound Rinaldo with a magic chain of woodbines, lilies and roses and laid him in her chariot (14:68). She is seen carrying Rinaldo, helped by an attendant maid. Or she stands in the car while her attendants lift the body, generally twined with plaited flowers. Or she drives her chariot through the heavens, bearing the sleeping knight. The chariot is usually drawn by horses, only rarely by dragons that the text specifies (dragons also drew the chariot of MEDEA, another witch).

3. *The warriors in Armida's garden.* Two knights, seeking Rinaldo, came to the Fortunate Isle in mid-ocean, where Armida had her palace, and whither she had taken Rinaldo. Refusing to be waylaid by nymphs bathing in a pool, they pressed on till they came to a table laid for a banquet under the trees (15:57–8).

4. *Rinaldo and Armida.* The favourite theme in art, from a famous passage (16:17–23) describing how the warriors came upon the lovers under the shady trees beside a lake. Gazing at his own reflection in his mistress' eyes, Rinaldo at the same time held a mirror to her face: each thus beheld their own image in love, hers smiling, his afire. They are depicted thus, Rinaldo reclining in her lap, his head against her breast, looking into her face and holding a mirror. The two warriors look on, concealed behind bushes or a tree. In the background may be seen Armida's palace.

5. *The abandonment of Armida.* Recalled to duty by his companions-in-arms, Rinaldo bade farewell. As their boat departed Armida stood on the shore begging him to stay. Her pleadings changed to curses when she saw that it was in vain, much as Dido's did at the departure of AENEAS (6). Finally, like Dido, she swooned. We see the three warriors in a boat offshore, with perhaps a boatman straining at the oar. On the beach Armida gesticulates, or has collapsed, fainting.

Ring. A symbol of authority, from the use of the signet ring which goes back to ancient Greece; a symbol also of delegated authority since such a ring might be passed to another (see JOSEPH, 3). The ring also symbolizes union, as in the marriage ceremony. Rings are part of the ecclesiastical insignia of office and in this context may be regarded in both symbolic senses. The 'fisherman's ring' worn by the pope is engraved with an image of St Peter in a boat drawing up a net. Cardinals and lesser dignitaries also wear distinctive rings. Three linked rings are a symbol of the Trinity. Both CATHERINE OF ALEXANDRIA and CATHERINE OF SIENA are represented in the role of 'bride of Christ', the mystic marriage with the godhead in which either the adult Christ or more often the Infant in the Virgin's lap places a ring on the saint's finger. FRANCIS OF ASSISI is depicted wedding Lady Poverty with a ring. For the wedding of the Virgin Mary and Joseph – her other suitors are present holding wands – see MARRIAGE OF THE VIRGIN. The doge of Venice presents a ring to a fisherman (MARK, 2). Three linked rings, each set with a stone (a diamond), were the *impresa* of Cosimo de' Medici

The Medici rings

(1389–1464); a diamond ring in the claws of a falcon with the motto 'Semper' was the *impresa* of his son Piero (1414–1469). The three FEATHERS of Lorenzo the

Magnificent (1448–1492) may pass through a ring. The two latter devices were used by the Medici popes Leo X and Clement VII. The Medici 'balls' that appear on the escutcheon of the Medici family are represented as flattish roundels, usually six or seven in number, but sometimes as many as eleven. They are seen for example in the friezes of the Medici palaces.

River. Paradise according to Babylonian tradition was watered by the Pison, Gihon, Tigris and Euphrates (see ADAM AND EVE, 1), four rivers which the Middle Ages made into symbols of the gospels. Primitive Christian art depicts Christ or the Lamb standing on a mound from which four streams flow. Medieval art often represented them in the form of conventional river-gods (see also APOCALYPSE, 9). The four rivers of Hades were the Acheron, Styx, Phlegethon and Cocytus, which Dante made into stages of punishment of the soul in hell (*Inf.* Cantos 3, 8, 12, 14). DANTE AND VIRGIL were ferried through the Stygian marsh by Phlegyas. But CHARON was the classical ferryman of the Styx, the river in which the infant ACHILLES (1) was dipped. Ferrymen in Christian art are JULIAN THE HOSPITATOR, and CHRISTOPHER who bore the Christ child on his back. In earlier representations of the LAST JUDGEMENT, especially Byzantine, a river of fire, like the Phlegethon, flows from the feet of Christ the Judge into hell taking the damned with it. The spirit that was believed by the ancients to inhabit a river was commonly represented as a god, with a crown of reeds and reclining on an overturned urn from which water flowed. The god appears in many river scenes (see URN). JOHN THE BAPTIST baptized in the Jordan, the river in which Naaman was cleansed at the bidding of ELISHA. HERCULES (5) cleaned out the Augean stables by diverting river waters through them. Bathers in a river may represent Summer in allegories of the FOUR SEASONS. See also STREAM.

Road to Calvary ('The Ascent, or Procession, to Calvary'; 'Christ bearing the Cross') (Matt. 27:32; Mark 15:21; Luke 23:26–32; John 19:17). Christ's last journey from the house of Pilate – where he had been scourged and then mocked by the soldiers who placed a crown of thorns on his head – to the hill of Golgotha where he was crucified. The account in the synoptic gospels is in one important respect at variance with John, though commentators do not regard the two as irreconcilable. John says simply, 'Jesus was now taken in charge and, *carrying his own cross*, went out to the Place of the Skull'. The synoptics on the other hand describe how Simon, a man from Cyrene in Africa, was made to carry the cross, Luke adding that a great throng followed, among them many women who lamented, and also the two thieves. Artists have depicted both versions. The eastern Church customarily showed Simon; the Byzantine painter's guide stated, 'Christ exhausted, falls to the earth . . . Simon the Cyrenian may be seen, grey-haired and with a round beard, wearing a short dress. He takes the cross upon his own shoulders'. This version was sometimes adopted by the early Italian Renaissance but in due course died out in the West, Simon latterly being shown giving merely token help to the Saviour. Western tradition overwhelmingly preferred the alternative image of Christ bearing his cross alone, a symbol of the burden the Christian carries through life. In the 14th and 15th cents. he is upright and walks without difficulty but in later art the cross grows larger and heavier and the character of the theme changes from one of triumph to pathos, with the emphasis laid on the Saviour's suffering. He falls beneath the weight of the cross; a Roman soldier goads him on. This common type of the fallen Christ, though without scriptural foundation, was naturally inferred from the part played by Simon. Though it was a historical fact that under the Romans a con-demned man carried his own cross, he bore only the horizontal piece to the

place of execution where the upright post was already fixed in the ground – an aspect of which artists were unaware. (See further under CRUCIFIXION, 1.)

For the journey to Calvary Christ no longer wears the clothes put on him at the mocking; his own have been restored to him, generally a blue cloak and a red under-garment. He still wears the crown of thorns. He may be drawn along by a rope held by a soldier. Representations of the procession include soldiers, perhaps holding standards bearing the Roman motto 'S.P.Q.R.' – 'Senatus Populusque Romanus'; sometimes the chief disciples, Peter, James the Greater and John the Evangelist; the two thieves (not carrying crosses); and the women mentioned by Luke whom tradition identifies with the Virgin and the Three Maries. According to the apocryphal Gospel of Nicodemus (in a much amplified rendering dating from the 15th cent.) John took the news to Mary who then came with Mary Magdalene, Martha and Salome (the mother of James and John) to the place of execution where, at the sight, the Virgin swooned. This incident is often transferred to the scene of the Road to Calvary, and is generally shown occurring at the moment of Christ's falling under the cross. She is seen collapsing into the arms of the other women or of John. Its Italian title is 'Lo Spasimo', the swooning.

Another figure who makes her appearance at the beginning of the 15th cent., probably through the influence of contemporary religious drama, is VERONICA. Legend tells that she came from her house as the Saviour passed by, and gave him a cloth to wipe the sweat from his face. The image of his features became miraculously imprinted on it. She is shown kneeling by the wayside holding the *sudarium*, or cloth, on which the features of Christ are portrayed. She may also be seen in the act of wiping his face.

For the episodes from the Old Testament which were said by medieval theologians to prefigure the bearing of the cross, see the following: ABRAHAM (4): *The binding of Isaac;* ELIJAH (2): *E. and the widow of Zarephath;* JOSEPH, son of Jacob (5): *Jacob blessing Ephraim and Manasseh;* MOSES (6): *The Passover and the death of the firstborn.* See also STATIONS OF THE CROSS. The image of Christ with the cross, appearing in a vision to a saint kneeling at the altar, is a popular theme in Counter-Reformation painting: see GREGORY THE GREAT (5): *Mass of St G.*

Road to Emmaus, see JOURNEY TO E.

Roch (Rock) (1293–1327). Christian saint, born in Montpellier, who travelled much in Europe devoting himself to nursing victims of the plague, whose patron saint he is. The Black Death swept Europe in the 14th cent. but it was not until the following century, when the disease was still widespread, that Roch became established as the protector of the sick. Thereafter his image occurs extensively in art, both as a devotional figure and as intercessor with the Virgin on behalf of her votaries, who thereby hoped to be spared infection. Or they are giving thanks for having escaped it. Roch may be seen in the company of SS SEBASTIAN and COSMAS AND DAMIAN who were also invoked against the plague. Because he made the journey to Rome, Roch is generally dressed as a pilgrim with STAFF and WALLET. He may have a scallop SHELL, the badge of the pilgrim, though this applies properly only to those who travelled to Compostella in Spain, the shrine of JAMES THE GREATER. Roch lifts his tunic to show a black spot inside his thigh, the part of the body where the plague typically first manifested itself. He is accompanied by his DOG. Scenes from his legend show him distributing his riches to the poor, and ministering to the sick in hospital. In Rome he stands before the pope. Stricken by the plague himself he lies in the desert; his dog is

nearby or brings him a loaf of bread in its mouth; he is watched over by an angel. He recovered and returned to his home town, but was so wasted by disease that he was unrecognized by the inhabitants and thrown into prison, where he eventually died. He is seen in prison, still with his dog and watched over by an angel. In 1485 Roch's remains were stolen from Montpellier by the Venetians and taken to Venice where the Scuola di S. Rocco was founded, a confraternity that cared for the sick under the saint's patronage. Similar institutions were established elsewhere in Europe from this time.

Rocks, gathered up by a naked man and woman and cast over their shoulders, the rocks assuming human form where they fall, DEUCALION AND PYRRHA; gathered by giants, the Olympians looking down from heaven, BATTLE OF GODS AND GIANTS; hurled by a one-eyed giant at fleeing lovers, GALATEA. A man bearing a rock uphill on his shoulders, or pushing it, SISYPHUS. A man chained to a rock, his liver pecked by an eagle, PROMETHEUS (2); the same, pecked by one or two vultures, TITYUS; maiden chained to a rock, rescued from a monster, PERSEUS (2), also HERCULES (18). Water flows from a rock when struck by the wand of MOSES (9). The rock is a symbol of Christ or of the Church, or of Christian steadfastness generally, an idea supported by numerous biblical metaphors. See also STONE.

Rod, see WAND.

Rodomont, a knight, see ANGELICA (4).

Roger (Ruggiero), see ANGELICA (2).

Roman Charity ('Cimon and Pero'). Of the examples of 'filial piety' in the literature of antiquity, that of Cimon and Pero was one of the ones that appealed most to artists of the 16th to 18th cents. in Italy and the Netherlands. Valerius Maximus, under the heading 'De pietate in parentes' (5:4), tells of a certain Cimon, an aged man, who was in prison awaiting execution and who was therefore given no food. The jailer allowed Cimon's daughter Pero to visit him. She nourished him by giving him her breast. The scene is a prison cell; the white-haired prisoner, usually manacled, reclines in the lap of a young woman who is suckling him. A jailer peers through a barred window; or executioners, swords in hand, enter the cell. Baroque examples are often a simple allegory of youth and age, frequently with a sexual emphasis. In the Neoclassical late 18th cent. the theme was treated as the moral exemplar of filial piety that it was originally intended to be.

Romuald (c. 952–1027). Benedictine monk who entered the Order as an act of atonement after his father had murdered a relative. Finding the monastic life of his day in need of reform he founded communities that were vowed to solitude and silence, of which the best-known was the monastery of Camaldoli in the Apennines near Arezzo. Romuald is old and white-bearded and is dressed in the habit of the Camaldolese Order, a striking, loose-flowing white garment with wide sleeves. He may hold a CRUTCH or a SKULL.

The vision of St Romuald. It was said that he dreamed, like Jacob, of a ladder ascending to heaven and that the monks of his Order were going up it clad in white. He may be seen seated with his brethren under a tree, pointing to the vision in the background. It was after this dream Romuald declared that the Order should henceforth be dressed in white.

Romuald is commonly seen in painting commissioned for the Benedictine communities. He may be in the company of other saints of the Order, BENEDICT and SCHOLASTICA.

Romulus (Livy 1:4; Plutarch 2:4, 6). Legendary founder of Rome, the twin brother of Remus. Their mother, a VESTAL VIRGIN, explained her pregnancy by claiming

she had been violated by Mars, the god of war. She was thrown into prison and the children were ordered to be drowned in the Tiber. They survived and were reared by a she-wolf, and by a woodpecker that watched over them and brought them food. The wolf is seen lying under a tree giving suck to an infant, while another plays nearby. The herdsman, Faustulus, who discovered them, is approaching. The god of the River Tiber reclines on his urn. Under the rule of Romulus the city of Rome grew in size and strength. It was by his deliberate design that the SABINE WOMEN were raped.

Rope. Christ was bound by the soldiers who arrested him (John 18:12), hence a rope became one of the Christian symbols of the BETRAYAL. He is sometimes depicted being led by a rope on the ROAD TO CALVARY. According to a medieval tradition JUDAS ISCARIOT died by hanging himself. A hanging woman was a medieval personification of Despair (see HOPE). A rope round the neck is the emblem of the penitent, as in the case of CHARLES BORROMEO. A martyr dragged through the streets, a rope round his neck, is MARK (3). A rope is the attribute of ANDREW, apostle, who was bound, not nailed, to the cross. NEMESIS holds a rope and a vase. The Gordian knot, binding a chariot, was severed by ALEXANDER THE GREAT (3). A bed lowered through the roof by ropes, see PARALYTIC, HEALING OF THE. See also GIRDLE; KNOT.

Rosary. A sequence of prayers to the Virgin; also a string of beads, the mnemonic device by which they are counted (see further, VIRGIN MARY, 15). A rosary is the attribute of DOMINIC, sometimes of CATHERINE OF SIENA, and may be one of the objects in allegorical STILL LIFE.

Rose. A flower particularly associated with the Virgin Mary who is called the 'rose without thorns', i.e. sinless. An early legend mentioned by St Ambrose tells how the rose grew without thorns until the Fall of Man. The Virgin is represented in Italian painting under the title Santa Maria della Rosa holding a rose (or it is held by the infant Christ). A red rose symbolizes martyrdom (the martyr's blood), a white one purity. Roses in her apron or lap are the attribute of ELIZABETH OF HUNGARY; a basket of roses and apples, of DOROTHEA. Angels with rose garlands hover above the latter at her execution. Roses sprout where the drops of blood of FRANCIS OF ASSISI fall to earth.

The rose was sacred to Venus in antiquity and is her attribute in Renaissance and later art, likewise of her handmaidens the THREE GRACES. The Renaissance likened the rose to Venus because of its beauty and fragrance, comparing the pricking of its thorns to the wounds of love. The goddess is depicted removing a thorn from her foot, the drops of blood staining white roses red (VENUS, 6).

Roxana, see ALEXANDER THE GREAT (8).

Royal wedding (Wedding feast) (Matt. 22:1–14; Luke 14:16–24). A rather difficult parable concerning a king who invited many guests to his son's wedding, but they all refused to come. He therefore sent his servants into the streets to fetch in any poor and infirm that they might find, to take the guests' places. The wedding itself was interpreted as the union of Christ and the Church; the king's servants standing for the prophets, the guests who declined being the Jews who denied the Saviour's Messiahship. Matthew in a further passage, probably grafted on from another parable, tells that one of the company, because he was not dressed in proper wedding clothes, was cast into outer darkness by the king's servants, 'for many are called but few are chosen.' That is to say, the unshriven sinner is not fit to enter the kingdom of heaven. The banqueting scene depicts a throng of common folk, some with crutches or with their arms in slings, seating themselves

at long tables. In the same picture we may see those originally invited making their refusals, and the rejected guest being cast into hell.

Rudder. The attribute of FORTUNE and of ABUNDANCE in the Roman era, and adopted with the same meaning by the Renaissance.

Ruggiero frees Angelica, see ANGELICA (2).

Ruins. The idea of the New Dispensation (Christianity) growing out of, or superseding, the Old (Judaism) was sometimes represented in later medieval art by the image of a building, the Synagogue, being dismantled and its bricks and stones used to construct a church, the New Jerusalem. The motif of the ruined building, with this symbolic meaning, came to be particularly associated with the scenes of the NATIVITY of Christ and ADORATION OF THE MAGI. In 15th cent. Netherlandish painting the ruin often has clear Romanesque features (see further ANNUNCIATION); in Italian Renaissance painting its style tends to be classical, and may here be regarded as symbolizing the decay of *Rudder* paganism. The revival of interest in Roman antiquity, especially in the 16th cent., led to the representation of the ruins of classical architecture as a subject in its own right, without symbolic overtones. There are many examples of this in the painting of northern Europe and Italy from this time onwards.

Ruler, usually together with the other tools of the carpenter and builder, the attribute of THOMAS, apostle; of Geometry and Arithmetic, two of the SEVEN LIBERAL ARTS; and of Melancholy, one of the FOUR TEMPERAMENTS.

Ruth. A Moabite woman and great-grandmother of David, and therefore, by the traditional reckoning, an ancestress of Christ, hence her place in Christian art. The very human and sympathetic study of her in the book of Ruth relates how she was married to a Hebrew immigrant in Moab and after his death left her native land and went with her mother-in-law Naomi, to Bethlehem. Here she was allowed to glean the corn in the fields belonging to Boaz, a rich farmer and kinsman of Naomi. Ruth, true to her nature, maintained, on Naomi's advice, a modest demeanour among the young men working at the harvest. One night she went and lay at the feet of Boaz as he slept in the field. By this act Boaz saw her virtue and later decided to assume the responsibilities towards her of a kinsman. In due course he married her. Boaz sometimes replaces David in the Tree of Jesse.

Sabine women. A well-known legend from the early history of Rome tells how Romulus, the founder of the city, succeeded by a ruse in ensuring the future growth of the population. He arranged a festival to which were invited the inhabitants of neighbouring settlements including the Sabines, with their wives and children. During the festivities, at a given signal, the young men of Rome broke into the crowd and, choosing only the unmarried maidens of the Sabines, carried them off. According to Plutarch 'they had taken no married women, save one,' and moreover 'they did not commit this rape wantonly, but with a design purely of forming alliance with their neighbours by the greatest and surest bonds.' Plutarch ascribes to this the origin of the custom of lifting a bride across the threshold of her husband's house.

 1. *Rape of the Sabine women* (Livy 1:9; Plutarch 2:14). Italian painting of the 15th cent. combines a scene of men and women in Renaissance dress being entertained by musicians and acrobats, with the scene of the rape in which the women are carried off by armed men. Outside the city walls other Romans beat off the forces coming to the rescue. Baroque artists depict a throng of soldiers, some on horseback, gathering protesting, tearful women into their arms.

2. *Reconciliation of the Sabines and Romans* (*Fasti* 3:199–228; Livy 1:13; Plutarch 2:19). The Sabine women accepted their lot. But later a Sabine army attacked the city in force and succeeded in overcoming part of it. They were prevented from going further, says Plutarch, 'by a spectacle, strange to behold, and defying description. For the daughters of the Sabines came running, in great confusion, some on this side, some on that, with miserable cries and lamentations, like creatures possessed, in the midst of the army and among the dead bodies, to come at their husbands and their fathers, some with their young babes in their arms, others their hair loose about their ears, but all calling, now upon the Sabines, now upon the Romans, in the most tender and endearing words.' Peace was thus unexpectedly brought about between the warring soldiers. This account provided the material for many paintings, especially of the baroque period.

Sacra Conversazione, see VIRGIN MARY (14).

Sacraments, see SEVEN SACRAMENTS.

Sacred and profane love, see VENUS (1).

Sacrifice. The making of an offering to a god, by way of expiation or in the expectation of benefits in return, forms part of the rites of many religions. In antiquity the offering might consist of food, or a libation, generally of wine, or a beast, commonly a sheep or ox, ritually slaughtered. The animal, garlanded with flowers, had its throat cut and its blood poured on to the altar fire, or sprinkled on the worshippers. Certain parts of it were burned, the remainder eaten as part of the ceremony. A pipe, commonly represented in art as a double flute, perhaps played by a Satyr, prevented the participants overhearing any extraneous ill-omened noise. This pagan rite came to be represented in the art of the Renaissance and later, either as an independent theme, when it is wholly profane in character, a simple revival of the antique spirit, or as a subsidiary element in Christian subject matter, such as the Virgin and Child, when its function is typological, that is, a foreshadowing of the Christian sacrifice of the death of Christ. (G. Bellini, 'The Blood of the Redeemer,' Nat. Gall., London, has two scenes in the background, a pagan sacrifice and MUCIUS SCAEVOLA, who sacrificed his hand.)

Biblical Scenes of Sacrifice: Lamb on altar, patriarch officiating with others, NOAH (3); boy on altar, patriarch with knife raised, ABRAHAM (4); old man (Manoah) and woman kneeling before altar, angel overhead, SAMSON (1); the young DAVID (1) anointed by Samuel beside an altar; a king before an altar, with idols, golden calf, SOLOMON (3); a maiden kneeling, about to be put to death before an altar, JEPHTHAH'S DAUGHTER; fire descending on altar consuming the sacrificial lamb, ELIJAH (3); PAUL, apostle (6), with Barnabas, rending their clothes at the sight of a pagan sacrifice. See also IPHIGENIA; POLYXENA.

Sagittarius (zodiac), see TWELVE MONTHS.

Sail. The attribute of FORTUNE, both in antiquity and the Renaissance, because she is inconstant like the wind; also of VENUS who was born of the sea. See also TORTOISE.

Salamander. A small amphibious creature resembling a LIZARD which according to the medieval bestiaries was not only impervious to fire but had the power to extinguish flames, a belief recorded earlier by both Aristotle and Pliny. It is hence an attribute of Fire personified, one of the FOUR ELEMENTS. A salamander,

Impresa of Francis I

with the motto 'Nutrisco et extingo,' or 'Notrisco al buono, stingo el reo,' – 'I nourish the good and destroy the bad,' was the *impresa* of Francis I (1494–1547), king of France and a patron of art and literature, and may be seen in the decoration of French royal houses of the period.

Salmacis, see HERMAPHRODITUS.

Salvator Mundi. One of the titles of Christ, in English 'Saviour of the world', applied to his devotional image, found more especially in northern Renaissance art, in which he is represented holding an orb surmounted by a cross, and making the sign of benediction. The figure of the Virgin may form a pendant subject.

'Salve Regina Mundi,' see NICHOLAS OF MYRA.

Samson. One of the Old Testament Judges. Though his term of office lasted twenty years none of his judicial acts are recorded. He emerges more as a swashbuckling adventurer of great physical strength, and a womanizer who, however, succumbed easily to female blandishment. It seems likely that some such historical figure existed whose legendary feats were kept alive in local traditions of storytelling. The biblical author enlarged and embellished them to serve the religious and patriotic ends of Israel. That version in turn captured other creative imaginations, not only of artists. Milton made a tragic hero of him. The medieval Church regarded him as one of the prefigurations of Christ. He is also the prototype of FORTITUDE, whose attribute is a broken pillar.

1. *Samson's birth foretold; The sacrifice of Manoah* (Judges 13). His birth was preceded by an annunciation. An angel, traditionally the archangel Gabriel, appeared to Samson's mother foretelling the event and prophesying that he would deliver Israel from her enemies the Philistines. Samson's father, Manoah, sacrificed a kid and the angel disappeared heavenwards in the flames on the altar. Manoah and his wife prostrated themselves before it. (Rembrandt, Dresden Gallery.)

2. *Samson slays the lion.* (Judges 14:5–9). Like HERCULES (1), Samson demonstrated his superhuman strength by slaying a lion with his bare hands. He is usually depicted astride the lion or with foot or knee in its back, grasping its jaws in his hands and forcing them apart. Combat with a single adversary was a subject that naturally tended to acquire a symbolic meaning. This instance, like David's fight with the lion, was interpreted by the medieval Church as the struggle of Christ against the devil.

3. *Samson smites the Philistines with the jawbone of an ass.* (Judges 15:14–19). Taunted by the Philistines, Samson, wielding an ass's jawbone, slew a thousand of them until they lay 'heaps upon heaps.' After this labour God caused water to flow from the jawbone for him to quench his thirst. (A jawbone is also usually the weapon with which Cain is depicted slaying Abel.) The curious incident of water flowing from the bone has been explained as a mistranslation. In the original Hebrew Samson drank from a spring whose name signified 'jaw', perhaps from the shape of the surrounding rock-formation.

4. *Samson and Delilah* (Judges 16:4–20). The Philistines, always seeking an opportunity to bring about Samson's downfall, saw their chance when he took Delilah, a Philistine woman, for a lover. They bribed her to persuade Samson to reveal the source of his great strength. Three times he gave her false answers but finally she succeeded in extracting the truth, that his strength lay in his hair which had not been cut since birth. In her chamber Delilah lulled Samson to sleep, his head in her lap, and then she signalled to a Philistine who lay in wait outside. The man quietly shaved Samson's locks and he awoke to find himself a helpless prey to his enemies. In earlier Renaissance examples Delilah is dressed

in contemporary fashions; in some later works she may be naked. A wine-jug or vase standing nearby implies that Samson is sleeping off his liquor. The Philistine holds a pair of shears, or Delilah herself may hold them. Samson is also depicted in the subsequent scene struggling with Philistine soldiers while, in the background, Delilah makes off carrying her money. The belief that a man's physical strength resided in his hair was widespread in primitive societies. In Renaissance and later art the theme may illustrate woman's domination of man and is then sometimes represented beside ARISTOTLE AND CAMPASPE; VIRGIL, LAY OF; HERCULES (17) and Omphale.

5. *Death of Samson 'eyeless in Gaza'*. (Judges 16:21–31). The Philistines captured Samson, blinded him and threw him into prison at Gaza, where in time his hair began to grow again. During a festival they brought him out to make sport of him. He was taken to a house full of Philistines where at his request a boy led him to the pillars supporting the roof, ostensibly so that he might rest. But Samson grasped the pillars and praying for vengeance, 'bowed himself with all his might.' The house collapsed killing him and large numbers of his enemies. The theme was used as a prefiguration of the mocking of Christ.

Samuel, Hebrew prophet and the last of the Judges, see DAVID (1); WITCH OF ENDOR.

'Sancta Dei Genitrix,' see VIRGIN MARY (Intro.).

'Sanctam Ecclesiam Catholicam . .,' see MATTHEW.

Sandals. A sword and a pair of sandals are revealed beneath a rock lifted by the young THESEUS (1). Winged sandals are the attribute of MERCURY and PERSEUS.

Santiago, see JAMES THE GREATER.

Sapientia, see WISDOM.

Sarcophagus, see TOMB.

Satan. In Christian belief a fallen angel who, with his fellow devils, is the enemy of God and actively promotes evil. The early Church taught that the fall of Satan preceded the creation of man, and saw an allusion to it in Isaiah (14:12 ff), 'How you have fallen from heaven, bright morning star (Lucifer) . . .' Medieval and early Renaissance art shows the rebel angels tumbling from heaven, acquiring tails, claws and other demoniac features as they descend. At the bottom lies Lucifer, perhaps in Leviathan's mouth. At the top, in heaven, are angels with lances and God enthroned. In the 16th cent. the theme merges with the 'war in heaven' (Rev. 12:7–9), the conflict between MICHAEL and Satan, the dragon.

The image of evil as a composite, zoomorphic creature belonged to ancient Persian and Egyptian religion. It was eastern influence that produced the many-headed monsters of the APOCALYPSE and the Satan of Byzantine art. Later western medieval art modified his shape, making it essentially human but retaining numerous bestial appendages: claws for hands and feet, a tail, limbs entwined with serpents, and sometimes wings as a reminder of his angelic origin. The grotesqueries that depict a human or animal face misplaced on the belly, buttocks or genitals seem to have been generated in the imaginations of later medieval monks; they found their way also into religious drama. The Renaissance took its image of the devil from the classical SATYR, with its horns and cloven hoof, signifying that paganism was the enemy of the Church. He may be disguised as a monk or wayfarer, betraying himself by a hoof or claw showing under his cloak. Satan features in the TEMPTATION IN THE WILDERNESS; DESCENT INTO LIMBO; LAST JUDGEMENT (6). For the evil spirits that the saints always so readily overcame, see DEMON. See also HELL.

Saturn. An early Roman god of agriculture who reigned on earth during the

Golden Age (see AGES OF THE WORLD). His festival, the Saturnalia, in December was the origin of our Christmas. The Romans identified him with the Greek Cronus, who probably originated as an agricultural deity of some pre-hellenic people. Cronus features in the Greek myth of the creation, from which Renaissance and later painters took certain themes.

1. *The castration (or mutilation) of Uranus* (Hesiod, *Theogony* 133–187). In the beginning Gaea (Mother Earth) and her son Uranus (heaven) coupled and produced the first race – the Titans. Uranus threw his sons into the underworld but Gaea in revenge gave the youngest of them, Cronus, a sickle with which he castrated his father. (See further, VENUS, 7.) Cronus is shown with a sickle or SCYTHE about to mutilate the aged Uranus. The scene may include an armillary SPHERE which here symbolizes the universe. (Vasari, Pal. Vecchio, Florence.)

2. *Saturn (or Cronus) devours his children (Fasti* 4:197–200). Mother Earth prophesied that one of Cronus' offspring would usurp him and so, to prevent this happening, he ate them (Goya, Prado, Madrid). When Zeus was born his mother wrapped a stone in swaddling clothes which Cronus unthinkingly devoured instead. Zeus was thus saved and finally overthrew his father.

Saturn thus has a scythe for attribute both as the Roman agricultural deity and through his Greek identity. Because of his age he may have a CRUTCH. Through Cronus, Saturn came to personify Time (see further, FATHER TIME), and acquired Time's attribute of the SNAKE in the form of a circle with its tail in its mouth, an ancient symbol of eternity, of Egyptian origin.

Satyr. In ancient Greece one of the spirits of the woods and mountains, identified with the god Faunus of Roman mythology. They were the attendants of BACCHUS (Dionysus) and derived from him their goat-like features: hairy legs and hooves, tails (especially in antique art), bearded faces and horns. (In this respect they resemble PAN.) Their brows are garlanded with IVY, sacred to Bacchus. They were lazy and lecherous and spent their time drinking and chasing NYMPHS. In medieval and Renaissance allegory they personify evil, more particularly Lust and in early examples may be labelled 'Luxuria' or 'Libido'. The horns and cloven hoof of SATAN derive from the Satyrs. With the MAENADS, the female followers of Bacchus, they participate in his orgiastic rites, the Bacchanalia. It was told that the Roman god Faunus, wishing to ravish his daughter, plied her with wine but only succeeded in having his way with her by turning himself into a snake; hence, it was said, the Satyr's attributes of the wine PITCHER and SNAKE. Satyrs play pipes and may hold a THYRSUS, a fertility symbol borrowed from Bacchus. As fertility spirits themselves they sometimes carry a CORNUCOPIA or baskets of fruit. Or they gather fruit from the trees in the company of nymphs.

1. *Nymphs and Satyrs.* Generally the nymphs of DIANA are depicted bathing or otherwise attending to their toilet in a woodland setting, while Satyrs, unsuspected, creep up on them. Or sleeping nymphs are having their robes gently drawn aside. Or the Satyrs pounce, capturing some maidens while others flee. Or all are reconciled and nymphs sit in the laps of dallying Satyrs. This mildly erotic theme, an allegory perhaps of Chastity overcome by Lust, was popular with baroque painters. A Satyr holding a wig of long hair, a nymph fleeing, see CORISCA AND THE SATYR.

2. *Venus and Satyrs.* A similar theme to the last: the goddess is surprised by Satyrs while sleeping or at her toilet. Or she sits in the lap of a Satyr. Cupid is usually present.

3. *The Satyr and the peasant.* A fable not from classical mythology but from Aesop and La Fontaine. A wayfarer, invited in from a cold wet night to sup with a Satyr and his family, first blew on his chilly hands and then on his bowl of soup. 'Be off!' said the Satyr, 'I won't have a guest who blows both hot and cold!' The theme was popular with 17th cent. Flemish painters who depict a humble farmhouse kitchen where the Satyr and his guest are at table, bowls of soup in front of them. Members of the household bring dishes, the wife sits with an infant in her lap. A dog, cats and poultry are around their feet.

See also: ANTIOPE (sleeping nymph); ANTONY THE GREAT (2); BACCHUS (2); DIANA (4); NEPTUNE (3).

Saul. The first king of Israel who reigned in the 11th cent. B.C. See DAVID (2); WITCH OF ENDOR.

Saw. Among other carpenter's tools, the attribute of JOSEPH, husband of the Virgin; and of Melancholy, one of the FOUR TEMPERAMENTS. As an instrument of martyrdom it is the attribute of SIMON ZELOTES and ISAIAH.

Saxa Rubra, Battle of, see CONSTANTINE THE GREAT (2).

Scales. A symbol of judgement, used for weighing good and evil, right and wrong. A sword and scales have been the attributes of JUSTICE personified since Roman times. The archangel MICHAEL has a pair of scales for the weighing of souls, a role performed by Mercury in antiquity. Logic, one of the SEVEN LIBERAL ARTS, weighs the true and the false in her scales. OPPORTUNITY balances her scales on a razor's edge. One of the four horsemen of the APOCALYPSE (5) holds a pair of scales. They are the attribute of the young Maurus, the pupil of BENEDICT. As a sign of the zodiac (Libra) they are associated with September, one of the TWELVE MONTHS. A sword thrown into a scale-pan by a soldier, BRENNUS.

Sceptre. A rod or staff, an emblem of authority and one of the insignia of royalty from early times. It generally terminated in some distinctive device: the sceptre of the Roman consuls was tipped with an eagle; of the English kings, with the orb and cross, or a dove; of the French kings, with the fleur-de-lys. Among the gods a sceptre is the attribute of JUPITER; CYBELE; JUNO (surmounted by a cuckoo denoting the deceived spouse). It is held by the allegorical figure of PHILOSOPHY; sometimes by JUSTICE and FORTITUDE; by the personification of Good Government (GOVERNMENT, GOOD AND BAD); by Europe, the leader of the FOUR PARTS OF THE WORLD. The wand or sceptre of the archangel GABRIEL is surmounted by a fleur-de-lys. A sceptre is the common attribute of a king when depicted in the exercise of his authority. A crown and sceptre at the feet of LOUIS OF TOULOUSE allude to his renunciation of the throne. A woman holding a crown and dagger, a sceptre at her feet, is Melpomene, the MUSE of tragedy. The sceptre is frequently a 'Vanitas' symbol, see STILL LIFE. See also CADUCEUS; THYRSUS; WAND.

Scholastica (*c.* 480–*c.* 543). The sister of St Benedict, said to have been his twin. Little is known of her except that she settled near Monte Cassino, dedicating her life to religion, and meeting her brother at rare intervals. According to some, a community of nuns grew up around her, and though she took no vows she is traditionally regarded as the first Benedictine nun. At her last meeting with Benedict, just before she died, it was said that she prayed for a tempest so that his departure might be postponed, and that this came about. (See BENEDICT, 9.) At her death Benedict saw in a vision her spirit leave her body in the form of a dove. This is also told of REPARATA. Scholastica is dressed as a Benedictine nun in black (see diag. RELIGIOUS DRESS) and generally holds a LILY and a CRUCIFIX. A DOVE issues from her mouth, hovers over her head, or rests on her hand or on

a BOOK. Scholastica is found in Italian and French pictures from the 15th cent., especially in works painted for communities of Benedictine nuns. She often stands beside Benedict.

Scipio. The family name, or cognomen, borne by two famous Roman generals, both commemorated in art. It was Scipio Africanus Major ('the Elder') (*c.* 234–*c.* 183 B.C.) whose victories in Spain and north Africa against the Carthaginians brought the second Punic war to an end. He owes his place in Renaissance literature and art to the Italian poet Petrarch (1304–1374) whose epic poem *Africa* was written to honour his memory.

1. *The continence of Scipio* (Livy 26:50; Petrarch, *Africa* 4: 375–88). A legendary act of clemency. After capturing the Spanish city of New Carthage the elder Scipio received as a prize of war a beautiful maiden. Learning that the girl was betrothed he summoned her fiancé and restored her to him unharmed, at the same time delivering a short sermon on the moral probity of the Romans. Scipio is seen in his tent, outside the city walls, in the act of handing back the girl to the bridegroom who kneels before him; or the pair stand before Scipio who blesses their clasped hands. The bride's parents approach, followed by attendants bearing a ransom of golden vessels. (Scipio handed back the ransom as a wedding gift to the bridegroom.) The theme was popular in Italian painting especially of the 15th cent. and made an apt decoration for the panels of marriage chests.

2. *The dream of Scipio.* Cicero's *Somnium Scipionis* relates a dream of the younger Scipio (*c.* 185–129), the grandson by adoption of Scipio Africanus Major. In the dream his grandfather appeared to him and described the heavenly abode to which the great and honourable on earth were admitted. A commentary on Cicero's work by the late Roman mythographer Macrobius (*fl. c.* A.D. 400) defined the virtues proper to the hero as the active and contemplative ways of life, in contrast to the ignoble pursuit of sensual pleasure. Renaissance humanist philosophers, to whom Macrobius was well known, modified his precept, maintaining that all three were gifts of the gods and all, in due proportion, the necessary ingredients of a full, harmonious personality, or 'universal man' (exemplified by the Renaissance prince and patron of arts and letters). The idea was expressed as an allegory by artists. Raphael (Nat. Gall., London) depicts the younger Scipio as a warrior in armour lying asleep under a bay tree. Behind him are two women. One, in plain sombre garb, offers him a SWORD and a BOOK (activity and contemplation); the other, more alluring yet still chaste, offers a sprig of MYRTLE (the attribute of Venus).

3. *The triumph of Scipio*, see TRIUMPH. See also CYBELE.

Scissors, see SHEARS.

Scorpion. From its treacherous, often deadly bite a symbol of Judas, and in secular allegory sometimes associated with Envy and Hatred. In antiquity it symbolized Africa and is an attribute of Africa personified, one of the FOUR PARTS OF THE WORLD; of Earth, one of the FOUR ELEMENTS; and of Logic, one of the SEVEN LIBERAL ARTS. As a sign of the zodiac (Scorpio) it belongs to October, one of the TWELVE MONTHS, and in this sense features in the fall of PHAETHON.

Scourging of Christ, see FLAGELLATION.

Scroll. The term denotes either the banderol or phylactery, the thin streamer carrying the inscription of saints and others; or the roll of parchment or paper, often substituted for the book, that identifies a writer when held in the hand. The *rotulus*, or roll, was the ancient form of the book and is therefore given more often to Old Testament writers, for example ISAIAH, JEREMIAH and other prophets.

This distinction between the old and the new is sometimes evoked symbolically, as in the DISPUTE WITH THE DOCTORS. But the scroll-book is also not infrequently the attribute of the evangelists, PAUL the apostle, and others. It is eaten by John the Evangelist (APOCALYPSE, 14). Twelve scrolls, representing the gospels translated into twelve tongues and held by an old man, may be seen in the DESCENT OF THE HOLY GHOST. A scroll is the attribute of several MUSES, in particular Clio (history) and Thalia (comedy), and of the SEVEN LIBERAL ARTS, especially Logic. See also WRITER.

Scylla, see GLAUCUS AND S.

Scythe, or sickle. The attribute of Saturn, the Roman god of agriculture, and of the old Greek god Cronus, with whom he became identified. Cronus castrated the aged Uranus with a sickle (see SATURN, 1). It was from Cronus that FATHER TIME acquired his scythe which, like the shears of Atropos, cuts life short. It has the same meaning when carried by DEATH. As a tool of the husbandman it is the attribute of Summer personified, one of the FOUR SEASONS, and occasionally of CERES. The enthroned Christ and his angels hold sickles in a scene from the APOCALYPSE (19). The adamantine sickle of PERSEUS was presented to him by Mercury, to behead Medusa.

Sea. The kingdom of NEPTUNE (Poseidon) and his retinue, the NEREIDS and TRITONS; the birthplace of VENUS (Aphrodite) who sprang from the waves. The ship-wrecked ULYSSES (4) on a raft takes a scarf from a sea-goddess. A swimmer coming ashore, a maiden receiving him, are HERO AND LEANDER; or Leander drowns and Hero plunges into the waves. Pharaoh's army is engulfed by the Red Sea (MOSES, 7); mankind and its dwellings by the Flood (NOAH, 2). A friar spreading his cloak on the waters is FRANCIS OF PAOLA. A bishop by the seashore, with a child on the sand beside him, is AUGUSTINE. See also SHIP; BOAT; EMBARKMENT FOR CYTHERA.

Sea-horse, see HIPPOCAMPUS.

Seasons, see FOUR SEASONS.

Sebastian. Christian saint and martyr about whom little is known. His legend, though without historical foundation, has an air of truth since it lacks the miraculous elements that surround the lives of many early saints. Sebastian was said to be an officer of the Praetorian guard in the time of Diocletian in the 3rd cent. He was secretly a Christian, a fact that was revealed when two of his companions named Marcus and Marcellinus were condemned to death for their belief, and Sebastian came forward to give them support. He was ordered to be shot with arrows, and was left for dead by his executioners. None of his vital organs was pierced (a detail not always observed), and his wounds though grave were not mortal. He was nursed back to health by, according to one legend, a widow named IRENE, and returned to confront the emperor with a renewed avowal of his faith. This time he was beaten to death with clubs, and his body thrown into the Cloaca Maxima, the main sewer of Rome. The familiar image of Sebastian was used by painters and sculptors of the Italian Renaissance as a vehicle for the portrayal of the standing male nude. He is either alone, as in devotional pictures, or in narrative scenes is surrounded by archers. He is bound to a tree or pillar, sometimes with his armour at his feet. He is pierced by several arrows. The background may be a view of Rome as seen from the Palatine hill, the supposed place of his martyrdom. The ancients believed that disease was caused by the arrows of APOLLO. The cult of St Sebastian as protector against the plague began in the 4th cent. which saw the building of the basilica over his tomb on the Via Appia at Rome. It was not widespread before the 14th. Votive

pictures of the Virgin and Sebastian have this connotation, especially when he is accompanied by ROCH, and COSMAS AND DAMIAN who were also invoked against pestilence. Sebastian is occasionally seen exhorting Marcus and Marcellinus on their way to execution.

Selene, see LUNA.

Semele (*Met.* 3:287–309). The daughter of Cadmus who founded the city of Thebes in ancient Greece. She was with child by Jupiter, a state of affairs arousing the jealousy of his wife Juno, who schemed to destroy her. On Juno's advice Semele persuaded Jupiter to make love to her for once in his full, divine glory. He did so, reluctantly, for the power of his lightning reduced the mortal Semele to ashes. Mercury saved her unborn child (who became the wine-god BACCHUS) by sewing it into Jupiter's thigh. Jupiter is depicted in the heavens, perhaps borne on the back of his eagle, surrounded by a blaze of light. He holds a thunderbolt in each hand. Semele lies dying on the ground before him.

Semiramis. The legendary founder, with her husband Ninus, of ancient Nineveh. Classical authors told of her imperious and warlike nature. Claudius Aelianus (*Variae Historiae,* 7:1) relates that the king of Assyria, hearing of the beauty of Semiramis, then an unknown girl, summoned her and fell in love at first sight. She requested that he give her absolute command over his kingdom for five days. This being granted, Semiramis ordered the arrest and killing of the king, and thus possessed herself of his empire. She is depicted receiving a crown from the kneeling king.

Semiramis called to arms. Valerius Maximus (9:3) tells how news arrived that Babylon was in revolt, just as the queen was at her toilet. She straight away dashed to arms, leaving her hair in disorder. According to Valerius a statue of her in this untidy state was later erected in Babylon. Both themes are found in baroque painting.

'Semper,' see FALCON.

'Senatus populusque Romanus,' see S.P.Q.R.

Seneca, Death of (*c.* 4 B.C.–A.D. 65) (Tacitus, *Annals,* 15:60–5). Stoic philosopher, the tutor of Nero and later, while in favour, influential in guiding the emperor's policies. After being charged with conspiracy he committed suicide on Nero's orders. Tacitus describes the dignity and fortitude with which he went to his death. Having dictated a dissertation he cut his veins and then took poison. Finally to hasten matters he was placed in a bath of warm water. His wife who attempted suicide with him was prevented by the Roman guard. The subject occurs frequently in the painting of Italy and northern Europe especially in the 17th cent., and reflects the revival of interest in the ideals of Stoic philosophy: the sovereignty of reason and the control of the emotions. Seneca is depicted in circumstances in which dignity is normally difficult to maintain. He is usually naked except for a loincloth, and is in a basin or bath of water. A woman may be kneeling beside him with pen and paper taking down his words. Roman soldiers stand guard. Nero may be present. (Rubens, Alte Pinakothek, Munich.) The subsequent scene of Nero surveying the body of the dead philosopher is also occasionally depicted.

Senses personified, see FIVE SENSES.

Serafina, see FINA.

Seraph, see ANGEL.

Sermon on the Mount ('The eight Beatitudes') (Matt. 5:1–12). 'When he saw the crowds he went up the hill. There he took his seat, and when his disciples had gathered round him he began to address them.' This is the first occasion in the

gospels on which Christ's teaching is related in detail. He began by treating of the eight conditions of blessedness: 'How blest are the poor, the sorrowful, those of a gentle spirit,' and so on. He is generally depicted standing on a low eminence surrounded by men and women listening, exchanging opinions or kneeling in prayer. In the background is the Sea of Galilee.

Serpent, see SNAKE.

Set-square. An instrument for measuring right-angles, usually with other tools of the carpenter and builder, an attribute of JOSEPH, husband of the Virgin; THOMAS, apostle; Geometry, one of the SEVEN LIBERAL ARTS; Melancholy, one of the FOUR TEMPERAMENTS; JUSTICE.

Seven Gifts of the Holy Spirit, see DOVE.

Seven Liberal Arts. The traditional curriculum of secular learning in the Middle Ages. It dates as a group from late antiquity. The seven were distinguished on the one hand from philosophy, the 'mother' of them all, and on the other from the Technical (or Mechanical) Arts such as architecture and agriculture which were the sphere of the craftsman or manual worker. They were divided into two groups, the *trivium:* Grammar, Logic (or Dialectics) and Rhetoric; and the *quadrivium:* Geometry, Arithmetic, Astronomy and Music. Their visual aspect was formulated in a 5th cent. treatise, *The Marriage of Philology and Mercury*, by the grammarian Martianus Capella, in which the Arts were personified by women, each with her appropriate attributes, and each accompanied by a well-known historical representative of her Art. Martianus' classification was used throughout the Middle Ages, some of its original elements surviving into the Renaissance and later. The medieval Church regarded the Liberal Arts as 'weapons against the heretics', and hence they are found in Romanesque and Gothic sculpture, sometimes paired off with the seven principal virtues (see VIRTUES AND VICES). In Italian art of the 14th cent. onwards they are found in the sculpture of tombs and pulpits, and in frescoes and other painting. They are somewhat rare outside Italy except in engraving and tapestry of the 15th and 16th cents. As a sign of the rising status of the artist in the Renaissance, Minerva, the patron of arts and sciences, may be seen introducing a painter to the assembled Liberal Arts. The historical representatives may be portrayed alone as symbols of the Arts, when they have the same attributes as the female personifications: Rhetoric usually by Cicero; Logic by Aristotle (who may hold a copy of his *Ethics* as in Raphael's 'School of Athens'); Grammar either by Priscian, the grammarian of the imperial court of Constantinople (*fl.* A.D. 500), or by Donatus, whose 4th cent. *Ars Grammatica* became the basis of medieval grammar; Geometry by Euclid, who holds compasses; Arithmetic by Pythagoras, who sometimes also doubles for Music in recognition of its mathematical basis; (Music is otherwise represented by Tubal-cain (Gen. 4:22), a descendant of Cain, whom medieval tradition credited with the invention of music and who holds a musical instrument); Astronomy by the Alexandrian astronomer Ptolemy (who was not infrequently confused with the Egyptian dynasts of the same name and who may therefore wear a crown).

The Arts as anonymous female figures are represented as follows:

Grammar, the foundation of all the others, has two young pupils at her feet, their heads bent over books. In Gothic art she may still have the WHIP given to her by Martianus, for chastisement. In the 17th cent. she takes on a new aspect, a woman watering plants, and perhaps holding a banderol with the inscription, 'Vox litterata et articulata debito modo pronunciata' – 'A literate and articulate tongue, spoken in the required manner', a definition derived from ancient

grammarians, quoted in Ripa's *Iconologia*, a 17th cent. iconographical dictionary.

Logic holds a SNAKE, sometimes two, or rests her hand on a nest of vipers. Or she holds a SCORPION or LIZARD, which do duty for a snake. Martianus called it 'involutus', or curled up. But the word also means 'wrapped up' hence the Middle Ages sometimes depicted it half hidden under her cloak to symbolize the wiles of sophistry. In the Renaissance she may hold SCALES for weighing the true and false, or FLOWERS; or a flowering branch. Alternatively Logic is represented as two old men, wearing togas, deep in discussion.

Rhetoric was given a martial aspect by Martianus, and in the Renaissance she may have a SWORD and SHIELD. But her usual attribute is a BOOK, perhaps entitled 'Cicero'. She may also hold a SCROLL, sometimes partly unrolled.

Geometry (from Gk, meaning measurement of the earth) has at all periods COMPASSES (dividers) for attribute and often a terrestrial GLOBE which she may be in the act of measuring (but see also *Astronomy*). She may occasionally have other instruments: SET-SQUARE and RULER.

Arithmetic. From the later Middle Ages onwards Arithmetic has a TABLET covered with figures, on which she may be writing. Or more rarely, she holds an ABACUS. Like Geometry she may have a RULER.

Astronomy (once part of the broader field of Astrology) has, from Martianus onwards, a GLOBE – strictly a celestial globe marked with the constellations, but not usually distinguished as such. Like Geometry she may measure it with COMPASSES. She has a SEXTANT, formerly used for measuring the stars, and sometimes an armillary SPHERE. Astronomy is also the realm of Urania, one of the nine MUSES, who shares the same attributes.

Music is typically represented as a woman playing an instrument. In the Middle Ages she has a row of three or four bells which she strikes with a hammer. Later instruments are the portative ORGAN, the LUTE, VIOL or violin, some also the attributes of CECILIA. She may have a SWAN, because of the legend of its song. As part of a series Music is sometimes represented by ORPHEUS charming the animals.

See also PHILOSOPHY who presides over the Liberal Arts.

Seven Sacraments. Of the Christian sacraments – acts conferring grace – Protestants generally recognize two, Baptism and Communion, and Catholics seven which comprise, in addition, Confirmation, Penance (Confession), Extreme Unction, Holy Orders and Matrimony, the last two still being at the time of writing mutually exclusive. They are seen on medieval fonts and as altarpiece cycles in early Netherlandish painting, where the subject seems to have had greater appeal, at least until the 17th cent. In the art of the Counter-Reformation their portrayal flourished, a reaction to Protestantism that denied the sacramental validity of penance, and which parted doctrinally from the Catholic Church on the interpretation of the Eucharist. Hence the popularity at this period of themes of penance such as St Peter weeping, or the kneeling Magdalen. The Last Supper was now treated as a communion of the apostles, and representations of the Virgin and certain saints on their deathbed receiving the last communion found favour. The Eucharist was even depicted in the form of a Roman Triumph, with a monstrance borne on a chariot. Poussin treated the sacraments as seven separate paintings, four of them based on the New Testament: The Baptism of Christ, The giving of the keys to Peter (Holy Orders), The Magdalen anointing Christ's feet (Penance), and the Last Supper.

Seven Sorrows of the Virgin, see VIRGIN MARY (2).

Sextant, or quadrant, instruments once used for determining the altitude of the stars, the attribute of Astronomy personified, one of the SEVEN LIBERAL ARTS.

Sextus Tarquinius, see RAPE OF LUCRETIA.

Sheaf, see CORN.

Shears (generally represented as sheep's shears, but sometimes as scissors), the attribute of Atropos, one of the THREE FATES, who cuts the thread of life; of AGATHA whose breasts were shorn. A man asleep in a woman's lap, another cutting his locks, is SAMSON (4).

Sheba, Queen of, see SOLOMON; TRUE CROSS, HISTORY OF THE.

Quadrant

Sheep, see LAMB; RAM.

Shell. The scallop shell was in antiquity the attribute of VENUS, who was born of the sea, or according to a few classical authors from the shell itself. She floats ashore in a shell or holds one in her hand. Drawn by dolphins or hippocampi it forms the car of the marine deities, NEPTUNE and GALATEA. FORTUNE, associated with the sea, may ride in a shell. The TRITON may use a conch shell for a trumpet. For reasons that are not altogether clear the scallop became the distinctive badge of the pilgrim to the shrine of JAMES THE GREATER at Compostella in Spain and is known to have been used from early in the 12th cent. Hence it became the attribute of the saint himself, and is often used in Renaissance and later art to designate pilgrims in general. Thus it may be the attribute of ROCH and is worn by Christ at Emmaus (SUPPER AT E.). Shells are used for cups and platters in the Golden Age (AGES OF THE WORLD). In a woodland setting a kneeling youth offering a shell as a cup to a maiden, sometimes on horseback, GRANIDA AND DAIFILO. The stones on the head or shoulders of STEPHEN sometimes resemble shells.

Shepherd. The symbolism of Christ and Christians as shepherd and sheep is founded on the parables in Luke (15:3–7) and John (10:1–18), and to a lesser extent by Psalm 23, Isaiah (40:11) and Ezekiel (34). But its translation into visual terms is largely confined to the very early centuries of Christian art when it is found in catacomb paintings and on sarcophagi and gems of the 3rd and 4th cents., and in 5th cent. mosaics. It had died out by the Middle Ages and is only rarely encountered in later painting. There are two main types. (1) The shepherd seated among his flock. He is young, generally beardless, and either holds a staff or plays a syrinx or lyre, an image derived from the classical ORPHEUS charming the animals. (2) The shepherd carrying a sheep on his shoulders, the 'Good Shepherd', again adapted from a pagan prototype, that of MERCURY, the guardian of the flocks, carrying a ram. The sheep rescued and restored to the flock symbolized the repentant sinner. (See also LAMB.)

An aged man kneeling before an angel, among shepherds and sheep, JOACHIM AND ANNE (2). A shepherd watching his flocks may be JACOB (3) serving Laban; the shepherds at Christ's Nativity, ADORATION OF THE S. A female saint dressed as a shepherdess, GENEVIÈVE. In secular art APOLLO (8) tends the flocks of King Admetus; MERCURY (1) with his flute lulls the shepherd Argus to sleep. The shepherd Paris appraises three naked goddesses, JUDGEMENT OF PARIS. PAN tends the sheep and goats of Arcady. See also the pastoral themes of ET IN

ARCADIA EGO; MIRTILLO, CROWNING OF; DAPHNIS AND CHLOE; ERMINIA AND THE
SHEPHERDS; GRANIDA AND DAIFILO; SILVIO AND DORINDA.

Shield. The surface of a shield was sometimes decorated so that its owner might
be identified in battle (e.g. with armorial bearings in the later Middle Ages). A
shield carrying the image of Medusa's head is the attribute of MINERVA; with
the image of a lion or bull, of FORTITUDE personified. The personification of the
Iron Age (AGES OF THE WORLD) carries a shield bearing a human-headed serpent.
A shield is the attribute of CHASTITY with which she protects herself from Cupid's
arrows, and hence of the virgin goddess DIANA; also of Rhetoric, one of the
SEVEN LIBERAL ARTS. Perseus' shield is brightly polished. A shield hanging from
a tree and pierced by an arrow, see ARROW. See also WARRIOR.

Ship. The early Christian Fathers and apologists likened the Church to a ship in
which the faithful found safety and were borne to salvation. The ark of NOAH
was an apt symbol of her protection, likewise the boat bearing the disciples,
the 'Navicella' as it is sometimes called, in the theme of CHRIST WALKING ON
THE WAVES. Tertullian (*c.* 160–230) compared the place of worship itself with a
ship, hence the word nave from the Latin *navis*, a ship. It appeared first in early
Christian painting in the Roman catacombs and on objects such as seals and lamps
of the same period. The mast is generally in the form of a cross and may be sur-
mounted by a dove. Sometimes the ship is borne on the back of a fish, the early
symbol of Christ. A ship is the attribute of PETER, apostle; of URSULA; of HOPE,
one of the theological virtues who wears it on her head. It is held in the hand of a
bishop, ERASMUS; of FORTUNE, whose foot rests on a globe; and of the Vestal
virgin CLAUDIA; the latter may drag a ship along with her girdle. Scenes of a ship
in harbour: a warrior on the prow holding an olive branch, met by warriors on
shore, AENEAS (9); a warrior disembarking, received by a king, JASON; a matron
going ashore holding a cinerary urn, AGRIPPINA AT BRUNDISIUM; maidens aboard,
perhaps massacred by soldiers, URSULA; sacks unloaded, watched by a bishop,
NICHOLAS OF MYRA (3); a young woman abducted, HELEN OF TROY. Scenes of storm
and shipwreck: a struggling crew among whom Christ sits peacefully, STORM ON
THE SEA OF GALILEE; demons fleeing from a ship, exorcized by three saints in a near-
by skiff, Mark (2); a sinking ship, a saint overhead calming the waves, NICHOLAS
OF MYRA (4); several sinking, a sea-god brandishing his trident to calm the waves,
NEPTUNE (2); Jupiter throwing down a bolt upon a storm-tossed ship, ULYSSES (3).
Man overboard, swallowed by a monster, JONAH; sailors overboard, fleeing from
wild beasts and changing into dolphins, BACCHUS (3). A figure bound to the
mast, ULYSSES (2). A ship guided by an angel, MARY MAGDALENE (4). A naval
battle, Lepanto, VIRGIN MARY (15). A burning ship, fired by nymphs, TELEMACHUS.
The state barge of the doge of Venice, WEDDING OF THE SEA. See also BOAT;
SHIP OF FOOLS.

Ship of Fools. The long allegorical poem, *Das Narrenschiff* (1494), by the German
scholar and satirical writer Sebastian Brant tells of a ship-load of fools who
set sail for the 'fool's paradise', Narragonia. The idea of an allegorical journey
by ship was known in didactic writing from the 14th cent. Brant's poem is a
vehicle for satirical comment on contemporary folly, loose-living and vice of
many kinds, drunkenness, lechery, corruption of the law and the clergy, quack
doctors and so on. The original edition was illustrated with many woodcuts,
some of which have been ascribed, without certainty, to Dürer. They were used
repeatedly in later editions and copied in foreign translations. The figures are
dressed in fool's cap and bells and are seen in many situations, by no means all
on board ship – Samson and Delilah typify the inability to keep secrets, Fortune's

wheel the folly of reliance on power, procrastination by the crows perched on the fool and croaking 'Cras, cras!' ('Tomorrow'). Erasmus' *Encomium Moriae, The Praise of Folly* (1509) with engravings by Holbein has several themes in common with Brant. The painting of the Ship of Fools by Bosch (Louvre) shows a drunken party on a boat including a nun and a monk singing, the former playing a lute.

Shooting a dead body. A test, like the judgement of Solomon, designed to elicit the truth by forcing a person to betray his inner feelings. In its original version, which has been shown to go back to the Babylonian Talmud, two rival claimants to an inheritance were ordered to knock on their father's tomb to call him back to life. The one who refused proved by his piety that he was the true heir. In later versions a judge ordered the father's corpse to be strung up. The 'sons' were then instructed to shoot it; the false one shot without compunction, the true one turned away. The story recurs, with variations, in the Middle Ages and was popularized in the 14th cent. *Gesta Romanorum*. Christian moralists interpreted the story as the conflict between greed for money, and reverence for a dead parent. (He who refused to shoot reached nearer to his father's heart.) The judge is sometimes SOLOMON himself. The theme is first represented in later medieval book illustration. It became widely popular in Italy, France and Germany in the 15th and 16th cents. The corpse is lashed to a tree, or strung up like Marsyas. One youth draws a bow; the other turns away, head in hands, or breaks his bow. A judge, enthroned, watches over the proceedings.

Shroud, a winding-sheet, the attribute of JOSEPH OF ARIMATHAEA. The brandeum, or shroud, pierced with a knife by GREGORY THE GREAT (4) shed blood.

Sibyl. In antiquity, a woman endowed with the gift of prophecy, in particular a priestess of Apollo. By the end of the Middle Ages the western Church, through its interpretation of their sayings as foretelling the Christian story, had accepted twelve of them as prophets of the coming of Christ, pagan counterparts of the Old Testament prophets. Their attributes are varied. They commonly hold a book, one of the Sibylline Books in which their prophecies were recorded. They are mostly represented as young women, and are frequently juxtaposed with the prophets. Their names (which indicate their place of origin) and their more usual attributes (among which are some of the instruments of the Passion and other Christian symbols) are as follows. Persian S.: lantern, serpent under her feet; Libyan S.: candle or torch; Erythraean S.: lily of the Annunciation; Cumaean S.: bowl, sometimes shell-like; Samian S.: cradle; Cimmerian S.: cornucopia or cross; European S.: sword; Tiburtine S.: a severed hand; Agrippine S. (perhaps a corruption of Egyptian): whip; Delphic S.: crown of thorns; Hellespontic S.: nails and cross; Phrygian S.: cross and banner of Resurrection. They often wear a kind of turban.

The Tiburtine Sibyl and the Emperor Augustus (*Octavian*). The Roman Senate decreed apotheosis – the deification, or recognition of a mortal as a god – for the Emperor Augustus. According to a Christian legend, when he consulted the Sibyl to know whether to accept, she foretold the coming of a child who would be greater than all the Roman gods. The heavens then opened revealing to the Emperor a vision of the Virgin standing on an altar with the infant Christ in her arms. The story was treated as a prefiguration of the coming of the Magi. The Emperor is sometimes shown removing his crown as a sign of adoration, or it may lie on the ground with his sceptre.

See also AENEAS; (8): *A. and the Cumaean Sibyl;* APOLLO (7): *A. and the Cumaean Sibyl.*

Sickle, see SCYTHE.

Sieve. The Vestal virgin TUCCIA proved her innocence by means of a sieve; it is her attribute and hence that of CHASTITY personified. A broken sieve is an attribute of BENEDICT.

Sigismunda, see GHISMONDA.

Silenus. In Greek mythology a rural god, one of the retinue of Bacchus, a gay, fat old drunkard who was yet wise and had the gift of prophecy. He leads the triumphal procession of Bacchus, perhaps riding in his own car drawn by an ass, but usually lolling drunkenly on the animal's back, supported on either side by Satyrs.

The triumph of Silenus. He is on foot or on his ass, borne along by a throng of Satyrs who hold drinking cups and bunches of grapes, and by Maenads with cymbals. They trail ivy, sacred to Bacchus.

Silver Age, see AGES OF THE WORLD.

Silvio and Dorinda. A pair of lovers from the pastoral play *Il Pastor Fido*, the Faithful Shepherd, by the Italian poet Guarini (1538–1612). The death of Dorinda (4:8–9) resembles the death of Procris (see CEPHALUS AND P.) and was brought about in much the same way. Dorinda, disguised as a shepherd and wearing a wolf's skin, was accidentally slain by Silvio when he was out hunting. The subject is found in northern baroque painting and shows Dorinda, an arrow piercing her bosom, lying in the arms of the old servant Linco. Silvio kneels beside her, offering another arrow to Linco, at the same time baring his breast, since he has no further wish to live.

Simeon, see PRESENTATION IN THE TEMPLE.

Simon Magus, the fall of, see PETER, apostle (12).

Simon Stock (?–1265). English Carmelite friar, born at Aylesford in Kent. He became the sixth General of the Order in 1247. Though never in fact canonized he is venerated throughout the Roman Catholic Church. He was said to have experienced a vision of the Virgin in which she presented him with a scapular, the long front-and-back apron worn over the monk's tunic. She promised him that the wearer would be protected against hell-fire. The cult of the scapular became widespread among Carmelites and was confirmed in a papal bull by John XXII. Simon Stock's vision is represented in works commissioned for Carmelite churches, and shows him kneeling before the Virgin, receiving the scapular from her hands or from the infant Christ seated on her lap.

Simon Zelotes (the Zealot). Apostle and martyr. Almost nothing is known about him, except that after the death of Christ he was said to have travelled through Syria and Mesopotamia with JUDE, preaching the gospel. According to the *Golden Legend* he was martyred by being sawn in half; another legend tells that he was crucified. His attribute is a SAW or a CROSS. His cult, with that of St Jude, was revived in Germany in the 11th cent. by the Holy Roman Emperor Henry III, a patron of art and learning. The figure of Simon is found more often in the art of northern Europe.

'Sine Baccho et Cerere friget Venus,' see VENUS (2).

Sisera, Slaying of (Judges 4:12–24). Sisera, the Canaanite war-leader, was defeated by the Israelites and fled from the battlefield. He took refuge in the tent of Jael, the wife of Heber the Kenite, who belonged to a tribe that was at peace with the Canaanites. Jael gave Sisera food and drink and made him rest. While he slept she took a hammer and a tent peg and drove it through his skull, nailing him to the ground. Then she called the Israelite commander to witness her deed. The subject is found chiefly in northern European art of the 16th and 17th cents.

Sisera, wearing armour, lies sleeping while Jael holds a nail or peg to his head, about to strike it with a hammer. Though she was not Jewish Jael was placed among the other heroines of ancient Israel. The subject sometimes makes a companion picture to JUDITH and Holofernes.

Sisyphus (*Met.* 4:460). One of four figures who are customarily linked in Greek mythology and in art (the others are IXION, TANTALUS and TITYUS) because they all underwent punishment in Hades for various offences. Sisyphus, a king of Corinth, was notorious in his lifetime for his cunning and double-dealing. He was condemned to push a great boulder uphill but it forever rolled down again just as he reached the summit. He is depicted thus, or carrying it on his shoulders.

Skaters on a frozen river: allegory of Winter, one of the FOUR SEASONS.

Skeleton. The personification of DEATH, often with scythe and hour-glass. Skeletons emerge from tombs and from the earth at the LAST JUDGEMENT (2). They sometimes replace the SKULL in 17th cent. funerary sculpture.

Skin. A pelt is the characteristic dress of JOHN THE BAPTIST. A lion's skin is worn by HERCULES and hence by FORTITUDE personified. See also FLEECE.

Skull, a symbol of death, of medieval origin, apparently unknown in this sense in antiquity. It may be accompanied by a toad or serpent. The contemplation of death as a spiritual exercise was recommended by the Jesuits, to be aided by the use of a skull. Saints at prayer are depicted, particularly from the end of the 16th cent., gazing at a skull, perhaps held in their hand. It is the special attribute of FRANCIS OF ASSISI, of ROMUALD, of the hermit saints, in particular JEROME, and of MARY MAGDALENE as a penitent. The skull as a reminder of the transience of life on earth is found in 'Vanitas' pictures (STILL LIFE). An old man examining a skull represents Old Age, one of the AGES OF MAN. In portraiture the sitter's hand resting on a skull is a mark of his piety: a laurel crown on the skull implies that his virtue and renown will survive him. A skull is the attribute of Melancholy, one of the FOUR TEMPERAMENTS. A skull at the foot of the cross, see CRUCIFIXION (9). See also DEATH; ET IN ARCADIA EGO.

Sleep, Kingdom of ('House of Sleep'; 'Kingdom of Hypnos'). Hypnos, the Greek personification of Sleep, was the brother of Thanatos, Death. Their mother was Night (Nyx), who is depicted with black wings outspread, holding an infant on each arm, the white one Sleep, the black one Death. Sleep has wings, like Death, and has the OWL and the POPPY for attributes. (The latter's narcotic properties were known in antiquity.) His dwelling-place is described by Ovid (*Met.* 11:589–632) as a cave on a hollow mountainside through which runs the River Lethe, represented as a somnolent river-god reclining on his urn. Sleep is on his couch which is draped with a canopy. Nearby is his son Morpheus, the god of dreams (hence 'morphia'), who is also winged; and often Death himself in a black robe. The place was once visited by Iris, the messenger of Juno, with orders to send Morpheus on an errand. She is shown descending on bright wings from a rainbow and rousing the sleepy gods. Another visitor was Juno herself who was hatching a plot against her husband Jupiter during the Trojan war and needed help in sending him to sleep. She is seen in the same setting alighting from her chariot drawn by peacocks.

Sloth (Lat. *Acedia; Pigritia*). One of the seven Deadly Sins, though very often omitted from the regular cycles of VIRTUES AND VICES in medieval sculpture, and a fairly rare figure in Renaissance art. Moralists distinguished between simple physical laziness, and a more refined mental inactivity, inducing melancholy, called *acedia*. To the medieval Christian *acedia* was a vice since it implied loss of faith, but to the Renaissance humanists it signified more a loss of creative

inspiration, and even acquired a certain virtuousness. Artists however relied on straightforward symbols: the ASS, which the obese figure of Sloth rides, or leans against; less often, the OX and the PIG – all regarded, unjustly perhaps except for the last, as slothful by nature. Idleness might in some circumstances lead to POVERTY, or in others, to LUST, and hence Sloth may be seen in association with either.

Smilax, see FLORA (2).

Snake, or serpent. A symbol of evil and a biblical synonym for Satan, 'the serpent of old.' But the snake also signified fertility, wisdom and the power to heal, and entered into the religious rites of early peoples, being worshipped by some as a god. The Latin word *draco* signifies both snake and DRAGON and both represent evil in Christian art. The image of SATAN embodies dragon-like features and his limbs may be entwined with snakes. The VIRGIN MARY (4) treads on a serpent to signify the vanquishing of sin or, in baroque art, Protestantism. The snake is sometimes seen at the foot of the cross (CRUCIFIXION, 9). A serpent in a chalice, i.e. a poisoned cup, is the attribute of JOHN THE EVANGELIST; in a loaf of bread (poisoned food), of BENEDICT. ENVY, whose venomous thoughts were nourished by a diet of snakes' flesh, has one for attribute. A snake with a female human head is DECEIT. A snake-haired woman is MEDUSA. Minos, the judge of the dead in HELL, winds his snake-tail about his own body. Scenes of the snake as death-dealing: a woman holding it to her breast, CLEOPATRA (3); entwining a woman's ankle or arm (Eurydice), ORPHEUS (2); entwining a man's corpse near a pool, other victims nearby, CADMUS; a man and two youths wrestling with snakes, LAOCOÖN. HERCULES as an infant strangles two snakes (14), and as a man slays the Lernaean hydra with his club (2). APOLLO slays the python with his arrows. A snake fastened to a man's wrist, shaken into a camp-fire, PAUL, apostle (11). The Persian SIBYL treads on a snake.

The snake was a phallic symbol associated with the earth goddess in the fertility rites of primitive man. It is possible that the snake of the Greek Athene (MINERVA) originated in some such earlier agricultural divinity whom she displaced. The serpent in the basket in the myth of the birth of ERICHTHONIUS, who was born from the spilling of semen on the earth, would seem to go back to the same source. A snake is the attribute of Earth personified, one of the FOUR ELEMENTS and of CERES who represents her. (See also LUST in this connection.) The association of the snake with a tree, the latter a female symbol of the renewal of the earth's vegetation, was found in the rites of the ancient near eastern fertility goddess Ishtar-Astarte. It was represented as a snake encircling a tree-trunk, which became the serpent of the Garden of Eden in Hebrew mythology (ADAM AND EVE, 2), and was apparently the brazen image made by MOSES (12) to protect the Israelites. The serpent as guardian of a tree occurs in the legend of JASON and the Golden Fleece, and the golden apples of the Hesperides (HERCULES, 11). The handling of snakes formed part of the rites of Bacchus and they therefore became the attribute of his attendants the SATYRS.

The snake is a symbol of PRUDENCE personified ('Be wary as serpents,' Matt. 10:16) and came to be regarded in this sense as the attribute of Minerva, the goddess of wisdom, though the origin of the latter association lay elsewhere as was noticed above. It is likewise the attribute of Logic, one of the SEVEN LIBERAL ARTS; INNOCENCE; Africa, one of the FOUR PARTS OF THE WORLD. The snake was associated with Asclepius, the Greek god of medicine (Lat. Aescula-pius) – a rather rare figure in Renaissance art – perhaps because of the sloughing of its skin, which was seen as a symbol of rebirth and healing. It is depicted

entwining his staff. (See also CADUCEUS in this connection.) A snake in the form of a circle, its tail in its mouth, was a religious image in ancient Egypt. Late antique mythographers interpreted it as a symbol of eternity and hence associated it with SATURN who personified Time, and JANUS, the god of the new year. It is found in Renaissance and later art attributed to these gods and to FATHER TIME.

Socrates (469–399 B.C.). The Athenian philosopher is commonly represented in two scenes, one an allegory reflecting his influence on the young, the other his death.

1. *Socrates and the mirror.* Diogenes Laertius in his 'Lives of the Philosophers' (2:33) relates that Socrates advised the young to look constantly in a glass so that, if handsome, they might become worthy of their beauty; if not, that they might make good the deficiency by their accomplishments. The allegory derived from this – of Socrates teaching youth self-knowledge, illustrating the motto 'Know thyself' – is found in Italian baroque painting. The philosopher points at a MIRROR into which a child or youth is gazing. Other young people may be standing nearby deep in thought. The mirror, as a symbol of self-awareness, is also associated with PRUDENCE and TRUTH.

2. *The death of Socrates.* Plato's *Phaedo*, a dialogue that deals with the immortality of the soul, concludes with the description of Socrates' death. In prison, sentenced to die on a charge of impiety and the corruption of youth through his ideas, he drank a cup of hemlock handed to him by a servant. Then, in the presence of his pupils whom he rebuked for their uncontrolled display of grief, with calmness and dignity he lay down to die. The theme, rare in Italian art, was popular with French painters of the Neoclassical school from the later 18th cent. The fortitude of Socrates as he reclines on his death-bed contrasts with the anguish of the young men about him.

Soldier, see WARRIOR.

Soledad, La, see VIRGIN MARY (2).

Solomon (*c.* 970–931 B.C.). The son of David and Bathsheba, and third king of united Israel; his wisdom was proverbial. Solomon's reign saw the construction of the Temple at Jerusalem. (Solomon may be depicted supervising the work.) His court was renowned for its magnificence and luxury. His countless foreign wives and concubines brought with them many pagan cults, leading Solomon into idolatrous forms of worship which contributed to the decline and ultimate division of the kingdom. Apart from a royal crown, he has no special attributes. His throne, which appears in several scenes, is described as being of ivory overlaid with gold and having six steps, each with a lion on either side. On the occasion of a visit from his mother, Bathsheba, (I Kings 2:19) to ask a favour of him, he seated her on a throne at his right hand, an episode that features in religious art as a prefiguration of the CORONATION OF THE VIRGIN. Solomon himself, like David, was an Old Testament 'type' of Christ.

1. *The Judgement of Solomon* (I Kings 3:16–28). Solomon was called upon to judge between the claims of two prostitutes who dwelt in one house, each of whom had given birth to a child at the same time. One infant had died and each woman then claimed that the other belonged to her. To determine the truth the king ordered a sword to be brought, saying, 'Cut the living child in two and give half to one and half to the other.' At this, the true mother revealed herself by renouncing her claim to the child in order that its life might be spared. The child was restored to her. The scene, widely depicted in Christian art, shows Solomon on his throne surrounded by courtiers, the two suppliant women

before him. An executioner stands holding the living child aloft in one hand, with a sword in the other. The dead child lies on the ground. The subject was made to prefigure the Last Judgement, and came to be used as a symbol of Justice in a wider sense.

2. *Solomon and the Queen of Sheba* (I Kings 10:1–13). The ostensible purpose of the queen's visit to Solomon was to satisfy her curiosity about the travellers' tales she had heard concerning his wisdom and the magnificence of his court. She came with a great camel train bearing gifts of spices, gold and precious stones. In return the king bestowed on her 'all she desired, whatever she asked, in addition to all he gave her of his royal bounty.' She is depicted in two ways; either before his throne, her attendants carrying pots and urns containing gifts; or she is seated at his side. The subject was an accepted prefiguration of the Adoration of the Magi.

3. *Solomon's idolatry* (I Kings 11:1–8). In his later years Solomon was drawn more and more to the pagan cults introduced into Israel by the women in his large harem who came from neighbouring kingdoms. The Bible mentions Chemosh and Moloch, gods who required human sacrifice, and Ashtoreth, or Astarte, the Canaanite fertility goddess whose totem was the 'asherah', the brazen serpent of Exodus (see MOSES, 12). Solomon is usually shown at an altar sacrificing a burnt offering. The scene may include pagan statues or a golden calf. The subject was used in Protestant countries of the 16th and 17th cents. to reflect their attitude towards the use of imagery in the Roman Church, regarded by the Reformation as idolatrous.

See also SHOOTING A DEAD BODY.

Solon, see CROESUS AND S.

Sophonisba (Livy 30:15). The daughter of the Carthaginian general Hasdrubal at the time of the second Punic war. She married a prince of neighbouring Numidia, allied to Rome, and succeeded in alienating him from his Roman masters. But he was captured by another Numidian leader Masinissa, who in turn fell in love with Sophonisba, and likewise married her. To prevent the loss of a second ally from the same cause the Roman general Scipio demanded that she be surrendered and sent captive to Rome. Her husband, not daring to defy Scipio, sent her a cup of poison which she drank. Sophonisba's death is a popular theme among baroque painters of Italy and northern Europe. She is generally richly attired and sits holding a large goblet, or receiving it from a kneeling attendant (Rembrandt, Prado, Madrid). The subject resembles ARTEMISIA drinking her husband's ashes.

Soriano portrait, see DOMINIC (7).

Soul. The Greeks believed that a man's soul emerged from his mouth as he expired at death. They represented this symbolically on sarcophagi as a butterfly emerging from a chrysalis. They later used the winged figure of Psyche (the Greek word for 'soul') who is personified in Apuleius' story, a motif that was transmitted to early Christian funerary monuments. The 'infusion' of a living soul into man at his birth was represented similarly by a small, winged, human figure. In classical art the act is performed by Minerva after Prometheus' creation of man. Christian art represents the infusion of the soul into Adam by God in a similar manner (Mosaic, St Marks, Venice). Byzantine art depicted the soul as a naked infant without wings, the type that became established in the West. Pictures of the death of a Christian martyr show the soul emerging from the saint's mouth, or carried up to heaven cradled in a napkin held by angels. At the Crucifixion the soul of the good thief is carried away by angels, that of the bad by demons.

Medieval art sometimes shows a contest between an angel and a demon for a human soul (cf ARS MORIENDI). (See also LAST JUDGEMENT, 3 and 5.)

Sower. A stealthy sower of seed, labourers sleeping nearby, WHEAT AND THE TARES. A sower of dragons' teeth, warriors sprouting from the earth, Minerva overhead, CADMUS. A sower, perhaps with the figure of Justice overhead, the Silver Age, one of the AGES OF THE WORLD. A sower represents October or November in the cycle of the TWELVE MONTHS.

Spade. An alternative to the HOE, with the same meanings.

Sparrow, in the hands of a young woman, signifies Wantonness, an aspect of LUST, from popular notions about the bird's nature; or it identifies her as Lesbia, the lover of the Latin poet Catullus (*c.* 84 – *c.* 54 B.C.) who commemorated her pet sparrow in his verses.

Spasimo, Lo, Virgin Mary swooning, see ROAD TO CALVARY.

Spear. The attribute of the WARRIOR and the HUNTER. It is seen in the hand of MINERVA, FORTITUDE, and CONSTANCY. The latter leans against a pillar. It is brandished by the allegorical figure of the Bronze Age, one of the AGES OF THE WORLD. A dart with a flaming tip plunged into a nun's bosom identifies TERESA. It was the instrument of martyrdom of THOMAS, apostle, who is sometimes depicted transfixed with spears, embracing the cross as he dies. The hunter's weapon is generally the lighter javelin, made for throwing, and is the attribute of the goddess DIANA and, in portraiture, of sitters bearing her name. Diane de Poitiers (1499–1566), the influential mistress of Henry II, king of France, was portrayed with the dress and attributes of the goddess. She took for an *impresa* a javelin entwined with a banderol bearing the motto 'Consequitur quodcunque petit,' – 'Whatever he follows after, he attains.' See also LANCE.

'Speculum sine macula,' see VIRGIN MARY (4, 5).

Sphere, Armillary. An old astronomical instrument in which the principal 'circles' of the heavens were represented by means of metal rings. It is an attribute of Astronomy, one of the SEVEN LIBERAL ARTS, and a symbol of the universe: see SATURN (1). See also GLOBE.

Sphinx (the 'Strangler'). In ancient Egypt a symbol of power and vigilance, represented as a lion with a human head. In classical Greece it was given a woman's head and breasts, and wings, the form generally adopted in Renaissance and later art. The sphinx was regarded by the Greeks as a repository of arcane wisdom: See OEDIPUS AND THE SPHINX. It is sometimes associated with lust in allegories of virtue against vice.

Armillary sphere

Spider. A woman turning into a spider, entangled in a web, ARACHNE. Spider in a chalice, NORBERT.

Spinario ('thorn-puller'), see FOOT.

Spindle. The attribute of Lachesis, of the THREE FATES the one who spins the thread of a human life.

'Spiritus oris nostri . . . ,' see JEREMIAH.

Sposalizio, see MARRIAGE OF THE VIRGIN.

Spindle

S.P.Q.R. 'Senatus Populusque Romanus,' – 'The Senate and people of Rome,' the motto borne on the standards of the Roman legions, until it was replaced with a Christian symbol by Constantine the Great (see CHI-RHO MONOGRAM). It marks the presence of the Roman soldier in several scenes from the Passion and from Roman history. It was adapted by other towns in the Renaissance: S.P.Q.V. (Venice) and S.P.Q.B. (Brussels).

Spring personified, see FOUR SEASONS.

Staff, with the scrip or wallet which often hangs from it, an attribute of the PILGRIM (under which see further). A pilgrim's staff surmounted by a red-cross banner is held by URSULA. Maurus, one of two pupils of BENEDICT, may have a pilgrim's staff. Missionary saints, such as PHILIP, apostle, may be depicted with a staff. A palm tree forms the staff of CHRISTOPHER. Staves crossed above the head of Christ seated, CROWNING WITH THORNS. See also CROZIER; SCEPTRE; WAND; CADUCEUS; JAMES THE GREATER.

Pilgrim's staff

Stag, or hart, the male deer, distinguished by its antlers, is the attribute of JULIAN THE HOSPITATOR; with a crucifix between its antlers, of EUSTACE and HUBERT. A stag or hind (the female is without antlers) pierced by an arrow is protected by GILES. In secular art it is the attribute of the huntress DIANA, who changed the hunter Actaeon into a stag. HERCULES (3) captured the Arcadian stag. Known for its fleetness and sharp senses, which make capture difficult, the stag is an attribute of Hearing, one of the FIVE SENSES and of PRUDENCE. Stags draw the chariot of FATHER TIME and DIANA. A winged stag was the *impresa* of Charles VI (1368–1422), king of France. A stag with a crown round its neck became an emblem of the French royal house from the reign of Charles VII (1403–1461), after the legend that such a beast knelt before the king on his entering the city of Rouen.

Stairs. Child ascending Temple stairs towards the high priest, PRESENTATION OF THE VIRGIN. A beggar dying under the stairs, ALEXIS.

Stake. Death by burning at the stake was, according to medieval biographers, the lot of the Christian martyr: see DOROTHEA and AGNES. In secular art OLINDO AND SOPHRONIA narrowly escape the same fate. Also tied to a stake are SEBASTIAN, pierced by arrows, and THECLA, surrounded by wild animals.

Star. To the Greeks and Romans the stars were divinities, a belief derived from the ancient religions of Persia and Babylon. The heavenly bodies were literally identified with the gods – Venus, Mercury, Saturn and so on – to be worshipped and propitiated according to the advice of the astrologers (in Persia, the magi). Thus the gods as planetary figures may be represented with a star on their brow. In a symbolic form the idea was absorbed by Christianity: Christ described as the 'bright star of dawn' (Rev. 22:16), the VIRGIN MARY (12) as Stella Maris. Early Renaissance art often shows a star on the shoulder of the Virgin's cloak. A star is the attribute of the Dominican THOMAS AQUINAS, worn on his habit, and of DOMINIC himself who has it on or above his brow. NICHOLAS OF TOLENTINO, an Augustinian, has a star on his breast and holds a crucifix entwined with lilies. The Virgin of the Immaculate Conception (VIRGIN MARY, 4) is crowned with a circle of stars, as is Urania, the MUSE of Astronomy; the former's are twelve in number. BACCHUS (4) flung the crown of Ariadne into the heavens where it became a constellation. A star led the magi from the east at the birth of Christ (ADORATION OF THE MAGI). The 'ancient' Christ of the Book of Revelation held seven stars in his right hand; the stars fell at the day of wrath (APOCALYPSE, 2 and 7). Twin stars, see CASTOR AND POLLUX.

Stations of the Cross ('Way of the Cross'; 'Via Dolorosa'). The places on Christ's route through the streets of Jerusalem where he supposedly halted on his way to Golgotha. In the late Middle Ages under the influence of the Franciscans the devotion of the Way of the Cross was introduced into the west in the form of a series of stopping-places in the nave of the church, or outdoors by the wayside,

each marked by some form of image representing the various incidents of the original journey, and before which prayers were said. Formerly seven in number they later became fourteen and so remain to this day. The stations are devoted firstly to the scenes described in the ROAD TO CALVARY, of which the chief are: Christ falling under the weight of the cross (three times), the meeting with his mother, with Simon the Cyrenian and with St Veronica. These are followed by CHRIST STRIPPED OF HIS GARMENTS, the nailing to the cross (see RAISING OF THE CROSS), the CRUCIFIXION, Christ laid in the arms of his mother (see PIETÀ), and the ENTOMBMENT.

Statue. Female, life-size, an astonished sculptor beside it, PYGMALION. Statue of Venus in a grove, putti playing, PUTTO. Male, usually life-size, fashioned by a god, PROMETHEUS (1) (or he applies a torch to it). Statue of a god or goddess on a pedestal before a temple or beside an altar, SACRIFICE. A bust surmounting a pillar, HERM. A Dominican carrying a statue of the Virgin over water, HYACINTH. Idolatry personified holds a small statue and has a cord tied to his neck and to the statue (see FAITH). A bronze idol of Apollo was dug up during the building of the monastery of Monte Cassino (BENEDICT, 7). Statues toppling from their pedestals or lying broken, FLIGHT INTO EGYPT (1).

Stella Maris, see VIRGIN MARY (12).

Stem of Jesse, see JESSE, TREE OF.

Stephaton, the sponge-bearer, see CRUCIFIXION (3).

Stephen (Fr. Etienne; Sp. Esteban). The first martyr, or 'protomartyr', who was stoned to death after arousing the wrath of the Sanhedrin, the Jewish legislative council in Jerusalem, by his celebrated sermon (Acts 7:2–56) in which he accused them of being 'stiffnecked' and of having murdered the Messiah whose coming their prophets had foretold. He was one of the first seven 'deacons' appointed by the apostles. Stephen is generally portrayed as a young man, beardless, with gentle features, and wearing the deacon's dalmatic (see diag. RELIGIOUS DRESS) – worn also by LAURENCE and VINCENT OF SARAGOSSA. The STONES, his special attribute, are held in his hand, or rest on his head or shoulders, or lie in a fold of his robe or on a book or at his feet. They are sometimes stained with blood. He also holds the martyr's PALM, and occasionally a CENSER.

1. *The ordination of Stephen* (Acts 6:1–6). It was presumed that the seven deacons were ordained by the apostle Peter. Stephen kneels before Peter who is about to lay a hand on his head; or he receives a chalice from him. The other six stand or kneel behind Stephen.

2. *St Stephen preaching; almsgiving.* He stands on a dais or step in a public place, or in the courtyard of the Temple, surrounded by a crowd of listeners who wear oriental robes and turbans; or he preaches to a group of seated women and children, perhaps the widows to whose needs as a deacon he had been charged to minister. Or he distributes alms to them. He is also seen brought before the high priest and the elders of the Sanhedrin whom he addresses.

3. *The stoning of Stephen.* At the end of his sermon, ' "Look", he said, "there is a rift in the sky; I can see the Son of Man standing at God's right hand!" Then they gave a great shout and stopped their ears. Then they made one rush at him and, flinging him out of the city, set about stoning him. The witnesses laid their coats at the feet of a young man named Saul.' Artists have depicted all the different elements in this passage. The elders in turmoil press their hands to their ears as Stephen points upwards to a vision of Christ in heaven. He is dragged along to his martyrdom by an angry crowd. He kneels in prayer or

lies in a stony place while his executioners hurl missiles at him. Saul is generally shown as an isolated figure to one side or in the background, with perhaps a heap of clothes at his feet.

4. *The finding of the relics of Stephen.* According to legend Stephen's grave was discovered in the year 415 after a priest named Lucian had been informed of its whereabouts in a dream by the Rabbi Gamaliel, the tutor of Paul. The body was conveyed to Rome and placed in the tomb of LAURENCE, who moved to one side to make room for it – hence his appellation 'the courteous Spaniard.' Gamaliel is depicted appearing in a vision to Lucian. The latter and the bishop of Jerusalem, who holds an ASPERGILLUM, watch over the disinterment of the saint's body.

Single scenes and narrative cycles of the life of Stephen are common in the art of the 15th to 17th cents., especially in Italy and France. As a devotional figure he often accompanies St Laurence.

Stigmata. Marks corresponding to the wounds of Christ which have sometimes been observed to manifest themselves on the bodies of the exceptionally devout as a consequence of religious transport. Stigmata are the attribute of FRANCIS OF ASSISI and CATHERINE OF SIENA.

Still life came into its own with the Dutch and Flemish painters of the 17th cent. The objects in a still-life painting of this period often contain a hidden allegory, either on the transience of the things of the world and the inevitability of death (the 'Vanitas' theme) or, by extension, on the Christian Passion and Resurrection. The meaning is conveyed by the use of objects, mostly familiar and everyday, which are given a symbolic connotation.

Vanitas (Lat., literally 'emptiness') is vanity in the sense, not of vainness or conceit, but of the evanescence or emptiness of earthly possessions. The surest indication that such a theme underlies a still life is a SKULL, the *memento mori* reminding us that we must die. An HOUR-GLASS, CLOCK or CANDLE all allude to the passing of time; an overturned vessel such as a CUP, PITCHER or BOWL, to the literal meaning of *vanitas* – emptiness. A CROWN, SCEPTRE, JEWELS, PURSE or COINS stand for the power and possessions of this world (represented by a terrestrial GLOBE) that death takes away. A SWORD or other weapon reminds us that arms are no protection against death. FLOWERS in this context, especially with drops of dew on leaves and petals, are symbols of short-livedness and hence of decay.

Allegorical still life assumes a specifically Christian meaning with the introduction of a glass of WINE, or a pitcher (presumed to contain wine) and a loaf of BREAD – the eucharistic elements. A vase of flowers in this context points the contrast between life on earth and in the hereafter. IVY, being evergreen, signifies eternal life and, when crowning the skull, may be taken to mean the conquest of death by the Resurrection. The Christian aspect is underlined by the use of the PELICAN or PHOENIX to decorate a vessel; it is made quite explicit with a CRUCIFIX or ROSARY. The traditional Christian symbols of the apple, pomegranate, black and white grapes, nut and other fruit, that are commonly found in pictures of the Virgin and Child in the 15th and 16th cents. (see further VIRGIN MARY, 13) were adopted with the same meanings in allegorical still life of the 17th cent. In this context a bird is a symbol of the human soul, a meaning familiar in antiquity; it is extended to other winged creatures, especially the BUTTERFLY. Thus a caterpillar, chrysalis and butterfly together signify not merely the insect life-cycle but the stages of man's earthly life, death and resurrection. A bird's EGG, especially with the shell broken, likewise implies resurrection. (The latter

motifs are sometimes also seen in the earlier pictures of the Virgin and Child.) It remains to add that such objects in a still life are not necessarily proof of conscious allegorizing on the part of the artist; they may indicate no more than the existence of a traditional repertoire of objects on which he was accustomed to draw.

Stone. Held in the hand: kneeling hermit, JEROME; warrior with falcon, BAVO; beggar-woman, her other hand winged and reaching up, POVERTY; Pharisee, beside him Christ and an accused woman, WOMAN TAKEN IN ADULTERY; a monk (Satan disguised), offering a stone to Christ, TEMPTATION IN THE WILDERNESS. As the attribute of STEPHEN stones rest on his head, shoulders, on a book or at his feet, and are sometimes blood-stained. Stones in a woman's lap are the attribute of Emerantiana (see AGNES). A stone lifted in a bird's claw, CRANE. See also ROCKS; OPERATION FOR STONES IN THE HEAD.

Stork. Classical writers and the medieval bestiaries mention the belief that the stork fed its parents when they were no longer able to care for themselves, hence the bird symbolizes filial piety in Renaissance and later painting. Storks draw the chariot of MERCURY. See also CRANE which it somewhat resembles.

Storm on the Sea of Galilee (Matt. 8:23–27; Mark 4: 35–41; Luke 8:22–25). As Christ and the disciples were crossing the Sea of Galilee their boat was struck by a sudden storm which threatened to sink it. The frightened disciples awakened Christ who was asleep on a cushion in the stern. He calmed the sea with a few words, and rebuked the awestruck disciples for their faint-heartedness. The scene is a ship tossing in heavy seas. Men struggle with the tiller and haul on the sheets. Christ sits peacefully in their midst, perhaps sleeping. The theme acquires allegorical overtones through the familiar Christian symbolism of the Church as a ship.

Stream. The Castalian stream was the source of poetic inspiration on Mount PARNASSUS. The Queen of Sheba walked through a stream rather than tread on the wood that bridged it (TRUE CROSS, HISTORY OF THE). See also RIVER.

Stultitia, Folly personified, see PRUDENCE.

Stylus, see TABLET.

Stymphalian birds, see HERCULES (6).

Succour. The aiding of the distressed, both by giving alms and tending the sick, is a widely depicted theme. The following may be distinguished.

Almsgiving. Deacon distributing alms to the poor, STEPHEN (2); deacon distributing church vessels, LAURENCE; bishop at cathedral door, THOMAS OF VILLANUEVA; black-habited monk giving shirt to leper, PHILIP BENIZZI. Among other almsgivers are: LUCIA; ROCH (a pilgrim); JOHN CHRYSOSTOM (a Greek bishop); MARTIN (2) on horseback.

Tending the sick. Beggars and cripples: ELIZABETH OF HUNGARY; victims of the plague, CHARLES BORROMEO who may give them communion; an injured man at the roadside, GOOD SAMARITAN; the sick lying in the streets, PETER, apostle (7); dying man borne by monk and angel, JOHN OF GOD.

'Sufficit unum in tenebris', see CANDLE.

'Sum quod eris, quod es olim fui,' see DEATH.

Summer personified, see FOUR SEASONS.

Sun. The attribute of TRUTH personified because all is revealed by its light. She holds it in her hand. The sun likewise revealed the love affair of Mars and VENUS (8). The sun, moon and stars were made on the fourth day of the CREATION. JOSEPH (1), the son of Jacob, dreamed that they bowed down to him. The sun and moon are represented in the CRUCIFIXION (11). For Apollo and Helios as

sun-gods, see APOLLO. The Woman of the Apocalypse was 'robed with the sun', see VIRGIN MARY (4).

Sunflower. A Greek myth (*Met.* 4:190–270) tells how Clytie, the daughter of a king of Babylon, was forsaken in love by the sun-god Apollo because he turned his attentions to her sister Leucothea. Clytie's jealousy was the cause of her sister's death. She herself, still spurned by the god, slowly wasted away and turned into the flower that always turns its face towards the sun. The marigold, which has this property, is likely to have been the flower of the Greek myth. (See FLORA, 2.) The common sunflower, *Helianthus annuus*, features in the several examples of Van Dyck's 'Self-portrait with a sunflower' in a similar sense, as a symbol of the artist's unswerving devotion to his patron King Charles I.

'Suore morte,' see BENEDICT (11).

Superbia, see PRIDE.

Supper at Emmaus (Luke 24:28–32). The sequel to the JOURNEY TO EMMAUS. Two disciples, Cleopas and one unnamed, were on their way to Emmaus, a village near Jerusalem. They were met by Christ who accompanied them, though they did not recognize him at once. At Emmaus they pressed him to remain with them, ' "For evening draws on, and the day is almost over." So he went in to stay with them. And when he had sat down with them at table, he took bread and said the blessing; he broke the bread, and offered it to them. Then their eyes were opened, and they recognized him; and he vanished from their sight.' It is a fairly late theme in Christian art, first found in French Romanesque churches of the 12th cent. Sometimes, as a fitting 'type' of the sacrament of Communion, it takes the place of representations of the Last Supper which customarily decorated the walls of monastic refectories. It was favoured by the Venetian school in its great 16th cent. period, and there it becomes wholly secularized in feeling. Rembrandt in the next century made several versions which restored the religious sentiment. In its essential form it shows three figures seated at table. Christ, in the centre, is in the act of breaking bread; on the faces of the other two is the dawning awareness of his identity. One tradition (see further, JOURNEY TO EMMAUS) shows Christ, and sometimes the two disciples, dressed as pilgrims, he with a hat hanging at his back, and the pilgrim's staff and wallet lying on the floor. A cockleshell, the distinctive emblem of the pilgrim in the Middle Ages, may be seen on the cloak of one of the disciples. Though it is the proper attribute of James the Greater, here it alludes merely to pilgrims in general. (See SHELL.) Among Venetian painters the treatment is expanded not only as to the lavishness of the table but in the number of guests, servants and others, maybe as many as fifteen or twenty, in the midst of which the central figures may be all but lost. In the Netherlands of the 17th cent. a relationship developed between representations of the 'Supper at Emmaus' and the Greek myth of PHILEMON AND BAUCIS, a similar account of hospitality given to the gods, who reveal their identity to their two hosts in the course of a meal. The classical theme is not uncommon in Netherlandish art of the period and there is well-adduced evidence that painters, in particular Rembrandt, based their treatment of the 'Supper' upon it. By a kind of cross-fertilization representations of the Philemon and Baucis theme, particularly in Dutch and German painting, came to acquire distinct Christian overtones.

Supplication. An act of petitioning by one person, who often kneels, before another. See also OBEISANCE for other similar themes. *Before Christ:* woman touching the hem of his garment, WOMAN WITH AN ISSUE OF BLOOD; woman pointing to a dog, disciples disapproving, DAUGHTER OF THE WOMAN OF CANAAN, CHRIST

HEALS THE; centurion, CENTURION'S SERVANT, CHRIST HEALS THE; leper, LEPER, HEALING OF THE. *Before a king enthroned:* woman swooning, ESTHER; a queen, her attendants bearing gifts, SOLOMON (2); ULYSSES (5) at the court of Alcinous; ORPHEUS (3) before Pluto and Proserpine. *Before a victorious warrior*, illustrating the virtue of clemency: youth and maiden, perhaps old couple following, servants bearing gifts, SCIPIO (1); females, both women and children, ALEXANDER THE GREAT (6); women with youths, a Roman setting, CORIOLANUS; an old man in a tent, Priam before Achilles, TROJAN WAR (5). Woman with servants bearing food, before a chieftain, DAVID (5). A patriarch followed by his wives, servants and herds, kneeling before another with soldiers, JACOB (3). Emperor at church door turned away by bishop, AMBROSE. Blind man, armour laid aside, dove of the Holy Ghost overhead, before Ananias, PAUL, apostle (2). Master seated at table, clerk with book beside him, complaining labourers, LABOURERS IN THE VINEYARD. A similar scene, a servant pleading or accused by his fellows, UNMERCIFUL SERVANT. From classical myth, THETIS kneels at the feet of Jupiter; PHAETHON (1) before Apollo. See further, POPE.

Susanna (O. T. Apocrypha). A fictional heroine whose innocent virtue triumphed in the end over villainy. The story is set in Babylon during the Exile and tells how Susanna, the wife of a prosperous Jew, was secretly desired by two elders of the community and how they plotted together to seduce her. She was accustomed to go into her garden to bathe, so one day the elders hid themselves there to wait for her. The moment her maids had gone, leaving Susanna alone, the two old men sprang out on the naked, unsuspecting girl. They threatened that unless she gave herself to them both they would swear publicly that they had seen her in the act of adultery with a young man, a crime for which the penalty was death. But Susanna spurned them and cried for help. The old men, thwarted, carried out their threat; Susanna was hauled before a court on the false charge, found guilty and condemned to die. At the eleventh hour the young Daniel came forward and cross-examined the elders. By the device of separating them from each other, he elicited conflicting evidence, thus proving Susanna's innocence.

In Hebrew the name Susanna means a lily, the symbol of purity. She appears in the earliest Christian art of the Roman catacombs perhaps as an example to the persecuted of that era of the final delivery of a righteous person from evil. The Middle Ages made her a symbol of the Church menaced by Jews and pagans. Medieval artists preferred the theme of Daniel executing justice, but from the Renaissance onwards they chose Susanna bathing, an opportunity for the portrayal of female nudity.

'Sustine et abstine,' see BERNARD.

Swan. Classical writers maintained that the swan loved music and uttered a beautiful song at its death. Perhaps for this reason it became associated with APOLLO and thence of certain MUSES. It is occasionally his attribute and that of the Muses Erato and Clio. Fable had it that the soul of a poet entered into a swan. Because of its beauty it is an attribute of VENUS; a pair draw her chariot. A maiden embraced by a swan is LEDA. A youth changing into a swan is Cygnus (PHAETHON). A swan forms part of the *impresa* of Claude, wife of Francis I, king of France: see GIRDLE.

Sword. The weapon of the soldier in many narrative themes (see WARRIOR); also a symbol of authority and of the administration of justice and, like the palm frond, the attribute of the Christian martyr. As the emblem of PAUL, apostle, it stands for the sword of the Spirit, 'that which the Spirit gives you' (Eph. 6:17); it was also the instrument of his martyrdom. Among martyrs with a

sword may be recognized JAMES THE GREATER; AGNES; piercing her bosom, JUSTINA; the same, with a lion, EUPHEMIA; piercing her neck, LUCIA; piercing a monk's breast or embedded in his skull, PETER MARTYR; embedded in a bishop's skull, THOMAS BECKET; piercing a book in a bishop's hand, BONIFACE; with an anvil, ADRIAN; a pair of saints, one with a whip, the other a sword, GERVASE AND PROTASE. A sword and a cloak are the attributes of MARTIN of Tours, who is also depicted in the act of cutting his cloak. A sword is occasionally the attribute of JULIAN THE HOSPITATOR. Seven swords piercing the Virgin's breast are her Seven Sorrows (VIRGIN MARY, 2). A sword emerges from the mouth of the 'ancient' Christ (APOCALYPSE, 2) and from the mouth of a warrior on horseback (APOCALYPSE, 22). A sword and a lily lie on either side of the face of Christ in Judgement (LAST JUDGEMENT, 1). The European SIBYL may hold a sword.

Among allegorical figures the sword is the attribute of JUSTICE (in portraiture a sword may signify that the sitter dispenses justice); CONSTANCY, who holds a pillar; FORTITUDE, a female warrior; WRATH, likewise a warrior; and Choler, one of the FOUR TEMPERAMENTS; Venice, with two lions (TOWNS AND CITIES PERSONIFIED); Rhetoric, one of the SEVEN LIBERAL ARTS; Melpomene, the MUSE of tragedy. A sheathed sword, the hilt bound, belongs to TEMPERANCE. A woman killing herself with a sword is the medieval Despair (see HOPE). The sword is a 'Vanitas' symbol (STILL LIFE). Sword and sandals are revealed under a rock lifted by THESEUS (1). A sleeping warrior offered a sword and book is SCIPIO (2). A ploughman offered a sword by a Roman soldier is CINCINNATUS.

Sylvester. Pope from 314 to 335 in the reign of Constantine the Great, the Roman emperor who brought an end to the persecution of Christians by granting recognition to their religion. According to a popular legend which is the subject of many pictures the emperor was baptized by Sylvester, though it is historically more likely that it was performed on his death-bed by Eusebius of Nicomedia. It was said that Constantine suffered from leprosy for which the only cure was to bathe in the blood of innocent children, until SS Peter and Paul appeared to him in a dream and told him instead to send for Sylvester. The emperor obeyed, was baptized by the saint and cured of his sickness – an allegory of his conversion to Christianity. Sylvester wears pontifical robes and either a mitre or tiara. He may hold the bishop's crozier or the pope's triple CROSS, and a BOOK. Or he holds portraits of Peter and Paul. An OX at his feet refers to the one he miraculously restored to life in a contest with a magician. A DRAGON, bound or chained, symbolizes paganism overcome.

The baptism of Constantine. Sylvester pours the baptismal water over the head of the emperor who kneels, naked but for a loincloth, in or beside the font. His armour and weapons lie in a heap on the ground. Roman soldiers look on, puzzled. The theme symbolizes an historic moment in the growth of the Christian Church – its official acceptance within the Roman empire.

Narrative cycles, found in the art of Italy, Spain and France, chiefly in the 13th – 15th cents., include the following scenes: Sylvester brings the ox back to life; he subdues the dragon; Constantine restores the innocent children to their mothers; he sees Peter and Paul in a vision; Constantine's messengers summon Sylvester; Sylvester baptizes the emperor. (See also CONSTANTINE THE GREAT, 3.)

Syrinx, a nymph, see PAN; the pan-pipes, see PIPE, and MUSICAL INSTRUMENTS.

T. A cross shaped like the letter T, called *tau* from the name of the Greek letter, was derived from the ancient Egyptian hieroglyph for life and hence became a symbol of life. It was adopted by the early Christians of Egypt as a form of the cross of Christ and is the emblem of ANTONY THE GREAT who lived in Egypt. As a

symbol of life it was traditionally regarded as the mark made on their doorposts by the Israelites on the eve of the exodus from Egypt, and as the shape of the pole on which the brazen serpent was raised (MOSES, 6 and 12). A T-square is the attribute, among other instruments, of Geometry, one of the SEVEN LIBERAL ARTS. See also CRUCIFIXION (2).

Tabitha, see PETER, apostle (8).

Tablet. Two tablets are the attribute of MOSES (11) who received them from God on Mount Sinai. They fall from the hands of the allegorical figure of the Synagogue (CRUCIFIXION, 12). A tablet and stylus are the attribute of Clio and Calliope, MUSES of history and epic poetry; of HISTORY personified; and of Arithmetic, one of the SEVEN LIBERAL ARTS. A sage beside whom a youth writes with a stylus on a tablet, HOMER. See also WRITER.

Tamar, sister of Absalom, raped, see DAVID (8).

Tambourine. The playing of drums by women formed part of the rites of Dionysus in ancient Greece. Hence his devotees, the Maenads, are typically represented beating a tambourine (see BACCHUS). It is an attribute of Vice personified (HERCULES, 21) and is held by Hercules (17) dressed as a woman. Erato the MUSE of love poetry may have a tambourine. JEPHTHAH'S DAUGHTER came to meet her father with 'tambourines and dances.'

Tancred and Clorinda (Tasso, *Jerusalem Delivered*, 12:65–9). Tancred, a Christian knight, one of the heroes of Tasso's epic poem of the first Crusade, loved the amazonian Clorinda who fought for the opposing Saracens. Not recognizing her in armour Tancred wounded her in combat. The dying Clorinda craved Christian baptism. Tancred fetched water from a little stream in his helmet and, on undoing her headgear, recognized his beloved. The theme is found in 17th cent. painting, chiefly Italian, and shows Tancred in the act of baptizing Clorinda. He kneels in full armour, pouring water from his helmet. She lies back, her armour partly removed, her weapons lying nearby. See also TANCRED AND ERMINIA.

Tancred and Erminia (Tasso, *Jerusalem Delivered*, 19:103–114). Tancred, during the assault on Jerusalem, engaged in single combat Argantes, an Egyptian ambassador to the city. Argantes was killed and Tancred severely wounded. Erminia, the daughter of a former Saracen king of Antioch, who loved Tancred, was fetched to the scene by the knight's armour-bearer Vafrino. She, crazed with grief, with the help of Vafrino removed Tancred's armour and dressed his wounds, cutting off her locks to bind them. Tancred is depicted partly naked, his armour removed, supported by Vafrino, Erminia kneels beside him, in the act of cutting her hair with a sword. The body of Argantes may lie in the background. Putti hover overhead, a sign of Erminia's love (Poussin, Hermitage, Leningrad, and Barber Institute, Birmingham, Eng.). Related themes are ERMINIA AND THE SHEPHERDS; TANCRED AND CLORINDA.

Tantalus. (*Met.* 4:458–9). One of four legendary figures who are customarily linked in Greek mythology and in art (the others are IXION, SISYPHUS and TITYUS), because they all underwent punishment in Tartarus for various offences. Tantalus, a king of Lydia, murdered his son and, according to some, was also guilty of revealing the secrets of the gods to mankind. His punishment was to stand forever up to his neck in a pool of water which receded from him when he tried to drink. Above his head hung branches bearing fruit which blew aside whenever he tried to grasp them. He was thus 'tantalized' and suffered eternal hunger and thirst.

Taper, see CANDLE; TORCH.

Tau-Cross, see CROSS.
Taurus (zodiac), see TWELVE MONTHS.
Telemachus. The son of Ulysses (Odysseus) and Penelope. The *Odyssey* relates that when his father failed to return home at the end of the Trojan war Telemachus set out to search for him accompanied by the goddess Minerva (Athene) who was disguised as his old guardian Mentor. A romance, the *Adventures of Telemachus*, by the French writer Fénélon, published in 1699, amplified Homer's narrative and was a source book for 18th cent. French artists. Fénélon relates how Telemachus was shipwrecked on the island of the goddess Calypso – where his father had earlier been imprisoned. Calypso fell in love with Telemachus and detained him by persuading him to relate his previous adventures. Venus sent Cupid to aid her in her designs, but Telemachus fell in love with Eucharis, one of Calypso's nymphs, provoking the goddess' wrath. Cupid incited the other nymphs to burn a new boat that Mentor had built. Telemachus was delighted by this delay to his departure but was thrown into the sea by Mentor where they were picked up by a passing vessel. Telemachus is depicted in the grotto of Calypso who is surrounded by her nymphs. Cupid may be present, and Mentor watches over the scene. The burning of the boat is also represented (Charles Natoire, Hermitage, Leningrad). See also ULYSSES.
Temperaments, see FOUR TEMPERAMENTS.
Temperance. With JUSTICE, PRUDENCE and FORTITUDE, one of the four Cardinal Virtues (see VIRTUES AND VICES). To the Middle Ages temperance often signified, as it may today, abstinence from liquor, and hence was represented by a woman pouring liquid from one vessel to another – diluting wine with water. This type is also seen in the Renaissance. A PITCHER and a TORCH suggest sexual moderation – water to put out the fires of lust. She occasionally has a CLOCK, to symbolize the well-regulated life, or a sheathed SWORD, the hilt bound with cord. But the normal attribute of Temperance is a BRIDLE, usually held in the hand, but sometimes with the bit in her mouth. Her opposing vice is Wrath who tears her clothes.
Temple. The temple of a pagan god, especially in Italian painting from the 16th cent., is often a round building, the pillars forming a circular colonnade which support the domed roof. Yet this shape was unusual in classical architecture, and the accepted shape for the ground plan of the medieval church was a Latin cross. Renaissance architects, following the principles first advocated by Alberti (1404–1472), reverted to the circle as the basis of the design of churches. The circle and the sphere were looked upon as the perfect shape, conforming to the Renaissance concept of God. He was the Cosmic Mind which took the form of a sphere containing the whole universe – spirit, mind and matter, in descending concentric stages. The designs of Alberti and those who came after him were influenced by the few remains of circular buildings such as the Roman Pantheon and the temple of Vesta. At the beginning of the 16th cent. Bramante's Tempietto, a church of classical circular form, with colonnade and hemispherical dome, was built at Rome. Raphael, depicting PAUL (8) preaching before the Athenian Areopagus, copied the Tempietto in order to represent a pagan temple of Mars. This form, or approximations to it, became the usual type of temple in pagan scenes of SACRIFICE, or in representations of stories such as CLEOBIS AND BITO. The statue of the god on a pedestal generally stands outside the building though in classical times it was housed in an inner chamber. A circular temple symbolizes the Christian Church in the hand of Europe personified, one of the FOUR PARTS OF THE WORLD.
The circle is used symbolically in representations of heaven as concentric

choirs of ANGELS, and in the arrangement of the disciples standing in a circle round Christ (Masaccio, 'The Tribute Money,' Brancacci chapel, Santa Maria del Carmine, Florence).

Temptation, see ADAM AND EVE (2).

Temptation in the wilderness (Matt, 4:1–11; Mark 1:12–13; Luke 4:1–13). After his baptism Christ fasted in the wilderness for forty days, and at the end of that time was thrice tempted by the devil. 'If you are the Son of God tell these stones to become bread,' Christ was told. Then setting him on a parapet of the Temple in Jerusalem Satan invited him to cast himself down to see if angels would save him. Lastly the Saviour was taken to the top of a mountain overlooking the kingdoms of the world. 'All these I will give you, if you will only fall down and do me homage.' Each time Christ repudiated Satan with quotations from the Scriptures. When the Devil had gone angels appeared and waited on Christ. Temptation in one form or another commonly lay in wait for those who retired to the desert which, to the ancients, was the traditional abode of demons – see for example ANTONY THE GREAT (1); JEROME (1). Of Christ's three temptations artists have preferred the episode of the stones, the easiest to interpret visually. The scene is usually a rocky place where Christ is confronted by Satan, who may appear in several guises. In Romanesque and Gothic art he is the typical demon of the period with horns, a scaly body, wings, and claws for hands and feet. The Italian Renaissance portrayed him as the 'fallen angel' or, in another convention, to illustrate his cunning, as an old man in a monk's habit. The latter generally betrays himself by revealing a cloven hoof or claw under his garments. He points to the stones on the ground or, more often, offers one in his outstretched hand. The scene on the mountain top shows Christ accompanied by angels, while Satan is falling headlong.

Angels ministering to Christ in the wilderness. In a green oasis in the desert Christ is surrounded by angels who are bringing water for him to wash his hands, dishes of food and baskets of fruit. He may be seated at a table under a tree. In the hands of Italian baroque painters the idea of adoration predominates: angels like putti are floating down or kissing the Saviour's feet.

'Tenuisti manum dexteram meam,' see FRANCES OF ROME.

Teresa (1515–82). Spanish Carmelite nun, born at Avila in Castile. She was active in the reform of the Order and established numerous convents in Spain which restored the stricter discipline of the original Rule. Their members were known as Barefoot, or 'discalced', Carmelites. The foundation by Teresa in 1562 of the monastery in Avila dedicated to JOSEPH husband of the Virgin, her patron saint, marked a stage in the growth of his cult and of his representation in devotional art. Teresa's personality was remarkable for combining a wealth of practical common sense with a strong mystical element. But the image of her that emerges through the art of the Counter-Reformation is, as might be expected, one-sided and presents only the visionary. She is sometimes depicted as a large woman with heavy, almost coarse, features, after the authentic portraits that exist; but more usually, especially in Italian painting, her appearance is much idealized. Among her many writings Teresa records the experience of a vision of an angel bearing a long golden spear or dart with a flaming tip, which it plunged into her heart. This symbolic implanting of *amor dei*, which has echoes of pagan Eros, was mentioned in the papal bull of her canonization (1622), and became the most popular motif in 17th cent. representations of the saint. She wrote also of a vision of the Virgin Mary and Joseph who placed on her a dazzling white cloak and a golden necklet hung with a cross – a token of divine approval of her

plan to found a monastery. The theme is frequently found in churches of the reformed Carmelites. Or she is seen kneeling before a vision of Christ who displays his wounds, or presents her with one of the nails of the cross. The latter is a variation of the theme of the mystic marriage, the nail being a substitute for the ring. She is also seen before Christ interceding for souls in purgatory, who are depicted below wringing their hands and looking up to her imploringly. Like other saints who left important written works, she is seen writing while the DOVE of the Holy Spirit hovers at her ear, inspiring her words. She was helped in her work of reform by the theologian and poet John of the Cross who is often represented beside her. He wears the Carmelite habit and may have books, his works, at his feet.

Terpsichore, see MUSES.

Thaddeus, see JUDE.

Thalia, see MUSES.

Thanatos, see DEATH; SLEEP, KINGDOM OF.

Theban Legion, see MAURICE.

Thecla. Traditionally the first Christian female martyr. She lived in Iconium, the Phrygian city visited by St Paul. Her story is told in the apocryphal Acts of Paul, parts of which date from the 2nd cent. The influence of the saint's preaching led her to reject her betrothed who thereupon betrayed her to the Roman governor. Thecla refused to recant her new faith, and was put to the stake, but the flames left her unharmed. She was thrown to the lions and bears in the arena and was untouched. After other ordeals she was released and retired to a mountain cave near Seleucia where she lived to a great age, performing acts of healing. Finally, to escape from a band of persecutors she disappeared into a cleft in the rock which opened to receive her. Many churches in Italy are dedicated to St Thecla. Her attributes are the martyr's PALM and sometimes a PILLAR round which flames are curling, or a ball of fire in her hand or at her feet. There may be LIONS or occasionally serpents at her feet. The scenes of her martyrdom show her seated in the arena, bound to a stake, and surrounded by wild animals, or tied to two bulls.

Theodore. A warrior saint of the Greek Church. Theodore was a Roman soldier of unknown date from Pontus in Asia Minor who became converted to Christianity. According to legend he set fire to a temple of Cybele and was put to death by burning or beheading. Later ramification of the legend brought about the invention of a second Theodore, an officer of high rank in contrast to the original Conscript, as he is known, and the two figures are occasionally represented side by side. Theodore is dressed either as a Roman legionary or a medieval knight, often on horseback. A legend, like that of St George, was told of him concerning a dragon. He has a dragon at his feet, or occasionally a crocodile, perhaps to distinguish him from the other saint. He was formerly a patron saint of Venice and is to be found in the art of that city.

Theodosius, emperor, see AMBROSE.

'ΘΕΟΘΕΝ ΑΥΞΑΝΟΜΑΙ,' see IRIS.

Theseus. Legendary Greek hero, king of Athens, and a famous slayer of monsters. He appears often in antique art on vases and frescoes but did not find wide favour with the Renaissance or later. He is represented as the typical young hero, usually naked except for a cloak and sandals, and perhaps a hat or helmet. He has no regular identifying attribute but is sometimes armed with a club like Hercules.

 1. *Theseus finds his father's sword* (Plutarch 1; Hyginus 14). Though his father

was king of Athens Theseus was born and brought up in Troezen. Here his father placed a sword and sandals under a heavy rock and left orders that his child was to follow him to Athens when he was strong enough to lift the rock and bring the tokens hidden underneath. Theseus is seen lifting a rock or a lump of masonry while his mother points to the sword and sandals lying beneath it.

2. *Theseus and the Minotaur* (*Met.* 8:169–173; Plutarch 1:19). Theseus' most famous exploit was to kill the Minotaur, the bull-headed monster born of PASIPHAË, which was kept in the Labyrinth of King Minos of Crete, and to which Athenian youths and maidens were regularly sacrificed. The king's daughter Ariadne fell in love with Theseus. She gave him a ball of string which enabled him to retrace his steps out of the maze after slaying the Minotaur. The pair fled to the island of Naxos where Theseus deserted Ariadne. (She was later rescued by BACCHUS, 4.) Theseus returned to Athens in a boat with black sails – forgetting a promise he made to his father to hoist white sails if the adventure succeeded. Seeing the boat from afar and thinking his son was dead Theseus' father threw himself into the sea, and thus Theseus became king of Athens. He is represented, in painting and sculpture, standing victorious over the dead monster, club in hand. He enters the Labyrinth having taken the thread from Ariadne; Ariadne stands on the shore of Naxos waving a flag of distress after a departing black-sailed ship. The scenes may be combined in one picture. The Labyrinth is generally depicted as a circular maze and follows an ancient traditional pattern. Virgil tells how Aeneas found a representation of it on one of the gates of the temple of Cumae where a cavern led down into the underworld (*Aen.* Bk 6). Hence it came to be represented in medieval churches as a Christian symbol of hell. The myth of the Minotaur was probably an echo of primitive bull-worship. Its image appears on Minoan coins and seals.

Among other deeds Theseus fought the Amazons when they attacked Athens. (See AMAZONS, BATTLE OF.) He played an active part at the wedding feast of his friend Pirithoüs the Lapith, which came to such a disastrous end. (See CENTAURS: *Battle of Lapiths and C.*)

Thetis. A Nereid, or sea-nymph, the mother of Achilles who was the Greek hero of the Trojan war. The *Iliad* tells that during the siege of Troy Achilles sent his mother to Jupiter (Zeus) with a petition concerning his quarrel with Agamemnon, the leader of the Greek armies. The scene shows Jupiter, sceptre in hand, enthroned majestically on cloud-capped Olympus. His eagle is perched near him. Thetis kneels before him, one hand reaching up imploringly to his chin. Juno (Hera), the wife of Jupiter, lurks in the background (Ingres, Aix-en-Provence). For the wedding of Peleus and Thetis see BANQUET OF THE GODS. See also VULCAN (3).

Thomas. Apostle, called 'Didymus' (twin), popularly known as 'doubting Thomas.' He is generally young and beardless, especially in earlier Renaissance painting. His attributes are a builder's SET-SQUARE or RULER (see below, 3), a GIRDLE (see below, 2) and a SPEAR or DAGGER, the instrument of his martyrdom. His inscription, from the Apostles' Creed, is 'Descendit ad inferos tertia die resurrexit a mortuis', a fitting text since it was Christ's resurrection that Thomas doubted.

1. *The incredulity of Thomas* (John 20:19–29). Thomas was absent when Christ first appeared to the disciples after his death and showed them his wounds. When told about it afterwards Thomas refused to believe until he had seen for himself. Christ appeared again when Thomas was with them and said to him, 'Reach your finger here: see my hands; reach your hand here and put it into my

side.' Thomas and one or two other apostles gaze in wonder as Christ holds out a hand. Or Thomas is shown touching with his finger the wound in Christ's side. The theme, continuously popular from the 13th cent., fulfilled what was once one of the main functions of religious art, to reinforce articles of Christian doctrine.

2. *The Madonna of the girdle.* A parallel story to the above, from one of several apocryphal Assumptions of the Virgin, of uncertain date, which were used for a similar didactic purpose. Thomas was once again absent at the crucial moment, this time from the death and entombment of the Virgin, after which her body was borne up to heaven. When he called on her for a sign that she had really ascended, she threw down her girdle. The episode sometimes forms part of the picture of the ASSUMPTION, or more rarely, the CORONATION OF THE VIRGIN. Thomas kneels on earth below holding, or reaching out for, one end of the girdle which the Virgin lets fall. Other apostles, or the archangel Michael may be present. The Virgin's tomb lies open and empty. The theme was popular among Florentine artists, because of the preservation of a holy relic, purporting to be the girdle, in the cathedral of Prato near Florence.

3. *King Gundaphorus' palace.* A 4th cent. apocryphal romance, The *Acts of Thomas*, tells of the apostle's missionary journey to India where a heathen king Gundaphorus ordered him to design and build a palace, and provided him with ample funds for the purpose. In the king's absence Thomas converted many of his subjects to Christianity and gave all the money to the poor. On his return Gundaphorus was infuriated to be told that he would not see the palace until after his death, since it was built in paradise. However a dead brother of the king unexpectedly came back to life and confirmed that what Thomas claimed was true, and so Gundaphorus became a Christian. This charming tale is the origin of Thomas' patronage of builders and architects. The theme appears in Gothic cathedrals but is rare later.

4. *The martyrdom of Thomas.* The same apocryphal source relates how Thomas died by the command of a pagan Indian priest, at the hands of four soldiers with spears. He may be depicted, transfixed with spears, embracing the cross.

Thomas Aquinas (*c.* 1225–1274). Medieval theologian, known as the 'Angelic Doctor.' His writings became the basis of much of the doctrine of the Catholic Church. He sought to achieve a synthesis between classical Aristotelian philosophy and Christian thought. As a young man he entered the Dominican Order, against strenuous opposition from his family, and devoted his life to teaching and writing. In Dominican art he stands for doctrinal orthodoxy and the casting down of heresy. Many popular legends grew up around him and some found their way into art. He wears the Dominican habit (see RELIGIOUS DRESS), and is typically of rather portly build. He has a STAR on his breast, and holds a BOOK or a CHALICE, occasionally a LILY. Like Gregory the Great he may have a DOVE at his ear, giving him divine inspiration. Nicknamed 'dumb ox' as a youth, he often has an OX for attribute. Among his many inscriptions should be mentioned, 'Veritatem meditabitur guttur meum et labia mea detestabuntur impium.' – 'For my mouth shall speak truth; and wickedness is an abomination to my lips.' (Prov. 8:7) This is placed as a quotation at the beginning of the *Summa contra Gentiles.*

1. *The temptation of St Thomas.* The *Golden Legend* tells how his family, in an attempt to deter him from his religious aspirations, 'put into his chamber a young damsel . . . and anon he took a brand of fire, and drove the damsel out.' He was then visited by two angels bearing a girdle of chastity and 'never after

felt pricking of his flesh.' Both scenes occur in earlier Renaissance painting. The girdle itself often forms his attribute.

2. *The visit of St Thomas Aquinas to St Bonaventura*. It was related that Thomas visited the Franciscan to ask from what books he drew his deep knowledge of God, and was answered that it came from the suffering and death of Christ on the cross. Thomas is seen in the cell of Bonaventura who is drawing aside a curtain to reveal a crucifix (Zurbaran, Berlin).

Thomas may be grouped with his namesakes, the apostle and THOMAS BECKET. He is to be seen enthroned between Plato and Aristotle, but tramples under his feet the three heretics Arius, Sabellius and Averroès. The last of these, a 12th cent. Arab philosopher, incurred the especial obloquy of the Dominicans. (He is depicted in hell in a fresco in the Camposanto, Pisa.)

Thomas Becket (1118–70). Archbishop of Canterbury and martyr. His appointment to the see brought about an estrangement of his former close friendship with Henry II. Ultimately the king's desire to be rid of his 'turbulent priest' led to his assassination by four knights as he knelt at prayer in a chapel of the cathedral. He is dressed in episcopal robes, and has a mitre and crozier; or he wears a black Benedictine habit under a red CHASUBLE (see diag. RELIGIOUS DRESS). Like PETER MARTYR he may have a sword embedded in his skull. In England effigies of Thomas were destroyed by Henry VIII, but they are widespread elsewhere in European art of the 12th to early 16th cents.

The martyrdom of St Thomas. The assassins, usually four knights in armour, are in the act of attacking Thomas. He kneels before an altar on which almost invariably a chalice stands. The hand of God may emerge from above to bless him.

Thomas of Villanueva (1488–1555). Spanish saint, remembered for his charity. Even as a child he followed the example of almsgiving set by his parents. At the age of seven he was said to have given away his clothes and food to poor children, and is thus depicted in Spanish painting. As a young man he entered the Augustinian Order, was ordained, and in later life became archbishop of Valencia. Throughout his life he was noted for putting money to charitable uses. As a devotional figure he is portrayed in episcopal robes, but holds a PURSE instead of a crozier. He is commonly represented in 17th cent. painting, nearly always in the act of giving alms, surrounded by the poor. He is seen thus, standing at the door of his cathedral, wearing the black robe of the Augustinians with a white mitre. See diag. RELIGIOUS DRESS.

Thread. The thread of life is spun by three women, the THREE FATES. A thread is held by THESEUS (2) entering the Labyrinth; it is paid out by Ariadne.

Three Fates. (Gk Moirai; Lat. Parcae). In Greek and Roman religion the spirits who were believed to determine man's destiny, not only the events of his life but its duration, which they fixed at his birth. Whether Jupiter, the omnipotent father of the gods, was bound by their decrees was a matter on which ancient opinion varied. Belief in their existence is said to have survived until today in parts of Greece where they are propitiated after the birth of a child. They are generally depicted spinning the thread of life, and measuring and cutting off the allotted length. They are usually old and ugly. Clotho has the distaff (or more rarely a spinning-wheel), Lachesis holds the spindle, while Atropos, the most terrible of the three, is about to snip the thread with her shears. But there is no firm agreement as to their functions. Sometimes Clotho spins the thread and Lachesis measures it with a rod. A basket of spindles may lie beside them. They often form part of larger allegorical compositions and are especially seen

with the figure of DEATH, a skeleton with a scythe, who may be riding on his chariot. See also MELEAGER.

Three Graces. The personification of grace and beauty and the attendants of several goddesses. In art they are often the handmaidens of Venus, sharing several of her attributes such as the ROSE, MYRTLE, APPLE and DICE. Their names according to Hesiod (*Theogony* 905) were Aglaia, Euphrosyne and Thalia. They are typically grouped so that the two outer figures face the spectator, the one in the middle facing away. This was their antique form, known and copied by the Renaissance. The group has been the subject of much allegorizing in different ages. Seneca (*c*. 4 B.C.—A.D. 65) (*De Beneficiis* 1. 3:2) described them as smiling maidens, nude or transparently clothed, who stood for the threefold aspect of generosity, the giving, receiving and returning of gifts, or benefits: 'ut una sit quae det beneficium, altera quae accipiat, tertia quae reddat.' The Florentine humanist philosophers of the 15th cent. saw them as three phases of love: *beauty*, arousing *desire*, leading to *fulfilment;* alternatively as the personification of Chastity, Beauty and Love, perhaps with the inscription 'Castitas, Pulchritudo, Amor.'

Three Maries at the sepulchre, see HOLY WOMEN AT THE SEPULCHRE.

Thunderbolt. The weapon of JUPITER was quite simply lightning, which was once imagined to be some form of missile. It is represented either as a double-ended, multiple-pronged and barbed fork or as a bunch of flames, perhaps zigzag in shape. Homer (*Odyssey* 24:633) refers to the god hurling a flaming bolt. He is depicted so doing in GODS AND GIANTS, BATTLE OF. As an attribute it is often held in the claws of his eagle. It is also the attribute of Fire personified, one of the FOUR ELEMENTS.

Thunderbolt

Thyrsus. A wand tipped with a pine-cone, the attribute of BACCHUS and of his attendants the SATYRS. The worship of the spirit of the pine tree was prevalent among the peoples of the ancient Near East and the pine-cone became a symbol of fertility. It is mentioned as an attribute of the wine-god by Philostratus the Elder (*Imagines* 1:18 and 23), a late antique writer (early 3rd cent. A.D.) whose descriptions of pictures were well known to the Renaissance.

Tiara. The distinctive head-dress of a POPE. Originally a plain, tall cap, it acquired during the Middle Ages three coronets, added one at a time, and assumed its final form in the early 14th cent. The coronets came to be regarded as symbols of the Trinity, or the three estates of the Church: Rome, Christendom and spiritual sovereignty. The tiara may be worn by God the Father, more often in early Netherlandish painting (see TRINITY); also by AARON, as a prefiguration of the Christian priesthood. See diag. RELIGIOUS DRESS.

Thyrsus

Tiger. Native of Asia and formerly of ancient Hyrcania, a district of Persia. According to the bestiaries it is the animal from which the River Tigris received its name. In art, tigers sometimes draw the chariot of BACCHUS (Horace, *Odes*, Bk 3. 3; 13–15).

Timoclea, see ALEXANDER THE GREAT (2).

Tithonus, see AURORA.

Tityus (*Aen.* 6:595–600; *Met.* 4:457–8). One of four legendary figures who are customarily linked in Greek mythology and in art (the others are IXION, SISYPHUS and TANTALUS), because they all underwent punishment in Tartarus

for various offences. Tityus was a giant who tried to rape the mother of Apollo and Diana and was killed by their arrows. He was stretched out, pegged to the ground, while two vultures eternally tore at his liver. Artists sometimes depict a single bird. PROMETHEUS (2) suffered a similar torture, only in his case the bird was an eagle. Except for this distinction the two themes are often hard to tell apart. In antiquity the liver, not the heart, was supposed to be the seat of the emotions; Renaissance humanists therefore made the theme an allegory of the enslavement of the body by sensual passion.

Toad. An attribute of Death, depicted in conjunction with a skull or skeleton. Toads eat the genitalia of a naked female personifying LUST. See also FROG.

Tobias (O.T. Apocrypha), the son of Tobit. Tobias' adventures with his companion and guardian, the Archangel Raphael, are told in the book of Tobit. The story opens in Nineveh during the Jewish exile in Assyria in the 8th cent. B.C. where Tobit, a devout Jew, lived with his wife Anna, and their son. He looked after his compatriots in need and saw to the proper burial of those who sometimes met their death at the king's hands. In his later years he lost his sight as the result of a curious accident: while he lay resting in the open, sparrows' droppings fell into his eyes setting up an inflammation that blinded him. Feeling that death was near Tobit instructed his son to make a journey to Media to collect certain money due to him. Tobias first of all looked for a travelling companion and met the archangel Raphael who agreed to accompany him. (Tobias took the angel for an ordinary mortal. The distinctive wings of the angel were a later Christian convention that derived from the classical Roman image of the winged Victory.) After receiving blind Tobit's blessing the pair set off, amid some lamentation from Anna, the mother. The young man's dog followed at their heels. Reaching the River Tigris Tobias went to bathe when suddenly a great fish leaped out of the water and would have devoured him. On Raphael's instructions he caught it and gutted it, setting aside the heart, liver and gall. The first two when burned, according to the angel, were good for driving off evil spirits and the gall would cure Tobit's leucoma. At their destination Tobias collected the money and then, at the angel's suggestion, they went to stay with a kinsman whose daughter, Sarah, would make an admirable bride for Tobias. But Sarah was unfortunately bewitched by a demon that had already caused the death of seven previous husbands before the marriages could be consummated. Nevertheless the wedding of Tobias and Sarah took place though not without misgivings. The demon was successfully exorcized with the aid of the burnt fish's offal and the couple then made a prayer of thanksgiving in their bedchamber. When they returned to Nineveh Tobias used the gall to restore his father's sight. The archangel, on being offered a reward by Tobit for all he had done, disclosed his identity, whereupon the father and son fell upon their faces before him.

Although the story as we have it probably dates from the 2nd cent. B.C. it includes elements of a remoter folklore, Assyrian and Persian. Among the folktales of Europe, too, are ones resembling it, such as 'The Travelling Companions' by Hans Andersen. Artists have illustrated most of the episodes, especially 'Tobias and the Angel', both dressed as wayfarers and accompanied by the dog. The dog, an animal regarded by the Jews as unclean, is an unusual feature and is seldom represented elsewhere in the Bible as man's friend. It was however a sacred animal to some of the Jews' near-eastern neighbours and Persian folklore may be the origin of its appearance here. The 'great fish' is thought to have been the crocodile whose liver and heart were used in ancient magic as a charm against demons. When carried by Tobias it is often no larger

than a trout. The healing of Tobit's blindness is usually shown as a kind of anointing though Rembrandt and other northern artists after him depict the performance of a surgical operation for cataract. This derives from the use of the word in the Dutch Bible for the 'whiteness' in Tobit's eyes. The concept of the 'guardian angel' was widespread in Renaissance Italy and the theme of Tobias was often used by a family to commemorate the travels of a son, in whose likeness Tobias would be depicted. The curing of Tobit's blindness was the subject of votive paintings donated by victims of the disease in the expectation that their sight would be restored.

Toilet of Venus, see VENUS (4).

'Tolle, lege,' see AUGUSTINE (2).

Tomb. The body of Christ laid in the tomb, ENTOMBMENT; likewise that of the Virgin Mary, DEATH OF THE VIRGIN. An angel sitting on an empty tomb, approached by three women, HOLY WOMEN AT THE SEPULCHRE. An empty tomb surrounded by the apostles, the Virgin above, ASSUMPTION; see also CORONATION OF THE VIRGIN, and THOMAS, apostle (1). Christ rising from the tomb, or floating above, holding a red-cross banner, RESURRECTION. Christ standing in a tomb, displaying wounds, MAN OF SORROWS. A figure, often swathed, emerging from tomb, Christ and others present, RAISING OF LAZARUS. Three open coffins containing corpses, encountered by three men, DEATH (2). A pastoral scene with shepherds studying a tomb, ET IN ARCADIA EGO.

Tomyris. Queen of a nomadic people of central Asia in ancient times. According to Herodotus (1:214), Cyrus the Great, the founder of the Persian empire, met his death in battle against her. Because of the circumstances, the episode came to be regarded as a symbolic act of justice, and paintings of it were commissioned to hang in courts of law. Moreover, medieval typology, revived in the 17th cent. by the Jesuits, made Tomyris a prefiguration of the Virgin triumphing over Satan. The army of Tomyris was led by her son who was tricked by Cyrus into partaking of a great feast. This tactic enabled the Persian king to slaughter large numbers of his enemy, and when the young man came to his senses he killed himself in shame. Tomyris swore to avenge her son's death with blood. In the ensuing battle Cyrus was killed. Not satisfied, the queen abused his corpse by cutting off the head and dipping it in human blood. She is seen holding Cyrus' head by the hair, about to dip it in an urn held by a female attendant. The head may still wear a crown. The decapitated body of Cyrus, in armour, sprawls on the ground. Tomyris may wear a turban, the conventional indication of an oriental, especially in baroque painting. Her courtiers, in art of the same period, sometimes wear Turkish dress. The theme resembles JUDITH and Holofernes where, however, the attendant holds a sack instead of an urn, and there are no courtiers. (Rubens, Louvre.)

Tongs, with hammer and anvil, the attribute of a bishop, ELOI, who tweaked the devil's nose with them, (the same story is told of the English St Dunstan); holding a glowing coal, ISAIAH. See also PINCERS.

Tooth, held in a pair of pincers, the attribute of APOLLONIA.

Torch. A symbol of life to the Greeks and the attribute of certain pagan gods and goddesses, but somewhat out of favour in Christian symbolism and art. A torch is the attribute of CERES, who holds it aloft when searching for her daughter (RAPE OF PROSERPINE). As the attribute of VENUS, CUPID and the PUTTO it signifies the fire of love. In the hand of Cupid, upturned and extinguished, it denotes that love is dormant or dead (see VENUS, 5), a motif also used on Renaissance funerary sculpture to mean death. AURORA, goddess of the dawn, goes before Helios'

chariot with a torch. In allegory it is the attribute of PEACE, who sets fire to a heap of weapons; of medieval TEMPERANCE who quenches it from a jug; occasionally of Sight, one of the FIVE SENSES. A woman holding a torch and dragging a youth before a judge is Calumny (C. OF APELLES). A woman on the seashore holding a torch is Hero (H. AND LEANDER). A god applying a torch to a male statue is PROMETHEUS (1) in the act of creating man; it may lie beside him when chained to the rock. A Dominican monk driving off a young woman with a flaming brand is THOMAS AQUINAS. A torch in a dog's mouth is the attribute of DOMINIC. The Libyan SIBYL may hold a torch or taper.

Tortoise, with a billowing sail on its back, was the *impresa* of Cosimo de' Medici (1389–1464). The accompanying motto was 'Festina lente,' – 'Make haste slowly,' that is, be slow but sure.

'Tota pulchra es, amica mea . . . ,' see VIRGIN MARY (4).

Totila, king of the Ostrogoths, see BENEDICT (10).

Tower. More than one legend tells of a daughter shut in a tower by her father to discourage her suitors. It is hence a symbol of chastity and the attribute of BARBARA, whose tower often had three windows. As an attribute of the Virgin of the ANNUNCIATION and of the Immaculate Conception (VIRGIN MARY, 4) the tower likewise symbolizes chastity. DANAË and CHASTITY personified are both depicted confined in a tower. The walled crown of CYBELE may resemble a tower.

Tower of Babel (Gen. 11:1–9). The people baked bricks and took mortar and said, 'Let us build ourselves a city and a tower, with its top in the heavens.' To humble their pride God confused the people's language so that they no longer understood one another, and scattered them over the face of the earth so that the building was not finished. Nimrod, the 'mighty hunter before the Lord', a legendary conqueror of Babylon in the 2nd millennium B.C., was traditionally said to have supervised the construction of the tower. It may be represented either with a roadway mounting spirally to the top, or with a succession of storeys, each narrower than the one below. Nimrod is sometimes seen directing the workmen who carry bricks and mortar. The idea of a variety of languages is conveyed by the portrayal of different racial types. The origin of the Tower of Babel was the 'ziggurat', a vast sacred edifice of brick, a feature of the larger Sumerian cities of Mesopotamia. A staircase led from the ground to a temple at the summit where a sacred marriage was enacted between the god and a priestess. (See also JACOB, 2: *Jacob's Ladder.*) The confusion of tongues, or babel, would reflect the impressions of the desert tribesmen in a city such as Babylon with its mixture of races and languages.

Towns and cities personified. The custom of representing a city by a female figure, usually armed with helmet, spear and shield was known in antiquity. Athens and Rome had such tutelary deities. Tyche, the goddess of fortune, who protected Byzantium and other cities, wore, like Cybele, a turreted, 'mural' crown. In the Middle Ages a similar female figure, armed and sometimes crowned, would be represented in a picture of a town, standing among the buildings. In such instances the figure was a simple personification of the town, not the portrayal of a protecting deity. From the 15th cent. 'Venice' is depicted crowned like a queen, enthroned and holding a SWORD. On each side of her is a LION, the emblem of St Mark, the city's patron saint. She may, as a maritime city, be accompanied by Neptune and other marine deities. Other cities had their personifications, though less clearly differentiated.

Trajan, Roman emperor, see GREGORY THE GREAT (2).

Transfiguration (Matt. 17:1–13; Mark 9:2–13; Luke 9:28–36). The occasion

when Christ manifested his divine nature to the disciples PETER, JAMES and JOHN. He took them up a mountain – traditionally Mt Tabor in Galilee – and in their presence became transfigured: his face shone like the sun and his clothes became dazzling white. MOSES and ELIJAH appeared on either side of him and conversed with him. A bright cloud overshadowed them and a voice from heaven said 'This is my son.' The apostles fell prostrate before the vision. Moses and Elijah, symbols of the Old Testament Law and Prophets, are portrayed in the manner of patriarchs, old and grey-bearded. Moses may hold a tablet of the Law or, in earlier Renaissance examples, have rays of light sprouting like horns from his head. Of the apostles Peter, with a short, curly, grey beard, is usually in the centre. John is the youngest of the three. The theme is represented in two ways. The earlier type, rarely found after the 16th cent., shows Christ standing on the 'mountain' – generally merely a low eminence or hillock – between Moses and Elijah, while the apostles half-recline at his feet, perhaps shielding their eyes from the brightness. The alternative type, more dramatic or 'devotional' in treatment, of which Raphael's picture in the Vatican is the most famous example, shows the Saviour floating in the air, as in an 'ascension.' The shining radiance – the 'bright cloud' – that surrounds him is reflected on the other five figures. The lower half of the picture may separately depict, by way of contrast, the episode which immediately followed Christ's descent from the mountain in which the disciples are engaged in argument with the Jewish scribes, and a father brings his epileptic son to Christ to be cured. The subject is found as early as the 6th cent. in the art of the eastern Church where, from that time, the Transfiguration was celebrated as a feast. In the West the feast was officially instituted in the 15th cent. and was especially fostered by the Carmelites whose traditional founder was Elijah.

Tree. The tree was worshipped among early peoples as a sacred object inhabited by a god. In the near east it was associated with the cult of the earth goddess whose rites were intended to promote the fertility of crops. Through its seasonal dying and renewal it became a female symbol of the earth's fecundity. The birth of Adonis from a tree, retold as a Greek myth, was originally celebrated as part of a primitive fertility rite (see ADONIS, BIRTH OF). (See also SNAKE in this connection.) In Christian art a bishop, his foot resting on an oak, the tree sacred to the Druids, is BONIFACE who devoted himself to converting the pagan. A hermit praying in a hollow tree is BAVO. A flowering tree is the attribute of a bishop, ZENOBIUS. See also JESSE, TREE OF; OAK.

Trial of Christ. The gospels are by no means unanimous in their account of the events that occurred between the arrest of Christ in the garden of Gethsemane and the moment that he was led away to be crucified. Taken together they can be made to form a continuous sequence in which he appears before no less than four judges in turn – in the case of Pilate, twice. All are represented in art, sometimes forming part of the cycle of scenes of the Passion.

1. *Christ brought before Annas* (John 18:12–23). Annas was the father-in-law of the high priest Caiaphas. Christ was brought before him bound, and was questioned about his teaching. He was afterwards sent on to Caiaphas. Christ stands before Annas with his hands tied. One of the guards with upraised arm is about to strike him. The scene is fairly rare and not easily distinguished from the next. According to John it was in the courtyard of the house of Annas that Peter thrice denied Christ, but the synoptic gospels place the episode at the house of Caiaphas. (See PETER, apostle, 4.)

2. *Christ before Caiaphas* (Matt. 26:57–68; Mark 14:53–65; Luke 22:66–71).

Christ's answer to Caiaphas that he was the awaited Messiah and the Son of God constituted blasphemy in Jewish law and was punishable by death, a sentence which under the Romans the Sanhedrin was not empowered to carry out. The scene before Caiaphas depicts the moment when 'the High Priest tore his robes and exclaimed, "Blasphemy!"' He is generally depicted baring his breast. A second high priest seated beside Caiaphas may be Annas whom Luke, in another context (3:2), refers to as jointly holding office with him. Christ stands with his hands tied, surrounded by armed soldiers. As in the previous scene one of them is about to strike him. Then followed the MOCKING OF CHRIST, treated in art as a separate theme.

3. *Christ before Herod.* Having been condemned by the Jewish court Christ was handed over to the civil authority for trial. Pontius Pilate, the governor of Judaea who was in Jerusalem for the Passover, examined him and finding no case to answer remitted him to Herod Antipas, the tetrarch of Galilee, who likewise happened to be in the city. (Luke 23:8–12). Herod questioned him eagerly 'hoping to see some miracle,' but Christ declined to reply. 'Then Herod and his troops treated him with contempt and ridicule, and sent him back to Pilate dressed in a gorgeous robe.' Herod wears a crown and is seated on a throne. Christ is before him. Behind stand a group of soldiers and bearded Jewish elders. A bystander brings the white garment that Christ is to wear.

4. *Christ before Pilate* (Matt. 27:11–26; Mark 15:2–15; Luke 23:13–25; John 18:28–40). Having questioned Christ further and found him innocent of any civil crime Pilate would have released him but for the clamour of the Jews that he be put to death. Pilate's wife sent her husband a message, 'Have nothing to do with that innocent man . . .' It was the custom at the Passover for the governor to release a prisoner chosen by the people, so Pilate asked them should he free Barabbas, a man imprisoned for rebellion and murder, or Christ. The mob, by now threatening violence, shouted for Barabbas, and for Christ to be crucified. Pilate, fearing a riot, gave way, but thereupon washed his hands in public to signify his refusal to be morally implicated in the decision. The theme is known in Christian art from the 4th cent. onwards. The scene is an open courtyard, or judgement hall, outside the governor's house. (According to John the Jews stayed outside to avoid defilement since the Passover was not yet eaten.) Pilate sits on a dais on the seat of judgement. In some early examples he wears a crown of bay leaves – the emblem of Roman authority. The motto, '*Senatus populusque Romanus*', may be seen on the entablature of a colonnade, or abbreviated, 'S.P.Q.R.', on the standard of a soldier guarding Christ. Christ himself stands before Pilate, bound by the wrists as in previous scenes. A group of Jewish elders are arguing their case vehemently. The messenger sent by Pilate's wife may be speaking into his ear or the woman herself may be present. Barabbas seldom features. When he does it is to be led from his cell or borne forward by the guards into the view of the people.

5. *Pilate washing his hands.* Pilate's symbolic gesture may form part of the previous scene but is more usually depicted as a separate episode. An attendant kneels before him holding a bowl, or pours water from a pitcher over his hands. In the background Christ is being led away. He was next scourged and crowned with thorns – see FLAGELLATION; CROWNING WITH THORNS; ECCE HOMO. The bowl, pitcher and towel are among the instruments of the Passion.

Triangle. A symbol of the Trinity. A triangular halo belongs to God the Father. As a percussion instrument the triangle is occasionally the attribute of Erato, one of the MUSES. See EYE.

Tribute Money. 1. ('Tribute to Caesar') (Matt. 22:15–22; Mark 12:13–17; Luke 20:20–26). When Christ was teaching in the Temple at Jerusalem the Pharisees asked him whether it was right to pay taxes to Rome, hoping thereby to trick him into an answer which either way would lay him open to accusation – by the Roman authorities or by those among the Jews who resented the tax. Pointing to the effigy of the emperor on a coin Christ silenced them with the reply, 'Render unto Caesar . . .' There may be no more than two figures, Christ and a Pharisee who holds the coin; or we may have a broader scene of the interior of the Temple with several figures surrounding Christ, their faces expressing cunning and malice. Christ's finger pointing upwards signifies, 'Render to God the things that are God's.' The sudden emergence of the theme in Christian art in the 16th cent. is attributed by some to its relevance to the state of war then existing between the Holy Roman Emperor Charles V and the Pope – which culminated in the sack of Rome in 1527.

2. (Matt. 17:24–27). At another time in Capernaum, Peter was asked by tax-collectors whether his master contributed to the tax levied on all Jews for the upkeep of the Temple. Jesus told Peter that if he cast his line into the lake he would find in the mouth of the first fish that he caught a silver coin sufficient to pay the tax for them both. Masaccio (Brancacci chapel, S.M. del Carmine, Florence) depicts Christ among the disciples and tax-collectors. Peter crouches at the water's edge drawing a coin from a fish's mouth.

Trident. A three-pronged fork, from antiquity the almost invariable attribute of NEPTUNE and the emblem of his authority. Its form may have been derived, like Jupiter's thunderbolt, from an attempt to represent lightning, since storms at sea were believed to be raised by the god. The trident is sometimes held by Amphitrite, the wife of Neptune.

Trinity. The doctrine that God is of one nature yet three persons, Father, Son and Holy Ghost, takes its authority from Matthew (28:19) and was expounded by Augustine in the *De Trinitate*. The absence of the theme from primitive and early medieval religious art is probably accounted for by the reluctance of the Church to represent naturalistically the first person of the Trinity who, being unseen, was unknowable. The Trinity might therefore be represented in the form of an ideogram, such as three interlocking circles. God the Father was depicted originally in symbolic form as an eye, or a hand emerging from a cloud, the latter perhaps holding a crown. The Holy Ghost was most often symbolized by a DOVE. The typical Trinity, first seen in French and northern Italian works of the 12th cent. and the most usual form in Renaissance and later art, portrays God the Father as an old man, perhaps long-bearded and patriarchal in appearance, sometimes with a triangular halo. He is placed behind and rather above Christ who is on the cross. He may hold each end of the *patibulum*, or crosspiece, in his hands; or he holds a book bearing the Greek letters A and Ω (or Ω) (alpha and omega). His feet may rest on a terrestrial GLOBE. The dove is just above Christ's head. Another, less common type that existed side by side with this represents the Trinity as three persons in human form. An alternative, derived from the teaching of the Creed that Christ sits on the right hand of God, shows the First and Second Persons, royally robed, seated side by side, God the Father with a sceptre, again perhaps with his feet on a globe, and Christ with a cross. The dove hovers between them. The idea of the Church's supremacy is sometimes conveyed by depicting both figures wearing the papal tiara. Another less common type found in 15th cent. Netherlandish painting depicts the Father, sometimes enthroned, supporting the limp body of Christ, somewhat in the

manner of a Pietà. See also ALL SAINTS PICTURE; CORONATION OF THE VIRGIN; VIRGIN MARY (17 *d*).

Triton. A merman – half man, half fish, perhaps with fins at the hips, – the son of Neptune and Amphitrite; also the name for mermen in general. Together with the NEREIDS, tritons are the escorts of Neptune and of Galatea, playing round them in the waves and blowing trumpets in the shape of a conch shell or horn. Tritons may alternatively be represented in normal human form.

Triumph. The official honour bestowed by the Roman senate on a victorious general, taking the form of a grand procession through the streets of Rome, in which the victor was borne on a bedecked triumphal car drawn by white horses. Renaissance Italy, with its love of public spectacle that had long been manifested in the traditional religious processions, revived the triumph, not only in honour of its princes and military leaders, but to glorify the gods and heroes of pagan antiquity, the famous poets of Greece and Rome, the Liberal Arts and so on. The idea of the triumph as an allegory was given literary expression by Dante in describing the pageant of Beatrice (*Purgatory*, 29), and later by Petrarch in his set of poems, the *Trionfi*. Illustrations of the latter began to appear in the 15th cent. and out of this grew the theme, widely popular in Renaissance and baroque painting, of the triumphal car bearing an allegorical or mythological figure surrounded by its appropriate attendants and attributes (see further under CHARIOT). In Petrarch's six poems each succeeding figure triumphs over the last: thus Love comes first, only to be overcome by Chastity, who in turn is followed by Death, Fame, Time and Eternity. Though a car is mentioned only in the first instance (a chariot of fire drawn by four snow-white horses and carrying a youth with bow and arrows, viz. CUPID), illustrators of Petrarch came to depict the rest in a similar manner. The series was commonly represented – not always complete – on Italian bridal chests (*cassoni*), and elsewhere as single subjects. They are rare outside Italy, but are sometimes found on 15th and 16th cent. French and Flemish tapestries.

Love: Of single subjects by far the commonest. Cupid stands on the car shooting his arrows; or he may be BLINDFOLD. Horses or goats draw the car. *Chastity:* Cupid kneels before her, blindfold, his wings tied, bow broken. There may be several women in the foreground, the Wise Virgins (see WISE AND FOOLISH VIRGINS), one of whom holds a banner bearing an ERMINE, symbol of purity. The car is drawn by UNICORNS. This was a popular subject for *cassone* panels, where Love and Chastity may be seen side by side as a moral example to the young bride. *Death* is represented by a skeleton with a scythe. The dead and dying are crushed under the wheels of his chariot which is drawn by oxen, usually black. *Fame* is usually winged, trumpets are blowing, elephants (or, more rarely, horses) draw the car, which may also bear kings or statesmen, or classical poets and historians, whom Fame has honoured. *Time* is portrayed as an old man with the usual attributes: wings, hour-glass and scythe. He may lean on crutches. His car is drawn by stags, which, like time, are fleet-footed. *Eternity:* often a religious allegory depicting the triumph of the Christian faith. The TRINITY or the figure of Christ is carried on the car which may be drawn by the Apocalyptic Beasts (see FOUR EVANGELISTS), or by angels. For the 'Triumph of the Eucharist,' see SEVEN SACRAMENTS.

Of the triumphs of pagan gods (not uncommon in classical art and frequently depicted in the Renaissance) are those of BACCHUS (generally accompanied by Ariadne), VENUS, JUPITER and APOLLO; GALATEA and NEPTUNE (marine Triumphs). The heroes of the ancient world whom the Renaissance honoured, especially

DAVID, SCIPIO and CAESAR, had their triumphs celebrated often though they are rare in the painting of northern Europe.

Trojan war. The war between Greeks and Trojans, legend probably rooted in history, in which Troy was besieged for nearly ten years, and finally sacked. The sources are Homer's *Iliad* and Virgil's *Aeneid*. The story was retold by writers of late antiquity and in the medieval romances of the 13th–14th cents. The theme of the *Iliad* is the Wrath of Achilles, and how he assuaged it by slaying Hector, the Trojan commander. The gods of Olympus themselves take sides and control the destinies of the warriors. It was common on Greek vase painting, comparatively rare in Renaissance and baroque art, and became popular again in the Neo-classical period, the later 18th cent. The *Aeneid* tells how the Greeks captured Troy with the wooden horse, and how Aeneas the Trojan prince escaped from the city.

1. *Achilles' quarrel with Agamemnon* (*Iliad* 1:121 ff). Agamemnon, leader of the Greek armies, had won a priest's daughter as a prize of war. On the advice of the seer Calchas he gave her up but, to compensate for her loss, arrogantly laid claim to a slave-girl, Briseis, who was the property of Achilles. The scene takes place before Achilles' tent. Just visible in the background are the masts and bows of the beached Greek ships. Agamemnon in splendid armour faces Achilles and points imperiously. Achilles angrily draws his sword. The goddess Athene (Minerva) who was on the side of the Greeks, intervenes just in time. Appearing in a cloud, she puts out a restraining hand or, as in Homer, grasps Achilles by the hair. Among other figures may be seen Calchas, an old white-bearded man dressed in flowing robes; and Nestor, wearing armour, the oldest of the Greek chieftains, who unsuccessfully attempted conciliation.

2. *Departure of Briseis* (*Iliad* 1:345 ff). Achilles yielded Briseis but sulkily refused to take any further part in the fighting. He is shown seated before his tent, a hand raised in farewell, or he is sunk in thought or in grief. Patroclus, his squire and close friend, leads Briseis towards Agamemnon or towards two heralds who have come to escort her away. Briseis looks back yearningly at Achilles. This theme and the quarrel are sometimes combined.

3. *Hector's farewell to Andromache* (*Iliad* 6:394–496). Hector the son of Priam, king of Troy, was commander of the Trojan armies and, moreover, a devoted husband and father. On the eve of battle he said farewell at the gates of Troy to his wife Andromache and infant son Astyanax. A moment of pathos, popular with artists, occurred when Hector held out his arms to embrace his son, but the child, frightened by the sight of Hector's plumed helmet, shrank back into its nurse's bosom. Other versions show Hector stepping from his chariot (not mentioned in Homer) or, having placed his helmet on the ground, holding Astyanax in his arms.

4. *Achilles dragging the body of Hector round the walls of Troy* (*Iliad* 22: 395–515). Achilles was spurred into battle by the death of his friend Patroclus, killed by Hector. Wearing new armour specially forged by Hephaestus (VULCAN), he slew Hector in single combat. To avenge himself, he tied the body by the heels to his chariot and dragged it off to the Greek lines, watched from the battlements by Andromache. The scene is before the city walls. A triumphant Achilles whips up his horses. Hector's naked body is stretched behind the chariot. Andromache, on the walls, swoons into the arms of her family. Or the corpse lies at the foot of Patroclus' funeral pyre.

5. *Priam and Achilles* (*Iliad* 24:469 ff). Priam, led unseen through the Greek lines by Hermes (MERCURY), came to Achilles to beg for the body of his son.

Achilles, his anger spent at last, granted the request. The scene is the interior of Achilles' tent. The king, old and white-bearded, kneels in supplication before the seated warrior, perhaps kissing his hand. Through the tent door the body of Hector may be seen still tied to the chariot.

6. *Andromache laments* (*Iliad* 24:718). The body of Hector is depicted lying on a couch in Priam's palace. In her grief Andromache throws herself upon it. Or she is seated beside it while Astyanax, here a young boy, kneels at her lap. Hector's armour is laid beside the couch. Other mourners may be present.

7. *The wooden horse* (*Aen.* 2:237 ff). The most familiar episode of the war, yet not often treated by artists, perhaps because the drama lacks a main character. The Trojans may be depicted pushing a great horse on wheels into the city. More usually it stands inside the walls with Greek soldiers pouring from a hole in its side. Armed Trojans try to repel them. Buildings blaze in the background.

8. *Aeneas carries his father from burning Troy.* (*Aen.* 2:671–729). Aeneas was a Trojan prince of a younger royal line. After striving bravely against the invading Greeks he escaped at night from the burning city carrying his father Anchises on his back, and leading his son Ascanius; his wife Creusa was lost in the darkness. As the epitome of filial piety, of the devoted son who cared for his father and family above all else, this came to be by far the most widely represented of the Trojan themes in painting and sculpture. The old man, borne on Aeneas' back or over his shoulder, clutches in his hands the family's precious devotional images, or 'household gods' (cf JACOB, 3). Ascanius runs by their side and Creusa sometimes follows. Virgil describes how a flame was seen to flicker about the head of Ascanius and how this was followed by a shooting star, signs from Jupiter that the boy was destined for greatness. The flame features in some pictures; the two men gaze up to the sky in wonder.

See also ACHILLES (4); HELEN; LAOCOÖN; MARS (2); POLYXENA.

Trousers, see BATTLE FOR THE TROUSERS.

True Cross, History of the. A medieval legend, existing in more than one version, that traces the history of Christ's cross from the Garden of Eden down to the time of the Emperor Heraclius in the 7th cent.

1. *The branch of the Tree of Knowledge.* Adam, when expelled from paradise, took with him a branch of the Tree of Knowledge. It passed from hand to hand, and in due course became the pole on which Moses raised the brazen serpent – an established prefigurative 'type' of the crucifixion (See MOSES, 12).

2. *The Queen of Sheba worships the wood.* The wood found its way to Jerusalem where it served as a bridge over a stream. The Queen of Sheba, at the time of her visit to SOLOMON (2) knelt down and worshipped it, its future having been foretold to her in a vision. Then with bare feet she walked through the stream rather than tread on the wood.

3. *The pool of Bethesda.* The wood was later found floating in the pool of Bethesda, whose waters had miraculous curative powers and were given to the sick to drink. It was taken from here to make the cross of Christ. The story thus provides up to this point a continuous chain of events between the Fall and the Redemption.

4. *The finding* (or *invention*) *of the True Cross.* Christianity became officially tolerated in the Roman empire by an edict of Constantine the Great in 313, and his mother HELENA thereafter devoted herself to its propagation by good works. She founded churches in the Holy Land and, according to legend, there discovered the cross of Christ. A certain Judas who knew its whereabouts but refused to tell was peremptorily put into a dry well by Helena, until hunger

persuaded him to change his mind. The three crosses of Golgotha, indistinguishable from one another, were dug up. A human corpse, placed in contact with each in turn, was miraculously restored to life on touching the True Cross. The three nails were also discovered by Helena.

5. *The raising of the True Cross* (*Golden Legend:* 'Exaltation of the Holy Cross'). In the 7th cent. one part of the cross was recovered by the Emperor Heraclius in the course of a victorious campaign against Chosroes (Khusraw) II of Persia whose armies had earlier overrun the Near East and carried off the cross. (The other part of the cross was in Constantinople.) Legend tells that the triumphal entry of Heraclius into Jerusalem with the sacred relic was halted by an angel who bade him humble himself. The emperor stripped off his royal robes and carried the cross into the city on foot or, in another version, riding an ass. He is sometimes depicted on horseback. The cross was erected on an altar, or on the hill of Golgotha. The execution of Chosroes by Heraclius for refusing baptism is also depicted.

The legend, in the form of narrative cycles, occurs in early Renaissance frescoes especially in Italy, in Franciscan churches dedicated to the Holy Cross (Ital. Santa Croce). The recovery of the cross by Heraclius is celebrated in the Catholic Church by the feast of the 'Exaltation of the Cross.' The theme of Heraclius' defeat of Chosroes forms a parallel to the victory of Constantine over Maxentius.

Trumpet. The straight trumpet, the Roman *tuba*, is the attribute of FAME. She sometimes has two, a long and a short. It is occasionally the attribute of the MUSES Calliope, Euterpe and, from the 17th cent., Clio. Trumpets are blown by angels to announce the LAST JUDGEMENT (4), and at the day of wrath (APOCALYPSE, 10). Seven priests blow trumpets, perhaps made of ram's horns, outside the walls of Jericho (JOSHUA). In concerts of angels from the 15th cent. may be seen the contemporary trumpet with a double bend, the forerunner of the modern instrument.

Truth. The allegorical figure of Truth is found in medieval psalters together with three other virtues, illustrating the Psalm (85:10), 'Mercy and truth are met together, righteousness (justice) and peace have kissed each other.' Though the idea of Truth's nakedness found expression in classical literature – it was her nature to be simple and unadorned – in the Christian era it was not until the 14th cent. that she was portrayed thus, by the side of Mercy who was robed. She took on a new role in the 15th cent. in the CALUMNY OF APELLES, and thereafter is found chiefly in secular art, becoming a widely popular figure in Renaissance and baroque allegory. The idea that Truth lies hidden was linked with that of Time as the instrument of her unveiling (i.e. truth will out in the long run). This was supported by the ancient saying, familiar to the Renaissance, 'Veritas filia temporis' – 'Truth is the daughter of Time'. Hence the theme of 'Time revealing Truth', common in the 16th and 17th cents., showing FATHER TIME in the act of drawing a veil aside from the naked figure of Truth, perhaps with baleful Envy and Discord lurking in the corner. Truth's ordinary attributes are the SUN, in the form of a radiant disk, held in her hand (its light reveals the truth: see VENUS, 8); a MIRROR (which does not lie); more rarely a PEACH with one leaf (symbols of the heart and tongue which, when united, speak the truth). A LAUREL crown is a reminder that victory, in the long run, is always hers. Her foot resting on a GLOBE signifies that she is above the common things of the world.

Tub. Three children in a tub before a bishop, NICHOLAS OF MYRA.

Tubal-Cain, personification of Music, one of the SEVEN LIBERAL ARTS.

Tuccia (Pliny, *Nat. Hist.* 28:12). In Roman legend a VESTAL VIRGIN who was accused of adultery but proved her innocence by filling a sieve with water which she miraculously carried without it leaking. As an allegorical figure Tuccia, holding her sieve, stands for Chastity. The Middle Ages, after Augustine (*City of God* 10:16), regarded her as a prefiguration of the Virgin Mary. Like MINERVA, HEBE and others in myth and legend, she was used as a vehicle for female portraiture, with the implication that the sitter shared her moral qualities.

Tullia (*Fasti* 6:585–610; Livy 1:48). The daughter of Servius Tullius, one of the legendary kings of early Rome (6th cent. B.C.). She was party to a conspiracy to overthrow her father and place her husband Tarquin the Proud on the throne. Servius was assassinated in the street after being forcibly ejected from the senate house. Tullia, on her way to greet her husband, drove her chariot over her father's dead body. The street was known as Vicùs Sceleratus – the accursed street – in memory of Tullia's impious crime. The scene is a street with a flying chariot, whose horses rear at a corpse lying in the roadway. Tullia signals to her chariot-driver not to halt. (Jean Bardin, Mainz Gall.).

Tunic, bloodstained, presented to a patriarch by his sons, JOSEPH, son of Jacob (1). The soldiers casting lots for Christ's tunic, CRUCIFIXION (4).

Turban. Ancient head-dress of eastern peoples, especially Mohammedan, consisting of a sash wound round the head, or round an under-cap. It was introduced into the West by the returning crusaders in the 11th cent. and was sometimes adopted, with elegant variation, as fashionable headgear by the Renaissance courtier. It is often used by artists to characterize Old Testament figures, the Saracen, the SIBYLS or to denote eastern origin or surroundings. See AARON; ADORATION OF THE MAGI; BARBARA; CROESUS AND SOLON; GEORGE; TOMYRIS; VERONICA.

'Turris David,' see VIRGIN MARY (4).

Twelve Months (Labours of the Months). The cycle of the months is represented from the early Christian era. It is found in Romanesque and Gothic churches of northern Europe, in miniatures, in medieval PSALTERS and BOOKS OF HOURS, and in Renaissance Italy. It is a popular theme in Brussels' and French tapestries of the 16th and 17th cents. The subjects generally depicted are man's labours in the fields, each appropriate to the time of year. (Harvesting, which normally belongs to August, may be earlier in examples from southern Europe.) Each month is usually accompanied by a corresponding sign of the zodiac, often by a pagan divinity, and occasionally by one of the twelve ages of man. It was the date of the sun's entry into the zodiacal sign which determined its month. No brief list can embrace all the variations of subject matter.

Jan. (Aquarius, Water-bearer). Husbandman felling trees, or feasting at a well-provided table. Couples dancing. Janus, the two-faced god of the new year (or of the past and future), closes a door on an old man, and opens another on a youth. *Feb.* (Pisces, Fishes). Grafting of fruit trees. Another indoor scene round the fireside. Venus and Cupid sailing in a strong wind, their draperies blown about. *March* (Aries, Ram). Peasant pruning vines or digging. Mars, the god of war, holding sword, waves a torch, accompanied by shepherd playing a lyre, and by a ram. *April* (Taurus, Bull). The training of Vines. Youth crowned with flowers. A bull garlanded with flowers (Jupiter in disguise) abducting a maiden (see RAPE OF EUROPA). *May* (Gemini, Twins). Nobleman on horseback or on foot, falcon on wrist, goes to his sport. Peasant rests in the shade or scythes the grass. The twins (Castor and Pollux) draw Venus' chariot, her veil borne by the Zephyrs. She is accompanied by Cupid. *June* (Cancer, Crab). Haymaker carrying scythe

or at work, or carrying hay. Phaethon falling out of the sky. *July* (Leo, Lion). Peasant sharpening sickle, cutting corn or carrying sheaves or threshing. Hercules, wearing lion-skin, leaning on his club, perhaps holding an apple of the Hesperides. *Aug.* (Virgo, Virgin). Harvesting, as in July, threshing with a flail or ploughing with oxen. Ceres, crowned with ears of corn, holding sheaf and sickle, riding on her serpent-drawn chariot. Triptolemus, the inventor of the plough, sits beside her holding the torch that lights her search for Proserpine. *Sept.* (Libra, Balance). Gathering or treading grapes. Wine casks. Threshing. Ceres, crowned with fruit, holding a cornucopia full of grapes and a pair of scales. *Oct.* (Scorpio, Scorpion). Casking the wine, or broadcasting seed held in apron. Bacchanalia with Satyrs and drunken Silenus crowned with vine leaves, holding a bunch of grapes. Maenad playing tambourine (see BACCHUS). *Nov.* (Sagittarius, Archer: a centaur with a bow). Peasants gathering wood, picking olives, sowing seed, tending pigs to fatten for Christmas. A Centaur (Nessus) abducting a woman (Deianeira) (see HERCULES, 23). *Dec.* (Capricorn, Goat: with a spiral tail for hindquarters). Digging in the fields. Killing pigs, baking, in preparation for Christmas. Or, as in January, feasting at table. A nymph (Ariadne) milking a goat (Amalthea), an infant (Jupiter) holding a milk bowl (see JUPITER, 1).

'Ubi est thesaurus tuus . . . ,' see ANTONY OF PADUA.

Ugolino della Gherardesca (died 1289). The leader of a Guelph party in Pisa and a political double-dealer. He was the victim of a conspiracy formed by the Archbishop of Pisa, Ruggieri degli Ubaldini, who imprisoned him in a tower with four of his sons and grandsons. In due course they were all starved to death. Their prison became known as the Tower of Hunger. The story was immortalized by Dante in the *Inferno* (32:124–33:78) and became a popular theme with artists of the 19th cent. Romantic school. Count Ugolino is seen in a prison cell surrounded by his dead and dying children. Or Ruggieri enters and discovers the corpses.

Ulysses (Gk Odysseus). A Greek hero, son of a king of Ithaca, the husband of PENELOPE and father of TELEMACHUS; he was renowned for his courage and his cunning. He joined the expedition against Troy after some initial reluctance (see *The madness of Ulysses* below), and played a part in persuading Achilles to do the same (see ACHILLES, 3). The principal story of his adventures and the source of most of the themes about him in art is the *Odyssey*, in which Homer tells of his journey home, beset by adversity, to the island of Ithaca after the fall of Troy. He suffered the enmity of Poseidon (Neptune) after blinding his son, the one-eyed giant Polyphemus; his travels were therefore liable to be interrupted by storm and shipwreck caused by the vindictive sea-god. The cycle of themes is found chiefly in Italian Renaissance painting. (Allori, Pal. Salviati, Florence.)

 1. *The madness of Ulysses* (Hyginus 95). Ulysses feigned madness to avoid having to set out for Troy. He dressed as a peasant, ploughed with an ox and an ass yoked together, and at the same time 'sowed' salt. Palamedes, another Greek warrior, soon put a stop to this nonsense: he is seen placing Ulysses' infant son Telemachus in the path of the advancing team.

 2. *Ulysses and the Sirens* (*Odyssey* 12:154 ff). On their way home Ulysses and his companions encountered the Sirens, bird-like creatures with the heads of women, who drew sailors to their death with their irresistible, magic songs. Ulysses is seen bound to the ship's mast gazing longingly towards a promontory where the Sirens sing; his men, their ears plugged with wax, ply the oars. On the beach are the bones of the Sirens' victims.

 3. *The cattle of Helios* (*Odyssey* 12:371 ff). Ulysses landed on a strange shore

where a herd of cattle belonging to the sun-god Helios were browsing. Confined there for many days by a storm his starving men eventually killed and ate the cattle. When they were once more on their way Zeus (Jupiter), the father of the gods, punished their wrongdoing by sending a hurricane and striking the ship with a thunderbolt. The men were lost but Ulysses reached safety clinging to a spar. There are two scenes: the men rounding up the cattle while others are leaping ashore from a boat; Zeus in the heavens throwing a bolt down upon the storm-tossed boat.

4. *Ulysses and the daughter of Cadmus (Odyssey* 5:408 ff). Shipwrecked by Poseidon, Ulysses clung to the remains of his battered raft. The sea-goddess Ino, the daughter of Cadmus, came to his rescue, giving him her scarf which had magic powers of protection. He is seen on his raft taking the scarf from the goddess. Poseidon rides over the waves on his chariot.

5. *Nausicaa; the court of Alcinous (Odyssey* Bk 6). Ulysses landed on the shores of the kingdom of Alcinous by a river where the king's daughter Nausicaa came with her maidens to wash clothes. Ulysses, naked but for a loincloth, creeps out of the bushes and approaches the princess. Her attendants, having finished their work, are making a picnic on the grass. They are startled at the sight. Others may be loading washing on to a cart. A later scene shows Ulysses in the palace presenting himself to King Alcinous.
See also CIRCE.

Unicorn. This strangely ambiguous symbol of female chastity is discussed in its religious and profane aspects under VIRGIN MARY (5). A series of scenes of a virgin and unicorn has been interpreted as an allegory of the FIVE SENSES. A unicorn is the attribute of JUSTINA OF PADUA, borrowed from her legendary namesake JUSTINA OF ANTIOCH. A unicorn resting in the lap of a virgin was the *impresa* of the Farnese family whose members held high ecclesiastical office and were patrons of art in Italy, especially in the 16th and 17th cents. (Farnese Palace, Rome.) A palm-tree, sometimes with a unicorn, was an *impresa* of the house of Este, patrons of the arts in Renaissance Italy. See also WILD MAN.

Unmerciful servant (Matt. 18:23–35). The parable of a king who was owed a very large sum by one of his servants but who cancelled the debt out of pity for the man's plight. The servant was himself owed a trifling amount by a fellow-servant whom however he dunned without mercy, finally having him thrown into prison for non-payment. On learning this the king revoked his act of clemency and had the unmerciful servant tortured until he paid up the original debt. This stern lesson in forgiveness is depicted in various ways. The king may be seen seated at a table, his clerk beside him with an open account book, while the servant stands pleading; or the servant is shown threatening his fellow, grasping him by the throat; or the servant once more stands before his master with his fellow-servants on either side accusing him.

Urania, see MUSES.
Uranus, Castration of, see SATURN (1).
Urn. A large vase with a rounded body and a short, fairly wide neck. Lying on its side, perhaps with water issuing from its mouth, it is typically the attribute, both in antiquity and in Renaissance and later art, of the god who was believed to inhabit a river. He is bearded, often crowned with reeds, and reclines on the urn, sometimes holding an oar. The image is widely used as the conventional indication of a river in themes with a riparian setting, for example: Tiber, HORATIUS COCLES; ROMULUS; HERCULES (15). Nile, MOSES (1). Pactolus, MIDAS. Peneus, APOLLO (9). Orontes, RINALDO AND ARMIDA (1). Jordan, BAPTISM. Lethe,

SLEEP, KINGDOM OF. Eridanus, PHAETHON (3). Ladon, PAN (1). Oeneus, JUDGEMENT OF PARIS. The same image of the river-god personifies Water, one of the FOUR ELEMENTS, and is also found in many pictures with marine themes. An urn is the attribute of the river-god Alpheus who pursued the nymph Arethusa (ALPHEUS AND ARETHUSA), and occasionally of PANDORA.

A funerary urn held by a woman on or alighting from a boat, AGRIPPINA AT BRUNDISIUM. It is also the attribute of the widow ARTEMISIA, perhaps inscribed 'Mausolus.' Severed head placed in an urn by, or before, two women, TOMYRIS.

Ursula (Ital. Orsola). Legendary saint who, with eleven thousand maiden companions, died in a massacre at Cologne on returning from a pilgrimage to Rome at some unknown date early in the Christian era. The historical evidence for her existence, let alone her companions', is negligble, yet such was the force of the legend that a 19th cent. iconographer condemned its critics as 'pitiably hard of belief.' The story appeared in several versions during the Middle Ages, including the *Golden Legend*, and narrative scenes, often in series, occur frequently in late medieval and Renaissance art, especially in Germany and Italy. In devotional images Ursula is portrayed as a young maiden holding an ARROW (by which she died), or a pilgrim's STAFF surmounted by the Christian banner of victory – a red cross on a white ground. Ursula was the daughter of a king of Brittany and so may wear a CROWN, and a cloak lined with ERMINE – white with black-tipped tails; the latter featured in the coat of arms of the medieval Duchy of Brittany. Ermine is also, appropriately here, a symbol of purity. Ursula sometimes stands, like the Madonna of Mercy (see VIRGIN MARY, 3), with her cloak extended on either side sheltering a number of young girls under it. (Today the Ursulines are a female religious Order devoted to the education of girls.) She may hold a SHIP in allusion to her journey.

Narrative scenes. Many episodes from the long narrative have been illustrated, not always consistently since they are drawn from different versions of the legend. The father of Ursula, a Christian king of Brittany, received ambassadors from a pagan king of England to ask for his daughter's hand in marriage to his son Conon. Ursula consented on the conditions – which she fully expected to be refused – that her future betrothed be baptized a Christian and accompany her on a pilgrimage to Rome, and that she be provided on her journey with ten virgin companions, she and they each to have one thousand attendants, likewise virgins. (Scenes show the ambassadors kneeling before the king. Later Ursula consoles her unhappy father, counting off her conditions on her fingers. The ambassadors present her answer to the English king and his son. The couple take leave of Ursula's father. Coats of arms help to identify the scene, the ermine at the Breton court, the three lions passant at the English.) They travelled by boat up the Rhine, halting at Cologne and Basle. (There are many scenes of the pilgrims embarking or going ashore. The boats, thronged with maidens, are in harbour. There is a city in the background; a Gothic cathedral indicates that it is Cologne; at Basle they are seen taking a road towards the mountains. A pope and cardinals on board tell us that it is the return journey. At Cologne Ursula lies in bed and dreams of the crown of martyrdom brought to her by an angel.) At Rome they were received by Pope Ciriacus who baptized Conon in the name of Etherius, and resolved to accompany them on their way home. (Ursula and the prince kneel before the pope at the gates of Rome or at a church door. Within, Etherius stands in the font receiving baptism; Ursula receives the sacrament.) Back at Cologne they found the city besieged by the Huns who killed first Etherius and then the virgins, after trying unsuccessfully to ravish them.

Ursula, having refused the barbarian leader's offer to become his bride, died by an arrow. (The massacre occurs either in the boats or on shore. Soldiers are seen attacking the maidens with swords, bows and spears. Etherius falls into the arms of Ursula as a soldier plunges a sword into his breast. At Ursula's martyrdom she stands outside the tent of the leader of the Huns, dismissing him with a gesture. A soldier stands with drawn bow. The cathedral of Cologne rises in the background.)

'Vae, vae, vae,' uttered by eagle, see APOCALYPSE (11).

'Vae victis,' see BRENNUS.

Vanitas, see STILL LIFE.

Vanity. In secular allegory one of the minor vices, generally represented in the Renaissance as a naked woman, seated or reclining on a couch, and attending to her hair with comb and MIRROR, the latter perhaps held by a PUTTO. The theme merges with the non-allegorical one of the recumbent Venus. The idea of vanity is conveyed by JEWELS, gold COINS, a PURSE, or more plainly by the figure of DEATH himself. An inscription on a scroll reads 'Omnia Vanitas' – 'All is vanity.' See also STILL LIFE for another aspect of Vanity.

Vase. The term is here used for a vessel generally without a handle, as distinct from the PITCHER or jug, and often having a narrow neck; otherwise perhaps with a lid. Unlike the pitcher it is not exclusively a receptacle for liquids. (See also JAR; PHIAL; POT; URN.) It is, among other vessels, the attribute of PANDORA, and of PSYCHE. A vase or jar of ointment, generally with a lid, is the attribute of MARY MAGDALENE and of IRENE. A similar receptacle may be seen in the hands of each of the *myrrhophores*, the HOLY WOMEN AT THE SEPULCHRE. A vase is the attribute of Smell personified, one of the FIVE SENSES and, a larger one, of NEMESIS. A vase from which a flame issues is the attribute of CHARITY and of Sacred Love (VENUS, 1). Vases are among the receptacles in which the Israelites gather manna (MOSES, 8). A lily, or other flower, stands in a vase in the scene of the ANNUNCIATION.

Veil, a covering for the head or face; the outer head-dress of a nun. The attribute of medieval CHASTITY personified. The veil of AGATHA was a miraculous protection against volcanic lava. VERONICA wiped the sweat from the brow of Christ with her veil. A veil was removed from the head of Alcestis when she returned from the underworld (HERCULES, 20). REBECCA covered her face with a veil on meeting Isaac.

Velasco, see BLAISE.

'Veni, electa mea . . . ,' see CORONATION OF THE VIRGIN.

Ventris ingluvies, see GLUTTONY.

Venus. Roman goddess identified with the Greek Aphrodite, the goddess of love and fertility, from whom Venus' familiar characteristics are derived; she is mother of CUPID; the THREE GRACES are her attendants. Among her many attributes are: a pair of DOVES or SWANS (either may draw her chariot), the scallop SHELL, DOLPHINS (both recall her birth from the sea), her magic GIRDLE, a flaming TORCH (both kindle love), a flaming HEART. The red ROSE (stained with her blood) and the MYRTLE (evergreen like love) are sacred to her. Venus is often simply a synonym for the female nude in art, without mythological or symbolic significance except for a few conventional attributes such as a mirror (as in the 'Toilet of Venus'), or a dove. Such paintings are sometimes in the likeness of the wife or mistress

Venus Pudica

of the artist or his patron. The nude Venus may assume a number of formalized poses, standing or reclining. Some standing figures originated in the religious statuary of antiquity, for example the *Venus Pudica* – Venus of Modesty – who stands somewhat as in Botticelli's 'Birth of Venus' with one arm slightly flexed, the hand covering the pubic area, while the other is bent so that it lightly covers the breasts (see also PYGMALION). The typical pose of the 'recumbent Venus' originated with Giorgione, and soon became established as a model for later artists.

1. *Sacred and Profane Love*. The idea of twin Venuses who represent two kinds of love was expressed by the Florentine humanists of the 15th cent. It was formulated by Plato in the dialogue on the nature of love in the *Symposium* (180 ff). The Celestial Venus symbolized love that was aroused by contemplation of the eternal and divine, the Earthly or Common Venus represented the beauty found in the material world, and the procreative principle. To the humanists both were virtuous, *Venus Vulgaris* being regarded as a stage on the way upward to *Venus Coelestis*. In art the two can be distinguished by their mode of dress. Earthly Venus is richly clad and may wear jewels, symbols of earthly vanities; heavenly Venus is naked and sometimes holds a VASE which burns with the sacred flame of divine love. To the Renaissance nakedness signified purity and innocence. Two adjacent female figures in medieval art, one naked, the other clad, stand for contrasting ideas such as the Old Eve and the New (the New is the Virgin Mary), or Truth and Mercy (see TRUTH). (See also NUDITY.)

2. *'Sine Baccho et Cerere friget Venus'* – *Venus, Bacchus and Ceres*. The saying, a quotation from the Roman comic dramatist Terence (*The Eunuch*, 732) implies that love grows cold without the stimulus of wine and feasting. The theme was popular in the 17th cent. especially with Flemish artists, following Ruben's treatment of it. A reclining Venus is approached by Ceres offering a cornucopia of fruit and vegetables and by Bacchus with grapes and a cup of wine.

3. *Triumph of Venus*. Venus is enthroned on her triumphal chariot drawn by doves, usually two or four, or by swans. She may be accompanied by Cupid flying nearby. When drawn by swans the chariot may be afloat. The theme occurs in 15th and early 16th cent. Italian painting, a period when civic processions, which often celebrated the triumph of pagan divinities, were popular in Italian cities (see TRIUMPH).

4. *Toilet of Venus*. The name for the typical reclining nude, or 'recumbent Venus', which came to the fore in Venetian painting of the late 15th and early 16th cent. She reclines on a couch while Cupid holds a mirror to her and perhaps the Three Graces adorn her.

Themes from Mythology

5. *Venus and Adonis*. The story, which has attracted not only artists but poets, including Shakespeare, tells that Adonis was the offspring of the incestuous union of King Cinyras of Paphos, in Cyprus, with his daughter Myrrha (see ADONIS, BIRTH OF). His beauty was a byword. Venus conceived a helpless passion for him as a result of a chance graze she received from Cupid's arrow (*Met.* 10:524–559). One day while out hunting Adonis was slain by a wild boar, an accident Venus had always dreaded (*Met.* 10:708–739). Hearing his dying groans as she flew overhead in her chariot, she came down to aid him but was too late. In the place where the earth was stained with Adonis' blood, anemones sprouted (see FLORA). Artists depict two scenes: (*a*) Adonis, spear in hand and with hunting dogs straining at the leash, is impatient to be off, while Venus imploringly tries

to hold him back. But she pleads in vain for, in the background, Cupid dozes under a tree perhaps holding an extinct torch, denoting the absence of Adonis' love. (*b*) In the forest a grieving Venus bends over the dead body of her lover, tending him, or pouring from an urn the nectar that causes his blood to fertilize the earth. Cupid assists her. A hunting horn lies on the ground, and Venus' chariot may stand nearby. The myth of the death of Adonis formed part of the annual fertility rites common to early civilizations of the Near East. In some cults the sprinkling of sacrificial blood was believed to fertilize the ground. The classical image of the mother goddess with her dying son in her arms may have been the original model of the PIETÀ.

6. *Venus and the Rose.* The rose, sacred to Venus, was originally a white flower but, according to one tradition, while Venus was hastening to help the dying Adonis a thorn pierced her foot and the drops of blood fell on the white petals, staining them red. Venus is usually shown seated, trying to remove the thorn, while Cupid helps her.

7. *The Birth of Venus.* According to one of the earliest Greek poets, Hesiod (*Theogony* 188–200), Venus was born of the sea – from the foam produced by the genitals of the castrated Uranus (see SATURN, 1) when they were cast upon the waters. She floated ashore on a scallop shell propelled by gentle breezes, and finally landed at Paphos, in Cyprus, one of the principal seats of her worship in antiquity. Her Greek name, Aphrodite, may be derived from *aphros*, foam. The type of 'Venus Anadyomene' (rising from the sea), representing her standing and wringing the water from her hair, was originally found in classical sculpture and is thought to derive from a lost work of Apelles.

8. *Venus and Mars.* The theme takes two forms: (*a*) The myth, as told by Homer in the *Odyssey* (8:266–365) and by Ovid (*Met.* 4:171–189), and found especially in 18th cent. French painting. Venus, married to Vulcan, the lame blacksmith of the gods, fell in love with Mars, the god of war, and lay with him in his palace. The sun-god Helios witnessed her infidelity next morning and informed her husband. Vulcan was furious and forged a net, unbreakable yet light as gossamer and invisible, which he fixed secretly to the lovers' bed. When they next made love the pair were promptly enmeshed and, unable to move, let alone escape, were caught in the act by Vulcan. He called on the other gods to witness the shameful spectacle, Mercury remarking tactlessly, 'Oh, for the same opportunity!' (*b*) As an allegory of Beauty and Valour, or the conquest of Strife by Love, Venus and Mars recline together, usually in a pastoral setting and sometimes sheltered by a canopy. His head may loll backwards in sleep. Amoretti play with the armour and weapons that Mars has put aside. In the Renaissance the subject sometimes commemorated a betrothal, the two figures being portrayed in the likeness of the engaged couple.

9. *Venus and Anchises* (Theocritus 1:105–7; Hyginus 94). Venus fell in love with Anchises, a Trojan shepherd of Mt Ida. Disguising herself as a mortal, she came to him adorned with jewels and anointed with perfume, and lay with him on his couch. The offspring of this union was Aeneas, the legendary ancestor of the Romans, hence the theme's significance. Venus is seated on a canopied bed by the side of Anchises who may be in the act of removing her sandal. Cupid is usually present. The words 'Genus unde Latinum' ('whence came the Latin race') from the opening of the *Aeneid*, may be included.

See also AENEAS; ATALANTA AND HIPPOMENES; BANQUET OF THE GODS; CUPID; JUDGEMENT OF PARIS; MARS; PUTTO (Venus Verticordia); SATYR; VULCAN (2).

'Verbum caro factum est,' see MARY MAGDALENE OF PAZZI.

'Vere filius Dei erat iste,' see LONGINUS.

'Veritas filia temporis,' see TRUTH.

'Veritatem meditabitur guttur meum . . . ,' see THOMAS AQUINAS.

Vernicle, see VERONICA.

Veronica. The woman who, according to legend, came forward and took her veil, or a linen cloth, and wiped the sweat from the face of Christ as he was bearing his cross to Calvary. The image of his features became miraculously imprinted on the material. (See ROAD TO CALVARY.) The supposed cloth, *sudarium* or vernicle, is preserved as a holy relic in St Peter's, Rome. Veronica, whose name means true image – *vera icon* – when represented as a devotional figure holds out the cloth which bears an image of the face of Christ, sometimes crowned with thorns. She may wear a turban, in allusion to her eastern origin. Veronica sometimes stands between SS Peter and Paul, the patron saints of Rome. The cloth may be carried by two angels.

Vertumnus (or Vortumnus) **and Pomona** (*Met.* 14:623–697 and 765–771). An Italian god and goddess, the protectors of gardens, orchards and the ripening fruit. Vertumnus tried to woo Pomona in various rustic disguises; as a reaper, herdsman and so on, but in vain. He finally gained her presence in the form of an old woman and proceeded to plead his own cause. When this also failed he suddenly revealed himself to her in his true shape, the resplendent, youthful god, and Pomona was conquered. The theme was popular with 17th cent. Netherlandish painters. The usual scene shows an old woman bending earnestly over the naked goddess, perhaps with a hand on her shoulder. Pomona is generally seated under a tree with a basket of fruit or a CORNUCOPIA beside her. She often has a pruning knife. Vertumnus is occasionally portrayed as a young god. The tree may have the tendrils of a vine growing up it, one of the ways, according to Ovid, in which the grape was cultivated. But he extends the idea metaphorically: the tree is the trusty husband to whom a wife may cling for support. In the picture it symbolizes Vertumnus' feelings for Pomona.

Vestal Virgin. Priestess of the temple of Vesta (Gk Hestia), the Roman goddess of the fire that burns in the hearth. One of the Vestals' duties was to keep the altar fire in the temple burning perpetually; they are sometimes seen feeding it with sticks. They were sworn to absolute chastity; breaking the vow was punished by burial alive, a subject also occasionally depicted. Two especially are remembered in legend, TUCCIA and CLAUDIA. Both were accused of adultery and both, in different ways, proved their innocence by performing a miracle. St Augustine disparaged them because they were pagans; the medieval Church however saw them as prefigurations of the Virgin Mary, and this partly accounts for their survival in art.

Via Dolorosa, see STATIONS OF THE CROSS.

Victory (Gk Nike). The personification of victory as a winged, female figure was known to the ancient Greeks and Romans. She was the messenger of the gods, a kind of angel, who descended to earth to crown the victor in a contest of arms, athletics or poetry. Her Roman image was the source of early representations of the angel in Christian art. Victory is rarely represented in the Middle Ages, but was revived in the Renaissance when she is seen bestowing a crown, usually a LAUREL, and a PALM branch. Or, in allegories of military victory, she is surrounded by, or reclines on a heap of weapons. She is sometimes accompanied by FAME. A vanquished foe may lie bound at her feet. See also HISTORY; HORATIUS COCLES.

Vigilance. One of the virtues required of monarchs and others in public life, hence

chiefly represented in secular allegory. The most popular attribute accompanying the female figure of Vigilance is a CRANE, the long-legged wading bird. It stands on one foot; the other is raised holding a stone in its claw. According to a legend mentioned by Aristotle in the *Historia Animalium* (9:10) and repeated in medieval bestiaries, when the bird fell asleep the stone dropped and immediately re-awakened it, so that it was ever watchful. Vigilance may, more rarely, have a LAMP and a strap – the latter to keep the schoolboy awake (Veronese: Doge's Palace, Venice). On Renaissance medals she is seen with a DRAGON, the vigilant guardian of the Golden Fleece, and with the apples of the Hesperides, likewise guarded by a dragon.

Vincent de Paul (*c.* 1580–1660). A French priest of humble peasant origin who devoted his life to the relief of the poor. He founded the Congregation of Mission Priests and the Sisters of Charity, missionary organizations whose work is today worldwide. He is commonly depicted in France, wearing the habit of the Priests of the Mission with the knotted girdle and black cassock. He holds an infant in his arms, and perhaps a Sister of Charity kneels at his feet.

Vincent of Saragossa. Spanish martyr, born at Huesca, he became deacon to St Valerius, bishop of Saragossa, and died at Valencia about 304 under the persecutions of the Emperor Diocletian. His various ordeals – probably borrowed from the legends of other martyrs – are related in verse by the 4th cent. Spanish religious writer Prudentius. He was widely venerated from early times and countless churches in Spain and France are dedicated to him. He is the patron saint of wine-growers. Vincent is depicted as a young man and, like LAURENCE and STEPHEN, wears the deacon's dalmatic. (See diag. RELIGIOUS DRESS.) It is sometimes difficult to distinguish him from Laurence since he too has a GRIDIRON, his instrument of martyrdom. Or he may have a WHIP. A RAVEN alludes to the bird that came to protect him when he was thrown to the wild beasts; a MILLSTONE to the one tied round his body when it was cast overboard into the sea after his death; a bunch of GRAPES to his patronage of viticulturists.

Vine. A common symbol of Christ and the Christian faith from its use in biblical metaphor, in particular Christ's parable of the vine, 'I am the real vine ...' (John 15:1–17). As a symbol of the Eucharist, see GRAPES. The vine was constantly used as a decorative motif in religious art and architecture. It is found on early Christian sarcophagi, in wall painting in the Roman catacombs, in Byzantine mosaics, and in medieval stained glass and stonework. The drunkenness of NOAH (4) depicts him naked in an arbour of vines. The classical god of wine, BACCHUS, has a crown of vine leaves and grapes; his follower, the fat drunken Silenus, is similarly garlanded. The vine is the attribute of the personifications of Autumn, one of the FOUR SEASONS, and of fat GLUTTONY.

Viol. A bowed instrument in general use between the 15th and 18th cents., descended from the medieval fiddle and the forerunner of the modern violin family. The smaller *viola da braccio*, or 'arm viol', was played in a somewhat similar position to the violin and was characterized by its sloping shoulders and 'C' shaped sound holes. The waist varied and was sometimes deeply curved. The bow-stick was generally convex. The larger bass *viola da gamba* had similar features and was held like the cello. In Renaissance painting either type, more usually the smaller, is the attribute of several MUSES, but especially Terpsichore (dancing and song) and of Music personified, one of the SEVEN LIBERAL ARTS. The smaller instrument is played in concerts of angels. The lyre of ORPHEUS, APOLLO and ARION may be replaced by a viol, especially the *lira de braccio*, a Renaissance instrument of the viol family having a characteristic heart-shaped

head (in which the pegs were inserted). A grey-bearded sage, crowned with laurel and playing a viol, is HOMER. See diag. MUSICAL INSTRUMENTS.

Violet. Christian symbol of humility and therefore associated with Christ on earth, usually as an infant. It is found in scenes of the Adoration, and in pictures of the Virgin and Child; also, rarely, at the foot of the cross. White violets sprouted from the death-bed of FINA.

Virgil, Lay of. A popular medieval fable, related by Boccacio, of the love of the poet Virgil for the daughter of a Roman emperor. But the princess secretly mocked him and decided to play a trick. Her chamber was at the top of a high tower, and it was arranged that Virgil be drawn up to her window in a basket. But on the journey up she left him suspended half-way in mid-air, exposed to the ridicule of the populace. He took his revenge by the use of sorcery, plunging the city into darkness for several days during which time the only way of lighting a torch was by placing it in contact with the girl's naked body. This allegory of the war of the sexes is found principally in early Renaissance art, especially in engravings and on Florentine birth trays (the *desco da parto*, used to bring food for women in labour). It generally depicts only the first part of the story, an example of woman's domination of man. It is found in conjunction with the themes of ARISTOTLE AND CAMPASPE; HERCULES (17) and Omphale; SAMSON (4) and Delilah, all of which express a similar idea.

Virgin Mary ('Madonna'). The mother of Jesus Christ. Her exceedingly rich iconography owes only a small part to the gospels, and seems to have grown over the centuries out of a need of the Christian Church for a mother figure, the object of worship that lay at the centre of many ancient religions. The challenge to her role such as was made by the Nestorians in the 5th cent. or the Reformation in the 16th served only to give fresh impetus to her portrayal on the part of those who venerated her. Nestorius denied that the Virgin could properly be called the 'Mother of God', she was the mother only of Christ the human, not the divine person. That view was condemned as heresy by the Council of Ephesus in 431, a verdict which fostered the dissemination of the image of the 'Mother and Child' as the representation of official doctrine. (Such images had already long existed in some pagan religions, notably that of the Egyptian goddess Isis holding her son Horus in her lap which survived well into the Christian era in several Mediterranean countries. The early Church adapted it, as it did other pagan images, to its own purpose.) The majestic effigies of the Virgin and Child enthroned that adorn many centuries of ecclesiastical architecture first became widely diffused in the West in the 7th cent. and were drawn from Byzantine models. From its earlier manifestation as a refutation of Nestorianism, it remained through the Middle Ages a statement of faith, as is made clear by the inscriptions that sometimes accompany it: 'Mater Maria Dei,' and 'Sancta Dei Genitrix.' Another early stimulus to the devotion of the Virgin was the discovery of what purported to be portraits of her, supposedly painted by St Luke. The growth of the Marian cult was to some extent countered by the Church's traditional hostility to women, an attitude that was very much alive among some earlier theologians and monastic institutions who used the figure of Eve, the temptress, by way of justification. It was the 12th cent. and even more the 13th that saw in the West a development so extensive as to be called 'mariolatry.' This was an era of religious ardour following the Crusades that reached its highest outward expression, many would say, in the Gothic cathedrals of France, which were often dedicated to 'Our Lady' – *'Notre Dame.'* Foremost among medieval theologians who inspired this movement was Bernard of Clairvaux

(1090–1153). He interpreted the *Song of Songs* as an elaborate allegory in which the bride of the poem was identified with the Virgin. That concept was indeed already known to the Middle Ages, but it was much amplified by St Bernard and became a source of much of the imagery surrounding the Virgin. (The accepted opinion today is that the work is a collection of love poems that were recited at wedding celebrations.) The Renaissance saw the replacement of the hieratic type of the Virgin and Child by others less formal, among them the Madonna of Humility seated on the ground, and the *Mater Amabilis*, the more maternal aspect of the mother-child relationship and perhaps the favourite image of her in the whole of Christian art. The Virgin as an object of veneration (as distinct from her portrayal in the narrative scenes of her legendary life-story) assumes several other forms, mostly of fairly late origin. Among the more important are the Virgin of Mercy (3) who shelters the penitent under her ample cloak, or kneels before Christ at the Last Judgement to intercede for the souls of the dead; the *Mater Dolorosa* (2) who grieves for her son, her breast pierced by seven swords symbolizing her seven sorrows, or sitting with his dead body in her lap; the maiden of the Immaculate Conception (4), a doctrine that was much disputed by medieval theologians but which gained ground in the 17th cent., fostered by the Jesuits, and was widely depicted from that time. Yet again, some aspects of her representation, such as the Virgin of the Rosary (15), were intended to inculcate specific devotions. The climate of religious fervour generated by the Counter-Reformation was manifested in the visions experienced by mystics, the outcome of prayer and sometimes fasting. The visions, which in many cases were borne out by their writings, might take the form of the crucified Christ, but in particular of the Virgin, generally with the Child. They are represented in Italian and to a lesser extent Spanish art from the end of the 16th through the 17th cents. Among those so depicted are IGNATIUS OF LOYOLA, PHILIP NERI and HYACINTH; of the earlier saints FRANCIS OF ASSISI and ANTONY OF PADUA are seen at this period receiving the Infant into their arms. Others to whom a vision of the Virgin appeared were CATHERINE OF SIENA, BRIDGET of Sweden, AUGUSTINE (5), ANDREW, apostle, and the Emperor Augustus (Octavian) (see SIBYL). The Virgin traditionally wears a blue cloak and veil, the colour symbolic of heaven and a reminder of the Virgin's role as Queen of Heaven. Her habit is usually red. In scenes of the Passion her colours are sometimes violet or grey.

Devotional themes are arranged below under three headings: Virgin without the Child; Virgin and Child alone; and Virgin and Child with other figures. Narrative themes from the life of the Virgin will be found elsewhere as follows: JOACHIM AND ANNE; NATIVITY OF THE VIRGIN; PRESENTATION OF THE VIRGIN; EDUCATION OF THE VIRGIN; MARRIAGE OF THE VIRGIN; ANNUNCIATION; VISITATION; DEATH OF THE VIRGIN; ASSUMPTION; CORONATION OF THE VIRGIN. Other themes in which the Virgin appears, not always in the principal role: NATIVITY; ADORATION OF THE SHEPHERDS; ADORATION OF THE MAGI; CIRCUMCISION OF CHRIST; PRESENTATION IN THE TEMPLE; FLIGHT INTO EGYPT; DISPUTE WITH THE DOCTORS; MARRIAGE AT CANA; and from the Passion cycle: ROAD TO CALVARY; CHRIST STRIPPED OF HIS GARMENTS; CRUCIFIXION; DESCENT FROM THE CROSS; BEARING THE BODY OF CHRIST; ENTOMBMENT; APPEARANCE OF CHRIST TO HIS MOTHER; ASCENSION; DESCENT OF THE HOLY GHOST.

Virgin without the Child

1. *The Virgin standing or enthroned.* The Virgin without the Child, either standing 'in glory' or enthroned is a type that derives from very early eastern

sources. Apart from its place in Byzantine mosaics it belongs principally to medieval church frescoes and sculpture, and is found, more rarely, in altar-pieces of the early Renaissance. It represents the Virgin's special role as a reflection of the Church's own being, a symbol of the Mother Church herself, reigning over mankind in her ineffable wisdom. In medieval examples she is much bigger than the figures surrounding her, thus adding weight to the idea of her majesty. Beneath her feet may be a crescent MOON, the ancient symbol of chastity. She may wear her customary veil, or, especially when enthroned, a crown. When holding a book – the Book of Wisdom – she is known as the Virgin of Wisdom, *Virgo Sapientissima*. The mystical literature of the 12th and 13th cents. commonly called her the Queen of Heaven, *Regina Coeli*, which art represented as the Virgin crowned, enthroned and holding an orb or sceptre (more usually with the Child). The portraits and half-length figures of the Renaissance and later, depicting the Virgin alone, either crowned or veiled and perhaps gazing devoutly upwards, belong to this category.

2. *The Virgin mourning; the 'Mater Dolorosa'; the Seven Sorrows of the Virgin*; *'La Soledad'*. Though the term *Mater Dolorosa* embraces the image of the mourning mother as she stands beside the cross, or sits lamenting over the dead body of Christ lying in her lap, we are here concerned with the Virgin alone. (For the others, see CRUCIFIXION, 5, and PIETÀ.) As the Virgin of the Seven Sorrows she is depicted with seven swords piercing her breast or framing her head, a literal rendering of the prophecy of Simeon that forms the first of the sorrows: 'This child is destined to be a sign which men reject; and you too shall be pierced to the heart.' (Luke 2:34–5.) (See PRESENTATION IN THE TEMPLE.) The other six are FLIGHT INTO EGYPT, Christ lost by his mother (see DISPUTE WITH THE DOCTORS), BEARING OF THE CROSS, CRUCIFIXION, DESCENT FROM THE CROSS, ASCENSION (when Christ finally parted from his mother). The Seven Sorrows were inaugurated as a Church festival by the Synod of Cologne in 1423 to form a counterpart to the existing series of Seven Joys. The subject is found particularly in the art of northern Europe, chiefly in 16th cent. Flemish painting where the swords may be replaced by representations of the seven episodes themselves, framing the Virgin. Some examples of the sword motif are to be seen in 17th cent. Italy and Spain. The solitary figure of the mourning Virgin, without the swords, is found from the 16th cent. onwards. Here she personifies the Church, left alone to bear the sorrows of the world after the disciples have fled, and is called the Virgin of Pity. She may be contemplating the instruments of the Passion. The theme was especially attractive to Spanish painters of the Counter-Reformation where it is called *La Soledad*, the Virgin of Solitude.

3. *The Virgin sheltering supplicants under her cloak*. The disasters that befell medieval man, such as war and disease, especially the plague, were seen as the workings of divine judgement. He might mitigate them however by placing himself under the protection of a tutelary figure, a saint or, to even greater purpose, the Virgin herself. The role of the Virgin as intercessor before God at the general resurrection is seen in representations of the Last Judgement. Her part as mediator of the living forms a large class of paintings, in which she is usually shown holding the Infant. (See below, 14: *Virgin and Child with saints and donors*.) The type we are concerned with here is the Virgin of Mercy alone, the 'Misericordia' without the Child. In its essentials it shows the Virgin standing, her arms outspread, holding out an ample cloak, as it were a tent, under which the diminutive figures of the supplicants are kneeling. She is usually crowned. The

cloak was used as a symbol of protection in antiquity and is found in Byzantine and medieval art having the same meaning, perhaps worn by Christ or by saints. The theme became widespread in the West in the 13th cent. in the art of the monastic Orders who seem to have vied with one another for the honour of being the first to adopt it. It was also commonly commissioned by the lay charitable confraternities of the late Middle Ages whose patron was the Virgin of Mercy, and by individual donors as a thanksgiving for victory in war or for protection against the plague. In the latter instance the cloak may form a shield against falling arrows, which from classical times were regarded as carriers of disease. Occasionally the figure of Christ may be seen above holding arrows in his hand. A kneeling donor may be presented to the Virgin by his patron saint, or the suppliants may comprise the members of a monastic Order in their distinctive habit (see RELIGIOUS DRESS); or, symbolic of mankind as a whole, men and women, both rich and poor, mingled together or separated into clergy on the right of the Virgin and laity on the left. Renaissance artists sometimes show the cloak supported on each side by angels, thus freeing the Virgin's arms for expressive gesture. The theme died out in the 16th cent. and is seldom found in the art of the Counter-Reformation.

4. *The Immaculate Conception.* The term refers not, as is sometimes supposed, to the conception of Christ in the womb of Mary (which is represented in art as the Annunciation), but to the conception of Mary herself in the womb of her mother Anne. According to that doctrine, since the Virgin was chosen – was indeed fore-ordained from the beginning of time – to be the vessel of Christ's Incarnation, she must herself be stainless (hence her title 'Purissima'); more specifically she alone of mankind was free from the taint of Original Sin: that is, she herself was conceived 'without concupiscence.' This idea which had been slowly gaining ground through the Middle Ages became a central issue of debate in the 12th and 13th cents. Among the monastic Orders the Dominicans, including Aquinas, denied the possibility of Immaculate Conception, while the Franciscans, excepting Bonaventura, upheld it. In the succeeding centuries the doctrine received various papal sanctions confirming its orthodoxy, and Spain in the early 17th cent. was placed under its tutelage. It was defined as an article of faith by Pius IX in 1854. The late appearance of the theme in Christian art may reflect not so much its controversial nature as the difficulty of establishing a representational type for so abstract a concept. It was first widely depicted in the 16th cent., often in the form of the Virgin standing or kneeling before the image of God the Father in heaven while about her, to indicate the debate that surrounded the subject, the Doctors of the Church argue and consult their books. Among them may be seen AUGUSTINE, AMBROSE, JEROME and BONAVENTURA. A writing friar may be Duns Scotus, a Franciscan, who strongly upheld the doctrine. An enthroned pope may be Sixtus IV, likewise a Franciscan, who sanctioned the Immaculate Conception as a Church festival. The manner of representing the Virgin herself in the 16th cent. reflects the role given to her by the Church as one predestined to bring about the redemption of man from the 'sin of Eve', hence her name 'the Second Eve.' She may stand symbolically on a serpent or dragon, in allusion to the words of God to the serpent in the Garden of Eden (Gen. 3:15), 'I will put enmity between ... your brood and hers. They shall strike at your head ...,' a prefiguration according to medieval theology of the coming of the Second Eve to bring about the vanquishing of Satan, the serpent. Likewise, Adam and Eve and the Tree of Knowledge may be seen beside the Virgin. Or we may find the inscription 'Dominus possedit me in initio viarum suarum ...'

(Prov. 8:22), a typological reference (see Notes: *The Typology of the O.T.*) to the idea of predestination: 'The Lord created me the beginning of his works, before all else that he made, long ago.' It was natural to draw on the Old Testament for metaphors to apply to one who was 'fashioned in times long past, at the beginning, long before earth itself.' The *Song of Songs* was a favourite source and from the 16th cent. art has many instances of the Virgin of the Immaculate Conception surrounded by the imagery applied in that book to the Shulammite maiden (*S. of S.* 6:13), whom the Middle Ages had identified with Mary. It was embedded in the popular mind from its occurrence in the medieval Litanies to the Virgin, a form of responsorial prayers in which the congregation took part. In their earliest examples the symbols may be labelled with their Latin texts: 'Pulchra ut luna, electa ut sol' – 'Beautiful as the moon, bright as the sun' (6:10); 'Flos campi' – 'The "rose" of Sharon' (N.E.B.: 'asphodel') (2:1); 'Lilium inter spinas' – 'Lily among thorns' (2:2); 'Turris David' – 'David's tower' (4:4); 'Fons hortorum' – 'The fountain in my gardens' (4:15); 'Puteus aquarum viventium' – 'A spring of running water' (4:15); 'Hortus conclusus' – 'A garden close-locked' (4:12). Also depicted are the palm tree (7:7); the 'Porta clausa' – 'The closed gate' (Ezek. 44:1–2); the 'Speculum sine macula' – the mirror, more often found in later examples: 'She is . . . the flawless mirror of the active power of God and the image of his goodness' (Wisdom 7:26); the OLIVE; the cedar of Lebanon; the tree of JESSE. Some of these symbols, such as the *hortus conclusus* and the mirror, allude to the idea of virginity in general and are found also in other Marian contexts.

In the art of the 17th cent., especially in Spain, the stimulus provided by the Counter-Reformation to the veneration of the Virgin led to a new type of the Immaculate Conception which rapidly established itself. The form was codified by the Spanish painter, writer and art-censor to the Inquisition, Francisco Pacheco in his *Art of Painting* (1649). The essential features were based on the pregnant 'Woman of the Apocalypse', 'robed with the sun, beneath her feet the moon, and on her head a crown of twelve stars.' (Rev. 12:1, see APOCALYPSE, 15), a type by no means new in the 17th cent. (Bonaventura in the 13th cent. had linked her with the Virgin) but which Pacheco took and amplified. He laid down that she be represented as a young woman of twelve or thirteen years, dressed in a white robe and blue cloak, her hands folded on her breast or meeting in prayer; the moon to be a crescent (the antique symbol of chastity), horns downward; round her waist the Franciscan girdle with its three knots. This image, sometimes with variations, is the most familiar version of the theme. It may include God the Father looking down from above, perhaps accompanied by the inscription, 'Tota pulchra es, amica mea, et macula non est in te' – 'You are beautiful, my dearest, beautiful without a flaw' (S. of S. 4:7). This type may also include some of the emblems mentioned above.

5. *The Virgin and the unicorn.* The UNICORN, associated in remote antiquity with the worship of a virgin mother goddess, was early linked with the idea of the virginity of Mary and of Christ's Incarnation. A medieval bestiary, based on the Greek *Physiologus* of about the 5th cent., reads, 'Sic et dominus noster Iesus Christus, spiritualis unicornis, descendens in uterum virginis,' – 'And thus did our Lord Jesus Christ, who is a unicorn spiritually, descend into the womb of the Virgin.' The legend of the mythical beast, whose horn had the power of purifying whatever it touched, and which could not be captured except by a virgin, was adopted as a Christian allegory in spite of its unmistakable phallic overtones. The unicorn resting its head on the breast of a virgin symbolized,

according to the *Physiologus*, the Incarnation of Christ. This image occurs in Romanesque and Gothic churches and is found particularly in painting and tapestries of northern Europe of the 15th and 16th cents. It often includes some of the accepted symbols of Marian virginity: the *hortus conclusus*, the 'enclosed garden' – a fence or wall surrounding the young woman and the beast; the *porta clausa*, the 'closed gate' behind which she sits. A mirror, one of the emblems of mother-goddess worship in antiquity, is here used as the well-established symbol of Mary's virginity, the *speculum sine macula*, or 'flawless mirror' of the book of Wisdom. She holds it in her hand and in it is reflected the head of the unicorn, symbolizing Christ, which rests in her lap. Near her may be a pomegranate tree, another metaphor for the Virgin, taken from the *Song of Songs*, and symbolizing chastity. The unicorn may be depicted alone in the fenced garden, chained to the pomegranate tree, suggesting Christ's Incarnation in the Virgin's womb, the idea of his imprisonment in the human flesh. Other themes, originally profane legend adopted by Christianity, may form part of a series. They depict the unicorn dipping its horn in a spring – the impregnation yet at the same time the mystic purification of the Virgin who is symbolized by the water (the *fons hortorum* – the 'fountain in my gardens' – of the *Song of Songs*, 4:15). The hunting of the unicorn shows the beast, pursued by a huntsman and dogs, 'taking refuge' at the Virgin's bosom (in the pre-Christian legend its phallic urge was tamed by the Virgin offering it her breasts). This was made into an allegory of the Incarnation in which the huntsman with his horn stands for Gabriel, the angel of the Annunciation. The dogs, in a perhaps overstretched use of symbolism, stand for Misericordia, Justitia, Pax and Veritas – Mercy, Justice, Peace and Truth – the virtues that followed Christ's coming to earth.

As a profane allegory of chastity, the virgin and the unicorn are found in late medieval and early Renaissance tapestry, generally woven on the occasion of a betrothal, and on the panels of Italian *cassoni* (brides' marriage chests). Unicorns draw the chariot of Chastity personified (see TRIUMPH).

Virgin and Child alone

The wide variety of well-established types frequently overlap, making tidy classification difficult. The Virgin may be seated on a throne or standing before it, or sitting on the ground. Pose and gesture are used to suggest numerous relationships between mother and child, or between the image and the spectator. Fruit, flowers and other objects are introduced with specific symbolic meanings. Accessory figures (see 14 below) make their appearance in well-defined roles.

6. *The Virgin suckling the infant Christ.* The 'Virgo lactans' or 'Maria lactans' is the most ancient type of Virgin and Child. What is thought to be the earliest example is a 3rd cent. fresco in the Christian catacomb of Priscilla at Rome which shows a seated woman holding a naked infant to her breast and apparently suckling it though, from the position of her draperies, the latter detail is not clear. The first established type was probably derived from the image of the Egyptian goddess Isis nursing her son Horus, the child seated across her lap in a stiff hieratic posture. In the 5th cent. the Nestorians' ridicule of the idea that the godhead could be suckled only served to strengthen the orthodox view and encourage its representation. The subject is found in early mosaics and in medieval church sculpture. It was the object of a cult that was widespread in Italy in the 14th cent. where many churches claimed to possess some of the Virgin's milk, preserved as a holy relic. It is found in Renaissance painting in several versions. The Virgin is sitting enthroned or on the ground (the 'Madonna of Humility'), or she stands. The Child either takes the breast in a wholly

naturalistic manner or sits facing the spectator in the lap of the Virgin, one of whose breasts is uncovered. The theme disappeared from art after the Council of Trent which forbade undue nudity in the portrayal of sacred figures.

7. *The Virgin and Child enthroned.* The Virgin enthroned, or *Regina Coeli*, the Queen of Heaven, is more often than not accompanied by the Child. The earliest examples in the West are seen in the mosaics at Ravenna and elsewhere. In early Italian painting the theme falls into three main types: the full-face frontal view of the Mother and Child, deriving from Byzantine art; the Virgin pointing to the Child, and the more maternal type in which the Child is embraced. When she is represented enthroned within a little chapel or some such conventional ecclesiastical building (in which she appears proportionately very large) the Virgin then personifies the Church. Otherwise the throne itself may embody architectural features, when it likewise connotes the Church.

8. *The Virgin with hands joined in prayer.* Either enthroned or not or perhaps in the setting of the Rose Garden (see 10 below), the Virgin is sometimes depicted in an attitude of adoration and is then called the 'Madre Pia'. Since her hands are joined the Child necessarily lies in her lap or on the ground. A similar sentiment is depicted in one type of the NATIVITY (2) in which the Virgin kneels in prayer before the Child who lies on the ground.

9. *The Virgin and Child with book.* The book, a common accessory in Renaissance painting, is traditionally the book of Wisdom and marks the Virgin as the 'Mater Sapientiae', the Mother of Wisdom. When held by the Child the book represents the gospels.

10. *The Virgin of the Rose Garden.* At the end of the Middle Ages and in the early Renaissance the Mother and Child may be depicted in a rose bower or before a hedge or trellis-fence of roses that form an enclosed space. She may be kneeling in the manner of the 'Madre Pia' before the Infant Christ who lies on the ground; or she is seated on the ground, the Virgin of Humility (see 11); more rarely she is enthroned. From early times the ROSE had a place in Christian symbolism, the red bloom signifying the blood of the martyr, the white, purity, especially that of the Virgin, who was also called the 'rose without thorns'. The image of the garden itself is drawn from the *Song of Songs* where the 'hortus conclusus', the 'enclosed garden' (4:12) was made to stand for Mary's virginity. The two figures are often accompanied by angels who may be casting rose petals on the Infant, or by saints and donors, as in a 'Sacra Conversazione'. (See 14 below.)

11. *The maternal Virgin.* The simple effigy of the Virgin holding the Child entered the West through Byzantine art. The formal eastern type with the mother full-face holding a stiffly erect, fully-clothed Child whose hand is raised in blessing was already giving way in the sculpture of Gothic cathedrals to a more intimate version in which the Child turns away from the worshipper and towards its mother. The image, commonplace in Catholic countries from its use not only in buildings of public worship but at wayside shrines and in private devotions became in the hands of Renaissance painters more and more imbued with human feeling until the religious sense was often lost altogether. The typical form, sometimes known as the 'Mater Amabilis', shows the Virgin half-length, wearing her traditional colours, the red robe under a blue cloak, and supporting the Child in her arms in any one of a number of conventionalized postures. One type, which appeared first in northern Italian painting in the 14th cent., is known as the Madonna of Humility (sometimes with the inscription 'Nostra Domina de Humilitate'). Its essential feature is that the Virgin is seated on the

ground, perhaps on a cushion. Medieval theology regarded humility as the root from which all other virtues grew, an idea appropriate to the Virgin from whom Christ grew. Religious meaning was often conveyed, especially in 15th and 16th cent. painting, not so much in the manner by which the figures were portrayed as by various symbolic objects held either by the Child or the Virgin or lying nearby. (See further, 12 and 13 below.)

12. *Attributes of the Virgin.* Many attributes have been mentioned already in connection with the Immaculate Conception and elsewhere. The following are also traditionally associated with her.

LILY, from antiquity the symbol of purity, to which its white colour lends meaning. More than any other it is the flower of the Virgin. The bride of the *Song of Songs* (with whom the Virgin is identified) is likened to it: 'A lily growing in the valley' and 'a lily among thorns' (2:1–2). It is particularly associated with the scene of the Annunciation.

OLIVE, the emblem of peace, sometimes substituted for the lily in paintings of the Annunciation of the Sienese school, since the latter flower was also the emblem of Siena's rival city, Florence.

STAR, usually seen on the Virgin's cloak. It derives from her title 'Star of the Sea' (Lat. *Stella Maris*), the meaning of the Jewish form of her name, Miriam.

Tree of JESSE. When an attribute of the Virgin it takes the form of a branch twined with flowers. This is the genealogical tree of Christ, stemming from Jesse, the father of David (Isa. 11:1–2).

13. *Symbolic objects in pictures of the Virgin and Child.* Objects, especially fruit, birds and drinking vessels, which may appear to be no more than miscellaneous elements generally found in a still life, in fact conceal a system of Christian symbolism. They are seen especially in the works of northern European painters of the 15th and 16th cents. The APPLE, usually held in the infant's hand, is traditionally the fruit of the Tree of Knowledge and therefore alludes to him as the future Redeemer of mankind from Original Sin. The ORANGE in Dutch painting has the same meaning (Dutch: *Sinaasappel*, Chinese apple). GRAPES symbolize the eucharistic wine and hence the Redeemer's blood, a concept expressed by Augustine, 'Jesus is the grape of the Promised Land, the bunch that has been put under the wine-press'. (See further, WINE-PRESS, MYSTIC.) A black bunch and a white probably allude to John's account of the wounding of Christ on the cross 'and at once there was a flow of blood and water.' (19:34.) Ears of CORN, in association with grapes, stand for the bread of the Eucharist. The CHERRY, called the Fruit of Paradise, given as a reward for virtuousness, symbolizes heaven. The POMEGRANATE, a fruit with several symbolic meanings, is here used to signify the Resurrection. It was in antiquity the attribute of Proserpine, the daughter of the corn-goddess Ceres, who every spring renewed the earth with life, hence its association with the idea of immortality and its Christian corollary, the Resurrection. The symbolism of the NUT, generally depicted as one half of a split walnut, was elaborated by Augustine: the outer green case was the flesh of Christ, the shell the wood of his cross, the kernel his divine nature. A jug or other drinking vessel may be presumed to contain wine or, if of glass, is seen to contain it, and thus bears the same meaning as the grapes above. A BIRD in pagan antiquity signified the soul of man that flew away at his death, a meaning that is retained in the Christian symbol. It is generally seen in the hand of the Child, and is most commonly a goldfinch. Its handsome plumage once made the goldfinch of all birds a favourite pet with children. The reason for its association with the Christ Child was, *a fortiori*, the legend that it acquired

its red spot at the moment when it flew down over the head of Christ on the road to Calvary and, as it drew a thorn from his brow, was splashed with a drop of the Saviour's blood. An interesting development of this scheme of symbolism occurred in the painting of northern Europe in the first part of the 17th cent. when the same objects came to be used in STILL LIFE, but yet retained, in their selection and arrangement, their meaning as statements of Christian belief.

Virgin and Child with other Figures

14. Virgin and Child with saints and donors. The image of the Virgin and Child framed on either side by the figures of saints is found in Christian devotional art of East and West from early times. In late medieval and early Renaissance art its typical form was the altar-piece in which the figures were confined in separate compartments or panels. This developed in the 14th and 15th cents into a unified representation, known as the 'Sacra Conversazione', or 'holy conversation', in which the saints were grouped in one picture, standing, or occasionally kneeling, in attendance on the Virgin (usually enthroned with the Child, but also at her Assumption or Coronation; a Sacra Conversazione is sometimes depicted with the Crucifixion). Saints of different ages are shown together, regardless of the period in which they lived. There are many reasons for the presence of a saint in a Sacra Conversazione. He may be the patron of the church for which the work was commissioned (John the Baptist is a common example) or of the city of its donor (Bernardino of Siena; Mark and Nicholas of Venice) – often a clue to the painting's provenance. Works produced for the monastic Orders will include the founder and other saints of the Order (Benedict and his sister Scholastica; Dominic and Peter Martyr.) Saints may personify moral and intellectual qualities, often in complementary pairs (Mary Magdalene as Penitence with Catherine of Alexandria as Learning). Another important class of the subject is the votive picture. donated to a church, monastery or charitable institution by way of thanksgiving for some favour received from heaven. The donor kneels beside his personal patron saint, who is often his namesake (as St Laurence was the protector of Lorenzo de' Medici), with maybe his wife and her patron opposite, and their children. The usual grounds for commissioning such paintings were deliverance from the plague (when Sebastian and other protectors from disease would be represented), military victory (warrior saints such as Maurice), or release from captivity, generally after military defeat (Leonard). It will be seen that a saint can have more than one role, which may often be determined by the company he keeps. (Paul, with Peter, symbolizes the founder of the gentile Church; with Benedict, Romuald and others Paul is a patron saint of the Benedictine Order.) The list that follows is far from exhaustive but includes the more familiar figures in their commoner roles. The reader will refer elsewhere, when necessary, to identify the saints by their attributes and dress.

Ambrose, P.S. (Patron Saint) of Milan; with Augustine, Gregory and Jerome, a Father of the Church.

Andrew, with Longinus, P.S. of Mantua. Thus, in a votive painting donated by Francesco Gonzaga, Marquis of Mantua, husband of Isabella d'Este, both patrons of artists.

Anne, mother of the Virgin, wife of Joachim, by whom she is sometimes accompanied.

Antony of Padua, with Francis, Clare, P.S. of Franciscan Order.

Antony the Great, with Augustine and Monica, P.S. of Augustinian Order.

Augustine, with Ambrose, Gregory and Jerome, a Father of the Church;

with his mother Monica and Antony the Great, the founder of the Augustinian Order; with Francis, a P.S. of the Franciscans; with Dominic, of the Dominicans.

Barbara, in votive paintings a protectress against lightning and storms; with Catherine of Alexandria, the personification of the secular (military) and religious arms of the state, respectively; with Mary Magdalene, of Fortitude and Penitence.

Benedict, founder of the Benedictine Order, sometimes with his sister Scholastica, a patroness of the Order; if also with Bernard and Romuald, P.S. of the Cistercians, the Order of reformed Benedictines; with Dominic, Petronius, P.S. of Bologna.

Bernard, a founder of the Cistercian Order; see also Benedict above.

Bernardino, P.S. of Siena, sometimes with Catherine of Siena.

Bonaventura, with Francis, and sometimes Elizabeth of Hungary, Louis IX, P.S. of the Franciscan Order.

Catherine of Alexandria, the personification of Wisdom; with Mark, Nicholas, George, Justina, P.S. of Venice; with Mary Magdalene, Learning and Penitence; with Barbara, the religious and secular (military) arms of the state; with Jerome, both stand for theological learning.

Catherine of Siena, with Bernardino, P.S. of Siena; with Dominic, P.S. of the Dominican Order; with Catherine of Alexandria, namesake.

Christopher, with George, a protector against danger.

Clare, with Francis, Antony of Padua, P.S. of the Franciscan Order.

Cosmas and Damian, P.SS. of the sick; with Sebastian, Roch, in votive pictures against the plague; with Laurence, patrons of the Medici family of Florence.

Dominic, a national saint of Spain; founder of the Dominican Order, sometimes with Peter Martyr, one of its P.SS.; with Benedict, Petronius, P.S. of Bologna.

Elizabeth of Hungary, with Martin, Roch and beggars and the lame kneeling, the protectress of the sick and needy.

Francis of Assisi, a national saint of Italy; founder of the Franciscan Order, sometimes with Antony of Padua and Clare, its P.SS.; with Dominic, the active and contemplative types of monasticism.

Francis Xavier, P.S. of Jesuits, sometimes with Ignatius of Loyola, founder of the Society of Jesus.

Gabriel, with Michael, archangels of birth and death.

Geminianus, bishop and P.S. of Modena.

George, warrior saint; with Christopher, a protector of those in danger; with Mark, Nicholas, Catherine of Alexandria, Justina, P.S. of Venice; with Sebastian, Roch, a protector against the plague.

Gregory, with Ambrose, Augustine, Jerome, a Father of the Church.

Ignatius of Loyola, founder of the Jesuits, sometimes with Francis Xavier of the same Order.

Jerome, the personification of theological learning, sometimes with Catherine of Alexandria who then has the same meaning; with Ambrose, Augustine, Gregory, a Father of the Church; with Mary Magdalene, Learning and Penitence.

Joachim, husband of Anne, the mother of the Virgin whom he sometimes accompanies.

John the Baptist, very common as the 'precursor' of Christ whom he may present with a gesture to the spectator; P.S. of countless churches, baptisteries and many cities, especially Florence which he shares with Laurence, Cosmas and

Damian; P.S. of the Florentine Lorenzo de' Medici; also of Francesco Gonzaga, Marquis of Mantua; with John the Evangelist, namesake, personifying respectively the rite of baptism and spiritual renewal through the gospels.

John the Evangelist, see John the Baptist above.

Justina, with Mark, Nicholas, George, Catherine of Alexandria, a P.S. of Venice.

Laurence, P.S. of Lorenzo de' Medici; with Leonard, Stephen, a deacon of the Church; with John the Baptist, Cosmas and Damian, a P.S. of Florence.

Leonard, with Nicholas, P.S. of prisoners, in votive pictures for deliverance from captivity; with Laurence and Stephen, a deacon of the Church.

Longinus, P.S. of Mantua. See also *Andrew*.

Louis IX, king of France; with Francis, Bonaventura, Antony of Padua, Clare, P.S. of the Franciscan Order.

Mark, with Nicholas, George, Catherine of Alexandria, Justina, the principal P.S. of Venice.

Martin of Tours, P.S. of beggars; with Roch, Elizabeth of Hungary, a protector of the needy.

Mary Magdalene, with Jerome, Penitence and Theology; with Barbara, Penitence and Fortitude; with Catherine of Alexandria, Penitence and Learning.

Maurice, warrior saint; with Michael, in votive paintings of thanksgiving for victory.

Michael, see *Maurice* above; with Raphael, the guardian angels of the young; with Gabriel, the archangels of death and birth.

Monica, mother of Augustine and P.S. of his Order, sometimes with Antony the Great.

Nicholas of Myra, with Mark, George, Catherine of Alexandria, Justina, a P.S. of Venice; with Leonard, P.S. of prisoners in votive pictures for deliverance from captivity.

Paul, with Peter, the joint founders of the Christian Church, symbolizing gentiles and Jews respectively; with Benedict, Bernard, Romuald, Scholastica, P.S. of the Benedictine Order.

Peter, apostle, see *Paul* above.

Peter Martyr, with Dominic, P.S. of the Dominican Order.

Petronius, bishop of Bologna; with Dominic, P.S. of that city.

Raphael, with archangel Michael, the guardians of the young, sometimes also with Tobias holding a fish.

Roch, with Sebastian and sometimes George, Cosmas and Damian, protector against the plague; with Martin, Elizabeth of Hungary, protector of beggars and other needy and ailing folk, in paintings for hospitals and charitable institutions.

Romuald, founder of the Camaldolese (a Benedictine reform), with Benedict, Scholastica and sometimes Bernard, P.S. of the Benedictine Order.

Scholastica, sister of Benedict; with him and sometimes Bernard and Romuald, P.S. of the Benedictine Order.

Sebastian, protector against the plague, sometimes with Roch, also Cosmas and Damian, and George.

Zenobius, bishop and P.S. of Florence, sometimes with John the Baptist, Laurence, Cosmas and Damian.

15. *The Virgin of the rosary; the vision of St Dominic.* Dominic kneels before the Virgin and Child enthroned, receiving a string of beads – the rosary – from the hands of one or the other. The rosary is used by Roman Catholics as a device for counting prayers that form the basis of three cycles of meditations on the 'mysteries of the Virgin'. The invention of the rosary was claimed for Dominic

(1170–1221) by early historians of the Order who related that the Virgin appeared to him in a vision and presented him with a chaplet of beads that he called 'Our Lady's crown of roses'. It was a medieval custom for a serf to present his master with a chaplet of roses as a token of his homage, hence perhaps the origin of the name. It was subsequently maintained on the contrary that the use of the rosary as an aid to devotion was first propagated by a Dominican friar towards the end of the 15th cent. However that may be, it was from this later date that the cult of the rosary spread widely, and it became the emblem of many religious and lay Orders. A miraculous power was often attributed to it, particularly that of combating Islam and the heresy of Protestantism. In art the earliest type of the Virgin of the Rosary is seen at the end of the 15th cent. and shows her framed in a MANDORLA made of roses, perhaps with every eleventh bloom larger than the rest, like the beads in a rosary. From the 16th cent. the predominant theme is the vision of St Dominic, found frequently in paintings done for his Order. It was fostered in the Counter-Reformation era as a counter to Protestantism. In later examples Dominic may be accompanied by Catherine of Siena, a leading patron saint of his Order, who is likewise seen receiving a rosary from the hands of the Virgin or Child. Victory in the naval battle of Lepanto (1571) in which the forces of Christendom defeated the Turks was attributed to the power of the rosary. The scene of the battle is sometimes joined to that of Dominic's vision.

16. *Our Lady of Loretto (the Virgin and Child on the roof of a house)*. The image of the Virgin and Child seated on the roof of a house that is borne aloft by angels supporting each of its four corners illustrates the legend that attaches to the shrine at Loretto. It relates that the 'Santa Casa', the house of Mary and Joseph at Nazareth, the same to which the angel of the Annunciation came, was carried away to safety by angels in the year 1291, when the Saracens were driving the Crusaders out of the Holy Land. They bore it first to a place on the coast of Dalmatia, but its final resting place was Loretto, a town near Ancona in the Italian Marches. The legend, apparently of 15th cent. Italian origin, was used by the Jesuits from the end of the 16th cent. to promote the town as a centre of pilgrimage. The theme therefore belongs principally to the art of the Counter-Reformation, and is common in chapels dedicated to 'Our Lady of Loretto'.

17. *The Holy Family.* The theme is a late one in Christian art and hardly emerges before the 15th cent. when it is seen in the painting of both northern and southern Europe. The term Holy Family is used to describe several different combinations of sacred figures which may be treated either in the devotional style, or as a narrative account of that early period in the life of Christ after the return from Egypt, when Joseph took his family and settled in Nazareth (Matt. 2:22–23).

(*a*) 'Virgin and Child with St John.' A very common group in Italian painting, popular in the 16th cent. The infant John the Baptist is naked like Christ, or wears his tunic of animal skins and holds a reed cross. Pseudo-Bonaventura, filling a lacuna in the gospel narrative, relates that the Holy Family on their return from Egypt stayed with Elizabeth, the cousin of the Virgin, and with her son the little St John, and tells how the latter showed respect to the Christ child, even though both were of tender years. This is the likely source of the type of adoring St John who kneels with his hands together before Christ. It is not uncommon for Elizabeth to be present in this scene. There is no scriptural authority for depicting Christ and St John together before Christ's baptism.

(*b*) 'Virgin and Child with St Anne.' The theme of the three generations,

grandmother, mother and child, found favour with the artists of northern Europe, especially Germany in the 15th and 16th cents. It is also seen in Italian, especially Florentine, and Spanish painting. One type, of which Leonardo's is the most famous example, shows the Virgin sitting in the lap of the seated Anne, while holding the Infant in her arms or dandling it at arms' length. This somewhat unnatural arrangement gave way to the more usual type showing the three sitting side by side with the Child in the middle.

(*c*) 'Holy Company'; 'Holy Kinship'; 'The Family of St Anne.' According to a late medieval legend Anne was three times married and by each marriage had a child called Mary (*Golden Legend:* Nativity of Our Lady). Each Mary married and produced offspring. This was one attempt to reconcile the conflicting statements by the evangelists concerning the family of Christ which theologians from Jerome onwards had grappled with. The family tree would be as follows:

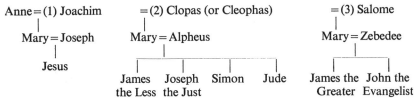

Anne = (1) Joachim = (2) Clopas (or Cleophas) = (3) Salome

Mary = Joseph Mary = Alpheus Mary = Zebedee

Jesus James Joseph Simon Jude James the John the

the Less the Just Greater Evangelist

The subject is seen most frequently in the art of northern Europe from the 15th cent. and shows the Virgin and Child surrounded by numerous members of this sizeable family. Those of Christ's generation are depicted as young children, watched over by their mothers, the three Maries. They may have the attributes by which they are identified as adult figures. The latter are accompanied by their husbands. Anne may also be present, sometimes with no less than all her three husbands. Elizabeth and John the Baptist may be present too. The theme died out with the Council of Trent.

(*d*) 'Virgin and Child with St Joseph.' The group to which the term Holy Family is most often applied. The cult of Joseph began to be promoted from the latter part of the 15th cent. from which time he features more frequently in devotional art. He is now less often the customary greybeard of the Nativity but begins to be portrayed as a younger man in the prime of life. The idea that this group formed an earthly trinity corresponding to the heavenly TRINITY of Father, Son and Holy Ghost was developed by devotional writers of the 16th cent. and later, particularly by the Jesuits. The two Trinities would be represented together in such a way that the one figure of Christ served for both. The background of domestic life features increasingly in later painting. The mother is sitting with a book or needlework in her lap and Joseph, the carpenter, is at his workbench. Both perhaps turn to gaze at the Infant lying in its cradle. Or all three sit at table taking their meal. A note of symbolism may be introduced with a chalice and bread on the table to suggest the Eucharist, or by some indication that the timber on the workbench will be used to fashion a cross. The group in an outdoor setting often resembles the Rest on the FLIGHT INTO EGYPT, but may be distinguished from it by the absence of baggage or a beast of burden.

Virginia (Livy 3:44–58; Valerius Maximus 6:1). A case of corrupt justice defeated, from the legendary history of ancient Rome. Appius Claudius, a decemvir – one of a board of ten legislators dating from the 5th cent. B.C. – secretly desired a virgin, the daughter of an honourable centurion. He conspired with one of his dependents to obtain her. The man was to lay claim to the girl as a former slave

and bring the case before Appius who would give judgement in the dependant's favour. So it fell out, not without an outcry led by Virginia's betrothed. But before the girl could be led away her father snatched a knife from a butcher's shop and stabbed her to death. The theme occurs in Italian Renaissance and baroque painting, and shows Appius on the judgement seat. Before him is the centurion about to stab his daughter. Appius' fellow conspirator may be recognized among the soldiers and women who are present.

Virgo (zodiac), see TWELVE MONTHS.

Virgo Lactans, see VIRGIN MARY (6).

Virgo Sapientissima, see VIRGIN MARY (1).

Virtues and Vices. The human figure, generally female and with identifying attributes, personifying an abstract concept, was well known in classical antiquity. The idea was taken up by the early Church which used it to teach a moral lesson by representing virtues and vices in conflict. This is seen in the *Psychomachia*, a long allegorical work by the 4th cent. Spanish poet Prudentius, which describes a series of single combats, Faith against Idolatry, Chastity against Lust, Patience against Wrath, Pride against Humility and so on, in which the virtues all finally triumph. The influence of Prudentius is found in Christian art until the 13th cent. Gothic sculpture commonly represents a virtue treading the appropriate vice, human or animal, beneath her feet. The canon of principal Christian virtues in the Middle Ages was made up of the three 'theological virtues' faith, hope and charity (I Cor. 13:13), and the four 'cardinal virtues', justice, prudence, fortitude and temperance. The latter were formulated by Plato in the *Republic* (4:427 ff) as the virtues required of the citizens of the ideal city-state. The Fathers of the Church sanctioned them for Christians: they were the benefits to be derived by man from the Eucharist. The cycle of seven virtues, sometimes paired with appropriate vices (not necessarily the seven Deadly Sins), was widely represented in medieval sculpture and fresco, often associated with the Last Judgement (Giotto, Scrovegni chapel, Padua). From the Renaissance they are usually found as separate figures, CHARITY and JUSTICE being the commonest. The vices particularly singled out for the Church's condemnation were LUST and AVARICE, and both are therefore frequently depicted. There was in addition a large family of minor virtues whose more important functions were the glorification of popes, kings and princes, both in life and death, and the celebration of public events. They are found less often in museums and galleries than on the ceilings and walls and in the sculpture of churches, palaces, public buildings and on funerary monuments.

The Renaissance saw a great secularizing movement in moral allegory. Artists from now on made use of the deities of classical mythology and the heroes and heroines of ancient history, especially Roman, to personify moral qualities. Thus, in a combat of Ratio and Libido, we have Apollo, Diana and Mercury fighting on the side of Reason, while Cupid, Venus and Vulcan are on the side of the passions. The choice between the paths of duty and pleasure are represented by a theme such as HERCULES (21) at the crossroads, or the dream of SCIPIO (2), an elegant development of the same idea. At a more mundane level Constancy is personified by MUCIUS SCAEVOLA, conjugal fidelity by AGRIPPINA or ARTEMISIA, justice by Cambyses (JUDGEMENT OF C.) and others, filial piety by AENEAS (1) rescuing his father, Cimon and Pero (ROMAN CHARITY), CLEOBIS AND BITO, and so on. Such subjects were not always confined to easel painting and sculpture. Allegories of love and chastity and other aspects of woman's relationship to man are found on Renaissance bridal chests (*cassoni*) or on the trays on

which food was brought to women at childbirth (*desci da parto*). Tapestry, used in the Middle Ages and Renaissance as wall-hangings in both ecclesiastical and domestic buildings, likewise presented moral exemplars to man in the surroundings of his daily life. In the 17th cent. the ceiling of a palace was often painted to extol the qualities of prince and cardinal by the use of the classical gods and goddesses and the conventional personifications of the virtues.

In representing the classical pantheon and the anonymous females that stood for the virtues and vices Renaissance and baroque artists had available for their guidance a number of dictionaries of mythography which appeared towards the close of the Middle Ages and later. Their authors drew on antique and medieval sources, adding their own, often fanciful, explanations of the emblems they were presenting. One of the most scholarly and influential was Cesare Ripa's *Iconologia*, published in 1593, and written not in Latin but Italian. It ran into many editions and was widely translated. It describes in detail, often with illustration, the proper attributes belonging to each personification, not only of virtues and vices but the four elements, the seasons, the parts of the world, the Liberal Arts and so on. Ripa's work determined the character of a large part of religious and secular allegory in the 17th and 18th cents.

Vision of the unclean beasts, see PETER, apostle (9).

Vision of the Virgin, see VIRGIN MARY (intro.).

Visitation. The visit of the Virgin Mary to her cousin Elizabeth, just after the Annunciation, is told by Luke (1:36–56). Their meeting was one of mutual rejoicing: Mary had conceived and Elizabeth was in the sixth month of pregnancy after a lifetime of barrenness. (Her child was John the Baptist.) The theme occurs in the cycle of scenes of the life of the Virgin, and is found also as a separate subject. In Gothic art the two generally greet each other formally with a bow; the Renaissance shows them in the act of embracing. Later works, particularly after the Counter-Reformation, treat the theme devotionally, showing Elizabeth kneeling in homage before the Virgin. The scene is usually in the open before the house of Zacharias, the husband of Elizabeth. She is portrayed as an elderly matron in contrast to the youthful Virgin. The women may be alone or, especially in 16th cent. Venetian painting, accompanied by two men: Zacharias, who was high priest of the Temple, wearing vestments, and Joseph, the husband of Mary. More rarely Mary Clopas (or Cleophas) and Mary Salome are present. (See VIRGIN MARY, section 17 (*c*) The 'Holy Company'.) The Byzantine painters' guide states: 'Behind them a little child with a stick upon his shoulder, at the end of which a basket is hanging. On the other side is a stable. A mule is tied to it and feeds.' These reminders of the Virgin's journey are occasionally found in the early Renaissance.

An attempt was made in early Christian art to represent visually Christ's Incarnation in the womb. It took the form of a small effigy of a child, as it were a foetus, usually framed in a medallion or MANDORLA, affixed to the Virgin's body. Called the 'Platytera', it appeared first in Byzantine art of the 5th or 6th cents and spread to the West in the later Middle Ages, especially Germany, in scenes of the Annunciation and Visitation. The women may each be shown with a manikin-like child lying against her breast or against the curved drapery covering her belly. The tiny figures may even be seen exchanging greetings. The motif excited some disapproval among churchmen and with rare exceptions died out during the 15th cent.

Volumnia, see CORIOLANUS.

Vortumnus, see VERTUMNUS.

'Vox clamantis in deserto,' see JOHN THE BAPTIST.

'Vox litterata et articulata . . . ,' see Grammar, one of the SEVEN LIBERAL ARTS.

Vulcan (Gk Hephaestus). In Greek and Roman mythology the god of fire (the volcano takes its name from him), and the blacksmith who forged the weapons of many gods and heroes. He was the educator of primitive man, and taught him the proper use of fire. He was the son of Jupiter and Juno. He was married to Venus who made a cuckold of him. (See VENUS, 8.) He was crippled from birth, or as a result of being thrown down to earth from Olympus by Jupiter in a fit of anger. He is seen in his forge standing at the anvil, hammer in hand, perhaps with a crutch under one arm or in an awkward posture because of his deformity. His assistants are the Cyclopes, the one-eyed giants, brawny men usually depicted with normal eyes, who tend the furnace or wield hammers. Helmets, breastplates and weapons forged by Vulcan lie about on the floor. As Hephaestus he was worshipped with Athene (Minerva) at Athens as the protector of craftsmen, and the two are portrayed together in this context. In allegories of the FOUR ELEMENTS Vulcan personifies Fire. His chariot is drawn by dogs.

1. *The finding of Vulcan.* When he was thrown down from Olympus, Vulcan landed on the island of Lemnos in the Aegean where he was looked after by the inhabitants. He is shown being helped to his feet by one of a band of nymphs.

2. *Venus in Vulcan's forge.* In the *Aeneid* (8:370–385) Virgil tells how Venus asked Vulcan to make a set of armour for Aeneas, her son, when he was about to go to war in Latium. The outcome of Aeneas' victory was the founding of a Trojan settlement on the Tiber from which, according to the legend, the Romans were descended – hence the significance of the occasion for the Italian Renaissance. The scene is Vulcan's forge where Venus stands watching, accompanied by Cupid. Another scene shows her handing over the arms to Aeneas. (Vulcan is also depicted forging the wings of Cupid in the presence of the infant God and Venus.)

3. *Thetis in Vulcan's forge.* Thetis, the mother of the Greek hero Achilles, went, like Venus, to Vulcan to ask him to make armour for her son. In the *Iliad* Homer describes in detail the wonderful craftsmanship with which it was wrought (18:368–616). The scene is very similar to the last, but can be distinguished by the absence of Cupid. Vulcan may be in the act of handing over Achilles' shield to Thetis.

See also APOLLO (2); PROMETHEUS (2).

Vulture. One or two vultures tearing at the liver of a naked man, TITYUS.

Walk to Emmaus, see JOURNEY TO EMMAUS.

Wallet, or scrip, hanging from the shoulder or from his staff is an attribute of the PILGRIM. The shoulder-bag, used when begging alms, is the attribute of the Capuchin FELIX of Cantalice. PERSEUS carried a magic wallet in which he kept Medusa's head.

Wand. A flowering wand, or rod, is the attribute of AARON and of JOSEPH, husband of the Virgin. At the MARRIAGE OF THE VIRGIN the unsuccessful suitors hold wands, one of whom may be seen breaking his wand across his knee. MOSES (9) causes water to issue from a rock by striking it with his wand. A wand is the attribute of Grammar personified, one of the SEVEN LIBERAL ARTS, who uses it to chastise her pupils. A magic wand belongs to the sorceress CIRCE. See SCEPTRE for the symbol of authority; also CADUCEUS and THYRSUS.

Warrior. Apart from the saint in armour, the individual soldier may be represented in secular themes not only fighting but sleeping, engaged in making love, threaten-

ing rape, and other unwarlike activities. The warrior is not always of the male sex. The following may be distinguished.

Warrior saints. With an anvil, ADRIAN; martyr's palm, banner of Resurrection, ANSANUS (especially Sienese); falcon at wrist, BAVO; stag, EUSTACE; millstone, perhaps a bucket, FLORIAN (German); slaying a dragon, GEORGE; a dragon, or crocodile, belongs also to THEODORE; bunch of keys, HIPPOLYTUS; on horseback, with lance or pyx, LONGINUS; standing with sword, or shield and lance, DEMETRIUS; holding cloak and drawn sword, MARTIN of Tours; martyr's palm, banner with eagle, red cross on breastplate, MAURICE; receiving the monk's habit from an abbot, WILLIAM of Aquitaine. A winged warrior is the archangel MICHAEL.

Fighting, or otherwise aggressive. On a bridge, warding off the enemy, HORATIUS COCLES; two on a bridge wrestling, one naked, ANGELICA (4); slaying a sage, ARCHIMEDES; on a white horse, slaying Saracens, JAMES THE GREATER (2); slaying a dragon, PERSEUS (2); ANGELICA (1); centurion about to stab a maiden before a judge, VIRGINIA; in a bedchamber threatening a naked woman with his sword, RAPE OF LUCRETIA; Greek soldier with raised sword about to sacrifice a maiden before a tomb, POLYXENA, SACRIFICE OF; maiden in encampment, threatened by archer, URSULA; several soldiers attacking women and children, Iron Age: AGES OF THE WORLD; similar, infants only slain, MASSACRE OF THE INNOCENTS; DAVID (4) and Goliath. See also BATTLE, SCENES OF.

Sleeping warriors. In a tent, guarded by a soldier, angel overhead, CONSTANTINE THE GREAT (1); beside a river, a woman kneeling by him, RINALDO AND ARMIDA (1); a woman hammering tent-peg into his head, SISERA, SLAYING OF; under a tree, a woman proffering sword and book, another a sprig of myrtle, SCIPIO (2); several round a tomb, HOLY WOMEN AT THE SEPULCHRE and RESURRECTION.

The warrior as lover. Reclining, sometimes asleep, his weapons having been laid aside become the playthings of amoretti, VENUS (8) and Mars; holding a mirror to his mistress, RINALDO AND ARMIDA (4). CUPID (5) as Love the Conqueror vanquishes a soldier.

Female warriors. MINERVA; Bellona, the sister of MARS; FORTITUDE personified; a dying female in armour attended by another, a male, TANCRED AND CLORINDA; female warrior among shepherds and basket-makers, ERMINIA AND THE SHEPHERDS.

A soldier kneeling before Christ, CENTURION'S SERVANT, CHRIST HEALS THE; kneeling before a fleece spread on the ground, GIDEON'S FLEECE; rending his clothes, met by a maiden, JEPHTHAH'S DAUGHTER; accompanied by Mercury, ULYSSES; abasing himself before a shrouded patriarch, phantoms hovering, WITCH OF ENDOR; on horseback, leaping into a pit, MARCUS CURTIUS; blind and begging, BELISARIUS; throwing his sword into a scale-pan, BRENNUS; placing his hand in a brazier, MUCIUS SCAEVOLA; gazing on a woman's body lying on a couch, NERO BEFORE THE BODY OF AGRIPPINA; two, covertly watching nymphs in a pool, RINALDO AND ARMIDA (3); three facing an old warrior who holds raised swords, HORATII, OATH OF THE; several sprouting from the earth, CADMUS; a group consisting of a warrior, a child, a lover and a grey-beard stand for the FOUR AGES OF MAN.

See also ACHILLES; AENEAS; ALEXANDER THE GREAT; CAESAR; CLEOPATRA; CORIOLANUS; GERMANICUS, DEATH OF; JOSHUA; SABINE WOMEN; TROJAN WAR.

Way of the cross, see STATIONS OF THE CROSS.

Weapons collectively feature in allegorical themes. In a 'Vanitas' picture they signify that arms afford no protection against death. The figure of PEACE sets fire to a heap of weapons, or breaks them under her chariot wheels. VICTORY reclines on a heap of armour and weapons. They are the attribute of Europe,

one of the FOUR PARTS OF THE WORLD, denoting her skill in the military arts; of the female personifying the warlike Iron Age, one of the AGES OF THE WORLD. CUPID (5) standing triumphant over weapons or playing with them symbolizes war overcome by love; as does the scene of VENUS (8) and Mars together, amoretti playing with his weapons. Weapons lying in a blacksmith's forge, VULCAN. See also individual weapons.

Web. A spider's web, a woman weaving at a loom or changing into a spider, Minerva present, ARACHNE.

Wedding at Cana, see MARRIAGE AT CANA.

Wedding Feast, see ROYAL WEDDING.

Wedding of the sea. The ceremony of the 'Sposalizio del mare' was performed at Venice on Ascension Day. It was the most brilliant of a number of annual Venetian festivals and took the form of a grand procession of boats, led by the doge in the state barge, the Bucintoro (or Bucentaur). Out at sea the doge ritually cast a ring into the water, saying, 'Desponsamus te, mare', – 'We wed thee, O sea'. The ceremony was inaugurated probably in the 12th cent. in memory of a victory in war, and came to be regarded as a symbol of the un-challenged position of Venice as a maritime power. The Bucintoro was a stately galley lavishly ornamented with gold, and may have derived its name from a figurehead that was half man and half bull. Its appearance in the 18th cent. is well known from Canaletto's paintings ('Ascension Day Fete', Royal Coll., Windsor).

Wedding of the Virgin, see MARRIAGE OF THE V.

Well. A meeting place in biblical themes. Camels are watered at a well by REBECCA as Eliezer offers her jewels. JACOB (3) meets Rachel at the well where she has come to water Laban's sheep. The pit into which his brothers threw JOSEPH (1) may be represented as a well; nearby are the Ishmaelites and their camels. MOSES (4) waters the sheep of the daughters of Jethro at a well, or drives away the shepherds. Christ meets the WOMAN OF SAMARIA at a well.

Whale. The Bible describes the creature that swallowed the prophet Jonah simply as a 'great fish'. Artists would in any case be generally unfamiliar with the appear-ance of a whale. In primitive Christian art where the theme of Jonah is chiefly found the fish is represented as a kind of sea-dragon or perhaps a hippocampus, occasionally a dolphin.

Wheat and the tares (Matt. 13:24–30 and 36–43). Christ's parable of the farmer who sowed a field of wheat, but while he slept his enemy came and sowed darnel, a grass-like weed, among the corn. The farmer let the field grow before separating the good from the bad so that he might more easily distinguish them. The interpretation, given by Christ to the disciples: the enemy was Satan; the good and bad seed, the righteous and sinners; the harvest was the Last Judgement, the time when the reapers, or god's angels, would come to separate the chosen from the damned. The scene is a field across which a sower stealthily makes his way while under a nearby tree the farmer and his men are sleeping.

Wheel. The attribute of Dame FORTUNE, denoting her instability, and of Inconstancy personified who may be seen in opposition to FORTITUDE. The punishment of IXION was to be bound to a fiery wheel. A wheel, perhaps double and having eyes in the rim, from the vision of EZEKIEL (1:1–28), forms part of the imagery of angels or of the throne of God. A wheel usually broken and studded with spikes is the attribute of CATHERINE OF ALEXANDRIA; a wheel with candles set round the rim, of DONATIAN.

Whip. One of the instruments of the Passion, from Christ's FLAGELLATION. It is

sometimes the attribute of the penitent MARY MAGDALENE, VINCENT OF SARAGOSSA and the Agrippine SIBYL. A pair of saints, one with a whip, the other a sword, are GERVASE AND PROTASE. A whip with three knots is the attribute of AMBROSE who may be depicted scourging the Arians. It is found in the hand of Grammar, one of the SEVEN LIBERAL ARTS, for the correction of her pupils. Christ brandishes a whip in the scene of the CLEANSING OF THE TEMPLE.

Widow's mite (Mark 12:41–44; Luke 21:1–4). A poor widow came to the Temple at Jerusalem and placed her last two coins in the chest for offerings. Christ drew the disciples' attention to her act, saying that the woman's gift was worth more than the large sums given by the rich because her sacrifice was greater. The scene is the interior of the Temple. Christ sits in the foreground addressing the disciples and pointing to a woman dressed as a widow who is placing a coin in a coffer. The presence of a richly attired woman, whom we may presume has just given her offering, rounds off the story.

Wild Man ('Homo silvestris'). In appearance the Wild Man is a human being covered with long shaggy hair. His weapon is a wooden club. He is confined with few exceptions to the secular art of northern Europe, and appears first in illuminated MSS at the end of the 13th cent. He is seen on French ivories of the 14th cent. and became widely popular on tapestries of the 14th and 15th centuries. The Wild Man's origins are uncertain but probably lie in western medieval man's beliefs concerning certain monsters that were ultimately based on his rather vague conception of the ape. The Wild Man symbolized lust and aggression in contrast not so much to the established Christian virtues as to the kind of spiritual love embodied in chivalry. He is thus seen in cycles of scenes battling with a knight, abducting the lady, but in the end being overcome. He is more commonly to be found fighting other monsters such as the unicorn, or among his own kind in the woods, often with a female, or at work, or sometimes dancing.

William of Aquitaine (Lat. Gulielmus; Fr. Guillaume) (died *c*. 812). Warrior saint, a duke of Aquitaine who was converted to Christianity by St Benedict of Aniane. He fought the Saracens, and after his conversion retired to a Benedictine monastery. He is depicted receiving the monk's habit from Benedict. He puts aside his armour as he kneels before the enthroned abbot. As a devotional figure he is dressed either in armour, or in the Benedictine habit with armour and a crown lying beside him.

Windmill. A knight tilting at a windmill, perhaps tumbling from his horse, DON QUIXOTE (3). Youths and maidens playing with toy windmills, an allegory of Air, one of the FOUR ELEMENTS.

Winds. Regarded in antiquity as divinities who controlled the fortunes of seafaring men. They were therefore propitiated by sacrifice (see IPHIGENIA). They were four in number (*Met*, 1:52–68). Their master was the god AEOLUS who kept them locked in a cave. In medieval and Renaissance art the winds are conventionally portrayed as bodiless heads, blowing with puffed cheeks. In subsequent Italian painting they may blow on a horn or conch. Two in particular are individually personified, the mild West Wind, or Zephyr, the husband of FLORA, and the aged BOREAS, the cold North Wind. A bodiless wind-god blowing the clouds is the *impresa* of Ranuccio Farnese, Duke of Parma (1569–1622), with the motto 'Pellit et attrahit', – 'He drives off (evil) and attracts (good)'. (Farnese Palace, Rome.)

Wine and bread are together the eucharistic elements (see LAST SUPPER; MASS) and may be represented symbolically as a glass or jug of wine and a loaf of bread, as in the SUPPER AT EMMAUS or STILL LIFE. The classical god of wine was BACCHUS.

His festivals, the Bacchanalia, were scenes of drunken revelry (see ANDRIANS). Wine spilling from a broken glass is an attribute of BENEDICT. See also GRAPE; VINE; REPAST.

Wine-press, Mystic. St Augustine likened Christ metaphorically to a cluster of grapes from the Promised Land which had been put under the wine-press. He was alluding to two passages from the Old Testament: the two men sent ahead by Moses to spy out the land of Canaan, who cut a bunch of grapes and carried it back on a pole (Num. 13:17–29); and the passage from Isaiah (63:1–6) describing the avenging God of Israel treading the oppressor nations in the wine-press of his wrath. The mystic wine-press finds visual expression particularly in French stained glass of the 16th cent. It depicts Christ kneeling under a press, a basin ready to receive his blood. Or the blood already flows and is gathered in barrels. The cross may be transformed into a press, the *stipes*, or upright post, having a spiral thread. The subject thus presented in a very literal manner the Catholic doctrine of the 'Real Presence' at the Eucharist. The theme of the grapes borne on a pole has its place in Christian art as a prefiguration of Christ on the cross. Moses' two spies carry a pole between them resting on their shoulders; from it hangs a huge bunch of grapes. Poussin (Louvre) used the motif to represent Autumn, one of the FOUR SEASONS.

Wings. The Greek and Roman messengers of the gods, VICTORY, MERCURY and IRIS, were winged, the descendants of very ancient pre-classical winged figures. From the stately Roman Victory was derived the image of the ANGEL, the Christian messenger of God, first seen in 6th cent. mosaics. The archangels GABRIEL, MICHAEL and RAPHAEL in common with other categories, or choirs, of angels are depicted with wings. (It may be noted in passing that the authors of the Old Testament, as is several times borne out (e.g. TOBIAS), envisaged the angel as indistinguishable from a human being and therefore presumably wingless.) Among the classical winged figures represented in the Renaissance and later are FAME (with trumpets), HISTORY (writing on a tablet), PEACE (with a dove), FORTUNE (blindfold, with a globe), the somewhat similar NEMESIS and numerous virtues and vices. Because they go fleetingly wings are given to FATHER TIME and OPPORTUNITY. NIGHT, who flies with two infants in her arms, or sits in the lamplight, is winged; the seated Melancholy (FOUR TEMPERAMENTS) is also sometimes winged. A figure reaching upwards with a winged hand is POVERTY. Winged sandals and head-dress are the attribute of PERSEUS who borrowed them from Mercury. The head-dress of both likewise has wings. DAEDALUS fashions wings with which he and his son ICARUS fly from Crete. CUPID and the PUTTO are winged.

Winter personified, see FOUR SEASONS.

Wisdom (Lat. *Sapientia*). In medieval religious allegory the figure of Wisdom has a BOOK and sometimes a SNAKE. The latter is also the attribute of PRUDENCE who sometimes replaces Wisdom in cycles of the virtues. Prudence, who might be thought of as wisdom in action, is the lesser virtue: 'How much better than gold it is to gain wisdom (*sapientiam*), and to gain discernment (*prudentiam*) is better than pure silver.' (Ps. 16:16.) In Renaissance allegory Wisdom becomes secularized. She is usually personified by MINERVA, in armour with spear, helmet and shield, and is thus distinct from Prudence who has a MIRROR and snake but is without martial features. Wisdom in the shape of Minerva has her OLIVE branch and OWL, and a book; the last may be offered for her perusal by Cupid.

Wise and foolish virgins (Matt. 25:1–13). The parable of the maids of honour who, according to eastern wedding custom, accompanied the bride to the house of the groom. Five of the ten maids had imprudently failed to provide themselves

with oil. When the groom arrived at midnight the five wise virgins entered the house, but the foolish, who had meanwhile gone to buy oil, returned later to find the door closed against them. By this parable Christ was warning his listeners to be in a state of preparedness for the Second Coming whose hour could not be foretold. As symbols of the Chosen and the Damned the virgins are often found in medieval representations of the Last Judgement, especially in the sculpture of French and German Gothic churches. The wise are seen being received at the gate of heaven by Christ or St Peter; the foolish knock in vain or are turned away, perhaps by St Paul, and descend into the jaws of Leviathan. The wise may be represented in the TRIUMPH of Chastity.

Witch of Endor (I Sam. 28). On the eve of a battle with the Philistines, Saul, the king of Israel, feeling himself forsaken by God in a critical hour, consulted a necromancer, the witch of Endor, to know what the future held. He commanded her to call up the spirit of the prophet Samuel who, during his lifetime, had been Saul's mentor and the grey eminence behind the throne. Samuel, the last Judge of the Israelites, had himself anointed Saul as their first king. In a cantankerous mood at being recalled from the Shades, Samuel foretold the worst, that neither Saul nor his sons would survive the morrow. In the ensuing battle his three sons were slain and Saul, wounded, threw himself on his own sword rather than meet death at the hands of the uncircumcised. Saul is shown on his knees before Samuel who rises, shrouded, from the earth, while spectral monsters float in the gloom. Necromancy, the art of prophecy by calling up the spirits of the dead, was widely practised in the ancient world. It had been expressly banned by Saul in the earlier and more prosperous days of his reign, but the Israelites showed a tendency to relapse into heathen practices in times of adversity. (Salvator Rosa, Louvre.)

Wolf. Sacred to both APOLLO and MARS in antiquity and hence, occasionally, their attribute. Wolves may draw the chariot of the latter. The wolf was honoured by the Romans because ROMULUS and Remus, the children of Mars and legendary founders of the city, were suckled by a wolf. The Middle Ages made the wolf a symbol of evil in a broad sense, because of its fierceness, cunning and greed; and, more specifically, of heresy. In Dominican painting of the 14th cent. dogs (*Domini canes*) are seen attacking wolves. It is sometimes the attribute of GLUTTONY. A well-known legend, often depicted, tells of the wolf of Gubbio, tamed by FRANCIS OF ASSISI. It is occasionally his attribute. A wolf's head forms part of a tricephalous monster symbolizing PRUDENCE.

Woman observed, always by men; she is more often nude and frequently bathing. A simple theme but, in the case of the Old Testament examples, given a typological gloss by the pious. Maiden bathing in garden, watched covertly, or approached, by two elders, SUSANNA. Woman bathing in her chamber, usually watched by a king and another from balcony, DAVID (7) and Bathsheba. Woman attired, bathing feet in pool, perhaps observed by a priest and others (Dorothea), DON QUIXOTE (6). Goddess and nymphs in a grotto, perhaps bathing, discovered by a hunter, Actaeon, DIANA (3). Nymphs spied upon by SATYRS. Woman in bedchamber, disrobed, spied upon by two concealed men, GYGES IN THE BEDCHAMBER OF KING CANDAULES. Gaggle of maidens by the roadside pointed out by old man to youth, GEESE OF BROTHER PHILIP. Princess and attendants picnicking, or washing clothes, approached by unkempt, naked man, ULYSSES (5) and Nausicaa.

Woman of Samaria (John 4:1–30). On the way from Judaea to Galilee Christ paused to rest by the spring called Jacob's Well outside the town of Sychar in Samaria. A Samaritan woman, an adulteress, who came to draw water was

astonished at his request for a drink, not only because it would not be the custom for a Jew to address a strange woman but because of the traditional hatred between Jews and Samaritans which extended, John tells us, to their not using vessels in common. Christ used the occasion to teach in metaphor: 'Everyone who drinks the water will be thirsty again, but whoever drinks the water I shall give him will never suffer thirst any more.' The disciples, returning from the town, were surprised to find Christ talking with a woman. The scene is a well, often under a shady tree, where Christ is sitting. He is in conversation with a countrywoman who has a pitcher. In Italian art the woman is occasionally portrayed richly dressed with braided hair and perhaps one breast bare, the conventional attributes of the courtesan. In the background are the walls of the town. The disciples are seen approaching along a road.

Woman taken in adultery (John 8:2–11). While Christ was teaching in the Temple at Jerusalem the Pharisees brought to him a woman who had been caught in the act of committing adultery. Under Mosaic law the punishment for the offence was stoning, but the Roman authorities had deprived the Jews of the power to impose the death penalty. What did Christ have to say, the Pharisees wanted to know, hoping to trap him into an answer that would offend either their own or Roman law. Christ bent down and wrote with one finger in the dust, and then said, 'That one of you who is faultless shall throw the first stone'. At this the woman's accusers went away mortified, and when they were alone Christ forgave her with the words, 'You may go; do not sin again'. John gives no explanation of Christ's writing on the ground though a medieval tradition had it that he was noting down the sins of the Pharisees. Artists depict various moments in the story. We see the woman brought before Christ by her accusers; he is sitting down with perhaps the apostle John beside him. Or he bends over writing with a finger on the floor; the Pharisees lean forward to read. Or we see their backs as they make their way out. The woman may have braided hair and usually has one breast bared, the usual attributes of the courtesan. One of the Pharisees may hold a book (the Ancient Law), or may have a stone in his hand.

Woman with an issue of blood (Matt. 9:20–22; Mark 5:25–34; Luke 8:43–48). Among the throng surrounding Christ as he was on the way to the house of Jairus (see below) was a woman suffering from a chronic haemorrhage. She unobtrusively touched the hem of his robe as he passed by, and was instantly cured. But Christ was intuitively aware of what she had done and turned to her, whereupon the woman threw herself at his feet. 'My daughter, your faith has cured you. Go in peace.' The scene is the entrance to Jairus' house. The woman kneels at the feet of Christ, one hand touching the edge of his garment. Jairus, a venerable, grey-bearded figure, stands beside him together with the disciples PETER, JAMES and JOHN. The subject may form a pendant to the RAISING OF JAIRUS' DAUGHTER, the episode that immediately follows in the gospels.

Women at the sepulchre, see HOLY WOMEN AT THE SEPULCHRE.

Wrath (Lat. *Ira*). One of the seven Deadly Sins, represented regularly in the cycles of VIRTUES AND VICES in medieval sculpture, but otherwise a somewhat infrequent figure in allegory. The common type, that of a wrathful person attacking a defenceless innocent, is found in all periods. The weapon is a DAGGER or SWORD and is brandished either by a warrior, a bandit or the conventional female. The victim, especially in medieval religious allegory, is often a monk. The figure of Wrath also occurs as one of the FOUR TEMPERAMENTS, and in either case has a LION for attribute. (See INNOCENCE.)

Writer. A pen and inkhorn, sometimes with a book, are the attributes of the four

evangelists and of several Doctors of the Church renowned for their writings, in particular AUGUSTINE, BERNARD of Clairvaux and THOMAS AQUINAS. Depicted in the act of writing are MATTHEW, an angel dictating his words; MARK, taking down the words of a preacher (St Peter); LUKE, a winged ox beside him; JOHN THE EVANGELIST (2) seated in a rocky desert, an eagle beside him. JEROME, with cardinal's hat and lion, sits in his study. GREGORY THE GREAT has a dove at his ear inspiring his words, as do the nuns TERESA, and BRIDGET of Sweden. The latter more often receives dictation from an angel. BERNARD has before him a vision of the Virgin. At the birth of JOHN THE BAPTIST (2) the old Zacharias sits writing. Christ writes with his finger in the dust watched by Pharisees and others, WOMAN TAKEN IN ADULTERY. The allegorical figure of HISTORY writes on an oval shield or tablet. 'Writing on the wall', at an eastern banquet, see BELSHAZZAR'S FEAST. See also TABLET.

Yew, see FLORA (2).

Yoke. The attribute of OBEDIENCE personified. It has the same meaning when placed by an abbot on the shoulders of a kneeling monk. A yoke was the *impresa* of some of the Medici family. Pope Leo X (Giovanni de' Medici) adopted it with the motto 'Suave'. ('Jugum enim meum suave est' – 'For my yoke is good to bear', Matt. 11:30).

Zacharias, high priest, see JOHN THE BAPTIST (1, 2).

Zaleucus, see JUDGEMENT OF Z.

Zeno (died *c*. 372). Bishop of Verona where a fine Romanesque church is dedicated to him. He was celebrated as a preacher and his sermons have been preserved. He is depicted as an old man, dark-skinned since he was born in Africa, and wearing episcopal robes and a mitre. His peculiar attribute is a FISH that dangles from the top of his crozier, from the popular tradition that he enjoyed angling. In early Renaissance painting he is seen exorcizing the daughter of the Emperor Gallienus; a demon issues from her mouth in the conventional manner.

Zenobius (died *c*. 417). A nobleman who was converted to Christianity as a young man and became bishop of Florence. He was a friend of AMBROSE. According to legend he had exceptional powers of restoring the dead to life and is often thus depicted in Florentine Renaissance painting. The favourite theme shows him in the street reviving a child that had been run over by an ox-cart. As the coffin of the saint was being borne to the cathedral it happened to touch a dead tree which immediately sprang into leaf; the present baptistery traditionally marks the site. Zenobius is portrayed as an elderly bishop. He occasionally has for an attribute a flowering TREE, or holds a model of the city of Florence. The fleur-de-lys, the emblem of Florence, may be seen in his halo, on the morse of his cope, or on a book. He is often grouped with the other patron saints of Florence and of Florentine families, JOHN THE BAPTIST, COSMAS AND DAMIAN and LAURENCE.

Zephyr, see FLORA (1).

Zeus, see JUPITER.

Zeuxis paints Helen. Zeuxis, the famous Greek painter of antiquity, made a picture of Helen (by reputation one of his greatest works) for the temple of Hera (Juno) at Agrigentum or, some say, at Croton. According to Pliny (*Nat. Hist.* 35:36) and others he had the maidens of the neighbourhood stripped for his inspection and, taking the most flawless part of the body of each, executed a composite picture. He is depicted working at his easel while the girls disrobe and await their turn. A similar story, represented in much the same way, was told of Apelles painting a picture of Diana of Ephesus,

Zodiac, signs of, see TWELVE MONTHS.

Icon Editions

74 75 76 77 10 9 8 7 6 5 4 3 2 1